TRAJECTORIES

Over the last forty years, cultural studies has persistently questioned cultural relations of power and has been a major force in the critical intellectual tradition. As the twentieth century draws to a close, cultural studies is undergoing a critical phase of transformation at local, national, regional and international levels.

Trajectories brings together critics, not only from countries such as America, Canada and Australia, which have a known cultural studies tradition, but from the East-Asia locations of Hong Kong, Korea, Singapore, Taiwan, The Philippines, Indonesia and Thailand. *Trajectories* constitutes a critical confrontation between the imperial and colonial co-ordinates of north and south, east and west. Without rejecting the Anglo-American practice of cultural studies, the contributors present critical cultural studies as an internationalist and decolonized project.

Trajectories links critical energies together and charts the future directions of the discipline. The contributors discuss subjects such as Japanese colonial discourse, cultural studies out of Europe, Chinese nationalism in the context of global capitalism, white panic, stories from East Timor, queer life in Taiwan and new social movements in Korea. The book ends with an interview with Stuart Hall.

Contributors: Ien Ang, Beng-Huat Chua, Budiawan, Hsiao-Hung Chang, Leo Ching, Renato Constantino, Ken Dean, Yung-Ho Im, Stuart Hall, Ichiyo Muto, Wing-Sang Law, Ding-Tzann Lii, Meaghan Morris, Stephen Muecke, Ashis Nandy, Cindy Patton, Mark Reid, Naoki Sakai, Ubonrat Siriyuvasak.

Editor: Kuan-Hsing Chen is Professor of Cultural Studies and co-ordinates the Center for Asia-Pacific/Cultural Studies at the National Tsing Hua University, Hsinchu, Taiwan. He is co-editor of *Stuart Hall: Critical Dialogues in Cultural Studies*.

CULTURE AND COMMUNICATION IN ASIA
Edited by David Birch
Deakin University, Australia

TRAJECTORIES

Inter-Asia Cultural Studies

Edited by
Kuan-Hsing Chen

with Hsiu-Ling Kuo, Hans Hang
and Hsu Ming-Chu

London and New York

First published 1998
by Routledge
11 New Fetter Lane, London EC4P 4EE

Simultaneously published in the USA and Canada
by Routledge
29 West 35th Street, New York, NY 10001

© 1998 Kuan-Hsing Chen editorial and selection. Individual contributors
own contributions

Typeset in Bembo by M Rules
Printed and bound in Great Britain by
TJ International Ltd, Padstow, Cornwall

British Library Cataloguing in Publication Data
A catalogue record for this book is available from the British Library

Library of Congress Cataloguing in Publication Data
A catalogue record for this book has been requested

ISBN 0 415 15324 7 (Pbk)
ISBN 0 415 15279 8 (Hbk)

CONTENTS

CONTENTS

LIST OF CONTRIBUTORS

Ien Ang is Professor of Cultural Studies at the University of Western Sydney, Nepean, Australia. Until 1990 she lived and worked in Amsterdam, the Netherlands, and lectured in various departments at the University of Amsterdam. Her most recent book is *Living Room Wars: Rethinking Media Audience for a Postmodern World*.

Budiawan is a student of Development Studies, Postgraduate Program, Satya Wacana Christian University, Salatiga, Indonesia.

Hsiao-Hung Chang is Professor of English at the National Taiwan University at Taipei. She is the author of *Postmodern/Women: Power, Desire and Gender Performance*; *Gender-Crossing: Feminist Literary Theory and Criticism*; *Sexual Imperialism: Gender, Race and Sexuality in the British (Post)Colonial Text*; and *Queer Desire: Gender and Sexuality*.

Kuan-Hsing Chen is Professor of Cultural Studies and the Coordinator of the Center for Asia–Pacific/Cultural Studies, National Tsing Hua University, Hsinchu, Taiwan.

Leo Ching is an assistant professor in Japanese Literature in Asian and African Languages and Literatures at Duke University. He has published articles on popular culture and colonial/postcolonial discourse. He is working on a book-length manuscript on the cutural ideology of 'dôka' (assimilation) in colonial Taiwan.

Beng-Huat Chua is currently Associate Professor of Sociology at the National University of Singapore. His most recent book is *Communitarian Ideology and Democracy in Singapore*. In addition to academic writings, he is a frequent contributor of social and political commentaries to the Singaporean national media.

Renato Constantino is Professor of History at the Philippines University. The authority on Filipino History, he has published over forty books.

Kenneth Dean is Associate Professor in the Department of East Asian Studies of McGill University in Montreal, Canada. His writings include *First and Last Emperors: The Absolute State and the Body of the Despot* (co-authored with Brian Massumi), *Taoist Ritual and Popular Cults of Southeast China*, *Epigraphical Materials on the History of Religion in Fujian* (co-edited with Zheng Zhenman), and the forthcoming *Lord of the Three in One: The Spread of a Cult in Southeast China*.

Stuart Hall is Professor of Sociology, Open University.

Hans Tao-ming Huang, who helped with editing the book, is a PhD student at Sussex University.

Ming-Chu Hsu, who helped with editing the book, is an MA student in the Department of Foreign Languages in the National Tsing Hua University, Taiwan.

Yung-Ho Im is Assistant Professor of Communication at Pusan National University in Korea. He got a PhD from the University of Iowa. His research interests include critical communication theories, social theories and critical approaches to the media industry and labor. He edited and translated some of Stuart Hall's early articles into Korean.

Hsiu-Ling Kuo, who helped with editing the book, is a postgraduate student of Art History at Warwick University.

Wing-Sang Law is a lecturer in General Education at Lingnan College, Hong Kong. He is one of the project leaders in the Program for Hong Kong Cultural Studies hosted by Humanities Institute at the Chinese University of Hong Kong. He is conducting research on political discourses and the formation of citizenship in Hong Kong.

Ding-Tzann Lii is Associate Professor in the Institute of Sociology and Anthropology at National Tsing Hua University in Taiwan. He is doing research on 'political possibilities of radical democracy' and 'the historical meaning of colonialism'.

Meaghan Morris is a critic, teacher, and independent thinker, based in Sydney.

Stephen Muecke is Professor of Cultural Studies at the University of Technology, Sydney. He is co-editor of *The UTS Review*, and author (with K. Benterrak and P. Roe) of *Reading the Country: Introduction to Nomadology*.

Ichiyo Muto is a member of the board of councillors of the Pacific-Asia Resource Center of which he was one of the founders. He has taught at the State University of New York at Binghamton as Visiting Professor since 1982; is a Council member of the People's Plan for the Twenty-first Century (PP21), and is a preparatory committee member of the Institute of People's Plan.

Ashis Nandy is a psychologist and political theorist who is Fellow and Director of the Center for the Study of Developing Societies in Delhi. Among his books are *At the Edge of Psychology, Alternative Sciences, The Intimate Enemy, The Illegitimacy of Nationalism, The Savage Freud and Other Essays on Possible and Retrievable Selves*.

Cindy Patton is Assistant Professor of Lesbian and Gay Studies at the Graduate Institute of Literal Arts at the Emory University, Atlanta. She is the author of many books and essays in cultural aspects of the AIDS pandemic, most recently, *Fatal Advice: How Safe Sex Education Went Wrong*.

Mark A. Reid is Associate Professor of English and Film at the University of Florida, Gainesville. He is the author of *Redefining Black Film, Post Negritude Visual and Literary Culture*, editor of *Spike Lee's 'Do the Right Thing'*, and co-editor of *Le cinema noir americain*.

Naoki Sakai is Professor of Asian Studies at Cornell University. He has published many books in English as well as in Japanese. His most recent publication is *Translation and Subjectivity – on Japan and Cultural Nationalism* (1997).

Ubonrat Siriyuvasak is a lecturer in Media Studies and Broadcasting at the Faculty of Communication Arts, Chulalongkorn University. Her interests are popular culture, public media and policies, and women and media.

TRAJECTORIES
Series Editor's Foreword

Critical scholarship in cultural and communication studies world wide has resulted in an increased awareness of the need to reconsider some of the more traditional research practices and theoretical/analytic domains of arts, humanities and social science disciplines, towards a recognition of the differing imperatives of what critical studies of culture and communication might look like in an Asian context. The demands for research materials, undergraduate textbooks and postgraduate monographs grow and expand with this increased critical awareness, while developments across the world continue to recognize the need to situate work in communication and cultural studies on and in Asia within a more global framework.

This series is designed to contribute to those demands and recognition. It is aimed at looking in detail at cultural and communication studies from critical perspectives which take into account different 'Asian' imperatives. In particular, it focuses on work written by scholars either living in or working on the region, who have specific interests in opening up new agendas for what constitutes critical communication and cultural studies within and about Asia. The overall aims of the series are to present new work, new paradigms, new theoretical positions, and new analytic practices of what might often be traditional and well established communication and cultural activities and discourses.

The theoretical direction of the series is principally targeted at establishing these new agendas and by critically reflecting upon the appropriateness, or otherwise, of theories and methodologies already well established, or developing, in cultural and communication studies across the world. Having said this, however, the series is not aimed at producing a monolithic blueprint for what constitutes critical cultural and communication studies in or about Asia. Neither is there a specific agenda for what the series might consider to be an appropriate critical cultural and communication studies for Asia.

The series is not, therefore, designed to create an orthodoxy for 'Asian' communication and cultural studies, but to open up new ways of thinking and rethinking contemporary cultural and communication practice and analysis in the arts, humanities and social sciences. The series is aimed to counter, as much as possible, those essentialising processes of colonialization, marginalization,

and erasure, which have taken place in the past by the unproblematized imposition of Western theory upon cultures, societies, and practices within, and on behalf of, Asia.

Many of the books in this series may not necessarily fit comfortably into traditional disciplines and paradigms of Asian studies or cultural and communication studies, and nor are they intended to. The main aim of the series is for all of its books to argue for a diversification and opening up of existing theoretical positions and specific discourses across a wide range of texts, practices and cultures. All of the books in the series will be positioned to argue persuasively for the development of studies in culture and communication which are able to frame critical commentary through theoretical and analytic practices informed first and foremost by a concern with Asian cultures and discourse.

The series has as its fundamental premise a position which argues that analysts can no longer operate as neutral, disinterested, observers of some 'reality' which supposedly pre-exists the discourses that they are analysing. To be critical necessarily means to be self-reflexive. In that sense, then, the series is designed to position cultural and communication studies in and about Asia as critical disciplines which require, within their own practices, an approach to developing some sort of praxis that enables the work that we do as analysts to significantly contribute to political, social, and cultural discourses and awareness, at both the local, regional, and global levels.

Series Editor: David Birch, Deakin University, Australia

Editorial Advisors
Ien Ang, Murdoch University, Australia
Tony Bennett, Griffith University, Australia
Kuan-Hsing Chen, National Tsing Hua University, Taiwan
Jae-Woong Choe, Korea University, Korea
Chua Beng-Huat, National University of Singapore, Singapore
Lawrence Grossberg, University of North Carolina, Chapel Hill, USA
Sneja Gunew, University of Victoria, Canada
Annette Hamilton, Macquarie University, Australia
Ariel Heryanto, Universitas Kristen Satya Wacana, Indonesia
Masao Miyoshi, University of California, San Diego, USA
Yoshinobu Ota, University of Kyushu, Japan
Gyanendra Pandey, University of Delhi, India
Ubonrat Siriyuvasak, Chulalongkorn University, Thailand
Panuti Sudjiman, University of Indonesia, Indonesia
Trinh T Minh-ha, University of California, Berkeley, USA
Yao Souchou, Institute of Southeast Asian Studies, Singapore
Robert Young, Wadham College, Oxford, UK

PREFACE
The Trajectories Project

This volume grew out of the two international cultural studies conferences, organized by the Center for Asia-Pacific/Cultural Studies, and the Institute of Literature (dismantled in 1995), National Tsing Hua University, Taiwan, in July 3–22, 1992, and January 6–15, 1995, and later known as the Trajectories project.[1] The first conference, entitled, 'Trajectories: Towards A New Internationalist Cultural Studies', aimed to reflect on the histories and politics of cultural studies and to investigate cultural production and consumption in various local contexts. The second one, 'Trajectories II: A New Internationalist Cultural Studies Conference', centering on 'Nationalism, Transnationalism, Neo-Colonialism and Post Nation-State Imaginary in the Age of Global Capital – The Transformation of Cultural Power in Taiwan, the Third World and the Asia-Pacific', investigated the colonial questions which have generated the contemporary rise of nationalism and then proceeded to locate practices, sites and strategies of resistance in the social movement sector.

The Trajectories project was initiated essentially out of a local concern. Perhaps, it was not a historical accident that the Trajectories project was initiated from the geo-political space of Taiwan. The shifting of gravity of the global economy towards the Asian continent, heralded by Japan in the 1980s, was later amplified by the so-called four tigers: Hong Kong, Taiwan, Korea, Singapore. East Asian economic growth reached its peak at the end of the 1980s and early 1990s, and has subsequently been overtaken by the rise of the 'next generation' – the four dragons, Thailand, Malaysia, Vietnam and Indonesia. It is already on the way to the Chinese mainland and will last for at least the next two or three decades. From the late 1980s to the mid 1990s, Taiwan was resourceful enough to attract not only international capital but also academic visitors from the outside, especially after the lifting of martial law in 1987, with the decline of the authoritarian regime. Suddenly, Taiwan became the unexpected site for international gatherings.

But the great local transformation since 1987 has gradually come to an end. A new nation-building and state-remaking project has been pursued by the Taiwan state. This change somehow coincides with the great transformation of Asia, the Third World, and the structure of global capitalism in the so-called

'post Cold War Era'. (This proved to be a problematic enunciation. Since the missile crisis between the US and China over the Taiwan Strait in March 1996, China has formally replaced the USSR as the latest cold war 'other' to the US imperial power.) Ambiguities, ambivalence, and uncertainty forced us to re-examine local and global situations. What do these transformations at various local, national, regional, international, and global levels mean? How do we place 'Taiwan' in these contexts? Does the contemporary rise of nationalism, not only in Taiwan but also in geopolitical sites such as South Africa, Eastern Europe, Quebec, Korea, throughout Southeast Asia and, prominently but largely unpronounced in the US, the EC and Japan indicate a different strategic maneuvering? What are the mechanisms of nationalist discourse operating within each specific context of the nation-state? Do nationalism and transnationalism feed into each other, and fail to function apart? Does this forecast the global rise of racism? What are the changing hierarchical structures of neocolonialism? Are we coming to a ruptural moment of capitalist formation? Or, is this a deepening of the long-term historical configuration? Can we, by working collectively, map out a more dynamic direction for the new world? Can we begin to think and propose new strategies moving beyond the boundaries of the nation-states by constructing an alternative cultural imaginary? What are the future possibilities for popular democratic culture throughout the world? For better or worse, we can be sure of one thing: we are facing a new reality and a new world (though for sure it's not a complete rupture and radical discontinuity), and there is an urgent necessity to understand the world in different terms, more flexible, more dynamic, and more explanatory. This set of problematics and concerns was the driving force behind the Trajectories project.

In spite of the limited resources (connections, financial constraints, etc.), the Trajectories project was able to bring together an international group of scholars associated with the intellectual project of cultural studies, coming from different geographical locations (Australia, Belgium, Canada, Hong Kong, India, Indonesia, Japan, Korea, Netherlands, Nigeria, Philippines, Singapore, South Africa, Taiwan, Thailand, UK, and the US), belonging to different generations, with different ethnic, racial, sexual and ideological subject positions. The conference participants were largely composed of organic-specific intellectuals involved not only academically but also politically at various levels and locations, and who are willing and understand the necessity to engage in genuine debate and dialogue beyond regional, national, sexual, racial and ethnic boundary lines.

Obviously, it is impossible at this point to reconstruct the intellectual mood of the conferences; and beyond that, various cultural forums organized during the first conference for the visitors to meet and discuss with musicians, film directors, and aboriginal, feminist, and labor activists as well as diverse intellectual groupings such as the editorial board members of *Taiwan: A Radical Quarterly in Social Studies* and of *Isle Margin*. Debates and disagreements were heated and conducted in an often antagonistic but also friendly mode. Through

these two and other international conferences, I myself, for one, realized that the most difficult boundaries to cross at this point in history are the regional, national, and sexual ones, largely due to the history of colonialism and systems of homophobic patriarchy. In these contexts, academic and otherwise, one is immediately positioned as someone 'representing' one's nation-state or sexual preference, regardless of holding a similar pan-leftist political position.[2] It is my conviction that the 'colonial' systems of capitalism, the nation-states, patriarchy, heterosexuality are yet to be decolonized. In some ways, what was presented and discussed at the conferences can be seen as operating within the problematic of decolonization effects. In short, the project of decolonization has to be pushed further, and this volume contributes to that.[3]

Despite the conflicts, contradictions and antagonisms played out in the process, the Trajectories project occupied certain unprecedented positions in the history of cultural studies. First, these were the first cultural studies conferences that took place outside the English speaking world.[4] The project opens a chapter in the history of critical cultural studies as an internationalist project. It constitutes a friendly but critical confrontation between 'East' and the 'West', the 'South' and the 'North' (all of which were once products of colonial encounters and the imperial imagination), among other co-ordinates. The very fact of the East Asia location of the conferences and of most participants coming from the Asia-Pacific region has in effect changed the received notions of cultural studies, or to use a fashionable term, 'provincialized' but not excluded Anglo-American practices. Beyond the mainstream recognition of the 'rise' of the region, this project hoped to generate critical accounts of local/regional transformation in the Inter-Asia region, definitely not a celebratory kick-out.

Second, to displace the pure ritual of academic–professional conferences, the two events not only gave enough time to individual presentations but focused on critical dialogues and discussions afterward. At the first conference, for instance, sessions could last for three or four hours. Enthusiastic questions and discussions came from the floor indicating that certain concerns can be shared, if one wishes to walk out of one's own little ghetto. Collectively, we hoped to demonstrate that intellectual work can be conducted in a more dialogic and less individualist way. For instance, Meaghan Morris and Cindy Patton's presence at the two conferences drew crowds from the local lesbian and feminist communities, despite the fact that the speakers were coming from the 'outside' and had to operate at the peak point of the nativist movement.

Third, various attempts to problematize the historical formations of cultural studies in different geo-political contexts and to address urgent issues emerging in the uneven globalization process will hopefully open the eyes of international readers. All these participants are coming from 'the local' but with a sense of the international/global. This is very different from the familiar type of knowledge production, which is either assuming one's context and theoretical framework to be somewhat universal or dominantly important and hence with no sense of one's own limited position, geographical or otherwise; or completely going

nativist, with no sense of the infiltration of global political and economic forces.[5] Most importantly, all these original contributions to the volume addressing various urgent issues, timely subjects and theoretical interventions could possibly generate further debates over the politics and directions of cultural studies.

As Jon Stratton and Ien Ang put it in a recent essay, the Trajectories project might be 'arguably the most subversive' of the recent conferences/events in cultural studies.[6] Whether the Trajectories project does have that 'subversive' effect remains to be seen, contingent upon the future trajectories of cultural studies. It also remains to be seen whether it will continue to take on the incomplete project of critical cultural studies as part of the global decolonization movement, or will be incorporated into the mainstream academic milieu.

Now, with the publication of this book, the Trajectories project is formally finished. But relationships among participants connecting to the Trajectories project have not come to an end. Trajectories contacts, I would hope, will start to sneak into other projects, producing unpredictable lines of flight.

KHC

NOTES

1 The original plan was to include the discussions which were most interesting. But the struggle for the past several years to search for such publishers failed. Not only entire discussions but also several papers already published elsewhere have had to be sacrificed.

2 It's less so with class differences, though the location of one's country in the hierarchical structure of global capital matters.

3 For detailed arguments, see my, 'Decolonization and Cultural Studies', *Taiwan: A Radical Quarterly in Social Studies*, no. 21, 1996: 73–139; and 'Decolonising Nationalism, Nativism and Civilisationalism', forthcoming.

4 My sense is that cultural studies as an international 'movement' is here to stay. Unlike other academically fashionable enterprises which came and left the scene, cultural studies, perhaps due to its concern with the social and the political has 'moved' concerned intellectuals to hang on to the project. As far as I know, there have been similar kind of new formations in this part of the world such as in Hong Kong, Japan, Singapore, Korea and even China. One of the landmark events was the Tokyo Conference – 'Dialogue with Cultural Studies', jointly organized by the Institute of Socio-Information and Communication Studies of the University of Tokyo and the British Council, in March 1996.

See Naoki Sakai's interview with Stuart Hall in this volume.

5 I have addressed these issues of the ignorance in the context of US knowledge production, which always takes for granted its own local-ness, but wants outsiders to 'contextualize' for the 'local' readers. See, 'Not Yet the Postcolonial Era: the (Super) Nation-States and Trans*nationalism* of Cultural Studies, *Cultural Studies* 6(1): 37–70.

6 See Jon Stratton and Ien Ang (1996), 'On the Impossibility of a Global Cultural Studies: "British" Cultural Studies in an "International" Frame', in David Morley and Kuan-Hsing Chen (eds), *Stuart Hall: Critical Dialogues in Cultural Studies*, London: Routledge, pp. 361–91.

ACKNOWLEDGEMENTS

This book is dedicated to the late Professor Edward T. Ch'ien (1940–96), a renowned Chinese intellectual historian. Edward supported the Trajectories project on various levels, even when he was away from Taipei, teaching in Hong Kong University of Science and Technology. Only after the event, I realized that he came back the second time to join Trajectories II Conference in January 1995 debilitated by cancer. Without his intellectual vision and unfailing support, I could not have organized these two seemingly impossible events. This project has been carried out in the critical spirit of Professor Edward T. Ch'ien.

I have been living with the project for the past six years or so, from organizing the first conference, to the present state of wrapping it up. The infinite process of micropolitical negotiation; the infinite anxiety of waiting for funding to come in; the infinite emotional ups and downs; the infinite postponement with getting a book contract. (In 1992, one of the interested publishers responded that if we got rid of the Asian names, then they would do it. Three years later, that became almost the reverse. The world certainly changed.) Now, the infinity seems to to come to an end. While I am writing, bits and pieces of the event come back to me as both nightmarish and joyous images.

I must first thank the funding sources which all came locally and provided the material basis to make the two conferences possible.

Far Eastern Memorial Foundation generously funded the first conference, and became the backbone of the second one. Without the Foundation's sympathetic support, it would have been impossible to complete the project.

Besides Professors Chu Yang, Chang Han-liang, Chen Chang-fan and Wang Chiu-Kuei, and Mr. Ching Heng-Wei who helped with locating part of the funding, and Mr. Fu Yiao-hsoing for contributing timely funds, I also wish to thank the following institutions:

Ministry of Education's Division for International Cultural and Educational
 Exchanges (twice)
National Science Council (twice)
Cultural and Education Foundation of the Shih-Hua Bank (twice)
Outdoor Life Magazine

Council for Cultural Construction
Government Information Office
China Times Publishing Company
The Cultural Foundation of the China Times
Pacific Cultural Foundation
ROC Association for Comparative Literature
ROC Association for English and American Literature
Research Center for Gender Studies, and the Department of Foreign Languages
 and Literature, National Tsing Hua University
Yuan-Liou Publishing Company
Australian Trade and Industry Office in Taiwan
Eslite Bookstore
Kuei-ling Bookstore
AL'AROMA CAFE

My comrades and colleagues Chen Tsung-shing and Yu Chi-chung helped locating funding and chasing up the problems in the two conferences. Rather than giving up on my instability, they protected and encouraged me over several years. Lu Cheng-hui, our drinking friend, then the co-ordinator of the Center for Asia-Pacific/Cultural Studies, and Lii Ding-tzann helped tremendously during the second conference. My special gratitude goes to all four of them. Members of the Center, Chyuan-yuan Wu, Wen-Li Soong, Ping Hui Liao, Daiwie Fu, among others, and the then co-ordinator of the Center for Gender and Society, Hsiao-ching Shieh, contributed as much.

The conferences could not operate without the enthusiastic efforts of friends and former students of mine to take on detailed work. Hisu-Ling Kuo and Hans Tao-ming Huang helped organizing two conferences, and further with transcribing the discussions (which eventually cannot be included here) and editing the present volume, later joined by Hsu Ming-chu. I thank them for their infinitely detailed efforts put into the project, and for their forgiving my incapability to be an efficient 'boss'. Chang Chi-ming and Wang Wen-chi helped twice with computer technology and documenting the events with videos as well as solidarity. For the first conference, I thank the meticulous efforts of Liu Yan-yu, Chen Li-ru, Ku Ming-chun, Sun Chia-shui, Feng Shu-cheng, Liao Ying-liang, Chiang Hui-shien, among others, and the artist Cheng Chun-dien for designing the posters. For the second conference, I thank Hsu Wei-chen, Yao Li-chung, Bai Hui-juan, Cheng Wei-jun, Lin Cheng-lun, Hsu Wei-chuan, among others, and my friend Huang Ma-li for designing the poster.

Former National Tsing Hua University president, now director of the National Science Council, Dr. Liu Chao-shien, and the former dean of academic affairs, now president of Ching Yi University, Dr. C.T. Lee, Professor Po-wen Kuo, then the dean of the College of Humanities and Social Sciences, and Professor Tsai Ying-chun, then the director of Institute of Literature have all encouraged and supported the events.

Beyond thanking contributors to the present volume, I would also like to thank Professors Tony Bennett and Renato Constantino for delivering keynote speeches to the two conferences, Meaghan Morris and Cindy Patton for presenting intriguing papers in both events, and Masao Miyoshi and Ashis Nandy for their special efforts to join us. I also wish to acknowledge many respected senior professors, friends and colleagues who helped and participated in the processes. For their support in chairing sessions or responding to the papers and presenting the papers which could not be included in the volume, I thank Professor Hsu Cheng-Kuang, Chu Wanwen, Louise Edwards, Ying-hai Pan and Chang Mau-kuei (Academia Sinica); Professor Han-liang Chang, Professor Yeh Chi-jeng, Hsiao-hung Chang, Liu Yu-hsiou, Sebastian Hsien-hao Liao (National Taiwan University); Naifei Ding, Josephine Ho, Karl Ning, and Wenchi Lin (National Central University); C.S. Feng, Fang-Mei Lin, and Li-Hsin Kuo (National Chengchi University); David Wang and Colleen Lye (Columbia University); Myung Koo Kang (Seoul National University); Stephen Chan (Hong Kong Chinese University); Fred Chiu, Siu Keung Cheung, and Luk Take Chuen (Hong Kong Baptist University), Marshall Johnson (University of Wisconsin); Brian Massumi (Australia); Roger Bromley (Nottingham Trent University, UK); Sandra Buckley (Griffith University, Australia); Kang Chao and Yuan-horng Chu (Tung Hai University); Zeo Tang (then with National Chung Cheng University); Kueifen Chiu (National Chunghsin University); Tani Barlow (University of Washington, Seattle); Briankle Chang (University of Massachusetts) who joined us twice in Taipei; Ray Jing (National Film Archive); Professors Chou Ying-shung and Ku Yenlin (National Chiao-tung University); Michael M. Cheng and Ru-Shou Robert Chen (Fu Jen University); Ming-chun Lee (Harvard University); Lucy Chen (UCLA); Surichai Wun'Gaeo (Chulalongkorn University, Thailand); André Frankovits (Human Rights Consultant, Australia); Kin-chi Lau (Lingnan College, Hong Kong); Hui shin Lun (Hong Kong University); Eric Louw (Rand Afrikaans University, South Africa); Chris Berry (La Trobe University, Australia); Paul Willemen (BFI); Obi Igawara (Warwick University); Chen Yingzhen (Ren-Chian Publisher); and Naoki Sakai (Cornell University).

The editors of *Isle Margin, Con-temporary, Awakening, China Tribune, China Times, New Left Review, Boundary 2,* and *Cultural Studies* generously offered space for publicity or reported the events. I also thank David Pickell and Wang Wen-chi for designing the publicity for journals.

I thank Meaghan Morris, Larry Grossberg, Sandi Buckley, Brian Massumi, Tani Barlow, Paul Willemen, Masao Miyoshi, Dave Morley for their help with finding an English publisher as well as for their support. Consultations with these friends in various stages made the project more of an international undertaking. Cindy Patton kindly offered strategies for organizing the shape of the book.

I single out and thank Victoria Smith and Rebecca Barden for their in-house help.

During the events, Wan Ping and Ni Chia-jane helped picking up and dealing with small holes; I thank them for their support from outside the academic context.

Lastly, I must once again thank Naifei Ding for living through the difficulties of these moments; without her support, I could not have survived.

1

THE DECOLONIZATION
QUESTION

Kuan-Hsing Chen

Problematics

Rediscovering the culture of 'Ours'?

This introductory chapter is a small theoretical exercise to trace selective episodes of responses to colonialism in the era immediately following the end of World War Two, essentially concerned with the problems *within* the (ex-) colonies, in order to situate the essays in the book. From the point of view of the history of a global decolonization movement (within which cultural studies has featured), the contemporary moment of the (ex-)colonies is still one of a process of decolonization, and in at least three connected but convolute forms: nationalism, nativism, and civilizationalism. All three of these forms have been endorsed but at the same time critically cautioned against by earlier analysts. Fanon's critique of nationalism in the 1940s and 1950s, during the peak points of the Third World independence movement, Memmi's questioning of nativism during the 1950s and 1960s, and Nandy's revitalization of a critical traditionalism (which I shall later describe as civilizationalism) some twenty years after the formation of India, are all connected to and emerged in response to what Young (1990) calls the West, what Sakai designates as 'the putative unity called the West' (1988: 477), or what Hall (1992) succinctly articulates as 'The West and the Rest'. But why, thirty or forty years later, are we (who live in the (ex-)colonized globe) still deeply shaped by the questions posed by our fore-runners in the critical tradition? Well, because of the neocolonial structure. We have been 'made' to identify with intellectual formulations coming from the (ex-)imperial centers, and hence have completely forgotten the powerful inter-ventions made by Fanon, Memmi, or Nandy. A sad story. If we had 'listened' carefully to them, we might have been better placed not to continue making the same mistakes. It is never too late to listen though. The problem is whether we have the desire to reconnect to the discursive formulations so as to empower ourselves and others.

This desire to retrieve the forgotten tradition of 'cultural studies' as practiced and produced outside the imperial center also has its own conjuncture: it

1

happens in an intense moment of this so-called post-cold war era when all of us are forced to walk out of our own little disciplinary ghettoes and geographical sites in order to more adequately respond to the questions of globalization and subsequent regionalization posed by the imperatives of transnational and global capitals. Under the fashionable sign, cultural studies, we might be able to get the necessary work done; at the same time, we might also be able to change the terrain of dominant cultural studies practices (which have run into a moment of crisis – depoliticization, dehistoricization and lack of sense of vision). The long term structural transformations from territorial colonialism to neocolonialism under the stamp of globalization signal the shifting gravity of capitalism. From Western Europe to the Atlantic and North America to the so-called Asia-Pacific, the entire Inter-Asia continent emerges as the forefront and site for political and economic struggles (I take special note of the rather unexpected coinage of the term, Inter-Asia, which is inspired by the establishment of the Inter-America Cultural Studies Network, to designate the linkage between North and Latin America). Throughout the Inter-Asia region, there is a weird sense of 'triumphalism' directed against the 'West', despite 'internal' antagonisms: the twenty-first century is 'ours'; 'we' are finally centered. Wherever one is geographically positioned, there is an emerging, almost clichéd formula: 'Asia is becoming the center of the earth and we are at the center of Asia, so we are the world.' This is where history comes in. Contrary to the now fashionable claim that we have entered the postcolonial era, the mood of triumphalism as reaction and *reactionary* to colonialism indicates that we still operate within the boundary of colonial history which has generated a whole set of what I would call the colonial cultural imaginary in which all of us are caught up. Triumphalism, one must point out, can be a foundational desire, preparing for the coming of the next wave of imperial colonialism. My own concern with decolonizing the cultural imaginary can thus be located at this general level: unless the cultural imaginary we have been living with can be decolonized, the vicious circle of colonization, decolonization and recolonization will continue to move on.

Here, in this introductory chapter, as a continuing effort to push forward decolonization projects, a rather simple theoretical proposition is put forward: the history of colonial identifications has set limits on the boundaries of the local cultural imaginary, consciously or unconsciously articulated by and through the institutions of the nation-state, which in turn has shaped our psychic–political geography.

The intellectual trajectories and theoretical articulations that arrive at this understanding have by no means come out of the blue. Indeed, there exists a rich tradition of anti-colonial cultural discourse in the Inter-China context. The archetypes are Lu Xun's famous early twentieth-century novels *The Story of A–Q* and *The Diary of the Mad Man*, which constitute an analysis of the self-hatred of a Chinese personality (until recently these texts had been prohibited from circulation in Taiwan due to Lu Xun's leftist politics); and the Taiwanese

novelist Yang Quei's personal history documenting colonial encounters with the Japanese in the 1930s and 1940s, which is an imaginative attempt to forge a class-based alliance across borders. Instead of tracing that line of thought, which requires even more space and time, I wish to link a set of discourses on colonial identifications. Not surprisingly, the central mediating figure here is Frantz Fanon. But to identify Fanon's problematic, we have to situate him within the polemical context against which he formulates his thesis; and in a later moment of colonial history, within which Fanon's formulation is elevated to other levels of abstraction. Therefore, I will begin within O. Mannoni, mediating through Fanon's articulation of 'colonial identification', and then move on re-read Fanon, Memmi, and Ashis Nandy in the light of the critique of nationalism, nativism and civilizationalism, in order to establish more viable positions, built on this critical tradition. It will become clear that, in positioning cultural studies as a decolonization movement which attempts to disarticulate the colonialist and imperialist cultural imaginaries that are still actively shaping our present, this chapter attempts to retrace an alternative trajectory of critical discourses generated 'outside' the imperial centers. The works of Frantz Fanon, Albert Memmi, and Ashis Nandy are re-read in terms of the problematic of colonial identifications which govern the space of the cultural imaginary. In locating the epistemic limits of these positions which emerged in different historical moments of decolonization, this chapter then turns to make a 'reconstructive' (rather than simply 'deconstructive') attempt by proposing critical syncretism as a political strategy (or ethics) that would enable us to move beyond the identity politics of multiculturalism (on an 'international' level – the logic of 'peaceful co-existence') and towards a utopian mode of 'postcolonial' identification or postcoloniality.

Cultural studies and/as decolonization

Growing out of the histories of world-wide decolonization movements, cultural studies has become a major force continuing that critical intellectual tradition both within and outside academic contexts. Having persistently questioned cultural relations of power in local social formations for the past forty years, cultural studies is now undergoing a critical phase of internationalization. Such a transformation is occurring very much in response to the changing dispositions and structure of global forces such as the transnationalization of capital, the realignment of the nation-states into regional super-states in the so-called post-cold war era, as well as the implementation of the interconnected high tech systems such as satellites and the Internet which makes talking across borders more possible. To be sure, the umbrella term – globalization – constantly being used nowadays to describe the latest developments cannot be disconnected from the history of colonialism and neoimperialism, but is very much a product of it. It is increasingly felt and recognized by practitioners of cultural studies that local cultural production and consumption can no longer be adequately

placed and analyzed without linking it to the global circuits constituted by the long-term historical trajectories of geopolitics and neocolonial structures. A more collaborative, collective, and comparative intellectual practice may well be the possible mode of knowledge production to multiply the directions of knowledge flow, and to better understand the changing shape of the world, if interventions in the global–local dialectic can be more effectively inserted.

Epistemologically and politically, cultural studies is much more prepared than any other intellectual tradition to pursue this difficult task. Cultural studies, at least in the critical Althusserian–Gramscian–Foucauldian complex, has always recognized that 'theory' is not a universal set of formal propositions but an analytical weapon generated out of and in response to local–historical concerns. Cultural studies insists on understanding historical contingencies and local specificities. Therefore, it never pretends to a universality of cultural analysis and openly acknowledges the relative autonomy of cultures in different geopolitical locations. At the same time, the belief in producing organic intellectual work has put cultural studies in touch with the currents of social conflicts. Concerns of and interaction with social and political movements (anti-war, working class, subcultural, counter-cultural, women's, gays and lesbians, anti-racist, aboriginal, environmental, alternative media, national independence, etc.) have not only produced undeniable tensions which kept the energies of cultural studies alive, but forced cultural studies to recognize the 'common' structures of domination: capitalism, patriarchy, heterosexism, ethnocentrism, neocolonialism, etc. Although the specificities and intensities of oppression vary from place to place, gender, sexuality, race, ethnicity, and class have been the central co-ordinating categories across geographical, national, and regional boundaries. Thus the critical vein of cultural studies has at least in discursive practices tried to maintain an internationalist spirit to combat the globalized multiple structures of domination together. In this sense, 'cultural studies', rather than modelling itself on traditional academic disciplines of the past, attempting to produce universal knowledge, can perhaps be more productively seen as an open-ended force field or a banner attempting to gather committed intellectuals to form an alternative international community to facilitate dialogues across national, sexual and racial/ethnic divides without sacrificing local trajectories.

The internationalization of cultural studies at this moment has been largely perceived as a new intellectual practice within the English speaking world, especially in the UK, the US, Canada, Australia, and perhaps less so in India, and even less so in the other English-speaking (ex-)colonies, such as South Africa, the Philippines, Singapore, and Hong Kong which in fact have for some time now engaged with the cultural studies project, not to mention the long tradition of cultural criticism in various sites which prepare the coming of the sign, cultural studies. Indeed, if one positions cultural studies as part of a global decolonization movement, obviously critical cultural analyses and practices have been going on in different parts of the non-English-speaking globe. To break existing structures of intellectual production and to build a wider

4

network of communities, there have been projects, which I have been noticing, in the hope that the too often unattainable cultural analyses done outside the dominant knowledge production systems can be made available within and outside the marginal sites, through established multinational publishing channels. Though some of the results can be charged as 'Asia-Pacific-centric', the attempt is consciously made not to reproduce a 'postcolonial' *resentment*.[1] I am fully aware of the danger of 'oceanic imagination',[2] the shift from the 'Atlantic' to the 'Pacific', which is part of the 'imperialist globalization'[3] project backed up by the Super State, Asia-Pacific Economic Cooperation (APEC). But we should be careful not to essentialize the necessary belonging of the 'Asia-Pacific' to a postcolonialist and neoimperialist operation; doing so would give up the power of geographical imagination to the super states.

Decolonization and its discontents

Marxism, identity politics and decolonization

Increasingly, the politically relevant side of postcolonial studies has pushed us to the critical limit in its recognition that politics at this moment of history are about decolonization. Though there are tremendous problems with the current booming of a postcolonial cultural studies industry,[4] (problems which I call a trade off between 'diasporic opportunism and native collaborationism'),[5] important political gains can also be retrieved in it. Strongly put, if postcolonial cultural studies still has any political edge, it is to be found in 'decolonization' at different levels of abstraction and aiming at different axes of identity politics and different analytical sites. Much of the work done in the field has, however, concentrated on decolonizing the imperial centers. The seminal work of Edward Said, Gayatri Spivak, Stuart Hall, Paul Gilroy, and the recent critical work such as Robert Young's (1990) *White Mythologies*, Iain Chambers and Lidia Curti's (1996) collection on *The Post-colonial Question* and Stuart Hall and Paul du Gay's (1996) edited volume on the *Questions of Cultural Identity*, have projected a necessary desire against 'Euro/America-Western-centrism'. Beyond recognizing the power of these critical interventions, one cannot but ask what happens to the ex-colonies outside the empires, especially the non-English ones? Stuart Hall, at the 1996 Tokyo conference, 'Dialogue with cultural studies', openly acknowledged the over-privileging of the English colonial experiences. Publication in the studies of colonialism in Japan, for instance, have been overwhelming in the post World War Two era;[6] it could be argued that the question of coloniality and postcoloniality has been the preoccupation of postwar Japanese intellectuals. And because of the hegemony of the English language and the controlled circulation of publication, none of these grounded historical-cultural works has been read in different parts of the world. Furthermore, the mainstream postcolonial movement seems to operate by means of a politics of forgetting (the past as well the 'rest' – the non-English

ones), as if something genuinely new has just been discovered. While the body of Fanon was over-emphasized, one forgets his predecessors Aimé Césaire and O. Mannoni, and his inheritors such as Albert Memmi and Ashis Nandy, and especially the earlier anti-colonial or even 'anti-westerncentric' figures in the Japanese, Indian, Korean and Chinese speaking contexts: Kawakami Hajime and later Maruyama Masao, Tagore, and later Gandhi/Nehru, Yi Tonghwi and Kim Myongsik, Lu Xun and Yang Kuei, among others; as if only the Euro-American writing tradition counts. In short, a whole body of anti-colonial discourses of decolonization generated outside the imperial metropolis, from the nineteenth century onwards, somehow has to be re-articulated to re-build the 'counter-colonial' tradition. This immensely important task is, of course, beyond the scope of this volume. But perhaps, refocusing on the decolonization question as the key site of postcolonial studies could signal a step forward.

It is probably fair to suggest that the intellectual umbrella under which a global decolonization movement could be initiated began with Marxism. For critical intellectuals in different parts of the world, the resources of thought and theoretical weapons did not simply come from the violence of colonial experiences, but also from the decolonization forces within the empire. I very much doubt there have been any other critical forces more influential than Marxism, both in terms of political practices and intellectual thought. The purpose here is definitely not to catalogue an inventory of the success and failure of Marxism, but to situate it within the long-term history of decolonization.

When European colonial imperialism reached its peak moment, partly triggered by the Industrial Revolution to outwardly expand capitalism, Marxism (in the founding moment of modern critical identity politics) 'discovered' capitalism and its historical agent for change – the working class. This naming itself presupposed an enunciative position 'outside' capitalism, in the name of socialism or communism. This future oriented politico-cultural imagination targeted a radical deconstruction of the empire by capturing its working logic and went further to posit a utopian blueprint. The presence of this alternative way of thinking and a desire for a different world slowly accumulated noises within the imperial center for the following century and a half. Half a century later, the Russian revolution of 1917 pushed forward the imagination. Marxist revolutionary theory, for the first time, had been 'proved' not to be a daydream, and injected hope into the decolonization forces within the centers of the capitalist world. And more importantly, Marxism offered anti-colonial movements in the colonies an alternative choice to capitalism. For better or worse, success or failure, most nationalist independence movements had to negotiate the Marxist seduction. Although the statist politics of the first and second internationals proved to be reproducing certain feudal elements of its parts (i.e., the rigid structure of hierarchy), the cultural imagination of an internationalism lingers on. To re-evoke the Russian revolution today is obviously ironical: from the competition between two systems, to the formation of the 'three worlds', to the end of the Cold War, the socialist–statist castles (Cuba, China, Vietnam, North

Korea, for instance) have been gradually sucked into the magnetic field of 'global capitalism'. How is this episode of history to be written? The easiest way is to erase the entire century, as if it never existed. But from a different point of view, just like imperialism, Marxism has not yet been sentenced to death: its critical elements have been saturated into different geographical sites, and can always be called upon to deal with difficult uncertainty. Simply put, the tradition of Marxism has established an imaginary discursive position 'outside' capitalism from which to critique internal logics of the latter; these decolonization forces appear and reappear through articulation to other elements in different temporary/spatial contexts. Perhaps, what is important is that, once one jumps out of the statist–nationalist socialism trap, that is, one no longer sees the capturing of state power as the ultimate goal; the sites of projection for Marxist desire become omnipresent, even minutely, though this understanding is only meaningful when decolonization is seen as a permanent silent revolution.

Let me emphasize here that, for at least a century now, Marxism can no longer be seen as something coming from the outside and has become part of the cultural subjectivity of intellectuals outside the imperial centers. To claim Marxism as the property of the West is just like claiming that technology belongs to the essentialist West. The reason Marxism survives is precisely its heterogeneity and its articulation to local intellectual histories.

On a theoretical level, the Marxism of the nineteenth century was never able to rid itself of its eurocentrism, but in effect generated a whole series of decentering movements to be followed even until now. Historical materialism, in its battle with idealism, radically historicized human social activities and institutions, and saw capitalism as a product of history and hence able to be superseded. On the other hand, it inherited the evolutionary view of history from the Enlightenment tradition, using the narrative of a universal proposition to cover the entire geographical spaces. It was precisely in this contradiction that universalism started to crack, beginning to loosen up the confidence of the Universal Subject. The birth of multiple resisting subjects of a micropolitics, gradually emerging on the historical platform, theorized a century later by the Foucauldian power/knowledge complex, was a necessary theoretical conclusion through a re-interpellation of Marxism mediating through Nietzsche. The whole series of 'epistemological breaks' was unstoppable: capitalist class, first world, male, whites, heterosexuals, etc. could not escape the fate of being decentered. Capitalism, World System, patriarchy, racism, heterosexual regimes were then constantly 'born', which generated exploding effects, just as when Freud 'discovered' the unconscious. To replace geopolitics, these parallel axes have been the historical trajectories of decolonization movements 'internal' to the imperial centers; but once, these trajectories of identity politics are linked to the emerging globalization movement, different forms of identity politics generate symbolic impacts and alliances and transcend geographical boundaries and national spaces, despite local differences. That the feminist and gay and lesbian, bisexual and transsexual movements (somehow parallel to the earlier

class movement of international communism) staged in the center-cores have generated global effects of decolonization are cases in point.

If, in the imperial centers, movements of class, gender/sexuality, and race/ethnicity have been the critical effects of decolonization, present in the form of identity politics, then outside the imperial centers, in the colonies and ex-colonies, the dominant practices of identity politics of decolonization have presented themselves in three interconnected forms: nationalism, nativism and civilizationalism. My central concern here is not to celebrate these decolonization moves; in recognizing the historical contingencies of the empowerment elements, I wish to pinpoint their critical limits so as to push the incomplete project of decolonization forward.[7]

Before entering into the key sites of the problems, let me briefly lay out my guiding lines of movement: the question of colonial identification (à la Fanon).

Re-reading Fanon's colonial identification

The story of colonial psychology: Mannoni

In her fascinating PhD thesis, entitled 'Monsters and Revolutionaries: Colonial Family Romance and Métissage', Françoise Vérges argues that Fanon's 'decolonization of colonial psychology' has to be placed against a prior moment, that is, the French tradition of 'psychology of the people' of the nineteenth century. Its theoretical motives were to clarify the relationship between race, culture and psychology; its problematic was set in place to deal with the disorder of the 'dangerous classes': the working class, the poor peasantry and the vagabond. Toward the end of the nineteenth century, the psychology of the people was expanded to the colony. To be brief, the epistemological foundation of colonial psychology was the political unconscious of the family romance: the relation between the child and its parents. The colonized subject was essentialized as poor in linguistic expression, and lacking the capacity of clear conceptualization; they believed in supernatural powers and fatalism; all their knowledge came from blind faith in their ancestors' superstition, and hence the native could not mature into an adult. Therefore the colonizer's mission was to guide them into a mature adult world. Of course, the entire formulation hid behind the name of 'science'; the validity of the psychologist's observation was built on the guarantee of scientific neutrality.

The rupturing point of a decolonization of colonial psychology, according to Vérges, was marked by the appearance of Octave Mannoni's *Prospero and Caliban: the Psychology of Colonization*, published in 1950, soon after World War Two. The turning point lies in Mannoni's bringing the colonizer into the picture of colonial relations, and starting to address the psychological condition of the previously covered-up 'master'. Unlike the colonial psychologist whose central concern was the colony where the researcher's enunciative position was an absent presence in the name of science, Mannoni's target is now the

colonizer and presupposes a relation of mutually constituted subjectivity. From this point on, colonial 'relations' sharply come into the picture. Fanon's landmark text, *Black Skin, White Masks* (1952), further radicalizes psychoanalysis as a weapon for anti-colonial struggle. Albert Memmi's *The Colonizer and the Colonized* (1957), George Lamming's *The Pleasure of Exile* (1960), all the way to Ashis Nandy's *The Intimate Enemy: Loss and Recovery of Self under Colonialism* (1983), and Ngugi wa Thiong'o's *Decolonizing the Mind: The Politics of Language in African Literature* (1986), have followed the problematic of the relations between the colonizer and the colonized, a problematic opened up by Mannoni. One could easily bash the theoretical dangers of binarism and essentialism in these works by evoking a sliding hybridity and performativity; but one might also run the danger of erasing historical antagonisms as motors of struggle. Once these categories (the colonizers and the colonized) are not taken as ontological and transcendental givens, the problematic remains useful as a beginning point to open up a historical space of imagination.

Re-reading Mannoni half a century later, one has to position his discourse symptomatically; it is as much a text of the psychology of colonization as a self-analysis of the colonizer. Even though he was obviously against colonial exploitation and racial discrimination, his enunciative position as a colonial information officer, who attempted to account for the 1947 anti-colonial revolt in which more than one hundred thousand Madagascans were killed, could not do away with the epistemic limits of eurocentrism. The borrowed Shakespearean figures, Prospero and Caliban, framed his entire analysis. The question to be posed is, why did the anatomy of the colonialist self happen at this particular moment? Perhaps Mannoni's attempt can be positioned within the wave of the postwar decolonization movement. Mannoni's analysis prepared the colonizer to face the anxiety of having to leave the colony; the uncertainty and the nostalgia for lost colonial privileges during a transitional period paved the way for Mannoni's courageous confrontation with the situation of the colonizer.

The central thrust of Mannoni's argument is that the psychology of colonization can be explained as an encounter between two types of distorted personalities: the colonizer's 'inferiority complex' and the 'dependency complex' of the colonized, which are mutually complementary. His explanatory baseline is founded on evolutionism, a universal history modeled on a person's life history and then mapped onto the entire world as different stages of personality development. After a child is born, the story goes, s/he slowly experiences his/her dependency on his/her parents; material conditions of existence, processes of socialization and affective development, etc., all form a dependency relation with the parents. A dependency complex is gradually formed. The turning point comes with anxiety and fear of being abandoned by the parents. On the one hand, this anxiety can lead to a more mature and autonomous personality, moving towards a rational individualistic mentality; on the other hand, it can also cultivate a lack of self-confidence, an inferiority

complex. The latter is then transformed into an abandonment of the parents; an unconscious form of repressed guilt which can be remedied by dominating others. According to Mannoni, the colonizers who were sent to the colony express this form of personality while the 'natives' remain still at the stage of the child's dependency complex. When they meet each other, it quickly becomes a symbiotic relationship.

Throughout the book, this founding narrative is constantly invoked to explain, for instance, the act of colonial revolt as anxiety at being abandoned, or the native's lack of gratitude toward the whites as a dependency complex. Even in its narrative closure, 'what is to be done', Mannoni proposes that political power should be handed over to the Fokon'olona, the tribal meeting, symbolizing the parents, so as to avoid the native's trauma of being abandoned.

Obviously, one does not have to argue about the eurocentric view of history in which Europe has reached its adulthood and the rest of the world remains childish, because to do this falls into a reductionist and evolutionary view of the singularity of history. One does not have to argue either about Mannoni's psychologizing moves to justify and explain away colonial domination. Once his simple picture of the children's history of development is challenged, Mannoni's explanatory framework crumbles.

Fanon's colonial identification

Prior to Fanon, Aimé Césaire angrily attacked Mannoni's eurocentric superiority in his *Discourse on Colonialism*,[8] a text that served as an inspiration for Fanon's intervention. If one reads Mannoni as a self-analysis of the colonialist personality, then Fanon's *Black Skin, White Masks* is the self-portrait of the colonized.[9] For Fanon, neither dependency complex nor inferiority complex is the essence of the colonial relation; both symptoms were imposed on the body of the colonized as a result of economic control and exploitation (1952: 11). Therefore, the alienation of the black cannot be reduced to the question of individual psychology; it is the social structure that conditions the collective psychoanalytic structure, hence, to use his words, 'the black man must wage his war on both levels' (ibid.: 11).

In the opening pages of *Black Skin, White Masks*, Fanon lays out his simple but enormously important 'discovery': 'At the risk of arousing the resentment of my colored brothers, I will say that the black is not a man' (ibid.: 8); 'The black man wants to be white' (ibid.: 9); 'Black men want to prove to white men, at all costs, the richness of their thought, the equal value of their intellect' (ibid.: 10); 'For the black man there is only one destiny. And it is white' (ibid.: 10). The colonized wants to displace the colonizer, identifies with and wants to be 'him'. That is to say, the Black's 'proof' can only be validated through recognition by the whites. Fanon sees this demand of recognition as an impossible task, where a permanent crisis lies: the foundational logic of colonialism is racism, essentialized racialist differences which cannot be overcome, otherwise

there would be no colonialism. He says, 'I believe that the fact of the juxtaposition of the white and black races has created a massive psycho-existential complex. I hope by analyzing it to destroy it' (ibid.: 12). Language and sexual encounter become his sites of analysis.

To use contemporary language, the Fanonian problematic becomes: how is the black's colonized subjectivity formed? Why does the black skin have to wear white masks? In a four page footnote, Fanon explains, 'When one has grasped the mechanism described by Lacan, one can have no further doubt that the real Other for the white man is and will continue to be the black man – and conversely. Only for the white man The Other is perceived on the level of the body image, absolutely as the not-self – that is, the unidentifiable, the inassimilable. For the black man, as we have shown, historical and economic realities come into the picture' (ibid.: 161). The colonial history of economic domination has put the entire Symbolic Order in the hands of the white colonials; the defining agent of the ideological structure belongs to the colonizer. Although subjectivity is always mutually constituting, the position the whites occupy reduces and treats the black on the level of biological color; the bodily difference marks the boundary of the white subject. For the whites, this has nothing to do with history and economics, but is a 'universal' difference. Only when the black man leaves his body, and enters into the white Symbolic Order, can he become 'man'. The black's self-understanding is defined through the eyes of the whites; he is only a half-man, a partial subject; only by whitening himself, can he become man. In this structure of oneness, the defining agent himself is above categorization: 'white' is not colored, but above colors. This makes troublesome and challenging questions impossible to pose. Within this symbolic system, 'the negro symbolizes the biological'; he is phallus, athlete, boxer, military, animal, devil, etc. Wherever he goes, the black is black. Only by wearing a white mask, can he relieve his anxiety. Suffering a permanent lack, a permanent self-doubt, the black is permanently locked into the white jail.

Quite unlike Mannoni, Fanon proposes a more politically charged psychoanalysis. He argues, 'as a psychoanalyst, I should help my patient to become conscious of his unconscious and abandon his attempts at a hallucinatory whitening, but also to act in the direction of a change in the social structure' (ibid.: 100). To situate Fanon's proposal within the colonial context, one might ask: is it possible to insert his collective analysis into the public space under the colonial regime? It is obviously difficult. Does this difficulty suggest that cultural decolonization of the psychoanalytic sort is only possible after the collapse of the empire? Even with the departure of the colonizer, can a critical self-analysis possibly change the long-term implanted psychoanalytic structure? Is the colonial condition simply a racial divide based on economic differences? Fanon obviously realizes that there are multiple structures of domination; he argues, 'colonial racism is no different from any other racism,' and that 'All forms of exploitation are identical because all of them are applied against the same 'object' man' (ibid.: 88). Fanon's immediate concern is targeted at territorial

colonialism. But through analysis, he was forced to understand the existence of multiple structures of domination.

Fanon's discourse has been sharply criticized for his blind spots such as sexism and homophobia, but none of his critics is willing to abandon the problematic he opened up. In his hands, colonization has been reconfigured to refer to other domains of power, not just colonial racism. More recently, Diana Fuss, for instance, having attacked Fanon's homophobic stance, concludes,

> When addressing the politics of identifications, Fanon fails to register fully the significance of the founding premise of his own theory of colonial relations, which holds that the political is located within the psychical as a powerful shaping force. I take this working premise to be one of Fanon's most important contributions to political thought – the critical notion that the psychical operates precisely as a political formation. Fanon's work also draws our attention to the historical and social conditions of identification. It reminds us that identification is never outside or prior to politics, that identification is always inscribed within a certain history: identification names not only the history of the subject but the subject in history. What Fanon gives us, in the end, is a politics that does not oppose the psychical but fundamentally presupposes it.
>
> (Fuss, 1994: 39)

In a way, 'colonization' as well as 'colonial identification' after Fanon no longer simply refer to racial divides. The emergence of identity politics (gender, sexuality, ethnicity, even class) in the post-war era can be understood as a Fanonian problematic.

Fanon's analysis was done right after the end of World War Two, within the mood of Third World national independence movements, which Fanon's later work helped to facilitate. After the withdrawal of the colonial master, after national independence, has a psychoanalysis of decolonization reached the end of its life?

Nationalism in Question

Algeria declared its independence in 1962. Fanon had participated in the revolution since the mid 1950s; before his death in 1961, he published his most influential work, *The Wretched of the Earth*. Participation in the process of the movement made him see the next wave of the problem. In the chapter on 'The Pitfalls of National Consciousness', Fanon painfully forecasts the problem: the colonizer leaves the previous colonial structure of relation unchanged; it 'puts on the mask of neo-colonialism' (1963: 152). 'If it [nationalism] is not enriched and deepened by a very rapid transformation into a consciousness of social and political needs, in other words into humanism, it leads up a blind alley' (ibid.:

204). When the colonizers are ready to go, they hand the regime to the 'native' bourgeois elites, who have identified with and internalized the culture of the colonial power, so as to maintain new colonial linkages to control the ex-colonies.

Predicated on the inside/outside metaphor or, to use Fanon's expression, Manichean divide, colonialism driven by the forces of capital established in the process of its expansion the structure of the nation-state as its mediating agent to unify internal differences *vis-à-vis* outside colonizers. Once the system of the nation-state was established and imposed on the globe, the most visible methods of evacuating the outsiders/colonizers were the nation-building and state-making projects. Third world nationalism, as a response and reaction to colonialism, was therefore seen as a necessary choice to signal autonomy from outside forces. With territories divided by the colonial powers throughout Africa, Latin America, and Asia, colonialist governments saw the rise of nationalist independence movements not so much as a threat but as a means to reduce their costs, meanwhile maintaining colonial linkages in trade and political influence. As Ashis Nandy succinctly puts it,

> In Manchuria, Japan consistently lost money, and for many years colonial Indochina, Algeria and Angola, instead of increasing the political power of France and Portugal, sapped it. This did not make Manchuria, Indochina, Algeria or Angola less of a colony. Nor did it disprove that economic gain and political power are important *motives* for creating a colonial situation. It only showed that colonialism could be characterized by the search for economic and political advantage without concomitant real economic and political gains, and sometimes even economic or political losses.
>
> (1983: 1)

To let colonies go then was the way to get to rid of the responsibilities but not the advantages of colonialism. 'Self-determination', a slogan heralded by younger generation colonial powers, proved to be not so much a humanist concern, but a political strategy to scramble up the already occupied territories in order to take a larger piece of the cake for 'national interests'. J.A. Hobson, as early as 1902, had discovered a close linkage between nationalism and imperialism, in that the latter cannot function without the former. By the 1940s, it had become clear that neoimperial nationalism was in good shape. Aimé Césaire's intuitive statement at that time was a warning to Third World intellectuals:

> I know that some of you, disgusted with Europe, with all that hideous mess which you did not witness by choice, are turning – oh! in no great numbers – toward America and getting used to looking upon that country as a possible liberator.
>
> 'What a godsend!' you think.

'The bulldozers! The massive investment of capital! The roads! The ports!'

'But American racism!'

'So what? European racism in the colonies has inured us to it!'

And there we are, ready to turn the great Yankee risk.

So, once again, be careful!

American domination – the only domination from which one never recovers. I mean from which one never recovers unscarred.

(Césaire, 1950/1972)

Here Césaire had already pointed to the transition from colonialism to neo-imperialism, from territorial acquisition to 'remote control'. But for the sake of power, third world nationalists did not seem to be bothered by the gradual formation of US hegemony, and still struggled for state independence with US military and financial 'help'. And the nation-state structure, finally implemented everywhere, proved to be the part of the neocolonial system. With no better choice, to counter an offensive nationalist-based colonialism, a defensive nationalism became the only unifying force opposing the colonizer.

In recognizing the almost inevitable historical necessity, one should not lose sight of the problems which come with nationalism. Shaped by the immanent logic of colonialism, Third World nationalism could not escape from reproducing racial and ethnic discrimination; a price to be paid by the colonizer as well as the colonized selves. Fanon identified the problem in 1961, 'From nationalism we have passed to ultra-nationalism, to chauvinism, and finally to racism'; 'We observe a permanent seesaw between African unity, which fades quicker and quicker into the mists of oblivion, and a heartbreaking return to chauvinism in its most bitter and detestable form' (Fanon, 1968: 156–7). Furthermore, the ruling elites, in their struggle over state power to replace the colonial regime, have mobilized the pre-existing ethnic differences to their advantage, and ethnic essentialism has been the easy way out. It is then understandable that ethnic nationalism since the post war era has dominated Third World politics, a reproduction of colonialism of the earlier moment. How true was Fanon's critique of nationalism?

Twenty-five years later, in 1985, *The South* and Vienna's Center for Development co-organized a conference, 'Decolonization and After – The Future of the Third World', to review the diverse practices and experiences of decolonization, forty years after national independence movements. Altaf Gauhar, a Pakistani writer and the editor of *The South* and of the *Third World Quarterly*, summarizes the situation in this by now often cited passage:

It did not take long for the people to discover that all that had been changed was the colour of their masters . . . independence brought little change and they remained chained to the same British-style institutions which the ruling elites manipulated and controlled to

perpetuate their own advantages . . . For the masses the achievement of independence was the end of their struggle and also the end of their dreams . . . nationalism could not serve either as a cover to conceal economic and social disparities nor hold back the tides of regional autonomous pressures . . . when cultural homogeneity and truly national consciousness failed to evolve, people began to revert to the security of their traditional parochial and class identities . . . The seeds of disintegration in the sub-continent [of India] were all sown in the colonial period. They are now coming to bitter fruition.

(Gauhar, 1987, cited in Kreisky and Gauhar, 1987: 4–5)

This passage coming from the Third World by no means expresses a nostalgia towards the colonial regime nor aims to legitimate the history of colonialism, but it puts a sharp focus on what has happened since the foreign power finally left. 'Internal colonialism' began, with essentially the same logic as 'external colonialism'. As Nandy forcefully put it, 'the rhetoric of progress uses the fact of internal colonialism to subvert the cultures of societies subject to external colonialism', and 'the internal colonialism in turn uses the fact of external threat to legitimize and perpetuate itself', but one has to understand that 'neither form of oppression can be eliminated without eliminating the other' (Nandy, 1983: xii). The inside/outside metaphor becomes the alibi for the national bourgeoisie to continue colonial ruling, and has thus put us in a position to question the legitimacy of using color, racial and ethnic distinctions to justify any form of nationalist governmentality.

Nativism

Right before and after national independence, nationalism has generated a by-product: nativism. If, for centuries, colonialism has carried out a 'civilizing mission' to remove 'backward' local tradition, and replace it with more 'advanced' modernization programs on every front, then the anti-colonial, national independence movement could no longer trust anything coming from the side of the colonial devils. A 'self-rediscovery movement' was called upon to discover our uncontaminated self and authentic tradition, to replace the deeply invaded colonial imagination. If, to juxtapose Fanon with Nandy, colonialism works by the mechanism of identification, through aggression and establishing the colonizer as the figure of modernity, to bind colonizer and the colonized together, then nativism works by an identification with 'the self'. Defined in relation to the 'non-native' colonial master, 'nativism' operates on every level of social formation. The official posts have first to be nativized; followed by changes of national flag and dress, the language, the curriculum, the textbooks, food, etc., though at gut level, colonial elements still permeate and could not be vacuum-cleaned overnight. And in fact, the colonial imagination has permeated the native's body and thought. Albert Memmi documented and

analyzed this nativist 'self-rediscovery movement' so well in the last two chapters of his rather neglected seminal work, *The Colonizer and the Colonized* (1957), published five years later than Fanon's *Black Skin, White Masks*, and four years before *The Wretched of the Earth*. Listen to Memmi: 'We then witness a reversal of terms. Assimilation being abandoned, the colonized's liberation must be carried out through a recovery of the self and of autonomous dignity. Attempts at imitating the colonizer required self-denial; the colonizer's rejection is the indispensable prelude to self-discovery' (1957: 128). Thus, from the very beginning of nativist decolonization, the colonizer is the key initiator. Once the movement starts, 'everything that belongs to the colonizer is not appropriate for the colonized . . . the rebellious colonized begins by accepting himself as something negative' (ibid.: 138). The colonized then will choose to destroy anything built by the colonizer. As Memmi saw it, for the nativization movement activist, 'The important thing now is to rebuild his people, whatever be their authentic nature; to reform their unity, communicate with it and to feel that they belong . . . he is even more ardent in asserting himself as he tries to assume the identity of the colonizer' (1965: 135); 'by taking up the challenge of exclusion, the colonized accepts being separate and different, but his individuality is that which is limited and defined by the colonizer. Thus, he embodies religion and tradition, ineptitude for technology of a special nature which we call Eastern, etc.' (ibid.: 136). To the colonialist category of the East and West, one could add Confucianism, the Culture of the Continent vs the Culture of the Sea. Desperately seeking essentialist differences constitutes the foundational, if not fundamentalist, drive of nativism.

In short, if Fanon's critique of nationalism was ahead of its time, then we still live under the shadow of Memmi's critique of nativism.

The rediscovery of the self in is no way bounded by the nation-state. It can go in any direction where a tradition of 'difference' (from the colonizer) can be discovered. The contemporary movement of 'Asianization' (against the 'West') of Asia, 'Africanization' of Africa (again, against the 'Western' hegemony), or even 'Europeanization' (against 'America') of Europe can be accounted for as a nativist move. The assertion and reclaiming of Asian, African or European values and of an Asian, African or European identity are not necessarily nationalist interpellation, but part of the nativist imagination.

Civilizationalism: East and West as colonial categories

The rediscovery of the self serves the function of empowering colonized subjects. However, a new form of 'empowerment' seems to emerge, slightly divergent from the nativist movement. One of the most powerful articulations recently emerging in the historical scene is civilizationalism. It is probably not an exaggeration to say that, the most influential academic essay of the 1990s has been Samuel Huntington's (1993) 'Clash of Civilizations'. For better or worse, the US right wing imperialist stand taken by Huntington has drawn responses

from all over the world; throughout the continent of Asia, essays, conferences, books, policy consultations, etc., have been generated within (rather than outside) the Huntington problematic. The simple division of the globe into seven or eight symbolic spaces has in effect constructed a new civilizational identification which everyone on earth is forced to take on. Huntington's proposal to US state power, at the end of his essay, seeks to exploit conflicts so as to maintain world hegemony, which will no doubt, if state machines are brought into the Huntington problematic (which seems to be the case in practice), generate global racism, nationalism, and regionalism, not to mention reactionary civilizationalism.

In sharp contrast to the colonizer's strategic mapping, the most articulate form of civilizationalism formulated by intellectuals in the (ex-)colonized societies, as far as I know, comes from the Delhi-based, prominent social psychologist, Ashis Nandy. In his recent book, *The Illegitimacy of Nationalism: Rabindranath Tagore and the Politics of Self* (1994), Nandy argues that nationalism is a by-product of Western colonialism, and hence illegitimate; according to his reading of Tagore and Gandhi,

> the fear of nationalism grew out of their experience of the record of anti-imperialism in India, and their attempt to link their concepts of Indianness with their understanding of a world where the language of progress had already established complete dominance. They did not want their society to be caught in a situation where the idea of the Indian nation would supersede that of the Indian civilization, and where the actual ways of life of Indians would be assessed solely in terms of the needs of an imaginary nation-state called India. They did not want the Indic civilization and lifestyle, to protect which the idea of the nation-state had supposedly been imported, to become pliable targets of social engineering guided by a theory of progress which, years later, made the economist Joan Robinson remark that the only thing that was worse than being colonized was not being colonized.
>
> (Nandy 1994: 3)

In other words, if Indian nationalism works on the level of the nation-state, civilizationalism operates in the larger historical space of Hindu civilization, which functions to resist being trapped into the colonial system of the nation-state. Nandy's articulation was actually grounded in his earlier seminal work, *The Intimate Enemy: Loss and Recovery of Self under Colonialism* (1983), which was a self-conscious theoretical undertaking in the tradition of Fanon and Memmi.[10] In Nandy's work, in contrast to the aggressiveness of Huntington's proposal, what he calls 'an unheroic but critical traditionalism' contributes 'to that stream of critical consciousness: the tradition of reinterpretation of traditions to create new traditions' (1983: xvii–xviii). Tradition, and its reinterpretation, then becomes the empowering ground on which the long-lasting cultural impacts of

17

Western colonialism can be combatted, because 'The West is now everywhere, within the West and outside; in structures and in minds' (ibid.: xi).

Although the differences between the offensive right-wing colonialist Huntington and the critical left-wing traditionalist populist Nandy are clear enough, the civilizationalist interpellation has to be carefully cautioned against.[11] The Huntington–Nandy articulation discloses a wider structure of feeling, a cultural imaginary, not limited to the Indian or US case. It perhaps projects an emerging realization in the so-called postcolonial context. That is, for the (ex-) colonized, nationalism is no longer the panacea, once magnified into global capitalism, the hierarchical structure of the nation-state more or less continuing the established order of colonialism with which one could not compete with its forerunners; at this moment, perhaps only by bringing out a 'higher' and 'larger' category, civilization, could seal the unsealable scar. In inventing and reinventing signs familiar to the popular imaginary and then articulating them as a higher form of universalism, the ex-colonized regains confidence in civilization, and thereby 'at least' beats the West in terms of cultural imagination. This is a perhaps one form of psychoanalytic identification of the 'postcolonial' imagination.

As I said, the discourse of civilizationalism has wider ramifications; such articulation also exists in recent expressions like 'cultural China' and even 'orientalism'. In a way, the signs of 'China', 'India', 'Islam', 'the Orient' are not necessarily nationalist concepts, but emotional signifiers; to reclaim 'a five thousand year history or four thousand' is once again a reaction and response to, shall we say, 'post' colonialism; it does not have concrete substance, but enables the scared subject to feel that it can reside more safely in a world full of cultural identity crises. The danger here is of course that these so-called non-Western big civilizations might fall into the logic of colonial competition and in a struggle over representing the Other of the West, to occupy the space of the non-West. A reproduction of ethnocentrism in structure? Isn't the center still the opposing West? Isn't there an exclusionary practice? Isn't the appearance of the 'North/South' divide, beyond political–economic levels, expressing a symptom on the psychoanalytic account? Surrounding these big civilizations, how are the little subjectivities which do not have an idea of a larger 'civilization' to hang onto, or are forced into an identification proposed by Huntington, to project their destinies and address their feeling of marginalization? Let us read Sri Lankan anthropologist S.J. Tambiah's articulation of what I call the 'little subjectivity' complex:

> Notwithstanding their genial qualities, Sri Lankans are also apt to be proud and arrogant abroad: they feel superior to the Indians, the Malays, the Chinese, perhaps even the Japanese. For their eyes are set on the West, particularly Great Britain, which was their colonial ruler from the early nineteenth century until 1948. They are proud of their British veneer: their elites acculturated more quickly than their

18

Indian counterparts; their island enjoyed a prosperity owing to its plantation economy that was the envy of its Asian neighbors; and the British raj established a school system and a transportation system that, because of the island's size, was more efficient than any could possibly be in the vast subcontinent of India. And therefore, although India is undeniably their parent in many ways, all indigenous Sri Lankans – Sinhalese, Tamil, Muslim – become visibly annoyed, if not outraged, if Sri Lanka is mistaken physically to be part of India (as many people in distant parts of the world innocently do), or if it is thought culturally to be part of 'greater India' (as some Indians patronizingly do).

(Tambiah, 1986: 2)

The cultural psychology Tambiah portrays reveals a general complex or sentiment of civilizationalism and little subjectivities that is only unique in its specificity. It also resonates in other geocolonial relations, if for example one replaces the term Sri Lanka with Taiwan or Canada, India with China or the US. What I am getting at is that the Huntington interpellation has historical–psychic support. The real danger is if Huntington's US imperialist articulation, to interpellate 'civilizationalist' identity, is really an 'upgraded' imperial nationalism.[12] The Huntington Clash has already generated enormous antagonism from China and Southeast Asia; but, as far as I can tell, all the nationalist–civilizationalist reactions have been sucked into his framing rather than challenging the framework as a whole.[13] Those geographical spaces with no clear belonging to the bigger civilizations are now forced to take sides and are boxed in by the Huntington categories. Sites where there is potential to be more syncretically hybrid might change their directions. Australia used to claim to be 'a multicultural nation in Asia'; but with a conservative government in power, the state identification has shifted toward a multicultural 'Western' nation in Asia.

What about the centrifugal core of magnetic field? The West is also an emotional signifier. More precisely, behind the West hides also a racist concept, white; the West contains no unity except color. Just like the East, at best it refers to another form of civilization; its floating signified changed historically according to the transformation of hegemonic positions: from Dutch and Spain, through the British and French Empires, to US neoimperialism. Doesn't 'The fall of the West' and the subsequent claim that 'the twenty-first century is x's century' project a 'postcolonial' desire?

Watch out for the Politics of Resentment!

If the cultural basis of colonialism was racism, and it generated an identification with the aggressor/colonizer, then one can say that the cultural basis of neo-colonialism is multiculturalism. Multiculturalism recognizes differences but

covers up ethnicity/race/nationality as the nodal point of division, and generates an identification with the self in the form of nativism and identity politics.

What reconnects and unifies nationalism, nativism, and civilizationalism is what Memmi calls, to use psychoanalytic language, 'resentment', which binds the (ex-)colonizer and the (ex-)colonized together. As I argued earlier, the inside/outside, self/other logic of colonialism lingers on in these three forms of decolonization, and a constant resentment against the (past or present) colonial outsider and/or the imaginary other is still at work, expressing itself in the form of racism. Memmi argues, 'though xenophobia and racism of the colonized undoubtedly contain enormous *resentment* and are a negative force, they could be the prelude to a positive movement, the regaining of self-control by the colonized' (Memmi, 1965: 132; my emphasis). We surely hope Memmi is right that we could eventually leave the negative force, but the dominant historical conditions do not seem to take us beyond resentment. Nationalism is on the rise, nativism still prevails, and civilizationalism begins to find a fully-fleshed life. Examining the 'global politics of resentment' at the present moment, one must acknowledge that Memmi's 1957 account of the 'self-rediscovery' movement in the context of Tunisia remains suggestive: we have not entered the postcolonial era, but are still trapped in colonial history.

If it is only by identification with strong signs (e.g. hoping to belong to a strong nation-state, or to an ethnic group in power) that one can relieve the anxiety of the subject's multiple splits, one has not in fact touched the core of the contemporary crisis; perhaps an understanding of the composition of the historical self is the starting point of relieving such a crisis. If one sees the subject as a site of hybridization, then only through a concrete projection of desire can one clarify the formation of subjectivity. Hybridity in this sense cannot be understood simply as an interaction and meeting of different races to decompose its form of articulation. It could mean the hybridization of the past and present, of forces pulled through by feudal and capitalistic modes of production, the intersection of cultures generated out of different geographical space. These cultural elements do not simply operate on the body of the subject; the very form of their articulation becomes extremely complex.

Imagining the 'postcolonial' way out: critical syncretism

Under such saturating (psychic) moods of resentment, how does one begin to develop possible cultural strategies to confront the situation?

Contesting multiculturalism and 'hybridity'

Assimilation, as the archetype of a colonial cultural imagination, has proved to be an oppressive, violent, and impossible operation. Is multiculturalism then the alternative? Multiculturalism has been formulated and practiced in different

places with different names: for instance, in the US, it is called multicultural-ism, in Singapore, multiracialism (see Chapter 9); in the Chinese Republic, the co-existence of five nations; and in Taiwan, the 'big four ethnicities'. Perhaps the most 'advanced' and 'progressive' form of multiculturalism can be said to be practiced in places such as Australia. But even in the most advanced instances, there are still lessons to be learned. Ghassan Hage, a Sydney University-based anthropologist of culture, has succinctly pointed out, multi-culturalism, as is practiced in the dominant Anglo-Celtic nationalist–Republican discourse, is in effect a collection of other cultures deployed for national if not nationalist window shopping. '[T]his exhibitionary multicul-turalism is the postcolonial version of the colonial fair' (1993: 133). For Hage, that multicultural policy 'allows' others to 'maintain their cultures' does not mean that it is 'not a fantasy of total control' (ibid.: 135). 'Multicultural lan-guage in this regard is merely moving along with the language of zoology' (ibid.); like zoology, the system of multicultural language classifies others, con-structs hierarchical orders, and as if in the zoo, minorities are displayed as rare animals. 'All ethnic cultures within the Anglo-Celtic multicultural collection are imagined as dead cultures that cannot have a life of their own except through the "peaceful co-existence" that regulates the collection' (ibid.: 133). In short, 'if the exhibition of the "exotic natives" was the product of the rela-tion of power between the colonizer and the colonized in the colonies as it came to exist in the colonial era, the multicultural exhibition is the product of the relation of power between the postcolonial powers and the postcolonized as it developed in the metropolis following the migratory processes that char-acterized the postcolonial era' (ibid.).

To reformulate Hage's theoretical articulation at a general level: if the cul-tural basis of colonialism is racism, and its cultural strategy, assimilation, which generates an identification with the aggressor/colonizer, then can one say that the cultural basis of neocolonialism is multiculturalism (which recognizes dif-ferences but covers its dominant ethnic position as the nodal point of divide), and its cultural strategy, peaceful co-existence, and which generates an identi-fication with the self in the form of nativism, civilizationalism and identity politics. The direction of an incomplete project of decolonization is then to interiorize others in a highly self-conscious manner; here 'others' are not simply racial, ethnic and national categories, but also class, sex/gender and geographical positionings; the highly structured hierarchy of differences has to be transcended through interaction, understanding and changes of objective conditions.

Colonialism is an imposed structure. From 1492 onward for four centuries, it radically transformed the world. The political epistemology of colonialism builds itself on a rigid 'inside/outside' distinction, and the main axes have been race and ethnicity: color, language, accent, religion, etc., mark the divide between the colonizer and the colonized; these are also cultural categories which mark hierarchies and unequal power relations. Sex, age and class in

colonial relations were often metaphorized: colonizers are male adults with higher class positions, while the colonized were seen as women, and/or children with lower class status. Decolonization movements have deepened the under-standing that an inversion of colonialism, a continuation of imposed colonial modes of thinking and categories turned upside down, would not answer. The political epistemology of decolonization could no longer put priority on race and ethnicity under which sexual, age and class differences are subsumed. Recognition of differences, erasing the hierarchical structure of differences, and interiorizing differences are the principle of its political ethics. To put it simply, decolonization is a permanent struggle against any form of domination.

Ghassan Hage's insight pushes us to question the structural enunciative posi-tions of the state apparatus, the power bloc, and the dominant culture in their handling of the problems of identity crisis: one might have good intentions but still generate the next wave of (neo)colonial domination. If that is the case, where can subaltern subjects go?

The fashionable wing of postcolonial theory proposes the concept and strat-egy of hybridity, partly developed out of the work of Fanon. In Homi Bhabha's hands, hybridity is not simply a descriptive concept, denoting the effects of the hybridization of different cultures in a colonial context; it also points to a strat-egy of resistance, especially in notions such as ambivalence. Its discursive level moves through cultural forms, colonial conditions, subjectivities, forms of resis-tance, and even to the level of political strategy and ethics.

In his article 'Signs taken for wonders', Bhabha (1994) attempts to re-read the historical records of an event which happened in Delhi around May 1817, using the concept of hybridity to capture the form of the struggle against colo-nial authority. Inheriting the Fanonian tradition of recognition as a practice of identification, Bhabha puts it this way,

> colonial hybridity is not a problem of genealogy or identity between two different cultures which can then be resolved as an issue of cultural relativism. Hybridity is a problematic of colonial representation and individuation that reverses the effects of the colonialist disavowal, so that other 'denied' knowledges enter upon the dominant discourse and estrange the basis of its authority – its rules of recognition. . . . Hybridity reverses the formal process of disavowal so that the violent dislocation of the act of colonization becomes the conditionality of colonial discourse.
>
> (1994: 114)

What Bhabha is getting at is that the exercise of colonial power produces the effects of hybridity; here, the effect cannot be understood as it used to be as being only monopolized by the colonizer, while the entire cultural tradition of the colonized was silenced. In fact, the colonized was 'more' hybrid than the colonizer in that 'he' has acquired the language, the accent and forms of

expression of the dominant; although the colonizer looks down on 'him', the latter can still use the colonizer's language to insert denied knowledges and traditions into the dominant discursive space, and in turn, the colonizer's unfamiliarity with this whole set of cultural codes puts the colonizer in crisis, and hence undoes his authority; this anxiety is nothing but a form of recognition. In this sense, the effects of hybridity are always ambivalent. On the one hand, the colonized operates within a colonial system of representation and always reproduces a pre-existing frame of relations. On the other hand, the colonized 'politely' contests the colonizer even when not being noticed by the latter.

In his article, 'The postcolonial and the postmodern', Bhabha (1994) points out further,

> The postcolonial perspective . . . attempts to revise those nationalist or 'nativist' pedagogies that set up the relation of Third World and First World in a binary structure of opposition. The postcolonial perspective resists the attempt at holistic forms of social explanation. It forces a recognition of the more complex cultural and political boundaries that exist on the cusp of these often opposed political spheres. It is from this hybrid location of cultural value - the transnational as the translational - that the postcolonial intellectual attempts to elaborate a historical and literary project. My growing conviction has been that the encounters and negotiations of differential meanings and values within 'colonial' textuality, its governmental discourses and cultural practices, have anticipated, *avant la lettre*, many of the problematics of signification and judgement that have become current in contemporary theory - aporia, ambivalence, indeterminacy, the question of discursive closure, the threat to agency, the status of intentionality, the challenge to 'totalizing' concepts, to name but a few.
>
> (1994: 173)

Here Bhabha not only displays his poststructuralist rhetoric but also reveals his subject positions: diaspora, transnational, postmodern, post-Freudian, etc. While colonialism in the process of dissemination becomes infinitely indeterminate: 'Yes, but . . .' becomes the standard formula. Robert Young (1990) has produced a more substantial critique of Bhabha's work, which we do not have to rehearse here. For my purposes, I only want to make two points. First, to catch colonial flashes through the poststructural eye, Bhabha radically de-historicizes his analytical objects. Colonial conditions however cannot stand still. Has the 'hybridity' phenomenon of 1817 continued to move on until now? What are the differences between then, and the present? Under what conditions could hybridity work differently? From Mannoni, Fanon, and Nandy, we have seen the emergence of a different problematic to confront a new structural condition: objects and mechanisms of identification configured as conditions

shift from the colonial moment to that of pre-independence, to post-independence. To isolate and slice out hybridity as a trans-historical figure runs the risk of an ahistorical and positivistic trap. Second, as an analytical concept, hybridity, operating on different levels of abstraction, has lost its theoretical positioning and diffused its critical function; just as the notion of mimicry has been operating as a descriptive as well as a strategy of resistance. More seriously, hybridity presupposes purity, something which is not hybrid. The encounter of two 'pure' cultures produces hybridity. Does that mean the uncontaminated, original culture has never been 'contaminated' by and mixed with cultural forces coming from the 'outside'? Which culture is not then hybrid? Paul Gilroy (1994) argues, 'the idea of hybridity, of intermixture, presupposes two anterior purities . . . I think there isn't any purity; there isn't any anterior purity . . . that's why I try not to use the word hybrid, because there are degrees of it, and there are different mixes. . . . Cultural production is not like mixing cocktails . . .' (1994: 54–5). To displace hybridity, Gilroy proposes that, 'What people call hybridity, what I used to call syncretism. I think I would prefer to stick with that – syncretism is the norm, but that dry anthropological word does not have any poetic charge of it. There isn't any purity: Who the fuck wants purity? Where purity is called for I get suspicious' (ibid.: 54).

The reconstruction of subjectivity: for a critical syncretism

In fact, syncretism is not necessarily an anthropological concept to describe processes of interactions between races; in religious studies and intellectual history, syncretism has been an important analytical concept. In *Chiao Hung and the Restructuring of Neo-Confucianism in the Late Ming* (1986), Edward T. Ch'ien deploys this concept as central to his explanation of the emergence of a syncretic consciousness to mix elements of Buddhism, Daoism and Confucianism to combat the orthodoxy of the dominant neo-Confucian school. According to Ch'ien, in Chiao Hung's mode of thinking, the three religions no longer maintain a relation of peaceful co-existence and compartmentalization; instead, they 'intermix' (1986: 15), they were 'mutually explanatory and illuminating' (ibid.: 14). On a theoretical level, for Ch'ien, syncretism not only emphasizes the process of mixing, but also indicates a much more active consciousness to justify this process (ibid.: 2). Therefore, according to him, syncretism implies the active participation of the involved subjects: the practices of the subject are not imposed upon and operate on an unconscious basis, but are self-reflexive processes that engage the interlocutors.

In this framework, the constitution of subjectivity is composed of three historically grounded sites of interaction and interarticulation: body (*sheng*), mind (*shing*) and desire (*chih*) – the well-known Chinese philosophical cosmology. This reformulation echoes Deleuze–Guattari's new social ontology. Individual and cultural subjectivities operate on these three historically constituted axes.

Unless these three elements are liberated simultaneously, subjectivity remains 'colonized', in the wider sense of the word.

Here I want to borrow and insert Ch'ien's concept of syncretism into the level of the ethics of decolonization, and give it a critical turn, so as to form an alternative cultural imaginary which breaks with colonial identification. I shall call it a critical syncretism. The key question here is the object of identification: the formation of colonized subjectivity has always been passive, reactive and imposed, and the colonizer has been its object of identification. In the decolonization movement, nativism and identity politics shift the object of identification towards the self. This can also be seen as a reaction against or a disidentification with the colonizer although it presents itself as a multicultural or multiple subject. To break away from the frame of colonial identification, a decolonization movement has to move on, actively searching out multiple objects of identification. The critical question becomes: who and what are the objects? If a critical syncretism presupposes a subject position, a position emerging from a history of left-wing decolonization movements, what could be its objects of identification?

To put it simply and bluntly, the bottom line of a critical syncretism is becoming others, to actively interiorize elements of others into the subjectivity of the self so as to move beyond the boundaries and divisive positions historically constructed by colonial power relations, patriarchy, capitalism, racism, chauvinism, heterosexism, nationalistic xenophobia, etc. Edward Said has argued, 'Imperialism consolidated the mixture of cultures and identities on a global scale. But its worst and most paradoxical gift was to allow people to believe that they were only, mainly, exclusively, white, or black, or Western, or Oriental' (1993: 336). The question, perhaps, is not simply and only, to break these ethnically, nationally, and geographically defined boundaries, but more actively, with what sort of specific subjects could one identify? The male chauvinist Oriental? Upper-class privileged whites? African governing elites who kill their own human right activists? Or the transnational corporate hybrid subject who rips off all the poor labor on earth? Certainly not. My own caution against the call for transnationalism in cultural studies is precisely that once we move out of the national boundaries, with whom could we connect? To what subjects could we devote our energies and project our own desires?

Imperialism has indeed produced hybrid subjectivities which made the 'return' to an uncontaminated self impossible. Imperialism has also pushed the world structure into globalization which deepens the 'hybridity' of the already hybrid subject. The flow of capital, of population, of cultural identity, etc. seems to be irresistible. Confronting the pressure of globalization, national–ethnic identity has undoubtedly emerged at this moment of history as a privileged problem as a result of heavy trafficking and interactions. In this process, national identity has been constructed as the main axis of identification. Where are you from? How long are you going to stay here? When are you going back to your country? Global bureaucracy, through the universal apparatus of ID cards and passports, constructs one's identity according to the

nation-state one belongs to. In the essay, 'The Question of Cultural Identity,' Stuart Hall pinpoints the contradictory effects of globalization:

1 cultural homogeneity and the global–postmodern breaks down national identity.
2 resistance to globalization has deepened national and local identity.
3 national identity is in decline, but new forms of hybrid identity are gaining their positions.

(Hall, 1992)

Hall's first proposition is indeed happening. The autonomy of sovereignty and territory has been challenged by the flow of capital, technology and population. But the second proposition is also happening: the global rise of nationalism is in part a response to the formation of global capital. Renato Constantino, the Filipino historian, has argued that postwar nationalist movements should be transformed into combat against neocolonialism on an economic level:

> In the past, the nationalist struggle focused on political independence. Nationalism expressed the opposition of the subject people to national oppression, namely the political rule of their colonizers. Today, national oppression still exists. It consists of the economic domination of former colonies by transnational corporations of the advanced capitalist states. Nationalism is still essentially the idea of independence but today, the emphasis is on economic independence.

(1988: 22)

For Constantino, today's Third World nationalism is defensive; but he also points out, 'nationalism should graduate to wider and deeper social struggles to eradicate all forms of exploitation' (ibid.: 23). Eradicating all forms of exploitation points to Hall's third proposition, that is, the emergence of new identities, represented by the identity politics of the new social movements, including the emergence of new immigrant communities, which challenge the dominant ethnic composition.

Under such conditions, what is crucial here is that once we refer all this back to the trajectories of decolonization movements, to depart (1) from identification with the colonizer and (2) from the nativist movement's narcissistic tendency of a subject split, what can be the next move for a decolonized/postcolonial object of identification without returning to reproduce the same structure? The proposal for a critical syncretism at least attempts to push this possibility into a more progressive, more liberating direction. Again, Said's conclusion to *Culture and Imperialism* is evoked here as a point of departure:

> No one can deny the persisting continuities of long traditions, sustained habitations, national languages, and cultural geographies, but

there seems no reason except fear and prejudice to keep insisting on their separation and distinctiveness, as if that was all human life was about. . . . It is more rewarding – and more difficult – to think concretely and sympathetically, contrapuntally, about others than only about 'us'. But this also means not trying to rule others, not trying to classify them or put them in hierarchies, above all, not constantly reiterating how 'our' culture or country is number one (or *not* number one, for that matter). For the intellectual there is quite enough of value to do without *that*.

(1993: 336)

What Said points to, to my reading at least, is the almost untranscendable sentiment and horizon of nationalism and the unconscious identification with the nation-state. I am not suggesting one should entirely give up one's national identity and pretend to be a world citizen, or to hold a privileged position of cosmopolitanism; but perhaps only through a constant suspension of putting the priority of 'national interest' as the beginning and ending point, can we then begin to become others.

Cultural studies as an intellectual and internationalist project has been formed by the postwar decolonization movement and has been a critical force to continue that tradition. In this era, half a century after the Second World War, we are perhaps finally in a better position to keep a critical distance in re-investigating the long term cultural impacts of the colonial–imperial cultural imaginary inscribed on the local cultural formation and collective subjectivity. The motive is of course to deepen and renew the critical forces of the decolonization movement, to break away from the neocolonial structure of identification, and to caution the formation of a next wave of imperialist desire. Cultural studies in Asia (not Asian cultural studies) then might be able to unpack the history of antagonisms and anxieties generated within the region. However, one has to be extremely careful with the celebratory aspects of regionalism; the imperialist 'Greater East Asia Co-prosperity Sphere' project, for example, launched in the 1930s was able to operate under the name of regionalism. The Singaporean sociologist Chua Beng-huat (forthcoming) has identified the re-emergence of the call for a regional identity in Singapore to name itself 'Asian' rather than Singaporean. Is a new Pan-Asianism emerging? How new is this form of articulation? From listening to the preachings of several national leaders, 'anti-West', 'anti-individualism' and 'anti-communism' or 'Confucianism' recur in exactly the same terms uttered in the 1930s; these are still the dominant rhetoric used to construct this 'new' identity. On the other hand, more than ever in the history of the twentieth century, those who live in the Inter-Asia (East, Southeast and South Asia) regions are also in a better position to know what is going on in this part of the world without mediating through the outside. None the less, to develop genuine understandings of 'ourselves' and 'neighboring others', the colonial cultural imaginary which has

generated such psychoanalytic complexes as civilizationalism and little subjectivities has to be decolonized first.

Postcoloniality and decolonization: reclaiming Marxism

It is perhaps time to sum up and address what decolonization and postcoloniality might mean in this historical conjuncture.

If, as I suggested in the beginning, postcolonial studies does not signify the announcement of the arrival of a postcolonial era, then its legitimacy lies in the positing of an ethical positionality beyond colonialism from which to rethink and re-examine the historicity of colonial effects; an 'imaginative outside' of coloniality, which is to argue that we don't have to live permanently under the shadow of colonialism. That is, postcolonial studies has to reconnect to its tradition, to reclaim its genealogical roots, to recharge its originating critical spirit, i.e., Marxism. Without reinventing tradition, we have no ground to stand on; without roots, we do not know where we have come from; without critical spirit, we will only flow with the dominant currents to become reactive and reactionary. Marxism could be the unifying link of forces between the imperial centers (already past or otherwise) and the semi-, ex-, or still-existing colonies. A newer kind of Marxism can multiply its objects of identification as well as its enemies and structures. No longer simply based on class politics of the narrower type, contemporary pan-leftist social movements of gay and lesbian, bi- and trans-sexual, feminist, labor, farmer, environmental, aboriginal, anti-racist, and anti-war groups need to work together and identify with each other across neocolonial borders, so as to collectively confront the global structures of heterosexism, sexism, capitalism, racism, ethnicism, and statism and super-statism. Subject positions and identities are produced by, and are the effect and product of, these structures, not the other way round. If we truly believe in the possibility of abolishing the structures of colonization (i.e., oppression and domination), then postcolonial studies has to be able to think and move beyond identity politics of any sort to avoid the territorialization of subjectivities and subjective positions. Without charting such imaginary space outside the structures of colonization, we will fall back on the peaceful co-existence logic of multiculturalism and will be defeated by the power blocs, locally and globally.

I hope it has become clear by now what I mean by decolonization. If decolonization, at this historical conjuncture, no longer simply means the struggle for national independence but a struggle to abolish any form of colonization, then postcolonial/cultural studies has to recognize that (1) structurally, neocolonialism, neoimperialism, and globalization are the continuity and extension of colonialism (in the wider sense of the word, meaning any structure of domination); (2) colonialism is not yet a legacy, as mainstream postcolonial studies would have it, but still a lively operator in any geocolonial site on the levels of cultural imaginary and identification which reconfigures itself to reshape the

colonial cultural imaginary in the changing historical process of encounters (i.e., regionalization, the shift from the Atlantic to the Pacific, etc.). That is to say, colonialism, engineered by the apparatus of capitalism, still covers the entire globe. The decolonization task of a postcolonial/cultural studies would then be to deconstruct, decenter, deform, debunk, disarticulate the colonial cultural imaginary produced in the historical process, and to reconstruct, rearticulate, reconnect a more democratic kind of imaginative lines of flight. In short, decolonization no longer refers to the objective historical movement in structure, but in action, in subjectivity, thought, cultural forms of expression, social institutions, and global political–economic structures. I have no intention of arguing that the only mission for cultural studies is decolonization, but I do believe that, to decolonize the colonial cultural imaginary (nationalism, nativism and civilizationalism) so as to free colonizing and colonized subjects from colonial history is one way, and only one way, to set the agenda for a politically-charged postcolonial cultural studies. As practitioners of cultural studies (lower case, without capitalizing the words), we have to see ourselves as the articulating agents and linking points of decolonization to continue that tradition of critical cultural studies; our research and discursive practices have to become the critical forces of that incomplete project of decolonization, at least to decolonize ourselves.

Rethinking the colonial, the nation-states and the movement

Against the background of the problematic of decolonization, the essays collected in the volume could be read not simply as the effects of decolonization, but also as decolonization of thought in action. As such, the book divides into three interconnected sections. Part I on 'Refiguring the colonial' takes issue with the mainstream celebration of the coming of the 'postcolonial era' and attempts to demonstrate that the current political, economic, psychic and historical structures still operate within the limits of the colonialism and neocolonialism which the decolonization movement has tried desperately to break away from. Because the history of colonialism still prevails, Part II on 'Inside/outside the nation/state' posits the neocolonial structure of the nation-state as an effect of colonization and decolonization, and seeks to unpack the antagonism inside the nation, between the states, among the nations/states within the regional complex, and global encounters. The task initiated here is to deconstruct the colonial cultural imaginary of the national space and to rethink the relation between cultural studies and the (transnational) state. Part III on 'Renegotiating movements' begins with the recognition that identity politics, as an effect of decolonization which somehow continues the problematic of colonial identification, has to be decolonized, and then moves on to renegotiate and re-establish the relation between cultural studies and social movement in the politics of decolonization.

Refiguring the colonial

Part I opens with Professor Renato Constantino's 'Globalization and the South'. Taking us back to the Spanish, and later US moment in Filipino history the renowned historian reminds us that the rhetoric of globalization could not deal with uneven structural development.[14] The North–South divide resurfaces. The North led by the US, Constantino argues, 'is aiming for a more thorough recolonization of the South through such globalizing institutions as the World Bank, IMF, GATT, transnational corporations and media', through means such as the control of global trade and intellectual property right (as a means to force local states to import more products from the US). In such circumstances, nationalism in solidarity as a defensive rather than offensive mechanism becomes 'the only weapon by which countries of the South can stop the extraction of their wealth and resources'. Carefully distinguishing the underdogs from the stake holders of the South who have been co-opted by and in collaboration with the northern powers, Constantino calls for a nationalist 'people's movement' originating from within civil society which will interact nationally and internationally, and 'create a more fertile ground for a productive conjuncture of progressive ideas and actions'. More specific arguments and strategies will be picked up later in Part III by Muto Ichiyo in, especially Chapter 18.

Speaking from the Philippines in Southeast Asia, Constantino situates the globalization question in the trajectories of colonial history, which is contrary to the mainstream Anglo-American celebration of globalization, which has the effect of blurring geographical boundaries and causing the decline of nation-states. Constantino's intervention, then, evidences a geopolitically defined enunciative position, which could not view globalization apolitically and historically.

Constantino's analysis hints that, throughout the twentieth century at least, the US has been a critical force *in*, if not part of, Asia. To make the story more complex, the entire Asia-Pacific region in the twentieth century and in the foreseeable future has been shaped not only by the culture of US imperialism, but also by the history of Japanese colonialism. Leo Ching's 'Yellow skin, white masks' (Chapter 3) takes us back to early twentieth century Japan to pinpoint how Japanese colonialism was articulated as cultural imagination. Through re-encountering two important authors, Okakura Tenshin and Taguchi Ukichi, Ching is able to show us how Japanese colonialist identity was able to emerge and be defined by its two imaginary others: the West and Asia. The double movement of 'becoming whites' and 'Asia is one' is defined not only by the category of racial distinction/sameness, but critically through class differences. This racial similitude and class distinction of Japaneseness (over its neighbors) serves the function of asserting its difference from the West, and at the same time of justifying the civilizing mission it prepared for the East Asia Co-Prosperity Project. Ching provides a much-needed service to cultural studies in that he puts cultural history back in his account so as to better understand the

shape of the contemporary cultural imaginary. Through Ching's analysis, one might be able to understand the ambivalent status of 'Japan' in the geopolitics of Asia: its insider/outsider status has been defined in that moment of history. Or, in fact, a pervasive difficulty is revealed, at least throughout the Asian continent, that the ex-colonized societies have to deal with the imposed cultural imaginary *vis-à-vis* 'the West', and at the same time to confront the 'neighbors' without falling into a mediation with the imperialist imagination. Ching's 'Japan' of the early twentieth century then becomes a miniaturized picture of the contemporary identity redefining crisis. With the triumphalist sentiment for the 'rise of Asia', the highly orchestrated talk on 'our' Asian values, which are distinctively different from the West's, heralded by various state machines, has been defined by a resentment against the 'colonialist West'. The recent report on the 1996 debate between Samuel Huntington, representing a right-wing neo-imperialist position, and scholars from the East and Southeast Asia region, gathering in Singapore and Malaysia, reveals such a dangerous dilemma.[15] An 'Asian' alliance was formed against the 'West'. On the other hand, when questions are asked – Is Asia one place? What *are* the Asian values? – then a universal Asian identity collapses, and differences of tradition, history and past hatreds resurface.

This newly emerging form of 'pan-Asianism' reminds us, in reading Ching's analysis, of the early twentieth century 'Greater East Asia Co-Prosperity Project' of Japanese colonialism. Though the historical conditions have been transformed in every sphere, the ideological articulation of a 'unity within difference' remains similar. Unlike the earlier practices, this round of realignment has seen a struggle for occupation of the leading position between multiple sites other than Japan: Lee Kwan-yew's Singapore, Mahathir Mohamad's Malaysia, Jiang Zemin's China.[16] Although, on the level of statist politics, one realizes the necessity of alliance of unified forces to balance US hegemonic imperialist 'free' attacks anywhere on earth, such as Clinton's missile game with Saddam Hussein, the danger of a colonialist imagination of the earlier mode as well as the reactive resentment defined by the 'West' has to be constantly guarded against.

It is clear then that the imaginary 'the West and the Rest' problematic still occupies 'our' psychic–cultural space. The West has to be dealt with not so much as a geographical entity but as emotionally charged imaginary. But of course, just as the imagination within the Asian continent changes over time, largely due to the shifting gravity of the global economy, the previous pinnacle of the West now reconfigures into a 'New Europe' in response to postwar US hegemony which has constituted Europe as its sub-colony. Paradoxically, Ching's analysis of Okakura Tenshin's 'Asia is one' which was formulated under the shadow of European colonialism is now taken up by the previously unquestionable assumption, whether 'Europe is one'. Ien Ang's timely analysis of the present state of eurocentrism takes up urgent issues confronting Europe. Taking her cue from the recent formation of the European Union, driven by political

and economic interests, the truly diasporic cultural studies scholar, who has lived in Indonesia and Europe, now based in Australia ('closer to home'), argues that its ideological legitimation lies in a self-conscious articulation of 'the unity of European culture'. This re-search of Europe, a re-europeanization, is now founded on a sense of crisis, an almost inverted logic of orientalism. Besieged by 'the Rest' to 'Westernize' (or in the Japanese intellectual tradition, to 'euro-peanize') themselves, European intellectuals are forced to take on the world-historical responsibility to fill in the content and form of the new prob-lems and new solutions confronting new Europe. As I pointed out earlier, the 'nativization' of Europe, which is the other side of the Asianization of Asia, is precisely in response to the presence of 'the Rest', the cultural others inside and outside the European continent. To my reading, Ang's acute observation is that this is perhaps the first time that a fully self-conscious articulation of euro-centrism is reclaimed, redeemed and reaffirmed, thanks to the deep sense of self-doubt and crisis caused by the realization that Europe is no longer superior but as ordinary as the others, in a politico-economic sense and that its 'unique' identity can only be redeemed by its sense of cultural superiority. The only legitimate critique can come from Europe itself, as self-defense, and more importantly as the revival of its own identity. The dialectic of eurocentrism and anti-eurocentrism thus absorbs the European subject into itself. This defensive mode of eurocentrism can perhaps be understood as a decolonization effect, a colonial legacy once priding itself now has to come to terms with its demise and its cultural relativity. But the final move is bound to see Europe losing control of its future trajectories. In the long run, Europe's transcendental superiority will be broken down, not solely through the deconstructionist movement, ini-tiated by the always-already hybrid subjects, but through more active engagement with the 'outside'. Ang cites Eco's statement on the task, 'In one hundred years Europe could be a colored continent. That's another reason to be culturally, mentally ready to accept a multiplicity, to accept inter-breeding, to accept this confusion. Otherwise it will be a complete failure'. In other words, the defensive self-absorption of eurocentrism will perhaps eventually be broken by the other from inside out, for the presence of the 'colored' immigrants mas-sively moving into the uncontaminated space will make the continent realize 'white' is not beyond categorization but also a 'colour' among colors. (It was truly amazing to watch the Hong Kong hand-over on TV in London. Indifference was the dominant mode. The nostalgic rhetoric to assert that 'we have done all the good things in Hong Kong, and hence New China' is symp-tomatic enough, especially when juxtaposed with the televized tear-shedding of Patton's family (don't cry guys, you have done all the good things, isn't it?). One could expect the English Left to celebrate the fact that English colonialism is nearly over and done with. Rid of this burden, the Left could be getting on with other important work. But, no, that's not what happened. The Left did not seem to know what to do with such an event, globally circulated through satellite. People in London do care though, on the other hand. They got into

a fight, on screen, about which side (Chinese Communist Party or Labour Party) had produced more and better fireworks!

If Europe is still caught up with its own colonial legacy, the 'almost last colony' (after 7 July 1997, the 'almost last' disappeared; but it does not mean Hong Kong is no longer inscribed by colonial traces), Hong Kong, ironically, is on its way to 'managerialize colonialism,' as the title of Law Wing-Sang's Chapter 5 suggests. Writing in the mood of the '1997' great transition ('to return to the motherland'), Law sharply poses the questions: 'Is nationalism really an opposing other to colonialism? Under what conditions would colonialist practices, as well as its principles, be not only tolerated by nationalism but be actively adopted as an ingredient of a nationalist project?' Armed with all the existing research on colonial history, anyone who is interested in how decolonization works will immediately embark on the almost last colony. As it turns out, according to Law, Hong Kong has actually become the 'manager' for its 'mother land' in mediating between colonial capitalism (the West) and the ongoing project of modernization in China. The dominant imagination of the possible location of Hong Kong in relation to power is thus mediating through the discourse of managerialism which articulates colonialism and nationalism as a project of modernization. What is most interesting in Law's analysis is his argument that present-day managerialism does not take shape in this transitional moment, but rather has a genealogical root in postwar colonial governmentality. Tracing the earlier local literati-modernizers' attempt to manage and co-operate with British colonial ruling, Law convincingly charts out the courses of discursive shifts in responses to changing political conditions from the 1960s onward. How local elites manage and cope with the post 1997 'recolonization' remains to be seen.

Hong Kong's 'colonial miracle' is further amplified in Chapter 6, Ding-Tzann Lii's 'A colonized empire'. As a colonial city-state, Hong Kong's most visible performance has been perhaps its cultural industry. From 1980 onward, Hong Kong films have dominated the market in East and Southeast Asia; moreover, Hong Kong action films have also deeply penetrated the home video market in such places as the west coast of the US. Puzzled by the colony's ability to export its cultural production, which seems to be unique in the history of colonialism, Lii attempts to identify the different cultural logics at work between the older mode of imperialist operation and this new 'colonized empire'. According to Lii, the modes of articulation which exist between the outside and the local shift from 'incorporation' to 'yielding'. No longer modeled on Hollywood's imposition on the local cultural space, the Hong Kong film industry actively invites local intervention in its production process so as to guarantee its cultural familiarity and relevance in different locales; even narrative elements and forms can be changed according to local market demands. The success of this operation has pushed Hollywood to reconsider its persistent working mode.

What lies behind Lii's analysis is a deeper theoretical concern: whether this

new form of marginal colonialism constitutes a rupture in the history of global capitalism, or is a new strategy for capitalist expansion.[17] A question, to be sure, which cannot be answered without further analysis in different sectors of production. But Lii's identification of the logic of yielding does point to an emerging form of transnational operation. For instance, the Taiwan-based computer company, ACE8, now the fifth largest in the world, has developed a new investment strategy which will not exceed 50 per cent of the overall capital, so as to motivate local mobilization of resources to generate profit. Of course, the sum total of interests for ACE8 will be greater. Whether this form of joint-venture will be more equal to local capitalists, less exploiting to local labor forces, and more of a 'cosmopolitanism' is still to be analyzed.

Central to Lii's argument is that the media industry in the periphery performs a function of regionalization and localization, that is Asianization. It is through mechanisms such as film and satellite TV that the imagined living community could be established. In effect, in conjunction with the rise of the mass market in the region, the potential of Hong Kong's cultural production lies in its ability to challenge the center, forcing Hollywood to change, for instance. As Lii puts it, 'If that occurs, the West and the East will have more of a dialogic and egalitarian relation. . . . It is in this spirit that I see marginal imperialism as an imperialism to end imperialism.' Whether Lii's forecast is true or not remains to be seen.

In this connection, Ashis Nandy's short chapter on 'A new cosmopolitanism: Towards a dialogue of Asian civilizations' (Chapter 7), representing his continuing effort to deconstruct the colonial West and to search for alternatives, can be read as a step further on the road to demonstrating how dialogues within Asia are possible. Nandy points out, 'Asia is a geographical, not a cultural entity'. Past attempts to define Asia culturally were essentially 'reactions to Western colonialism', not an autonomous search for cultural unity. Excepting perhaps, Okakura's 'Asia is one', there are not enough cultural resources to formulate axes of dialogues without mediating through 'the West'. Nandy's entire essay is, then, at pains to detail 'the West *inside* Asia', which often results in an Asian voice spoken through a Western tone. What gives Nandy tremendous hope are the changing historical conditions within which 'Asia has now a place for even the West . . . the West itself might some day have to return through Asia.' This obsession with the 'West', though no less problematic, as pointed out earlier, is indeed a historically, psychoanalytically grounded reality to be disarticulated and decolonized.

Read together, the essays in Part I can be seen as a refiguring of colonial history, an attempt to come to terms with 'the West' or Western colonialism, a decolonization movement in thought.

Inside/outside the nation/state

As the figure of the colonial continues to occupy a critical imaginary space, its by-product, the nation-state, is now emerging more than ever as the central

articulating agent in the Asia-Pacific. Contrary to the will of theorists located in the (ex-)colonial centers, the nations/states in the region are, instead of declining, becoming the most powerful forces to be confronted. The question of national identity and nationalism in relation to that of the regional and the global straddles the region. The heightened ethnic–nationalist conflicts are fought through and articulated by the state leadership; the migration of labor and capital is tightly controled and organized by the states; the alliance of the states resulted in the intra-regional formation of super states such as ASEAN. Part II takes on different levels of response to questions of the nation and the state without falling into the trap of nationalism and statism.

In Chapter 9, 'Culture, multiracialism and national identity in Singapore', Chua Beng-Huat, perhaps one of the most prolific writers in Southeast Asia, extends the argument of his important book, *Communitarian Ideology and Democracy in Singapore* (1995), to retrace the shaping of the cultural sphere by the formation of the Singapore nation-state, uniquely constituted as a multiracial nation, and the recent claim of an 'Asian' identity so as to erase and unify differences. Rather than celebrating multiracialism and its attendant multiculturalism, Chua details the mechanisms which 'enable the state to place itself at a "neutral" position above the discursively constituted "races" and their respective positions and derives for itself a high degree of relative autonomy through its exercise of power, while simultaneously insulating itself from claims of entitlement of the people as both racialized collectives and individual citizens'. The failure to install Confucianism as a state ideology *vis-à-vis* the West to construct a Singaporean identity has forced national policy to take the 'Asianization' turn; it claims to inherit not one but three major Asian civilizations: 'Chinese/Confucian, Malay/Islamic and Indian/Hindu-Buddhist'. This reconfiguration of mutiracialism serves a double function not only to 'multi-civilizationalize' its internal cohesion, but also to meet the demand of a global–regional trend. As Chua points out succinctly, 'in self-interest, it is of strategic economical and political importance for Singapore to insert itself into a larger piece. Asia may not need Singapore, but Singapore needs Asia.' (The same thing can be said of Taiwan, Australia, New Zealand, etc.) Chua's words may well be modest in scope, but the political and cultural mood of Asianization does begin to resonate throughout the continent. This 'needing Asia' operates beyond the state–capital alliance to influence the movement sector. The long-term impacts on cultural formation in each locale remain to be seen.

If, as Chua puts it, 'Singapore was a reluctant nation' of the postcolonial sort, then Thailand is perhaps the only nation-state in Asia which has never been colonized by imperial powers as others have. However, this does not mean Thai culture is not subject to hegemonic influences. Without too much historical baggage and resentment inherited from colonial masters, Thai culture seems to have taken in outside resources in a more open-ended syncretic form. Ubonrat Siriyuvasak's 'Thai pop music and cultural negotiation in

everyday politics' (Chapter 10) traces the historical formation of contemporary pop music, and analyzes how in this wide cultural field, diversified musical forms are now adopted by different social groups. The categorization of pop music into Lukkroong, Luktoong, String and Pleng Pua Chiwit, as a result of syncretic articulation of Thai musical forms and Western pop/rock, does not designate simply competing genres, but a battlefield of cultural struggle between the urban and the rural, the elite and the poor, tradition and modernity, the state and the popular, sensuous pleasure and piousness, the attempt to regulate and control, and the attempt to resist and appropriate, and the music industry and an alternative intellectual underground. The categories become incommensurably fluid, due to the music industry's incorporation and blending of genres as well as subject groups' adaptation to new historical conditions. What we see in Ubonrat Siriyuvasak's analysis is the negotiating process of cultural forms and practices. As she puts it, 'popular culture is a relatively open arena in which a variety of discourses are played out simultaneously.' The new direction of Pleng Luktoong, for instance, 'converges with the emerging ethos of secularization, but at the same time, resists its inhumane mode of social relations . . . The tragic feeling of hopelessness is accelerating not receding. Nevertheless, the aggressive beat of disco music expresses the rage, the frustration and the fear with optimism in its style of eroticism and humor.' The cultural geography of music which she is able to construct here is perhaps unique only in its historical specificities. With the formation of a culture industry in the region, the dominance of the American Top 40 and Rock 'n' Roll has been in decline since the early 1980s. For three or four decades, the pervasive infiltration of American pop and rock transformed the music landscape. Nevertheless, there seems to be a syncretic process at work to articulate the local and the outside rather than a 'universal abandon'. Wherever one moves within the region in Japan, Korea, Taiwan, Singapore, the Philippines, no matter whether the lyrical languages are understandable or not, one does sense and feel a 'common' musical language, though not without specific local distinctions. In fact, anyone living in East Asia would notice that a strange, hybrid form of pop music has developed across that region. One does not have to understand the lyrics of the songs, but could still shake one's body and enjoy 'oneselves'. I once went with feminist friends in Seoul to a lively concert, performed by a syncretically dressed folk singer (a hybrid composite of Boy George, Barbra Streisand and the Korean folk tradition). Even without the ability to understand the Korean language, I did not have to count on translation. It just did not matter. It was the best performance I have ever witnessed. The physically short singer could, in one song, sing like a macho man with extremely low pitch, but also could yell out in an unbelievably feminine tone with the highest pitch. This East Asian form of cultural production obviously grew out of long-term colonial history: Japan, the US, and now Hong Kong; almost exactly the similar historic logic could apply in the Taiwan KTV instance (see Chen, forthcoming). The colonial and neocolonial cultural

traditions produced a widely acceptable rhythm for the body, mediating through electronic media. Further historical comparative studies, targeting various sites such as music production, can be done to identify the logics of articulation between the local, the regional and the global.

If Chua's and Siriyuvasak's essays center on the interaction of the nation/state with the outside, Budiawan's Chapter 11, 'Representing the voices of the silenced: East Timor in contemporary Indonesian short stories' takes on the difficult task of recovering the suppressed voices of East Timor within the context of Indonesia. The difficult situation after 1975 has been oppressive to people living within Indonesia, partly through the state's censorship of information flow; even if it is known, it is mediated through preferred, official narratives. In response to the mainstream formulation, Budiawan attempts to recover an alternative narrative of East Timor through critical analysis of contemporary short stories. 'When journalism is silenced, literature has to speak.' Budiawan reflexively argues, 'Interestingly, the practice of using "unity and oneness" to judge that others have no sense of nationalism is also often found in civil society itself. . . . In short, the construction of nationalism as a grand story has constituted a comfort zone which makes people "feel (more) secured" in it, so that they do not want to be thrown out of such comfort.' The wider ramification of Budiawan's analysis is that critical intellectuals everywhere can be oppositional to the state, but they are still bound up by the nationalist cultural imaginary constructed by the state machine. How to move out of nationalistic entrapment becomes a strategic question.

In this context, Chapter 8, Kenneth Dean's 'Despotic empire/nation-state' begins to locate possibilities arising out of local practices. Through his fieldwork on religious practices in South and Southeastern China, Dean identifies the way traditional popular cultural forms in local systems of exchange respond to, and operate beyond, the nationalism formulated by the state. The heavy trafficking of popular religious organizations across borders, between Fujian province, Taiwan and Chinese communities in Southeast Asia, made possible by global capital flows, Dean argues, seems to be in effect a desire to resist the 'totalizing project of nationalist modernity'. The 'authentic mazu' was traveled in Taiwan in 1997. Throughout the island, 'she' was enthusiastically welcomed. Controversies occurred. The Taiwanese independent faction of the fundamentalist kind argued that these Chinese people were trying to make monies (donations) from our people's pockets. We have to stop them. On the other hand, when Da Lai La Ma was here, the fundamentalist agitated for Tibetan independence (to project the desire of themselves). Well, it did not matter for the religious populace. The stupidity of the political nation-state was passed over. Thousands and thousands of people went to these types of ceremonies. These fragmented examples of resistance, Dean argues, 'achieve maximum flexibility by re-inventing [themselves] at a level of individuation both below that of the homogeneity demanded by a nation, and yet at the same time, at a level that is suppler and more vibrant than the rigid consistency

of a state'. The cracks and leaks, always existing in the community's subtle encounters with the state, construct a relative autonomous space for the 'assemblage of desire operating at the communal level to simultaneously resist the state and inscribe the all too human'. Whether these popular practices could transform the rigidity of statist form remain an open-ended question; but the very existence of such form does indicate cultural resources available for 'creative local responses to global capitalism and nationalistic cultural hegemony'.

If Ken Dean is desperately seeking an alternative modality to the trans-local in response to capitalism and statist nationalism, then Mark Reid's Chapter 13, 'African-American cultural studies' can be read as charting out major strategies practiced in African-American history, and the subsequent critical attempt to move beyond the existing limits. The strategies emerging in successive historical trajectories – a conservativist accommodation, a liberalist appropriation and a nationalist resistance – constitute the contemporary relations of African-American culture and mainstream European hegemony. In response to these racially bounded articulations, Reid observes an emerging critical paradigm to account for gender, sexuality and class issues, under the rubric of 'postNegritude'. The cultural historian argues, 'the root of postNegritude is the psychical and cultural history of postcolonialism. A postNegritude orientation appropriates ideas while it resists the colonizing urge to find legitimacy in the arms of static academic discourses.' Through analysis of Marlon Riggs' *Tongues United* and Spike Lee's *Jungle Fever*, Reid's postNegritude shift not only interrogates the rigidity of identity politics, but goes one step further to advance a critical synthesis. The direction Reid's chapter takes echoes a much-needed epistemological break in the wider spaces of cultural studies; a 'critical syncretism' might be a beginning point to think about different levels of analysis between and across geographical spaces.

Meaghan Morris's analysis of 'white panic' in Chapter 12 charts the psychosocial complex within the history of Australia. Her powerful analysis, through the figure of Mad Max, leads us to a thorough understanding of the present moment of the Pauline Hanson phenomenon. To my own understanding, the popularity of the Hanson agenda is not only racially based but also class grounded. The multicultural policy of the state, as a mechanism to seduce 'Asian' capital for Australia to survive economically, has been dominant for the past twenty years, with the result that the state has forgotten the 'white' laboring classes who now feel emotionally and politically excluded by the system. Their revenge, then, is not only directed against state policy, but also projects a resentment against the middle class, more well-off migrants who are now taking away what 'we' had before. The agency, Hanson, turns this class resentment into racist politics and erases class politics by centering on the ethnic nationalism question. Morris's account of white panic, though not directly targeted at the Hanson phenomenon, offers a longer term trajectory for us to understand the basis of this political maneuvering.

Though the articulation could be seen as a model to understand the wider context of white panic across the globe, one has to be reminded of its regional specificities. Australia's white racism was and has been 'defensive' rather than 'aggressive'. As a political practice that has constituted the dominant 'Asian' imaginary of 'Australia', the White Australia policy was interestingly entangled with the Taiwan question. The policy was implemented in 1901, the time of Australian federation, six years after Taiwan became the first Japanese colony in 1895, as the result of winning the Sino-Japan war. To defend itself from the feared Japanese colonialism, colonial racism was adopted to exclude any 'colored immigrants'.[18] This defensive mechanism of fear has later defined the difficulty of Australian national identity *vis-à-vis* 'Asia' throughout the twentieth century, even to the present day, when 'Australia' has become the ideal site of immigration for the middle classes from the entire Asian continent. In other words, the history of white panic did not happen recently, but started in the late nineteenth century, the peak moment of global colonialism within which Japanese fascistic militarism was situated. As I proposed earlier, the relationship of Asia with the world could be seen in light of 'Japan's' relation to the world in this earlier moment of history, though Japan no longer monopolized the position to speak to, and be defined by, the colonial 'West'. Therefore, though Australia's national identity was historically defined by 'Japan' after 1895, like Japan, Australia's positioning and identity was and has been bounded by its location within the colonial and neocolonial structure. This is, to be sure, not to defend Australian white racism, but to explain how that overt discrimination could be understood to take place at a specific historical conjuncture. Seen from this angle, 'Australia' should be held responsible for the racist formation of White Australia policy, but others are also culpable: Japanese colonialism and English imperialist colonialism, in their competition with other colonial powers, were equally guilty of the specific Australian practice. Unfortunately, the reactive state leadership in the region erased the earlier part of history to hold Australia responsible for its own conduct; and hence completely deleted the problems of other colonial forces. Thus understood, we who live in the region should not give the cultural power to reactionary state leaders to continue that line of colonial racism, to exclude 'white' Australia.

Colonial conquest has forced Australia and New Zealand to be part of 'Asia', and these two geographical spaces could be seen as part of Inter-Asia, economically and politically. In fact, to make the always-already hybrid 'Asia' more culturally mixed is only one step short of preparation against the global rise of racism. And in fact, tremendous lessons can be learned from Australia's instance in preventing ethnic and racial war from happening on a global scale.

Having analyzed cultural practices in relation to the nation and states in various contexts, let me end with Tony Bennett's 'Cultural studies: the Foucault effect', the keynote address to the first Trajectories Conference, which unfortunately could not be published here. But I do feel an obligation to 'include' his address in this context. In his essay, Bennett is arguing for a paradigm shift

in cultural studies, that is, from Gramsci to Foucault; or more precisely, from a particular version of Gramsci to a particular vein of Foucault. Bennett argues that:

> Foucault's work points to 'the increasing governmentalization of social relations as a necessary and inescapable horizon of contemporary social and political life which, as such, conditions both the kind of practical influence intellectuals can reasonably expect to have and the manner in which that influence can be exercised. . . . This entails recognizing that changing how cultural resources function in the context of relations of power usually involves modifying the ways in which cultural forms and activities are governmentally deployed as parts of programs of social management. This, in turn, requires that intellectuals lower the threshold of their political vistas in a manner that will enable them to connect with the debates and practices through which reformist adjustments to the administration of culture are actually brought about.

What is crucial in Bennett's shift is, indeed, a rethinking of the uneasy relation between cultural studies and the state (or to use his term, governmentality). In the past, cultural studies practices have grown out of and have always seen themselves as a counter-hegemonic formation. (I am not trying to romanticize cultural studies here; but most critical practitioners would agree on this at least, unless one is simply using the sign, cultural studies, to be a careerist.) Its intellectual contribution has been a critique of the state, mainstream culture and the hegemonic power bloc. The mood seems to have changed. There is a vein of cultural studies hoping to generate more influence in the cultural sphere. The Australian Key Center for Cultural and Media Policy, directed by Bennett, is a representative case. Given the condition that one should not essentialize the role of the state and the Australian state might well be different, the shift seems to be taking place elsewhere. For instance, Eric Louw, in a recent discussion of cultural studies in the new South Africa, has detailed a dilemma: used to being an oppositional anti-apartheid practice, under a new political regime, cultural studies in South Africa has become a cultural and media policy think-tank. A similar 'opportunity' is also opened by structural changes in places such as South Korea after Kim Young-sam, Taiwan after Lee Teng-hui, and the Philippines after Aquino. In fact, once the city of Taipei was taken over by the former opposition, a mainstream feminist then articulated a position called 'state feminism' to justify her own bloc's alliance with the city-state, in order to win over resources; and in so doing, allied the feminist movement to the 'powers that be'. Is cultural studies most politically effective if it works with and becomes part of the state apparatus? Should cultural studies constantly distance itself from the power bloc? These issues are worth debating. At least in the

Australian context, once the conservative government took power, the optimism around working for the state in order to transform the 'national' cultural space seems to be called into question.

Renegotiating movements

As many practitioners have already pointed out, for the past three decades or so, the question of resistance has been central to the project of cultural studies. It almost becomes a standard procedure, in the concluding part of the analysis, to project a desire to locate sites or implications for resistance. 'Resistance studies' are no doubt essential to keep optimism alive. But the search for resistance often distorts analysis, which blinds critics' eyes to the problems involved. So often, it turns out to be either lip-service or a release of intellectual guilt. Power is everywhere, so is resistance – end of story. No doubt, part of the contribution that cultural studies has been making is the constant accumulation of analysis to bring to light the fact that resistance does exist, no matter how disparate and discrete it may be. This mundane reminder, or what Meaghan Morris calls the 'banality of cultural studies', might well be the past, present and future 'basic needs' of cultural studies. But the academicization of resistance coincides with colonization of the subaltern subjects into scholarly commodities. Furthermore, if the institutionalization of cultural studies on campus is the only direction of the future, how is it different from other academic practices, often trashed by cultural studies practitioners? Obviously, there is that general sentiment of 'not quite enough' as just that. How can the analysis and practices be articulated to other critical social forces? What then can be the political project of cultural studies from the 1990s onward?

As I stated at the very beginning, cultural studies grew out of the global decolonization movement, expressed largely in the form of social movements. Cultural studies in England has been connected to the labor, anti-nuclear, anti-racism, immigrant and women's movements; in South Africa, to the anti-apartheid movement; in the US, to the feminist, gay and lesbian, and ethnic minority movements; in Australia, to the working class, women's, aboriginal, and immigrant movements; in Korea, to the feminist, and workers' movements, etc. To say the least, if there have been no constant challenges from the movement sectors and no responses to social struggles, cultural studies might have been buried long ago.[19] Epistemic stability in cultural studies has been interrupted by the emergence of new subjects: working class youth, women, gays and lesbians, aboriginals, and immigrants. In response to waves of new contradictions, Marxism, feminism, Queer studies, postcolonial studies, diasporic studies, etc., have become the motor forces which drive the cultural studies project forward.

There is nothing nostalgic about this remembering. Without tradition, there is no solid basis for constructing effective politics. But when one looks around, how much work has been done in the field to focus studies on the social

movements, or to analyse these agencies of social changes?[20] This is then the motive of Part III.

Obviously, one of the most energetic forces emerging in the 1990s is the gay and lesbian movement. Its tactics and strategies seem to have fundamentally transformed the earlier images of social movement. The play with mainstream media politics constitutes one of its keys.[21] To cite Manuel Castell's inversion of the standardized formula – 'Think Locally, Act Globally' – media politics can be one of the explanations of the global impact of Anglo-American gay and lesbian movements.

Hsiao-Hung Chang, in Chapter 14, importantly documents a particular event in action. Arguably, the Queer (tung-chih) movement in Taiwan is the most energetic and visible form of social movement at this moment, almost to the extent of displacing the earlier momentum of the feminist movement. The 'success' of this movement has its specificities for various reasons. First, lesbian activists, who were mostly the younger generation students in the late 1980s, who gained organizing experiences in the feminist movement, who have learned from and have been nurtured by the earlier generation of academic feminists associating with various women's organizations, are now taking the lead in the movement. Gay men, on the other hand, do not have that peculiar historical experience. And therefore, the organizing capacity mostly belongs to the lesbian subject. Second, the booming of the commodification of identity has, since 1994, produced an entire industry of queer writing, for instance; a considerable number of gays and lesbians or their sympathizers are now occupying strategic positions in the publishing houses, or in the wider media space. Third, now that the feminist movement is gradually moving into and being incorporated into the state power (on the level of county, city and national assembly) through familiar mechanisms such as granting of funding to conduct 'research' projects for state policy, conservative right-wing feminists begin to suppress any 'non-acceptable' identity, so as to win over middle-class support. The intensity of this desire to be part of the state (some elements which used to be 'oppositional' are now part of the reconfiguration of political power) can even be strong enough to formulate a 'state feminism' position. Under such conditions, the used-to-be 'sisters' or 'daughters' (i.e., lesbians) are now under attack.

Chang's analysis of 'queer valentine' might be understood in such a context. When the used-to-be oppositional political party is taking over Taipei City, resources have begun to flow into movement sectors across the board, to implement city policies, so as to win election tickets. Here, nationalist politics meets sexual politics, and of course, sexual politics is bound to lose. Taipei New Park has been the landmark site for gay sex/gatherings for the past thirty years. But now the state is trying to reclaim the 28 February 1947 (228) massacre, to put a memorial monument and museum into the New Park and the Park is about to be evacuated for 'sacred' uses.[22] The 228 event was the symbolic foundation of the Taiwan Independence movement and is sacred to Taiwanese nationalism.

There is a feeling that it should not be associated with queer sex. Bushes were torn down, toilets 'cleaned up'. To defend 'our' own territory, an alliance of activist groups was formed into 'queer front' (tung-jeng). Chang's analysis centers on one episode of the movement. The strategy adopted was to draw media attention so as to press the state to concede – a strategy commonly practiced by movement sector of other sorts. The University Women Student Alliance made a 'toilet movement' occupying men's rest rooms to call public attention to the problem of limited space in women's toilets. The Labor movement did a tremendous amount of cultural work during the 1996 Presidential election: the 'black hand' band sang songs like the Internationale, a theater group imitated high-kicking women's dancing style, etc., during the 'public hearing' to interrogate politicians' public policy proposals. But activists know too well that one cannot play media politics without grassroots organizing, whereas the feminist and gay and lesbian movement was either centering on lobbying for state policy or media politics, without a grassroots element. The problem is difficult to resolve, largely because national, if not nationalist, politics has been easily accessible.

To get back to the tension between the feminist turn to conservatism and lesbian activism, it is worth documenting an episode which reveals the conflicts. In a recent public forum, some 200 people were present to debate on the relationship between feminism and lesbian activism, for the first time. Over 90 per cent of the participants came from the gay and lesbian sector. This under-participation of feminist constituencies is symptomatic enough: the mainstream state feminists escaped from the scene. And worse, the more established feminists kept on talking about the necessity for a lesbian subjectivity to emerge, without noticing that the event itself was nothing if not assertion of such subjectivity. Conservative feminist ignorance of queer identity/politics is evident in such a gathering. A well-known liberal feminist ended up by saying, 'Oh well, in other panels, there was always a man there to be ridiculed and served as a target of attack, and today I am playing that role.' With that statement, she failed to address the problem that she was part of the patriarchal system and she refused to recognize the existence of the heterosexual structure from which she benefits so much. Such a homophobic mentality prevails in the mainstream feminist movement. But this is not to suggest that warning has never been given before to deal with this delicate relationship between gender and sexual politics. The quarterly cultural-political magazine, *Isle Margin*, published a special issue on the subject in 1993; the 'Women nation – fake identification' issue, no. 9, attempts to bridge that gap of consciousness. The discursive formulation did not receive any serious attention from the feminist establishment. 'Yes, "we" see "you", but "you" have to stand on "your" own', has, since then, become the standardized response from the mainstream feminist sector. A split in the feminist movement seems now inevitable. Unfortunately, this is the problem of any form of identity politics: carving up the territory, no desire to connect with others, mind one's own business.

Like Chang's attempt to analyze the cultural politics of the queer movement but operating on a different site, Cindy Patton demonstrates how cultural criticism has been strategically practiced in constructing discursive space in the international AIDS project. Patton's 'Critical bodies' (Chapter 16), conducted in a dialogic style at the 1992 Trajectories Conference, is a critical intervention to remind us that social movements can no longer be narrowly confined, conducted and understood within national boundaries. The effects of AIDS organizing in the Western context does have global impacts, such as the fact that community-based programming to suit local needs has become a model for AIDS activism; the ways of perceiving the HIV 'problems' tend to 'feminize "Asian AIDS"'; and international health policy will influence the distribution of resources throughout the world. In this arena of international organizing, cultural criticism has become central to frame the issues, to construct the terrains and to formulate strategic languages to win over popular support. This is where media politics, grassroots organizing, and cultural criticism intersect. Patton's implicit call for alliance and intervention from the cultural studies side has to be paid special attention. It cannot be that cultural studies only belongs to the university campus; it is relevant to the politics of the real movement world, and cultural studies has to recharge its desire to find the appropriate sites other than academic journals to relink to the movement and the world of cultural politics. The ghettoization of cultural studies into pure academicism is unjustified and escapes into self-interest to secure its own academic space where all its energies are wasted. This is particularly true in the US context, which is at once the most visible and the worst model available. But once the desire is projected into places other than university campuses, once energies are spent in the movements, the cultural studies world then becomes completely open-ended and has a real bearing. Besides Patton's type of AIDS activism, the University of Technology, Sydney, recently developed the 'Shop Fronts' project, led by media/cultural studies scholar, Jeannie Martin, to organize critical scholars in responses to the activist and community demand, to undertake research for them. This attempt to reconnect scholarship with activism is potentially a better model than the campus activism rhetoric.

In fact, this 'activist scholar' mode has been widely practiced in the Inter-Asia region, in Japan, Korea, Hong Kong, Taiwan, Thailand, Malaysia, Indonesia, Sri Lanka, India, etc., in these places, intellectuals have always been at the forefront; and the most dramatic instance seems to be in the Philippines, where, for instance, several thousand NGOs are operating on the University of Philippines campuses. In this connection, Stephen Muecke, the first cultural studies professor in Australia, through his own long-term involvement in the aboriginal community in the Australian context, surveys the main players and strategies in the struggles for indigenous rights in Australia. Chapter 15, 'Cultural activism – indigenous Australia 1972–94' sets out to distinguish political from cultural activism, a common strategy adopted by 'indigenous' activists. As Muecke puts it, 'Cultural activism can have the same result as political activism, but it doesn't

look the same. It has the feature of mobilizing cultural representations as performances. It is a tactical "bring out" of cultures as a valuable and scarce "statement".' In analyzing the photo of Denis Walker's children, widely released in newspapers in Australia, Muecke argues that there has been a long tradition of Aboriginal cultural activism, to evoke and reproduce their own traditions. In dialogue with aboriginal activist, Martin Nakata, Muecke concludes by proposing to widen the scope of aboriginal cultural activism: 'Apart from street theater, cultural activism can also take the form of international conferences for indigenous peoples, and essays like Nakata's articulate local dispossession and international history.' Indeed, if aboriginals across the globe do not belong to the colonial system of the nation-state, the question of how to culturally bypass the simple 'Declaration' model of the UN (more precisely the US – united states, in every sense of the word) to form international alliances is a critical issue to be confronted.[23]

The kind of cultural activism is further amplified in Yung-ho Im's 'The media, civil society and new social movements in Korea 1985–93' (Chapter 17), which traces the developments of various citizens' press movements against the mainstream press. Sympathetic and yet critical, Im convincingly shows the dilemma and structural problems within and outside the movements. The middle class reformist tendency, the obsession with media (celebrity) politics, the lack of grassroots solidarity, hierarchical structure internal to the movement organizations, leadership's personal connections and struggle for power, the inability to transform the structural operation, the overwhelming power of the state even after the 'political democratization' process, etc., all point to problems confronted in Korea; and in fact, elsewhere such as in Hong Kong, Taiwan, Singapore and the Philippines, and South Africa. In my reading, there seems to be structural similarity in these places in terms of the historical dynamic between the state, civil society, capital and neocolonial power. The post-World War Two national decolonization movement in the East Asia region saw a common tendency of the emergence of authoritarian regimes, partly established by the US neoimperialist power. With the alibi of combating the 'communist bloc', the US set up political regimes which were easier to control; within this neocolonial structure, the 'big' state monopolized the power over capital and civil society. In the subsequent era, which saw tremendous economic growth, the formation of what can be termed a 'consumer society', within which the middle class were no longer satisfied with the feudal mode of political life, and radically challenged the authoritarian regime. During this moment, we saw the loosening of state control and its decades of violence, and long-term repressed social energies began to emerge. This was perhaps the era of social movement. The aggregation of different social forces was gathered under the name of civil society, with, at their fore, the oppositional political (underground) coalition, using the social antagonism to fight for power under the rhetoric of democracy. The so-called 'political democratization' ended up following the US model of party politics, and electorate democracy of a formalistic type, usually exploiting

long-term ethnic and regional divides.[24] With the overturn of the political regime, the political realignment between the capital sector and what used to be oppositional forces in the civil society, in struggle over state power, has become the dominant power. Class politics dissolved into the background of the political scene. A proper capitalist society is now in shape, if not yet in its ideological readjustment, which partly explains why state power in these countries is still strong: the state used to control and also 'take care of' everything, and now the oppositionals are in power, and should do a better job. After a decade of turmoil and transition, radical social energies are by now either exhausted or co-opted into political systems. One often hears talk of the disappearance of social movements, and that the only possibility for further change lies in 'parliamentary democracy'.

It is in this conjuncture that Muto Ichiyo's 'Alliance of Hope and challenges of global democracy' (Chapter 18) tells a different story: the social movement has not finished and in fact has just begun. An internationally respected activist scholar for the past forty years, Muto Ichiyo proposes a paradigmatic shift in global politics: a non-statist, people-to-people centered politics of a 'transborder participatory democracy'. The dominant model for oppositional politics, a struggle for taking over state power as the ultimate political agenda, has to be re-examined. Muto's proposal, to be sure, is not one based on anarchism, but stresses the need to bypass state power so as to widen global social spaces for subject groups to exercise their own power. State bureaucracy is definitely needed to run day-to-day public work, such as transportation, water supply, etc. As Muto strongly states, 'It is this global structure [of domination] that we face and are called upon to transform. For without disintegrating the global power center and replacing it with an alternative governance of the people we can hardly hope to ensure the survival of human kind, hand down a life-giving environment to the coming generations on this planet, let alone overcome the immense gap between the rich and poor in the world.' How to implement the project? There is no definitive answer. But an attempt to construct such a model has already taken place. The PP21 (the People's Plan for the twenty-first Century) project was inaugurated in 1989, in Japan. Three hundred and sixty activists from Asia, the Pacific and other continents met with thousands of Japanese activists to formulate long-term plans. The second round took place in Thailand, in 1992; and prior to that, people's movement representatives from six Central American countries met in Managua with a Japanese PP21 group under the aegis of the newly-organized PP21 Central America.[25] In 1996, the third convergence took place in Nepal. It was in these gatherings that the new concept of 'transborder participatory democracy' was put forward, with the people of the world as the constituency. Muto recalls, 'It is a permanent democratization process based in "democracy on the spot" – emancipatory transformation of everyday relationships in the family, community, work place and other institutions of life – extending beyond social, cultural, and state barriers, and reaching, influencing and ultimately controlling the global

decision-making mechanisms wherever they are located.' We should not over-romanticize the PP21 project. It has its own problems: it attempts to cover too much, with limited resources and organizing power. But this is one of the few ideal visions available to those who are aiming to change the world, and indeed, the ideal has been put into practice. The optimism of the project is, to my reading, based on a desire to change, an impossible hope to link hopes together; to use Muto's term, 'the alliance of hope' to construct an 'international civil society' to prevent the over-expansion and over-power of the state and capital. The challenge is more than immense. 'This is the challenge we need to take. It is indeed a profound change that we need to work. But that we have gathered here in this Encounter is proof enough that the march has begun.'

With the spirit set by the exemplary project PP21, it is at this moment of temporary narrative closure that we come back to the historical unifying forces of an open-ended Marxism, a Marxism without guarantee, to recycle Stuart Hall's widely circulated phrase. This book ends with Naoki Sakai's dialogues with Stuart Hall, conducted in Tokyo, during the 1996 conference on 'Dialogues with cultural studies', organized by the Institute of Information and Communication Studies, University of Tokyo, through the endless effort of Professor Tatsuro Hanada. In this encounter of historical instance, cultural studies in England (or more precisely, the legacy of a Birmingham version), the new left of cultural studies was put in the spotlight to 'converge' with its counterpart in Asia: the Marxist tradition in Japan. In reading the interview, I was forced to realize that perhaps the most established and influential tradition of Marxism is no longer in its originating space – Europe, but in other geographical sites such as Japan. Marxism in Japan is not only occupying the center space of Japanese academies, but is still a lively influence on Japanese culture and society. There is a Gramsci society in Kyoto, Althusserian Marxism in Tokyo, cultural studies groupings in Fukuoka, Osaka, Kobe, Kyoto, Tokyo, and prominent journals such as *Thought, Modern Thought, Critical Space* and the highly acclaimed activist journal, *IMPACTION* which links cultural studies with social movement sectors, and book series published by the publisher, Iwanami (not to mention the long-term translation tradition, e.g. an anthology of the *New Left Review* was published in 1964, when the journal started only in 1960), to continue a Marxist line of thought.

The critical point to stress here is not so much the fact that Europe no longer has the copyright over Marxism, since it is everywhere, and more lively than its European counterpart, but that, as I argued earlier, Marxism, as a symbolic sign to reconnect different geographical sites, different intellectual traditions, and political practices, has to be reclaimed to perform its historical mission in linking critical energies together and in charting out directions to converge for the future. This is where cultural studies practitioners and social movement activists could take on the political and intellectual responsibility to move forward in fulfilling the incomplete project of decolonization.

Notes

1 Other papers first delivered in the conferences already published elsewhere have to be excluded here. See Preface, note 1. The fact, that these 'other' papers are mostly generated outside English-speaking contexts, says something about the global knowledge production system.
2 I am appropriating Chris Connery's (1996) formulation of the 'oceanic feeling' here.
3 See the 'Declaration of the People's Conference Against Imperialist Globalization', 23 November 1995, Manila.
4 For specifics, see Chen (1996).
5 An 'empirical' study is ongoing, under the title, 'Diasporic Opportunism, Native Collaborationism'. The former term refers to those who reside in the imperial center space: not only selling their pc (multicultural) identity, they monopolize speaking positions to block voices coming from 'home'; and the latter points to those 'returnees' from the neocolonial empire, who have clearly projected a desire to 'return' to the center: they become native informant (drawing on theories produced in the empire, partly enunciated by the diasporic opportunists), to 'report' local information, and become academic brokers in collaboration with the center powers, diasporic or otherwise, left or right.
6 See for instance, the recent publication of eight volumes of *Modern Japan and Its Colonies*, released by Iwanami publisher (Tokyo), 1993.
7 Given the limited space here, I could not escape from a reductive account of these forms. For details, see Kuan-Hsing Chen (forthcoming).
8 See Césaire (1950/72: 39-43). For instance, 'If you criticize the colonialism that drives the most peaceable populations to despair, Mannoni will explain to you that after all, the ones responsible *are not the colonialist whites* but the colonized Madagascans. Damn it all, they took the whites for gods and expected of them everything one expects of the divinity' (p. 41).
9 One could perhaps argue that *Black Skin, White Masks* was written in response to Mannoni. Chapter Four, 'The So-Called Dependency Complex of Colonized Peoples', begins with a citation of Césaire and then goes on to attack Mannoni.
10 Nandy puts it, 'The broad psychological contours of colonialism are now known. Thanks to sensitive writers like Octave Mannoni, Frantz Fanon and Albert Memmi we even know something about the interpersonal patterns which constituted the colonial situation, particularly in Africa. Less well known are the cultural and psychological pathologies produced by colonization in the colonizing societies' (*The Intimate Enemy*, 1983: 30). Then he goes on to analyze India.
11 For detailed analysis on Nandy and Huntington, see Kuan-Hsing Chen (forthcoming).
12 For a detailed account, see Chen (forthcoming).
13 See for instance, Wang (1995), an edited volume in response to Huntington. Moreover, he was invited to Singapore and Malaysia to debate with 'Asian' scholars in September 1997.
14 The work of Professor Renato Constantino, who has published over forty books, cannot be summarized here.
15 See Hsu Tsung-mau (1996), 'The Clash of Civilization vs. the China Threat: A Report on the Debate between Huntington and the Singaporean and Malaysian scholars reflecting the Differences of Perceptions of the East and West,' *China Times*, September 17, page 9, for the report.
16 See for instance, Mahathir Mohamad (1995), 'Alliances and collaborations within the Pacific Rim,' in *The Pacific Rim in the 21st Century: Alliances and Collaborations in the Asia-Pacific* (Selangor Darul Ehsan, Malaysia: Asian Strategy and Leadership Institute); Jiang's recent adoption of the key term, postcolonialism, see Kuan-Hsing

Chen, 'Missile Internationalism', presented at the 'Salon de Refuse: Internationalism and Asian Studies', organized by Sakai Naoki and Tani Barlow, Hawaii, April 1996.

17 The question was raised by Lii's respondent, Masao Miyoshi, in the conference context. Whereas Lii sees the phenomenon signal a rupture, Miyoshi tends to take this mode of articulation more as a strategic maneuvering of transnational capital.

18 For an interesting account of the Japan–Australia relationship before the end of World War Two, see Frei (1991).

19 Strangely enough, if one re-evokes that tradition of necessary connection in history, one can often be charged with being a Leninist or Stalinist.

20 The strong linkage between academic knowledge production and social activism has been firmly established in the Philippines context. For decades, active connections with NGOs (non-governmental organizations) have been part of intellectual life on the university campus. A recent project, Shop Front, initiated in the University of Technology, Sydney, is one of the experiments directly linked to practitioners of cultural studies, to do research in response to various community groups.

21 Manuel Castells, in a 1995 lecture, termed such a turn as 'Think locally, Act globally'.

22 The 228 event happened in 1947 when the Nationalist army took over Taiwan from the hands of Japan. A massive number of local people (estimated at sixty thousand) were killed in the process. This episode of history had been suppressed until 1987, the end of martial law. In recent years, the state has been pressed to deal with the responsibility for the state violence.

23 See for instance, Native People Address the the United Nations (1994). It is so obvious that 'native', the colonialist term, is still adopted by the colonial formation of the UN. UN is nothing but an alliance of state machines from which, for instance, Taiwan's aboriginals have always been excluded, for the simple reason that ROC is not part of the UN. But what do aboriginals have to do with the nation-state? It is obviously not the choice of aboriginals to live within the structure of the nation-state.

24 In Korea, the political transformation is termed as 'from military regime to civilian government', where in Taiwan the mainstream rhetoric is 'from authoritarianism to democracy'; the difference in formulation echoes the long term established critical tradition in the former context.

25 For detailed documentation of these events, see People's Plan for the 21st Century (1996).

References

Berger, Mark T. (1996), 'Yellow Mythologies: The East Asian Miracle and Post-Cold War Capitalism', *Positions: East Asia Cultures Critique* 4: 1, 90–126.

Bhabha, Homi K. (1994), *The Location of Culture*, London: Routledge.

Blaut, James M. (1992), *1492: The Debate on Colonialism, Eurocentrism and History*, NJ: African World Press.

—— (1993), *The Colonizer's Model of the World: Geographical Diffusionism and Eurocentric History*, NY: Guilford.

Césaire, Aimé (1950/1972), *Discourse on Colonialism*, NY: Monthly Review Press.

Chatterjee, Partha (1993), *The Nation and Its Fragments: Colonial and Postcolonial Histories*, Princeton, NJ: Princeton University Press.

Chen, Kuan-Hsing (1994), 'The Imperialist Eye: The Cultural Imaginary of a Sub-Empire and a Nation-State,' *Taiwan: A Radical Quarterly in Social Studies*, 17: 149–222 (in Chinese); translation in Japanese appeared in *Shiso* (*Thought*), 1996 (859): 162–221.

—— (1996), 'Not Yet the Postcolonial Era: the (Super) Nation-State and Trans*nationalism* of cultural studies,' *Cultural Studies* 10(1): 37–70.

—— (1997), 'Multiculturalism or Neo-Colonial Racism?' *Ritsumeikan Studies in Language and Culture*, 8 (5/6): 347–76.

—— (forthcoming), 'Watch out for the Civilizationalist Interpellation: Huntington and Nandy,' in *Taiwan: A Radical Quarterly in Social Studies*.

Chen, Pingyuan (1992), *The Narrative Form of Chinese Novels*, Peking. (in Chinese)

Cheng, Weng-Liang (1996), 'Anti-Colonial City during the Japanese Occupation Period: A Cultural History'. MA Thesis, Graduate Institute of Building and Planning, National Taiwan University, Taiwan.

Ch'ien, Edward T. (1986), *Chiao-Hung and the Restructuring of Neo-Confucianism in the Late Ming*, New York: Columbia University Press.

Cho, Hae-Joang (1995), 'Constructing and Deconstructing "Koreanness" in the 1990s South Korea', unpublished manuscript.

Cho, Hee-Yeon (1997), 'The State and Society in East Asian Accumulation – "The Political Sociology of East Asian Accumulation" and the Dialectic of Civil War, Modernization and Democratization in Taiwan and South Korea,' unpublished manuscript presented in the occasional forum of *Taiwan: A Radical Quarterly in Social Studies*, Taipei.

Chua, Beng-Huat (1995), *Communitarian Ideology and Democracy in Singapore*, London: Routledge.

Connery, Christopher L. (1996), 'The Oceanic Feeling and the Regional Imaginary,' in Rob Wilson and Wimal Dissanayake (eds), *Global/Local: Cultural Production and the Transnational Imaginary*, Durham, NC: Duke University Press, 284–311.

Constantino, Renato (1988), *Nationalism and Liberation*, Quezon City, Philippines: Karrel, Inc.

Cummings, Bruce (1984), 'The Legacy of Japanese Colonialism in Korea,' in Peter Duus *et al.* (1984), 478–96.

Dai, Jinghua (1995), *Breaking Out the Mirror City: Women, Cinema, Literature*, Beijing: Writer's publisher. (in Chinese)

Duus, Peter, Roman H. Myers, and Mark R. Peattie (1984), *The Japanese Colonial Empire, 1895–1945*, Princeton, NJ: Princeton University Press.

Duus, Peter, Roman H. Myers, and Mark R. Peattie (1996), *The Japanese Wartime Empire, 1931–1945*, Princeton, NJ: Princeton University Press.

Fanon, Frantz (1963/1968), *The Wretched of the Earth*, New York: Grove.

—— (1952/1967), *Black Skin, White Masks*, New York: Grove.

Frei, Henry P. (1991), *Japan's Southward Advance and Australia: From the Sixteenth Century to World War II*, Honolulu: University of Hawaii Press.

Gauhar, Altaf (1987), 'Asia: the Experience of the Sub-continent,' in Bruno Kreisky and Humayun Gauhar (eds), *Decolonization and After: the Future of the Third World*, London: Southern Publications, 51–61.

Gilroy, Paul (1994), 'Black Cultural Politics: An Interview with Paul Gilroy by Timmy Lott,' *Found Object* 4: 46–81.

Hage, Ghassan (1993), 'Republicanism, Multiculturalism, Zoology,' *Communal/Plural* (2): 113–38.

Hall, Stuart (1991), 'The Local and the Global: Globalization and Ethnicity,' and 'Old and New Identities, Old and New Ethnicities,' in Anthony D. King (ed.), *Culture, Globalization and the World-System*, London: Macmillan, 19–39; 41–68.

—— (1992), 'The Question of Cultural Identity,' in S. Hall, D. Held, T. McGrew (eds), *Modernity and Its Future*, Cambridge: Polity Press, 274–316.

—— (1992), 'The West and the Rest: Discourse and Power,' in Stuart Hall and Gram Gieben (eds), *Formations of Modernity*, Cambridge: Polity Press.

Halliday, Jon and Gavan McCormack (1973), *Japanese Imperialism Today*, NY: Monthly Review.

Heryanto, Ariel (1995), 'What Does Post-Modernism Do in Contemporary Indonesia?' *SOJOURN: Journal of Social Issues in Southeast Asia*, 10(1): 33–43.

—— (1997), 'Simulacra in a Postcolonial State: Power Relations in New Order Indonesia,' unpublished manuscript.

Hobson, J.A. (1902/1965), *Imperialism: A Study*, Ann Arbor: University of Michigan Press.

Huntington, Samuel P. (1993), 'The Clash of Civilizations?' *Foreign Affairs* 72(3): 113–38.

Iwanami Publisher (1993), *Modern Japan and its Colonies*, 8 volumes.

Journal of Southeast Asian Studies (1996), special issue on 'The Japanese Occupation in Southeast Asia'.

Kang, Min Jay (1996), 'Urban Transformation and Adaptation in Banka, Taipei Marginalization of a Historical Core'. PhD Dissertation, University of Washington.

Kang, Sang-jung (1996), *Orientalism and Its Other Side – Modern Cultural Critique*, Tokyo: Iwanami. (in Japanese)

Kaplan, Amy (1993), '"Left Alone with America": The Absence of Empire in the Study of American Culture,' in Amy Kaplan and Donald E. Pease (eds), *Cultures of United States Imperialism*, Durham, NC: Duke University Press, 3–21.

KASARINLAN: A Philippine Quarterly of Third World Studies (1992), special issue on 'The Philippine Left', 8(1).

Ker, Rey-ming (1996), *Taiwan Can Say No*, Taipei: Yeh-Chiang.

Kiernan, V.G. (1980), *America: The New Imperialism: From White Settlement to World Hegemony*, London: Zed Press.

Kim, Seong Nae (1995), 'The Iconic Power of Modernity: Reading a Cheju Shaman's Life History and Initiation Dream,' in Kenneth M. Wells (ed.), *South Korea's Minjung Movement: The Culture and Politics of Dissidence*, Honolulu: University of Hawaii Press, 155–65.

—— (1996), 'Mourning Korean Modernity: Violence and the Memory of the Cheju Uprising', unpublished manuscript.

Komagome, Takeshi (1996), *Japanese Colonial Empire and Its Cultural Integration*, Tokyo: Iwanami. (in Japanese)

Kratoska, Paul H. (1995), *Malaya and Singapore During the Japanese Occupation*, Singapore: Singapore University Press.

Kreisky, Bruno and Humayun Gauhar (1987), 'Introduction', in Bruno Kreisky and Humayun Gauhar (eds), *Decolonization and After: the Future of the Third World*, London: Southern Publications, 1–7.

Lamming, George (1960, 1992), *The Pleasures of Exile*, Ann Arbor: University of Michigan Press.

Lee, Geok Boi (1992), *Syonan Singapore under the Japanese, 1942–1945*, Singapore Heritage Society.

Lo, Hui-wen (1996), 'A Historical Analysis of the Importation of the Japanese Visual Products in Taiwan (1945–1996)'. MA Thesis, Graduate Institute of Journalism, National Cheng-Chi University, Taiwan.

Lohia, Rammanohar (1963), *Marx, Gandhi and Socialism*, Hyderabad: Rammanohar Lohia Samata Vidyalaya Nyas.

Mannoni, O. (1950/1990), *Prospero and Caliban: The Psychology of Colonization*, Ann Arbor: University of Michigan Press.

Memmi, Albert (1957/1965), *The Colonizer and the Colonized*, Boston: Beacon Press.

Muto, Ichiyo (forthcoming), *New Social Movement in Japan: Its Emergence and Development*.

Nandy, Ashis (1983), *The Intimate Enemy: Loss and Recovery of Self Under Colonialism*, Bombay: Oxford University Press.

—— (1994), *The Illegitimacy of Nationalism: Rabindranath Tagore and the Politics of Self*, Delhi: Oxford University Press.

Native People Address the United Nations (1994), *Voice of Indigenous Peoples*, Native American Council of New York City, Santa Fe, New Mexico: Clear Light Publishers.

Ngugi wa Thiong'o (1986), *Decolonising the Mind: The Politics of Language in African Literature*, Nairobi: Heinemann Kenya.

Nishikawa, Nagao (ed.) (1995), *The Formation of the Nation-State and Cultural Transformations*, Tokyo (in Japanese).

—— (1996a), 'Two Interpretations of Japanese Culture,' in Gavan McCormack *et al.* (eds), *Multicultural Japan: Palaeolithic to Postmodern*, Oxford University Press, 245–64.

—— (1996b), 'Cultural Studies in the Kanji Cultural Sphere: On the Concepts of Civilization and Culture, and the Nation-State', *Historical Studies of Cultural Exchanges* (Osaka), 1997 (1): 15–33 (in Japanese).

Ota, Yoshinobu (1993), 'Objectification of Culture: The Creation of Culture and Identity in the Tourist World,' in *The Japanese Journal of Ethnology* 57(4): 383–410.

—— (forthcoming), 'National Anthropology by Creative Imitation: Japanese Discussions on "Postmodern Anthropology" as Performatives'.

Paredes, Ruby R. (Ed.) (1989), *Philippine Colonial Democracy*, Quezon City: Anteneo de Manila University Press.

Peattie, Mark R. (1988), *Nan'yō: The Rise and Fall of the Japanese in Micronesia, 1885–1945*, Honolulu: Hawaii University Press.

People's Plan for the 21st Century (1996), *Shaping Our Future: Asia Pacific People's Convergence – Report of the Third Convergence since Minamata February–March 1996 in South Asia*, (eds) Kin-chi Lau, Lakshmi Daniel, and Tarcisius Fernando, published by PP21 Council Organizing Committee and Nepalese Organizing Committee for 1996 Kathmandu Convergence.

Said, Edward (1993), *Culture and Imperialism*, New York: Alfred A. Knopf.

Sakai, Naoki (1988), 'Modernity and Its Critique: The Problem of Universalism and Particularism,' *The South Atlantic Quarterly* 87(3): 475–504.

Sakiyama, Masaki (1996a), 'Style on "Style": Rethinking Cultural Studies and Cultural Critique,' *Thought (Shiso)*, 886: 146–77 (in Japanese).

—— (1996b), 'Irony and Arming/Syncretism,' *Modern Thought*, 24(11): 232–48.

Saravanamuttu, Johan (1995), 'Post-Marxism: Implications for Political Theory and Practice,' *SOJOURN: Journal of Social Issues in Southeast Asia*, 10(1): 45–64.

Shimizu, Hiromu (1992), *Cultural Politics: Discourses on the 'February Revolution' in the Philippines*, Tokyo (in Japanese).

Solomon, Jon (1997), 'China and the "Discourse of National Spirit": Towards a Politics of Dislocation.' PhD Dissertation, Cornell University.

Sugihara, Toru (1991), '"Orientalism" in the German Empire: The Kaiser's Journey in the Orient (1989) as an Example,' *Kansai University Review of Economics and Business*, 20(1): 101–31.

—— (1992), 'Colonial Voyages to "Manchester of the Orient": A Social History of the Korean Migration to Osaka, 1923–1945'.

Sung, Chiang, *et al.* (1996), *China Can Say No*, Taipei: Jen-Jiang (in Chinese).

Tambiah, S.J. (1986), *Sri Lanka: Ethnic Fratricide and the Dismantling of Democracy*, Chicago: University of Chicago Press.

Tomiyama, Ichiro (1990), *Modern Japanese Society and 'Okinawan'*, Tokyo: Economic Review (in Japanese).

—— (1995), *Battle Field and Memories*, Tokyo: Economic Review (in Japanese).

Ueno, Toshiya (1996), *Situation: The Cultural Politics of Pop and Rock*, Tokyo (in Japanese).

Vérges, Françoise (1995), 'Monsters and Revolutionaries. Colonial Family Romance and Métissage', PhD thesis, University of California at Berkeley.

Wang, Hui (1996), 'From Cultural Debates to Debates between Science and Metaphysics,' *The Scholar* 9: 131–90 (in Chinese).

Wang, Ji-shih (ed.) (1995), *Civilization and International Politics: Chinese Scholars on Huntington's Theory of the 'Clash of Civilizations'*, Shanghai: People's Publisher (in Chinese).

Wilson, Rob (1997), 'Reimagining the American Pacific: From *South Pacific* to Bamboo Ridge and Beyond,' paper presented at the 'Colonialism and Its Discontents' Conference, Taipei.

Winchakul, Thongchai (1994), *Siam Mapped: A History of the Geo-Body of a Nation*, Honolulu: Hawaii University Press.

Young, Robert (1990), *White Mythologies: Writing History and the West*, London: Routledge.

Zhang, Jingyuan (1992), *Psychoanalysis in China: Literary Transformations 1919–1949*, Ithaca: East Asia Program, Cornell University.

Part I

REFIGURING THE COLONIAL

2

GLOBALIZATION AND THE SOUTH

The Philippine experience

Renato Constantino

The Philippines is a classic example of a country which has undergone transition from colony to neocolony and now, like other countries of the South, is a target for recolonization by the North under new and sophisticated forms.

In the Philippine case, the Spaniards arrived with their Sword and Cross, initially imposing their rule by force of arms. Then they established a frailocracy, whereby the religious orders who came to own vast tracts of land, together with a favored class of Spanish officials, controlled the political, social, cultural and economic life of their native allies who were instrumental in securing the acquiescence of the natives through the propagation of religious passivity and fatalism. Religion colonized their consciousness and perpetuated their subservience.[1]

When the Americans came at the turn of the century, the Filipinos had already deposed the Spaniards and established their independence in the first anti-colonial revolution waged in Asia. The triumphant revolutionary forces inaugurated the first Philippine Republic,but this was strangled in its infancy by American aggression. In the ensuing Philippine–American War, some 600,000 Filipinos died actively resisting the new invaders or as a result of disease and dislocation in the wake of the conflict.[2]

If the Spaniards had the Cross and the Sword, the Americans had their equivalents in the Krag rifle and the English alphabet. After the Pacification Campaign designed to wipe out all resistance and brand all those who continued to resist as bandits and brigands, the Americans proceeded to ensure the making of good colonials through their control of education. As the decades of American colonial rule rolled on, generation after generation of Filipinos went through systematic colonial brainwashing. History was mythologized to create an altruistic image for the American colonizer; our language was deprecated, our consumption habits were molded to suit American products and our social and cultural life underwent a fast process of Americanization (Constantino, 1974). Modernization was equated to Westernization, a process which today is

taking place throughout the globe. Homogenization of culture through Northern monopoly of the means of communication and information began during the days of colonialism.

Although the popular forces continued the revolutionary tradition mainly through the trade union and peasant movements, the native elite early on actively collaborated with the American rulers and in fact became their conduits. The Philippine economy too was shaped to conform to the colonial division of labor, providing raw materials such as sugar, coconut oil, and hemp to the American market and importing finished goods from the United States.

Though many countries like the Philippines gained formal political independence after the Second World War, as neocolonies they were still under the economic domination of their former imperial masters. In the Philippines, parity rights demanded by the United States ensured that Americans could enjoy the same prerogatives as Filipinos in exploiting the country's natural resources and investing in its industries. Economic control was combined with political, military and cultural subjugation. Elected Filipino leaders always had to have the blessing of the powers that be in Washington, where Philippine foreign policy was virtually formulated. Military imposition and dependence were exemplified by the presence of military bases on Philippine soil, reliance on American-provided hardware, training and other forms of assistance as well as membership in American-sponsored regional alliances.

Culturally, Filipinos remained captives of an enduring colonial mentality which was reinforced by continuing miseducation, widespread advertising and demand for US-based media. The Philippines is probably the only country in Asia where the question of whether the national language or English should be the medium of instruction is still being debated.

Today, the American bases are gone due to a confluence of several factors: the damage wrought by the eruption of Mount Pinatubo, US military cost-cutting with the winding down of the Cold War with the Soviet Union, and nationalist pressure mounted by the combined forces of the Philippine Senate and the parliament of the streets. However, this concrete gain in asserting national sovereignty is an isolated one. Today the US, after being rejected by Thailand, Malaysia, and Indonesia is poised to ask the Philippines to accept the stationing of navy ships as prepositioned arsenals for any emergency. President Ramos has indicated a favorable response should the request be made. For starters, the US is invoking the provisions of the Mutual Defense Agreement to have access to sea ports for provisions and repairs.

Today we see countries of the North under the leadership of the United States resolving their contradictions at the expense of the South. The Cold War is over but global military strategic plans are being refurbished no longer against a fallen enemy but clearly to confront any opposition from countries of the South which have long been the victims of Western exploitation.

The Columban discovery of America ushered in the age of colonialism. The prosperity of the North came from the wealth of conquered territories. Today,

wealth still flows from South to North because of the various mechanisms applied by the latter.

Flow of resources

Under a triumphant global capitalism, the North is aiming for a more thorough recolonization of the South through such globalizing institutions as the World Bank, IMF, GATT, transnational corporations and media.

The international debt of developing countries is the primary instrument for the integration of the South in the global economy governed by the North. Through structural adjustment programs imposed by the World Bank and through the IMF's debt-related conditionalities, Northern investments, products and tied loans freely enter Southern borders and reshape Southern economies according to Northern interests. These programs call for export orientation, import liberalization, devaluation, and privatization, together with cutbacks in government spending and increased taxes. They result in production to serve the needs of foreign markets rather than those of our own people, the decimation of domestic industries which cannot withstand foreign competition, more foreign economic control as government abdicates its prerogatives in favor of private interests, and more poverty and marginalization for the vulnerable groups who comprise the majority.

Debt service has also become the most effective way for the North to extract wealth from the South. A reverse flow of resources has been taking place. For example, the South Commission reports that in the years 1986–88 alone, the net resource outflow from South to North as a result of debt service amounted to a hefty $168 billion (Report of the South Commission, 1990: 58). The transnational creditor banks are making a killing, mostly by expert maneuvering in the world's volatile financial markets. For in this new age of international capitalism, an autonomous financial market has emerged, and the activities of this powerful sector are no longer connected to production but to speculation. In the case of the Philippines, debt service in the years 1986–92 amounted to $23 billion while new money coming in through loans, etc. was just $14 billion (Ofreneo et al., 1994: 14). Thus there was a negative outflow of $9 billion, while the debt stock increased from $28 billion in 1986 to over $35 billion in 1994 (Business World, 1994).

Indebtedness also has severe environmental implications for Southern countries. The pressure to earn dollars to pay debts at any cost forces them to export their precious and often irreplaceable natural resources, leading to forest denudation, destructive open-pit mining, overfishing, etc.

The huge outflow of resources from the South actually sustains overconsumption in the North. The wasteful, throw-away lifestyles of Northern societies put a lot of pressure on the global environment. The average citizen of an advanced country consumes fifteen times as much resources as the average citizen of a developing country (Schaten and Schaten, 1987: 85). The North,

which holds only 20 per cent of the world's population, accounts for three-quarters of the world's energy use, and two-thirds of the world's metal consumption (Korten, 1991: 88).

Control of global trade

The North's exploitation of the South is also manifest in its control of global trade. The international buying and selling of tea, coffee, cocoa, forest products, tobacco, jute, copper, iron ore, and bauxite is in the hands of transnational corporations based in the North. They buy from the South and sell to the North, reaping superprofits from their transactions. Through international subcontracting, they are able to order inexpensive products such as garments, handicrafts, processed food, etc., from Southern countries, which shoulder all the hassles and risks of production.

Through the General Agreement on Tariffs and Trade (GATT), unequal trade between the North and South will worsen. GATT will institutionalize import liberalization on a global scale, eventually allowing the unlimited entry of competing foreign goods to the ruin of the local industries of the South. In the case of the Philippines, farmers will be hit hard by the import of rice, corn, pork, and other food products. The country's food security will be endangered by GATT which will foster the conversion of agriculture towards the production of export crops. More and more of our agricultural lands will be developed for the production of fresh and processed fruits and vegetables, cut flowers and orchids, and ingredients for animal feed for export to the tables and farms of the North. Much of our fish and prawns end up in Japanese homes. By and large, these are capital-intensive operations which will force small farmers to become dependent on subcontracting or to sell their lands to big agribusiness corporations. These developments will leave less and less of our agricultural resources for the benefit of our people.

Intellectual property rights

GATT will have other negative effects on the South. Investors from the North will gain national treatment to the detriment of local entrepreneurs. They will have the same privileges as their Southern counterparts without the concomitant obligations of citizenry. Compared to the parity rights extracted from us by the Americans, Southern nations will now have to grant parity rights to capitalists of all other nations. Moreover, GATT has expanded its scope to trade-related services which complement the operations of transnational corporations. All these will lead to the adjustment of local laws, even of constitutions, to accommodate the requirements of GATT. Through GATT's provisions on intellectual property rights, the North will institutionalize its control over technology, especially its newer and higher forms. Through its ownership of patents, Northern interests will monopolize production of the most lucrative high-technology goods which they will sell to the South at

enormous profits. They will be able to gain control of resources, processes, and even live species originating from the South such as those now being used in indigenous medicine. They will also be able to exert power through more sophisticated forms of genetic imperialism, as they invent new and possibly harmful life forms in their profit-seeking experiments in biotechnology.

The Philippine experience with the drug industry is perhaps instructive in this regard. In the 1970s, the government exerted efforts to combat the control by transnational corporations of the local drug market. The latter were dominant because they owned the patents, thus preventing Filipino drug manufacturers from producing these patented medicines at lower costs. Actually, what the foreign drug firms were doing was just importing the products from their mother companies and packaging them in the Philippines, reaping huge profits through their transfer pricing arrangements between principal and subsidiary. The government then wanted to amend the patent law to allow drug manufacturers to produce the products being monopolized by the transnationals but it met with strong opposition not only from foreign drug corporations but also from their respective embassies. Nothing came of the effort at that time but a decade later, under the Aquino administration, the Generic Drugs Act was passed. This law sought to undercut the monopoly position of the transnationals by requiring every producer to include in his advertisements and packaging the generic names of the drugs together with their patented brand names. Lack of co-operation from doctors undercut the effort to popularize generics. Moreover, global firms were able to adjust to the generics law and even gain from the new trends ushered in by it. They are now engaged in the manufacture of natural and herbal medicines, many of which are based on indigenous knowledge.

The onset of GATT is expected to lead to an escalation of the current trend and alarm bells are already ringing. Not only medicines but also other products originating from the South will pass into the control of the North.

The instruments of globalization have been extremely successful in many parts of the South, particularly in Asia and Latin America. This is clearly manifested in the Philippines which is a model of a subcontracting state with virtually no independent national economy and existing mainly as a subsystem of Northern corporations. Whatever industrialization has taken place is due to the relocation of labor intensive and/or highly polluting processes of production from high-wage countries of the North. The export industries which developed in the last decade or so – garments, electronics, handicraft, food processing, etc. – have served mainly to supply the North with cheap labor-intensive-commodities that if produced by an expensive work force in the advanced industrial states would not be competitive.

The nation–state and homogenization

Globalization also has its cultural and ideological weapons in the form of education, media, advertising, etc. These weapons present and justify the Northern

model of development as the only one valid for the South to emulate; they also propagate a Northern consumerist lifestyle which creates an almost universal market for Northern goods. The homogenization of culture is ongoing, as Northern films, videos, news agencies, and broadcasting firms shape the world view of populations across the continents.

Mass media have indeed become the main instruments of large-scale homogenization which has transformed culture into a global growth industry. With the rapid development and widespread use of high technology, culture has been industrialized. It has been transformed into another commodity in the international marketplace, earning billions of dollars for the enterprising producers of knowledge and imagery.

The transition from watching to buying is necessarily a short one for consumers who have the means. They begin to dress, speak, sing, dance, and act like the models they see. Lifestyles change as a consequence, becoming part and parcel of the political economy of homogenized culture. The best proof, perhaps, is what is happening to the Filipino elite and to the middle class pretenders to elitism, who are now almost indistinguishable from their counterparts in Los Angeles or New York. Cultural homogenization has become a formidable obstacle for those seeking social transformation.

The cumulative effect of cultural homogenization is to erase national barriers, to dilute national identities and to denigrate nationalist ideas as obsolete and anti-development. The age of globalization is nothing more than the intensification of European diffusionist views which categorized the peoples of the South as the objects of civilizing efforts. This is the racist attitude which was used to justify colonialism. It is now being used to promote a recolonization of the South in new forms.

The nation state is being eroded by the onslaughts of transnational corporations, their home states and other imperial forces which have become increasingly sophisticated in their strategies and tactics. For example, they have abandoned the dictators they used to support with material and military resources because they have realized that the strong men they propped up during the Cold War had become threats to their regions and to the ecomonic interests of Northern corporations (Constantino, 1994). Northern governments led by the United States are ostensibly exercising diplomacy and negotiating for the restoration of democracy in the most benighted parts of the South, in the process co-opting the human rights discourse for their narrow interventionist ends. They are recycling old ideas, such as free trade, to justify reconquest of the South through globalization. Given these trends, there is need to re-examine the nature of the developing states and to explore the strengthening of civil society to counteract the anti-people thrusts of globalization.

Nationalism and southern solidarity

Nationalism is the only defense against the North's globalizing and homogenizing thrusts. It is the only weapon by which countries of the South can stop

the extraction of their wealth and resources, thereby stemming the tide of environmental degradation caused by the North's overconsumption. Although it cannot be denied that nationalist forces associated with the left are at a momentary disadvantage because of the collapse of the Soviet Union and the States of Eastern Europe, there are many opportunities for them to gain momentum precisely because now they are forced to be more creative and more rooted in Southern realities in order to advance. These nationalist defenses against Northern intrusions can also be the basis of Southern solidarity.

Nation states of the South today need stronger defenses against their old colonial masters now acting together to further control their economies. Nationalism, however, does not advocate closing our doors to foreign trade. It is not for autarky, it is not anti-development, and it does not long to return to an idealized past. What nationalism seeks to assert in this day and age is rather simple: that the people of the South have the right to choose for themselves the economic policies that will benefit them. Nationalism, therefore, has a global dimension in the attempts of countries of the South to act together and forge among themselves forms of cooperation leading to collective self-reliance.

Because those holding the reins of government, in general, come from sectors already co-opted by the Northern powers, because technocrats trained by multilateral institutions and Northern academies man the policy-making bodies of these countries, and because many of those in the middle and upper levels of society have uncritically accepted the hegemonic discourse laid down by the North, nationalism has to be a people's movement which can confront the ideological premises that today support the globalizing thrusts of the developed countries. This people's movement must start exerting pressure on their leaders to resist the onslaughts on their sovereignty and their very survival. This exercise in people empowerment could be the last line of defense of each nation state and at the same time mark the beginning of cohesive struggles of developing states.

We are now seeing how the Soviet-style socialist states who have opted for the free market panacea are suffering. Market style reforms have not delivered the goods, even the advanced capitalist states are gripped by crisis. Given the hold of capitalist states on global media, the so-called crisis of socialism has overshadowed the recurrent crisis of capitalism, but to the perceptive observer it is obvious that international capital has no long-term solutions to the world's pressing problems other than its attempts to salvage its position by further exploitation of the South. It is in these attempts where opposing forces may develop as new social forces, new social classes and movements emerge.

A common analysis among Southern states of present-day problems of capitalism in crisis will eventually lead to an alternative system based on the democratic participation of the people.

A hopeful sign is that in many countries of the South the forces of civil society are being strengthened by new movements – ecological, consumer, feminist, peace, human rights, health, anti-debt, etc., – which are emerging and

developing alongside traditional trade union, agrarian, and independence movements. The interaction among these movements nationally and internationally will create a more fertile ground for a productive conjuncture of progressive ideas and actions.

Notes

1 For a discussion of the nature of Spanish colonialism, see Constantino, R. (1976) *The Philippines – A Past Revisited*, Quezon City: Foundation for Nationalist Studies, chapters 3–5.
2 On the Philippine–American War, see ibid., chapters 13–15.

References

Constantino, R. (1974) *Identity and Consciousness, The Philippine Experience.*
—— (1994) 'Human rights: A southern view', paper submitted to the Conference on Human Rights, Tripoli, Libya, Oct. 1994.
Korten, D. C. (1991) 'International assistance, a problem posing as a solution', in *Development*, a journal of SID.
Ofreneo, R.P.,Taguiwalo, J. and Tanada, K. (1994) Freedom from Debt Coalition papers, *Filipino Women and Debt in the '90s*, Freedom from Debt Coalition Women's Committee.
'Outstanding foreign debt up 3% to $35 billion', *Business World*, Oct. 11, 1994.
Report of the South Commission (1990) *The Challenge to the South*, Oxford: Oxford University Press.
Schaten, J. and Schaten, G. (1987) *World Debt: Who is to pay?* London: Zed Books.

3

YELLOW SKIN, WHITE MASKS

Race, class, and identification in Japanese colonial discourse

Leo Ching

Not White, Not Quite, Yet Alike

'Somehow, I still do not quite understand. I am simply marveling at the Japanese of old who had chosen a quiet view such as this as one of the Three Scenes of Japan. There is no scent of human being in this scenery. The people of my country would find this solitude unbearable.'

'What province are you from?' I asked earnestly.

He smiled in a strange manner and looked at me in silence. Although I was somewhat puzzled, I asked again.

'The Tôhoku region, isn't it?'

All of a sudden, he became visibly irritated,

'I am from China; you cannot not have known.'

(Dazai Osamu, *Sekibetsu* (Regretful Parting))[1]

This scene, played out in the province of imperialist Japan, tells of the sudden and fortuitous discovery of an imperial subject. It is a scene of mis-recognition and mis-identification where personal and national identities are destabilized and conflated by the likeness of the bodily signs and the ambivalence of a linguistic signifier – both 'country' and 'province' can be expressed by the word *kuni* in Japanese. Unlike the European encounter with its racial Others, this absence or invisibility of otherness posits a moment where a deferral between seeing and knowing, perceiving and conceiving is enacted, an instant where difference would be suspended and displaced if silence was kept.

Generally speaking, Western imperial and colonial theatre is framed and firmly inscribed in the familiar duality of West and non-West, 'white' and non-'white', self and other. It is where the site/sight of domination is always emanated from a white gaze, perusing the bodies of the non-white others as fixed objects, ontological impossibilities. It is a drama of oppression that Fanon painstakingly describes:

65

> I had to meet the white man's eyes. An unfamiliar weight burdened me . . . In the white world the man of color encounters difficulties in the development of his bodily schema. Consciousness of the body is solely a negating activity . . . I move slowly in the world . . . I progress by crawling. And already I am being dissected under white eyes, the only real eyes. I am fixed.
>
> (Fanon, 1967: 116)

For Fanon, the 'eyes of the white men' constitute the agonizing psychic identification of the Negro. What else can a Negro be but 'an amputation, an excision, a hemorrhage' spattered with black blood? In this particular colonial society, the appearance, the difference, the 'fact of blackness' is an 'unalterable evidence', inescapable from white voyeuristic gaze. A Negro of Antilles might have acquired the fluency of the French language and the culture of the metropolis, but he or she is still incarcerated by the 'racial epidermal schema, unable to be assimilated, unable to pass unnoticed'.[2] 'Race' – in its most commonsensical conception of 'black' and 'white' – becomes a trope of an ultimate, irreducible difference, acting as a powerful ideological formation which disavows and sublates the otherness (alterity) that constitutes the symbolic domain of colonial identification.

The manichean division and social antagonism coloring Western colonial relations is, for a moment and on the face of it, masked in the Japanese case thereby bringing to light a particularity of Japanese colonial discourse:[3] that is Japan as the sole non-Western (read non-'white') colonial power whose imperial dominions and colonial possessions are populated with peoples not utterly different from themselves in racial make-up and cultural inventions. Western imperialism and subsequent colonization found their victims dispersed far from the European continent and their remoteness and differences (seen from the European point of view) were easily reified, idealized, debased and negated. The proximity – in both geographical and cultural terms – of Japan to its empire requires the Japanese to create rather different sets of what Edward Said has called the 'strategy of positional superiority' (Said, 1978: 7).[4] In other words, caught in between the contradictory positionality of not-white, not-quite and yet-alike, Japan's domineering gaze towards its colonial subjects in the East must always invariably redirect itself, somewhat ambivalently, to the imperialist glare of the West.[5] What characterizes Japanese colonial discourse then, is this uneasy oscillation between being both the seeing subject and the object being seen. Put differently, within Japan's immediate colonial theatre (Taiwan, Korea, Manchuria, and arguably China), the concept of 'race', in its initial manifestation, loses its readily identifiable referent, and not unlike 'class', the central category of Marxist social analysis, it becomes an abstraction, not deducible from the biological system itself. Since racial taxonomy was already well inscribed into the imperialist world system in which Japan made its untimely (from the Japanese perspective, of course, timely) entry, Japanese race-writing

must rearticulate and recontextualize the existing Eurocentered racial schema-tization externally, and construct and invent an ideology of racial affinity internally in fostering what Benedict Anderson (1983) has called an 'imagined community'. To this external–internal dialectic, as the following pages attempt to show, Japan's 'othering' of its colonized becomes indispensable. Furthermore, I would like to argue, within the above-mentioned dialectic, Japan's racialism is incumbent and crucial in concealing, and even suppressing, a very real and material exigency of early Meiji nation formation: that is, class struggle.

This however, is not to insist on the primacy of class as an analytical category over other relevant social constructs such as gender, ethnicity or religion, but only to draw attention to two important, but often neglected, observations in the studies of imperialism and nationalism in which the concept of race has pro-vided the ultimate trope of difference. First, as J.A. Hobson's classic study of British imperialism has shown, imperialist expansion, by securing the 'acquies-cence . . . of the body of a nation . . . partly by appeals to the mission of civilization, but chiefly by playing upon the primitive instincts of the race,' only benefited a particular class of people, namely the financiers and the investors (1965: 212). Second, recent theorization of race has warned against the con-ceptualization of racial ideologies as wholly autonomous, disengaged from the various social conflicts, and the facile reduction of these ideologies to the effects of these other relations. As Paul Gilroy writes, '[r]aces are not . . . simple expressions of either biological or cultural sameness. They are imagined – socially and politically constructed – and the contingent processes from which they emerge may be tied to equally uneven patterns of class formation to which they, in turn, contribute' (1990: 264). The discussion of race in colonial Japan therefore, must finally open up to symbolize a wider antagonism to which the very enunciation of race attempts to obfuscate.

Scientific racism, a discourse closely linked to Europe's encounter with the non-Europeans in the eighteenth and nineteenth centuries, justified and legiti-mized the imperial ideology that the 'lesser' races demanded imperialization and colonization, and that it was the 'white man's burden' to brighten the dark con-tinents with light. It is in this highly racialized world between lightness and darkness, white and non-white, colonizer and the colonized, that the 'yellow' people of Japan made their anomalous imperialistic entry. It is Japan's contra-dictory historical positionality inbetween the margins of 'white' and 'black', colonizer and colonized, that the articulation and rearticulation of 'race' has taken place in Japanese colonial discourse. In other words, how did imperial Japan position and imagine itself racially (and of course culturally and nationally) in relation to both the 'white' imperialists and its 'yellow' and later 'brown' colonial subjects? More importantly, as I would like to argue, it is this globalized imperialist structure and colonial endeavor that enabled Japan's racial imaginings in the first place, and not the other way around. On the one hand, Japan needed to respond to the prevalent racist-thinking in order to elevate itself above and differentiate itself from the wretched of the earth in identification

with the 'white' colonial powers. Yet on the other hand, paradoxically and con-
comitantly unable to escape the epidermal classification of this very scientific
racism, it consequently constructed a racial and cultural interconnectedness
with its 'yellow' neighbors in justifying its own colonial endeavor. It is through
the readings of two Meiji intellectuals, Okakura Tenshin and Taguchi Ukichi
that this contradiction and incoherence between identification and disidentifi-
cation, avowal and disavowal that the arbitrariness and inventiveness of racial
identities become evident and crucial in the analysis of Japanese imperialism and
its subsequent colonization of Asia. Historically speaking, the writings of
Okakura and Taguchi are crucial not only in their exigency exhibited amidst
the tension between Japan and the West, mediated by the discourse on Asia, but
that they are also texts on the verge of the emergence of what Karatani Kôjin
has called, the 'consciousness of autonomy' (*jizokuteki ishiki*) – a way of think-
ing and talking about Japan, about 'things Japanese' (Karatani, 1990: 22).
Furthermore, these texts provide a glimpse of the contours of Japanese colonial
technology. Okakura's call for trans-Asian value-system and a unique position
for Japan in it was taken up by the nationalist ideologues in the early 1940s to
intensify Japan's imperialistic endeavors in Asia. The problematic exemplified by
Taguchi's racialism continued to surface in the debate on colonial policies in
delineating the relative cultural and racial positions of the colonized to the
Japanese colonizer.

'Asia is one'

Okakura Tenshin begins his *The Ideal of the East* with the following notorious
passage:

> Asia is one. The Himalayas divide, only to accentuate, two mighty civi-
> lizations, the Chinese with its communism of Confucius, and the
> Indian with its individualism of the Vedas. But not even the snowy bar-
> riers can interrupt for one moment that broad expanse of love for the
> Ultimate and Universal, which is the common thought-inheritance of
> every Asiatic race, enabling them to produce all the great religions of
> the world, and distinguishing them from those maritime peoples of the
> Mediterranean and the Baltic, who love to dwell on the Particular, and
> to search out the means, not the end, of life.
>
> (Okakura, 1904: 1)

Okakura wrote most of his important works in English and published them
overseas (in Great Britain and the United States, to be specific). *The Ideal of the
East*, perhaps his most representative work, was first published in London by
John Murray in 1903. It was in 1922 when Nihon Bijutsuin published *Okakura
Tenshin Zenshû*[6] that *The Ideal of the East* was first translated and made available

to the Japanese. But it was not until the early years of Showa, in anticipation of an all-out war, that Okakura's translated texts began to be read widely.[7] What is striking about the above passage is not only Okakura's flawless English but also his all-encompassing tone. As a geographical entity, Asia has historically been inhabited by various civilizations which have interacted with one and other. Despite this intercourse, historical developments have prevented the emergence of anything like a single Asian culture, not to mention race. Obviously Okakura himself is not oblivious to the heterogeneity and diversity within Asia. Upon returning from his four-month journey to China in 1893 Okakura published a number of articles in Japanese in which he observed the regional differences and local complexities within China. In 'Shina nanboku no kubetsu' (Distinction Between North and Southern China), he argues that two distinctive Chinese cultures have developed, one along the Yellow River to the north and the other around the Yangtze River to the south. The two regions are visibly different: as Okakura 'crosses the Luo Water moving to the West', he sees the vestige of Han and Tang, but he is greeted by the appearance of Sung as 'the scenery changes completely when he steps out of Chengdu', a city in the upper stream of the Yangtze (quoted in Irokawa, 1970: 26–7, and Ooka, 1985: 18–19).

In another article titled 'Shina no bijutsu' (The Art of China), contrary to common belief and perception, Okakura boldly draws the similarity between China and Europe, and stresses China's dissimilitude with Japan. He writes:

> What has impressed me deeply, is none other than the relationship between China and Europe. As one studies that relationship from Japan, one cannot help but to hold on to the feeling that China and Europe are drastically different. However, as one enters the interior and investigates in detail, one finds that rather than Japan, China has more in common with Europe.
>
> (quoted in Ooka, 1985: 26)

The herders on horseback driving the sheep in the sunset of Luoyang, and the scattered tiles and bricks of the old capital, all created the illusion for Okakura of being in Rome. He further points out that 'lifestyle in China is acutely different from that of Japan': from the shoes the Chinese wear for walking, the table they use for dining to the bricks and tiles they cover for sheltering, 'their lives seem to share many similarities with Westerners'. The interesting thing about both articles is that they are observations made from Okakura's own experience in China, not a removed or second-hand speculation from Japan.

From the above publications in Japanese for a readership in Japan, it is apparent that Okakura's personal experience (his being there) has convinced him of the irrefutable 'differences' existing in China, not to mention throughout Asia.

So why does he insist that Asia is one in a book addressed to a Western readership? How is Asia one? Why must Asia be one, and more importantly, what entitles Okakura, a Japanese, to speak of Asia as one?

I must emphasize here that Okakura is not speaking of an Asia that has reached a fixed, rigid, finished, and final form. The unity of Asia, despite periodical inter-tribal upheavals and numerous ethnic conquests, lies in the 'old energy of communication' embodied by Chinese humanism (Confucianism) and Indian spirituality (Buddhism). Furthering his logic on this premise, Okakura argues that 'it is also true that the Asiatic races form a single mighty web' (Okakura, 1904: 3). In spite of irreducible historical contingencies and differences in particular regions or locales, there exists a perceivable unitary structure: 'Arab chivalry, Persian poetry, Chinese ethics, and Indian thought, all speak of a single ancient Asiatic peace, in which there grew up a common life, bearing in different regions different characteristic blossoms, but nowhere capable of a hard and fast dividing line' (ibid.: 3–4). It is not difficult to discern here the Hegelian organicist philosophy which Okakura has taken from his mentor and friend Ernest Fenellosa.[8] Asia is organic in character, a functional interdependence of parts; each is a necessary part of the organic growth and unity of all of Asia. Therefore, it is by no means preposterous to suggest that 'Islam itself may be described as Confucianism on horseback, sword in hand' (ibid.: 4). Historical changes (dynastic upheavals, imperial conquests, etc.) do occur, but they do not negate the fundamental totality of Asia. From India to China, from the 'Mohammedan conquest' to the 'Mongol tyranny', from the 'Tartar hordes' to the 'Hunas, the Sakas, and the Gettaes', each struggles and at times displaces the other, but they do not falsify each other (ibid.). Historical conflicts and their ensuing changes are the necessary developments to the dynamic growth of Asia.

Putting aside the problematic in Okakura's crude and groundless, if not idealistic formulation of an Asian unity, the historical context to which his proposition evolved cannot be overlooked. It goes without saying that Asia is not simply and straightforwardly a geographic category. Like 'the very invention of Africa (as something more than a geographical entity), [Asia] must be understood, ultimately, as an outgrowth of European racialism . . .' (Appiah, 1991: 151). Asia is neither a cultural, religious or linguistic unity, nor a unified world. The principle of its identity lies outside itself, in relation to (an)Other. If one can ascribe to Asia any vague sense of unity, it is that which is excluded and objectified by the West in the service of its historical progress. Asia is, and can be one, only under the imperial eyes of the West. Therefore, Okakura's Pan-Asianism must be understood not as a self-reflexive realization based on any genuine cultural commonality, but a historical construction deeply implicated within the historic-geopolitical East–West binarism in which the putative unity of Asia, or the East, is 'invented' or 'imagined' in direct opposition to another putative unity of the West. Hence it is not at all surprising that many Japanese scholars have interpreted Okakura's assertion of a single Asian consciousness as

a passionate and desperate call for solidarity against Western imperialism and colonialism. But only in that context.

A Yellow Shade of Pale

In Jack Snyder's *Myths of Empire* (1991), which analyzes the various over-extensions committed by the great powers in the industrial era, a painting depicting a Japanese attack on a Russian position near the Yalu River during the Russo-Japanese War is used as the cover illustration. The representation provides an interesting glimpse of racial visualization and identification in early-twentieth-century Japan. Although I have yet to determine the artist of this painting, the portrayal of the Japanese soldiers in poses of heroic determination – stabbing the Russian soldier, uprearing the imperial flag and brandishing the saber in striking motion – amply suggests the work of a Japanese. However, dispositions aside, there appears to be no physical difference between the Japanese and the Russians. The Japanese bear a strong facial resemblance to the Russians and look distinctly 'European' in their military mustaches and well-trimmed haircuts. In fact, they are virtually identical except for the military hats, the darker uniforms and the red-colored bag that distinguished the Japanese soldiers from their Russian counterparts.

It is obvious from this representation that a mechanism of identification is at play in which a fantasmatic image of a rather extraordinary 'Japaneseness' is being constructed. However, this process of identification is not an uncomplicated one. The initial attachment can take on a 'hostile coloring' and become identical with the wish to replace. As Freud writes, '[i]dentification, in fact, is ambivalent from the very first; it can turn into an expression of tenderness as easily as into a wish for someone's removal' (Freud, 1958: 47). Here, of course, Freud is speaking of the boy's identification with the father in the early stage of the Oedipal complex. Simultaneously or soon after the initial identification with the father, the boy develops a 'straightforward sexual object-cathexis' towards his mother. Initially, these two expressions co-exist without mutual influence or interference. Later however, the two psychologically distinct ties converge as required by the resolution of the Oedipal complex, the boy recognizes the father as the impediment in his way to his mother and wishes to take his father's place. What is important in the context of our discussion is that identification is inherently conflicting and even contradictory, characterized not only by what one would like 'to be', but also what one would like 'to replace'. Although in the artist's portrayal the Japanese soldiers are physically identical to the Russians, the identity of Japan as an imperial power is constituted only by the differentiation and hence the annihilation of the Russians. One only has to remember that the Russo-Japanese War was a Japanese attempt to remove Russia's military influence and to replace its imperial dominance in the Korean peninsula. One also should recall that it was the outcome of the Russo-Japanese War that changed the way Japan was to be perceived by

71

both its Asian neighbors and the Western powers. For an instant at least, Japanese victory suggested a possibility that a non–Western, non–white power can successfully challenge Western imperialism; a psychological impact that gave great impetus to nationalistic movements throughout Asia.[9] And yet under Western eyes, the Japanese behavior appeared to be rather uncharacteristic for a 'lesser' race. Henceforth, on the one hand, Japan was to be considered a political threat to the balance of power in Asia, and on the other hand, it was soon to be bestowed the approbation of 'honorary whites,' and to join the ranks of the colonial powers.[10]

Japan's identification with the 'white' race is of course far from being a 'natural' one. Visible morphological characteristics such as skin, bone and hair that enabled the categorical division of people into broad racial groupings such as 'white', 'black', or 'yellow' in the first place cannot simply be altered or transformed through representation. What imperial Japan needed in justifying its newly found status was not only a rhetoric of identification with the West, but also a systemic differentiation and dissociation – on biological and sociohistorical grounds – from its Asian neighbors. In his 'Refuting the Yellow Peril', written during the Russo-Japanese War, Taguchi Ukichi undertakes the seemingly improbable if not impossible task of demonstrating the 'truth of the Japanese race' – that the Japanese belong not to the 'yellow' but the 'white' race. As apparent from the title of the essay, Taguchi's purpose is to undermine the West's fear of the alleged danger of a predominance of the yellow race, with its enormous numbers, over the white race. The point here, however, is neither a refutation of the arbitrariness of the racial category 'yellow,' nor the rejection of a Western racist paranoia. To Taguchi, the yellow race does exist, it's just that the Japanese did not belong to it! 'The Yamato people', Taguchi asserts, are 'racially distinguished' from the Chinese, whom he sees as the embodiment of the yellow race, and are 'racially similar to peoples of India, Persia, Greece and Rome'. As a result, if one can only recognize the erroneousness that classified both the Japanese and Chinese as the yellow race, then 'the yellow peril is nothing but a groundless rumor' (Taguchi, 1990a: 485).

If the yellow peril is only 'an illusive dream of some Europeans', and yellowness is a misnomer wrongly applied to the Japanese race, then what exactly distinguishes and exempts the Japanese from the yellow peoples? Taguchi admits that 'the so-called yellow blood' people and 'the descendants of the aborigine' exist in the Japanese race, but historically 'those who occupy the superior position in Japanese society are definitely not the yellow people'. These aristocrats and well-to-dos have stored in their veins the 'blood from the descendants of the heavenly gods' (ibid.: 485–6).[11] Once the origin of the Japanese race is located and anchored in this mythological divine will, it becomes a transcendental signifier to which all other meanings can only concur. It is interesting, and yet ultimately crucial, that Taguchi conceives of Japanese racialism in class terms. There are two sets of contradictions implicit in his text, one external, the other internal, that he and the emerging Meiji nation-state must confront.

First of all, how to recontextualize Japan's seemingly color-coded racial affinity apart from the Chinese, the consummate embodiment of the yellow people, and to simultaneously articulate an immanent whiteness that on the face of it, is nonexistent? Secondly, how to negotiate the disparity between the aristocracy and the wealthy who are racially pure and the masses of the lower classes who exhibit traces of yellowness, in constructing the myth of a collective Japanese people in which that very difference must, at least on the surface, be erased? These contradictions are resolved, or appear to be resolved, by Taguchi through a metanarrative of the history of the Japanese people.

According to Taguchi, upon their mythical descent, the imperial race were encountered by the early inhabitants who had 'burrowed and nested' on the island of Japan. Despite their initial resistance and subsequent rebellion against the imperial people, they were easily defeated and subjugated by the imperial army. Unlike the 'Anglo Saxon that exterminated the native inhabitants in North America, and unlike the Spaniards that practiced miscegenation with the indigene in South America, [the imperial people] used a different method in subduing and domesticating [the early inhabitants]: slavery' (ibid.: 488). Furthermore, historically, the people of Japan are divided into two general groupings: the *ryô*, the good, and the *sen*, the lowly.[12] Taguchi observes that nevertheless, 'with the passage of time and the effect of humanness', (*saigetsu no keika to ninjo no dôri*) the slaves were emancipated and allowed to intermarry. Taguchi is also quick to add that in reality, the slaves have become 'free citizens' long before the official abolishment of slavery; the master–slave relationship has long ceased, and evolved into more of a landlord–tenant, employer–employee relationship (ibid.: 491). As a result, the blood has become 'very contaminated', so even he can hardly 'recognize the differences between the imperial people and the domesticated native inhabitants'. Since, however, there are essential 'good and evil in human nature', (*ninjo ni wa onozu kara kou ari*) it is not difficult, even today, to 'distinguish the racial differences'. The history of Japan then, according to Taguchi's narrative, becomes the realization of its superior racial essence through the conquests and subjugation of the lesser people despite the eventual intermixing/contamination of its blood by the offspring of the native inhabitants. The historical presence of the enslaved indigene is responsible for the West's mis-recognition and mis-classification of the entire Japanese race as yellow people together with the Chinese race. Ironically, it is through this very 'contamination' – this mixing of the 'higher' and the 'lesser' bloods – that a 'homogeneous' Japanese race – regardless of the asymmetrical power relations and antagonism inherent in social categories such as class and gender – can be constructed. It is important to underscore here that Taguchi's effort to distinguish and differentiate the imperial race from the yellow race, not unlike Okakura's writing in English, is constituted and conditioned on how the Japanese race is seen by the Western/white surveying eye. Despite the visible traces of yellowness amongst the Japanese people, if one were to, as suggested by Taguchi, 'investigate in detail the extremes between beauty and ugliness,' one is

likely to see beyond/behind the observable yellowness and discover the latent, but obscured whiteness (ibid.: 497).

'Race' make-up

Since the Japanese possesses only the appearance of the yellow race, once make-up is applied and embellishments are adorned, Taguchi claims, the Japanese still 'might fall short of the very fine Anglo Saxon race, but is definitely a cut above its inferiors' (ibid.). Consequently, Taguchi suggests two ways in which the Japanese race can raise its respectability in Western eyes: proper grooming and the prolonging of youthful prime. He argues that the main reason for the West's derision is the Japanese inattention to proper grooming. First of all, Taguchi decries, there are too few women over the age of thirty who powder their face, and too many men still compelled by the feudal custom to regard grooming and Western clothing as unsoldierly and disgraceful. As a remedy, Taguchi believes that 'wearing hats would have the advantage of not only whitening all Japanese men and women's faces, but also ennobling their status. And by putting on little pretty suits, [the men] would become gentlemen at once' (ibid.: 499).

Secondly, according to Taguchi, the 'prosperous age' (*seiji*) of Japanese men and women is rather brief as compared to their Western counterparts. The 'beauty of their colors' lasts from the age of 15 or 16 to 35, and 22 or 23 to 50 for both women and men respectively. Beyond that, 'their faces wrinkle and their vigor lessens'. Taguchi contends that if Japanese citizens consisted of only 'beautiful men and women in their prime', Japan would 'certainly come to be respected by the rest of the world'. The most urgent task then, is to 'prolong the youthful prime of Japanese men and women' (ibid.: 499–500). Taguchi offers the Japanese two highly dubious and gender specific ways in achieving this. He urges the men to eschew what he perceives as the 'excessive protectiveness' from their parents which he contrasts with the supposedly extreme individualistic behavior of the Anglo Saxon race. And he encourages the women to change their feudal demeanor and to engage in more physical exercises in order to have healthier babies.[13] What Taguchi calls the 'social reform' which is imperative for improving the perception of the Japanese abroad, can be achieved only through the collective 'shedding of the remaining feudal practices' (ibid.: 500).

The yellow peril then, concludes Taguchi, is 'principally a problem regarding the features of the Japanese race' (ibid.); a sur/facial mis-perception by the West. Lurking beneath Taguchi's racialism is the assumption that the Japanese race already possesses *a priori*, a particular 'epidermis' that distinguishes itself from the yellow race, and if the Japanese would only comport itself accordingly, its affinity to whiteness will become discernible. What is further implied here then, perhaps inadvertently, is that whiteness and the attributes associated with it, is not an inherent property of a particular race *per se*, but a position that is occupiable, a role that is playable, through certain corporal objectifications and

social articulations. That is to say if the yellowness of the Japanese race is 'made-up' by Western racialist classification, then its whiteness can be (re)covered through proper 'make-up'. At first glance, Taguchi's argument seems to question and even resist the dominant scientific racialist discourse that arbitrarily posits a direct correspondence between gross morphology and cultural capacity. For if the Japanese race has displayed characteristics that are incongruous to the very racial classification that underpin the hierarchical (social, cultural and political) explanation of all human beings, then the color line that divides and separates becomes merely imaginary and even traversable. However, as aforementioned, Taguchi does not refute the theoretical underpinnings of Western racialist discourse; his interest lies only in extricating and thereby elevating Japan from one racial category to another. Taguchi's rebuttal of racialist classification is not a rejection, but a revaluation and celebration thereof. He merely displaces or shifts the valuations attached to the racial vocabularies onto another, and accepts the terms and rules set by the dominant discourse. For him, whiteness still represents non-violable human/societal characteristics that are reflective of its superior status in the world system. And yellowness still reflects the inherent inferiority that is represented by the backward-looking Chinese society. In fact, by projecting yellowness onto the Chinese and away from color *per se*, Taguchi internalizes the terms of Western racialized and scientized discourse, and in turn distances Japan from complete application of the negative elements of racialist discourse to itself. Furthermore, by emphasizing the differences with the Chinese/yellow race – creating new facts that supports the distinctions – Taguchi conveniently recontextualizes Japan out of Asia.

Taguchi's argument for Japan's identification with the white race seems to follow a simple syllogism, a series of logical deductions based on the premises of equivalence or inequivalence of two binary oppositions. First of all, he begins with the dominant racial supposition that whiteness is not yellowness (whiteness ≠ yellowness). Secondly, he follows with the identification of the yellow race with the Chinese race (and Chinese = yellowness). Thirdly, Taguchi asserts the absolute difference between the Chinese and the Japanese races (since Japanese ≠ Chinese). And finally through logical deduction, Taguchi concludes with the similarity between the Japanese and whiteness (therefore, Japanese = whiteness).

The dialectics of identity and difference

Although Okakura's Asian culturalism and Taguchi's de-Asianizing racialism appear to be articulating two opposing positionalities of Japan in relation to its Asian neighbors, it soon becomes apparent that they are two sides of the same imperialist coin. Okakura's Asianism is merely a backdrop to a thinly disguised celebration of Japan's 'manifest destiny' and an essentialist advocating of Japan's uniqueness. And Taguchi's de-Asianism is a conscious attempt to conceal the

historical interconnectedness between Japan and Asia in light of Japan's imperialist expansionism. For Okakura, China and India, the two once great traditions of Asia, now lie in ruins: 'Dynastic upheavals, the inroads of Tartar horsemen, the carnage and devastation of infuriated mobs . . . have left to China no landmarks, save her literature and her ruins, to recall the glory of the Tang emperors or the refinement of Sung society' (Okakura, 1904: 5). Similarly in India, '[t]he grandeur of Asoka – ideal type of sovereigns of Antioch and Alexandria – is almost forgotten among the crumbling stones of Bharhut and Buddha Gaya' (ibid.: 5–6). While past glories of China and India can now only be recognized amidst ruins, '[i]t has been, however, the great privilege of Japan to realise this unity-in-complexity with a special clearness' (ibid.: 5). And we can observe here the facile conflation and substitutions of categories such as 'culture,' 'nation' and 'race'.

The privilege of Japan, according to Okakura, rests in the particular identity of the Japanese race. He writes:

> The Indo-Tartaric blood of this race was in itself a heritage which qualified it to imbibe from the two sources, and so mirror the whole of Asiatic consciousness. The unique blessing of unbroken sovereignty, the proud self-reliance of an unconquered race, and the insular isolation which protected ancestral ideas and instincts at the cost of expansion, made Japan the real repository of the trust of Asiatic thought and culture.
>
> (1904: 5)

Although articulated differently than Taguchi's – association rather than disassociation – what we have here is another example of blatant ethnocentrism and cultural essentialism: a 'chosen people' whose racial superiority is assumed, not unlike Taguchi's Japanese who have in their veins the 'blood from the descendants of the heavenly gods'.

It is therefore not surprising when Okakura comes to a predictable conclusion that '[i]t is in Japan *alone* that the historic wealth of Asiatic culture can be consecutively studied through its treasured specimens' (ibid.: 6, emphasis added). Following a kind of a Hegelian dialectic, Okakura sought to discover in Japan a higher synthesis of Indian 'individualism of the Vedas' (thesis) and Chinese 'communism of Confucius' (antithesis). For Okakura, as for Hegel, history is teleological. And the 'history of Japanese art becomes thus the history of Asiatic ideals – the beach where each successive wave of Eastern thought has left its sand-ripple as it beat against the national consciousness' (ibid.: 8–9). Japan is more than the 'real repository' of Asian spirituality, it has now been endowed with the historical mission not only to represent, but also to speak for the highest ideal of Asia. The 'glory of Continental Asia' has always brought inspiration to Japan, but it is now Japan's 'unassailable original destiny', its 'most sacred honor' to 'hold itself invincible, not in some mere political sense alone,

but still more and more profoundly, as a living spirit of Freedom, in life, and thought, and art' (ibid.: 20).

What then emerge from Okakura's nebulous and amorphous unity of Asia are equally mystified nativist characteristics particular to the Japanese which enabled Japan to 'welcome the new without losing the old'. Here one senses not an organic 'similarity' of, but distinctive 'difference' advocated between Japan and Asia. And 'equality' and 'superiority' can be easily substituted for 'similarity' and 'difference' respectively. Okakura's conviction of Japan's unique-ness[14] is evident in his description of Japan's landscape:

> The waters of the waving rice-fields, the variegated contour of the archipelago, so conducive to individuality, the constant play of its soft-tinted seasons, the shimmer of its silver air, the verdure of its cascaded hills, and the voice of the ocean echoing about its pine-girt shores – of all these was born that tender simplicity, that romantic purity, which so tempers the soul of Japanese art, differentiating it at once from the leaning to monotonous breadth of the Chinese, and from the tendency to overburdened richness of Indian art.
>
> (1904: 16)

Through Okakura's prolific prose writing, an essentialized and idealized image of Japan is rendered for the consumption by the West. In his representation, Okakura in fact, to borrow Said's phrase, 'participates in [his] own Orientalizing', in representing Japan as the West would want to see it (Said 1978: 325). Furthermore, obviously with Western readers in mind, the superi-ority of Japanese art, imbued with indigenous nourishing, is stressed and differentiated from the 'monotonous' Chinese and 'overburdened' Indian coun-terparts. What sets Japan apart from other imagined communities – hence its uniqueness, its supremacy – is Japan's 'racepride and organic union [that] has stood firm throughout the ages'; the 'national genius' that has never been over-whelmed by periodic continental surges. As a result, there 'has always been abundant energy for the acceptance and re-application of the influence received, however, massive' (Okakura, 1904: 19–20). In other words, Japan's uniqueness lies in its ability to adopt and to adapt to external influences without losing its own 'essence'. But why is this attribute uniquely Japanese? Did Buddhism travel from India through China to Japan unmediated? What about Korea's indigenous appropriation and modification of continental cultures? One might speak of the 'extent' of acculturation or transculturation, but even such gener-alization must be grounded within specific historical contexts and their respective geopolitical power relations.

Whereas for Okakura the uniqueness of the Japanese race is embedded in Japan's past historical relationship to the Asia continent, for Taguchi however, it is the historical present that Japan's uniqueness is to be articulated. In 'A Study of the Japanese Race' published in 1906, Taguchi observes that Japan's recent

behavior has brought doubts to the minds of the Europeans in their racial clas-
sification. For Japan's defeat of imperial China and its subsequent victory over
the 'first-class nation Russia', suggest that perhaps the Japanese are 'a peculiar,
an extraordinary race', probably a different breed all together from the peoples
of Asia. The West's apprehension and incredulity stem from, according to
Taguchi, the unprecedented brevity to which Japan has elevated its status from
'half-barbarian' to an imperial power. And it is the 'Meiji revolution', a 'revo-
lution' that surpasses even the British and French revolutions, that is responsible
for 'Japan's achieving in half of a century, the civilization that took European
nations hundreds of years to develop' (Taguchi, 1990b: 503). It is to close in this
disparity between appearance and content, sur/face and depth, in the eyes of the
West that Taguchi begins his study of the Japanese race. For Taguchi, only the
extraordinary/non-yellow people, with their essential attributes – that are sim-
ilar to the superior white race – can accomplish what the Japanese are capable
of. The classification of the human races in the Western mind depends on the
circular analysis that relates the visible to the invisible and back to the visible
only to reaffirm the existing hierarchy of human societies. It is a process in
which the baseness of the character of the non-West is deduced from the rela-
tion of the visible (from the imperial gaze of the West) to the invisible, and then
projected back onto the concrete and the observable.[15] Although the Japanese
race displays the visible signs of an inferior race (yellowness), it also already pos-
sesses the appearance of the white race (in terms of modernization, militarism,
etc.). And only by differentiating and denying its visible sign of yellowness, and
concomitantly eliminating the invisible lowliness associated with it, can Taguchi
locate an inherent/invisible Japanese racial essence that corresponds outwardly
with its imaginary whiteness.

The process of differentiation and identification is not, as Taguchi would have
it, a result of an *a priori* essentialized Japanese racial identity, but rather, it is an
a posteriori effect of enunciation within a specific historical contextuality. In fact,
as Taguchi's own text has shown, racial identity is unstable, never secured and
even usurpable. And its production is an ongoing process of differentiation –
Japaneseness is what yellowness is not. What is essential here, to quote Joan W.
Scott in a different context, 'is to historicize the question of [that particular
racial] identity, to introduce an analysis of its production and thus an analysis of
constructions of and conflicts about power' (Scott, 1991: 16). Contrary to the
commonsense belief that racial hierarchy and discrimination exist because of
people's existing and inherent differences, rather, as I have tried to suggest with
the production of Japanese cultural and racial discourse, that it is incumbent
upon colonial expansionism. It is the process of exploitation and discrimination
itself that produces and establishes racial identities and differentiation in a system
of asymmetrical power relationship, not the other way around. Taguchi's deni-
gration of the Chinese race should not be interpreted as the recognition of
inherent differences (morphological and cultural) between two distinct
categories of peoples – for the very categorical notions of 'Chinese' or

'Japanese' are discursive entities emerging only as a reactionary response to the process of global imperialism. The very process of dissociation and differentiation from Asia is a historical contingency, an retroactive gaze and an inverse act that aims to conceal the historical interconnectedness between Japan and Asia, and to overturn Japan's historical 'subordinated' positionality in relation to China. In other words, in order to sustain its colonial economy, Japan must reinvent, reconstitute previous imaginings of Asia, and establish the superiority, the typicality of itself in terms of the inferiority or atypicality of its Asian neighbors. It is only through the dislocation of itself from the putative unity of Asia can Japan relocate its position amongst the Western imperial powers.

Ironically, it is precisely against this 'modern' appearance of Japan in which Taguchi celebrates that Okakura evokes his culturalism. Japanese consciousness must be revitalized, argues Okakura, if Japan were to preserve its sovereignty from the portentous danger of Western encroachment. 'The opium war in China, and the gradual succumbing of Eastern nations, one by one, to the subtle magical force which the black ships brought over the seas' are all sad lessons which made Japan 'keenly alive to the necessity of unity at any cost' (Okakura, 1904: 212). And on Japanese soil, Okakura sees that a battle is waged between Asiatic ideal and European science. Japan, he writes, ever since the arrival of Commodore Perry,

> was eager to clothe herself in new garb, discarding the raiment of her ancient past. To cut away those fetters of Chinese and Indian cultures which bound her in the maya of Orientalism, so dangerous to national independence, seemed like a paramount duty to the organisers of the new Japan.
>
> (1904: 219)

Reproaching the 'inexperienced' and 'undiscriminating' Meiji leaders for embracing Christianity with the same enthusiasm with which they welcomed the steam engine, adopting Western costumes as easily as machine guns, appropriating political theories and social reforms already worn out in the land of their birth, Okakura warns against the 'frenzied love of European institutions' which has brought 'wholesale ravages' of Japan's ancient customs.

The 'strange tenacity' of Japan, however, Okakura tells his Western readers, will not succumb to the domination of the West. Japan's unbroken sovereignty and its empowerment as the sole heir to Asian ideals have enabled Japan to remain true to itself. The 'instinctive eclecticism of Eastern culture' which Japan owes to Asia, has 'made her select from various sources those elements of contemporary European civilization that she required' (ibid.: 222–3). Not only will Japan persist, but so will the ideals of the East. For Okakura, the East is what the West is not; and the 'simple life of Asia need fear no shaming from that sharp contrast with Europe in which steam and electricity have placed it today' (ibid.: 236). While the West has 'time-devouring locomotion', Asia enjoys the

'far deeper travel-culture of the pilgrimage and the wandering monk'. While Europe is materialistic, competitive, particular, Asia is spiritual, peace-loving and universal. Okakura writes:

> [T]he glory of Asia . . . lies in that vibration of peace that beats in every heart; that harmony that brings together emperor and peasants; that sublime intuition of oneness. . . . It lies in the dream of renunciation that pictures the Boddhi-Sattva as refraining from Nirvana till the last atom of dust in the universe shall have passed in before to bliss. . . . It lies in that worship of Freedom.
>
> (1904: 238–9)

And the spirituality of the East will overcome the materiality of the West.

Okakura is quite right, of course, in his assessment of what was the imminent threat of European imperialism to Japan.[16] And his critique of Japan's undiscriminating and heedless 'Westernization' in the early Meiji period reflects the exigency and chaos to which the conflation of modernity and modernization is always an inevitability for the non-West. However, what appears to be Okakura's critique of modernity is, in fact, a celebration thereof. His attempt at counterhegemonic cultural analysis fails to recognize the historicity of the East/West, spiritual/material, pre-modern/modern binary oppositions in which his argument is grounded. This binarism is firmly entrenched in the geopolitical configuration of the world in which the West has constantly to exclude, suppress and eliminate Others in order to ceaselessly transform its self-image. And much like Taguchi's acceptance of pre-existing racist categories, not only is this binarism never interrogated, it is even tacitly accepted, reproduced and reinforced. What we see in Okakura is what Kwame Anthony Appiah has called a 'reverse discourse' where 'the terms of resistance are already given us, and our contestation is entrapped within the Western cultural conjuncture we effect to dispute. The pose of repudiation actually presupposes the cultural institutions of the West and the ideological matrix in which they, in turn, are imbricated' (Appiah, 1991: 145). Okakura's fetishist attitude toward 'tradition' or 'past ideals', as mentioned earlier in his geographic description of Japan, reproduces exotic particularizations for the consumption of his Western readership. In other words, Asia is (re)presented as refined, delicate and harmonious, not rational, powerful and competitive. Asia is defined and can only be defined through negation, by what the West is not; the Other whose subjectivity is forever denied. In the end, Okakura's defiant rhetoric and nativist assertion only serve to reconfirm and reinforce the universalist position of the West.

Furthermore, the monolithic notions of an Eastern ideal or Asiatic mode (or an equally unitary Western or European consciousness) are nothing but constructed identities. Like nationalism which is essentialized through narrative with the careful selective remembering and forgetting (not to mention inventing) of the past that underpins group identity, regionalism is constructed

through a projected suppression of topographical differences (historical and cultural) into a homogeneous legacy of values and experience. After all nationalism and regionalism are not that different; regionalism is only a concealed version of nationalism. Behind Okakura's noble plea for Asian nations to protect and restore Asiatic modes, to recognize and develop consciousness of those modes, lurks Japan's fateful mission '[n]ot only to return to [Japan's] own past ideals, but also to feel and revivify the dormant life of the old Asiatic unity' (Okakura, 1904: 223). Hence it is easy for Okakura to overlook and even endorse Japan's homegrown imperial venture into Asia. The Sino-Japanese war (1894–5) is nothing but 'a natural growth of the new national vigor . . . [that] revealed [Japan's] supremacy in the Eastern waters . . . and which has yet drawn [Japan and China] closer than ever in mutual friendship'. Furthermore, the victory over China has 'aroused Japan to the grand problems and responsibilities which await [Japan] as the new Asiatic power' (ibid.: 223).

The nation-thing and its contradiction

Once the invention of a unique Japanese race is established, it is only a quick step to a hasty conception of what by now has become a familiar imperial ideology: the civilizing mission. For Taguchi, revolutions – like the Industrial and the French – are essentially 'contagious' (*densenteki seishitsu*). And so is Japan's. He writes:

> When we reflect on the records of the revolution of Japan's restoration (*nihon no ishin no kakumei*) from its beginning to the present, it is not appropriate for [Japan] to have all to itself the taste of four-classes equality and constitutional government (*shimin byôdô rikken seifu*). Because it would be good to distribute them to Korea, and in order to provide people's rights movement to China, we are trying to spread (*densen*) the neighboring countries with that revolution. And finally we are about to attack Russia. How to infect (*kansen*) Russia still remains a question; however, I believe this is where us Japanese will display our skill.
>
> (Taguchi, 1990a: 504)

What is noteworthy here, aside from Taguchi's apparent indifference to the inherent contradiction between revolution and restoration, is his reference to the 'taste' (*aji*) of the supposedly developmental and universal fruit of 'modernity' which Japan must share with, or rather bring to, its neighbors. This notion of a sensory fulfillment, or what Slavoj Zizek, following Lacan, has called enjoyment, is useful here in teasing out the paradoxical nature of Taguchi's racialism. According to Zizek, it is the specific enjoyment, that excessive 'substance', that must be added so that a Cause, or what he calls the Nation Thing, can obtain its positive ontological consistency:

> A nation exists only as long as its specific enjoyment continues to be materialized in a set of social practices and transmitted through national myths that structure these practices. To emphasize in a 'deconstructionist' mode that Nation is not a biological or transhistorical fact but a contingent discursive construction, an overdetermined result of textual practices, is thus misleading: such an emphasis overlooks the remainder of some real, nondiscursive kernel of enjoyment which must be present for the Nation qua discursive entity-effect to achieve its ontological consistency.
>
> (Zizek, 1993: 202)

In other words, it is the particular ways in which a given ethnic community organize its enjoyment through national myths that constitute its nationalism. And ultimately it is the threat of that enjoyment by the presence of the 'other', and their differing enjoyments that incite and promote ethnic and racial tensions. In the context of our discussion then, Japan's 'taste', or rather its enjoyment, of 'modernity' is perceived to be threatened by the presence of the yellow people, and their association with Japan. It is as if China and Korea, with their stubborn clinging of feudal practices, their inability to change, and their refusal to enjoy 'modernity', are thus the thieves of Japan's own enjoyment. For if the West continues to lump the Japanese in with the yellow race, Japan will be deprived of its recognition as an emerging world power, as destined by its racial constitution. The threat here is that the Asians, or the yellow people, will 'invalidate' them and the Japanese will thus lose their unique racial/national identity. As a result, a distinct color line must be drawn. It is as if only through imperialist coercion, to make them 'more like us', learning Japan's way of enjoying, can Japan sustain its enjoyment. It is here, however, where the paradox of Japan's racial essentialism and its imperialist aggression lies: since Japaneseness, with its constituting uniqueness and superiority, is inaccessible to other Asians, its imperialist and colonial endeavor will ultimately threaten that very ontological existence. Put differently, if Japan's enjoyment is only possible through the differing enjoyment of the 'Others', would not the annihilation of that difference eradicate Japan's own enjoyment?

What this paradox reveals, to quote Zizek again, is that '[w]hat we conceal by imputing to the Other the theft of enjoyment is the traumatic fact that we never possessed what was allegedly stolen from us' (1993: 203). Therefore, isn't the hatred of the yellow people also the hatred of the questionable 'modernity' of Japan – a particular moment that Okakura wants to replace with a universal Asiatic ideal? Isn't it precisely that progressive surface – the seemingly 'modern' Japan – assumed by Taguchi before he can unveil the hidden Japanese racial essence, the kernel of his despising? Isn't it the concealment or the repression of those contradictions, or what Fredric Jameson (1981) has called the strategy of containment – that denial of those intolerable contradictions lies hidden beneath the social surface, and the simultaneous projection on that very ground a

substitute that renders existence partly bearable – the foundation to which Taguchi's racial theorization can even begin? If we are to insist on the internal–external dialectics of Taguchi's racialism, and to investigate the gaps and contradictions in what he has called the 'revolution of Japan's Meiji restoration', I think what Taguchi's racialism – demarcating and forging racial lines that have never existed – and Okakura's culturalism – implicated in the ubiquitous West and deeply entrenched in a nationalistic rhetoric – eventually attempted to conceal is none other than the internal contradictions of Japan's nascent state-directed capitalist development. By positing an essential racialism through the myth of class equality or cultural unity, it is as if all social contradictions – the continuing impoverishment of the peasantry, the displacement of the rural population, the proletarization in the state-directed industries, the exploitation of female factory workers, etc. – which are inherent and indispensable to the emergence of the Meiji state and Japanese capitalism, can presumably be annulled. Furthermore, if we are to read Taguchi's text not simply as the undertaking of a historian, a literary writer or a social critic, but also of an economic thinker who was lauded as the Adam Smith of Japan for his fervent advocacy of free trade and market economy in compliance with the early Meiji state ideology, his racialism cannot be reduced to the rearticulation of racial category alone. It is Japan's capitalist development, and the concomitant repression of the very contradictions of that development, that Taguchi's text is able to recontextualize the already existing conceptual category of race, and to dissociate Japan from the fear of the yellow peril.

Notes

1　*Regretful Parting*, narrativized through the recollection of an old Japanese doctor who was a classmate of Lu Xun at Sendai medical school, chronicles the Chinese writer's renowned 1902 sojourn in Japan. Dazai's work, written in early 1945, owes its very production to Japanese wartime imperialist policy and its phantasmagoric vision of a Greater Eastern Co-Prosperity Sphere. Commissioned by the Japan Literature Patriotic Association (*nihon bungaku hôkokukai*), the government organization that sponsored three Greater East Asian Writers' Conferences in 1942, 1943 and 1944 respectively, *Regretful Parting* was to be published in accordance with the Association's policy to 'create and to publish novels of grand scale and conception, to announce to the people of Greater Eastern Asia the tradition and ideal of the imperial nation, and to instill in them the great spirit of the Joint Proclamation'. For a more detailed account of the Conferences and Dazai's involvement in it, see Ozaki (1991), especially chapters 1&2: 'Daitôa bungakusha taikai ni tsuite' (On the Greater East Asian Writers' Conference), and 'Daitôa kyôdô sengen to futatsu no sakuhin' (Greater East Asian Joint Proclamation and Two Literary Works).

2　Fanon is careful to caution us that blackness is not simply a natural and biological 'fact', but a 'fact' that is at once historically and socially constituted and politically constitutive. He writes, 'Below the corporeal schema I had sketched a historico-racial schema. The elements I used had been provided for me not by 'residual sensations and perceptions primarily of a tactile, vestibular, kinesthetic, and visual character,' but by the other, the white man, who had woven me out of a thousand

details, anecdotes, stories' (Fanon, 1967: 111). Blackness, whiteness, or any other identities, have to be constructed, narrated, learned, and played out.

3 The point, of course, is not to single out Japanese imperial and colonial experience as particularly particular thereby running the risk of acquitting them of their criminality and vileness. What I am attempting is to draw attention to the complexity of different colonial experiences at their specific historical contexts and to show how imperial exploitation and colonial oppression manifest themselves in different guises.

4 I should underscore here that even the seemingly apparent cultural or racial 'affinity' between the Japanese and their colonial neighbors should be grasped as a historically specific discourse that is not based on some 'natural' or 'visual' evidence, but is itself a rather contradictory and highly contested system of colonial enunciation and definition. See, for example, Komagome (1996).

5 I borrow the not-quite/not-white formulation from Bhabha (1984: 132).

6 The collected works were edited by Saito Takazô and published almost ten years after Okakura's death in commemoration of Nihon Bijutsuin's twentieth anniversary.

7 Okakura's other works in English were also published abroad and translated into Japanese first in the 1922 zenshû by Nihon Bijutsuin and various translations and retranslations were done thereafter. *The Awakening of Japan* was first published in 1904 by Century of New York and in 1905 by John Murray of London. Different versions of the Japanese translations were published in 1939 and 1940. *The Book of Tea* was first published in May 1906 by Fox Duffield of New York and in 1935 by Angus & Robertson of Sydney. Japanese versions were first translated in the zenshû of 1922, then in 1929 and 1939.

8 Ernest Fenellosa came to Japan in 1878 as an instructor of philosophy at the University of Tokyo. Okakura studied under Fenellosa and served as his interpreter in their effort to restore and preserve Japanese artifacts which were largely neglected and even destroyed under the torrent of 'Westernization'. Despite Fenellosa's sincere interest and genuine enthusiasm for Japanese art, he qualifies as unmistakably Orientalist. Fenellosa saw in 'traditional' Japanese art the spiritual values with which to resist the materialistic and depersonalized industrialization of the nineteenth-century West.

9 It must be underscored here that the initial favorable responses by the Asians to Japan's victory over Russia has less to do with the preference of Japanese aggression than the resentment against Western imperial and colonial presence. For example, *Eastern Journal*, an all-round magazine in Shanghai had the following analysis of the Russo-Japanese war:

> There are two large questions lingering on the minds of the Chinese people. First, between despotism and constitutional government. . . . Second, the question of survival of the fittest between the yellow race and the white race. If Russia wins and Japan loses, our citizens will certainly see 'white prosper, yellow decline' as the axiom of the law of nature, that even a self-determining nation like Japan cannot contend . . . If the hearts of the people are dead, all far-reaching schemes will disappear, can there be such a fearful darkness like this?
>
> (Gen An-sei, 1991: 153)

10 The complicity between the Western colonial powers and Japan is evident when Theodore Roosevelt, despite pleas from the US minister of legation in Seoul to intervene, saw Japan's control over Korea as an appropriate check-and-balance to further Russian expansion. In the Taft–Katsura Agreement of July 1905, the US acknowledged Japan's predominance over Korea in exchange for Japan's recognition of American hegemony over the Philippines. And England too, in negotiating the

terms of the Anglo-Japanese Alliance in August 1905, acquiesced to Japan's political, military and economic interests in Korea.

11 The literal translation of '*tenson jinshu*' would be 'the people descending from *Ninigi no mikoto*, the grandchild of Amaterasu ômikami'. It is a widely held myth that the Japanese imperial line is traced to Amaterasu, the Sun Goddess.

12 The lowly are further divided into four classes with the first three originally belonging to the imperial race. These four classes consist of first, ex-officials who were released from duties due to crimes such as the violation of law, conspiracy against the imperial throne, etc.; second, the guardians of the imperial grave sites; third, servants and peoples of the aristocrats, and finally, slaves made of captives from Korea and native inhabitants. According to Taguchi, strict hierarchization of class has prohibited inter-marriage not only between the *ryômin* and the *senmin*, but also amongst the subdivisions of the lowly people, so as to prevent the intermixing of bloods.

13 This overtly paternalistic formulation of the sexual division of labor is of course, symptomatic of a covertly chauvinistic discourse of nation-building that reinforces and is complicit to the existing patriarchal structure.

14 I should mention here that the conviction of ethnic uniqueness is not unique to Japan. My interest here, however, is to analyze the relation between Okakura's nativist assertion and his alleged pan-Asianism in its specific historical context.

15 This system of classification and understanding, which David Spurr (1993) has termed the 'rhetoric of empire', emerged when a paradigm shift occurred in the development of natural history at the end of the classical period. Classification, which hitherto primarily concerned itself with the mere 'nomination of the visible', began to establish for each natural being, a 'character based on the internal principle of organic structure', and to create a hierarchy based on the relative complexity that each species demonstrates. This mode of perceiving and conceiving, according to Spurr, requires a complicated process of seeing beyond the seeming: to classify therefore meant no longer simply to arrange the visible, but to perform a circular analysis that related the visible to the invisible, its 'deeper cause', then rose again toward the surface of bodies to identify the signs that confirmed the hidden cause. The key to knowledge then, is grasped through an invasive thrust into the interiority of the examined object. Upon withdrawing, the interior 'truth' give rises to meaningful differences and differentiation which more often than not, confirm and reaffirm the *a priori* commitment to hierarchization and preconceived differences manifested on the exteriority. This functionalism, when applied to the classification of human beings, requires and privileges a penetrating I/eye over a fixed 'them,' and firmly establishes an asymmetrical power relationship and an irreconcilable gap between the viewing/examining subject and the viewed/observed object that is by now made familiar by the critique of anthropology and ethnography. Furthermore, this investigation of the Other does not end 'there'. It always returns to 'here'. The imperialist gaze upon the Other sets up a mirror that inevitably produces an inverted self-image of the West. See Spurr (1993).

16 One must remember here that *The Ideal of the East* was written in 1903, eight years after the Sino-Japanese war, merely a year before Japan's defeat of Russia. Japan by then was already a proud possessor of its first colony, Taiwan. Japan's military strength has ensured that any serious threat from the European powers was improbable.

References

Anderson, B. (1983) *Imagined Communities*, London: Verso.

Appiah. K. A. (1991) 'Out of Africa: Topologies of nativism', in D. LaCapra (ed.) *The Bounds of Race: Perspectives on Hegemony and Resistance*, Ithaca: Cornell University Press.

Bhabha, H. (1984) 'Of mimicry and man: The ambivalence of colonial discourse', *October* 28: 125–33.

Fanon, F. (1967) *Black Skin, White Masks*, trans. C. L. Markmann, New York: Grove Weidenfeld.

Freud, S. (1958) *Group Psychology and the Analysis of the Ego*, trans. and ed. J. Strachey, standard ed., New York: W.W. Norton & Company.

Gen, An-sei (1991) *Nihon ryûgaku seishin shi* (The History of Studying Abroad in Japan), Tokyo: Iwanami shoten.

Gilroy, P. (1990) 'One nation under a groove', in D. T. Goldberg (ed.) *Anatomy of Racism*, Minneapolis: University of Minnesota Press.

Hobson, J.A. (1965) *Imperialism*, introd. P. Siegelman, Ann Arbor: University of Michigan Press.

Irokawa, Daikichi (ed.) (1970) *Hihon no Meicho*, vol. 39, *Okakura Tenshin*, Tokyo: Chûôkôron sha.

Jameson, F. (1981) *The Political Unconscious*, Ithaca: Cornell University Press.

Karatani, Kôjin (1990) *Shûen o megutte* (Regarding the End), Tokyo: Fukutake shoten.

Komagome, Takeshi (1996) *Shokuminchiteikoku nippon no bunka tôgô* (The Cultural Integration of Colonial Japan), Tokyo: Iwanami shoten.

Okakura, Tenshin (1904) *The Ideal of the East With Special Reference to the Art of Japan*, 2nd edn, New York: E.P. Dutton & Co.

Ooka, Makoto (1985) *Okakura Tenshin*, Tokyo: Asahi Shinbumsha.

Ozaki, Hotsuki (1991) *Kindai bungaku no shôkon* (The Scar of Modern Literature), Tokyo: Iwanami shoten.

Said, E. (1978) *Orientalism*, New York: Vintage Books.

Scott, J.W. (1991) 'Multiculturalism and the politics of identity', *October* 61: 12–23.

Snyder, J. (1991) *Myths of Empire, Domestic Politics and International Ambition*, Ithaca: Cornell University Press.

Spurr, D. (1993) *The Rhetoric of Empire*, Durham, NC: Duke University Press.

Taguchi, Ukichi (1990a) 'Ha kôkaron (Refuting the yellow peril)', in *Teiken Taguchi Ukichi zenshû*, vol. 2, Tokyo: Yoshikawa kobunkan, 483–500.

—— (1990b) 'Nihon jinshu no kenkyû (A study on the Japanese race)', in *Teiken Taguchi Ukichi zenshû*, vol. 2, Tokyo: Yoshikawa kobundan, 501–14.

Zizek, S. (1993) *Tarrying With the Negative*, Durham, NC: Duke University Press.

4

EUROCENTRIC RELUCTANCE

Notes for a cultural studies of 'the new Europe'

Ien Ang

'Eurocentrism' has become a guaranteed term of abuse in cultural studies and postcolonial studies today, a bad Other against which good, 'politically correct' positions often impulsively define themselves. Yet, as with all terms of abuse, the meaning of the term is rarely clarified. All too often, to be accused of Eurocentrism is rather simplistically to be charged with racism, white suprema-cism, a Western superiority complex, and complicity with colonialism, all at one go. In such discursive assaults a militant, self-righteous, hyper-oppositional stance serves only to deflate itself through the unproductive demonization of a grandiose, abstract, Euro-Other.

In this respect, Ella Shohat and Robert Stam's book *Unthinking Eurocentrism* (1994) has been a welcome and important contribution to a more precise and nuanced analysis of contemporary Eurocentric discourse. While Shohat and Stam see Eurocentrism, racism and multiculturalism as interrelated issues, they are careful not to conflate these terms into an indistinguishable jumble. One can be a self-conscious antiracist and still be Eurocentric, they observe, 'for the simple reason that Eurocentrism is the "normal" view of history that most First Worlders and even many Third Worlders learn at school and imbibe from the media' (Shohat and Stam, 1994: 4). This normalized, Eurocentric view of his-tory is one which posits Europe as the sole 'motor' for progressive historical change in the world, as the unique bearer of modern civilization, and as the deliverer of modernity to the rest of the world. Eurocentrism, according to Shohat and Stam (ibid: 3), 'sanitizes Western history while patronizing and even demonizing the non-West; it thinks of itself in terms of its noblest achievements – science, progress, humanism – but of the non-West in terms of its deficien-cies, real or imagined'. They see Eurocentrism as 'an ideological substratum common to colonialist, imperialist, and racist discourse', 'a form of vestigial thinking which permeates and structures *contemporary* practices and representa-tions even after the formal end of colonialism' (ibid.: 2). *Unthinking Eurocentrism* is a useful and admirable assault against this hegemonic discourse through the lens of a multiculturalist approach which is aimed at a 'decolonization of global

culture' through a critique of Eurocentrism as shaped and represented in the media. The book is presented as an effort 'to "multiculturalize" a cultural studies field often devoid of substantive multicultural content' (ibid.: 4). In this sense, the book can be seen as a very significant contribution to the bridging of cultural studies and postcolonial studies.

At the same time, the authors are careful not to come across as indulging in 'Europe-bashing'. They are at pains to emphasize, more than once, that they are not attacking 'Europe *per se*', not Europeans, but rather 'dominant Europe's historically oppressive relation to its internal and external "others"' (ibid.: 3) and the Eurocentric modes of thought that continue to normalize this hierarchical power relation, past and present. However, 'since Eurocentrism is a historically situated discourse and not a genetic inheritance, Europeans can be anti-Eurocentric, just as non-Europeans can be Eurocentric' (ibid.: 4).

Of course, this urging dissociation of Eurocentrism and Europe/Europeans is eminently understandable, and necessary, in a theoretical context conscious of the dangers of essentialism and determinism (genetic or otherwise). However, one unfortunate consequence of such a disentanglement of discourse and subject is not just that it lets Europe/Europeans off the hook, as it were, but also, more significantly, that it tends to relegate Europe/Europeans to the realm of the imagination. That is, in the critique of Eurocentrism 'Europe' generally operates as a discursive figure, an ideological fiction, not as a real place where real people, mostly Europeans, live. In this sense, postcolonial theory often inadvertently inverts the Orientalist practice of constructing 'the Orient' as a fictive product of European thought (Said, 1978): now, it is 'Europe' which becomes the purely symbolic (if historically pertinent) object which forms the epistemological *raison d'être* and condition of possibility of postcolonial theory. As I have put it elsewhere, anti-Eurocentric discourse enunciated by postcolonial non-Europeans:

> often amount[s] to nothing more than a form of 'counter-othering', based on as much ignorance about the actual realities of contemporary European societies as they (rightly) level against classic European attitudes to their own places. This doesn't mean that Europe isn't Eurocentric – in fact it is, and becoming more so in a rather troubling manner – but that modern [or should I say postmodern] Eurocentrism should be *analyzed* in its concrete manifestations rather than merely imputed.
>
> (Ang, 1992a: 318)

In this chapter, I want to re-establish the relationship between Eurocentrism (as a particular discourse on world history and culture) and the European subject of that discourse, 'Europe' as the concrete, culturally and geographically specific site where this discourse has been historically produced and still is produced today. As Shohat and Stam (1994) have remarked, Eurocentrism has remained

a pervasive discourse even after the formal end of European colonialism. They remark that the residual traces of European world domination have naturalized Eurocentrism as 'common sense' to such an extent that it has become 'an implicit positioning rather than a conscious political stance' (ibid.: 4). I want to suggest that this is especially the case in Europe itself, where Europeanness and Eurocentrism are often self-identical: most Europeans are unthinkingly Eurocentric indeed because Eurocentrism is, in a fundamental way, formative of and crucial to the European sense of cultural identity. That is, in the European context Eurocentrism does not only manifest itself in the form of generalized and objectified discursive structures as discussed, for example, by Shohat and Stam (1994), but also, importantly, as a historically sedimented mode of subjectivity: the Eurocentric construction of the world is a defining factor in the European Subject's sense of self – the paradigmatic European Subject being the bourgeois male. Therefore, the questions informing this paper are: how are Eurocentric modes of thinking articulated within contemporary European culture itself as an 'implicit (self)positioning', a lived structure of feeling? How does this structure of feeling inform the experience of being European in the late twentieth century? And what is the politics of European Eurocentrism today? These questions go some way towards what I would call a cultural studies of contemporary Europe – that is, an understanding of 'Europe' not just as an abstract idea, but as a concrete, complex and contradictory social space where particular forms of cultural practice and lived experience are shaped, negotiated, and struggled over.

I cannot, of course, offer such an analysis in any comprehensive manner in the context of this chapter. Instead, I will concentrate mainly on a discussion of intellectual debates on 'Europe' among European intellectuals – not in the Foucauldian sense of 'specific intellectuals' but in their Sartrian self-conception as 'universal intellectuals', whose role is characterized by Edward Said (in Kearney, 1992: 107) as 'heightening consciousness, becoming aware of tensions, complexities, and taking on oneself responsibility for one's community'. As is well known, we live in a historical moment in which Europe is once again asserting itself at the world-historical level, particularly through the formation of the European Community (EC), and since 1992 the European Union (EU). And while this initiative for 'European integration' has been motivated primarily by the economic and political necessities of late-twentieth-century global capitalism, driven by the interests and aspirations of business and political elites, its ultimate ideological legitimation is routinely sought and defined in terms of the unity of European culture, and an awareness of that unity (Wilterink, 1991: 130; Morley and Robins, 1995: 76). In the lead-up to '1992', the question of the 'New Europe' was debated intensely among European intellectuals, who saw it as their task to address 'the cultural question of Europe's vision of itself and of its formative relationship to the wider world beyond its historic frontiers' (Kearney, 1992: 7). Eminent European public intellectuals from across the continent such as Jürgen Habermas, Jacques Derrida, Julia Kristeva, Umberto

Eco, Milan Kundera and Edgar Morin (to name but a few) have all contributed to 'thinking Europe' (to echo the title of Morin's 1987 book on Europe). While a range of diverse views, emphases and attitudes are expressed in these intellectual discourses, they all seem to be undergirded by a certain 'desire for Europe' – a 'new' Europe not solely defined by materialist economic and political forces but, more importantly, by a cultural, even spiritual 'common destiny', Europe as 'a conscience, a culture, a history, a thought, a feeling, a hope and even a will', as the French intellectual journal *Le Débat* put it (quoted in Riemenschneider, 1992: 151).

But while this highly idealist imaginary 'Europe of the intellectuals' is generally presented as a necessary counterbalancing perspective to the 'real' Europe of the politicians and the bureaucrats, it doesn't escape the traces of Eurocentric thought which it is claimed precisely to transcend. Sometimes the need to maintain a redeemed Eurocentric perspective is even paradoxically made explicit, as in what German writer Hans Magnus Enzensberger (1990), one of Europe's leading left intellectuals, has termed 'reluctant Eurocentrism'. This is a kind of self-conscious, self-castigating form of Eurocentrism articulated especially in relation to Europe's complex and controversial world historical role. Enzensberger's sarcastic rendering of a reluctant Eurocentrism, which I will discuss in more detail below, comes down to a rueful acceptance of a necessarily Eurocentric world view despite a profound awareness of the destructive elements of Europe's history. We have no choice, according to Enzensberger, because now that the 'rest' of the world is busy 'Westernizing' itself, it remains up to the West itself (i.e. Europe) to remain at the forefront of world historical change. As Enzensberger (1990: 31) put it, 'An exotic alternative to industrial civilization no longer exists. We are encircled and besieged by our own imitations.' This 'we', of course, is the European Subject, who projects himself as the creator of a 'modernity' which is now, in Enzensberger's observation, being imitated by all others while Europeans themselves have become increasingly doubtful about the blessings of modern life and aware of the problems of modern 'progress'. In this context, so Enzensberger seems to imply, it is Europe's responsibility to find solutions to these problems, because the rest of the world is still grappling with the questions that were on the agenda in Europe and North America a hundred years ago. 'The new problems are being posed here, and here alone, and here alone are to be found, sparingly enough, the new solutions.' (ibid.: 32) As we will see, it is precisely this sense of doubt about Europe's achievements, coupled with a strong sense of world-historical responsibility, which is commonly articulated by European intellectuals in their reflections on 'the new Europe', and which simultaneously confirms and affirms their rootedness in Eurocentric thought.

The affective disposition which is articulated in intellectual imaginings of the 'new Europe', then, reveals a distinctively European way of self-enunciation. I want to suggest that this affective disposition is characterized by a peculiar Eurocentric reluctance – incapability, unpreparedness – to see Europe and

European culture as ordinary, as it were (cf. Williams 1989), that is, just as ma-terially particular and historically specific as any other culture in the world, and therefore as intrinsically non-transcendental. I am interested in the political implications of this European Eurocentric reluctance to see its own non-tran-scendentality, especially in the context of a critical transnationalist cultural studies (for this, see Ang and Stratton, 1996). What role does 'Europe' play in these times of accelerated change in geopolitical and geocultural power relations under the aegis of global capitalism (e.g., the demise of 'actually existing social-ism' in Eastern Europe and the rise of the Asia–Pacific as the alleged new economic powerhouse at the brink of the twenty-first century)? Can this new world (dis)order be described as 'post-European', as some suggest (cf. Pocock, 1991)?

Before I continue, let me make explicit the position from which I speak here. I wasn't born in Europe. I spent my early childhood in Indonesia, and since 1990 I no longer live in Europe. But I spent my formative years and was edu-cated in the Netherlands, where my parents decided to relocate the family in the wake of political turmoil in postcolonial Indonesia in the mid-1960s. The Netherlands, Indonesia's ex-colonizer, is a small country which defines itself self-confidently and taken-for-grantedly as European. Dutch colonialism was one of the major agents of European global conquest, and the country's wealth has been founded in no small part on the economic rewards of colonial trade in the Dutch East Indies (as Indonesia used to be called) – still witnessed by the 'embarrassment of riches' displayed, for example, in the world-renowned, seventeenth-century architecture of the Amsterdam city center (cf. Schama, 1987). Today, Dutch culture sees itself as exceedingly liberal, tolerant, and modern. Located at the intersection of the three most powerful European nations, Germany, France and Britain, it boasts the internationalist orientation of an accomplished cosmopolitan nation: thus, at school I was taught, as many Dutch middle-class children did, German, French and English, as well as Latin and Greek - the classical languages of European civilization. My familiarity with the (Dutch inflection of the) European 'structure of feeling' then is mainly derived from twenty-five years of participant observation, if you like, and of an intense experience of 'Europeanization'. However, as a migrant into Europe and as a non-white person, I never *quite* became a 'real' European. And since, in this respect, I was not only a marginal European then but also a *post*-European now, presently living and working in Australia (where I moved in 1991), I hope I can now speak, more or less, as both an 'insider' and an 'out-sider' of Europe.

My interest in discerning the constituent features of what might be called 'European subjectivity' then has personal underpinnings: I want to understand the distinctive European ways of belonging which, having been so close, were nevertheless ultimately inaccessible to me. But this personal interest also has political bearings. After all, my narrative is part of that significant historical turn-around in which Europe was transformed from a continent of emigration –

underpinned and made possible by the colonization of large parts of the world outside the continent – to a continent of immigration, when masses of people from previously colonized countries and refugees opted to start a new living in the metropolitan West. This epochal change has introduced an unprecedented cultural and ethnic heterogeneity throughout European space, and arguably the difficulty many Europeans experience in coming to terms with the presence of non-white and non-Western others amongst their midst – resulting in widespread xenophobia 'reaching even normally very peaceful countries like the Netherlands and Sweden', according to Swedish sociologist Göran Therborn (1995: 242) – is one of the most pressing problems for European culture at the brink of the twenty-first century (see e.g., Webber, 1991).

It is not easy to pin down what makes 'European subjectivity' – in a very generalizing way – distinctive. While there has been a lot of work on the cultural differences and identities of marginalized, subordinated or disadvantaged groups in contemporary cultural studies, there seems to have been hardly any interest in the identities of the dominant (and it seems reasonable to assume that Europeans, as a category, form a dominant group in the world, the many and various disadvantaged groups within Europe notwithstanding). In this respect, recent work on the construction of whiteness has been extremely important (Hall, 1992; Ware, 1992). However, while Europeanness is hegemonically seen as equivalent with whiteness – which is why, as Paul Gilroy (1993: 1) puts it, 'striving to be both European and black requires some specific forms of double consciousness' – the two terms should not be equated. I am referring here not so much to the fact that not all Europeans are white (which is Gilroy's intervention), but that not all whites are Europeans. In this sense, Shohat and Stam's (1994: 1) description of white Americans and Australians as 'neo-Europeans' seems unnecessarily reductionist and homogenizing. There is more to (the hegemonic conception of) being European than being white, despite the crucial importance shaped by racialist discourse in constituting the imperial sense of European superiority. The contemporary, late-twentieth-century sense of Europeanness is a complex construct molded by the specific social and cultural experiences of living in Europe, informed by the articulation of specific histories and geographies, political traditions, economic and climactic realities, linguistic varieties, architectural environments, and so on, which makes 'European subjectivity' very different from, say 'American subjectivity' or 'Australian subjectivity'.

Of course, I am not saying that all Europeans are the same, nor that they all equally inhabit the dispositions of European subjectivity. As Therborn (1995) has remarked, European identity needs to be distinguished from the identities of Europeans. However, if 'Europeanness' does not saturate the subjectivity of actual Europeans (who differ widely in terms of class, gender, ethnicity, regional and religious background, and so on), a 'European subjectivity' may still be talked about as a culturally particular, historically constructed, psycho-social affective formation which informs, in subtle and elusive ways, what it means to

be European. Enzensberger expressed this affective formation eloquently in terms of a formative affection, a profound underlying sentiment:

> I became a European by leaving Europe. To my surprise, whether I returned from Siberia or Latin America, from East Asia or California, I repeatedly sensed a feeling which was unfamiliar to me before: the joy of patriotism. Wherever I landed, in Budapest or Rome, in Amsterdam, Madrid or Copenhagen, I was always overwhelmed by the sure feeling that I had come home.
>
> (1987a: 25–6)

It is clear that speaking of 'Europe' as if it had an 'identity' and a 'culture' in any essentialist, homogeneous, and singular sense would run the risk of reproducing precisely the abstractions of Eurocentric discourse itself. In countering such a move Europeans routinely conjure up the enormous cultural, linguistic and national diversity of the European continent. And as is well known, European unification is by no means uncontested, especially in those nation-states (such as the British) where fear of the loss of national sovereignty is a strong sentiment. However, we should recognize that this very emphasis on the sacrosanctness of 'national culture' is in itself a very modern European idea. As authors such as Ernest Gellner (1983), Benedict Anderson (1983) and Eric Hobsbawm (1990) have shown, the nation-state as the elementary unit on which the organization of the modern world order is based, originated in eighteenth-century Europe and it is a number of West European nation-states – perhaps best epitomized by France – which fit most organically to Ernest Gellner's definition of a 'nation' as a standardized, homogenized high culture, pervading an entire population, and not just an elite minority, reinforced and sustained through systems of mass-education and communication organized by a centralized state (Gellner, 1983: 54–5). Thus, contemporary national(ist) resistance to European supra-nationalism should not at all be seen as an anti-European stance; on the contrary, it is very much part of European culture for nation-states within Europe – say, France or the Netherlands, not to mention Britain – to assert and defend their relative autonomy on the basis of a secure sense of a separate, highly developed, state-based, national identity *within* Europe.[1] As Jan Nederveen Pieterse (1992: 5) has put it, 'Each European country . . . assumes a double identity, national and as member of a United States of Europe, each a gateway towards, or a ramparts of the European world.'[2]

Enzensberger's joyfully patriotic affective recognition of Europe as 'home' illuminates the fact that we should not underestimate the real and perceived underlying samenesses which have made it historically and epistemologically possible for 'Europe' to have become such a powerful political and discursive force in the first place. The idea of 'Europe' as more than just the name to describe a geographical region (with uncertain boundaries toward the East)[3] but as a cultural entity with moral superiority and rational supremacy has

underpinned the legitimacy of universal European dominance throughout the colonial period (Hay, 1968; see also Bartlett, 1994 for a history of 'the Europeanization of Europe' before, and as an historical preparation for, modern European colonialism).[4] Central to this legitimation process, of course, was the ideology of the Enlightenment, with its universalist ideals of humanism, rationalism, individual freedom, and progress. The subject of these ideals was/is 'Europe', imagining itself as the pinnacle of modern civilization. In this discourse, Europe equals modernity, and the modernity of Europe consists of the Enlightenment itself, which, according to Habermas (1983), remains an (uncompleted) project still worth pursuing for humanity as a whole.

What matters in this context is not the philosophical depth or virtue of the legacy of the Enlightenment (a topic sufficiently debated among philosophers themselves) but, rather, the more 'superficial' impact of the instinctive cultural identification of Europeanness with the 'Enlightened Modern' which still informs contemporary, self-definitions of European culture and identity. This is not only evident in intellectual discourse on 'Europe', but is also palpable in the realm of public culture and common sense. For example, George Steiner sees in the coffee-house the unifying factor of European culture (drawing the Eastern boundary of the continent along the way):

> if you draw a line from Porto in Western Portugal to Leningrad (but certainly not Moscow), you can go to something called a coffee-house, with newspapers from all over Europe, you can play chess, play dominos, you can sit all day for the price of a cup of coffee or a glass of wine, talk, read, work. Moscow, which is the beginning of Asia, has never had a coffee-house. This peculiar space – of discourse, of shared leisure, of shared exchange of disagreements – by which I mean the coffee-house, does define a very peculiar historical space [of shared European culture].
>
> (quoted in Kearney, 1992: 43)

The culture of the coffee-house, of course, is a legacy of the burgeoning seventeenth- and eighteenth-century bourgeois public sphere analyzed by Habermas (1962) and Richard Sennett (1978). Both Habermas and Sennett argue that the coffee-house as a meeting-place where people entered into conversation with one another and exchanged information and ideas was on the decline by the late eighteenth century, replaced by the cafe and the pub where, in Sennett's account, not public speech but silence, or public privacy, was the norm. In this respect, says Sennett (1978: 81), 'the coffeehouse is a romanticized and overidealized institution: merry, civilized talk, bonhomie, and close friendship all over a cup of coffee, the alcoholic silence of the gin shop as yet unknown.' Seen this way, Steiner's elevation of the coffee-house as that which marks the specificity of contemporary European culture relies at least in part on this romanticized idea of a past institution. Nevertheless, Steiner is right to

suggest that residues of this past do still make their presence felt in the fabric and texture of European everyday life until this day: anyone who has lived in a major European city is instinctively familiar with the leisurely, cosmopolitan 'feel' of this bourgeois culture of 'shared exchange of disagreements', even though the coffee-house in today's commercialized, mass-mediated society no longer plays the central political role in rational and informed debate (so cherished by Habermas) that it used to. Arguably this 'feel' is also what enables Enzensberger to call Europe as a whole 'home', over and above the peculiarities of individual European nations such as Sweden and Spain, Portugal and Poland (see Enzensberger, 1987).

But the surface cosmopolitanism of modern European culture – exemplified today by the easy and comfortable movement from one European capital to the next, from one European language to the next, the seemingly effortless appropriation of 'other' cultures on Europe's own aesthetic and normative terms (e.g., primitive art, jazz, world music) – goes hand in hand with a deeper provincialism based on the naturalized, self-confident assumption that Europe is (still) the cultural center of the world, despite its loss of global economic and political power after 1945. Wilterink (1991: 129) cites the outcome of a recent study among postgraduate students at the prestigious European University Institute in Florence (a European Community institution) who were asked to describe 'European identity'. More than two-thirds of the respondents agreed with the statement that 'we, Europeans, have a common identity which distinguishes us from people from other parts of the world.' The two most frequently used words to characterize that identity were 'culture' and 'history', to the effect that Europe was thought to have '*more* culture' and '*more* history' than the rest of the world. Of course, this is a highly select group which cannot be considered representative for all Europeans; nevertheless, their views are significant precisely because they do represent Europe's intellectual elites which have been so vocal in formulating contemporary Euro-talk.

The self-glorification expressed in such examples of how Europeans see themselves reveals a certain *affective peculiarity* of European culture, which marks the fundamental difference between Eurocentrism and 'mere' ethnocentrism. While all cultures are ethnocentric to the extent that, in Zvetan Todorov's (1993: 1) words, 'ethnocentrism consists in the unwarranted establishing of the specific values of one's own society as universal values', Eurocentrism is distinctive because it has been undergirded by the historically realized worldwide hegemony of its subject. As Gerardo Mosquera puts it:

> Eurocentrism is the only ethnocentrism universalized through actual world-wide domination by a metaculture, and based on a traumatic transformation of the world through economic, social and political processes centered in one small part of it.
>
> (1992: 36)

In other words, Eurocentrism distinguishes itself by the ultimate *absolutism* of its claim that Europe is the privileged site of 'Western civilization', and therefore of modern civilization *per se*. In this context, universalist pretensions – Europe is the world, or what the world should be – and particularist distinction – Europe is a special place, and not anyone can be a European – tend to get fused. While 'Western civilization' is constantly referred to in terms of the *universal* Enlightenment ideals and values, these ideals and values are invoked simultaneously as *uniquely* European (from where, like one-way traffic, it is to be diffused to the 'rest').

An unquestioned and unquestioning sense of superiority is thus inscribed as an implicit positioning in the very fabric of European self-consciousness, as the survey from Florence suggests. The European structure of feeling is loaded with the implicit, lived certainty that there is no better and more worthy culture than European culture itself – this, in fact, is what could be described as epitomizing the *pleasure* of being European. American film critic J. Hoberman tried to grasp the 'feel' of this European complacency in that monumental year of 1992: 'To depart from New York for the heart of Europe, the Netherlands or Germany, is to beam down to an advanced world - confident, orderly, strangely optimistic, newly self-absorbed' (Hoberman, 1992: 51). A comfortable and self-contained 'fullness' to European identity is recognized here even at the level of the day-to-day experience of the world. Indeed, even when it comes to consumer culture – presumably a quintessential pillar of American, not European, world hegemony – many things European are instinctively equated with 'quality' in the European mind: German cars, French wine, Italian style, British pop, not to mention European cinema or European public broadcasting (for a discussion of the notion of 'quality', see Brunsdon, 1990). The pleasurable assumption that Europe is a fundamentally and essentially *civilized* place – having come out of a catastrophic episode of near destruction earlier in the century – is one of the most pervasive myths constituting the self-imagining of European identity and culture today, at least in Western Europe.[5]

It is for this reason that protest against so-called 'American cultural imperialism' has very different meanings in Europe compared to the rest in the world. In many countries of the 'Third World', 'Americanization' (or more generally, 'Westernization', which emphatically includes 'Europeanization') is often perceived as the unwelcome cultural side-effect of enforced social and economic modernization, and the struggle against it (through forms of government intervention) is generally cast in terms of the need to protect the fragile project of postcolonial nation-building against the disruption and 'spiritual pollution' supposedly caused by the invasion of American mass culture. In other words, Third World opposition against 'American cultural imperialism' is generally framed by a self-perception of economic and political powerlessness and social and cultural vulnerability.[6] European protest against the same 'evil', on the other hand, is generally launched in a spirit of absolute certainty about the moral and aesthetic superiority of 'pure' European culture, which remains

essentially associated with the refined, the elevated and the cultivated, with Civilization, with Art and Value. American culture – especially American popular culture – functions here as the antithesis of European Culture. As Morley and Robins put it, ' "America", as the container of that "experience that cannot be tolerated", assumes a fantasy dimension as that which always threatens to "contaminate" or overwhelm European cultural integrity' (1995: 80). For example, French intellectuals described the opening of a EuroDisney theme park near Paris in 1992 as a 'cultural Chernobyl', lamenting the danger of the 'radio-active' fall-out of so much American vulgarity so close to the alleged cultural capital of Europe![7]

Illuminated here is not just the fact that the high/popular hierarchy is still firmly in place in European discourse on culture, but, more importantly, that the defense of 'high culture' takes on not just a conservative, but a *critical* value in European cultural self-enunciation (see e.g., Rigby 1991; Gripsrud, 1989). Even European critical theory, from philosophical Marxism to French poststructuralism – theoretical traditions so influential in cultural studies and widely interpreted as subversive and radical in the Anglophone world – is steeped in a solidly entrenched high cultural supposition. This is articulated, for example, in a pervasive bias towards high modernist aestheticism in what the Americans call 'French theory', as observed by Andreas Huyssen:

> Flaubert, Proust and Bataille in Barthes; Nietzsche and Heidegger, Mallarmé and Artaud in Derrida; Nietzsche, Magritte and Bataille in Foucault; Mallarmé and Lautrémont, Joyce and Artaud in Kristeva; Freud in Lacan; Brecht in Althusser and Macherey, and so on *ad infinitum*. The enemies are still realism and representation, mass culture and standardization, grammar, communication, and the presumably all-powerful homogenizing pressures of the modern State.
>
> (1986: 208–9)

The investment put within Europe to the maintenance of the categorical separation of high culture and popular culture – what Huyssen calls the Great Divide – is so persistent, I want to suggest, because in a fundamental sense this divide is *constitutive* of modern European civilization – the civilization that has gained world hegemony in the period of high imperialism. And it is by insisting on the absoluteness of the value of High Culture that European identity is thought to sustain itself in the face of social, economic and cultural change as a result of formal decolonization, transnationalization of capitalism, technological development, the globalization of flows of people, goods and images, and the general 'postmodernization' of the world. Seen this way, the postmodern dismantling of the high/popular divide would be tantamount to a dismantling of European identity itself![8] Paradigmatically, the European Subject needs the modernist sense of hierarchy in order to realize itself, in which the idea of 'Europe' itself is held out as the name for a universalist promise, a dream, a transcendental ideal.

The late-twentieth-century project of European unification can be seen, at one important level, as a renewed effort to achieve this European self-realization. That is, if the creation of the European Union has been motivated ostensibly by economic and political considerations, I want to suggest that what has made the project possible – its 'psycho-geographical' (Morley and Robins, 1995: 197) condition of possibility – was precisely the shared sense of Europeanness, and its concomitant desires and ideals, which I have tried to describe here. There is a historical poignancy to this sense of sharing, the shared experience of tragedy, as George Steiner remarks: 'History might become the passport of shared identity . . . We have lived through something so unspeakable. We were so close to the possibility of there being no Europe at all' (in Kearney, 1992: 53). This is why the Second World War – experienced as the watershed 'unspeakable' event which threatened to destroy the whole of Europe – is of key symbolic importance, not just at the national level, but more importantly at the pan-European level: the active memory of this event – ritualized in dozens of annual commemoration ceremonies throughout the continent – plays a central role in the ongoing construction of the European imagined community. More recently, the collapse of communism in Eastern Europe and its turbulent aftermath has both further complicated and intensified the desire for 'Europe': this collapse has been strongly accompanied by the notion of a 'return to Europe' on the part of the postcommunist countries, especially those in Central Europe (see eg Shöpelin and Wood, 1989), while the diverse ethnic nationalist revivals in several of these countries are generally lamented as a *regression* from the European ideal (Hobsbawm, 1992; Ignatieff, 1994). Yet even Croatian nationalism, for example, is informed by a sense of superiority over Serbia as Croatians consider themselves to be 'more European' than the Serbs. This is a clear example of how the mechanisms of Eurocentric discourse still undergird the power politics which is currently being undertaken to launch 'Europe' as a renewed world power into the twenty-first century.

This does not mean that this reassertion of European power goes unquestioned. Indeed, it is precisely intellectuals who have expressed profound doubt about this newly empowered 'Europe'. This doubt is inescapable, historically speaking, and is informed by a bad conscience about the dubious achievements of European history, specifically the history of colonialism and imperialism, the two World Wars, and the Holocaust. That many liberal intellectuals in Europe feel an agonizing need to come to terms with the destructive legacy of European world hegemony is exemplified in these two quotes, one by a French and the other by a Dutch contemporary philosopher:

Is the European idea liberty, democracy, literacy, style? Europe invented the individual; it also invented the death of the individual. Europe invented humanism; it also invented crimes against humanity. . . . Mapping out the spirit of Europe is also and by necessity doubting it. . . . I see this acting out of doubt for instance in the particular form

of European masochism or guilt which is the other side of colonialism and which now leads us to take the blame for everything that went wrong in the world, and to ignore or deny that colonialism was not only destructive.

(Compagnon, 1990: 3–4, 6)

The ambivalence of our culture, and of our rationality in particular, is evident in [the] relationship [of modern, western civilization to other cultures]. We must make a clear distinction between a closed, imperialist reason, which has legitimated the historical dominance of Europe and has accorded a false universality to European/western particularity, and an open, critical reason, which has precisely unmasked the former as eurocentric and ideological. While Europe used to hold other cultures in contempt and to absolutize its own, critical reason has enabled us to see through European (cultural) imperialism and finally recognize the value of other cultures.

(Lemaire 1990: 43)

These quotes illustrate how common (self)doubt is in intellectual discourses on 'Europe'. But they also illuminate that this doubt acquires a redemptive quality precisely as it becomes the very marker for the universal uniqueness and superiority of European identity. The British author Timothy Garton Ash puts it this way:

That phenomenon of doubt . . . has always been characteristic to Europe, even at the height of its self-confidence. It has always been the case in Europe that we first came up with an absolute, and then put question marks behind it. That capacity to doubt about its own absolutes, to relativize its own universality, is, I think, an essential feature of the history of European thought.

(1987: 37–8)

There is something truly disturbing about this hypostatization of critical reason at the very heart of these highly sophisticated intellectual articulations of European identity, for it ultimately serves as a vehicle for a *reconstructed* European superiority, one suitable for postcolonial times. Here we arrive back at Enzensberger's 'reluctant Eurocentrism', the cultural logic of which can now be spelled out. In Enzensberger's view it is time for Europeans, especially progressive Europeans who are still in search for a better world, to go beyond a self-castigating anti-Eurocentric stance, because:

The vitality of the West derives, in the end, from the negativity of European thinking, its eternal dissatisfaction, its voracious unrest, its lack. Doubt, self-criticism, self-hate, even, are its most important

productive forces. It's our strength that we can't accept ourselves and what we have produced. That's why we regard Eurocentrism as a sin of consciousness.

(1990: 32)

However, as Enzensberger notes with a heavy dose of sarcasm, the solidarity with the 'Third World' which many young and idealist leftwing Europeans have displayed since the 1960s and 1970s is often motivated by a misguided sense of guilt and feel-good self-deception which is just as condescending towards the non-European Other. Enzensberger refers cynically (perhaps too cynically) to 'the ritual playing of Chilean protest songs in Berlin bars' which 'had no noticeable influence on the bloody courses of events in that country' (ibid.: 27). This Eurocentrism that poses itself as anti-Eurocentrism, as Mosquera points out, 'despite its good intentions and indisputable value, would perpetuate the distortion produced by its single perspective and existing circuits of power' (1992: 37). In such a scheme of things, the European subject remains the Subject of history, even in his acting-out of anti-imperialist self-criticism. Implicit in this claim, very common in the ranks of the European radical left (at least until solidarity with the 'Third Word' became *passé* some time around 1980) is the assumption that the non-European Other depends on the European self for its liberation from the impositions of European imperialism. Paradoxically, then, European 'unhappy consciousness' (Hegel) only intensifies European self-love, even though it is sometimes disguised as self-hate, as Enzensberger suggests. Jacques Derrida, in his own essay on 'Europe', deconstructs the dialectic implied here this way:

> Old Europe seems to have exhausted all the possibilities of discourse and counterdiscourse about its own identification. Dialectic in all its essential forms, including those that comprehend and entail anti-dialectic, has always been in the service of this autobiography of Europe, even when it took on the appearance of a confession. For avowal, guilt, and self-accusation no more escape this old program than does the celebration of the self.
>
> (1992: 26)

Locked into the stranglehold of this dialectic, Enzensberger seems to be quite adamant about the impossibility for Europeans to step out of the Eurocentric frame, even if it disguises itself as *anti*-Eurocentrism: therefore, the only way to reconcile the dilemma is what he calls a *reluctant* Eurocentrism, one that revels in not wanting to be one. However, the effect of this reluctant Eurocentrism is perhaps even more insidious than the gung ho Eurocentrism of the Eurocrats of the 'New Europe', the European Union. In his own way, Enzensberger himself embraces a kind of reluctant Eurocentrism which puts European critical intellectuals in the *privileged* position of criticizing Europe and European culture

– thereby excluding non-European Others from doing so. In short, one thing that the proposition of self-doubt as a (uniquely) European quality signifies is the assumption, or narcissistic conceit, that Europe has the intrinsic capacity to interrogate itself, or stronger still, that Europe is its own best critic; that Europeans are the best anti-Europeans.

Dipesh Chakrabarty (1992), the Indian historian who has formulated the terms of a project he calls 'provincializing Europe' as an attempt to dismantle a singular concept of 'world history' in which 'Europe' has a monopoly on the idea of the modern, suggests that '[t]he idea is to write into the history of modernity the ambivalences, contradictions, the use of force, and the tragedies and the ironies that attend to it' (Chakrabarty 1992: 352). However, for Enzensberger (1990), disregarding or oblivious of the non-European efforts of scholars such as Chakrabarty and many others, such a project can only be undertaken by Europe itself. In the contemporary world, criticism of Europe can only be European self-criticism, according to Enzensberger, because the rest of the world – not least the developing world – is becoming ever more 'Westernized', that is, 'Europeanized'. (Significantly, the formative and distinctive role of the United States in the development of the 'new world order' remains obscure in this discourse.) What Enzensberger sees, from his provincial European perspective, is that European culture *is* becoming the universal culture, despite formal decolonization. He suggests that the Third World *wants* to become European. The result is that 'they' imitate 'us', including our 'bad' habits and inventions:

> the commodities, appliances and machines are only the most visible part of what the 'developing countries' import. We supply them with weapons and toxins, techniques of government and propaganda. Even the symbols of their sovereignty are slavish imitations of what they believe they have liberated themselves from through bloody struggles; the idea of the nation, the slogans of revolution, the concept of the party, the emblems of statehood from national anthem to constitution, from flag to protocol.
>
> (1990: 25)

He sees this 'Europeanization' of the world as a sign of 'the massive approval [for] our civilization' and it is this, what he calls 'Eurocentrism of the underdeveloped' which leaves the West, i.e., Europe, alone to question itself. As Enzensberger revealingly puts it, 'The true Eurocentrics are the others' (1990: 26).

The critical theoretical point to be made here relates to Enzensberger's implicit assumption that 'Westernization', or the universalization of 'Europe', is a linear, homogenizing process, turning the world into a single global culture, marking the universal triumph of Western industrial-capitalist civilization, 'the bulldozer of world history, which clears away everything which blocks its way

and levels every traditional culture' (ibid.: 25). What Enzensberger doesn't see is how these traditional 'other' cultures do not absorb 'Western' culture passively, but actively indigenize and appropriate, negotiate and sometimes resist its forms and practices, contributing to the creation of a 'global culture' which is by no means homogeneous, but internally fractured and contradictory. In other words, what he doesn't recognize are the complexities of the postcolonial world, where, as a result of the legacy of European imperialism, historically diverse and specific 'involuntary modernities' have been put in place which are inevitably internally heterogeneous, divided and contested, as the work of Chakrabarty (1992), among others, shows (see also Ang and Stratton, 1996; Bhabha, 1994; Prakash, 1995).

Enzensberger's position then is a paradoxical one, and exemplary of many European intellectual perspectives on 'Europe' and the world. On the one hand his critical intellectualism has made him into one of the most astute critics of contemporary European societies (see e.g., Enzensberger, 1987; 1994). On the other hand, however, the speaking position from which he makes his often biting observations is one of full immersion in a European 'we', which cannot dissociate itself from its absolutist self-image as the sovereign Cartesian subject.[9] This illuminates a gross difficulty for European identity to see itself as historically particular, and in relation to this, to take cultural others - inside and outside of its borders – seriously as co-eval *historical subjects* (Fabian, 1983). This European Subject cannot imagine that non-European others might have some pertinent role to play in the deconstruction and reconstruction of 'Europe' (Wolf, 1982). The Other, with no agency of its own, is always defined as being at the receiving end of processes of 'Europeanization' and 'Westernization'. What is not acknowledged is that those at the receiving end of these processes are actively making their own histories even if it is always inescapably in conditions not of their own making. To be sure, this is precisely what is implied in the notion of postcoloniality (Young, 1991; Bhabha, 1994). As Stuart Hall (1996: 250) has put it, 'the "post-colonial" marks a critical interruption into that whole grand historiographical narrative which . . . gave this whole global dimension a subordinate presence in a story which could essentially be told from within its European parameters'. Enzensberger's discourse, no matter how critical of 'Europe', displays a markedly Eurocentric reluctance to recognize that critical interruption. In this sense, reluctant Eurocentrism can be described as a 'politically correct' version of a more general, unreflexive European chauvinism which is quite widespread throughout the continent, described by Jan Nederveen Pieterse in this way:

> European chauvinism is now prosperous, complacent, aloof. Fortress Europe, in its cultural uniform is not expansionist but critical. Many 'progressives', intellectuals and left-wing people included, share this kind of definition of situation. Europe is their castle. Europe is the fortress of their mind. As much as they identify with the Europe of the

Enlightenment, they abhor 'Islamic fundamentalism', and since 'Thirdworldism' is out of fashion, they look down, if they look at all, on the poor in the Third World.

(1991: 6)

It is clear, however, that as the end of the twentieth century draws near, 'world history' is no longer explainable from an exclusively Eurocentric point of view. For example, consider the spectacular rise of East Asian capitalism as a significant step in the plural history of modernity. As Therborn (1995: 363) remarks: 'For the first time since the Industrial Revolution there has emerged in East Asia a kind of rich and developed society owing virtually nothing to Europe.'[10] Furthermore, Therborn goes on to say:

On the eve of the twenty-first century, Europe is no longer the center or the vanguard of modernity, and whether it constitutes a major alternative for the future is at least open to doubt. Moreover, Europeans are a small minority of humankind, about one-eighth of the world's population. To the Europeans themselves, the legacy of a specific history remains and will remain important. Its sediments, from Antiquity to the industrial class struggle, are built into the European House. To the rest of the modern world, however, the lights of Europe are growing dim.

(1995: 363)

But there appears to be a great reluctance to accept this cool sociological-historical observation in contemporary European intellectual discourse. Perhaps this impending geopolitical and geoeconomic provincialization of Europe in the globalized world of the twenty-first century is too unbearable a thought for most European intellectuals. This may be why intellectual discourse on the 'New Europe' so often takes on an idealistic, even prescriptive quality: it prefers to speak about what 'Europe' *should* be rather than about the actual, changing historical circumstances and complex power relations which shape and determine the conditions of life for the millions living on the continent. Even Derrida, the father of deconstructionism, does this when he says: 'it is necessary to make ourselves the guardians of an idea of Europe, of a difference of Europe, *but* of a Europe that consists precisely in not closing itself off in its own identity and in advancing itself in an exemplary way toward what it is not' (Derrida, 1992: 29). Here, I would argue, Derrida's gesture towards a deconstruction of 'Europe' (through the familiar poststructuralist method of avoidance of closure) is recuperated within a highly European ethical language of the intellectual's 'duty' and 'responsibility'.

But Derrida's position is especially interesting here because he represents the growing number of very important intellectuals who have put the vexed issue of 'the Other' on the European intellectual agenda. Derrida, an Algerian Jew,

now revealingly describes himself as 'someone who, not quite European by birth, . . . , considers himself, and more and more so with age, to be a sort of over-acculturated, overcolonized European hybrid' (ibid.: 7). Echoing Homi Bhabha's (1994) theorization of hybridity and Julia Kristeva's (1991) call for recognizing 'the stranger within ourselves', Derrida seeks to find a route for European renewal by promoting a conception of European identity as partial, plural and open: 'I am European, I am no doubt a European intellectual . . . but I am not, nor do I feel, European *in every part*. . . . By which I mean, by which I wish to say, or *must* say: I do not want to be and must not be European through and through, European *in every part*' (Derrida, 1992: 82). Such redefinitions of the European intellectual self are increasingly common today, as one can increasingly no longer ignore the changing realities of European life as we approach the twenty-first century. It is questionable, however, how such philosophical invocations of hybridity *as task* − in the context of a prolonged universalist ideal of 'Europe' − will have any practical bearings in the concrete social and political changes that lie ahead. Will the European subject be up to the task?

At least one famous European intellectual has shown a healthy skepticism towards all this highmindedness. Umberto Eco sketches this scenario:

> I dislike the use of terms like 'should' or 'would' that imply a certain will and intention. It is irrelevant what Europe wants or doesn't want. We are facing a migration comparable to the early Indo-European migrations, East to West, or the invasion of the Roman Empire by the Barbarians and the birth of the Roman–German kingdoms. We are not just facing a small problem of immigration from the Third World; if that were so, it would be a problem for the police, for the customs, to control. The new migration will radically change the face of Europe. In one hundred years Europe could be a colored continent. That's another reason to be culturally, mentally ready to accept a multiplicity, to accept inter-breeding, to accept this confusion. Otherwise, it will be a complete failure.
>
> (Quoted in Kearney, 1992: 97)

To be sure, there are clear signs that it is precisely from the ranks of the 'colored' that the post-European transformation of 'Europe' will be initiated.

Notes

1 Within the European Union, Ireland is the only exception here, as Irish nationalism always had to define itself *against* the European idea. See Gibbons (1992). Ireland's membership of the EC is therefore very controversial among the Irish. When a recent referendum in Ireland resulted in a 'vote' *for* the Maastricht treaty, the Eurocrats' response was that this was a 'sensible' decision on the part of the Irish.

2 The standard formula for reconciling the antagonistic forces of integration and

autonomy is the mantra of a phantasmatic 'unity in diversity' which, of course, can only ever be an unstable and unsatisfactory compromise. Illustrative for the difficulty of reconciling national differences at the European level, is the way in which the European Union handles the problem of language. To formalize the principle of equality, the EU officially recognizes the national languages of *all* the twelve member states – English, French, German, Italian, Spanish, Dutch, Danish, Portuguese and Greek – which means that *all* EU documents have to be published in *all* these languages, and that for *all* these languages a whole battery of translators and interpreters are hired within the EU bureaucracy (Wilterink, 1991).Thus, modern European Identity is essentially imagined as a mosaic of separate national identities, not as a syncretic melting pot. The emphasis, as Robins notes, is precisely on the preservation of a variety of cultural heritages, both national and regional.

3 This uncertainty creates all sorts of troubles, e.g., in the problems of whether or not Turkey belongs to 'Europe' and could be admitted to the EU.

4 Bartlett argues that since the later Middle Ages 'there has been enough common ground among different parts of western and central Europe to make it reasonable to see this region of the world as a whole' (1994: 1). These commonalities were established long before the formalized division of the region into separate nation-states took place. What Bartlett calls 'the Europeanization of Europe' entailed a process of cultural homogenization resulting from the military hegemony of the Frankish empire of Charlemagne, which through conquest and colonization of the regions around it imposed the spread of common social and cultural features throughout most of the continent, e.g., an international religious order (Latin Christendom) and the institution of the university. 'By the fourteenth century a large part of Europe, including England, France, Germany, Scandinavia and northern Italy and Spain, had come to possess a relatively high degree of cultural homogeneity' (Bartlett, 1994: 313), and in many ways it is not accidental that precisely these countries – comprising what is now commonly referred to as 'Western Europe' – should still form the powerful and authoritative core of contemporary, postcolonial Europe. It is from this core that internal colonialisms such as the English in the Celtic world and the Germans into Eastern Europe were initiated. That the medieval history of intra-colonial expansion within the continent shares many characteristics of that of modern times (but now with an extra-European, global reach) is not at all surprising, according to Bartlett, who contends that 'the mental habits and institutions of European racism and colonialism were born in the medieval world' (ibid.).

5 It is worth noting here that other parts of the Western world such as the United States, Canada and Australia, while seen in European eyes as 'transplanted Europe', are of course considered less truly European – and therefore less 'cultured' and 'civilized' than Europe itself (Compagnon, 1990).

6 Needless to say, 'Third World' perceptions of 'Western' cultural imperialism as if it were an external threat to be warded off through nationalist cultural closure is itself fraught with problems. For a comprehensive critique of the concept of 'cultural imperialism', see Tomlinson (1991).

7 Ironically EuroDisney, anticipated by Americans and Europeans alike as the ultimate conquest of Europe by American popular culture, turned out to be an economic failure: the theme park did not attract the millions of European visitors it expected. Apparently, 60 per cent of those who did visit EuroDisney were Americans, Canadians and Japanese (quoted in Rodeway, 1995: 261) – a statistic in itself worth pondering when it comes to what makes the European disposition distinctive. Furthermore, as *Newsweek* (1992: 10) observed, those Europeans that do visit EuroDisney undertake the trip not *because* it is American but 'almost *despite* Mickey's nationality'. Could this be the sign of a generalized European snobbishness which

considers itself too sophisticated and too cosmopolitan for the deliberately childlike charm of Mickey Mouse and his friends? This snobbishness arguably reflects the aesthetic absolutism of what Pierre Bourdieu (1984) calls 'the aristocracy of culture'. Bourdieu refers here to the French bourgeoisie, but I believe that his thesis can be applied more generally as a sociological explanation of the persistence of the high culture/popular culture divide in Europe. It is in such examples that one can see that Eurocentrism is not just a philosophical discourse, but a firmly entrenched structure of feeling inscribed in the European affective economy. This is one reason why Williams' notion that 'culture is ordinary' would be an unlikely principle for official cultural policy in the European context – in contrast, for example, with a country such as Australia where the concern is more with the need for 'culture' to play a practical role in community building and the reinforcement of national identity than to uphold elite values of excellence and distinction thought to be universal. Thus, while in Australia there are rules for 'local content' on national television to ensure domestic audiovisual production, in the Netherlands similar arrangements are in place to ensure that there will be enough 'cultural programs' on television – a category which, in the Dutch context, has connotations of artistic 'specialness' and is sharply demarcated from 'ordinary' 'information' and 'entertainment' (which, by implication, are *not* 'cultural'). For a characteristically European defense of 'high culture' from a critical intellectual perspective, see Gripsrud (1989).

8 See Huyssen's (1986) emphasis on the postmodern as the historical and political blurring of 'the great divide' in his book *After the Great Divide*. Huyssen offers a wealth of examples from the world af arts and culture in post-World War Two Europe which illuminate the high cultural resistance against the critical postmodernist assault on that 'great divide', leading to 'the futile attempt to define the postmodern in terms of style alone' (ibid.: viii). Indeed, I would suggest that the reduction of postmodernism to style represents a depoliticization of the postmodern in the European context, insofar as the idea of 'postmodern art' keeps intact the categorical distinction between Art and popular culture.

9 It is worth noting here that Descartes' Enlightenment adage 'cogito, ergo sum' marks the philosophical expression of radical doubt which characterizes European cultural self-constructions as completely self-generating.

10 For a discussion on the rise of 'East Asia', see Dirlik (1994); Berger (1996).

References

Anderson, B. (1983) *Imagined Communities: Reflections on the Origin and Spread of Nationalism*, London: Verso.

Ang, I. (1992a) 'Dismantling "cultural studies"', *Cultural Studies* 6 (3): 311–21.

—— (1992b) 'Hegemony-in-Trouble: Nostalgia and the ideology of the impossible in European cinema', in: D. Petrie (ed.), *Screening Europe*, London: BFI.

Ang, I. and J. Stratton (1996) 'Asianing Australia: Notes toward a critical transnationalism in cultural studies', *Cultural Studies* 10 (1): 16–36.

Bartlett, R. (1994) *The Making of Europe: Conquest, Colonization and Cultural Change 950–1350*, London: Penguin Books.

Berger, M.T. (1996) 'Yellow mythologies: The east Asian 'miracle' and post-Cold War capitalism', *Positions: East Asia cultures critique* 4 (1): 90–126.

Bhabha, H. (1994) *The Location of Culture*, London: Routledge.

Bourdieu, P. (1984) *Distinction. A Social Critique of the Judgment of Taste*, Trans. R. Nice. Cambridge, MA: Harvard University Press.

Brunsdon, C. (1990) 'Problems with quality', *Screen* 31 (1): 67–90.

Chakrabarty, D. (1992) 'Provincializing Europe: Postcoloniality and the critique of history', in *Cultural Studies* 6 (3): 337–57.

Compagnon, A. (1990) 'Mapping the European mind', *Critical Quarterly*, 32 (2): 1–7.

Derrida, J. (1992) *The Other Heading: Reflections on Today's Europe*, Trans. P.-A. Brault and M.B. Naas. Bloomington and Indianapolis: Indiana University Press.

Dirlik, A. (1994) *After the Revolution: Waking to Global Capitalism*, Hanover and London: Wesleyan University Press.

Eco, U. (1992) 'Chaosmos: The return of the middle ages', in Kearney (ed.).

Enzensberger, H.M. (1987) *Ach Europa!* Frankfurt am Main: Suhrkamp Verlag; Eng. trans. *Europe, Europe*, London: Picador (1990).

—— (1990) 'Reluctant Eurocentrism: A political picture puzzle', in his *Political Crumbs*, Trans. M. Chalmers. London: Verso.

—— (1994) *The Civil War*, Trans. P. Spence and M. Chalmers. London: Granta.

Fabian, J. (1983) *Time and the Other*, New York: Columbia University Press.

Garton Ash, T. (1987) 'Hèt Europese vraagstuk', in: W.L. Brugsma (ed.), *En toch Europa*, Amsterdam: Balans.

Gellner, E. (1983) *Nations and Nationalism*, Oxford: Basil Blackwell.

Gibbons, L. (1992) 'Identity without a center: Allegory, history and Irish nationalism' *Cultural Studies*, 6 (3): 358–75.

Gilroy, P. (1993) *The Black Atlantic: Modernity and Black Consciousness*, London: Verso.

Gripsrud, J. (1989) ' "High culture" revisited', *Cultural Studies* 3 (2): 194–207.

Habermas, J. (1962) *Strukturwandel der Öffentlichkeit*, Neuwied and Berlin: Luchterhand.

—— (1983) 'Modernity – an incomplete project', in: H. Foster (ed.), *The Anti-Aesthetic*, San Francisco: Bay Press.

Hall, C. (1992) *White, Male and Middle Class*, London: Macmillan.

Hall, S. (1996) 'When was "the post-colonial"? Thinking at the limit', in: I. Chambers and L. Curtin (eds), *The Post-Colonial Question: Common Skies, Divided Horizons*, London: Routledge.

Hay, D. (1968) *Europe: The Emergence of an Idea*, (rev. edn) Edinburgh: Edinburgh University Press.

Hoberman, J. (1992) 'Europa Europa', *Village Voice*, 17 March, 51–4.

Hobsbawm, E. (1990) *Nations and Nationalism Since 1780*, Cambridge: Cambridge University Press.

—— (1992) 'Whose fault-line is it anyway?', *New Statesman and Society*, 24 April: 23–6.

Huyssen, A (1986) *After the Great Divide*, Bloomington: Indiana University Press.

Ignatieff, M. (1994) *Blood and Belonging: Journeys into the New Nationalism*, London: Vintage.

Kearney, R. (1992) *Visions of Europe*, Dublin: Wolfhound Press.

Kristeva, J. (1991) *Strangers to Ourselves*, Trans. L. S. Roudiez, New York: Columbia University Press.

Lemaire, T. (1990) *Twijfel aan Europa*, Baarn: Ambo.

Malcomson, S. (1991) 'Heart of whiteness', *Voice Literary Supplement*, March.

Morin, E. (1987) *Penser l'Europe*, Paris: UGE.

Morley, D. and K. Robins (1995) *Spaces of Identity: Global Media, Electronic Landscapes and Cultural Boundaries*, London: Routledge.

Mosquera, G. (1992) 'The marco polo syndrome. Some problems around art and Eurocentrism', *Third Text*: 35–41.

Nederveen Pieterse, J. (1991) 'Fictions of Europe', *Race and Class*, 32 (3).

Pocock, J.G.A. (1991) 'Deconstructing Europe', *London Review of Books*, 19 December, 6–10.

Prakash, G. (ed.) (1995) *After Colonialism: Imperial Histories and Postcolonial Displacements*, Princeton, NJ: Princeton University Press.

Riemenschneider, R. (1992) 'The two souls of Marianne: National sovereignty versus supranationality in Europe', in: M. McLean and J. Howorth (eds), *Europeans on Europe: Transnational Visions of a New Continent*, Basingstoke: Macmillan.

Rigby, B. (1991) *Popular Culture in Modern France*, London: Routledge.

Rodeway, P. (1995) 'Exploring the subject in hyper-reality', in S. Pile and N. Thrift (eds), *Mapping the Subject: Geographies of Cultural Transformation*, London: Routledge.

Said, E. (1978) *Orientalism*, Harmondsworth: Penguin.

Schama, S. (1987) *The Embarrassment of Riches: an Interpretation of Dutch Culture in the Golden Age*, London: Collins.

Schöpelin, G. and N. Wood (eds) (1989) *In Search of Central Europe*, Oxford: Polity.

Sennett, R. (1978) *The Fall of Public Man*, New York: Vintage.

Shohat, E. and R. Stam (1994) *Unthinking Eurocentrism: Multiculturalism and the Media*, London and New York: Routledge.

Steiner, G. (1992) 'Culture – The price you pay', in Kearney (ed.).

Therborn, G. (1995) *European Modernity and Beyond*, London: Sage.

Todorov, Z. (1993) *On Human Diversity. Nationalism, Racism and Exoticism in French Thought*, Trans. C. Porter. Cambridge, MA and London: Harvard University Press.

Tomlinson, J. (1991) *Cultural Imperialism: A Critical Introduction*, London: Pinter.

Ware, V. (1992) *Beyond the Pale: White Women, Racism and History*, London: Verso.

Webber, F. (1991) 'From ethnocentrism to Euro-racism', in: *Race & Class*, 32 (3): 11–17.

Williams, R. (1989) 'Culture is ordinary', in his *Resources of Hope*, London: Verso.

Wilterink, N. (1991) 'Europa als ideaal', in T. Zwaan *et al.* (eds), *Het Europese labyrint*, Amsterdam: Boom/SISWO.

Wolf, E. (1982) *Europe and the People Without History*, Berkeley: University of California Press.

Young, R.J.C. (1990) *White Mythologies: Writing History and the West*, London: Routledge.

5

MANAGERIALIZING COLONIALISM

Law Wing-Sang

Hong Kong was almost the world's last colony and 1997 was a watershed of the process of decolonization. Yet over the last years of transition few observers in Hong Kong failed to be amazed by this process, in which a glorious history was almost becoming an ironic joke. For the Chinese government, spurred by nationalist rhetoric, preservation of the *status quo* was a paramount concern. Always at odds with the colonial powers, the Chinese did not spare their vehement condemnation of the British government, particularly when it seemed to be unco-operative in the 'transitional' affairs of Hong Kong. In particular, they stood firm to oppose any reforms that would alter past colonial practices. This was evident in halting reforms to make representations in the legislature wider. Curtailing social welfare provisions was another example. It appeared that the Chinese side was committed to safeguarding colonialism before it was extinguished in Hong Kong, both in terms of its institutional make-up and its ideological axioms. All these were done in the name of preserving Hong Kong's stability and prosperity. Although the disputes between Britain and China were too convoluted to engage in here, the sense of historical irony is obvious enough. Some may put the blame on the politics played by an emerging group of so-called power-maniacs or 'steer-turners', yet this is still an intriguing case illustrating how nationalist discourse can accommodate its polar opposite, namely, colonialism, or *vice versa*.

It is now commonly understood that nationalist movements emerge in different forms as reactions to colonial domination. However, historical records show a less clear picture on whether or how nationalistic discourses can lead to genuine political and cultural decolonization. Spreading in the politically decolonized world are national, ethnic and racial dominations which are driven by fabricated imaginary schema which lend support to new hierarchies based on diversified categories of identity. These imaginary schema of conflicting identity are usually inherited from the colonial past and are complicitly forged and shaped by both the colonizer and the colonized. During the anti-colonial struggles, they are usually built into nationalist projects of revival. The function of them in the post-colonial time is rather to set the terms in which the modernization project is to be managed. If the case of Hong Kong can offer an

example by which these intricate but paradoxical relationships between nationalism and colonialism can be examined, they have to be seen as having been mediated by a set of managerial discursive processes feeding on the urban–rural imaginary schema formulated over the past years. For example, managerialization has helped a self conception of the local regime of elite power to be consolidated, in such a way as to be incorporated into a Chinese nationalist reclaiming of sovereignty. Although this was certainly a uniquely local process, the understanding of it cannot be divorced from the wider context of contemporary Chinese intellectual discourse.

Involuted colonial discourse

Amongst the modern Chinese intellectuals-cum-literati, the call for Chinese national self-strengthening is always underpinned by a strong anti-Western sentiment. It has been observed, however, that this anti-Western feeling has always been coupled with a similar quotient of self-hatred in regard to Chinese tradition.[1] Nevertheless, this contradiction, the underlying call for cultural transformation, poses an embarrassing dilemma to anti-imperialistic movements which try to affirm a resistant identity by retrieving Chinese native traditions. One way or another, such cries are always coupled with an equal desire to see the natives radically transformed.

The constant inquisition by intellectuals into what prevents China from being as strong as the West illustrates clearly the way in which colonial perceptions are internalized and reflected. This involuted, orientalist view has indeed been the common presupposition of nationalist–modernist scholarship, which is seen very much as the offspring of Western–Sinological discourse. A classic example is the reception of Fairbank's (1957) historical study of contemporary China. Although his 'response-and-challenge' model is now seen as too simplistic in its detail, Fairbank's dichotomous schema of East and West was the initial launching pad for many projects on cultural modernization. Hence, in the absence of a thorough political colonization by Western powers, we, however, will not be surprised to find among the Chinese modernizers an obsession for deploying cultural markings in such a way as to self-orientalize China.

To be sure, self-orientalization is not the same as orientalism, understood as a Western reproduction of oriental stereotypes. It differs mainly in terms of its assessment about the possibility of spiritual and institutional transformation that is needed for modernization. The nationalist modernizers do not share with older colonizers the vision of a universal cultural standard, but are nevertheless interested in discovering 'useful' cultural traits for their own modernization mission. In other words, they believe strongly the 'perfectability' of the 'natives', even if it sometimes implies the need to continue with the disrupted colonialist's civilizing mission in other forms.

In this chapter, the intimacy and complicity between the advocates of nationalist modernization and colonialism can be illustrated by the example of two

Hong Kong social thinkers. Their writings spell out, in sequential levels, the trajectory in which nationalist aspiration to cultural transformation can be facilitated by colonial experiences. Their cases also show how discursive shifts and displacements have been possible under a managerial conceptual framework.

We will first discuss the case of Ambrose King, a celebrated advocate of modernization in the 1970s, who belongs to the postwar generation of Chinese intellectuals in exile, bequeathed with the baggage of Chinese nationalistic legacies. While working in Hong Kong, King found himself located in a very specific setting where his nationalist concern was not contradictory with his ideological involvement in British colonial rule. It was precisely this flirtation with colonialism which gave rise to a discursive innovation which only Lau Siu Kai was able to bring ahead in a later date. By abstracting the local cultural attributes further and further away from the context of nationalist politics, Lau ended up turning Hong Kong culture into a manageable entity which could be fitted into both colonial and national governmental projects alike.

Synarchy and 'administrative absorption'

Born in mainland China 1935, King was educated both in Taiwan and the United States. Settled in Hong Kong, initially with a status as an 'expatriate', King was, however, almost the first Chinese scholar to write on post-War Hong Kong politics. In a colonial system where politics, as well as the research on it, were generally discouraged, his thesis *'Administrative Absorption of Politics'* stood out as a classic description of British colonial rule in Hong Kong. When it came out in the early 1970s only a few British writers had written on this theme.

By the term administrative absorption, King referred to the processes by which local Chinese elites were coopted through diverse channels and participated in colonial governance. This thesis had a monumental impact, both academically and politically, for it was through it that new concepts and terminologies were introduced into colonial discourse. Consultative democracy, for example, became a popular and useful phrase for colonial authorities to conduct public relations exercises, selling to their mother country and the world at large a new kind of 'democratic' system. In an age when the trend towards global decolonization no longer morally or politically legitimized British rule, King's analysis helped the colonial bureaucrats to justify and defend themselves in the face of challenges coming particularly from their home country.[2] Hong Kong's polity was constituted by an appointed governor who was assisted by bureaucrats and advisory bodies, composed, again, only of appointed members. Within this milieu, King's labelling of this type of democracy, was timely and serviceable.

King did not, however, mean to make his analysis a suitable apology for the British. His nationalist's concern, typical of the exiled literati, unwittingly compelled him to locate the experience of Hong Kong within a larger Chinese context. For this, he likened Hong Kong's postwar colonial rule to an idea proposed by Fairbank, that is, synarchy (Fairbank, 1957). In a short essay, Fairbank

discusses a prevailing power-sharing arrangement between foreigners and local officials in many treaty-ports in the late Q'ing period. Refusing to treat 'synarchy' as the outcome of, or camouflage to, modern imperialism, he situates this synarchic rule in the context of Chinese history which was supposedly characterized by a long tradition of alien rule, with a 'well-developed institution of foreign participation in its government'. Avoiding any detailed analysis on the asymmetric power structure within such arrangements, synarchy is to Fairbank almost the last vestige of East–West co-operation on an equal basis. It was therefore lamentable that this 'quaintly convenient' arrangement was destroyed in face of the rising nationalistic sentiment.

In the 1960s and 1970s, Fairbank was seen by the critics of American-China-watchers almost as an instrument or official ideologue of the American government (see Peck, 1969). To them, Fairbank's 'response-and-challenge' model was problematic. Attribution of China's turmoils to internal obstacles that made China fail to respond, served only to justify the continued presence of Western powers in China. Failure of synarchy, then, could be read as illustrative of the native's capacity to adapt to stimuli brought by the march of progress initiated from the West. In sharp contrast, King offered a different reading of Fairbank in which pessimism had evaporated and the denigrating gaze reverted. By interpreting Hong Kong 'administrative absorption' as more or less equivalent to joint-administration, it appeared that the shattered dream of synarchy had miraculously survived. Unlike the former treaty-ports, which exemplified the existing incomplete or 'semi-colonial' status, Hong Kong was deemed to be a 'decently' preserved colony *par excellence* in which joint-administration could be experimented. What could not be done in other places, could, it was felt, be done in Hong Kong. If this reinvigoration of the colonial imaginary seemed conspicuously incongruous with his public status as a liberal-reform advocate to the Nationalist regime (KMT) in Taiwan, it did not embarrass King. This was because the affirmation of colonial rule in Hong Kong did not entirely result in the negation of nationalism. This interpretation was boosted by the success of colonial-capitalist rule in Hong Kong in contrast with the failure of communism, a critique endorsed by the Taiwan Nationalist regime admidst the then Cold War rivalry.

However, whatever the reasons for the collusion between colonial self-legitimation and nationalist anti-communism, this discourse had moved a long way from its original proposer. Fairbank was definitely more cautious about the success of synarchic rule. While the Chinese reformist Westernizers in the late Q'ing period generally believed that learning Western know-how (*yung*) would not hamper Chinese cultural integrity (*t'i*) and treated synarchy as merely a way to learn the Western administrative techniques which China lacked, Fairbank was deeply reflective of how wrong they were.[3] However, the same *t'i/yung* problematic kept recurring in contemporary Chinese intellectual history. The choice was always pushed to the extreme, of either an iconoclastic cry for 'total Westernization' or a traditionalist deference to the gulf between the Chinese

and the West. King, however, added a new dimension in an attempt to solve this dilemma. Abstracting from the specific historical context of the 'old' synarchy, King discovered in Hong Kong a new ideal combination in which elements of different domains could be selectively brought together to operate under the framework of an 'administrative state' (Harris, 1988). It was therefore necessary to re-appropriate the concept of synarchy from Fairbank, as it served as a bridging term intelligible to both the nationalists and the new breed of Hong Kong colonial technocrats, who, like King, were trained as experts in administrative science. Under this new managerialist framework, the merit of British colonial rule for the nationalists lies not in its space allowed for national identity to flourish, but, paradoxically, in the downright suppression (through 'administrative absorption') of the pursuit of nationalist *t'i*.

The discursive shift involved here is significant, as it spells out the necessity, if not a strategic choice, for a modernization project to compromise the pursuit for an inner cultural domain. It also reduces institution buildings to purely administrative businesses. However, this compromise does not annul the role played by indigenous culture. Instead of securing a national space by invoking traditional culture, the issue now is rather the effective disciplining of that culture. In his study of local political culture, King offered selected interpretations of an apathetic Chinese culture as having contributed to the success of Hong Kong. However, the project of managerializing colonialism could only be pushed to its apex by Lau Siu-kai, King's colleague in the Chinese University of Hong Kong.

Utilitarian familism

Lau Siu-kai belongs to the first postwar generation of Hong Kong sociologists. His elaborate, yet often clumsy, theories claim to have sorted out all the socio-political pre-conditions that have contributed to Hong Kong's success. One of the key concepts he has deployed, is what is known as 'utilitarian familism', which is modified from the conventional Sinological characterization of the Chinese filial piety and generated from a series of positivistic survey. For Lau, this summarizes a set of general attitudinal orientations that were manifest in the postwar Chinese immigrants whose materialism made them the ideal economic men. Ambiguously, however, the immigrants were not individualistic *per se*, for their utilitarian impulse was preceded by their attachment to familistic values. With such an inward-looking attitude, the local Chinese community has been described as essentially self-contained, with a 'prefer to be "left alone"' mentality. As a result, or as a pre-condition of that described above, a 'minimally-integrated socio-political system' is said to have been established, where the polity and the society are seen as mutually secluded. This delicate balance has been possible because Hong Kong people were allegedly more interested in family than in politics, turning always to their familial relatives for help, instead of making demands on the government. This image of overtly

materialistic people who lack class consciousness, and who are influenced by the short-term, with an aloofness to society, is reminiscent of the Lewisian notion of 'culture of poverty' popular in the 1960s (Lewis, 1959). The difference between Lewis and Lau is that Lau has a culture getting out of poverty. The familistic culture of peasant immigrants has also been discussed in Banfield's study of the Italian cities in which he found a kind of 'amoral familist' (Banfield, 1958). However, without acknowledging either of the above, Lau claims to have found a feature unique to Hong Kong, unlikely to be replicated elsewhere (Lau, 1982: 182). Also, far from a sign of the maladapted peasants to city life, Lau's version of familistic personality is curiously functional to colonialism and modernization. To Lau,

> the (Hong Kong) Chinese society can be considered as an inward-looking, self-contained and atomistic society with apolitical orientations and low potentials for political mobilization. Such a society is a *perfect complement* to the 'secluded' bureaucratic polity, and their coexistence as well as mutual avoidance provides a clue to the explanation of political stability in Hong Kong. (my emphasis)
>
> (1982: 68)

Compared with King's imagery of synarchy, which describes Chinese elites' participation as the precondition of the success of post-War British colonial rule, Lau offers more of a culturalist than political account of this colonial 'miracle'. Moreover, this 'culture' is not autonomous from the institutional context. Lau maintains that it was resulting from the very social structure that was over-determined by the march of industrial modernization. He says,

> Hong Kong's Chinese society is a product of the mutual adjustment of an *admixture* [sic] of Chinese people who are divided by ethnic, territorial, dialectal and ideological identifications and who are suspicious of one another, all the while confronted with the pressing need to deal with the birthpains of a rapidly industrializing society. (my emphasis)
>
> (1982: 67)

Lau's conception of Hong Kong society provides an image of a blend of ethnicities. The great job this society has done is to mix up the divided Chinese. Lacking the Protestant work ethic, as described by Weber, but with thanks to the exceptionally encouraging environment provided by colonial rule, the spiritual driving force for industrialization was somehow released, preparing the new immigrants, who as Hong Kong people, created a colonial miracle. Far from being created *ex nihilo*, this character of an enterprising New Man has preserved all the valuable traditional traits required for colonial rule with a hidden proclivity towards subservience. In talking about the 'legitimacy' which the colonial government enjoys, Lau writes,

114

There is a certain *a priori* character to colonial authority. In the first place, it is very natural for the Chinese subjects to transfer their traditional conception of authority as a 'given', a fixture in the cosmic order, to their colonial master. (my emphasis)

(1988: 20)

However, it should not be inferred that Lau's docile Hong Kong people is a simple extension of King's image of the apathetic Chinese. If it were the case, Lau's work would not come up with a distinct Hong Kong identity which the younger citizens so proudly claim, matching it with the aspirations of the post-War generation of elites. To them, it is the managed city life and urban structure of Hong Kong that has provided opportunities for a valuable, apathetic culture to develop to perfection. This urban imaginary does not only have ecological significance but also profound political and administrative implications.

Urban society and depoliticization

Lau puts the importance of urban setting in his project of colonial modernity in the following terms:

> First, the insignificance of a rural sector in Hong Kong distinguishes it from other developing countries where the sharp contrast between the urban and the rural sectors is a highly destabilizing force . . . Second, geographical mobility and the relaxation of social control in an urban society make the continuation of Chinese families founded on traditional principles impossible, thus allowing utilitarianistic familism to flourish. . . . Third, . . . as a municipal government, these [public] demands [for urban services], when they are forthcoming, are of such a nature that confrontation between the government and large organized groups in society can in the main be avoided. This is because of the 'divisibility' of urban services, which discourages the formation of broadly-based demand-making groups.

(1982: 180–1)

To Lau, the politically, though definitely not economically, self-contained city managed to weaken its ties to traditional Chinese familism conceived as unfavourable to modern economic development. Yet the radical transformation of 'national character' could still not be successful if it were not for the ways in which city life is administered. In Lau's view:

> The non-ideological nature of urban service demands renders them amenable to pragmatic administrative resolution. The fragmentation of demands for urban services makes aggregation of demands over a large geographical area difficult; therefore they can be *easily dealt with* by the

bureaucracy, particularly when the level of demands is as generally low as it is in Hong Kong. The urban nature of Hong Kong thus contributes to pragmatic, ad hoc and piecemeal issue resolution (my emphasis).

(1982: 181)

The piecemeal nature of urban issues, as understood by Lau, plays a crucial role in his framework of managerialism. He argues that it is only in such a small urban society that people's demands can be kept to a minimum, and to which the responses constitute only what he calls 'boundary politics'. In this style of informal and non-institutionalized politics, only incremental, gradual and minor changes are possible. As a result, a fuller integration of the bureaucratic polity and the Chinese society, said to be detrimental to political stability, can be fortunately prevented. As Lau writes:

> Through the selection of enforcement or non-enforcement of rules, the dampening of issues by means of persuasion, compromise, co-optation, bargaining, cajoling, assuming threatening postures or deliberately setting up informal rules, the government is able to avoid formal restructuring of the political institutions in the colony. As informal concessions granted are usually couched in secrecy and are highly diversified and individualistic in nature, they usually fail to aggregate into system-changing forces.

(1982: 169)

Lau's quite unconventional projection about city life is possible only against an imaginary landscape featured by the aversion to the rural hinterland, the image of which is usually associated with a backward and turbulent China. This strong anti-rural feeling is widespread in Hong Kong, as witnessed by the banal media stereotypes of Third World countries as places flooded only with chaos, conflicts and social upheavals. Hong Kong is constantly being reminded rhetorically of her urban and stable *status quo* and modernization is said to be possible only if a society can shake off the traditional, backward and despotic rural hinterland. However prevalent this stereotype, it is only Lau who has tried to give it a 'systematic' explanation. Instead of a coherent theory of urbanism, he repeatedly affirms the technologization of city life. Rural obstacles to modernization can be overcome with the indispensable help of the small-scale bureaucractic governance. No longer beset by the rural nightmares such as regionalism and other derived conflicts, a city, governed by a 'detached' colonial authority, is the ultimate answer to the question of political as well as economic development. In the world-wide race for development, Hong Kong is therefore said to be structurally 'privileged' to be both colonial and urban.

However, while the anti-rural sentiment Lau expresses bespeaks of the

avant-gardist consciousness of the young modern elites in Hong Kong, it sits uneasily with Lau's admiration of the familistic values bequeathed by traditional Chinese society. At one point, Lau expresses this nostalgia by warning against the secular process of disorganization that Chinese society is undergoing. In one of his essays he issues a warning about 'the process of industrialization, commercial growth, and the rise in living standards, urbanization, and Westernization . . .' (1983: 552-3) which would bring about a disorganized Chinese society. The greatest threat of these secular trends lies in the acceleration to expand governmental services that is likely to come along. Urbanization, having once promised to provide a crucible for merging and forging a new species of modern enterprising man out of the ruins of traditions and provincialism, turns back and casts a shadow on this modernization march. Rising aspiration, enlargement of service and welfare responsibilities of the government, demands for more formal institutions and procedures, and even the increasing attraction of ideological persuasion, are all said to be eroding the delicate balance and mutual seclusion between polity and society.

Obviously, this version of urbanism as a threatening way of life contradicts Lau's previous portrayal of a 'small urban society' which promises him a manageable course of modernization. However, what this contradiction points to, is less an inconsistency of theory, but a sliding between speaking positions. An expedient use of the city as a metaphor for indigenized and managerialized colonialism is betrayed by his supposed role of a social scientist adhering to doctrines and observations of modernization. Hong Kong, once being taken as a port functional only to imperial expansion, is reinscribed as a city in itself. It is only by setting up a new hierarchical scheme of urban–rural imaginary, that the colonial system can be thought of as a system capable of running on its own. 'Urban society' serves Lau, therefore, only as a launching pad to transpose the speaking position of colonial ruler into that of local elite-modernizer. By abstracting out the 'rationalities' lying behind postwar colonial rule, having them reconstituted into a set of aptly applied governing technologies, colonialism can thus be reappropriated by local power aspirants or collaborative elites who are interested to see colonial rule maintained in a renovated form in the course of modernization.

In King's characterization, colonial rule resurrected a partnership in 'synarchic' rule. But for Lau, it transformed itself into a set of administrative technologies. Thereby, we can understand why the ambivalent and contradictory view on city does not in fact damage Lau, because his *opus operatum* is chiefly to transpose the orientalist denigration and appropriation from East–West dichotomy to rural–urban hierarchy. Understandably, the conceptual play set up within Lau's managerialist vision, is less bounded by scientific rigor, bureaucratic or even technological rationality *per se* than the degree to which 'urbanity', and cultural traits are governable. They are part and parcel of the secret codes decipherable for successful social and cultural engineering.

Grand political design for colonizers

In the early 1980s, the menace of a disorganized metropolis once prompted Lau to speak as a reformist (Lau, 1983: 562). He criticized the restricted and ineffective extent of local administration reform recommended by the 1980 Green Paper. However, he did not treat such calls as violating the imperative of continuously depoliticizing society because such concessions were merely a matter of strategy. With the ultimate goal being the restoration of the self-regulatory capacity of the familistic Chinese society, his proposal was designed within the parameters of supplanting the defunct traditionalist intermediate organizations with a modern outlook. Within these parameters, limited politicization should be carried out for the sake of a successful continuation of depoliticization. He wrote,

> The insertion of an intermediate layer between the government and the people will necessarily be depoliticizing because it is comparatively *easier to coopt* a limited number of local leaders into the political process than to control a huge, unruly mass of people. (my emphasis)
>
> (1981: 883)

It was indeed the spirit of the early to mid-1980s local administrative reforms where Lau's influence in terms of ideas, rationale and philosophy, if not the actual operative calculation, was prominent. The limited reforms were characterized by a conservative move of introducing, at a staggering pace, a cumbersome and inegalitarian system of 'functional constituency' seldom found elsewhere in the world. Wavering between democracy and blatant bureaucratic autocracy, the intent of setting up such a system was to proactively fragment society in order to maintain the power of the administrative state. The result of this reform was indeed mixed. While defusing the pressures on the British to implement thorough democratic electoral reform, scrambling to squeeze into the narrow categories of functional constituencies had been politicizing the society in the past decade. However, this failure of political design did not hamper Lau's model as an ideologically useful tool.

In the late 1980s, when the decline of British rule was imminent, Lau wrote a number of influential articles to win for him a new career under the newly configured Chinese authorities (Lau, 1988) as an advisor and the 'mini-constitution's' drafter. Extending his thesis about the political docility of the Hong Kong Chinese, he sold to the Chinese side a new package of ideas on the architecture of future governance. By proposing to build a new governing coalition composed of old and new power elites, he put aside his previously held opinions on the contradictory diagnoses of the modernizing city. Based upon his perceptions of the essence of Hong Kong's political culture, he was even more unequivocal about the managerialist desire underpinning his analysis. He concluded in one of those essays that it was only by 'following the development

of Hong Kong, the relation between the polity and the society should be tackled more *skillfully*' (1988: 117).

Amidst the tide of changing political allegiances undergoing in the late transitional period, Lau's scholarly apologies for British colonialism were admittedly less repugnant, relatively speaking. For what he did was just to turn Hong Kong into a model from which any can come and learn. In transforming colonial experiences into nationalist modernizing know-how, ideologues of the state are well aware of the need to domesticate feudalism (understood as the 'tameable rural other'). In one way or the other, those state managers are indeed tacit allies of Bill Warren who believes that underdeveloped societies need more, but not less, colonialism to overcome their 'other/past' (Warren, 1980). In the case of Lau, Chinese traditional values were accountable for the failure of modernization in China. This, in spite of familistic values which can, under 'enlightened' colonial rule, be informed by managerial strategies, and become a culture readily useable to maintain a self-regulating and modern society. Whereas the old colonial projects are infamous to the colonized, the national/native elites' own effort to model and remodel their colonial endeavors can come under the banner of a righteous nationalism. It explains why Lau's ideas were so easily picked up by the Chinese state.

National project of recolonization

Nevertheless, a 'valuable' Hong Kong culture ready to be appropriated by China illustrates by itself the irony and tension of the Chinese nationalist modernization project. As Hong Kong's identity cannot now be read in isolation from its relationship with China, the tortuous path of 'socialism with specifically "Chinese" characteristics' also needs an 'other', such as Hong Kong, to be both affirmed and disavowed. To make Hong Kong thoroughly 'Chinese', by restricting its political and cultural autonomy, can no doubt demonstrate the 'Chinese' capacity to run and rule a modern city. Yet what is *sui generis* Hong Kong, read as modern as such, would risk being destroyed. This dilemma underlies the anxiety that the Chinese officials showed, as the date of 1997 was fast approaching. This anxiety, underlaid by the fetishistic desire toward Hong Kong, was best demonstrated by a metaphor used by a Chinese reformist Vice Prime Minister, Li Ruihuan. In issuing an implicit warning against the possible mindless destruction of Hong Kong that may be caused by the communist hardliners' mishandling of Hong Kong affairs, he likened Hong Kong and its values to the 'tea stain' of the renowned traditional taste of the Yi Xing teapot. He said that only the dilettante would buy a precious antique teapot and be foolish enough to clean away the 'stain', which was precisely the source of the tea's unique taste. However, as some critics put, it is the sometimes unconsious drive to keep the teapot clean, as to demonstrate the success of decolonization and triumph of nationalism, that incessantly pushes the hardliners to introduce the PRC's system and style of governance to Hong Kong. Shrewd as it may be

as a euphemistic expression of criticism, Li's metaphor denotes the whole array of ungraceful desires with regard to the colonial experience that China has too regretfully missed in her glorious days as a 'central empire'.

Hong Kong, as a gateway to modernity via colonialism, is too important to be lost in the Chinese quest for modernity. It is also the fragility of Hong Kong as a teapot that bespeaks of the illusory character and double-edged nature of the national/colonial fantasy held by China. Hong Kong can be of use to China so long as she remains useful as a teapot yet, at the same time, a broken teapot is a nightmarish disaster. Therefore, the current project of recolonization, or in other words, the replacement of the old colonizer by the new, is complicated by the psychologically triumphalist revenging mind ridden with an inferiority complex. This is symptomatic of a magnified paranoia of Hong Kong's threat to China's own stability, dignity and identity.[4] Rosaldo describes 'imperialist nostalgia' as the desire to have back that (or those) one has participated in destroying (Bammer, 1995). In Hong Kong, the impulse to destroy and the counter-impulse to embrace the other run simultaneously. Colonial legacies are hated and loved at the same time. To Beijing's eyes, one's patriotic devotion is measured not by participation in street demonstrations against Japanese appropriation of Diaoyu Islands, but how much one can teach them the colonial ways to rule Hong Kong.[5]

Within this sometimes ambiguously re-doubled colonization project, local elites' positioning is less ambivalent. For the 'tea stain', sediment from numerous usages, is treasure only to connoisseurs; it requires proficient 'experts' to be advisors to guide the formation towards good taste. It tells the reason why managerialism, as the ideology of the experts in governance, has to be mediating between colonialism and nationalism as a pair of twin discourses.

Notes

1 This has been captured by Lin as 'radical anti-traditionalism', characteristic of the May Fourth generation (Lin, 1979).
2 A number of Fabian backbenchers in the British Parliament were particularly critical about the ways British colonial rule was carried out in the territory (Hong Kong Research Project, 1974).
3 The distinction between *t'i* and *yung* in contemporary Chinese thinkers such as Chang Chih-tung is analogous to Chatterjee's differentiation between the inner (cultural/spiritual) and the outer (institutional/material) domains (Chatterjee, 1993). However, the *t'i/yung* philosophical couplet had a far more complex meaning in pre-modern and early modern Chinese intellectual tradition than the Chang's modernist interpretation (see Levenson, 1958; Gedalecia, 1974).
4 The truth of describing the process of transfer of sovereignty as recolonization is no more evident than the Preparatory Working Committee's (PWC) proposal to restore a number of previous laws amended under the Bill of Rights. The aim of this move is to retain the extensive state powers enjoyed by the previous colonial authority in the hand of the future SAR government.
5 The Chinese 'united front' co-optation policy is more extensive than the British one. Appointments of Hong Kong Affairs Advisors, District Affairs Advisors, as well

as many other official titles, have been utilized to co-opt loyalists. Prominent in number among those co-opted elites are those who used to serve the colonial government. They are ridiculed as 'worn-out batteries' by local critics.

References

Bammer, A. (1995) 'Xenophobia, Xenophilia, and No Place to Rest', in Brinker-Gabler, G. (ed.) *Encountering the Other(s). Studies in Literature, History, and Culture,* Albany, NY: SUNY Press.

Banfield, E.C. (1958) *The Moral Basis of a Backward Society,* New York: Free Press.

Chatterjee, P. (1993) *The Nation and Its Fragments. Colonial and Postcolonial Histories,* Princeton, NJ: Princeton University Press.

Fairbank, J.K. (ed.) (1957) *Chinese Thought and Institutions,* Chicago: University of Chicago Press.

Gedalecia, D. (1974) 'Excursion into Substance and Function: The Development of the t'i–yung Paradigm in Chu Hsi', *Philosophy East and West* 24:443–52.

Harris, P. (1988) *Hong Kong. A Study in Bureaucracy and Politics,* Hong Kong: Macmillan Publishers.

Hong Kong Research Project (1974) *Hong Kong. A Case to Answer,* (booklet)

King, Y.C. Ambrose (1981) 'Administrative Absorption of Politics in Hong Kong: Emphasis on the Grass Roots Level', in A. King and R. Lee (eds) *Social Life and Development in Hong Kong,* Hong Kong: Chinese University Press.

Lau, S.K. (1980) 'Social Accommodation of Politics: The case of the Young Hong Kong Workers', *Occasional Paper, No. 89, The Chinese University of Hong Kong Social Research Centre.*

—— (1981) 'The Government, Intermediate Organizations, and Grass-roots Politics in Hong Kong', *Asian Survey* 21, 8: 865–84.

—— (1982) *Society and Politics in Hong Kong,* Hong Kong: Chinese University Press.

—— (1983) 'Social Change, Bureaucratic Rule, and Emergent Political Issues in Hong Kong', *World Politics* 35, 4: 544–62.

—— (1988) *Reform of Political System and Political Development in Hong Kong,* Hong Kong: Wide Angle Press.

—— (1990) 'Institutions without Leaders: the Hong Kong Chinese View of Political Leadership', *Pacific Affairs* 63, 2: 191–209.

Lau, S.K. and Kuan, H.C. (1988) *The Ethos of the Hong Kong Chinese,* Hong Kong: Chinese University Press.

Levenson, J.R. (1958) *Confucian China and Its Modern Fate. A Triology,* Berkeley: University of California Press.

Lewis, O. (1959) *Five Families,* New York: Basic Books.

Lin, Yu-sheng (1979) *The Crisis of Chinese Consciousness: Radical Antitraditionalism in the May Fourth Era,* Madison: University of Wisconsin Press.

Warren, B. (1980) *Imperialism: Pioneer of Capitalism,* London: New Left Books.

6

A COLONIZED EMPIRE

Reflections on the expansion of Hong Kong films in Asian countries

Ding-Tzann Lii

Hong Kong is a colony, and a third-world peripheral 'country' in the contemporary world system. Given this historical and structural marginality, Hong Kong has nevertheless created an 'empire' in the film industry at least among Asian countries. Such a phenomenon indeed poses itself as an anomaly to theoretical discourses on imperialism, particularly on media imperialism (Leung, 1993). According to the tenets of media imperialism, the unidirectional nature of international media flows closely reflects the hierarchical imbalance of world powers. The underdevelopment of the media industry in third world countries is therefore considered a result of the overwhelming media penetration by the core powers and habitual media dependency of the periphery countries (Schiller, 1979; Armes, 1987; Tomlinson, 1991). Thus, with the domination of Western media, the development of an indigenous media industry is necessarily impeded. However the history of Hong Kong's film industry shows the opposite scenario.

According to Jarvie (1977: 57), in the first half of this century, Hong Kong cinemas were dominated by Western movies like other third world countries, and the box office gross revenues of indigenous movies were significantly below those of foreign movies. Even in 1962, eight out of the ten top grossers were Western movies (Lee, 1991: 55). However, the domination of imported movies in the Hong Kong movie market in the early decades did not hinder the development of the local film industry. As Leung (1993: 30–1) points out, the domestic market share of foreign movies dropped steadily between the 1970s and 1990s. In 1979, two-thirds of box office returns went to imported, mainly Hollywood, productions. However, the box offices of imported movies only grossed 21 per cent in 1991 and 16.7 per cent in 1992 in the local market, and the trend continues to decline (see Leung, 1993: table 6). Hong Kong, Leung argues, is one of the few territories in the world where indigenous movies, rather than foreign movies, dominate the box office.

More importantly, Hong Kong's film industry not only resists foreign

domination, but also 'invades' other countries, thereby creating a new type of imperialism, which this paper is designed to explore. Table 6.1 indicates that in most major Asian countries, the number of Hong Kong movies comprised more than one-third of the imported movies. In some countries, such as Thailand and Pakistan, the market share of Hong Kong movies even exceeded 50 per cent. Moreover, recent data show that two-thirds of imported movies in South Korea are from Hong Kong (*Ming Sung Pao*, 20 August 1992, p. 10). In terms of box office performances, the top ten grossers in Singapore in 1982 were all Hong Kong products (*Singapore Daily*, 23 January 1983). In Japan, Kung-fu star Jackie Chan was voted in 1994 as the thirteenth most important movie star of the past century, ranked after Gary Cooper and before Kevin Costner (*United Daily*, 18 March 1994). Table 6.2 reveals that the number of top ten grossers in Taiwan between 1984 and 1993 was 44 from Hong Kong, and the number for Hollywood was 41. In other words, in Taiwan, Hong Kong movies are even more popular than Hollywood ones. In South East Asia, Hong Kong movie stars are so popular that they draw huge crowds almost everywhere (Chan, 1991:77). Hong Kong has created a movie empire, at least among the Asian countries.

Table 6.1 Percentage of Hong Kong movies in different markets

	1978	1980	1982	1984	1988	1989	1992	1993
Australia	12.4	17.5	16.9	14.8	16.3	13.4	–	–
Brunei		45.6	–	–	–	–	–	–
France	9.5	17.0	17.9	13.3	8.5	3.7	1.8	2.7
Germany	11.0	18.2	6.9	2.1	1.4	1.1	1.3	0.5
Indonesia	–	17.0	26.9	33.0	–	–	–	–
Korea	3.2	10.3	13.8	–	26.1	31.7	23.0	20.5
Malaysia	40.5	48.5	32.6	–	13.5	29.5	–	–
Pakistan	7.9	–	–	–	34.12	50.6	35.9	44.0
Philippines	–	39.0	39.0	–	25.9	18.6	–	–
Singapore	34.3	36.6	25.5	–	–	–	–	–
Thailand	40.1	–	–	–	52.0	52.4	–	–

Source: UNESCO, Annual Statistics; 1982-95

A kind of imperialism?

As discussed above, Hong Kong's film industry has succeeded not only to resist foreign domination, but also to invade neighboring countries, thus creating a new type of imperialism. Why is this a kind of imperialism? And what is new about it? As we know, essential to the discourse of media imperialism is the 'development of underdevelopment' of the media industry in dependent countries. It is always argued that media penetration from core powers 'creates an audience whose loyalties are tied to brand named products' (Schiller, 1979: 23). Under such circumstances, a dependency relation is established, and the

indigenous film industry is impeded accordingly. *In other words, media exporting turns into 'imperialism' when it creates damage and results in underdevelopment for the indigenous media industry.* In what follows I will use Taiwan's movie market as an example to show that Hong Kong movies represent a new type of media imperialism as defined above.

As Figure 6.1 shows, in the late 1960s, the number of movies produced in Taiwan was a little more than that in Hong Kong. By the 1970s, however, the two areas had experienced a differential development. While the number increased steadily in Hong Kong, it declined in Taiwan, except between 1978 and 1982 and between 1986 and 1988.[1] Since 1991, the annual number of movies produced in Taiwan has been less than forty (Chen, 1995). 'Who killed Taiwan movies?' has become a critical question in Taiwan's film community (*Hong Kong Economic Journal*, 12 March 1993). Indeed, from Figure 6.1, we can clearly see that the number of movies produced in the two areas are causally interdependent with each other; an increase of one is usually at the expense of the other. More specifically, Hong Kong's increase is achieved at the expense of Taiwan. The development of one has led to the underdevelopment of the other. This is exactly a Marxist definition of exploitation and economic oppression (Wright, 1993). On the level of consumption, exploitation and oppression are even more intense. As Leung (1993; 87-8) points out, in the late 1960s and early 1970s, Taiwanese movies were quite popular in Hong Kong and Southeast Asia. Hong Kong cinemas were even dominated by imported Taiwan movies. However, toward the end of the 1970s, the situation changed dramatically. As Table 6.2 shows, in the early 1980s, Hong Kong movies were more popular

Source: 1968–1985 from Lu, 1994; 1986–1993 from the government Information Office, Executive Yuan, R.O.C.

Figure 6.1 The number of movies produced in Taiwan and Hong Kong (1968–93)

124

Table 6.2 The number of top ten grossers in Taiwan, by areas; 1984–93

	Taiwan	Hong Kong	USA	Others
1984	2	4	3	1
1985	1	3	5	1
1986	2	6	1	1
1987	2	5	3	0
1988	2	4	3	1
1989	1	4	5	0
1990	0	2	7	1
1991	0	4	6	0
1992	0	6	4	0
1993	0	6	4	0
Total	10	44	41	5

Source: 1984-91; computed from Appendix 1

than Taiwan's. Among the top ten grossers, Hong Kong movies always accounted for four to five, while Taiwan had only one or two. In the 1990s, the situation became even worse; no Taiwanese movies reached the top ten; nevertheless, Hong Kong movies became even more popular (Chen, 1995). In other words, the expansion of Hong Kong movies creates the underdevelopment of Taiwanese movies. This situation has also occurred in other Asian countries, e.g., Korea (*Ming Sung Pao*, 20 August 1992). It is in this sense that we consider the expansion of Hong Kong movies among Asian countries as imperialism.

Marginal imperialism: what is new about it?

What is new about Hong Kong's imperialism? As stated above, Hong Kong is a colony situated at the periphery of the world power system. However, *the colony is becoming imperialist, and is establishing itself as an empire. What are the implications of the new kind of imperialism associated with the colonized empire?* To begin with, Hong Kong imperialism is new in the sense that it is different from the old one, which is created by the Western core (including Japan), and is therefore referred to here as 'core imperialism'. In contrast, the imperialism as exemplified by Hong Kong movies emerges at the margin of the world system, and occurs primarily within third-world countries. This is why I refer to it as 'marginal imperialism'. Historically speaking, marginal imperialism associated with a colonized empire occurs for the first time in capitalism when a marginal power in the third-world has created an empire and become imperialist itself. Thus, it becomes an interesting question to ask if the new type of imperialism in the periphery is the same kind as the old one in the core, or if it represents a different category from the old one? Does a colonized empire create a rupture in the development of capitalism, or does it just continue, reproduce or even deepen capitalistic expansion? In a word, does 'marginal imperialism' represent

a different stage in the history of the global expansion of capitalism? Let me start with the notion of 'mode of articulation' to further explore the issue.

Modes of articulation

As many studies (e.g., Wallerstein, 1989) have pointed out, since its emergence in the Western core, capitalism has been expanding throughout the world and, therefore constitutes a world system. Under this formulation, peripheral areas will be gradually incorporated into the system, and become capitalistic societies in all major aspects, e.g., modes of production, transaction relations, and ways of living. In other words, capitalism will 'totalize' and 'incorporate' the world.[2]

It must be emphasized that the process of imperialist totalization is not only physical expansion and material incorporation; it is most of all an ideological domination. As Said indicates:

> Neither imperialism nor colonialism is a simple act of accumulation and acquisition. Both are supported and perhaps even impelled by impressive ideological formations that include notions that certain territories and people *require* and beseech domination. . . . the vocabulary of classic nineteenth-century imperial culture is plentiful with words and concepts like 'inferior' or 'subject races,' 'subordinate people,' 'dependency,' 'expansion,' and 'authority.'
>
> (1994: 9)

In other words, imperialism contains a cultural dimension; it is by means of cultural domination that an empire can finally establish itself. It follows that the Western media functions as 'the ideologically supportive informational infrastructure of the modern world system's core – the multinational corporations'. Western media, according to Schiller (1979: 23), act as agents for 'the promotion, protection and extension of the modern world system'.

It becomes clear that essential to the discourse of (media) imperialism is a notion of 'modes of articulation' in terms of incorporation. 'Modes of articulation' here refers to the manner in which the 'other' is connected to 'the imperialist self'. As many studies (e.g., Ennew and Tribe, 1977; Petra, 1987) have pointed out, the Western core has imposed a capitalistic mode of social relation (e.g., class relations and market relations) upon the peripheral 'other'. As a result of this imposition, the social relations or the ways of life of these 'others' are transformed, or even disappear. Under such circumstances, the 'other' ceases to be a system different from the Western one; it is incorporated into the Western system, and becomes the inferior part of the system. More specifically, the other and the self are articulated together, yet hierarchically juxtaposed, through the incorporation of the other by the self. These are the ideal-typical characterizations of modes of articulation in core imperialism.[3] This chapter is not designed to join the discussion on the issue. Instead, I will

argue that marginal imperialism, as exemplified by Hong Kong's film industry, has manifested a very different mode of articulation from the core one. The imperial self here yields into, not incorporates, its other, thereby creating a historical juncture where the peripheral 'other' surfaces as a subject in the discourse of global capitalism. This is indeed where the process of localization has come in. Under this conceptualization, marginal imperialism represents a rupture (at least in form, if not necessarily in content), not continuity, to global expansion of capitalism. Before elaborating on the issue, let me first explain the notion of yielding and its relations to marginal experiences.

Yielding and marginal experiences

Yielding represents an opposite mode of articulation to incorporation. While incorporation refers to transformation of 'other' by imperial self, yielding refers to the withdrawal of the imperial self into 'other'. In a different context, Taussig (1993: 46) defines yielding as 'the trend to lose oneself in the environment instead of playing an active role in it . . .' According to Taussig, since the Enlightenment, humans tend to dominate their external worlds by treating them as 'objects' to be used or to be studied. Under such circumstances, the self/other relation constitutes a dominant/dominated relation. However, Taussig continues (ibid.: 25), with the development of technology, particularly reproductive technology such as photography, external 'objects' can be transformed into 'subjects'. For example, an ordinary object can become engrossing when it is well-pictured. The term 'engrossing' here implies that we as the observers are absorbed by the object. We no longer treat the objects as something external waiting to be used or studied. In contrast, *we 'space out', go outside of ourselves, and blend into 'others'* (ibid.: 38). This is what is referred to here as 'yielding'. According to Taussig (ibid.: 46), there are two types of yielding: active and passive. In 'active yielding', the self not only passively enters into the other; it also actively interacts with the 'other', thus creating a new synthesis-form with a higher order than the original ones.

For Taussig, yielding is an alternative science representing a radical reversal of Enlightenment science's aggressive compulsion to dominate external worlds. Thus, yielding is a new science to end science (ibid.: 32). In this chapter, I will appropriate the notion of yielding for my discussion of marginal imperialism as exemplified in Hong Kong cinemas. As will be demonstrated later, Hong Kong movies yield to, not incorporate, the 'other'. Why do Hong Kong movies manifest the peculiar mode of articulation when compared with their Hollywood counterparts? I think this might have to do with its marginal experience of being a colony, and being situated at the periphery at the same time.

Hong Kong has been a colony for almost a century. Colonial experience, as Nandy (1982) indicates, is similar to slave experience. In a master–slave relation, Nandy (ibid.: xv–xvi) contends that the master always views the slave as an object, or a thing to be used; however, the slave must view the master as a

human subject. To use the terminology designated in this chapter, the slave must yield to the master. The external object is no longer an object to a slave. Rather, slaves as 'self' have to go out of themselves, and blend into the 'other'. The relation between self and other, or between subject and object here breaks down. For Nandy (ibid.: xv; 75), therefore, the slave and the colonized represent a higher-order of cognition, by means of which a higher level of universalism can be developed. Under this formulation, the colonized do not remain the simple-hearted victims of colonialism. Rather, 'they become participants in a moral and cognitive venture against oppression. They make choices. And to the extent that they have chosen their alternative within the West, they have also evaluated the evidence, judged and sentenced some while acquitting others' (ibid.: xiv). In other words, owing to colonial experience, the colonized have learned to actively yield to, and blend into 'others'. In this sense, the experience of being colonized can have a radical meaning in our discussion of marginal imperialism. Being a colony, if this argument is plausible, Hong Kong would have developed a cognitive orientation of yielding, which is different from the one developed by the West, the master-never-being-a-slave. It is here that we see how Hong Kong cinema goes out of itself, and blends into its others (the Asian countries), thus creating a synthesis-form with a higher cognitive order. This is what I refer to as Asianization.[4]

In addition to the colonial experience as discussed, the structural position of being situated in the periphery also contributes to the development of a yielding mode of articulation. As one of my informants tells me, the production of Hollywood movies is always global in horizon. It never targets a specific area as its potential audience; rather, it always aims at the world as a whole. Under such circumstances, a universal form which works everywhere is created, and capitalism expands globally, not locally. On the contrary, being situated in the periphery, Hong Kong is less likely to view the entire world as its potential audience or consumer. Rather, it always limits itself to Chinese society, or Asia at most. This 'regionalization' enables Hong Kong to take local characteristics into account, and to yield into its others. With the joint operation of its structural position and colonial experience, Hong Kong therefore develops a new mode of articulation when it becomes an imperialist itself. *As Taussig (1993: 32) has pointed out, yielding is a new science to end science. Yielding in this chapter is viewed as a new imperialism to end old imperialism. It is here that I see a rupturing and a transformation in the global expansion of capitalism, and here that I see the radical meaning associated with marginal imperialism explored here.* In what follows I will compare Hong Kong movies with Hollywood's to show the different modes of articulation between the two.

Hollywood and Hong Kong compared

Hollywood has been the movie center of the world, and Hong Kong is seen as the 'Hollywood of the East'. In this section, I will try to demonstrate that while

Hollywood has tried to incorporate its others, Hong Kong yields. Before performing the textual analysis, I will briefly discuss the difference in the structures and organizations of the industry between the two.

The structure of a movie industry

As we know, the film industry has a three-part structure: production, distribution and exhibition, and Hollywood is best characterized by 'vertical integration' among the three (Wasko, 1994). To use the relationship between Hollywood and Taiwan as an example, the distributors in Taiwan are 'branches' of their main companies in the US or UK.[5] All important decisions (e.g., personnel and budgeting) are made by the main companies; and local distributors in Taiwan have no real decision-making power in the marketing process. In terms of exhibition, any movie shown in Taiwan cannot be edited or cut without permission from the main companies. Thus, distribution and exhibition in Taiwan are designed to serve the needs of the production center in the core. As Figure 6.2 shows, in Hollywood, there exists a uni-directional relationship from production to distribution, and on to exhibition. Any feedback from distribution or exhibition to production is not possible. This is not the case with Hong Kong.

Hong Kong movies were characterized by 'vertical integration' during the 1950s and 1960s. However, after the 1970s, Hong Kong movies experienced a reduction in vertical integration, and a process of decentralization and diversification began to evolve (Leung, 1993: 81). Most important to our discussion is the de-centralization process in the so-called 'pre-sale' practice, meaning a system which requires distributors to pay before a movie is actually made. As Leung (1993: 82) points out, the availability of financial investment from overseas distributors by the 'pre-sale' practice has boosted film production in Hong Kong. More importantly, the function performed by the distributors increasingly exerts pressure on the production strategies of Hong Kong movies. Thus, important decisions in terms of genres, casting and storylines can be influenced by overseas distributors. This accounts for why so many international elements can be found in Hong Kong films. Thus, as Figure 6.2 shows,

(1) Production
(2) Distribution
(3) Exhibition

Figure 6.2 The relationship among production, distribution and exhibition, Hollywood and Hong Kong compared

a feedback exists from distribution back to production. It is here that local (overseas) elements have entered the production process, and the uni–directional integration associated with Hollywood movies breaks down. Consequently, the mode of articulation between self and other shifts from incorporation to yielding.

Textual analysis

It is almost impossible to give samples which represent either Hollywood or Hong Kong. The number of movies made in the two areas is too many, and the style too variant, for us to have an effective way of conducting sampling. Thus, I will take a more comprehensive way to conduct my textual analysis. I examine all the top ten grossers in Taiwan's movie market during the 1984–93 period (See Appendix 1). Among these 100 top ten grossers, Hong Kong has 44, whereas Hollywood has 41 (Table 6.2). These 85 movies are my sample texts for analysis.

Among these sample cases, I further divide them into two major categories (Table 6.3). The category 'self only' applies to those movies which deal only with their own society (the US or Hong Kong). The category 'with other' applies to movies which contain elements of 'other'. The 'classical' is a kind of residual category which deals with neither the self nor the other, but with traditional China (in the case of Hong Kong) or traditional Europe (in the case of Hollywood). Thus, it is not classifiable for my purposes. As Table 6.3 shows, 15 out of 44 Hong Kong movies contain important elements of other countries, the number for Hollywood is 9 out of 41. On the other hand, the number of movies which deal mostly with Hong Kong itself is only 19, while the number for Hollywood movies dealing solely with American society is 30. Apparently, Hong Kong has a much higher proportion of movies which are international or other-oriented, attesting to the hypothesis that Hong Kong is more likely to yield.

In contrast, Hollywood is much more self-oriented. Most Hollywood movies are about American society, and convey messages about the American way of life. Since many studies have been done on the issue of the way these American movies exert a cultural impact upon 'the other' (e.g., Dorfman and Mattelart,

Table 6.3 The self–other relation: Hong Kong and Hollywood compared

	Hollywood	Hong Kong
'Self' only	30	19
With 'other'	9	15
'Classical'	2	10
Total	41	44

Source: Computed from Appendix 1

130

1975; Ang, 1985; Barker, 1989), I will not go into textual analysis on this category of movies. Suffice to say that through these potential 'carriers' of American values, the peripheral culture is gradually incorporated into the capitalist form of social relations. In other words, the other ceases to be an alien to the imperialist self; it is incorporated into the system of the self, and becomes the lower parts of the world-system. This is what is referred to here as the incorporative power of capitalism.

More importantly, 'other' is not simply less likely to appear in Hollywood movies; it manifests a different mode of articulation when it does appear. Among the nine movies having 'others' in them,[6] only two (*Dances with Wolves* and *Platoon*) are partial exceptions, and the other movies, which I analyze, clearly manifest an incorporated mode of articulation. Most typical are the *Indiana Jones* series and the *Rambo* series.

The *Indiana Jones* series, directed by Spielberg, is about the archaeologist Dr. Jones's adventure in the East. In the process of the adventures, Dr. Jones encounters his oriental 'others', and a specific mode of articulation between the Western 'self' and the Oriental 'others' therein emerges. In Part II, for example, Indiana Jones arrives at an Indian village, where hundreds of village boys are taken away by a secret cult. Dr. Jones therefore decides to penetrate the cult to rescue the captive boys. It is here that we see how the dominant/dominated relation in the actual power relationship of the world is reflected in the movie's structure. Simply, the West is the saver and the hero, whereas the East is the one to be saved and rescued. This self–other relation actually continues and reproduces the prevalent motif of colonial movies, where the colonizers are usually depicted as enlighteners, teachers, priests, and the colonized are the people to be enlightened, taught and saved (Lii, 1996). Furthermore, in the course of Dr. Jones' adventures, many exotic scenes associated with the cult, and with India as a whole, are deliberately shown with a mocking tone. Under Spielberg's camera, India is not only poor and ignorant, but also mysterious, primitive and barbarous (snakes and monkeys are eaten). In the final scene, Dr. Jones, surrounded by a group of applauding villagers, kisses his woman and heroically accepts the worship of the villagers.

The heroism revealed in the *Indiana Jones* series is indeed very typical of Hollywood mainstream movies which contain elements of 'Other'. The *Rambo* series is another example. In Part II, for example, Rambo penetrates deep into north Vietnam, and in Part III, he again penetrates deep into Afghanistan to rescue American captives. Needless to say, Rambo defeats his rivals (North Vietnamese and Russians, respectively) with his 'extraordinary' wisdom and determination. What I want to emphasize here is the role that children (and to a lesser degree, women) have played in this type of movie. Both in *Indiana Jones Part II* and in *Rambo*, there are oriental boys who serve as assistants to the hero. These boys are shown taking pride and pleasure in being helpers. Indeed, the boys are true worshippers; they are loyal and submissive, and are willing to make sacrifices. Through a boy's and a woman's eyes, the great hero becomes even

greater, and through the sacrifice of boys and women (as in *Rambo Part II*), the mission of the hero becomes even more sacred and legitimate. In this sense, the boys can be seen as 'the idealized others' of the Western imperial self. In the Western imaginary, the East will be best when it turns into a boy, who is loyal to the hero, and remains subordinated and submissive.

The self–other relationships as revealed in *Indiana Jones* and *Rambo* are very typical to the other movies I examine here, i.e., *Rocky* series (Part IV), *Die Hard* and *Black Rain*. More importantly, the 'other' as characterized by Hollywood mainstream movies applies not only to the third world, but also to a first world country such as Japan (*Black Rain*), or Europe (*Die Hard*). In *Black Rain*, for example, the Japanese are seen as overly rigid people who follow group codes with no room left for individuality and spontaneity. In contrast, American culture is seen as flexible and creative. In the end, the Japanese protagonist was made to identify himself with the American protagonist to accomplish their joint project. Thus, the self–other relationship here is as typical as that appearing in *Indiana Jones* and *Rambo*. It is 'an incorporation' in the sense that 'others' are viewed as weird, ignorant, or barbarous because they are put into the same value/knowledge/moral system with the imperial self. In other words, within the characterization of Hollywood movies, the self–other relation has shifted from a juxtaposition of two systems to an articulation into a single hierarchical system. The imperial self has *incorporated* others and *subordinated* them at the same time, and the other becomes an object to be satirized and laughed at under the imperial gaze.

Yielding in Hong Kong movies

Being a colony situated on the periphery, Hong Kong does not impose a universal form which applies to the whole world, but targets specific areas. For example, some movies, such as *Ashes of Time* and *Taoxue weilong*, even have different versions for different areas. This 'targeting' enables Hong Kong movies to yield and to blend into others. The 'pre-sale' institution discussed above is another example showing that the blending process is created by the feedback of distribution to production. Under such circumstances, the local elements of the distributed areas enter into production, accounting for why there are so many 'others', including actors and storylines in Hong Kong movies. With the blending process and the dialogical exchanges among these Asian countries, a new synthesis therefore emerges, which is referred to here as 'Asianization'. In what follows I will analyze the fifteen movies[7] sampled, among them nine are Jackie Chan's, four are Chow Yun Fat's, and two are Jet Li's. Let me start with Chan.

In the textual analysis of Chan's nine movies, I will first attempt to demonstrate that Chan has called an end to the incorporating mode of articulation associated with the core imperialism of Hollywood. As stated earlier, the 'other' in a Hollywood film is always seen as being inferior to the self. 'They' are either

ignorant or barbarous, and are always waiting to be enlightened or saved. This stereotypical characterization sees a turning point with Jackie Chan. It must be pointed out that in Chan's films, he plays the hero, a fact which is not much different from a Hollywood film. However, in a Hollywood film, the 'evil' of the other reflects mostly a *cultural judgment*, whereas in Chan's films, such 'evil' merely reflects a *social fact*. Take *Indiana Jones* as an example. When Steven Spielburg employs a very mocking attitude to depict an exotic India, he is obviously making a cultural judgment which implies backwardness and savagery of the country. The scenes on monkey-eating and snake-playing are all good examples. The horrifying scene on 'heart-plugging' even hints at the cruel and ferocious 'other'. Jackie Chan, in contrast, hardly uses frivolous satire when dealing with the customs of the 'other'. In his films, the 'bad' guy is mostly a thief, a bandit or a gangster (such as those in the *Armor of God* series and in *Crime Story*). Those bad guys have not done anything particularly vicious, and unlike *Indiana Jones*, there has never been a close-up of such conduct. Thus, the depiction of the other in Chan's films is almost funny, yet not mocking, let alone satirical. Those 'bad' things are common social facts which take place everywhere, and the society depicted does not feel ashamed of having them. Thus, Chan's characterizations of the 'other' reflect social facts, yet no cultural judgments are cast upon them. This attitude towards the 'other' differs drastically from the mainstream Hollywood movies examined above. In this respect, though remaining unyielding, Jackie Chan nevertheless puts an end to imperial incorporation.

Aside from making no cultural judgment, Jackie Chan also tends to 'mystify' his 'other'. More specifically, he almost never specifies the society to which the bad guys belong. In *The City Hunter*, for example, the bad guys are international bandits from the high seas. In the *Armor of God* series, the bandits come from a desert. Both high seas or the desert are geographical locations which can't be identified. In other words, the bad guys are not members of any specific society; they are 'mysterious others'. Thus, the 'other' in Chan's films is not only culturally neutral as discussed; it is de-objectified. No one specific society is charged with the bad conducts, and the 'other' is publicized and made to disappear.

In addition to the termination of the incorporate mode of articulation, Jackie Chan often goes further and yields into his 'other'. As pointed out, there are two types of yielding: active and passive. In passive yielding, the self 'spaces out', and goes into the 'other', and then disappears. This is a process of self-denial and self-negation. In active yielding, the self goes out of oneself and blends into the 'other', thus creating a synthesis with a higher cognitive order than the original ones. *Mr. Canton and Lady Rose*, the *Project A* series, and *Kuaichan che* are examples of passive yielding. *The City Hunter*, the *Armor of God* series, and *Police Story III* are examples of active yielding. Let me start with passive yielding.

Mr. Canton and Lady Rose is typical of passive yielding. In the movie, the contrast between good and evil, high and low, and noble and humble are all turned

upside down. For example, the male protagonist Guo Zhenhau (Jackie Chan), and the female protagonist Yang Luming are the 'good guys' of the movie. They are both from China. Duan Yihu, though sometimes taking advantage of others, is none the less loyal to his friends. He comes from Taiwan (judging from his accent). The number one 'bad guy' Li Zhifei is a native of Hong Kong. He says one time, 'If Hong Kong people were reliable, sows would climb trees.' The number two 'bad guy' Gu Xingchuan is also from Hong Kong. Thus, we can see clearly that all the 'bad guys' in the movie are Hong Kong people, yet all the 'good guys' come from 'other' places, such as China and Taiwan. Even British officers act to join Guo and Yang to help them accomplish their mission. Thus, the power relation associated with core imperialism as exemplified in Hollywood movies such as *Indiana Jones* is reversed. The other becomes the good, the saver and the helper, whereas the imperial self has turned into the evil and the bad. This self-denial and self-negation is a typical case of passive yielding. In the *Project A* series, Jackie Chan is so loyal to the colonial government that he even refuses to identify himself with the Chinese revolutionary of the Qing dynasty. This 'spacing-out' of the self in Other serves as another example of passive yielding.

Aside from passive yielding, Jackie Chan also actively yields to his Other, thus creating a synthesis which transcends both the self and the Other. This is what I mean by 'Asianization' – a fusion or synthesis of different Asian cultures into one Asian Culture.[8] In *The City Hunter*, for example, Jackie Chan, Huixiang and Chinzu (the heiress of a Japanese tycoon) take an ocean liner heading for Japan. On their way, they are attacked by a group of international bandits, who conspire to kidnap Chinzu. A new group of Chinese, Hong Kong, Japanese and Taiwanese is thus formed to fight against the international bandits, who are mysterious Others as defined above. The animated war episode displays a fusion of local color of China, Japan and Hong Kong, and manifests a distinctive style of Asia. This formation of a new Asia symbolizes the birth of an Asian entity in its embryo form. Similar characterizations appear also in *The Police Story III*, where a grand fusion among Hong Kong, China, Singapore and Malaysia is created. This grand fusion has reached its high tide in the *Armor of God* series, however. In both Part I and Part II, the male protagonist (Jackie Chan) is named 'Asian Hawk'. The only thing we know about his background is that he is an Asian with yellow skin. In other words, what Jackie Chan stands for is Asia, not Hong Kong. This creation of an Asian entity is the most important message that Chan's works have conveyed. It is here that we see the essential feature of marginal imperialism.

Chow Yun Fat is another superstar, and his *Heroes* series (including *Heroes, A Better Tomorrow I, II, III*) is very popular in Asia. Essential to the series is an image of self-as-hell, and other-as-paradise. In *Heroes*, for example, Hong Kong (the self) is seen as a place of danger, violence, cruelty and insecurity. 'Bad' things take place there, and 'good' people are thus forced to leave for other places (i.e., Singapore and Malaysia). It is in these 'other' countries that people find security, warmth and peacefulness. This self–other contrast as hell vs. paradise remains

unchanged throughout Chow's *A Better Tomorrow* series. Indeed, 'Other' in the series has become a metaphor of tomorrow which is hopefully better, and the 'self' of course represents 'today' which is not good. Under this formulation, the only hope for Hong Kong people is to escape from 'today' and move into 'tomorrow' – be it 'everywhere' in *Part I*, New York in *Part II* or Canada and Taiwan in *Part III*. This escape from 'self' into 'other' is very typical of a yielding mode of articulation characteristic of Hong Kong movies.

Besides Jackie Chan and Chow Yun Fat, Jet Li's *Huang Feihong* series also shows a yielding mode of articulation. In *Part II*, the cultural dialogue between Chinese medicine and Western medicine is an active yielding. The cooperation between Huang Feihong and foreign embassies to save children is an active yielding too. More importantly, the suffering of Chinese people in the late Qing Dynasty is seen as a result not of Western colonization, but of the superstition and backwardness of Chinese tradition, as exemplified by the cult of 'white-lotus'. This is a sign of self-negation and passive yielding. In the end, the children with Western education are regarded as 'hopes' of China, a fact which shows again an active yielding of articulation. In *Part III*, Shisan Yi represents love and marriage in Western culture, while Huang Feihong represents Chinese values. In the end, Huang and other Chinese identified themselves with Shisan Yi, embodying again the yielding mode of articulation. To recall *Black Rain*, in which the Japanese man was made to identify himself with the American protagonist to accomplish their goals, in Hong Kong movies, however, yielding, not incorporation, prevails. Among the fifteen movies discussed, none has shown an incorporating mode of articulation, attesting to the argument of yielding associated with marginal imperialism.

Marginality, localization, and globalization

It has been argued that capitalism is spreading throughout the world and thereby constitutes a world-system in which the capitalistic mode of social relations will become the major form of life. Although some studies[9] show reservations about the degree of capitalistic expansion, most do not deny the incorporating and totalizing power associated with the logic of such expansion. Under this formulation, Western media are seen as 'the ideologically supportive information infrastructure' functioning as agents for the extension of the modern world system. In this chapter, however, I contend that periphery media, exemplified by Hong Kong movies, serve to regionalize and to localize, not to continue the global expansion of capitalism. The process of localization (Asianization) and regionalization here mainly derives from Hong Kong's marginality in being a colony and a periphery 'country' at the same time. As pointed out, being located in the periphery, Hong Kong is less likely to view the whole world as its target, and being a colony, Hong Kong is made able to yield to, and to identify itself with 'other'. It is here that I see an important structural source of localization in global capitalism.

Localization and globalization are two processes of the same trend; they indeed constitute each other. However, most studies on the issue posit that localization reflects the efforts on the part of local subjects to protect themselves from modernity's hegemonic process of integration. It is always argued that, through reappropriation and rearticulation by local subjects, the universal aspect of capitalism is thereby made specific and localized (Friedman, 1990). Under this formulation, it is local agents who actively reconstruct the universalistic logic inherent in global capitalism, and capitalist cooperations only adapt and adjust to what is needed locally. In this chapter, however, my argument has been that the imperial self (with a past experience of being marginal, of course) may actively yield into its Other, and the process of localization may also reflect efforts not only of 'Others', but also of the imperial self. It is in the active yielding of the marginal imperialist that the capital logic is localized.

It must be emphasized again that only a marginal imperialist can yield; the core imperialist cannot. This is so because core imperialists always have the whole world as their objects, and because they have been masters who need not yield to their slaves. Under such circumstances, localization is not even within the cognitive maps of the core capitalists, if there is no challenge and competition from locals. In other words, in order for core capitalists to be able to yield, there must exist challenges from local areas, either by local subjects or by marginal imperialists. The emerging marginal empire, the Hong Kong film industry, can play the role of a challenger who forces the Western imperialists to yield and to localize. For instance, as already pointed out, Hong Kong movies are even more popular than Hollywood's in many Asian countries, thus posing a substantive challenge to Hollywood. It is only in this kind of situation that Hollywood would start to yield. As already indicated, Hollywood has planned to invite several famous Hong Kong actors for example, Jackie Chan, Chow Yun Fat, Jet Li and Leslie Cheung, to join its movies (*United Daily*, 2 January 1995; *Dacheng bao*, 29 March 1994; *China Times*, 27 December 1994; *World Screen*, December 1993). If this becomes the case the storylines of Hollywood movies will be changed dramatically. This is so because, while the Shanghainess of the boy in *Indiana Jones* is only of secondary significance, Jackie Chan, if he is going to be in Hollywood movies, will definitely be of equal importance to Stallone or Schwarzenagger. The West and the East will have more of a dialogical and egalitarian relation in movies, and the traditional dominant/dominated relation in films between the West and the East will be changed. As a result, a yielding mode of articulation will emerge. In other words, Hong Kong could potentially challenge Hollywood and force Hollywood to learn to yield, and to change. It is in this spirit that I see marginal imperialism as an imperialism to end imperialism.

A final remark

In this chapter, I have used the Hong Kong film industry as examplification in arguing that marginal imperialism has created a yielding mode of articulation,

which is different from the incorporating mode of articulation associated with core powers. What I want to emphasize at the end of the paper is the fact that marginal imperialism has taken place not only in the film industry in Hong Kong, but also in other industries in other peripheral 'areas.' For instance, many Taiwan capitalists are heavily investing in other third world countries, especially in Southeast Asia (Chen, 1994). Indeed, Taiwan, Hong Kong, Singapore, and South Korea have replaced the US or Japan as the major foreign capitals in Vietnam, Thailand, the Philippines, and Malaysia. Restated, a new kind of imperialism, in which the Hong Kong film industry is but only one example, is taking place among third world countries. How are we going to conceptualize and theorize this new phenomenon? Is it characteristically different from the core imperialism, or is it just a replication of the old one? Does it represent a different stage of capitalism, or is it just a deepening of the global expansion of capitalism? From what I have discussed in this chapter, I would argue that marginal imperialism, owing to the exploitation it involves, is still an imperialism in an *economic* sense. But *culturally*, marginal imperialism does manifest a different mode of articulation from the core one. This emergence of a 'culture' category seems worth pursuing further. But to have a more solid answer to the historical question posed above, more empirical studies are definitely needed.

I am grateful for the helpful comments of David Birch, Kuan-hsing Chen, Ya-shu Chen, Mark Gibson, Masao Miyoshi, Meaghan Morris, Paul Willemen and participants of Trajectories II. I also thank Chen Zhaoyong, Hu Junyuan, and You Huifen for their assistance. A version of this paper has been published in *Taiwan: A Radical Quarterly in Social Studies*. No. 21, January, 1996.

Notes

1 In the late 1970s, many restrictions were placed on Hong Kong movies throughout Southeast Asia (Leung, 1993; 65). In the late 1980s, five major distribution companies in Taiwan organized to protect the local film industry there.

2 This topic has been widely discussed. See a good review by Hopkins and Wallerstein (1987).

3 Some studies have reservations on the thesis of totalization and incorporation, contending that peripheral areas do retain some aspects of the traditional mode of production. See Chayanov, 1966; Alavi, 1975.

4 In a different context, Chua (1995) also sees a process of 'Asianization' in Singapore in terms of national identity. Since Singapore was also a colony like Hong Kong, Chua's observation can be viewed as another example to the argument of this chapter.

5 'UIP' in England deals with international distribution for three major Hollywood companies (Universal, Paramount, M.G.M.).

6 1 *Indiana Jones and the Temple of Doom*; 2 *Rambo: first blood (II)*; 3 *Rocky III*; 4 *Platoon*; 5 *Rambo III*; 6 *Die Hard*; 7 *Indiana Jones and the Last Crusade*; 8 *Black Rain*; 9 *Dances with Wolves*.

7 The fifteen movies sampled are: Chan's: 1 *Project A*; 2 *Knaichan che*; 3 *Armor of God*; 4 *Project A II*; 5 *Mr. Canton and Lady Rose*; 6 *Armor of God II*; 7 *The Police Story III*;

8 *Zhongan Zu*; 9 *The City Hunter*; Chow's: 10 *Heroes*; 11 *A Better Tomorrow*; 12 *A Better Tomorrow II*; 13 *A Better Tomorrow III*; Li's: 14 *Huang Feihong II*; 15 *Huang Feihong III*.

8 An interesting comparison can be made with Kolde (1976) and Gibson (1995), who also see an 'intensive interactivity' taking place in the Pacific Rim. To Gibson and Kolde, however, the fluidity and multigeopoliticity of the Pacific Rim is due to ocean currents, not marginality, as proposed in this chapter.

9 See note 3.

References

Alavi, H. (1975) 'India and the Colonial Mode of Production', *Socialist*.

Ang, I. (1985) *Watching Dallas: soap opera and the melodramatic imagination*, London: Methuen.

Armes, Roy (1987) *Third World Film Making and the West*, Berkeley: University of California Press.

Barker, M. (1989) *Comics*, Manchester: Manchester University Press.

Chan, C.W. (1991) 'Hong Kong TV Culture Prevails in Southeast Asia', *City Entertainment*, no. 323.

Chayanov, A.V. (1966) 'The Theory of Peasant Economy', in D. Thorner, R. Smith and B. Kerblay (eds), Irwin.

Chen, K.H. (1994) 'The Imperialist Eye: The Cultural Imaginary of a Sub-empire and a Nation-State', *Taiwan: A Radical Quarterly in Social Studies*, no. 17.

Chen, R.S. (1995) 'Statistical reports on the Cultural Ecology of Taiwan Cinema: 1990–1995', unpublished manuscripts.

Chua, B.H. (1995) 'Culture, Multiracialism and National Identity in Singapore', paper presented at Trajectories II, Taipei.

Dorfman, A. and Maffelart, A. (1975) *How to Read Donald Duck: Imperialist Ideology in the Disney Comic*, New York: International General Edition.

Ennew, H. and Tribe, K. (1977) 'Peasantry as an Economic Category', *Journal of Peasant Studies*, 4(4): 295–322.

Friedman, J. (1990) 'Being in the World: Globalization and Localization', *Theory, Culture and Society*, vol. 7: 311–28.

Gibson, M. (1995) '"Being Political" in Communication and Cultural Studies: Theorizing the Pacific Rim', *Australian Journal of Communication*, 22(2): 95-107.

Hopkins, T.K. and Wallerstein, I. (1987) 'Capitalism and the incorporation of new zones into the World-economy', *Review* 10(5/6): 763–79.

Jarvie, I. (1977) *Window On Hong Kong: A Sociological Study of the Hong Kong Film Industry and Its Audience*, Hong Kong: University of Hong Kong.

Kolde, E.-J. (1976) *The Pacific Quest: The Concept and Scope of an Oceanic Community*, Lexington, MA: Lexington Books.

Lee, Paul (1991) 'The Absorption and Indigenization of Foreign Cultures', Hong Kong Institute of Asia-Pacific Studies, HKIAPS reprint series, No. 11.

Leung, Grace L.L. (1993) *The Evolution of Hong Kong as a Regional Movie Production and Export Center*, Master Thesis, Chinese University of Hong Kong.

Lii, D.T. (1996) 'Marginal Empire: The Case of Hong Kong's Film Industry, with Hollywood and Colonial Japan Compared,' *Taiwan: A Radical Quarterly in Social Studies*, 21: 141-70.

Lu, Fei-I (1994) *Statistics of Film Production in Taiwan*, Taipei: Information Bureau, R.O.C.

Nandy, Ashis (1982) *The Intimate Enemy: Loss And Recovery of Self Under Colonialism*, New Delhi: Oxford University Press.

Petras, J. (1987) 'The Latin America Agro-Transformation from Above and Outside', in *Critical Perspectives on Imperialism and Social Class in the Third World*, Monthly Review.

Said, E. (1994) *Culture And Imperialism*, New York: Vintage.

Sahlin, M. (1990) 'The Political Economy of Grandear in Hawaii from 1810 to 1830', in Ohnuki-Tierney (ed.) *Culture Through Time*, Stanford: Stanford University Press.

Schiller, H.I. (1979) 'Transnational Media And National Development', in Nordenstreng and Schiller (eds.) *National Sovereignty And International Communication*, New Jersey: Ablex.

Taussig, M. (1993) *Mimesis And Alterity*, New York: Routledge.

Tomlinson, J. (1991) *Cultural Imperialism: A Critical Introduction*, London: Pinter Publishers.

Wallerstein, I. (1989) *The Modern World-system, vol. III, Second Era of Great Expansion of the Capitalist World Economy*. San Diego, CA: Academic Press.

Wasko, J. (1994) *Hollywood in the Information Age*, Austin: University of Texas Press.

Wright, E.O. (1993) 'Class Analysis, History and Emancipation', *New Left Review*, no. 202.

Appendix 1

The yearly top ten grossers in Taiwan, by areas; 1984–93

Year	Rank	Title	Area*	Other**
1984	1	Indiana Jones and the Temple of Doom	US	Y
	2	A計劃 Project A	HK	Y
	3	Never Say Never Again	US	N***
	4	快餐市 Kuaianche	HK	Y
	5	天生一對 Tensen Idwei	TW	N
	6	全家福 Quanjiafu	HK	N
	7	Ghostbuster	US	N
	8	七隻狐狸 The Seven Foxes	TW	N
	9	望鄉 Home Town	JP	Y
	10	鐵板燒 Tiebanshao	HK	N***
1985	1	Rambo: First Blood Part 2	US	Y
	2	Back to the Future	US	N
	3	A View to a Kill	US	N***
	4	暫時停止呼吸 Zhanshi tingzhi huxi	HK	N
	5	福星高照 Fuxin gaozhao	HK	N***
	6	小丑與天鵝 The Clown and the Swan	TW	N
	7	The Killing Fields	UK	Y
	8	Amadeus	US	U
	9	龍的心 Longdexin	HK	N
	10	The Terminator	US	N

Appendix 1 *cont*

Year	Rank	Title	Area*	Other**
1986	1	警察故事 Police Story	HK	N
	2	龍兄虎弟 Armor of God	HK	Y
	3	好小子 A Good Guy	TW	N
	4	英雄本色 A Better Tomorrow	HK	Y
	5	八二三炮戰 The War of 8-23	TW	N
	6	一見發財 Yijian facai	HK	N
	7	新里見八犬傳 The Story of Eight Dogs	JP	N
	8	富貴列車 Fuguei lieche	HK	N***
	9	Rocky 4	US	Y
	10	小蝦米對大鯨魚 Xiaoxiami dui dajingyu	HK	N***
1987	1	A計劃續集 Project A 2	HK	Y
	2	The Living Daylights	US	N
	3	報告班長 A Report to the Squad Leader	TW	N
	4	Platoon	US	Y
	5	倩女幽魂 Qiannu youhun	HK	U
	6	大頭兵 The Soldiers	TW	N
	7	英雄好漢 Heroes	HK	Y
	8	衛斯里傳奇 Wei Sili chuanchi	HK	N***
	9	Beverly Hill Cop 2	US	N
	10	監獄風雲 Jianyu fengyun	HK	N
1988	1	The Last Emperor	UK	Y
	2	First Blood 3	US	Y
	3	警察故事續集 Police Story	HK	N
	4	Die Hard	US	Y
	5	報告班長續集 A Report to the Squad Leader II	TW	N
	6	飛龍猛將 Feilong mengjiang	HK	N
	7	英雄本色續集 A Better Tomorrow II	HK	Y
	8	天下第一樂 The Happiest Thing in the World	TW	N
	9	八星報喜 Baxing baoxi	HK	N
	10	Fatal Attraction	US	N
1989	1	Indiana Jones and the Last Crusade	US	Y
	2	奇蹟 Mr. Canton and Lady Rose	HK	Y
	3	悲情城市 A City of Sadness	TW	Y
	4	Rain Man	US	N
	5	Licence to Kill	US	N***
	6	Lock Up	US	N
	7	Black Rain	US	Y
	8	急凍奇俠 Jidong qixia	HK	N***
	9	至尊無上 Zhizun wushang	HK	N***
	10	英雄本色3 A Better Tomorrow III	HK	Y
1990	1	Die Hard 2	US	N
	2	Pretty Woman	US	N
	3	Total Recall	US	N
	4	賭神 Dushen	HK	N***
	5	The Gods Must Be Crazy 2	SA	Y

Appendix 1 *cont*

Year	Rank	Title	Area*	Other**
	6	人間道　Renjiandao	HK	U
	7	Honey, I Shrunk The Kids	US	N
	8	Back To The Future Part 2	US	N
	9	When Harry Met Sally	US	N
	10	Look Who's Talking	US	N
1991	1	Ghost	US	N
	2	The Terminator 2: Judgement Day	US	N
	3	Dances with Wolves	US	Y
	4	Home Alone	US	N
	5	Robin Hood : Prince of Thieves	US	U
	6	飛鷹計劃　Armor of God 2 : Operation Condor	HK	Y
	7	整人專家　Zhengren zhuanjia	HK	N
	8	縱橫四海　Zungheng sihei	HK	N***
	9	賭俠　Duxia	HK	N***
	10	The Silence of the Lambs	US	N
1992	1	Basic Instinct	US	N
	2	警察故事3：超級警察　Police Story 3	HK	Y
	3	新鹿鼎記　Xinludingji	HK	U
	4	Lethal Weapon 3	US	N
	5	新鹿鼎記 2：神龍敎　Xinludingji 2: Shenlongjiao	HK	U
	6	Hook	US	N
	7	笑傲江湖之東方不敗　Xiaoao jianghu zhi Dongfang Bunai	HK	U
	8	新龍門客棧　Xinlongmen kezhan	HK	U
	9	The Last Boy Scout	US	N***
	10	黃飛鴻男兒當自強　Huang Feihong II	HK	Y
1993	1	Jurassic Park	US	N
	2	城市獵人　City Hunter	HK	Y
	3	唐伯虎點秋香　Tang Bohu dian Qiuxiang	HK	U
	4	武狀元蘇乞兒　Wuzhuangyuan Su Qiuxiang	HK	U
	5	The Fugitive	US	N
	6	Cliffhanger	US	N
	7	方世玉第一集　Fang Shiyu diyiji	HK	U
	8	The Bodyguard	US	N
	9	重案組　Crime Story	HK	Y
	10	黃飛鴻之獅王爭霸　Huang Feihong III	HK	Y

Note: * area: US: USA (Hollywood)
 ** other: If contents of the movies contain element of 'other'
 Y: Yes
 N: No
 U: Unclassifiable, which refers 'Chinese Classical' or 'European Classical'
 *** having 'other' which serves only as a background against which an event takes place, yet no significant dialogue between 'self' and 'other'
Source: 1984–91; annual statistics of Chinese Movies
 1992-93; *Ta Chung Poa*, 24–25 December, 1993

A NEW COSMOPOLITANISM

Toward a dialogue of Asian civilizations

Ashis Nandy

Asia is a geographical, not cultural entity. Though many Asians have defined their continent culturally during the last 150 years, that definition can be read as an artefact of Asian reactions to Western colonialism rather than as an autonomous search for larger cultural similarities. In this respect, the Asia of anti-imperialist intellectuals like Rabindranath Tagore is much like the Africa of the likes of Leopold Senghor. The difference is that while cultural definitions of Asia have been mainly a psychological defence against the internalized imperial fantasy of the continent as a location of ancient civilizations that had once been great and were now decadent, decrepit and senile, the idea of Africa as a cultural area has been mainly a defence against the internalized fantasy of the continent as an abode of the primitive and the infantile. Both definitions have been shaped by the imperial metaphor of the body, built on European folk imageries of stages of life as taken over and remodelled by nineteenth-century biology and social evolutionism.

However, there has been, outside the realm of these definitions and self-definitions, an Asia which does not probably even see itself as Asia. That Asia has known the West for about two millennia and interacted with it seriously for over six hundred years. But it began to have a third kind of close encounter with the West starting from the eighteenth century, when the Industrial Revolution and the discovery and colonization of the Americas gave the West a new self confidence *vis-à-vis* Asia. By the end of that century, for the West, Asia was no longer a depository of ancient riches – philosophies, sciences or religions that had crucially shaped European civilization, including its two core constituents: Christianity and science. Nor did Asia remain solely a depository of the exotic and the esoteric – rare spices, perfumes, silks and particularly potent mystics and shamans. It was now redefined as another arena where the fates of the competing nation-states of Europe were going to be decided. The two centuries of Europe's world domination had begun.

It is at the fag end of that phase of domination that we stand today, ready to pick up the fragments of our lives and cultures that survive European hegemony

and intrusion. For while some Asians have become rich and others powerful during the phase, none has emerged from the experience culturally unscathed (Chinweizu, 1980).

No culture ever responded to Europe's colonial encroachment passively, though many Asian nationalists of earlier generations felt that that was exactly what their cultures had done.[1] They felt ashamed about that imagined record of passivity and sought to correct that historical failure.[2] While that sentiment survives among Asia's ruling elite and young Asians charged with nationalist fervour, it is now pretty obvious that Asian civilizations, whatever else they did, certainly were not idle spectators of their own humiliation and subjugation. They coped with the West in diverse ways – sometimes aggressively resisting its intrusiveness, sometimes neutralizing it by giving it local meanings, sometimes even incorporating the West as an insulated module within their traditional cultural selves (Nandy, 1983). Even when they seemed to collaborate, that collaboration had a strong strategic component.

However, all Asian cultures have gradually found out during the last two hundred years that – whatever might have been the limits of cultural tolerance in European Christendom or the traditional West – the modern West finds it particularly difficult to co-exist with other cultures. It may have a well-developed language of co-existence and tolerance and well-honed tools for conversing with other civilizations. It may even have the cognitive riches to study, understand or decode the non-West. But, culturally, it has an exceedingly poor capacity to live with strangers. It has to try to either overwhelm or proselytize them. Is this a gift of the urban–industrial vision and global capitalism which, unsatiated even after winning over every major country in the world, have to penetrate the smallest of villages and the most intimate areas of personal lives? Is it a contribution of the ideologues of development, who after all their grand successes, feel defeated if some remote community does not fall in line or some stray critics or scattered activists attack them? There are no easy answers, but I do not find that even most of the Western scholars and activists who have identified with the colonized societies and fought for their cause, sometimes at immense personal cost, have usually supported the 'right' causes without any empathy with native categories, language or theories of dissent, without even a semblance of respect for the indigenous modes of resistance, particularly if such modes also claim a philosophical status that does not derive from the known world of knowledge. It will not be uncharitable to say that these well-meaning dissenters, too, have struggled to retain the capital of dissent in the West and to remain the spokespersons of the oppressed of the world – whether the oppressed be the proverbial proletariat or the not-so-proverbial women, working children or victims of environmental depredations. Even decolonization demands Western texts and Western academic leadership, they believe. And many Asians, especially the expatriate Asians in the first world, enthusiastically agree.

When the West was partly internalized during the colonial period, its cultural

stratarchy and arrogance, too, was internalized by important sections of the colonised societies and by societies not colonized but, like Korea, Japan and Thailand, living with deep, though often unacknowledged, fears of being colonized. Like Africa and South America, Asia too learnt to live with this internalized West – the feared intimate enemy, simultaneously a target of love and hate – as I have elsewhere described it. Psychoanalysis should be happy to identify the process as a copybook instance of the ego defence called 'identification with the aggressor'. Today, this adored enemy is a silent spectator in even our most private moments and the uninvited guest at our most culturally typical events and behavior. For even our religions and festivities, our birth, marriage and death rituals, our food and clothing, gods and goddesses, our concepts of traditional learning and wisdom have been deeply affected by the modern West. Even return to traditions in Asia often means a return to traditions as they have been redefined under Western hegemony. Even our pasts do not belong to us entirely.

This is not an unmitigated disaster. It is possible to argue that Asia, Africa, and South America are the only cultural regions that are truly multi-civilizational today. Because in these parts of the world, living simultaneously in two cultures – the modern Western and the vernacular – is no longer a matter of cognitive choice, but a matter of day-to-day survival for the humble, the unexposed and the ill-educated. Compared to that multicultural sensitivity, the fashionable contemporary ideologies of multiculturalism and postcoloniality often look shallow and provincial.

One of the most damaging legacies of colonialism, however, lies in a domain that attracts little attention. The West's centrality in any cultural dialogue in our times has been ensured by its dominance over the language in which dialogue among the non-Western cultures takes place. Even when we talk to our neighbors, it is mediated by Western assumptions and Western frameworks. We have learnt to talk to even our closest neighbors through the West, and we are afraid that when we discuss the possibilities of a culturally autonomous dialogue outside the West, that discussion is not unencumbered by a series of friendly neighborhood demons. These demons look like attenuated, domesticated versions of the West, but are actually parts of our exiled selves waiting to take over and guide us into a trajectory of closed or monolithic futures presided over by alien gods.

These inner demons have subverted most forms of attempted dialogue among the non-Western cultures. All such dialogues today are mediated by the West as an unrecognized third participant. For each culture in Asia today, while trying to talk to another Asia culture, uses as its reference point not merely the West outside, but also its own version of an ahistorical, internalized West, which may not have anything to do with the empirical or the geographical West. One can no longer converse with one's neighbor without conversing with its alienated self, its internalized West, and without the sanction of this internalized West.

Is another model of cultural exchange – I almost said multiculturalism –

possible? I neither can hope to give a complete answer to this question nor fully defend any tentative answer that I give. But, as a part-answer, I shall offer you a few propositions, hoping that at least some of them you will find sensible.

First, all dialogues of civilizations and cultures today constitute a new politics of knowledge and of cultures. For, whether we recognize it or not, there is a major, powerful, ongoing, official dialogue of cultures in the world. The format of that dialogue has been standardized, incorporated within the dominant global structure of awareness, and institutionalized through powerful international organizations. It can be even seen as a format that has been refined and enshrined as part of commonsense in the global mass culture. In this dialogue, the key player naturally is the modern West, but it also has a series of translators in the form of persons and institutions whose main job is to either interpret the modern West for the benefit of other cultures or interpret other cultures for the benefit of the modern West, both under the auspices of the West. The dominant dialogue is woven around these twin sets of translations.

Consequently, all proposals for alternative formats of dialogue are both a defiance of the dominant mode of dialogue and an attempt to question its hegemony, legitimacy or principles of organization. Even a symposium or scholarly volume on the possibilities of such a dialogue can be read as a form of dissent and as an intervention in the politics of dialogue.

Second, the presently dominant mode of dialogue is hierarchical, unequal and oppressive, because it disowns or negates the configurative principles of the self-definitions of all cultures except the modern West. It is designed mainly to specially protect the popularized versions of Western self-definition in global mass culture. The mode ensures that, in the global citadels of knowledge, only those parts of self or other cultures are considered valuable or noteworthy which conform to the ideals of Western modernity and the values of the European Enlightenment. (As if the Enlightenment in seventeenth-century Europe said the last word on all problems of humanity for all time to come and subsequent generations had been left with only the right to work out local editions of the Enlightenment vision!) The other parts of non-Western selves are seen as disposable, disfunctional encumbrances. The European Enlightenment's concept of history has been complicit with this process (Nandy, 1995: 44–66). That history has as its goal nothing less than the decomposition of all uncomfortable pasts either into sanitized texts meant for academic historians and archeologists or into a set of tamed trivia or ethnic *chic* meant for fastidious tourists. It is not unlikely that in countries like China, Japan and India, the coming generations will know their pasts only as a set of processes or stages of history that have led to the modernization of their societies. The rest of their pasts will look like scholastic esoterica meant for the practitioners of disciplines such as anthropology, history of religions, fine arts or literature. The process is analogous to the way the pharmaceutical industry systematically scans the ingredients of traditional healing systems for the natural agents they use, so that their active principles can be extracted and disembedded from their earlier context

and incorporated into commercially rewarding elements of the modern knowledge system.

The argument is that, however apparently open and non-hierarchical the existing, official mode of dialogue, its very organization ensures that, within its format, all other cultures are set up to lose. They cannot – and dare not – bring to the dialogue their entire selves. They have to hide parts of themselves not only from others but also from their own Westernized or modernized selves. These clandestine or repressed part-selves have increasingly become recessive and many cultures are now defined not by the voices or lifestyles of a majority of those living in the cultures but by the authoritative voices of the anthropologists, cultural historians and other area specialists speaking about these cultures in global fora[3]. These hidden or disowned selves can now usually re-enter the public domain only in pathological forms – as ultra-nationalism, fundamentalism and defensive ethnic chauvinism. They have become the nucleus of a new kind of paradigmatic contradiction in our public life – between democratic participation and democratic values. Democratic participation is valued but not the conventions, world-images and philosophies of life the participants bring into public life.

Third, the dominant official mode of dialogue also excludes the disowned or repressed West. Over the last four hundred years, in their mad rush for total modernization and total development, some of the developed societies have lost track of important parts of their own pre-modern or non-modern traditions, at least as far as public affairs are concerned. These lost traditions are now often seen as cultural liabilities that provide a handle to romantic visionaries from the environmental and the peace movements in the North and the South. Attempts to re-empower such traditions have had a short shelf life in this century. Mainstream Europe and North America would rather define themselves as monocultures of hyper-consumption and mega-technology, which have nothing to learn from the rest of the world, than as culturally plural or splintered entities nurturing contesting visions of the future.

Fortunately, the disowned West, however small, is not dead, perhaps not even powerless. It senses the damage the West's cultural dominance is doing to the West itself. It senses that the dominance, apart from the devastation it has brought to other parts of the world, has increasingly reduced the Western imperium to a provincial, culturally impoverished existence. Europe and North America have increasingly lost their cosmopolitanism, paradoxically because of a concept of cosmopolitanism that considers Western culture to be definitionally universal and therefore automatically cosmopolitan. Believe it or not, there *is* a cost of dominance, and that cost can sometimes be heavy.

Any alternative form of dialogue between cultures cannot but attempt to rediscover the subjugated West and make it an ally. The attempt to do so could be an important marker of the new cosmopolitanism that would use as its base the experience of suffering in Asia, Africa and South America during the last two hundred years. These parts of the world can claim today that they have

learnt to live with two sets of truly internalized cultural codes – their own and, for the sake of sheer survival, that of the West. From colonialism and large-scale deculturation they may have learnt something about what is authentic dissent even in the West and what is merely a well-intentioned but narcissistic effort to ensure that the worldview of the modern West does not collapse. The first identifier of a post-colonial consciousness cannot but be an attempt to develop a language of dissent which would not make sense – and will not try to make any sense – in the capitals of the global knowledge industry. Such a language cannot be fitted in the available molds of dissent as an Asian, African or South American subsidiary of a grand, multinational venture in radical dissent.

A dialogue of civilizations in the coming century will demand adherence to at least four cardinal methodological principles. First, it will demand for the participating cultures equal rights to interpretation. If elaborate hermeneutic strategies are brought to bear upon the writings of Thomas Jefferson on democracy and Karl Marx on equality – to suggest that Jefferson's ownership of slaves did not really contaminate his commitment to human freedom or that Marx's blatantly Eurocentric, often racist interpretations of Africa and Asia were all meant for the benefit of the oppressed of the world – the least one can do is to grant some consideration to Afro-Asian thinkers and social activists who were as much shaped by the loves and hates of their times. We do not have to gulp down their prejudices and stereotypes, but we can certainly show them the consideration we show to Plato when we discuss his thought independently of his comments on the beauties of homosexuality.

Second, the new dialogue we envision will insist that we jettison the nineteenth-century evangelist legacy of comparative studies which offsets the practices of one civilization against the philosophical or normative concerns of another. Colonial literature is full of comparisons between the obscenities of the caste system *in practice* in South Asia and the superior humanistic values of Europe articulated in the Biblical texts or, for that matter, even in the rules of cricket. In reaction, many defensive Indians compared the moral universe of the *Vedas* and the *Upanishads* with the violence, greed and ruthless statecraft practiced by the Europeans in the Southern world, to establish the moral bankruptcy of the West. The time has come to take a less reactive position, one that will allow us to enrich ourselves through a cultural conversation of equals. Cultures, we know, do not usually learn from each other directly; they own up to new insights as only a reprioritization of their own selves, revaluation of some cultural elements and devaluation of others. Every such conversation is also an invitation to self-confrontation. It allows us to arrive at new insights into social pathologies to which we have become culturally inured.

Thus, an authentic conversation of cultures presumes that the participants have inner resources to own up the pathologies of their cultures and the willingness to bear witness to direct experiences of victimhood, whether it be located within one's own culture or without. Such a frame of dialogue cannot but reject any explanation of such pathologies as the handiwork of marginal

persons and groups misusing their own cultures. A dialogue is no guarantee against future aberrations, but it at least ensures self-reflexivity and self-criticism. It keeps open the possibility of resistance. This is particularly important in our times, when entire communities, states or cultures have sometimes gone rabid. If Europe has produced Nazism and Stalinism in our times, Asia has also produced much militarism and blood-thirsty sadism in the name of revolution, nationalism, and now, development. Not long ago, Cambodia lost one-third of its people, killed by their own leaders, who believed that only thus could they ensure prosperity, freedom, and justice to the remaining two-thirds. The birth of India and Pakinstan was accompanied by the murder of a million people and the displacement of another sixteen million. Such traumas remain to be confronted and, if I may borrow a term from clinical psychology, worked through.

Finally, a conversation of cultures subverts itself when its goal becomes a culturally integrated world, not a pluricultural universe where each culture can hope to live in dignity with its own distinctiveness. The nineteenth-century dream of one world and global governance has made this century the most violent in human experience and the coming century is likely to be very skeptical towards all ideas of cultural co-existence and tolerance that seek to cope with mutual hostilities and intolerance by further homogenizing an increasingly uniform world and within the format of nineteenth-century theories of progress or social evolutionism.

The idea of Asia carries an ambivalent load in our times. It was for two centuries converted artificially into a backyard of Europe, where the fate of the world's first super-powers were determined. It is for our generation to negotiate the responsibility of redefining Asia where some of the greatest cultural experiments of the coming century may take place. For by chance or by default, Asia now has a place even for the West. Asia once held in trusteeship even Hellenic philosophy and for a few hundred years European scholars went to the Arab world to study Plato and Aristotle. We might even be holding as part of a cultural gene bank aspects of traditional Western concepts of nature (as in St Francis of Assissi or William Blake) and social relationships (as in Ralph Emerson and Henry Thoreau) to which the West itself might some day have to return through Asia.

Notes

1 On the technology of resistance to such hegemony, see for instance Scott, J. (1989) *Weapons of the Weak*, New Haven,Conn: Yale University Press; also Erikson, E. H. (1969) *Gandhi's Truth: On the Origins of Militant Nonviolence*, New York: Norton.

2 Many of the ultra-nationalist movements in contemporary Asia derive their strength from that reading of history. The Hindu nationalist movement in India is a reasonably neat example.

3 Clandestine or secret selves are different from repressed selves. The former are accessible to the person but hidden from public life or from segments of public life to which the person himself or herself owes allegiance. See for example Nandy, A. (1995) 'The savage Freud: The first non-Western psychoanalyst and politics of

secret selves in colonial India', *The Savage Freud and Other Essays in Possible and Retrievable Selves*, New Delhi: Oxford University Press, and Princeton, NJ: Princeton University Press. pp. 81–144; and 'The other within: The strange case of Radhabinod Pal's judgment on culpability', Ibid., pp. 53–80.

References

Chinweizu (1980) *The West and the Rest of Us*, London: NOK.

Nandy, A. (1983) *The Intimate Enemy: Loss and Recovery of Self Under Colonialism*, New Delhi: Oxford University Press.

—— (1995) 'History's Forgotten Doubles', *History and Theory*, Theme Issue 34: World Historians and Their Critics, pp. 44–66.

Part II

INSIDE/OUTSIDE
THE NATION/STATE

DESPOTIC EMPIRE/
NATION-STATE

Local responses to Chinese nationalism in an
age of global capitalism

Kenneth Dean

Introduction

From the people, to the people: this means: take the ideas of the people (scattered and unsystematic ideas) and concentrate them (through study turn them into concentrated and systematic ideas), then go the masses and propagate them until the masses embrace them as their own, hold fast to them and translate them into action, and test the correctness of these ideas in such action. Then once again concentrate ideas from the masses and once again go to the masses so that the ideas are persevered in and carried through. And so on, over and over again in an endless spiral, with the ideas becoming ever more correct, more vital and richer each time. Such is the Marxist theory of knowledge.

(Mao, 1965, Vol. 3: 119).

'Over and over again in an endless spiral.' These words seem to prefigure a trajectory in the making, the soaring, spiraling skyrocket of the Chairman's consciousness, lighting the way for the transformation of society. The Chairman's dream of a spiral of ever-expanding class consciousness, with him leading the way, led from the Yan'an caves to the land reform movement to the collectives to the Great Leap Forward to the communes to the Great Proletarian Peoples' Cultural Revolution to the Shanghai Commune. Each political campaign leading, in theory, to a more expansive class consciousness, allowing in turn for an expansion of the boundaries of communal life. As if to chart the expanding consciousness of the peasantry, the sizes of the ubiquitous Mao buttons began to grow from a tab the size of a coin to a badge that covered the breast. Mao Zedong's thought had taken root in the hearts and minds of the

peasantry and had begun to grow on every chest in China. It is not surprising that Deng is said to have refused to allow the widespread distribution of his image in the early years of his reign. No image could compete with the Chairman's.

There was another spiral developed at Yan'an, an inversionary rhetoric intended to strip down the individual, and rebuild them as a good communist. This achieved institutional form in the Rescue Campaign, the culmination of the Rectification Campaign. Kang Sheng, the Director of Public Security, put it this way:

> Why does the Communist Party make so much effort to rescue you? Simply because it wants you to be Chinese, and not to be cheated into serving the enemy. Those of you who have lost your way, be conscious, take a firm decision, repent to the party, and cast off the special agent's garb, cast off the uniform of the fifth column, put on Chinese clothes, and speak about the deception, the insults, and the injuries you have suffered, and confess to the crimes you have committed. The Communist Party welcomes those of you who have lost footing to become Chinese and oppose Japan and serve the country. . . . We were concerned about you, afraid you would commit suicide. . . . When a person confesses to the party we immediately remove the evidence about him, remove his name from the ranks of the special agents and we are happy that he has become conscious. The Communist Party has saved another person! Finally, I warn those who do not wish to confess, we have maintained a lenient policy, but leniency has a limit.
>
> (Kang Sheng 'Rescue Those Who Have Lost Their Footing',
> 15 July 1943, trans. Byron and Pack, 1992: 179)

In this confessional/salvationary mode, the self is completely absorbed into State desire; conciousness, clothing, Chineseness, even life itself are provided by the Party, emblem of the State, of course, in the figure of the dictatorship of the proletariat.

Images of China at the height of the Cultural Revolution center on Mao's image in ways that we have seen in similar movements in Russia. Since about 1979, another set of images of Mao began to circulate in Southern China. These too were talismanic images of the Chairman, or of Zhou Enlai, pasted to bus windows, or hanging from rear view mirrors in taxis in Xiamen and Guangzhou. Many drivers in this area kept images of local gods in their vehicles. It seemed that somehow Mao was becoming transformed into some kind of protector deity.

Twentieth-century popular culture in China is characterized first and foremost by political cultural forms instituted by the Chinese Communist Party. These forms go back to experiments by party leaders in the Jiangxi Soviet base areas and later in Yan'an, at the end of the Long March. These cultural forms

have been implemented by a hierarchical Leninist party organization, and involve a strong emphasis on ideological indoctrination in class analysis by means of mass political campaigns involving political study sessions featuring small guided groups, mandatory participation, and self-confession or labor reform in case of ideological error. Many aspects of the institutionalization of these cultural forms resemble those remarked on by students of nationalism and nation-building in the West. These include the spread of literacy, the establishment of a standardized modern education system, the official insistence on a national 'standard' language (the Mandarin dialect, putonghua), the rise of officially controlled print and electronic media, and the codification of a nationalist history of the rise to independence of the Chinese people. Other processes are particular to the influence of Mao Zedong, and the peculiarities of his vision of the relation between himself and the people. These include the emphasis on class struggle, and the need to wage continual class warfare even after the establishment of the party-led state. The party organization and the machinery of political study are still intact, after nearly fifty years of the People's Republic. But much has changed in the aftermath of the death of Mao, the economic reforms of Deng Xiaoping, and the collapse of legitimacy experienced by the CCP after the events of 4 June 1989.

If it is undeniable that political culture and ideological training are a pre-eminent part of popular culture during the forty-five years of the People's Republic, and if it is also true that global capitalism has now entered into the bloodstream of contemporary China, it is perhaps all the more remarkable that the last decade should have witnessed the revival of a vast array of traditional popular cultural forms, especially in South and Southeastern China, but elsewhere across China as well. We tend to focus on urban China when thinking about popular culture, neglecting the fact that three-quarters of China is still rural and primarily agricultural. The relaxing of mass political campaigns in the wake of economic reforms and party inertia has allowed for the restoration of tens of thousands, if not hundreds of thousands, of temples across South China. It has also ensured at least a partial transmission of the basic ritual traditions by the older generation, who last took part in them in the 1940s, to the post-revolution generation. This chapter will explore the significance of this communal activity.

Despotic empire/nation-state

There is a curious relationship of parallelism and antithesis between Sinological readers of late imperial China as a despotic cultural system and modern China watchers who see a modern, nationalistic nation-state, controlled by a rigid, totalitarian Leninist party unwilling or unable to allow unofficial modes of popular expression. The traditional view of traditional China pictured an empire based on cosmic correspondences, governing by means of a principle of homology, whereby every level of state and society merely repeated in more or

less exalted or debased form, a core set of rituals of dominance and sub-servience. This view of course leaves no room for creative response, resistance, or co-option on the part of lower levels of society.

The modern view of modern China is equally exaggerated. Somehow China transformed overnight, or by deceptively diverting honest nationalist feelings, into a totalitarian, modern nation-state. The government controlled official cul-ture, and the only 'unofficial culture' which existed was urban-based, dissident culture. The dissidents of course were champions of democracy, and harbingers of civil society, and all would have gone as in a familiar Polish fairy tale if it had not been for the vicious, ultimately futile tyranny of the old dinosaurs, who cling ferociously to power as paranoia settles over their dimming minds.

Neither side of the tradition/modernity polarity can account for the extra-ordinary impact of global capitalism on China over the last decade and a half. China has renounced its Maoist effort to go it alone, and has instead gone into debt to the tune of some 70 billion US dollars by 1992. GNP has risen rapidly, although in a regionally highly unbalanced way. These flows of capital have transformed China's relations with the world system. The new relations have been analyzed in political, economic, and cultural terms. A few critics have noted the loss of independence, the growth of dependency, the dangerous overheating of the economy, the spread of corruption, inflationary pressures, massive unemployment or underemployment, and the limitless and unsustain-able rise in expectations, not to mention the extraordinary spectacle of a socialist country turning a largely blind eye to potential and real abuses of the work force employed by foreign joint ventures. But most have gloated at the rationalizing effects the market will somehow magically bring to China. Nothing is impos-sible for market forces, which will somehow lead to respect for human rights, the rise of democracy, and China's integration into the G7, you name it.

Some observers have been less sanguine about the future of China. Recently these commentators have begun to question whether China will remain intact into the twenty-first century. Will China be able to withstand the pressures of internal dissent, factionalism, ethnic strife, differential regional rates of economic progress, inflationary pressures, soaring expectations, and ever-expanding for-eign investment and debt servicing. Some have argued that the southeastern part of China may eventually break away (Freidman, 1994).

These suggestions relate to an intense interest in looking at East and partic-ularly Southeast Asia from a more strategic perspective, which has led to much discussion of a Greater Chinese sphere of cooperation (Harding, 1994), with its unpleasant reminder of the Greater East Asian Co-Prosperity Sphere. This sphere, which includes China, Taiwan, and Hong Kong, and arguably extends to Chinese communities and individuals across Southeast Asia and the world, is already a major world economic force (Ash and Kueh, 1994). So far, most ana-lysts of Greater China have focused on the obvious complexities of the political interrelationships between the members of the Greater Chinese sphere, or on the rapidly growing economic ties between China, Taiwan, and Hong Kong.

Less attention has been given to cultural links, mainly because these are considered to be of a secondary importance. Where there has been discussion, it has focused on themes like Confucian capitalism and New Authoritarianism (Tu Weiming, Yu Ying-shih). This high cultural rhetoric is sometimes contrasted with a discussion of pop cultural links between Taiwan, Hong Kong and China, such as youth culture, cinema, pop music, karaoke and Walkmen (Gold, 1993; Chow, 1991). In these treatments, we find culture as commodity, or culture as cop-out, a form of autonomous, anonymous protest.

A basic problem with much of this literature relates to the underlying notion of culture, which is based on a Western, social scientific view of culture as a realm of culturally specific eternal truths underlying the values and motivating the actions of the social agents in a particular cultural system. Culture can then be treated at two levels, the first being the separate sphere of eternal truths, the second being the realm of everyday cultural symbols and artistic or religious production, a sphere epiphenomenal to political, economic, and social actions. The problem with this understanding of culture is that it assumes a Western, rationalistic 'common-sense' framework for the interpretation of political, economic, and social actions, allowing of course for certain effects of the culturally specific set of underlying truths. A more thorough-going sense of culture in the everyday would suggest that the parameters of what constitutes the political, the economic, the social, and the 'common-sensical' would all be saturated with cultural difference. In this view, the application of and resistance to forces in the political, economic, social, artistic, and religious realms would be the ground from which culture emerges (Farquhar and Hevia, 1993). If this is true, it would be necessary to build upwards through various levels of cultural engagement, the family, the lineage, the village, the region, the province, and the shared culture, to the level of the nation before one could get a sense of the meaning of something like nationalism in the Chinese context. At each of these levels, a different libidinal economy would be at play, a different regime of desire. One would also want to work back downwards through the levels of state institutions: the party, the schools, the army, the prisons, the hospitals, the tax system, etc., to examine the variety of responses and resistances to nationalizing projects.

Take the case of nationalism. In much of the literature, it is assumed that nationalism has become a key strategy for Chinese elites in the last hundred years, and so therefore it is possible to analyze their actions according to various Western models of nation-building, institutionalization, cultural iconoclasm, modernization, etc. This application of Western models of elite political struggle has made it difficult to see the central role of the contestation and reinvention of 'Chinese culture' by local cultural forces throughout the processes of the application and resistance to these nationalizing and modernizing efforts at many levels and in many parts of China. This Westernized discourse has also suggested as inevitable or teleological the development of the modern nation-state in China, and around the globe. Nationalism is reduced to a

technique in the arsenal of modernization and nation building. We need instead to consider the role of revolutionary nationalism in China as a key element in a cultural project, a project involving the formation of a particular form of state desire.

> It is true that the elements that combine to form a state are the products of a gradual evolution. However, the State itself is without lineage. It's a consistency, a way in which elements hold together and move in concert. All the elements may be present without taking on state consistency. . . . The taking on of state consistency is always an imposition on the elements inducted into the state. . . . When a state happens, it happens instantaneously: if the parts of a state form an organic unity no one part is logically prior to any other. The elements either consist as State desire, or they do not.
> (Dean and Massumi, 1992: 79, where this view is developed in more detail in relation to the formation of the First Chinese Empire)

Nationalism is a totalizing procedure that is absorbed into state desire, where it meshes with other channels of desire, from other lineages and discourses. The state is the level of consistency that combines discourses, abstract machines, and disciplinary institutions. Nationalist thought is no more autonomous in the Western world than it is in the non-European world (LaMarre, 1993).

> The state's power (and that's one of the reasons for its strength) is both an individualizing and totalizing form of power. Never, I think, in the history of human societies – even in the old Chinese society – has there been such a tricky combination in the same political structures of individualization techniques, and of totalizing procedures.
> (Foucault, 1982: 23)

> However, relations of power, and hence the analysis that must be made of them, necessarily extend beyond the limits of the State. . . . The State is superstructural in relation to a whole series of power networks that invest the body, sexuality, the family, kinship, technology, and so forth.
> (Foucault, 1980: 122)

I would like to explore the possibility in this chapter that we can discover a wide array of different abstract machines of desire at the communal level in different local cultures of China as they transformed over time. Some of these formations may reveal surprising qualities, resistant to certain aspects or effects of capitalism and to dimensions of state desire. The complex resources of the local forms relate, on the one hand, to the long negotiation with the Chinese state, which resulted in a variety of state intrusions into communal life, and creative reactions

to these intrusions. On the other hand, a variety of structures developed at the communal level to absorb, withstand, or reconfigure flows of capital, many of which prefigure the rise of the world capitalist system.

With this is mind, I would like to talk today about a different way of viewing local culture and community and a different dimension of the cultural interaction between Taiwan and Southeast China, particularly Fujian province, namely the sphere of popular religion, local culture, and regional ritual systems. I will first discuss general features of the historical development of local cultural systems in Southeast China. Then I will discuss how elements of these local cultures have been brought into play in this area in recent years. I will demonstrate the complex interplay of forces at work in this local response – local, Taiwanese, and Overseas Chinese support and appropriation, as well as government efforts to co-opt the expression of local cultural forms. In the conclusion, I return to the question of nationalism and suggest that it may be time to start thinking beyond the nation-state and more in terms of local cultural spheres of exchange.

Alternative communities

Recently, in the West, in the wake of the rise of vicious ethnic and nationalistic strife in Yugoslavia and elsewhere, a number of questions have been asked about underlying assumptions of modernization theory and the recidivism of nationalism (Zizek, 1990). The revival of nationalism in the West, in Quebec as well as at the fringes of the Soviet empire, also raises complex problems for those theorists of postmodernism and late capitalism who had announced the imminent end of the nation-state, the withering away of civil society, and the rise of all kinds of transnational flows of ethnic groups, information, capital, and communications (Harvey, 1989; Jameson, 1991; Appadurai, 1990). The relentless rise of the right-wing in American politics, particularly under the Reagan administration, and more recently with the Contract with America, reveals the continuing role of archaic processes in the US body-politic will very likely have extremely unfortunate consequences, involving the reassertion of nationalist themes (Dean and Massumi, 1992).

Certain observers have remarked on the fact that many theories of the end of the nation come out of a series of reflections upon the most developed sectors of the developed world, and may fail to comprehend the continuing importance of nationalistic or nationally-based socialist movements in other contexts. Thus there has been some recognition of the need, from a range of different perspectives, to continue to support independence movements in many parts of the world, and to understand the role of nationalism in these movements (Constantino, 1978; Ahmad, 1992; During, 1990). The nature of this support is marked by the ever-increasing hybridization of the center of the empire by the peoples of its periphery which has been widely remarked (Bhahba, 1994; Chow, 1991). At the very least, we will have to continue to respond to, and seek alternatives to, nationalist pressures well into the next century. One way to do

this, I would suggest, lies in the examination of the resources of local cultural formations.

The literature on nationalism has provoked a range of responses from post-colonial intellectuals (Ahmad, 1992; Chatterjee, 1986). They have questioned whether nationalism is a necessary framework for understanding either history or the nature of the nation state. Relatively few of these concerns have found their way into the discussion of Chinese nationalism. Partha Chatterjee's book, *The Nation and its Fragments: Colonial and Postcolonial Histories* (1993), provides a series of interesting perspectives on colonial and nationalist narratives of the nation. Chatterjee suggests that *community* may be the disruptive term under the seamless surface of the interlocked discourse of Reason and Capital, and further suggests that there is a great deal to be learned from the study of marginalized, subaltern communities, as well as the contradiction between community and nation in postcolonial states. He argues that, in the West, capitalist relations and capitalist forces have increasingly invested the public sphere, which was conceived as a bridge between civil society and the state. With the investment by capital of the public sphere, state and society become linked in the form of the nation. At this point, the only community imaginable is the nation, which extends its disciplinary mechanisms throughout society in an effort to extend cultural hegemony, homogenizing social forms, and preventing any independent development of alternative community. In his analysis of Gandhi's political movement, he suggests that nationalist thought in its anti-colonial mode moves through a communitarian rejection of the psuedo-community constructed by capital (Chatterjee, 1986). He argues that this is a necessary moment in nationalist logic, but that with the successful establishment of the independent nationalist nation-state, the drive towards development, whether socialist or capitalist, falls back into the narrative of the march of capital, which demands the homogenization of cultural forms, and their subsumption under the aegis of a nation-state.

Anthropologists such as Marilyn Strathern (1992) have examined ways in which alternative modes of exchange build up alternative modes of community and personhood. The narrative of the endless expansion of capital would appear to threaten to subsume all such alternative forms. Nationalism then appears as a particular moment in this all-consuming trajectory. The power of the local community to disrupt the nation and its narration/s was, however, already suggested by Maurice Godelier in his cautious effort to revive a refurbished version of the Asiatic Mode of Production and to raise questions about historical necessity in a Marxist context (1978). Godelier was raising the possibility of a series of alternative rearrangements of the developmental phases of orthodox Marxist teleology. Perhaps the analysis of multiplicity in community will enable us to think beyond determinate developmental schemes, and find resources to respond to the rush of capital into the postmodern. Before exploring these issues, let us review some recent literature on Chinese nationalism.

Theories of Chinese nationalism

Lucian Pye, representative of a conservative Western political science approach, entitled a 1993 essay 'Nationalism Shanghai'ed'. Here we recall the well-known accusation by Chalmers Johnson that the CCP manipulated peasant nationalism into support for their cause. This argument has been problematized in Duara's (1988) study of the collapse of the local cultural nexus of power in Shandong in the Republican period which he suggests was a result, not of Japanese incursions, but of the encroachment of organs of the modern nation-state (temples converted into schools and police stations). Duara provides a vision of a cultural apocalypse waiting for something to provide an answer. The answer, he implies, would have to provide a cultural solution, not a purely political one.

Tracing the problem further back, Townsend (1992) remarks that the Sinologist narrative of Chinese history as a transition from 'culturalism' to 'nationalism' fails to take account of the existence of forms of pre-modern nationalism in earlier periods of Chinese history, the survival of forms of culturalism in modern nationalism, and the complexity of imperial understandings of ethnicity and state nationalism. Townsend concludes by sketching the impact of nationalist discourse on four different overlapping 'Chinese nations'; the ethnic Han Chinese nation, the multi-ethnic Chinese nation-state; the pan-Asian Chinese cultural unity; and the world-wide Chinese community, which is sometimes considered to share Chinese nationality. He notes the tensions that underlie these often mutually incompatible visions of the Chinese nation at different levels.

Duara (1993) notes the important role of ethnic nationalism, or anti-Manchu racism, in the founding of the Republic of China. He agrees with Townsend that the culturalism/nationalism paradigm is inadequate. He argues that a wide range of shifting boundaries can be found in different levels of Chinese society around the question of nationalism, and that these involve competing, contested narratives of the origin and direction of the nation, the role of race, and the nature of the collectivity.

Allan Chun (1994) traces the institutionalization of cultural hegemony in Taiwan under the Guomindang (Nationalists) over three different phases. These policy phases were partly developed in response to cultural movements underway in China, and partly as part of a process of consolidating rule and building a nation on Taiwan. Chun argues the dominant role of the state in dictating the limits of cultural development. His study has the advantage of refocusing the question back to cultural concerns in an age of global capitalism, such as the selective invention of 'tradition', and the institutionalization of this vision into everyday life, and the totalizing and individualizing powers of the state, as seen in cultural hegemonic practices carried out by the Guomingdang.

A recent study by David Apter and Tony Saich (1994) has attempted to trace the cultural dimensions of the moment at which the Chinese Communist Party developed its model of social transformation, the Yan'an Way. They describe the

formation of a political discourse community bound together by symbolic capital. Mao, who they picture as a cosmocratic bricoleur, culls myths and stories into a mythologic featuring himself as the salvationary figure. He creates in this way a utopican republic, instructional and military, which becomes a simulacrum of revolutionary moral perfection. In this sacred space or stage, Mao creates an inversionary discourse taught through a process of exegetical bonding, whereby concept becomes precept. They picture Yan'an as involving a logocentric model of collective individualism, rather than the methodological individualism of most econocentric political scientific models. A logocentric model involves 'projections made on the basis of some doctrinal definition of necessity that specifies its own rules and theoretical principles and for which it provides its own logic'. Yan'an embodies 'a radical, disjunctive, and transformational nationalism . . . (that is) redemptive in origin, (and which) create republics of truth, real or imagined'. The logocentric model 'offers alternative truths on which to act and promises to those who accept such truths that acting on them will transform one's own conditions by altering the conditions of society at large'. Yan'an emerges as a charmed circle that Mao would seek to universalize after winning control of China. But 'Mao's was a theory of peasant revolution based on symbolic capital. But after the revolution succeeds, and after the peasantry provides the economic capital for the party-state, the peasantry must wither away, because it has no potential of universalizing itself in a highly developed modern nation'. In Yan'an, Mao spins stories of China's humiliation (the Opium War, the Long March, and the party struggles for leadership) that shrewdly force him into the center of history. The stories become a mythologic, events justify the theory. 'Mao begins as a bricoleur: his logic begins with a series of mythic narratives that create a space for the logic. . . . although Mao begins as a mythmaker, he enters into his own narrative to emerge as the personification of logic.' But with the taking of power, the interior mythologics becomes reified into a legitimizing myth. At this point, '(t)he system transcends the conditions of its own possibility' (Apter and Saich, 1994).

One of the proudest proponents of the Yan'an Way, Mark Selden, revisited the topic (1995), and drew some darker conclusions from the Rectification campaigns. In the same issue of *Modern China*, Philip Huang analyzes the use of class struggle in the land reform movement (resulting in a redistribution of 43 per cent of the nation's cultivated land) in three stages between 1937 and 1952 during the Sino-Japanese War. His emphasis is on the transformation of class struggle from an interpretive technique to a master narrative and narrator of Chinese cultural change. 'The political decision of the Party to make land reform a moral drama of class struggle for every village and every peasant was to turn into a powerful imperative to manufacture class enemies even where none objectively existed according to the Party's own criteria.' Huang traces the transformation of official ideology into hegemonic discourse. 'But that hegemonic culture of class struggle was built on the widening gap between representational and objective reality.' Huang then explores Mao's expansion of

class struggle, equating capitalist roaders with class enemies in the Cultural Revolution, which led to a 'nebulous politics of representation combined with violent methods of the Land Reform movement. . . . It was in the Cultural Revolution that the disjunctions between representational and objective reality grew so wide and so glaring as to bring the collapse of the entire discourse of class struggle' (Huang, 1995).

It is hard to know at this point what kind of master narrative will emerge, after the death of Deng, and the inevitable reassessment of 4 June 1989. The cultural fever of the late 1980s Chinese intellectual scene, despite its flirting with futurism and phenomenological philosophy of history, remained largely locked into a despairing cultural iconoclasm reminiscent of May 4th intellectuals – I am thinking of works like the *River Elegy*. Discussions of New Authoritarianism or New Conservatism sound increasingly self-serving and inadequate to the situation. Some efforts in film in this period proved more interesting, because they focused more ironically on moments in the master narrative itself, like Chen Kaige's *Yellow Earth*, with its de-mythologizing of the Yan'an experience. In fact, the work of artists, writers, and film-makers who were amongst the sent-down youth during the Cultural Revolution, and who have attempted to grapple with the 'roots of Chinese culture' and the representation of women and the peasantry in contemporary China, demonstrates a particular potential. Many of these writers find themselves drawn to speak globally for the subaltern, but some have realized the power of the fragment in the politics of cultural representation. The power of the fragment, noted by Benjamin, is particularly evident in the works of Lu Xun, who, after all, never wrote a full length novel.

Frederic Jameson's desire (1986) to read Lu Xun's works, and those of any and all other Third World writers, as national allegory, has been severely criticized by Aijaz Ahmad (1992). In fact, Naoki Sakai singled out the *refusal to represent the nation* as a salient quality in the work of Lu Xun (Sakai, 1990). Xiao Hong similarly rejected the writing of women into the nationalist narrative (Liu 1993). Rey Chow has pointed out alternative readings invited by the works of Xiao Hong, Ding Ling, and other women writers of the 1920s and 1930s that transgress against the modernist representation of women as masochistic icon or sacrificial victim (Chow, 1991). Ding Ling was of course one of the victims of the Rectification Campaign in Yan'an. And who could forget Mao's remarks in the *Talks at the Yan'an Forum on Literature and Art* (Mao, 1965: Vol. 3) that 'the ironic mode is no longer necessary' for the socialist period. Of course, the greatest irony was the establishment of museums all over China to 'the great culture hero' Lu Xun. His grave countenance stares at visitors with a tortured look in great empty museums that resemble nothing so much as the iron house of his famous anecdote:

> Imagine an iron house having not a single window and virtually indestructible, in which there are many people soundly asleep who are about to die of suffocation. Yet from slumber to demise – it does not

cause them to feel the sorrow of impending death. Now if you raise a shout to wake up a few of the relatively light sleepers, making these unfortunate few suffer the agony of irrevocable death, do you really think you are doing them a good turn?

(Lu Xun, Preface to *A Call to Arms*)

One feature that the writings of Lu Xun and Xiao Hong share in common is the intensely difficult relationship with their home village, or local culture. But the quality I admire most in their work is the strength with which they confront this difficulty, never claiming to speak for the peasantry, aware of their alienation, but fascinated and horrified by their complicity in the gap in representation and communication. Mao Zedong would not be so hesitant.

Mao's *Report from Xunwu*, which only recently became available, was written in 1930. He spent ten days with a team of eleven researchers analyzing a Hakka region in Southeast Jiangxi. Amongst the many significant findings was the discovery that 80 per cent of land-holdings were under the control of 'temple associations, or other co-operative associations'. Given the time constraints, and the political pressures of the moment, the *Report on Xindun* is a remarkable piece of work. But it is one thing to do the fieldwork yourself, to get down in the villages. It is quite another to codify the method, and send urban intellectuals down to 'propagate them until the masses hold them as their own'. This technique would quickly degenerate into the creation of quotas, falsified reports, and the imposition of cultural hegemony/homogeneity on the diverse cultural forms encountered throughout China during the various mass political campaigns initiated over the next fifty years (Huang, 1995).

Local cultures

Let us move now to the products of a different arena, filled with different apparatuses for the construction of consciousness, and the inscription of bodies. There can be no question but that China developed an immensely intricate and hierarchical social order, with a plethora of ritual forms and discrete ritual traditions and local cultures. For different periods in Chinese history, in different regions, it would be useful to map out changing cultural arenas and apparatuses of power. These arenas and apparatuses are developed for the induction of bodies into identities that accept certain parameters of repeatedly performed identification – the family, the lineage, the village, the culturally defined region, the economically-oriented market region, the political administration. Many of these levels will be established through rituals. Certain rituals mark and perform entry into specific groups over the life cycle. Others, like exorcisms of the possessed, re-inscribe identity within the accepted terms of the culture. Many celebrate the presumed divine sanction of these naturalized relations.

As a general illustration of some of the processes discussed above, one might look at the example of a Chinese festival centering around a ritual for the

birthdate of a local god. Imagine a small child witnessing the range of physical and emotional expression taking place. Inside the temple, and outside on stage at crucial moments in the liturgy, Taoist priests perform the stylized gestures of imperial court audiences, complete with intricate dance, the manipulation of court tablets, kowtows, presentations of memorials, offerings of tea, etc. Outside the temple, the mediums present a range of what defines extreme behavior, including grimaces, mudras, trance dance, hyperventilation, screams and cries, transformation into animal modes, body mutilation, etc. On stage, the entire range of stock character types, human situations and moral dilemmas, and stylized embodiments of emotional states are represented. Before the altars, villagers kneel and burn incense, present offerings, and pray fervently. Village headsmen perform dignified movements of kneeling and offering inside and outside the temple. Performing arts troupes highlight gender roles with cross-dressing and lewd songs and dances. A tremendous variety of food offerings, incense and smells of all kinds, smoke, color and sound flow through the charged space of the ritual. Like physical forces, these flows impact upon the bodies of the participants, transforming them and forcing a reactive response. A tremendous range of culturally specific bodily gestures and embodied registers of intensity is presented for emulation and improvisation. The child may grow up to be a medium, or a village representative, an actor or actress, or a villager burning incense in the ritually prescribed fashion. The child gradually develops an understanding of or an ability to perform this repertoire of physical gestures and trajectories of intensity. Such a process could be viewed metaphorically as the irrigation of the ritual body, creating channels of intensity and trajectories of gesture, voice, and rhythm. Although tending to solidify into fixed forms, opportunities abound for the mixing of flows, the transformation from intensity to intensity, or the pursuit of lines of flight from cultural processes of iteration and citation (see Butler, 1990, 1993; for analyses of flows of force in ritual see Gil, 1985).

The particular coalescence of flows (consistency) that takes place in a given ritual is unique. Thus new ritual forms could present an entirely different set of relations with the surrounding context. Indeed such historical changes theoretically could be quite complete. Similarly, rather than insisting upon any essential nature of the individual, or the *a priori* status of any particular process of the formation of individual identity, the variety and continuous transformation of local cultures suggests a more complex, agonistic drive towards individuation. By individuation, I refer both to processes of the coalescence of cultural practices as well as to processes of individual identification with some of these practices (see Deleuze and Guattari, 1988; and Simendon, 1992). The underlying assumption is that the material force of desire within any particular body exceeds the capacity of any particular assemblage of cultural codes and spheres of subjectivity, which means that every such assemblage is open to change, or is riddled with lines of flight.

Each phase of local cultural change involves a different set of relationships

between the key elements of the local culture; between the central or local government and the locality, between the Buddhist monastic estates, the lineages, and the popular cults, between the local communities, between the rival or parallel ritual traditions, between the gentry, the government, and the commoners, between the inside and the outside, between the forces circulating through the regions, some captured, some translated, some intensified and others diverted. Each phase was marked by a new set of central ritual forms. This process involved the development of apparatuses of individuation such as the various rituals, arenas, and levels of ritual interaction. They also engender a discursive practice in the textual production of local gentry, forever reinterpreting classical practice in light of local variations. Taoist priests, marionettists, playwrights, stone carvers, artists, actors, cooks, and mediums also actively participate in the elaboration of local culture.

In contemporary Southeast China, local culture is increasingly affected by powerful flows unleashed by the implosion of the state, the resurgence of 'tradition', and the deterritorializing impact of multinational capitalism. The agricultural infrastructure of the irrigation systems, buttressed during the 1950s and 1960s, is now under attack. Deforestation, industrial pollution, an explosion in construction, and a breakdown of command structures, all are putting impossible demands on the ecology of the area. Yet simultaneously, village level, and increasingly, regional ritual systems are being restored. According to a survey I have started of several hundred villages in the irrigated Putian plains in Fujian province, the average village has six temples, each housing on average fifteen deities. Something like forty-five days of ritual performances take place on an average in each village every year. Some villages hold over 250 days of theater and ritual a year. Children in rural Putian have now reached adolescence in a world marked increasingly by temple festivals and ritual performance of cultural difference. Of course, these same years have seen the rapid expansion of multinational capitalism into Southeast China. It is still too early to discern the boundaries, or the significance, of the collision of flows at work in this period. We can only begin to map the process of the melting of some powerful institutions, the sedimentation of attitudes and identities induced through repeated rituals, and the lines of tension in play in the contesting of the value and legality of these ritual forms.

Ritual form may be the leading element in the channeling of affect (intensity and sensation) in the elaboration of local culture. These minglings of bodies with physical and supernatural forces proceed by phases. These phases are not linked dialectically, but through a process of self-organization. Self-organization leads to the channeling of flows, which over time lead to sedimentation in more or less supple structures, in some cases leading to rigidification in long-lasting institutions (political hierarchies, power-monopolizing lineages). Yet even rigid structures slowly flow, can mutate, or become re-incorporated into new self-organizing processes (DeLanda, 1992). Each phase of local cultural transformation involves different mechanisms of indivuation which work to shape

particular bodies and subjectivities. This suggests that individual subjectivities are constructed in relation and in reaction to the forces moving through the environmental and socio-cultural fields. These forces are gathered into particularly intense relations in the course of those rituals that dominate specific phases. Analysis of the channeling of affect in ritual can therefore assist in mapping the processes and phases of local cultural self-definition. The transitions from one phase to another are moments of significant system-wide hesitation before dangerous bifurcations. They are not teleologically determined, dialectically impelled, or logically necessary. Lines of flight appear all the time, and bifurcations lead to distinctly different formations.

This vision of shifting phases and apparatuses of local cultural development within China suggests a break with the traditional, static, homological model of the role of ritual in Chinese culture. In that model, imperial ritual is the model of modeling, the principle of homology descends from the court to the fief to the family. Kinship ritual is presumed to be modeled on imperial court ritual. The government is presumed to work through institutional homologies via the ritual sacrifices at the alters of soil and grain of each district, the City God temples, and the shrines to officially recognized and canonized local deities. However, I have suggested above that many other features of environment and evolving local cultural power relations determined the ways in which this system of homology would be incorporated and co-opted by local culture. This is more than saying that every homology of the center at the peripheries runs the risk of achieving too great a local independence and striving for a life beyond the limits of a copy. Rather, this view challenges the scope of the homological imperial model (and its easy acceptance in a West determined to demonstrate the passivity and abjectness of Chinese culture). To challenge such a fundamental principle of both the Chinese discourse of Li and the common Western model of Chinese ritual is to raise the possibility of a multivocal understanding of 'Chinese culture' from below. Rather than seeing all local cultures at all times rising to a common level of unity in a vision of inevitable centrality of the cosmic role of the Chinese Emperor, perhaps we can imagine a vast variety of locally rooted and constantly changing conceptions of cosmos and individuality, rising out of local and immediate contests of power and metamorphoses of bodies. This does not mean that the cosmos looks different according to where you are situated in it, as in functionalist readings of Chinese religion, but rather that the cosmos itself is constructed and subject to change, along with the individual, and that the changing set of perspectives on a changing cosmos can never be encompassed in a single system.

When we look at the local cultures of Southeast China over time, we are struck by the differences and the similarities with something like the *negara* of Bali, described so poetically by Clifford Geertz (1980). Geertz describes a theater state, where the performance of rituals of competitive prestige constructs and circulates political power. He contrasts this form of political organization with the patrimonial state, the manorial state, or the despotic state of the Asiatic

mode of production. The latter inevitably recalls images of the hydraulic empire of Karl Wittfogel (1957), and the model of imperial control at the rural level sketched out by his student, Xiao Gongquan (Hsiao, 1960). Several authors have demonstrated the important and long-term role of the State in major irrigation projects in the Yellow River, Yangtze River, and Tongting Lake regions. In the area we have discussed today, we see a wide range of levels of government involvement and forms of local control, all manifesting in varied modes of ritual construction of local power relations. Here there is no simple answer to the politics of the irrigation system, where local communities are neither as smooth a category of sluice-gates in the flow of ritually constructed power as in Geertz's model of Bali, nor as rigid and isolated as the terror-stricken villages of Wittfogel's model, quaking in the shadow of the despot. Instead, the communities themselves transformed over time in relation to each other, to the irrigation system as a whole, and to the State and its representatives.

If rituals are, as Lévi-Strauss said, primarily machines for the suppression of time (see Gil, 1985), and, one might add, apparatuses for the establishment of the boundaries of identity, then we can see many examples of these processes in the local level rituals I have briefly mentioned above. Imperial ritual asserts the cyclic nature of time, and the role of the Emperor in moving time forward into another repetition. Taoist ritual works with a deconstruction of time, reversing the flow of time into a world prior to time, while at the same time, performing a revelation and destruction of cosmic texts which completes an immense cycle of time. All these processes suppress the irreversibility of time by reducing time in different ways to spatial forms. In their respective contexts – the imperial court, the altar of heaven, the City God temples, the temples of local deities, lineage halls, and individual homes, they drew individuals into the preparation and performance of rituals in ways that marked and empowered their identities. Yet the changing ritual orders of the local cultures of China, and their complex shifting institutional arenas, suggest that any one individual would be simultaneously transfixed by several overlapping vectors of change. Time moves at different speeds, sweeping individuals and partial understandings along at varied trajectories.

General characteristics of local cultural production

It would be possible, in the context of this discussion of the local cultures of Fujian, with its festivals of the gods of the different local pantheons, complete with ritual dramas and dramatic rituals, to trace a circuit from rituals designed to address individual life crises to rituals that involve families, neighborhoods, entire villages, entire irrigation systems, entire geographic or linguistic formations. These rituals are based on an underlying Taoist liturgical framework, but are adapted to local customs and local needs and local realities. The Taoist priests, spirit mediums, Buddhist monks, Three in One Masters, Confucian Lishi (masters of ceremony), geomancers, and village temple altar masters all

produce different kinds of written scriptures and liturgies for the locally defined pantheon. Plays are developed to further integrate the local pantheon and local mythology with the rituals for individuals and communities. Taoists work themselves into a central position in the legitimation of community temple-based initiation rituals. They develop an entire set of rituals and certificates to preserve an eternal centrality in a process that could very well have started out as an indigenous shamanistic religious tradition. The circuit moves in spiral from individual ritual needs to spirit mediums' incantations to Taoist liturgical texts to ritual theater to testimonials on stone to massive temple fairs to transversal flows of local level social and cultural power to memorials written by local gentry to temple gazetteers to government titles of investiture – a tremendous circulation of texts, bodies, food, money, music, legends, desire. We are talking about the process of the production and re-production of local popular culture.

Perhaps we need to reconsider the starting point of the spiral of popular culture. Rather than basing it in rituals designed to address individual crises, individual needs, or a fundamental sense of lack, loss, or limitation, we could look instead to the relationships *between* and *beyond* individuals. This goes for the question of agency in cultural production as well. We can extend our search for the authors of popular cultural texts forever, and come up with a few over time. A more productive approach might be to focus on the in-between of bodies, the flows of language and legend, the shifting social organization, the rising tide of commercialization, the militarization of society, the decline of the Buddhist monasteries, and later the decline of the major lineages, the rise of the temple networks within the irrigation systems, etc. This kind of multivalent approach to cultural phenomena could lead to a new way of examining ritual experience.

Hou Ching-lang (1975) demonstrated that the development of rituals for filling the underworld treasury with spirit money arose in the Song dynasty (ninth–eleventh century) shortly after the spread of paper money for commercial purposes. Perhaps the shock value of the destruction of ingeniously crafted simulacra of objects of value – stacks of cash, mansions of paper, even armies of terra-cotta soldiers – was designed to force the participant observers to stare into the mirror of death, to be witness to the destruction of the individual and the transvaluation of values. Rather than search for specific individuals or agents that can be said to have shaped popular culture, we might look beyond the model of the individual author or intentional ego – and look as well beyond the generalized, reified model of the impact on popular religion of Taoist liturgy – look instead at the modes and mediums of the communication of culture – the rituals, the plays, the festivals themselves as process of cultural self-construction.

In this way, one could see new formations of relationships between bodies emerging through ritual as a process of incessant becoming. It is crucial that we do not see ritual as an end-point or a point of eternal return, a motor of changeless cultural re-production. Instead, we need to study changes in popular culture over time, as revealed in evolving ritual traditions, changing regional

theatrical genres, and their ever-changing ritual contexts in relation to other, simultaneous changes in Chinese society.

The process of circle or spiral of textual proliferation from seance to chant to scripture to liturgy to playscript and back to chant and seance involves a joyous and continuous excess, a colossal collective word-play, a process of language speaking itself, of a local culture working itself out. Texts take shape not so much as efforts to impose a hegemonic homology of elite values upon the unsuspecting, illiterate, and powerless masses, but instead as the manifestation of the power of local culture, defining itself, exulting in itself, playing itself out.

I think that anyone who has attended a highly charged village festival in Taiwan or China will understand what I mean when I refer to a level of ex- perience that transcends the individual and generates a multitude of new planes of experience among the assembled crowd. A proliferation of multiplicities that can be analyzed as new sets of relations, new collective bodies undergoing innumerable transformations, new collective subjectivities constructing them- selves.

How is what I am describing anything more than a populist evocation of cul- tural resources, or a totalizing counter-desire to state desire in its nationalist mode? First, I have tried to suggest that local cultures can be approached in terms of a historical model of local transformations and internally generated changes. Secondly, I have made reference to structural features of multiplicity. One could point to several dimensions of communal life within regional or local cultural contexts in China that provide resources for the continuing vital- ity of those cultures. These include; (1) a multitude of transversal flows within and between different cult centers and incense division networks; (2) a consid- erable number of parallel, sometimes rival ritual traditions available at the communal level; (3) multiple vertical fields of literacy/cultural knowledge (sym- bolic capital or intellectual property) handed down within households or through apprenticeships and reaching into village life (Chinese medicine, geo- mancy, literate scribes, Confucian masters of ceremony, etc.); (4) multiple principles of inter-belonging or co-ownership criss-crossing the community such as lineage or kinship groups, state-based systems related to taxation and mutual self-defense and policing, temple-based circuits involving shares in the collective community – all of these distinguished by different regimes of offer- ings, prestations, and ritual performance (Wilkerson, 1994); (5) complex interlarding of representatives of official culture – retired officials, failed literati, and local gentry, in village life; (6) a profusion of associational forms that could take shape within many of the other social groupings already mentioned (lin- eage, temple, etc.), and which often are used to pool capital or mitigate against capital fluctuations (Sangren, 1984). Perhaps most intriguing of all is the struc- tural principle of transformation of households, based on the effects of partible inheritance, which theoretically impel a movement from small families to extended families, to hereditary lineages, to class-dominated to contractual lin- eages, and then back again into smaller and smaller units. In other words, many

of these different elements of discrete multiplicities are constantly in movement. Finally, I would like to mention the ever-present potential for revelation, the eruption of a representation of spiritual power into the community, the formation of a new cult, which can cause a rearrangement of the flow of power between all the social groupings mentioned above. Revelation through spirit writing means that the history of the community can constantly be re-narrated. The codification of these contested histories is part of the role of ritual specialists in bringing local culture into the sphere of national culture.

In general, one can conclude that a close examination of rural popular culture, both in traditional times and to a surprising extent even today, reveals cultural forms built around religious rituals and social networks engaged in ceaseless strategies of contesting local histories. There are countless instances of the popular appropriation of imperial codes or nationalist codes or ritual codes or hagiographic codes for purposes of local self-definition. The elaboration of new subjectivities based in complex local pantheons with their own ritual traditions and ritual drama within distinct communities of Southeast China should be seen as paradoxically both the evolution of local cultural unity and as the successful attainment of cultural difference.

Center or periphery?

For many years, research on Taiwan was considered marginal or peripheral to the 'true China', which was of course inaccessible to both Taiwanese and Western scholars. This attitude enabled some scholars to categorize Taiwan itself as an anomalous, peripheral culture, which could only shed a distorted light on 'Chinese culture' on the mainland. There is a danger that the same marginalization will be attempted with studies on Fujian, or Minnan culture. It is therefore important to provide a broader model of the historical process of local cultural self-definition throughout China.

Many specialists have stressed the techniques of cultural hegemonism employed by the Chinese empire in late imperial times (Hsiao, 1960). However, growing evidence from concrete studies in Ming and Qing history increasingly reveal a picture of spreading commercialism, weakening government control, and growing local self-government. Indeed, as more and more anthropologists join forces with historians to research the cultural histories of distinct regional or local cultures in China, a very vibrant picture of local culture begins to emerge that does not conform to the accepted hegemonic homologies model. Tu Weiming in his essay on 'Cultural China: The Periphery as Center' (1991), quotes Yu Ying-shih to the effect that 'the center is nothing, the periphery is all'. It is possible to rethink the process of local cultural self-definition in late imperial and perhaps contemporary China itself in these terms, rather than in relation to the diaspora of the contemporary international Chinese intelligentsia as Tu would have it. One could argue that Confucian classical texts and political philosophy increasingly attained transparently ideological status, while

at the same time local cultures came more into themselves in a process of manipulating Confucian ideology, and bending it to fit the needs and realities of local customs, which were continually changing. The reinvention of traditional forms would mark a similar effort to play with the space left open by contemporary CCP vacillation on the centrality of class struggle in the formation of 'Chinese culture'.

Conferences of the gods

Much of this appropriation of contested space and contested meanings has taken place in what might be described as 'conferences of the gods'. Some twenty conferences have been held in Fujian alone over the past decade on the major cults of the area. The most prominent of these is the cult of Mazu, Goddess of the Sea, with its mother temple in Putian, Fujian, its thousands of temples in Fujian and along the entire coast of China, and its several hundred branch temples in Taiwan and Southeast China. Other major local deities have also been the subject of official conferences. These conferences were all officially approved, especially those involving scholars from overseas. They were all presided over by local officials, sometimes from the local city level ministry of culture, or the political consultative congress (*zhengxie*), or by the party secretary, or the mayor, or the propaganda department, or the United Front people. Aside from these figures, who approved the holding of the conferences, the conferences were also attended by a large group of intellectuals, usually numbering about fifty, including university professors, associate professors, and assistant professors, and local scholars from the regional academic organizations under the control of the *zhengxie*. Then there was another group made up of sponsors (usually Taiwanese members of temple committees connected to the respective cults) and local figures connected to the founding temples. Following the format of most Chinese conferences, these conferences of the gods included an opening ceremony, where the top-ranking local officials and top university professors spoke, then several days of small group presentations, leading to a final conference where reports on the small group presentations were made, and invited speakers presented papers. The conferences were usually followed by a tour of the sites connected to the cult. These tours, and the conferences as well, were tantamount to an official stamp of approval on the cult, and so the conference groups were met with great fanfare when they arrived at the founding temples.

There were, however, many taboos and prohibitions surrounding these conferences. The local officials began each conference by denouncing the feudal superstitious nature of the cult in question, and suggesting instead a commemorative approach to the cult deity, who should be lauded for their contributions to society (of their times), and their enduring example to later generations. This kind of euhemeristic treatment will no doubt bring to mind the ceaseless efforts of Confucian officials to rein in *yinsi*, heterodox cults, over the ages. But the situation for the intellectuals was even more complex. Many of them had been

forced for years to ignore the importance of these cults for the local history of Fujian. Now they were being asked to present papers on these gods with very little material to work with. The regional gazetteers were turned inside out but only a few references could be found. These were stretched and bent into several conference papers. The slim materials on the developments of the cults on Taiwan available to the mainland intellectuals became grist for the mill of many a paper. Any reference, no matter how minor, in the writings of local literati, could win an enterprising academic a ticket to a conference, with several days of free meals, a set of materials and a commemorative attache case. Sometimes, local level scholars had the advantage, in that they had been storing away local historical materials for years. A few of them were keen supporters of these new developments. Nevertheless, the scholarly content of most of the papers presented at these conferences has not been significant. But the degree of government acceptance and confirmation of the cults has been extremely significant.

The government clearly hopes to exploit the Taiwanese and Overseas Chinese interest (communities from the Philippines, Indonesia, Malaysia, Singapore, and Thailand are all represented) in the cults of the Fujian to entice investments and to build up 'unofficial links' with non-governmental groups. On the other hand, they feel that they are riding an unpredictable force. Governmental groups were involved in planning the first international Mazu conference in 1990. Before it was held, however, a local meeting was called, and materials worked up for presentation at the larger conference.

The government is not, however, monolithic, nor is it insusceptible to pressure from outside groups, or from retired cadres. Moreover, one must note that there has been a certain amount of confusion generated by the competing claims of different divisions of the government. Thus the Taiwan division of the United Front must compete with the Tourism Division, and the latter has to compete with the Cultural Division, and both of these with the Religious Affairs Division, and all of these with the Party Secretary and the people responsible for long range economic planning and development. These issues frequently complicate the local coordination of policy towards a major cult center. The case of the Mazu temple on Meizhou island is a good example. There, large amounts of money are being donated to the temple committee, run by the capable Ah-be. Local officials did not dare demand a share of these funds for fear of blocking the flow. Ah-be has no doubt been quick to play on their fears. Meanwhile, other government bureaus located an overseas investor, originally the Libao multinational, to whom they ceded 'development rights' of the island for ten years, effectively giving over control for a series of what have so far turned out to be empty promises regarding the construction of hotels, apartment blocks, and other facilities. Meanwhile, another pool of money has been used to establish a Mazu research foundation, headed by the director of the Putian Zhengxie. So this powerful faction also has an incentive to discourage direct government intervention in the temple funding process.

Taiwanese support has been behind the majority of the conferences of the gods. The Beigang Chaotian gong Mazu temple has issued a colorful pamphlet boasting that it was the sole sponsor of the second International Mazu conference, held in 1991. The intense rivalry between Mazu temples on Taiwan has found in the Fujian connection a new playing field full of interesting possibilities. (See Sangren, 1988, on the Taiwanese Mazu temples.) For example, the Dajia pilgrimage to the Chaotian gong in Beigang is well known in Taiwan. The entire pilgrimage lasts a week, is conducted on foot, in costume, with several elaborately carved and immensely heavy sedan chairs carrying the Dajia gods. However, in 1987, rather than visit Beigang, the Dajia pilgrims decided instead to return to Meizhou. In this way, they greatly enhanced their status on Taiwan, not least for their audacity. But the Dajia pilgrims went one step further. They 'discovered' the original birthplace of Mazu in Gangli village of Zhongmen xiang, overlooking the Meizhou bay. By supporting the still-disputed claims of the temple there to be the mother temple of the cult, the Dajia pilgrims put themselves in a new relationship with the newly anointed founding temple. The other Mazu temples on Taiwan were quick to react. I have mentioned the support of the Beigang Chaotian gong for the second Mazu conference. They also sponsored the reconstruction of various parts of the Meizhou temple (which had been completely destroyed in the Cultural Revolution). The Lugang Mazu temple lost no time in building a pavilion midway up the hill behind the temple. Inside the pavilion is a large poster of the god statue from Lugang. They also sponsored the construction of an immense statue of the goddess on the top of Meizhou island, which would ensure that every visitor would walk past the pavilion and the Lugang Mazu.

The conference of the gods where local support was most clear to me was the Lin Long jiang Academic Conference. Lin Long jiang is Lin Zhao'en (1519–98), who founded the Three in One religious movement in Putian, Fujian, combining Confucianism, Taoism and Buddhism. His disciples made him into a god, and he is worshipped to this day in over a thousand temples in the Xinghua cultural region. Virtually every temple in Putian and Xianyou counties, and many in northern Hui'an and southern Fuqing counties, have a temple dedicated to the Lord of the Three in One. In some areas, such as the central artery of commerce, political force, and transportation along the Fuzhou-Xiamen highway between Putian and Hanjiang, the cult is a exclusive grouping of people interested in the scriptural teachings and the neigong system of inner cultivation. In other areas along the rocky coastline and in the mountains of Xianyou and Putian, the cult has sometimes taken over as the principal form of popular religion in the villages. The cult has been struggling to regroup and obtain official recognition. With the support of about three dozen temples in Malaysia and Singapore, along with three or four in Taiwan, the leaders of the cult managed to repossess the Ancestral Temple of the cult on East Mountain in Putian city from the military. They did their own surveys of the cult, and reprinted scriptures, and sought to standardize ritual practice. In an effort to secure

government support, they convened a conference in 1987. The conference was rather bizarre. It was paid for entirely by the Three in One. All the local assistants at the guest house they booked were members of the cult. After being severely lectured at during the opening ceremony by the head of the Political Consultative Congress, who warned them against performing any acts of feudal superstition, they went on with the conference. Because the cult has long maintained a high level of textual study rather reminiscent of CCP political study sessions they had several elderly gentleman at the conference with long white beards who lectured on the Four Books and the Five Classics, and on the importance of inner cultivation in the modern age. Many of these gentlemen were retired lawyers, teachers, even local government officials or military men. Indeed, the wealth of local connections these cult leaders maintained goes a long way to explain their success in holding the conference. Nevertheless, rumor had it that one high level official complained that Putian would soon be known as the feudal superstition capital of China if similar conferences were allowed to go on.

Another level of support for these kinds of conferences comes from lineages. I will give one example. The descendants of Cai Xiang live in the village of Cai Dong on the coast of the Meizhou bay in Putian. Over ten thousand Cai's live in some fifteen villages near Caidong. A few years ago the leaders of the lineage organization began to organize extensively within the nearby villages, and amongst the far-flung branches of the lineage. They made contacts with branches as far away as Japan, Jiangxi, and Guangdong. They made a formal request to the Putian city government to build a Cai Xiang Memorial Hall. When this was granted they pooled funds from the various branches of the lineage and built the hall. The next step was the holding of an academic conference. Leaders of the lineage were also on the editorial board, and any critical comments about Cai Xiang were systematically removed. Having won governmental permission to build the Memorial Hall and hold the conference, the next step was to use some 'left over funds' from these projects to build a massive ancestral hall. I attended the consecration of the hall in October 1991. It was a spectacular event. Groups of Taoist and Buddhist priests conducted simultaneous, parallel rites of consecration, culminating in the animating by dotting with red ink of hundreds of ancestral tablets. The resurgence of lineages as a major network in local level society is an important phenomenon elsewhere in contemporary China as well (Cohen, 1990; 1991).

Contesting symbols of space and time

These conferences of the gods are but one instance of the manipulation of traditional symbols of space and time, in this case the birthdates of the gods, into representations of state or local authority. Another way in which this happens is when traditional seasonal festivals, such as Chinese New Year and the Lantern Festival, are transformed into national festivals. It is important to note that these state celebrations are contested at the same time (celebrated differently

or appropriated) by local groups for their own purposes (Wang, 1992).

The points where these different versions of the annual festivals are celebrated become rival maps of the power networks energizing the locality. Of course there are some spaces that belong to the government, and that the government can reclaim with the aid of modernized traditional festivals. Governmental buildings, public highways, school-yards, auditoriums, etc., all are swept up into the official celebration. All these celebrations reaffirm the organic links between the government and its units (*danwei*). The state-sponsored parades of marching bands, school children, and advertising floats adorned with figures from traditional operas move along the major highways that have been carved through the crowded lanes of the old cities.

But the cities had a different organization of space, the ward system, and each ward had its own temple. In Quanzhou there were thirty-six ward temples, with seventy-two temples for subdivisions of the wards. In the past ten years, many of these have been restored. An alternative map of the circuits of power within the city is revealed during the traditional seasonal festivals of the gods, particularly the Lantern Festival, when different temples around the city visit one another. Quanzhou is rather unique, in having a cultural ministry that has sought to protect and even support or co-opt some of the traditional community structures (Wang, 1995). And even there, urban development threatens to destroy communal relations. In general, there appears to be a growing and perhaps irreversible gulf between urban and rural symbolic systems. Children and young teenagers in the villages have spent their entire lives punctuated by increasingly elaborate village festivals, while kids of a similar age in many cities have little or no contact with this realm of symbolic experience.

In addition to the annual festivals celebrated nation-wide, a second calendar underlies the cultural self-definition of each locality. This is the calendar of the birthdays of the local gods. Every locality has a different local pantheon, built up out of the legends and efforts of successive generations. Ritual specialists, artists, playwrights, actors, marionettists, musicians, local literati, stonemasons, carpenters, wood-carvers, paper-cut artists all work to celebrate their local culture, putting the collective representatives of local symbolic value into visual form. The effort of the government to step in and hold the 'conferences of the gods' in time with the birthdates of the gods represents an effort to co-opt these defining moments in the rhythm of local time into a political statement.

State festival/local festival

As soon as the government touches it, the cult transforms into a distorted image of an official state organ, with brass bands, dancing lions and dragons, bands of school children, or old folks' disco-dancing aerobics groups. All the spontaneity of the local festival, and all the traditional underlying structure, is missing. Fortunately, these events, although somewhat grotesque, are limited to those rare occasions when representatives of the government deign to visit the cult centers

with an approving air. This temporary appropriation of the cult's symbolic space is played out in a formalized fashion. Of course, such official visits and signs of recognition are not a new phenomenon. The local appropriation or official authorization has been an aspect of the history of every cult in China.

'This land is your land, this land is my land'

The local festivals of the cults raise another important spatial issue: the question of scope of cult activity and their interface with the State. Many villages in traditional times were linked into ascending regional hierarchies. Each level of the hierarchy could be marked by a regional association, often symbolized by a common cult. In other words, a village would first hold a procession around the village to affirm the spiritual territory of the god. Next the village would join in a procession linking several villages in a local association. Finally, the village would join in a grand procession linking several regional associations under the common symbol of a major regional cult, like the city god of Hanjiang, or the Humane Emperor of the Temple of the Eastern Peak of Jiangkou, or the Jade Emperor in the Temple of the Towering Clouds on the top of Hugong Mountain, the highest point in the Putian plains. These processions could involve between thirty-six and a hundred and eight villages. The last of these grand processions took place in the 1930s. Many of the lower level processions have been restored, but the larger spatial claims of the higher level cults run up against the local governments claims to oversee the major roads and public spaces of the area. Innumerable stories are told of the last minute intervention, sometimes quite heavy-handed, of the State in a large-scale procession. Stand-offs between officials and Overseas Chinese or their local representatives have become a regular feature of these events. Without a far more accommodating attitude on the part of the authorities, this issue will remain a flashpoint for the growing contradiction between official mass culture and local cultural forces.

In October of 1993, the massive, ornately carved sedan chair of the Humane Emperor or the Temple of the Eastern Peak was carried in a procession around the fifty villages in the Jiangkou Nananbi irrigation system. This was the first time in sixty years that the procession marking the highest level of the nested ritual systems of the area had been carried out. But it turns out that this particular procession was always carried out once every sixty years, at least since the middle of the Ming dynasty (mid-sixteenth century). So a spatial and temporal cycle has been completed, and a statement of local cultural autonomy and self-determination has been made.

Conclusions: the construction of local culture and the paradox of late capitalism

The situation of popular religion and local culture in China over the past fifty or sixty years presents fascinating contrasts and comparisons with those on

Taiwan. Recall the early KMT efforts to limit or suppress Taiwanese popular cults and festivals. These efforts were in part a carry-over from the early policies of the Republican period, with their iconoclastic attack on Chinese traditions, especially religious or popular traditions. The would-be architects of the new Chinese nation-state intended to replace such localized structures with a nation-wide bureaucracy of schools and police stations, set up within former temples (Duara, 1989; 1995). But on Taiwan there was an added gulf between Mandarin elite culture, even if Westernized and Christianized, and Hokkien culture. Despite these deep seated contradictions, the realm of popular religion has grown and flourished in Taiwan, becoming an important political force in local elections, as well as a center of local power, prestige, and cultural expression. The degree to which popular religion has maintained itself in a rapidly mod-ernizing economy is indeed interesting, and may suggest a possible direction for the evolving relationship between local cultural, and political and economic forces in Fujian. A great deal of work is now being done on Taiwan on local customs, what with major annual festivals of local theater, several new museums in the planning stages, massive research projects underway, and Hokkien and Hakka being taught in the schools. One could also argue that this attention reflects a concern that these traditions are threatened as never before by ever-accelerating modernization. Some observers have claimed to find in recent works of Taiwanese cinema a despairing over the loss of meaning in indigenous local culture, underlined by a hopeless sense of terminal dependency in the world capitalist order (Jameson, 1994). Others have suggested that these efforts are in fact a dimension of the extension of government controlled cultural hegemony into the everyday (Chun, 1994). Based on my own fieldwork in Taiwan, and the commentary of many ethnographers (Ahern, 1981), I would argue for the uncontainable vitality of Taiwanese culture at the popular level, as manifested in temple festivals, processions, ritual theater and feasts. This is a cul-tural force that is increasingly self-conscious (Constantino, 1978).

Some observers feel that the combination of Taiwanese or Overseas Chinese funding, cynical or self-serving governmental approval, and the local scrambling for monetary support has led to a distorted form of popular religion in Southeast China (Siu, 1990). There are at least two issues at stake here. First there is the question of the authenticity of the religious expression in the cult centers in China. That question still deserves serious study, if one was interested in the phenomenology of religion, but the important thing to note for the pur-poses of this discussion is that the new circumstances outlined above and their constitutive symbols provide new possibilities, new tools for local appropriation and co-optation. The potential roles for popular religion are expanding, rather than being perverted into a empty simulacrum. The range of support for the conferences I have discussed indicates that we are dealing with a widespread and deeply rooted phenomenon with important implications not only for Fujian–Taiwan relations, but also for the cultural development of China as a whole.

A second question concerns the role of the cult centers in relation to Taiwanese circuits of pilgrimage and local cultural self-identification. There are many possibilities here as well. The mainland centers may fade in importance after the novelty wears off, and the complications of dealing with the authorities there takes its toll (Sangren, 1992). In terms of the dynamics of the division of incense system, however, access to the Fujian cult centers can certainly expand the range and flexibility of the Taiwanese systems. One can indeed imagine stronger connections being built up over the long term. In the short term, my guess is that the paradoxical situation of semi-open status of the cult centers will lead Taiwanese cults to turn inwards, focusing upon their own links and organizations. This could take a number of forms, some institutional, some anti-institutional. An example of the former would be the recent formation of a Taiwan-wide Baosheng Dadi temple association, and the publication of an illustrated volume listing all the Baosheng Dadi temples on Taiwan. Another example would be the self-conscious effort on the part of some Taiwanese intellectuals to claim that Mazu belief-spheres (regional networks of temples) represent a peculiarly Taiwanese phenomenon, one that could be said to define the essence of the Taiwanese experience (Lin, 1990). An example of a somewhat anti-institutional formation might include the wider, more commercialized pilgrimage circuit around several of the main Mazu temples all around the island, rather than just to one.

The greater flexibility of 'Chinese culture' as a whole, and particularly the ability of local cultures to manipulate official codes and symbols of authority may paradoxically be a result of the loosening up of central-command codes and territorial codes by the spreading of capitalist flows of all kinds. Yet it is precisely those flows which threaten the local cultural forms with all kinds of appropriation and transformation, not to mention imposing grave risks to the economic stability of the province. The commercialization of Chinese television, the commodification of culture, the transformation of pilgrimage into cash-crop tourism, and the expanding impact of homogenized international postmodern capitalist culture (best exemplified by the karaoke craze sweeping across China), all serve to confuse the traditional structural interface between the State and the Locale, providing new opportunities and new technologies for both sides while transforming the contestants in the process. The overriding impression given by the economy and society (and culture) of Southeastern China is one of sheer speed – like an accelerating train that everyone is trying desperately to catch a ride on, and which we can only hope will not suddenly derail.

Can one reach any conclusions about the relationship between the forces of local cultural self-organization and the nationalistic desires of the state, or the visions of a Greater Chinese Econonic Cooperative sphere of the future? Increasingly, the urge towards unification that was manifest in early discussions of Greater China have given way to a vision of informal ties, or ties that bypass explicit political form. This is not to say that tremendous nationalistic pressures do not threaten to erupt into open conflict within China and in different

sectors in Taiwan, or between China and Taiwan. But what I have been out-lining today is the potentiality on the part of local Chinese culture to achieve maximum flexibility by re-inventing itself at a level of individuation both below that of the homogeneity demanded by a nation, and yet at the same time, at a level that is suppler and more vibrant than the rigid consistency of a state.

I began the chapter with the image of Mao as a spiraling skyrocket, explod-ing into shining fragments. Some of these fragments have been gathered up in the formation of a multitude of other spirals, the process of re-invention of local cultural forms. Last Chinese New Year I saw a portrait of the young Mao on a placard decorated with Christmas tree lights leading a procession of lanterns and gods in sedan chairs around the backstreets of a city in Xianyou. I am suggest-ing that the multiple spirals of local culture across China are in part a response to the hegemonic, totalizing project of nationalist modernity, in its particularly convoluted Chinese expression. This is not a simple opposition between local culture and community on the one hand and nationalistic modernization on the other. The point is rather that the 'universalist' claims of 'modern Western social philosophy are themselves limited by the contingencies of global power' (Chatterjee, 1993). As Naoki Sakai pointed out, this kind of universalism is dependent on particularism (1989). I am more interested in pointing to evi-dence of widespread, fragmented resistances to the normalizing project of nationalism, and suggesting that it is in the study and performance of these forces of resistance, these 'insurrections of subjugated knowledges . . . whose validity is not dependent on the approval of the established regimes of thought' (Foucault, 1980: 79–82) that we may find the resources for creative local responses to global capitalism and nationalistic cultural hegemony.

Before closing on what may still be seen as a naively populist note, or a total-izing counter-desire, let me also quote Foucault on the dangers of an appeal to community:

> You wonder if a global society could function on the basis of such divergent and diverse experiences, without a general discourse. I think on the contrary that it is precisely the idea of a 'social ensemble' that resorts to utopia. This idea has taken root in the Occidental world, in the quite particular historical lineage that resulted in capitalism, To speak of a 'social ensemble' outside of the only form that we know it is to dream on the basis of yesterday's elements. We blithely believe that to demand of experiences, actions, strategies, and projects that they take into account the 'social ensemble' is to demand the minimum of them. The minimum needed for existence. I think on the contrary that it is to demand the maximum of them; that it is even to impose upon them a single impossible condition, because the 'social ensemble' func-tions exactly in such a way that, and with the aim that, they can't take place or succeed or be perpetuated. The social ensemble is that which should not be taken into account, unless it is with the object of

destroying it. One can only hope then that there will no longer be any-
thing that resembles a social ensemble.

(1973: 41–2, translated in T. LaMarre (1993: 8))

Of course Foucault is speaking here about *Western* imagined 'social ensembles'.
It may be possible, if what I have outlined above on changing strategies of resis-
tance to state desire within 'Chinese culture' has any validity, to analyze the
shifting boundaries of local formations of desire that escape the totalizing pres-
sure of the capitalist-invested 'social ensemble', as much as they avoid the
individualizing, homogenizing pressures of the nation-state. However, no one
should deceive themselves into thinking that local Chinese communities will
renounce their patrilocal nature, with its attendant patriarchal domination of
women. The potential for human abuse is enormous under these conditions. It
is precisely in its ability to achieve and activate a separate sphere of domination
from the totalizing and individualizing powers of the State that the community
manifests its powers of resistance. Part of the task of analysis is to uncover the
assemblages of desire operating at the communal level to simultaneously resist
the State and inscribe the all too human.

Is it conceivable, then, that the standard bearer of 'Chinese culture' might be
a local spirit medium, a ritual specialist, or some other local cultural figure,
rather than a Confucian cadre in a business suit? That what has been termed the
'ecstatic substratum of Chinese culture' has the power to resist and *transform*
alongside trans-national forces to prevent the formation of rigid statist forms? If
so, then perhaps the power of communal cultural ties within regions of China
or Greater China can put its own spin on the coming millennium.

References

Ahern, E. (1981) 'The Tai Ti Kong festival', in E. M. Ahern and Hill Gates (eds) *The
Anthropology of Taiwanese Society*, Stanford: Stanford University Press.
Ahmad, A. (1992) *In Theory: Classes, Nations, Literatures*, London: Verso.
Anderson, B. (1983) *Imagined Communities, Reflections on the Origin and Spread of
Nationalism*, London: Verso and New Left Books.
Appadurai, A. (1990) 'Disjuncture and difference in the global cultural economy', *Public
Culture*, Vol. 2, No. 2, Spring 1990.
Apter, D. and Saich, T. (1994) *Revolutionary Discourse in Mao's Republic*, Cambridge, MA:
Harvard University Press.
Ash, R.F. and Kueh, Y.Y. (1994) 'Trade and investment flows between China, Hong
Kong and Taiwan', *China Quarterly* 136: 711–45.
Bhabha, H. (1990) 'DissemiNation', in H. Bhabha (ed.) *Nation and Narration*, London:
Routledge.
—— (1994) *The Location of Culture*, London: Routledge.
Butler, J. (1990) *Gender Trouble: Feminism and the Subversion of Identity*, London:
Routledge.
—— (1993) *Bodies That Matter*, London: Routledge.

Chatterjee, P. (1986) *Nationalist Thought and the Colonial World: A Derivative Discourse*, London: Zed Press.

—— (1993) *The Nation and Its Fragments: Colonial and Postcolonial Histories*, Princeton, NJ: Princeton Univerity Press.

Chow, R. (1991) *Woman and Chinese Modernity: The Politics of Reading between East and West*, Minneapolis: University of Minnesota Press.

—— (1990–91) 'Listening otherwise, music miniaturized: a different type of question about revolution', *Discourse* 13/1 (Winter 1990–91).

Chun, A. (1994) 'From nationalism to nationalizing: cultural imagination and state formation in postwar Taiwan', *Australian Journal of Chinese Affairs* 31, Jan. 1994.

Cohen, M. (1990) 'Lineage organization in North China', *Journal of Asian Studies* 49.3: 509–34.

—— (1991) 'Being Chinese: The peripheralization of traditional identity', *Daedalus* 120.2: 113–34.

Constantino, R. (1978) *Neocolonial Identity and Counter-conciousness: Essays on Cultural Decolonization*, White Plains, NY: M.E. Sharpe.

Dean, K. and Massumi, B. (1992) *First and Last Emperors: The Absolute State and the Body of the Despot*, New York: Autonomedia.

DeLanda, M. (1992) 'Nonorganic life', *Zone 6: Incorporations* 1992: 129–67.

Deleuze, G. and Guattari, F. (1988) *Thousand Plateaus*, trans. B. Massumi, Minnesota.

Duara, Prasenjit (1988) *Culture, Power, and the State: Rural North China: 1900–1942*, Stanford, CA: Stanford University Press.

—— (1993) 'De-constructing the Chinese nation', *Australian Journal of Chinese Affairs* 30, July, 1993: 1–26.

Farquhar, J. and Hevia, J. (1993) 'Culture and American postwar historiography of China', *Positions 1.2* (Fall, 1993): 486–525.

Foucault, M. (1977) *Discipline and Punish: The Birth of the Prison*, New York, Pantheon.

—— (1979) *A History of Sexuality*, New York: Pantheon.

—— (1980) 'Truth and power' [Intervista a Michel Foucault, 1977], in C. Gordon (ed.) *Power/Knowledge: Selected Interviews and Other Writing 1972–1977 by Michel Foucault*, trans. C. Gordon, Brighton, Sussex: Harvester Press.

—— (1982) 'The subject and power', in H. L. Dreyfus and P. Rabinow (eds) *Michel Foucault: Beyond Structuralism and Hermeneutics*, Chicago: University of Chicago Press.

—— (1993) 'Michel Foucault: propos recellis par M.-A.Burnier et Phillipe Graine, *Actuel* n. 14, novembre 1971,' *C'est demain la veille*, trans. T. Lamarre, Paris: Editions du Seuil.

Friedman, E. (1994) 'Reconstructing China's national identity', *Journal of Asian Studies*, 53.1, 67–91.

Fu Yiling and Yang Guozhen (eds) (1987) *Ming Qing Fujian shehui yu xiang cun jingji* (Fujian society and village economy in Ming and Qing times), Xiamen: Xiamen University Press.

Geertz, C. (1980) *Negara: A Theatre State*, Princeton, NJ: Princeton University Press.

Gil, J. (1985) *Metamophoses du corp*, Paris: La Difference.

Godelier, M. (1978) 'The concept of the "Asiatic mode of production" and Marxist models of social evolution', in Seddon, D. (ed.) *Relations of Production*, London: Frank Cass.

Gold, T. (1993) 'Go with your feelings: Hong Kong and Taiwan popular culture in greater China', *China Quarterly*, 136.

Harding, H. (1994) 'The concept of "Greater China": themes, variations, and reservations', *China Quarterly* 136: 660–86.

Harvey, D. (1989) *The Condition of Postmodernity*, Oxford: Blackwell.

Hobsbawm, E. (1990) *Nations and Nationalisms since 1780*, Cambridge: Canto.

Hou Ching-lang (1975) *Monnaies d'offrande et la notion de tresorerie dans la religion chinoises*, Memoires de l'Institut des Hautes Etudes Chinoises, vol. 1, Paris.

Hsiao, Kung-Chuan (1960) *Rural China: Imperial Control in the Nineteenth Century*, Seattle: University of Washington Press.

Huang, P. (1995) 'Rethinking the Chinese revolution' and 'Rural class struggle in the Chinese revolution: representational and objective realities from the land reform to the cultural revolution', in *Modern China* 21, January 1995.

Jameson, F. (1986) 'Third world literature in the era of multinational capitalism', *Social Text* Fall, 1986.

—— (1991) *Postmodernism, or The Cultural Logic of Late Capitalism*, Durham, NC: Duke University Press.

—— (1994) 'Remapping Taipei', in N. Browne, P.G. Pickowicz, V. Sobchack, E. Yau (eds) *New Chinese Cinemas: Forms, Identities, Politics*, Cambridge: Cambridge University Press.

LaMarre, T. (1993) 'Sexuality and transgression in the modern Japanese novel (nation and literature after Foucault)', paper presented at the *Beyond Foucault* conference, Toronto, Canada, October 1993.

Lin Meirong (1990) 'Zhanghua Mazu de xinyangquan' (The Zhanghua Mazu belief circle), *Bulletin of the Institute of Ethnology*, Academia Sinica: 68: 41–104.

Lin Wenhao (1992) *Haineiwai xueren lun Mazu* (Foreign and domestic scholars discuss Mazu), Putian: Zhongguo shehui kexue chubanshe.

Liu, L. (1993) 'The female body and nationalist discourse: the split national subject in Xiao Hong's *Field of Life and Death*', paper, 1991, quoted in Duara (1993).

Mao Zedong (1965) *Selected Works of Mao Tse-Tung*, 5 volumes, Beijing: Foreign Languages Press.

Pye, L. (1993) 'Nationalism Shangai'ed', *Australian Journal of Chinese Affairs*, 29, 107–33.

Sakai, N. (1989) 'Modernity and its critique: the problem of universalism and particularism', in Masao Miyooshi and H. D. Harootunian (eds) *Postmodernism and Japan*, Durham, NC and London: Duke University Press.

Sangren, P. S. (1984) 'Traditional Chinese corporations: beyond kinship', *Journal of Asian Studies*, 43, 3: 391–415.

—— (1987) *History and Magical Power in a Chinese Town*, Stanford, CA: Stanford University Press.

—— (1988) 'History and the rhetoric of legitimacy: The Ma Tsu cult of Taiwan', *Comparative Studies in Society and History*, 30, 4: 674–97.

—— (1992) 'Power and transcendance in the Ma Tsu pilgrimages of Taiwan', *American Ethnologist*.

Schipper, K.M. (1990) 'The cult of Baosheng Dadi and its spread to Taiwan – A case of Fenxiang', in E. Vermeer (ed.) *Development and Decline of Fukien Province in the 17th and 18th Centuries*, Leiden: E.J. Brill.

Selden, M. (1995) 'Yan'an Communism reconsidered', *Modern China* Vol. 21, January.

Simendon, G. (1992) 'The genesis of the individual', *Zone 6: Incorporations* (1992): 297–319.

Siu, H. (1990) 'Recycling ritual', in P. Link, R. Madsen, and P. Pickowicz (eds)

Unofficial China: Popular Culture and Thought in the People's Republic, Boulder, CO: Westview.

Strathern, M. (1992) 'Qualified value: the perspective of gift exchange', in C. Humphrey and S. Hugh-Jones (eds) *Barter, Exchange and Value: An Anthropological Approach*, Cambridge: Cambridge University Press.

Townsend, J. (1992) 'Chinese nationalism', *Australian Journal of Chinese Affairs*, 27: 97–130.

Tu Weiming (1991) 'Cultural China: the periphery as center', *Daedelus* 120, 2.

Wang Mingming (1992) *Flowers of the state, grasses of the people: yearly rites and aesthetics of power in Quanzhou in the Southeast Coastal Macro-region of China*, PhD thesis, Dept of Sociology and Anthropology, SOAS, University of London.

—— (1995) 'Place, administration, and territorial cults in late imperial China: a case study from south Fujian', *Late Imperial China*, 16.1, June: 33–78.

Wilkerson, J. (1994) 'The "Ritual Master" and his "Temple Corporation" rituals', *Proceedings of the International Conference on Popular Beliefs and Chinese Culture*, Taipei: Center for Chinese Studies.

Wittfogel, K. (1957) *Oriental Despotism: A Comparative Study of Total Power*, New Haven, CT: Yale University Press.

Zizek, S. (1990) 'Eastern Europe's republics of gilead', *New Left Review* 183: 50–62.

Further reading

Byron, J. and Pack, R. (1992) *The Claws of the Dragon: Kang Sheng – The Evil Genius Behind Mao – and His Legacy of Terror in People's China*, New York: Simon and Schuster.

Dean, K. (1993) *Taoist Ritual and Popular Cults of Southeast China*, Princeton, NJ: Princeton University Press.

Dean, K. and Zhenman, Z. (1993) 'Group initiation and exorcistic dance in the Xinghua region', in Wang Ch'iu-gui, (ed.) *Minsu quyi 85: Zhongguo Nuoxi, Nuo wenhua guojiyantaohui lunwenli (Proceedings of the International Conference on Nuo Theater and Nuo Culture)*, 1993, vol.2: 105–95.

—— (1995) *Epigraphical Materials on the History of Religion in Fujian: Volume 1: The Xinghua region*, Fujian Peoples' Press.

Duara, Prasenjit (1995) *Rescuing History from the Nation: Questioning Narratives of Modern China*, Chicago: University of Chicago Press.

During, S. (1990) 'Literature – nationalism's Other? The case for revision', in Bhabha, H. (ed.) *Nation and Narration*, London: Routledge.

Jiang W. (ed.) (1992) *Mazu wenxian ziliao* (Documentary materials on Mazu), Fuzhou: Fujian Peoples' Publishing House.

Li Xianzhang (1979) *Boso shinkō no kenkyu* (Studies in belief in Mazu), Tokyo: Taizan Bumbutsusha.

Li Zhisui (1994) *The Private Life of Chairman Mao*, New York: Random House.

Lu Hsun (Lu Xun) (1990) *Diary of a Madman and Other Stories*, translated by W. Lyell, Honolulu: University of Hawaii Press.

Mao Zedong (1990) *Report from Xunwu*, translated by R. Thompson, Stanford, CA: Stanford University Press.

Renan, E. (1994) 'What is a nation?', in H. Bhabha (ed.) *Nation and Narration*, London: Routledge.

Said, E. (1978) *Orientalism*, New York.

Schram, S. (1976) *The Political Thought of Mao Tse-tung*, New York: Praeger.

—— (1994) 'Mao at 100', *China Quarterly*, 176.

Tian Rukang (1990) 'The decadence of Buddhist temples in Fukien in late Ming and early Ch'ing', in E. Vermeer (ed.) *Development and Decline of Fukien Province in the 17th and 18th Centuries*, Leiden: E.J. Brill: 83–100.

Vermeer, E.B. (1990) 'Introduction', and 'The decline of Hsing-hua prefecture in the early Ch'ing', *Development and Decline of Fukien Province in the 17th and 18th Centuries*, Leiden: E.J. Brill: 5–34; 101–62.

Xiamen Wuzhenren yanjiuhui and the Qingjiao Ciji donggong dongshihui (eds) (1992) *Wu Zhenren yanjiu* (Research on the Perfected Wu), Xiamen: Lujiang chubanshe.

Xiao Yiping, Lin Yunsen and Yang Dejin (eds) (1987) *Mazu yanjiu ziliao huibian* (Comprehensive collection of research materials on Mazu), Fuzhou: Fujian Peoples' Publishing House.

Zhang Xudong (1994) 'The political Hermeneutics of cultural constitution: Reflections on the Chinese "Cultural Discussion" (1985–1989)', Working Papers in Asian/ Pacific Studies, Duke University.

Zhangzhou Wuzhenren yanjiuhui (ed.) (1989) *Wuzhenren xueshu yanjiu wenji* (Collected academic essays on the Perfected Wu), Xiamen: Xiamen University Press.

Zheng Zhenman (1987) 'The system of irrigation of agricultural lands in the Fujianese coastal areas in the Ming and Qing and (its relationship to) local and lineage organization', *Studies in Chinese Socioeconomic History*.

—— (1992) *Family-Lineage Organization and Social Change in Fujian During the Ming and Qing*, Hunan: Hunan Educational Press, PhD Dissertation Series.

Zito, A. (1993) 'Ritualizing *Li*: implications for studying power and gender', *Positions* 1.2: 321–48.

—— (1994) 'Skin and silk: significant boundaries', in A. Zito and Tani Barlow (eds) *Body, Subject & Power in China*, Chicago: University of Chicago Press.

Note Portions of this chapter also appear in K. Dean (1998) *Lord of the Three in One: The Spread of a Cult in Southeast China*, Princeton, NJ: Princeton University Press.

9

CULTURE, MULTIRACIALISM, AND NATIONAL IDENTITY IN SINGAPORE

Chua Beng-Huat

If cultural hybridization and syncretism is a mark of postcoloniality, then the cultural sphere in Singapore may be said to be 'postcolonial'. Yet, with slightly more than three decades of political independence, its political sphere is still firmly placed in the modernist trajectory of nation formation; whereas post-coloniality requires for its politics the deconstruction of the nation-state as a move to escape from Eurocentrism of the colonial masters.[1] This chapter seeks to trace the path by which the processes of nation-state formation in Singapore reshape the cultural sphere; first, through the erection of racialized boundaries in an attempt to erase hybridity, and the subsequent homogenization of the racialized population to arrive at a definition of Singapore as an 'Asian' nation. However, this newly invented Asian identity appears to have little relevance to the culture of everyday life.

Hybridity in everyday life

When left alone, 'hybridity' in cultural practices develops as a result of the routines of everyday life in Singapore, a multi-ethnic society. The following instances document this.

1 In the time of mercantile colonialism, when the economy was dominated by commodity traders, business transactions among Asians were conducted through a mixture of ethnic groups and languages. For example, Indian traders purchased from Chinese traders and shipped to India, Indonesian and Malayan produce, such as sago flour, copra, and spices. They imported from India cotton yarn and jute, sold these to Chinese traders who re-exported the same goods to textile mills in Hong Kong and Saigon via an extensive overseas Chinese trade network. To facilitate this inter-ethnic trade, every Indian trader had his own Chinese broker to act exclusively on his behalf. In this partnership, the trader and his broker shared equally the

10 per cent commission earned from every order purchased from Chinese traders. What made this arrangement the epitome of inter-ethnic cooperation was the medium of communication: Indian traders spoke no Chinese, and Chinese brokers no Indian languages, the medium used between the partners-in-trade was a pragmatic mixture of Malay and English.

2 Food is an area of obvious cultural hybridity. One example is a street-food called *mee goreng*. It is known to Singaporeans as 'Indian' food. However, *mee* is Chinese made noodle and is not an Indian staple; *goreng* is the Malay word for frying. What makes it 'Indian' is that it is only served by Indian hawkers; of course, it could not be found in India, the imagined homeland of Singaporean Indians. A second instance concerns Malay food. Malays as Muslims have a strict religious injunction against pork; whereas, pork is the main meat for Singaporean Chinese, largely *Hokkien*. Yet one can readily find *halal* or 'Islamized' Chinese food in Singapore; in such instances, fish is substituted for pork while all other ingredients remain the same. Chinese food is thus made consumable to Malays. The Chinese have few food injunctions and regularly consume Indian and Malay food.

3 Multi-ethnicity implies and implicates multi-religiosity. With perhaps the exception of fundamentalist Christianity, the other religious practices in Singapore appear able and ready to absorb elements from each other. Although Muslims by canonical profession, the Malays accept certain indigenous animistic practices which refer to specific local spirits, known as *datuk* ('grandfather' or 'lord'), in specific sacred sites. Such spirits are adopted by Chinese as *datuk gong*; they would erect small shrines at the sacred locations, often under a tree, dedicated to the spirit (Wee, n.d.: 29). (*Gong* in Chinese also refers to 'grandfather' but is often a term used to designate deities in their syncretic polytheistic practices.) In deference to Islam, no image of the spirit is placed in the shrine and pork is never part of an offering, contrary to Chinese spirit worship where the deity is always represented by a sculptural or pictorial image and pork is always part of the prayer offerings. Malay animistic belief is thus 'Sinicized'.

These three instances are illustrative of the extensive relaxation of differences in the daily lives of the nominally Chinese, Malays and Indians living in Singapore. As hybrids, these practices emerge in the interstices of the cultural boundaries of three ethnic groups; they emerge as consequences of contacts between cultures.[2] The insinuation of such hybrid practices pushes back ethnic cultural boundaries to create space for the inventions of new cultural phenomena.[3]

Hybridity in everyday life is sufficiently prevalent that it is signified locally by the term *rojak* culture. *Rojak* is a dish that mixes together rather disparate ingredients: the 'Chinese' version of which includes, at least, deep-fried dried bean curd, slices of raw pineapple, turnip and cucumber, a handful of cooked local vegetable called by its Malay name *kangkong* and bean sprouts, a pinch of banana flower – other ingredients, such as cooked cuttle fish slices, are added by

particular hawkers at their own discretion and taste – all tossed thoroughly with a dressing made of dense, strong smelling shrimp paste, tamarind sauce, and heaped spoons of crushed peanuts, sugar, and chili.

Divisions in state practices

There is no state without ideological interests which translate into generating, promoting and sustaining of cultural practices. Contrary to the ready emergence of hybridity in everyday life, the cultural activities promoted by the Singapore state are inclined to deepen divisions either through using existing differences or creating new ones. The following instances are illustrative of this tendency.

1 A compulsory curriculum in religious knowledge as moral education was introduced in 1982 as an effort supposedly to shore up the moral values of a population that is increasingly exposed to what ruling politicians perceived as potentially 'negative' foreign cultural influences. Each secondary school student was to study one of the following: Buddhism, Islam, Christianity and Hinduism, all scripture-based religions with fixed canons. This posed a problem for the large majority of nominally 'Taoists' among the Chinese. The Taoist label denotes not a religion as such but the syncretic, polytheistic and non-canonical practices which emphasize the performative features of rituals and are transmitted through oral traditions. This syncretism has enabled the Chinese to absorb the above mentioned *datuk gong* and worship in Hindu temples. Such 'unruly' syncretism is not subjected to any formal discourse and is thus administratively ungovernable. In its place, Confucianism, another canonical teaching, was introduced as a curriculum for children from Taoist families.[4] The introduction of the curriculum concurrently denied the existence of the above mentioned hybridity in religious practices and imposed clearly delineated religious boundaries which separate the population. Greater details on foreign influence, moral education and religious knowledge will be discussed later in the chapter.

2 In the same effort to combat 'negative' foreign influences, every student must enrol in classes in his or her so-called 'mother-tongue', in addition to English, which is the primary medium of instruction. The mother-tongue languages are defined restrictively along 'racial' lines: Chinese must study Mandarin, Malays study standard Malay and Indians predominantly study Tamil. (From now on, the term 'race' will be used instead of 'ethnicity' because it is the preferred term of the state.) 'Mother tongue' learning is meant both to help to secure the racial identity of students and to impart to them moral 'ballast' against foreign influences (Clammer, 1985; Purushotam, 1989). Crossing of racial/linguistic lines is discouraged. The potential for multilingualism which the school curriculum could have provided – one home language and two school languages – is eliminated.

So too is the potential for extending and reinforcing language hybridity in everyday life through multilingualism in schools. Consequently, as formal education spread, the hybridity of everyday language practices correspondingly declined. English has become the only language of inter-racial communication.[5]

3 After more than three decades of rapid capitalist economic growth since 1960, the social body is now economically stratified. Although there is now little abject poverty, about 20 per cent of the population can be classified as poor, in relative deprivation terms (Chua and Tan, 1995). To help these families, the government has sponsored the development of so-called 'community self-help' organizations. A very small sum of money, ranging between one to eight dollars, is deducted from the compulsory monthly social security savings of every working person as a contribution to these organizations. The collected funds are used to conduct both remedial classes for children and classes in skills upgrading for the adults of the families.[6] These organizations are divided along racial lines; each working individual's contribution is allocated to his/her 'racial community'.

The obvious and fundamental questions are: why is it necessary for the Singapore state to govern through insistence on divisions? If a Singaporean 'national' identity requires as a basic condition a 'forgetting' of racial differences among the population, how does this insistence, which apparently undermines the national project, coexist with strategies for the promotion of a national culture and identity?[7] To answer these questions, one needs to return to the conditions within which Singapore emerged as a nation.

Multiracialism as national policy

Singapore was a reluctant nation. Political independence was thrust on the population in 1965, when it was forced to leave Malaysia. With independence, a new arrangement between the races had to be worked out. The Chinese, though numerically dominant, were of migrant stock and morally had no exclusive proprietary right to the new nation. Furthermore the geopolitical condition of archipelagic Southeast Asia places them in a region of an overwhelming Malay-speaking population of Malaysians and Indonesians, who were unlikely to accept a Chinese nation in their midst with equanimity. On the other hand, the Malay population of Singapore, though regionally indigenous, was numerically a minority which was unable to dominate Singapore politics. Finally, the Indians were both migrant stock and in numerical minority. Given these conditions, 'multiracialism' as administrative principle appeared the most defensible and practical. Accordingly, Singapore was declared constitutionally a multiracial nation which 'protects' the Malays and Indians by formally denying the Chinese majority dominant status in all spheres of social life.[8]

As a national policy, multiracialism requires for its rationality a discourse of race, constituted by the multiple ways through which the ontology of race is discursively thematized and insinuated into the social body as a 'relevant' phenomenon, the better to rationalize strategies of social discipline. In Singapore, this discourse is so constituted: one's race is officially defined by patriarchal descent; a person's racial descent defines his or her 'culture' (multiculturalism); the racialized culture is assumed to be embedded in the language of the race which is assured continued existence through compulsory school instruction as the 'mother tongue' language of the student (multilingualism).

In this formulation of race/language/culture, differences among the population have been sharply reduced. In the case of language, for example, dialect differences which created sharp divisions among the Chinese, have been suppressed by the exclusive promotion of Mandarin as the 'language of the Chinese' in the mass media.[9] Language differences among Malays, Javanese, Bawaenease, and Arabic are officially ignored and the speakers of these languages are to 're-emerge' under a common formal 'Malay' language. Differences between Indians were initially eliminated by privileging Tamil, a south Indian language, as the 'race' language. Subsequently, in response to protests from other Indian language speakers, Hindi, Punjabi, and Bengali have been made available as official 'mother tongues'.

Overlapping religious affiliations and differences are also subjected to a process of simplification and symbolic representation. Malay as a 'race' is further defined by Islam; all Malays are by constitutional definition Muslims; Hinduism is identified with 'Indians', although less than 60 per cent of the people grouped under the 'racialized' group are Hindus, the rest are either Muslims, Buddhists or Christians; while religion is completely excluded as a marker of Chinese, whose religious affiliations are as varied as the Indians. This uneven overlapping of religion and ethnicity nevertheless facilitated certain pragmatic practices of 'religious equality'. For example, two annual public holidays are dedicated to Islamic (Malay) festivals, one each to Hinduism (Indian) and Buddhism (Indian and Chinese) festivals, two to Chinese New Year, which are religiously unmarked, and finally, two for Christians, Christmas and Easter, which are racially unmarked.

As the above administration of language and religion makes clear, a discourse of race is inscribed at the center of the 'culture' of Singapore. The boundaries of each 'racialized' group were redrawn and (re)enforced in order to attribute to each group a 'homogenized' existence. The multiple layers of race-cultural activities – both sponsored by the government and organized by the racialized groups themselves – have given rise to an impression that the 'cultures' of Singaporeans are frozen in three respective 'traditions'. The result is a generalized refrain, not only in official but also popular and academic discourses, that Singaporeans can be represented in a simple formula of 'CMIO' – 'Chinese', 'Malays', 'Indians' and 'Others' (Siddique, 1989). This is an impression very

much promoted by the state itself to achieve certain ideological and administrative effects.[10] Thus, whereas multiracialism as an abiding position could have encouraged hybridity as a means of representing multiculturalism, this is not to be. The opposite has taken hold.

Multiracialism and its effects

Multiracialism and the neutral state

The enforced separation of the population into bounded and homogenized races under official multiracialism has one immediate political effect. It enables the state to institute formal 'equality' between the 'races'. Through formal racial equality, the state is then able to see itself ideologically as an equal and disinterested protector of the rights of each group, within the boundaries of 'national' interests. The state, therefore, claims for itself a 'neutral' space above all racialized groups, without prejudice or preference.[11] This neutrality gives it a high level of relative autonomy to govern. The advantages to be derived by the state is best illustrated through the government's position *vis-à-vis* the numerically dominant Chinese population.

Non-identity of interests: state and majority-race

To preserve its relative autonomy, logically, the state must resist formal identification with the interests of the Chinese majority, even if practically the latter's interests cannot be ignored. Otherwise, its relative autonomy would be compromised. Formal neutrality enables the PAP government to erase the political space that it might have made available to the Chinese when the latter became discursively 'one' race with 'one' language. The government's racial neutrality formally suppresses the possibility of any Chinese chauvinistic attempt to transform their 'racialized majority' interests into 'national' interests.[12] This suppression is disclosed by a comment made by a conference of African leaders who were visiting Singapore. They were impressed by the absence of special privileges being granted to the Chinese majority and were convinced that a similar absence of privileges for the majority tribes would have been politically unacceptable in their own nations (*Straits Times*, 10 November 1993).

Thus, any conceptual reduction of the Singapore state to a Chinese state because of its majority population misunderstands the political character of the state. Similarly, the suspicion that promotion of Mandarin among the Chinese is at once an attempt to Sinicize Singaporean society and culture is misplaced, because to eliminate 'racial' differences is to eliminate one of the mechanisms of the government's instrument of social control.[13] The insistence on 'racial' differences provides the rationale for the state to police inter-racial boundaries. In the name of preventing 'race riots', sanctions are raised against anyone who

publicly raises social issues on the basis of race. The absence of inter-racial conflict since 1964 is read, locally, as the effect of both 'equal' treatment of the 'races' and stringent policing of their points of contact.

Internalization of racial differences and self-discipline

Such insistence of 'racial' divisions has the effect of forcing individuals who are interpellated into the 'races' to turn in on themselves and the 'racialized' problems they face. The institutionalization of this inward-looking process is evident. Certain social problems are racialized and each group is to find its own solution, if necessary, with the help of state agencies. This can be illustrated by focusing on Malays, the second largest race in Singapore.

For example, due to their statistical over-representation among drug addicts, drug addiction is increasingly being seen as a Malay problem. Malay community organizations are asked to contribute actively to assist in solving the problem within their community (*Straits Times*, 6 December 1994). Yet, taking the addicted population as a whole, drug addiction is overwhelmingly a problem among lesser-educated and lower-income individuals. That there is a higher representation of Malays is quite likely a result of the fact that Malays are over-represented in the lesser-educated population. A national conception of the problem and possible solutions should therefore be focused on issues of unequal distribution of incomes, instead of reducing it to a problem of the Malay race.[14] A second 'Malay problem' is their apparent relative economic position *vis-à-vis* other races. As a legacy of Singapore's history of development, Malays have ended up predominantly in the lower income strata (Li, 1989). As comparisons of relative wealth are unavoidable, Malays are exhorted not to compare their circumstances with the better positioned Chinese but to examine and compare their present circumstances with their own past, and finally, to discover for themselves the fact they have improved and should continue to develop self-help strategies towards higher achievement. This 'internalization' of economic disadvantage is 'encouraged', if not imposed, on the Malays for fear that cross comparisons with other groups may lead to inter-racial conflicts.

In such instances where the discursively constituted 'races' turned in on themselves, the opportunities for individual citizens to make direct claims on the state to ameliorate their difficulties are deflected. The case of the above mentioned 'self-help' agencies for respective races illustrates this tendency. Arguably, the establishment of three racially exclusive agencies to manage a set of social and economic problems which are common to lower-income households is both unnecessary and costly. Furthermore, the different sizes of the racialized groups have resulted in unequal distribution of assistance among the similarly needy, with the 'Indian' organization being least able to cater to its designated constituency (Rahim Ishak, 1994). Concerns of costs and substantive equality of care should be grounds enough to suggest that a national administration be

developed to manage the social problems of relative deprivation. However, this is resisted by the government because the self-help organizations leave the state much less encumbered by citizen's welfare claims, a great advantage in a globalized capitalist economy.[15]

Deflected from the state, what emerges, instead, are multiple layers of organized self-disciplining activities, which act to fortify and harden the boundaries of the discursively constituted races themselves, with often injurious effect on those who are at the boundaries of the 'races'. An example is the 'concern' expressed by Malay organizations regarding the conversion of Malay individuals to other religions. Converts often face serious psychological trauma from being cast as less than desirable Malays and the anxiety expressed by the Malay organizations is itself a reflection of the felt need to maintain group solidarity in a highly racialized social space.

Displacement of everyday life

Finally, the racialized cultural discourse displaces much of the substantive everyday life experience shared by all Singaporeans as a consequence of being part of a disciplined workforce subject to the logic of globalized capitalism.[16] This ideological displacement of cultural entailments of capitalism is managed through 'naturalizing' capitalism as both unavoidable and necessary to the physical survival of everyone. Its necessity is made manifest in its ability to fulfil not only the demand of 'making a living' of each citizen but, beyond this, the expansion of material comfort, as the desired realization of 'a full life' (Goh, 1976); a reality evidenced by the continuing economic growth over the last three decades. The population is placed in a position of no choice but to develop the necessary capitalist attitudes in order to survive. So formulated, the state seeks to avoid political stresses that would emerge if the effects of the rapid integration of Singaporeans into the global economy, such as increasingly apparent social stratification, were discursively thematized and thus politicized. As will be shown in the next section, the ideological trajectory of the Singapore state does not stop at naturalizing the attitudes towards capitalism but takes it into the space of the 'national'.

The discussion so far can be summarized: multiracialism, while seemingly giving race a rightful and prominent place in the public sphere, in practice reduces the political currency of race by undercutting its potential use as a basis of making claims on the state. Multiracialism and its attendant multiculturalism as national policy enable the state to place itself in a 'neutral' position above the discursively constituted 'races' and their respective cultures and derives for itself a high degree of relative autonomy in its exercise of power, while simultaneously insulating itself from claims of entitlement of the people as both racialized collectives and individual citizens. This is all the more effective when multiracialism may be invoked as one which 'protects' the rights and empowers the groups themselves both culturally and politically.

CHUA BENG-HUAT

Against the 'Westernization' of Singaporeans

A 'nation' requires a 'national' culture to substantiate its geographically delin-
eated boundaries. In Singapore, this is an acute issue because for the past three
decades of nationhood, the collective energies of the people have been directed
towards building the economy.[17] Economic success has undoubtedly imparted
to its citizens a sense of achievement and national identification. However,
economics alone is insufficient ground for the formation of a 'nation' and a
'people'. This was made obvious when a brief economic downturn in the
mid-1980s led to a significant rise in emigration to developed economies;
prompting a government minister to draw the analogy of Singapore as a five-star
hotel instead of home to some of its citizens. Multiracialism which enforces
racial bonds only makes the absence of a national culture more apparent.
National culture and identity must therefore be built on other grounds.

Since the 1970s, an abiding worry of the long-governing People's Action
Party (PAP) has been the corrosive effects of Western influence on Singaporeans
that come with economic modernization. It is convinced that the way to check
insidious Westernization is a deep inscription of traditional values in the social
body. As stated in 1971 by Lee Kuan Yew, Prime Minister from independence
in 1959 to 1990: 'We must give our children roots in their own language and
culture, and also the widest common ground through a second language . . .
[T]hen we shall become more cohesive a people, all rooted in their traditional
values, cultures and languages; but effective in English, a key to the advanced
technology of the West, from where all our new and more advanced industries
come' (*Straits Times*, 29 April 1971). The assumption being that the English-
educated, 'through knowledge of their "mother tongue", will obtain "cultural
ballast" enabling them to survive the supposed deracinating effects of
Westernization and "Western values"' (Koh, 1981:292). Hence, the earlier dis-
cussed 'mother-tongue' language education policy. Note that the space for a
'national' culture of a 'more cohesive people' remained unmarked in the Prime
Minister's statements. The cultural space of the multiracial nation was still con-
ceptually occupied by the side-by-side placement of the different races/cultures.
Nevertheless, the trope of 'Asian' as a re-presentation of 'traditions' and 'tradi-
tional values' and, ideologically more significantly, as the Other of the corrosive
West was already at hand.

There were, however, serious doubts in different circles concerning the sub-
stance and the authenticity of so-called 'Asian values' and their place in a
modern capitalist nation. For example, in a conference on 'Asian Values and
Modernization', held at the University of Singapore in 1976, the then minister
of foreign affairs, Rajaratnam wondered aloud whether such a thing as 'Asian
values' existed (1977); while Ho Wing Meng, then head of the philosophy
department, argued that what passed as Asian values 'were in fact responsible for
the economic and social backwardness of Asian nations, and too many proved
on closer examination to be superstitious, oppressive tradition and outmoded

194

custom, or otherwise quite fictitious' (Koh, 1981: 294). The Chinese language press was, however, in no doubt about what counted as Asian values: 'diligence, not attaching too great an importance to personal gains or loss, to be filial to one's parents and respectful to one's elders, to be thrifty . . . and be prepared to repay society . . . to be sympathetic to others' misfortune and sufferings and ready to give help'. Conversely, the press spelt out the so-called 'decadent' Western values that were to be avoided: 'individualism, hedonism and generally self-centred "antisocial" habits which undermined the Asian work ethic and group solidarity, thereby threatening the social fabric of the Asian society' (Koh, 1981: 294). To Koh, a university lecturer in English literature, the above listed 'Asian' values were 'wishful, communal and too narrow to serve or are, in any case, universal' (ibid.).

The hesitancy of English-educated Singaporeans to subscribe to an idea of 'Asian values' was thus met by the self-assured poise of their Chinese-educated counterparts, who were self-assured in conceptions of the content and the cultural and political significance of Asian values. This was symptomatic of a significant division within the Singapore Chinese population, indicative of the discursively constituted character of the so-called Chinese 'race'.

In addition to the already analyzed 'racialization' of Singaporeans, a number of ideological moves were emplaced with the above 'cultural' configuration of the social body in Singapore. First, the terms for defining the West as the Other, for 'demonizing' the West – excessive individualism as a result of the entrenchment of the idea of 'rights' in liberal ideology and hedonism through excessive consumerism, often supported by social welfarism rather than hard work; second, this demonization of the West and the search for a Singaporean national culture and identity were conjoined and, finally, Singaporean 'national' culture was to be grounded in 'Asian traditions'. In the 1990s, the absence of a 'national' culture is to be strategically and productively combined with the sense of cultural vulnerability to enunciate a national culture for Singapore through the idea of an 'Asian' nation, passing Confucianism *en route*.

Confucianism abandoned

In 1979, a ministerial review of the education system suggested that moral education be made a school subject because 'deculturalization brought about by the large scale movement to education in English' had led to the loss of 'the traditional values of one's people and the acquisition of the more spurious fashions of the West' (*Straits Times*, 15 March 1997). Lee Kuan Yew's response was: 'Confucianist ethics, Malay traditions and the Hindu ethos must be combined with sceptical Western methods of scientific inquiry, the open discursive methods in the search for truth; more specifically, students must be made to place group interests above individual interests' (*Straits Times*, 15 March 1979). Moral education was thus to be taught in secondary schools via 'religious knowledge'

in Christianity, Buddhism, Hinduism and Islam.[18] For Chinese who professed none of these religions, Confucian ethics was offered as a residual option.

Conjuncturally, the critique of individualism in Singapore coincided with American neo-conservative critiques of excessive individualism for undermining any meaningful sense of community and unity of collective purpose (Steinfels, 1979), leading to a general 'malaise' in the United States.[19] For example, In *Japan as Number One: Lessons for America*, Harvard sociologist, Ezra Vogel, who had until 1975 never 'questioned the general superiority of American society and American institutions' wrote, 'I found myself, like my Japanese friends, wondering what had happened to America' (Vogel, 1979: iiiv). Concerned Americans were advised to look East, especially to Japan and the newly industrializing economies of Hong Kong, Taiwan, South Korea and Singapore, for lessons that might help to heal America of its apparent economic and cultural malaise.[20]

In the search for an answer for the rise of capital in Asia, a summary judgment of neo-conservative academics was that the 'cultural' factor was an essential ingredient for the success. As Berger argues, 'it is inherently implausible to believe that Singapore would be what it is today if it were populated, not by a majority of ethnic Chinese, but by Brazilians or Bengalis – or, for that matter, by a majority of Malays. Specific elements of Chinese culture have contributed to the economic success of the city-state; they have given it a comparative advantage – no less, but also no more' (Berger, 1987: 166). The 'Chinese cultural elements' were distilled to a single source, neo-Confucianism (MacFarquar, 1980). Confucianism was consecrated to a role akin to that of Protestant ethic in the rise of capitalism in the West (Tu, 1991). This argument was quickly picked up by the PAP government.

What followed was an example of the process of mutual benefit between the institutionalized production of knowledge and the exercise of power. Academic 'knowledge' lends legitimacy to the government's attempt to inscribe 'Confucianism' as the essential 'nature/truth' of the Chinese. To revitalize this 'truth' through education, the government provided resources to further the investigation and accumulation of knowledge of Confucianism. Indicative of the absence of Confucian tradition in Singapore, overseas scholars, primarily expatriate Taiwanese scholars in the US, were engaged not only to develop teaching materials but also to extend Confucian teachings to the entire Chinese population through pubic lectures. A well-endowed Institute of East Asian Philosophy was established to bring the best in the tradition to conferences and research.[21]

In 1982, along with other religious knowledge classes, Confucian Ethics was introduced as a course in moral education. It was poorly subscribed. By 1989, its 17.8 per cent enrolment of all eligible Chinese students compared poorly with 44.4 per cent in Buddhist Studies and 21.4 per cent in Bible Knowledge (Kuo, 1992: 17). Non-Chinese students were totally absent. The greater appeal of established religions indicated again the absence of Confucianism as a foundational idea in the daily life of the Chinese in Singapore.

Meanwhile, the findings of a government-commissioned study on religion implicated the Religious Knowledge courses in intensifying religious fervor and religious differences among students, and possibly in the long term, contributing to inter-religious/racial conflicts (Kuo *et al.*, 1988). Apparently heeding the warning, Religious Knowledge courses were phased out by 1990 and with them, Confucian Ethics. Beyond the school curriculum, belief in the significance of Confucianism as the cultural foundation of so-called 'East Asian capitalism' was also weakening. With the retirement of its first Confucian scholar-director in 1989, the Institute of East Asian Philosophy was renamed the Institute of East Asian Political Economy with its research focus redirected accordingly.

The attempt to entrench an elaborate Confucian philosophy in the ideological landscape of Singapore had failed and been abandoned but its spirit was resurrected and re-adorned in a different guise, within the government's persistent perception of the presence of a 'moral crisis' due to Westernization.

Asianization and its effects

As institutions of state-sponsored Confucianism were being dismantled, the government called for the institutionalization of an explicit 'national ideology'. The new Prime Minister, Goh Chok Tong, initiated the process by referring to the book, *Ideology and National Competitiveness: A Study of Nine Countries*, co-edited by George Lodge and Ezra Vogel (1987). Its thesis is that a nation's economic competitiveness is affected by whether its people are relatively more 'individualistic' or 'communitarian'; the dominance of communitarianism explains why the East Asian capitalist nations could catch-up with the industrial West in a brief two decades. Goh noted, 'Like Japan and Korea, Singapore is a high-performance country because we share the same cultural base as the other successful East Asians, that is, Confucian ethics' (Goh, 1988: 15), now radically reduced to a single dimension; 'communitarianism'. However, according to him, Singaporeans have been shifting increasingly towards individualism, the code-word for Westernization, risking decline in economic competitiveness. To counter this shift, a parliamentary committee was appointed to develop a 'national ideology'.

In January 1991, a White Paper on Shared Values was tabled in parliament. The term 'ideology' was replaced to eliminate any Marxist and/or communist ideological baggage. The White Paper states that the institutionalization of these values is 'to evolve and anchor a Singaporean identity, incorporating the relevant parts of our varied cultural heritages, and the attitudes and values which have helped us to survive and succeed as a nation' (1991: 1). The five Shared Values are: nation before community and society before self; family as the basic unit of society; regard and community support for the individual; consensus instead of contention, and racial and religious harmony. One should note readily the privileging of the collective at each successive level of social

organization. This privileging is represented by the government as the distilled 'essence' of the 'communitarian cultures of Asia'. Its enshrinement as the 'national ethics' presents Singapore as an 'Asian' nation with a 'national' culture that values consensus and communitarianism.

It may be ironical that the smallest nation in Asia should present itself as a representation of the world's largest continent and that its political leaders should be among the most vocal in defining the essential 'Asian' values.[22] Yet in many ways it is well disposed to do so. First, with a per capita income only after Japan, it may be considered economically most successful among the 'new' nations in Asia. Second, by virtue of its constituent Chinese, Malay and Indian population, Singapore is well-placed to present itself as the inheritor of three major Asian traditions – Chinese/Confucian, Malay/Islamic and Indian/Hindu-Buddhist – and thus as a suitable site for distilling the cultures of Asia to their common essence.[23] Finally, in self-interest, it is of strategic economical and political importance for Singapore to insert itself into a larger piece. Asia may not need Singapore, but Singapore needs Asia.[24]

With 'Asianization', the ruling PAP has arrived at a new threshold of ideological/discursive rationalization. 'Consensus' and 'communitarianism' now serve as the outer limits of politics; they require as their 'reality' the self-reduction of demands by parties in contention in the name of the 'national (collective) interest'. For example, industrial relations is governed by the communitarian ideology of 'tripartism' of employers, employees and the state. In the interest of uninterrupted production, guidelines for annual wage increases are set by a National Wage Council, which apportions profit to capital and wage increases to labor within the larger national economic scenario. Similar logic applies in race and class relations, where the economically disadvantaged are discouraged from comparing themselves with the advantaged, lest the inequalities be politicized and political stability in the nation jeopardized. Any politicization of inequalities is labeled as 'politics of envy', attributing unbecoming civic behavior to the disadvantaged, rather than recognizing them as individuals with legitimate complaints.

In all these instances, the state again places itself in a 'neutral' space above contending groups; its neutrality is supposedly made manifest in its strategic interventions which ostensibly take care of the 'national/collective' interests. 'Asianization' thus reinforces the Singapore state's claim to administrative 'neutrality'; the authority of the state is thus fortified by Asianization.[25] Such is the current turn in the ideological formation of the Singapore state, which must be seen as a temporary closure rather than the end-point in the framing of a 'national' identity.

Conclusion: a return to culture

Being a new nation-state, state formation processes are still very active in Singapore. State activities are pervasive and analytically captivating.

198

Consequently much of the existing analysis is focused on them, often with the tacit assumption that these activities always achieve their desired results. Looking exclusively at the political institutional structure, the PAP government therefore appears to be a monolithic authoritarian enterprise in full hegemonic control of the population (Rodan, 1992; Wong, 1991).

We need to venture into the non-coordinated realm of everyday life where the effects of the ideological moves of the state are felt and responses generated to lift part of the veil of the tacit assumption. In this realm, the idea of 'Asianness' seldom feature in mundane lives of individuals. Furthermore, their activities often constitute ways of escaping the ideological formulations of the state. Given that individuals do not consciously coordinate their mundane activities with the macro-economic and political structures that govern national and global levels, it is difficult to organize the following points in an analytically self-consciously structured fashion. For convenience, different income groups are used to roughly organize the observations.

One popular response to the pervasiveness of the state is the different ways of 'privatizing' life by individuals with different incomes. At the bottom are those who have to expend an overwhelming amount of their energy in 'making a living', a concern that defines their daily life. Already inarticulate but further silenced and denied the space for complaints by the so-called 'politics of envy', a significant number made their uncoordinated presence felt in the ballot box at the general election in 1991. The result was that the PAP lost three additional seats in its almost absolute dominance in Parliament. Voters in these constituencies, residing in the public housing estates and supposedly grateful to the PAP government for quality shelter, voted for the opposition to protest their economic conditions rather than in favour of communitarian concerns.

High income individuals have the 'privilege of wealth', common in global capitalism. They can pay all the taxes levied on them, educate their children abroad, be avid consumers of excessive luxuries, purchase foreign residency or citizenship; in short, they can escape all the clutches of the state. For these 'globalized' individuals, concern for the Singapore state and its practices is just another matter of personal preference and they appear on the whole not to be interested. This is reflected in the PAP government's radical increase in remuneration packages for politicians in office, in the hope of inducing or enticing the privileged into politics.

It is in the middle-income level where a multiplicity of responses can be found. Here, artists are the most articulate, among whom dramatists are most directly critical.[26] There are two notable developments. First, is the staging of multilingual plays, including the prevalence of Chinese dialects, with English subtitles being flashed on an unobtrusive small screen at the upper corner of the stage. A hybridity of tongues protests the eraser of collective memories effected by the elimination of Chinese dialects from the public sphere; the prevalent use of dialects inverts the primacy of English in the political hierarchy of languages.

Second, is the use of 'Singlish', a speech style that is grammatically and

lexically a mixture of English and largely, but not exclusively, Hokkien, the dominant dialect among the Chinese in Singapore. This is a confrontation between 'hybridity' and 'purity'. The use of Singlish in some local television entertainment programs, including advertisements, has been proscribed by the government. On the other hand, once used by the educated to put down the lesser educated, Singlish has emerged as a preferred medium in local plays. In the mundane sphere where it has always been a means of expressing informality between friends, Singlish has also correspondingly gained popularity. These 'rojak language' plays are directly political, the more so because they are subject to state censorship by the Ministry of Information and the Arts, without being of organized politics.

Outside the artistic space, livelihood dependence either on licenses to practice or on contract work with state agencies reduces the space for professionals to respond publicly to state activities. Among these most highly educated individuals, privatization often intensifies alienation not only from the highly centralized state but also from the 'self'. Absence of opportunity to partake in public debates makes the illusion of citizenship – that one's existence as a citizen should matter to the larger picture of the nation – painful to bear. Under such conditions, allegiance to the state is perhaps one of pragmatic convenience. When it can no longer be borne, some will begin to seek a public voice in the press.

A recent instance involves a locally well-known short story writer, Catherine Lim, who wrote on two separate occasions, full page critical political commentaries in the national press. One commented on the 'affective division' between the government and the population; the other on the apparent 'differences' between the two personal styles of the prime minister and his predecessor who remains highly influential in cabinet. Both the gesture and the content were quite out of expectation and equally out of sync with her morally conservative short stories. The commentaries, in prose that is more eloquent than most Singaporeans are able to master, articulated some of the commonly held feelings among Singaporeans.[27] The commentaries drew 'firm' responses from the prime minister. He read the commentaries as undermining the authority of his office and repeated the government's position that those who desire to make such commentaries should join a political party and take public responsibility for their words. Public resonance to the unexpected commentaries from an unlikely source was obvious in the letters to the press; all objected to the prime minister's response (*Straits Times*, 6 December 1994).

The government's preference that commentators join political parties is simple: political parties operate within delimited institutional space and are readily policed by the rules of oppositional politics; while individual commentaries are both political and troublesome. They are political because they are personal comments on the way one is governed as a citizen, a politicized self. Nevertheless, although personal, such comments are aimed at drawing resonance with prevailing but silenced sentiments among fellow citizens. This is part

of the 'print' that is central to the 'imagined nation' (Anderson, 1983). They are troublesome because they are unpredictable both in sources and contents. Lim's case elucidates all the random features of individualized politics. The randomness makes it difficult for the state to respond at the multiplicity of loci; yet respond it must or it would be tantamount to conceding to the critic. Also, randomness protects individual commentators from disciplinary action of the state because as individual statements they harbour no interest in taking over state power. Again, such commentators are political without being *in* politics. The multiplication of these individuals and their commentaries is, clearly, a strategy in expanding the political sphere, and an index of the expansion.

Away from political commentaries, another area where the concerns of the state are displaced by mundane activities is in consumption behaviour. Having no natural resources, the Singapore state sees high savings rate as a foundation stone of its economic well being. The result is that Singapore has one of largest foreign reserve funds in the world. Forty per cent of the monthly income of each worker is extracted compulsorily into a government-managed social security fund. Further private savings are encouraged by heavily restricting consumer credit through control of credit card issues and policing of advertisements that encourage 'excessive' consumerism, in spite of the fact that to protest against consumption in a capitalist economy is a logical contradiction and a losing battle in the long term.

The brunt of this constraint and complaints on consumerism are levelled at the young. Nevertheless, the young appear to be learning quickly to use the credit facilities that banks are only too happy to provide; for example, university undergraduates take 'study' loans to purchase designer goods and holidays abroad (*Straits Times*, 13 December 1994). Even without credit facilities, the estimated potential consumer spending of teenagers in Singapore currently stands at about $450 million a year. Because of limited land, cars and private houses are prohibitively priced and out of reach for most families. Consequently, the body has become the locus of consumption, particularly for the young where the need to own a house is still far on the horizon of possessions. The visibility of consumption on the body only leads to further condemnation of 'excess' by the guardians of thrift. Against the background of an unceasing exhortation to save, such behaviour is political without necessarily having subjective intentions.

The above instances, among others, exemplify that daily life is, without conscious organization, seeping constantly out of the monolithic ideological and managerial structure of the Singapore state. None of the activities refer to the 'Asian' identity which the government is attempting to inscribe on the social body. Perhaps, the 'Asian' identity is one that the state requires to rationalize its own activities to itself. The activities in everyday life do not add up to an inversion of society over state but they certainly create more civic and political space than is commonly assumed. Nor is there in these activities necessarily a desire among Singaporeans to change the ruling government; a desire which democratic critics would like Singaporeans to have. Most citizens appreciate the

economic skill of the PAP government and, by and large, are willing if not happy to let it continue as economic managers, but would prefer greater room to exercise their personal preferences regarding the relevance or otherwise of organized politics. This instrumental pragmatism, although irksome to the PAP government, is one it well understands.

Notes

1 For a thorough and critical discussion of the postcolonial discourse, Third World nations and global capitalism, see Dirlik (1994) and Chen (1996).
2 The more emotive term 'race', rather than 'ethnicity', is used here because it is the preferred term of the Singapore government.
3 This discussion on hybridity and interstices is heavily distilled from the complex text of Homi Bhabha (1994).
4 It should be noted that the curriculum in religious knowledge was removed in 1990 when it was discovered that the curriculum had led to greater religious commitment among individual students and the hardening of religious divisions between them (Kuo et al., 1988).
5 However, local language practices cannot be erased without a trace. What has emerged is a language called 'Singlish', which contains deviations in grammar, in syntax and lexicon from 'standard' English (Bloom, 1986; Pennycook, 1994).
6 In addition, the government will provide to poor households who have less than $1200 monthly income, a grant of $30,000 to enable them to purchase a two-bedroom public housing flat. It should be noted that all government subsidies are distributed within an 'anti-welfare' ideology. Consequently, to reduce the needy families' discretion in using the subsidies, no cash is given directly to the families, subsidies are managed as inter-agency transfers within the government (Liew, 1993).
7 On 'forgetting' as a necessary process in the formation of nations see Ernest Renan, 'What is a nation?' in Homi K. Bhabha (ed.) Nation as Narration (1990) London: Routledge, pp. 8–22.
8 Accordingly, political parties in Singapore have always been multiracial in composition. The single exception is a small Malay party which is a legacy of the days in which Singapore was part of Malaysia; it is a left-over of the United Malay National Organization, the ruling party in Malaysia. In any case, even this exclusive party is looking for ways to become multiracial.
9 Reflecting the multiracialism policy, Mandarin in Singapore is known as the 'language of the Chinese' (huayu), in contrast to being known as the 'national language' (guoyu) in Taiwan and 'the common language' (putonghua) in the People's Republic of China (Chun, 1994).
10 From an anthropological viewpoint, this impression may be considered to be seriously mistaken (Benjamin, 1976; Clammer, 1985).
11 The position of the state under multiculturalism appears to be generalizable to other states that have multiculturalism as an official policy; see for example, McLellan and Richmond (1994).
12 Exactly the opposite strategy is developed in neighboring Malaysia, where the political dominance of Malays and other 'indigenous' peoples are constitutionally guaranteed.
13 Besides, as Clammer (1985) points out, the insistence that a Singaporean's culture is defined in terms of race along patrilineal lines excludes by its logic the possibility of assimilation into another race/culture.
14 An interesting counter to this reduction is given by the prominent Malay sociologist,

Syed Hussein Alatas. He argues that on the basis of statistical reasoning, then, murder is a Chinese problem, since most people who are convicted of murder in Singapore are Chinese.

15 This should, of course, lead us to the issue of 'welfarism' in Singapore which has been taken up elsewhere see Chua (1991) and Castells (1988).

16 Ironically, evidence of the overwhelming significance of this emergent culture of capitalist industrialism can be readily found in both self-congratulatory celebration of the 'new' Singaporean (Thumboo, 1989) and conversely, in conservative critiques of the same 'new' Singaporean as mindless consumers in a 'cult of materialism' (Ho, 1989).

17 Faced with 'racial' plurality, the political leaders chose to construct 'a pragmatic identity with development and economic success as the symbols of identification' (Chan and Evers, 1978). The sense of the urgency to develop a national culture is evident not only in the formation of a National Arts Council and the construction of a National Arts Centre but also in 'recoveries' of the past by voluntary initiatives, such as a national heritage 'hunt' conducted by the Heritage Society and month-long activities with 'memory' as theme, including a conference on 'Our Place in Time' aimed at rethinking the history of Singapore, in the alternative arts space, the Substation in September, 1994.

18 'Religious knowledge' classes were meant to translate theology to moral education, it was religion without god.

19 According to the neo-conservatives, the claims to individual rights in liberal democracy and 'the self-seeking hedonism of the consuming masses . . . leaves modern society without a set of meanings to ground the spirit of civic sacrifice needed to sustain a liberal polity burdened with increasing (social welfare) responsibilities' (Steinfels, 1979: 162).

20 Others like Robert Bellah and his students looked deeper into the US itself to recover the community and the communitarian spirit in the everyday life of ordinary Americans (Bellah, et al., 1985).

21 For details of this process see Chua (1995, chapter 7).

22 Among the more vocal Singaporeans who espouse this position is Kishore Mahbubani, Singapore's Permanent Secretary of Foreign Affairs, for example see Straits Times, 16 September 1994.

23 Malaysia, which has similar constituent racial groups, could have represented itself in similar ways. However, the Malays have laid claim to being indigenous to Peninsular Malaya, thereby rendering Malaysia a Malay nation, where Malay political dominance is irreplaceable. Furthermore, given the religious identity of Malay with Islam, the Malaysian leadership is keen to establish its own niche to represent the much larger, global Islamic nation.

24 Symbolically, perhaps, for Singapore to present itself as a representative of the entire Asian continent is a move of self-elevation of status in the international forum that is available only to small states. Any large country to do so would obviously be charged with harboring imperialist desires; thus the economic presence of Japan in Asia has often been read as reviving its Second World War imperialist ambition of developing an 'Asian co-prosperity sphere' with itself as the centre.

25 It should be noted that the authority of the state is also fortified by the intrinsic elements of Confucianism, such as acceptance of hierarchical order, respect for authority of elders and political leaders, and finally, the affinity of 'organicist' ideology with authoritarianism.

26 In November 1994, the first explicit political farce was staged, re-enacting the 1987 detention of a group of young social workers by the Internal Security Department. 'Undercover' is written by a young journalist, Tan Tarn How and staged at the Black Box Theatre by the professional company Theatreworks.

27 Catherine Lim, 'The Great Affective Divide' *Straits Times* (3 September 1994) and 'One government, two systems', *Straits Times* (20 November 1994).

References

Anderson, B. (1983) *Imagined Communities: Reflections on the Origin and Spread of Nationalism*, London: Verso.

Bellah, R., Madsen, R., Sullivan, W.M., Swindler, A., and Tipton, S.M. (1985) *Habits of the Heart*, Berkeley: University of California Press.

Benjamin, G. (1976) 'The cultural logic of Singapore's multiculturalism', in R. Hassan (ed.) *Singapore: Society in Transition*, Kuala Lumpur: Oxford University Press.

Berger, P. L. (1987) *The Capitalist Revolution*, Hants, England: Wildwood House.

Bhabha, H. (1994) 'The commitment to theory', in *The Location of Culture*, London: Routledge.

Bloom, D. (1986) 'The English language and Singapore: a critical survey', in Basant K. K. (ed.) *Singapore Studies: Critical Surveys of the Humanities and Social Sciences*, Singapore: Singapore University Press.

Castells, M. (1988) 'The development of a city-state in an open world economy: the Singapore experience', BRIE Working Paper No.31, Berkeley: University of California Press.

Chan, H. C. and Evers, Hans-Dieter (1978) 'National identity and nation building in Southeast Asia', in P. S. J. Chen and H. D. Evers (eds) *Studies in Asean Sociology*, Singapore: Chopmen.

Chen, K. H. (1994) 'The imperialist eye', *Taiwan: A Radical Quarterly in Social Studies* 17: 149–222.

—— (1996) 'Not yet the postcolonial era: the (super) nation-state and transnationalism of cultural studies', *Cultural Studies* 10: 37–70.

Chua, B. H. (1991) 'Not depoliticized but ideologically successful: the public housing program in Singapore', *International Journal of Urban and Regional Research* 15: 24–41.

—— (1995) *Communitarian Ideology and Democracy in Singapore*, London: Routledge.

Chua, B. H. and Tan, J. E. (1995) 'Singapore: new configuration of a socially stratified culture', Working Paper No.127, Department of Sociology, National University of Singapore.

Chun, A. (1994) 'From nationalism to nationalizing: cultural imagination and state formation in postwar Taiwan', *Australian Journal of Chinese Affairs* 31: 49–69.

Clammer, J. (1985) *Singapore: Ideology, Society and Culture*, Singapore: Chopmen Publishers.

Dirlik, A. (1994) 'The postcolonial aura: Third World criticism in the age of global capitalism', *Critical Inquiry* 20: 328–54.

Goh, C. T. (1988) 'Our national ethic', *Speeches* (Ministry of Information and the Arts, Singapore) 12: 12–15.

Goh, K. S. (1976) 'A socialist economy that works', In C.V. Devan Nair (ed.) *Socialism that Works*, Singapore: Federal Press.

—— (1979) *The Goh Report*, Singapore: Ministry of Education.

Ho, W. M. (1989) 'Values premises underlying the transformation of Singapore', in K.S. Sandhu and P. Wheatley (eds) *Management of Success*, Singapore: Institute of Southeast Asian Studies.

Koh, T. A. (1981) 'Cultural development in Singapore', *Southeast Asian Affairs 1980*, Singapore: Institute of Southeast Asian Studies.

Kuo, E. C. Y. (1992) 'Confucianism as political discourse in Singapore: the case of an incomplete revitalisation movement', Working Paper no. 113, Department of Sociology, National University of Singapore.

Kuo, E. C. Y., Quah, J. and Tong, C. K. (1988) *Religion and Religious Revivalism in Singapore*, Singapore: Ministry of Community Development.

Li, T. (1989) *Malays in Singapore: Culture, Economy and Ideology*, Singapore: Oxford University Press.

Liew, K. S. (1993) *The Welfare State in Singapore*, Unpublished Master of Social Science Thesis, Department of Sociology, National University of Singapore.

Lim, C. (1994a) 'The great affective divide', *Straits Times*, 3 September.

—— (1994b) 'One government, two styles', *Straits Times*, 20 November.

Lodge, G. and Vogel, E. (1987) *Ideology and National Competitiveness: An Analysis of Nine Countries*, Boston: Harvard Business School Press.

MacFarquar, R. (1980) 'The post-Confucian challenge', *The Economist* February 9.

McLellan, J. and Richmond, A. (1994) 'Multiculturalism in crisis: a postmodern perspective on Canada', *Ethnic and Racial Studies* 17: 662.

Pennycook, A. (1994) *The Cultural Politics of English as an International Language*, London: Longman.

Purushotam, N. (1989) 'Language and linguistic policies', In K.S. Sandhu and P. Wheatley (eds) *Management of Success*, Singapore: Institute of Southeast Asian Studies.

Rahim Ishak, L. Z. (1994) 'The paradox of ethnic-based self-help groups', in Derek, D. C. (ed.) *Debating Singapore*, Singapore: Institute of Southeast Asian Studies.

Rajaratnam, S. (1977) 'Asian values and modernization', In Seah C. M. (ed.) *Asian Values and Modernization*, Singapore: Singapore University Press.

Rodan, G. (1992) 'Singapore's leadership in transition: erosion or refinement of authoritarian rule?', *Bulletin of Concerned Asian Scholars* 24: 3–17.

Siddique, S. (1989) 'Singaporean identity', in K. S. Sandhu and P. Wheatley (eds) *Management of Success: The Moulding of Modern Singapore*, Singapore: Institute of Southeast Asian Studies, pp. 563–77.

Steinfels, P. (1979) *The Neoconservatives*, New York: Simon and Schuster.

Thumboo, E. (1989) 'Self-images: contexts for transformations', in K.S. Sandhu and P. Wheatley (eds) *Management of Success*, Singapore: Institute of Southeast Asian Studies.

Tu, W. M. (1991) *The Triadic Chord: Confucian Ethics, Industrial East Asia and Max Weber*, Singapore: Institute of East Asian Philosophy.

Vogel, E. F. (1979) *Japan as Number One: Lessons for America*, Cambridge, Mass: Harvard University Press.

Wee, V. (n.d.) 'Secular state, multi-religious society: the patterning of religion in Singapore'.

Wong, L. (1991) 'Authoritarianism and transition to democracy in a Third World state', *Critical Sociology* 18: 77–101.

10

THAI POP MUSIC AND CULTURAL NEGOTIATION IN EVERYDAY POLITICS

Ubonrat Siriyuvasak

The analysis of popular music[1] presented in this chapter offers an illustration of my general argument that popular culture is a relatively open arena in which a variety of discourses are played out simultaneously. My view is that the production of meaning in pop music or rock n'roll is neither the consequence of total manipulation from the music industry, nor is its cultural expressivity the sole result of historical resistance, as (sub-)culturalists or most commentators argue. Instead, this chapter subscribes to Aiewsriwong's (1985) notion that Thai popular music, and particularly Pleng Luktoong, is the product of a complex articulation between Thai folk music and Western pop/rock. My analysis therefore, focuses on the ideological interface in this innovative synthesis. The central question is, how are sensual pleasure and everyday politics accommodated or resisted within this arena? The former contradicts the Buddhist ethos of piousness and sensual restriction, whilst everyday politics is closely regulated by both the state and the music industry.

As opposed to most commentators in the sociology of music who investigate either the lyric or the imagery of pop stars, I propose to explore both since it is their combination which forms the discourse of pop and rock. How then, are lyrics and music juxtaposed? In the standardized formulas, are they always harmonized? Are there instances of contradictions between the forms and contents and the overall imagery? Or perhaps there are fragmented imageries within which several layers of encoding are interwoven. And finally, is there a certain degree of openness which allows for different appropriation by audience members?

'Pleng Luktoong': forms of pop resistance and accommodation

Before we embark on the analysis of 'Pleng Luktoong' a brief sketch of the contemporary pop scene is called for. Thai popular music was conceived largely during the era of 'cultural modernization' and popularized on state radio in the

1940s. In its adoption of the Western system of musical scores and notation it broke with the classical court music of the *ancien régime*. This *dontri sakol* or modern music forms the bedrock of contemporary Thai popular music. However, the standard Thai form of dancing, *ramwong*, designed to accompany the new music continues to draw on the graceful and restrictive physical movement of court dancing. This constitutes the official definition of sensual pleasure. But I shall come back to this point later.

The social categories of Thai popular music

Although Thai popular music generally represents a synthesis of Western pop/rock, and folk, and ballad, the emergence of the four main genres: the Lukkroong, Luktoong, String and Pleng Pua Chiwit, have allowed particular social groups to realign the power relations within this cultural field. For example, while Lukkroong continues to represent the official bourgeois notions of romance and sensual pleasure, the other genres align themselves with the social and political opposition of these.

The initial categorization of Thai popular music into Luktoong and Lukkroong coincided with the introduction of television and the entrenchment of militarism in the 1960s. The folk styles of 'Pleng Chiwit' or 'Pleng Chaobaan', were incorporated into the new music, and the stories of the common people were presented with a romantic nostalgia for the village community and its values (Nawikamoon, 1978; Siriseriwan, 1984). Among them however, were songs depicting the harsh reality of peasant life and celebrating their class integrity: *Tung Ruang Thong* ('The Golden Field') and *Klin Klon Sab Kwai* ('Muddy Odor and Stinking Water Buffalo'), for example. The artists insistence on presenting the 'other' reality of Thai society produced the dichotomy of Luktoong/Lukkroong, the names quite literally contrasting the country (*toong*) with the city (*kroong*). But more importantly, it refers to the social division of the audience into the poor and the elite, as much as to the contrast in musical forms.

Luktoong's opposition to the romantic view of the world of the elite is constituted through its synthesis of traditional popular art forms and topical and realistic lyrics. Pleng Luktoong borrows from these lyrical structures the style of humor and satirical expression. As a separate genre, it redefines sensual pleasure by juxtaposing folk ballads and the rhythmic popular forms of Lamtad, Pleng Rua, Pleng Puangmalai for example, with the popular discourse of everyday life. A large number of the love songs mix the prominent Luktoong and pop/rock music with folk style lyrics which talk about sex as pleasurable as well as normal. However, it is the singing which is distinctively different from Lukkroong. By slurring their notes and words, Luktoong singers represent their class background and oppose the elite parole designated as the national Thai language.

'Pleng Pua Chiwit' emerged in the late 1960s among the Left. It was

influenced by the anti-establishment American folk-rock represented by Bob Dylan and Joan Baez. Their social and political commentaries were mostly accompanied simply by acoustic guitar, with occasional insertions of mouth organ or Thai flute. Its celebration of the poor and the marginalized social groups on the other hand, draws from the Luktoong genre. By contrast, Pleng Pua Chiwit is highly intellectual and politically forthright. In effect, the genre is banned from the radio though distribution is possible via audio cassette and live performance on university campus. Caravan, the most prominent group, joined the Communist Party of Thailand along with thousands of Left students and intellectuals in the aftermath of the student massacre in 1976. Their revolutionary songs, which incorporate ethnic tunes and local instruments, are broadcast on the underground VOPT.

Although the middle-class youths who tuned in to the Anglo-American pop/rock located themselves within the Lukkroong category, they regarded the music as 'old fashioned' and 'dull'. In the 1960s and 1970s, young musicians began to mime to rock stars such as Elvis Presley and Cliff Richard and the Shadows and 'The shadows' became the generic name for rock bands. This was transformed into 'String', a new genre of pop/rock with Thai lyrics, in the 1980s. Within this category however, there was a wide range of music, from teeny-bopper to hard rock as well as a divergence in their discourses.

In the 1980s, Pleng Luktoong continued to be located on the AM band whilst the other three genres and Anglo-American pop/rock were played on the FM stations, although the latter was also broadcast on some AM stations. Having said this however, the music industry of the 1980s was vibrant and its audience was highly sensitive to the fluidity of these genres. As will be demonstrated in more detail presently, Luktoong is moving from its established singing tradition towards the performance style of Western rock stars. On the other hand, Pleng Pua Chiwit is seeking a new identity. Its hard-hitting criticism and socialist utopia has been romanticized and diluted to suit the new era of political accommodation.

In fact, the categorization of popular music noted here can only provide a crude guideline. Any rigid conception is quickly outmoded in this shifting cultural field. The music of the group Carabao for example, was created from a number of styles. Its popularity in the mid-1980s was based on a successful synthesis of music and lyrics that cut across divisions of form. They celebrated the common people in the Luktoong tradition but within a rock music framework, some of which was hot dancing music for the discotheques. At the same time it also combined Pleng Pua Chiwit's intellectual style with Luktoong's humor and satirical tunes.

Critics however, were unable to fit this music into any of the existing categories. Some were reluctant to call these songs Pleng Pua Chiwit. For the more purist critics, Carabao are too sensual and commercialized. At the same time, from the Establishment point-of-view, the band's political position and imagery is ambivalent and suspect. In their ragged mock-military uniforms

and hippy hair styles they campaigned for the leaders of the 1983 coup in the 1984 general election, for example. For the Luktoong DJs and their audience, the style and background of Carabao diverge so far from the Luktoong genre that it is necessary to view the group as having a unique form of its own. For the state, their usage of local dialects and bold images of sexual desire, was a constant threat to the nationalist and moralist ethos. Some of the Carabao's songs were therefore banned from being broadcast.

Luktoong music and performance: regulation and contention

In the age of 'mechanical reproduction', Thai popular art forms have been transformed. On the one hand, folk music is privatized by the music and broadcasting industries. On the other, its oppositional discourse is incorporated into the new form of Pleng Luktoong. In this synthesis, the definitions of sensual pleasure promoted by the music industry and by the traditional popular art forms, converge on the notion of 'jouissance' or bliss (Barthes, 1975). The presentation of sensual rhythms in the music or lyric or a combination of both offers 'physical' pleasures as opposed to the 'intellectual' pleasure of Lukkroong. They require the audiences' active involvement rather than passive consumption. The following advertisement for Azona's cassettes sums up the music industry's notion of pleasure, 'good songs, loud music, sensual and entertaining, your happiness is provided by us in the tapes'.

The industry's promotion of sensual pleasure was largely mediated by radio and television. For the Luktoong show bands and their audiences however, public performance continued to be the highlight of popular entertainment. As Prani Wongtes (1984) argued, popular festivities, be they religious or social, generally culminated in an explosion of 'sensual pleasure'. Sexual desire and opposition to paternalism for example, are often played out in these open but socially designed arenas. During the past decades, the Luktoong show has been integrated into these celebrations and sensual explosions. But how does this new popular art form present itself in this complex matrix?

The structure of the show, a combination of glamorously staged revue and comical and sexual folk vaudeville, is designed to fulfill the ideals of pleasure demanded in popular entertainment. The rhythmic gyrations of the women dancers or *haang kruang* (literally the minors) in their sexy costumes, is the culmination of the show's visual pleasure. The *haang kruang* dance is in the style of the can–can or modern Western styles which are regarded as the most sensual in the Thai social context. This presents a challenge to the official, restrictive definition of physical pleasure.

Since the Luktoong show is mostly staged in temple grounds, religious regulation ensures that the sensual explosion is confined to the vocal and visual imagery on the stage. Physical participation during these festivities generally takes the form of *ramwong* or dancing in a circle. It is standard Thai dancing officially designed to curtail physical contact between the dancers. As a result,

the socially sanctioned sensual pleasure offers two complementary forms: the visually sensuous *haang kruang* and the physically restrictive *ramwong*.

The imagery of the Luktoong show associated with popular festivities was dramatically transformed in the 1970s and 1980s. Although its public dimension was maintained, commercialism became far more prevalent. Shows are now staged more regularly in the secular venue of the cinema. This contributes a new quality to sensuous pleasure. Sayan Sanya's show for example, reinvested one million bahts (approximately £25,000) in its sound system and it became common to invest as much in the electronic sound equipment as in the revues themselves. Dancing and costumes are meticulously redesigned for this profane atmosphere. The visual pleasure is thus extended, though it remains assigned to the dancers.

The music industry on the other hand, takes the notion of 'jouissance' a stage further. Vocal, visual and physical pleasure are all concentrated in the 'individual' singer. The 'star' becomes the epitome of the blissful experience. The vocal and physical pleasure which are presented on two separate planes in the live Luktoong show are merged. This has two significant implications. The hierarchical separation between the singer and the dancers, which coincides largely with gender divisions, is challenged. Second, while it approximates more closely to the imagery of String and Anglo-American pop/rock, recorded Luktoong's contestation with the officially defined notion of pleasure is deepened.

As Benjamin (1970) has argued, the 'mechanical reproduction' of the arts paves the way for new kinds of appropriations and re-creations of artistic forms. Unmediated and mediated enjoyment provides for different effects that can be complementary. For the live Luktoong show, the central problem is that their 'relative autonomy' is severely threatened. For the music industry, the show is essential in creating the 'aura' of artistic authenticity. The twin concepts of standardization and uniqueness are fundamental to the industry's commercial logic. What at first seemed to be an unresolved conflict of interests was in fact a reciprocal relation, though one not without tensions.

For the audience, the peasantry and the poor in particular, the annual or bi-annual access to the sensual pleasures of the show became an everyday experience through the broadcasting media. More importantly, it accelerated the secularization of sensual pleasure. New references were introduced for renegotiation. Soul and disco dancing or *din* (literally twisting) for example, evident in private celebrations, were gradually incorporated into the temple ground events. The mediation of television on the other hand, contributes what Benjamin called absorption and distantiation in the consumption of the arts. The audience becomes emotionally involved but at the same time, they are made into experts or critics through their distance from the artists.

Luktoong lyrics: resistance and accommodation

Through Luktoong music the popular practice of sensual pleasure becomes part of everyday politics. But it is not an unrestrained field. On the contrary, resis-

tance and alternative points of view exist in a fragile equilibrium among the social forces engaged in the encoding and decoding of pop. Stringent state regulations are imposed on top of the already tight religious and social sanction in this arena. The state in particular, closely regulates any entertainment which is in 'bad taste'. or 'unpatriotic' or 'critical' of the government or its institutions. In order to thrive amidst these political and commercial tensions. Pleng Luktoong must constantly realign itself. As a result, the discourse can be apparently accommodating in its content yet remain structurally resistive.

The synthesis of humor and satire in Luktoong's lyrics however, has evaded state censorship and produced some of the classic social commentaries in popular music. Paibun Butrkan for example, wrote *Yomabaan Jao Ka* ('Oh! Mephisto') after his *Klin Klon Sab Kwai* ('Muddy Odor and Stinking Water Buffalo') was banned by the Phibun government. His composing career, between 1949 and 1972, coincided with the entrenchment of the military regimes. In response, in *Yomabaan Jao Ka*, he presents an abstract but moralistic lyric which allows for a variety of interpretations.

> *Yomabaan Jao Ka* ('Oh! Mephisto')
>
> Oh! Mephisto, please listen to me
> Why do good people die so soon?
> Oh! Mephisto, why do the wicked live?
> Devilish but they survive
>
> The good die one by one
> This world is intolerable yet I can't escape
> It was men who are frightened by the devil
> Now, they scare the devil away.

Despite the carefully calculated ambiguity of this lyric. Paibun still attracted a charge of insinuating class differences. At the same time, he also composed a series of songs devoted to motherhood, for example; *Mae* ('Mother's Bosom'). These were popularized on Radio Thailand and used for Mother's Day celebration. Paibun in fact, admonished Cholati Tarnthong, one of his students, arguing that 'a composer cannot write only political songs because that would mean ending up in jail . . .' (Changyai, 1986: 64).

In contrast, *Puyai Li* ('Village Head Li'), written by Pipat Boribun during the military regime of Sarit, is highly comical. Its parody of village meeting mocks the hierarchical power between the establishment and the villagers.

> *Puyai Li* ('Village Head Li')
>
> In the year 1961, Puyai Li called a meeting
> The villagers all assembled at Puyai Li's house

Now Puyai Li will tell you what he was told
The state ordered, they ordered that peasants
must raise ducks and sukorn (pig)

Ta Si hua klon (the drunkard) asked
'What is a sukorn?'
Puyai Li stood up right away and said.
'Sukorn is nothing but a ma noi.'
Ma noi, ma noi tammada (repeat)

The word game is based on the colloquial *mu* (pig) and *ma* (dog) which are also abusive terms. To avoid the vulgarity they are officially called *sukorn* and *sunak*. The narrator humourously depicts a surreal village meeting in which no talking back is permitted. But as it happens the contrast between the polite and vulgar vocabulary produces misunderstanding and reveals the ignorance of the village head. The link between knowledge and power is broken. More importantly, the story makes fun of authority whilst defying the newly launched modernization scheme.

As these examples show, commentaries on militaristic power are possible but rare. They must be cautiously woven into humor or abstract satire. In contrast, ordinary soldiers are praised for their patriotism and heroic deeds. Most Luktoong stars pay tribute to the glorious warriors who are one of 'us', in songs like Yodrak Salakjai's *Rangwan Nakrob* ('A Warrior Reward'), Sayan Sanya's *Kampatiyan Taharn Kla* ('Oath of a Warrior'), and Rangsri Serichai's *Kiat Taharn* ('Glory of a Soldier'). Yodrak Salakjai's hits in particular, are associated with the macho but highly patriotic imagery of the defender of the realm in juxtaposing the hero in uniform with love and sex. They include *Taharn Rua Ma Laew* ('Here Comes the Navy'), *Taharn Sang Mia* ('A Soldier's Goodbye'), *Tor Chor Dor Jai Diew* ('True Love of a Border Patrol') and the most recent hit, *Tanarn Mai Pai Kong* ('The New Conscript').

Whilst the power of the military is glorified politicians often bear the brunt of the criticism as in songs like: Kamron Sampunnanon's *Mon Karnmuang* ('The Magic of Politics') and Songkroa Samattapapong's *Pak Krasob Ha Sieng* ('Political Campaign of the Sack Party'). Although Pleng Luktoong shares a similar worldview to the traditional institutions and the military in its presentation of those 'corrupted', 'slick' and 'power seeking' politicians, their dissension does not support the 'status quo' unequivocally. Commentaries on the bureaucracy for example, argue against the present structure of power relations. Government officials are definitely seen as 'them' and they are presented as 'oppressive' and 'power corrupt', as in Kamron Sampunnanon's *Krai Taan Tan Ka* ('Those Oppose, They Kill'). In identifying with the common people, Pleng Luktoong constantly makes attempts to challenge the institutions of power though accommodations are imperative. We therefore find defiance as well as glorification of power in Pleng Luktoong.

212

None the less, social comment is not confined to Pleng Luktoong as critics would have us believe. This may have been true in the past, particularly during the period of military dictatorship, but today's pop stars and rock bands in the String genre also promote alternative views in order to appeal to their audiences. While commentators such as Wongtes (1984) and Supasakorn (1979), praise Pleng Luktoong for its social commentary, the love songs are often neglected. Yet the bulk of the Luktoong are love songs compared to the 20 per cent or so of commentaries (Phutharaporn, 1985). Indeed, it is in the love songs that Pleng Luktoong is most contentious both culturally and politically. There are two distinctive features, drawn basically from the folk tradition, which the Luktoong brings to oppositional discourse. Firstly, its unfailing identification with the peasantry, the common people and the poor and secondly, its expression of sexual desire.

By situating lovers in the context of their material condition, Pleng Luktoong connects the notion of love with the question of social differentiation. The bulk of the love stories, whether sexual or tragic, are about people who identify themselves as 'Luktoong'. They are: the peasant lads/girls, the lorryman, the fisherman, the boxer, the taxi-driver, the factory worker, the maid, the bar girl, the prostitute, and a range of country boys and girls from Supanburi, Khonkaen, Isan or the northeast. These are clearly presented in either the name or the contents of the song. Equally important is the fact that the stories are told by these same 'Luktoong' people. Nearly all the Luktoong singers come from the peasantry or have a rural backgrounds (Nawikamoon, 1978). The first generation of Luktoong singers, such as Chai Muangsing and Kuanjit Sriprajan, were reputable folk singers. The present Luktoong stars are mostly from the central province of Supanburi (with a very distinctive accent) or the northeast. They are either self-educated, like Pumpuang Duangjan, or have minimum education, like Sayan Sanya. A number of successful songwriters, such as Cholati Tarnthong and Wichien Kamcharoen, are from the provinces and began their career as Luktoong singers. Their biographies are not only starkly different from artists of the other pop genres but are firmly grounded in the 'popular'.

In the tragic love songs, social differentiation is constantly invoked. Suriya Rungtawan's *Sub Mun* ('Ten Thousand') for example, tells the story of a poor peasant who could not afford the ten thousand bahts dowry for his marriage. In other songs the imagery of the rich and of the city are presented with a mixture of awe and distrust. The country people are presented as innocent and easily deceived. Metaphors such as AM girl/FM man, tractor/Mercedes are frequently used to signify the antagonistic relationship between the peasant girl and the rich man from the city. These rural/urban and peasant/elite polarities were central to one of the top hits of the early 1980s. *Kao Wain Raw* ('Waiting in the Queue') by Sornpet Sornsupan. It is based on the highly popular cliché 'pai don kao lok ik laew' or 'you are fooled again'.

Kao Wain Raw ('Waiting in the Queue')

You are fooled again, my dear, will you ever learn
You wanted diamonds but you were heart broken
Now you are in tears, don't you ever learn
You are fooled again, why don't you try to learn
You are taken by his wealth but not my true love
Now you are in tears.

You run away from this poor man
You want the millionaire
He deceives you to his heart's content
He deceives you, he fools you
Ah, my dearest, ain't it just too bad!
Please come back to me, to my true love
I will be waiting in the queue
I will father your first born, my dear

These unresolved tragedies, enmeshed in the asymetrical power relation of sex and class are juxtaposed with comical tunes and rhythmic music. Thus, the contradiction of tragedy and comedy is simultaneously experienced and enjoyed. As Lop Burirat, the songwriter, pointed out:

'Luktoong must be pleasurable in all aspects . . . I think the music must come first . . . and the sound . . .you must keep on with different phoneme until you find the exact sound . . . these are vocal and graphic . . . I write comical and rather sexy songs so it's even more difficult . . . I have to bear in mind that if it becomes too graphic it might never reach the audience . . .'

(Burirat, 1986)

When the balance is struck the song becomes a hit. More importantly, catch phrases from songs such as *pai don kao lok ik laew* (you are fooled again) or *rak sib law raw sib mong* (wait for the lorryman at ten) are incorporated into the oppositional discourse of journalists and the Left, who use them to criticize the government for failing to fulfill their political mandate.

Luktoong's second central feature, the expression of sexual desire, is diametrically opposed to the notion of romantic love presented in the music of Lukkroong or String. Male singers are especially forthright since the main thrust is in 'talking sex'. Sexual puns and metaphors for sexual intercourse are abundant. But as noted above, songwriters are cautious of censorship. For the state, 'obscenity' is defined first and foremost by the language and the sexual imagery created by the words. *Jud Tien* ('Light the Candle'), *Ham Tiem* ('False Organ'), *Parinya Ki Kwai* ('Graduate on Buffalo Back') and *Law Ai Kae*

('Seduction') for example, are banned from being broadcast because of their 'obscene' lyrics. In practice however, sexual explicitness is not contained purely in the lyric. It can also be presented in the music and the 'vocal' of the singer as well as the words or in a combination of these elements. Together with the visual imagery and the 'physical' impact of the music they generate blissful sensual pleasure.

The niche secured by Pleng Luktoong not only compromises the state, but 'talking sex' becomes part of everyday politics. As with tragic love songs, catch phrases from erotic lyrics and poems are widely adopted and used in a variety of contexts. At the same time, this enables the sexual passivity of women generally presented by male songwriters and vocalists to be challenged. *Diew Kaw Mum Sa Rok* ('Want to Have You') written by Lop Burirat and originally sung by the songwriter himself for example, was later recorded by a female singer, Chantara Tirawan, and expressed in reverse. A variety of lyrics, sexual and non-sexual, are re-written to the melody of Jud Tien for example whilst textile workers sing and dance to the protest lyric they write to the same tune. These 'decodings' demonstrate the range of divergences from the 'encoded' imagery of the songs and suggest that a range of potential meanings can be created.

Stars and style: images and sensual pleasure and modernity

This section takes the case of Pumpuang Duangjan, the most recent Luktoong superstar (1982–92), as a way of exploring how the imagery of sensual pleasure is produced and presented. Pumpuang is the third Luktoong vocalist, and the first contract artist for Azona to earn the title 'superstar'. Her predecessors, Surapol Sombatjaroen and Pongsri Woranut, were independent artists. Their title of King/Queen of Luktoong was largely associated with their distinctive 'grain of voice' and the popularity of their shows. Pumpuang on the contrary, merges these criteria with the industry's 'sales record' through the consolidation of her innovative singing and dancing style. On the production side, disco music and the visual image on television become the predominant modes for generating blissful experience. But as noted earlier, neither the artist nor the music industry is able to monopolize on the definition of 'jouisance'. On the one hand, the music industry's attempt to break with Luktoong music convention is circumscribed by its internal tensions and the audience's discursive formations. On the other hand, it is also contained by the dominant social and political sanctions. These pressures assimilate any 'alternative' or 'counter' cultural form into their terms of reference as will be illustrated below.

Pumpuang Duangjan: the making of a 'Luktoong' superstar

Pumpuang Duangjan or Rampung Jitharn was the fifth of twelve children from a working class family in Supanburi. Her mother was a sugar cane cutter.

Her father used to be a popular art performer. She had only two years of primary education. At twelve, she started her apprenticeship with one of the prominent Luktoong bosses from Supanburi, Waipot Petsupan. She learned to sing and dance in the *haang kruang* style as well as to stand in for the vaudeville and comedian of the show. With her all-round talent, Nampung Muangsupan (as she was named then) began to develop a different style from previous Luktoong singers. However, the imagery remained confined by the gender divisions of the Luktoong show. Whereas male vocalists, such as Sayan Sanya or Yodrak Salakjai, aspired to be Luktoong singers from the moment they began their music careers, women must start from the bottom rung as dancers. They either remain there or if they do make it to the front of the stage they are expected to project a feminine imagery in the love songs (Supasakorn, 1979).

In some of Pumpuang's earlier songs, *Kaew Raw Pi* ('Kaew is Waiting for You'), *Tung Nang Koy* ('The Maiden Field'), and *Sao Na Sang Fan* ('A Peasant's Girl Goodbye') for example, the imagery of a shy peasant girl prevails. These songs juxtapose the Luktoong vernacular with a mixture of Luktoong music and folk tunes, while her persona identifies with the majority of the Luktoong fans, the theme of the music and lyrics is romantic not erotic. In these formative years, Pumpuang was largely enveloped within the mainstream of Luktoong's tragic love songs.

In the late 1970s, Nampung Muangsupan (Honey of Supan) was renamed Pumpuang Duangjan (Pretty Boobs). The change of name shifted the sweet feminine imagery to that of a sexy woman unprecedented in the Luktoong world. This reversal of imagery was the decisive break that propelled Pumpuang Duangjan to stardom, as she pointed out in a television interview in May 1986:

> I actually resent the name because it represents both boob and bum . . .
> I think its indecent . . . but I wasn't about to give up . . . what strikes
> me is that the fans seems to like my new style very much . . .when I
> wore long hair, look lady like, my songs never really hit the chart . . .
> I like this trendy style and a bit of masculine smartness.

This is the point of departure from which sensual pleasure in Luktoong music is reworked into a new collage, her voice and persona is juxtaposed with the comical and erotic style once confined to male singers. As the composer, Lop Burirat, described it:

> Pumpuang has the personality for this type of playful and sexy song . . .
> her singing ability fits in well with her style . . . in fact, she is capable
> of a variety of styles and this makes things easier for both of us.

Lop Burirat composed *Haang Noi, Toi Nid* ('Budge a Little') using a disco beat and highlighted the music with saxophone and trumpet. Its success was followed by the second cassette, *Krasae* ('Come on, Baby!'), in a similar style.

While the music is highly 'physical' the lyric is both sexually enticing and comical. The style of humor and satire match the beat of the city. As the composer explained:

> I think it's about time we stopped repeating ourselves . . . I want to try to capture the mood of the city and the young of today . . . I write these rhythmic, and colourful tunes in a new style . . . I prefer to call it the electronic Luktoong.

In contrast to other reputable Luktoong stars, Pumpuang's commercial success marks a break from the present Luktoong tradition in both its musical form and its emphasis on the 'independent' artist. This leap however, was prompted as much by the commercial logic of the music industry as by rapid social transformation. More and more of the landless peasantry, both male and female, were turned into urban industrial labor. A large number were becoming 'export laborers' working in the Middle East, and the advanced industrial countries such as Germany and Japan. Amidst this fundamental shift in social relations, how could the Luktoong music continue to relate to and express the feelings and identities of its audience?

Sex and modernity: the new 'Luktoong' musical collage

The two cassette albums, *Haang Noi, Toi Nid* ('Budge a Little') and *Krasae* ('Come on, Baby!') released by Azona in 1984 and 1985, marked the turning point in the new 'Luktoong' collage. These ten-track albums were both composed and produced by Lop Burirat, the comic songwriter. In each album, the disco beat was used in the two promoted tracks. *Puchal nai Fan* ('The Man in My Dream') and *Haanng Noi, Toi Nid* ('Budge a Little') In the first album, and *Ah, ha . . . Law Jang* ('Ah, ha . . . Cutie!') and *Krasae* ('Come on, Baby!') in the second album. The rest of the songs are tragic love songs in the familiar Luktoong style such as, *Sao AM* ('AM Girl'), *Jub laew La* ('Kiss Goodbye'), *Ja tang Pi* ('When Will It Be?'), *Ronghai bon Lang Kwai* ('Weeping on Buffalo's Back').

The introduction of the disco beat into Luktoong music is a radical divergence from established Luktoong forms. It is the moment when Luktoong aligns itself with 'modern' String or pop/rock. At the same time, it is a return to the deep roots of rhythmic folk tunes and their sexual openness. In order to accommodate conventional elements along with the new synthesis in the same album, the collage does not depart entirely from its tradition. On the contrary, it attempts to reconcile these diverse trends through the persona of the presenter of the discourse – the star vocalist. Furthermore, the industry pays tribute to the official ideology in the 'extra' tracks such as *Siam Muang Yim* ('Siam, the Land of Smile') which was marked out as the third promoted track in the *Haang Noi, Toi Nid* album. This illustrates particularly well how Azona must comply with

the dominant political and social constraints at the same time as developing strategies to widen and maintain its audience. The following show how these contending discourses are played out.

The promoted duos in each album differ in their musical composition and their imagery of sexual relation. Azona prioritizes tracks with comparatively subdued music juxtaposed with an erotic monologue ['The Man in My Dream' ('Budge a Little' album) and 'Ah, ha . . . Cutie!' ('Ah, ha . . . Cutie!' album)] over the unconventionally physical disco beat in 'Budge a Little' and 'Come on, Baby!' These pre-emptions are however, overturned. The hits are the disco tracks that express sexual desire in a playful 'dialogic' lyric. The eroticism in 'Budge a Little' and 'Come on, Baby!' is presented in a cock-teasing manner woven into the chemistry of the lyric and the physical impact of the music. The bliss is produced by the texture of the 'utterance' punctuated by the 'physical movement' of the disco music.

The following translation of these lyrics cannot do justice to the poetic quality of the songs, but will suffice as an illustration of the divergences in the sexual imageries they represent. In the first hit, 'Budge a Little', for example, the parody of the words and the tune of the saxophone created the colour and its sensual texture.

> *Haang Noi, Toi Nid* ('Budge a Little')
>
> (chorus) Budge a little, a little more (repeat)
> Na, na, na, na, na, na, na, na, you innocent
> Stretching your arms, you are getting closer
> Now you are leaning on me. Uh!
>
> Na, na, na, na, na, na, na, na, mischievous grin
> Thinking about it, you signal now and again
> Wah, you jump on me
> Stealing a kiss and you won't budge, Uh! (chorus)

By contrast, 'Come on, Baby!' moves a step further in the rhythmic vigor of the music and its sexual imagery. The song is a teaser in a style similar to Budge a Little but concludes with an enticing invitation.

> *Krasae* ('Come on, Baby!')
>
> (chorus) Come on come on, yeh, yeh. come on.
> If you love me baby, don't just look on
> Come on, come closer, faster
> Be gentle to the taste of sweetness
> If you care for me, I will be yours (chorus)

So smart, so handsome, how naive you are
If you stay cool, you won't taste the honey
Just look on, over the corner you are shaking
Come on, baby, if you're shy you won't get it.

The sexual invitation is hidden in the pun and the metaphor of the Luktoong vernacular. Pumpuang is able to present this sexy imagery in her playful style of singing and dancing. In contrast, the intimacy of sexual intercourse presented by the erotic 'sound' in 'The Man in My Dream' and 'Ah, ha . . . Cutie!' although parodied by the playful tunes of the saxophone and trumpet, walk the tight rope between eroticism and pornography in their visual imagery and vocal expression.

Pu Chai Nai Fan ('The Man in My Dream')

I am a gal, looking for a pal.
Last night I dreamed, a wonderful dream
I met my prince charming
He took me to the cinema
He took me to the garden
He put the flower in my ear.
Once, twice and thrice
He tried in vain.
I woke up at four, he is no more
What a shame, Ooh, what a shame!

Oh, what a dream!
He is such a man, so gentle, so sweet
I dream of him,
Seducing, touching, embracing me
It's all in a dream.
Ooh, what a shame, what a shame . . .

The act of sexual intercourse is presented in both the sounds and the metaphors in the poem. The 'dream' however, is used as a double device. Apparently, a self-regulatory measure, in its fantasy it reaches deeper into the reality of the sub-conscious. Pumpuang 'talks sex' in the same way as the Lamtad or the Pleng Choi of the folk tradition in which the 'Mae Pleng' or female singer is as witty and enticing as her male counterpart. In the past, this tradition of openness to female sexual desire has been restricted by the official definition of sensual pleasure. By dropping the Lukkroong musical style from the Luktoong songs the folk notion of sexual pleasure is revived.

Building on the success of the first two hits. 'Ah, ha . . . Cutie!' challenges the official moral code further by emphasizing the 'female gaze' of a sexually liberal

219

woman and her disregard of fidelity, thereby turning the conventional double sexual standard upside down.

Ah, Ha, Law Jang ('Ah, ha . . . Cutie!')

Ah, ha, how cute. Ah, ha, how cute!
Whose lover is he? So good looking
My eyes meet his. Ah. ha, my heart leaps
Ah, ha, so cute. Ah, ha, so handsome!
I want to hold you
Are you single?
Shall I take him?

He is so muscular. I want to touch him
I want to be closer
To whisper that I am so lonely
Ah, ha, cutie, so handsome
Whose lover is he?
Is it a mystery, cutie?
I want to be with you tonight
Ah, ha, how cute . . . so cute

These playful but erotic tunes present sexual desire from a woman's perspective as both pleasurable and modern. The restrictive visual presentation on television and film however, delimit and disrupt the 'authored' meaning of the discourse. On television for example, 'Ah, ha . . . Cutie!' and 'The Man in My Dream' are presented in straight singing and dancing without the re-creation of the music video. In the film *Mupun Konmai* ('The New Hit Man') produced to promote these albums. 'Ah, ha . . . Cutie!' takes on a comical imagery instead of eroticism. Pumpuang is presented as witty and boyish as opposed to the meek hero. The scene shows Pumpuang sitting by a large pond watching a young man (the hero) bathe. As she sings, the bathing images reverse the meaning of the lyrics. The macho appeal, for example, turns out to be an old man emerging from the other side of the pond with mud on his head and a frog jumping on his frail arm muscle. On the other hand, the visual imagery of 'The Man in My Dream' is confined to Pumpuang singing in her bedroom. The camera concentrates on the facial expressions of Pumpuang wishing the dream would come true. However, the visual censor that closes off further slippage of this erotic tune opens itself at once to the audience potential fantasies.

In Pumpuang's singing and dancing style the established 'Luktoong' outlook is disappearing. For example, the slurring of the notes is no longer apparent in these hits although it remains in the love songs in both albums. But more importantly, the image of a modern city girl negates the association of 'Luktoong' with 'otherness' and 'low culture'. The new collage strives to

eradicate these derogatory connotations, and at the same time to establish a new ground. As Pumpuang remarked:

> When I perform at the Dusit Thani in front of the Duchess and her daughter the audience expect to see a 'Luktoong' show . . . well, what they see is contrary to their expectations . . .afterwards, they say it is a modernized Luktoong . . . it's not the real thing, they say . . . you must tell me how to act like a Luktoong or how not to be one . . . these new songs are sort of a cross between String and Luktoong. . . . I like Michael Jackson, the way he dances . . . I also like the self confidence and the style of Anchali Jongkadikit (The recent woman rock star) . . . you know, at first Azona is not sure if I can dance but I think the point is proven.

In the past, sacred blessings were bestowed upon outstanding proponents of the Luktoong tradition. But in this new milieu, both the media and show business hasten to assimilate Pumpuang into their terms of reference. Her style is acclaimed for its 'modernity' and its high international standard. As one of the most prestigious literary and popular entertainment critics, Khunying Jintana Yossuntorn, explained in a review:

> How come I miss this superstar? . . . I want to drop the prefix Luktoong and just call her the superstar of pop music . . . her style of singing and dancing is undoubtedly modern and in the best of taste . . . if someone tells me Pumpuang is from Broadway or London I would not doubt for a minute . . . she really has the style . . . is Pumpuang merely going to be the Luktoong Superstar?

Pumpuang's imagery is not only 'modern' in appearance. Her public persona merges with the liberal conduct of her private life which breaks the social norms on sexual restriction. She openly discusses her love affairs with her present husband, for example, thereby avoiding further publicity of the scandal by confronting the issue head-on.

In the midst of this new sensual explosion however, we also witness a different imagery being 'preferred' by the bulk of the Luktoong fans. They are unmoved by the exciting new music. The other hit, that emerges besides the promoted tracks, is the tragic love song, *Sao AM* ('AM Girl'), on the 'Budge a Little' album expressing the unresolved class differences typical of the Luktoong tradition.

> *Sao AM* ('AM Girl')
>
> We peasants dress in patung,
> Carry our loads, working in the field
> Speak our common language.

Listen to the AM band, our transistor radio
It's in our basket, in our luggage.

Tune in to our pleasure
AM and the Luktoong music
We plough the field, we earn our living
Our food is common, vegetable and fishes

You city bloke, don't want your false hope
It's not a good match, you listen to the FM
Bangkokians are deceitful, they say
We AM girls are fearful

Stay with your city people
Rural folks are not your type
Seduce me, then you will not return
FM girls are pretty, and fair
Soon the AM girl is forgotten

This track reproduces the style of music, singing and imagery of the mainstream Luktoong love song alongside the new collage of the sexy and modern woman. In this way, the fans are able to appropriate their preferred imagery according to their discursive formation and 'taste'.

At the other end of the sensual spectrum, the album also contains political inserts. *Siam Muang Yim* ('Siam, the Land of Smiles') for example, clearly identifies with the dominant ideology of the triple alliance. In the words of the composer,

> The 'extras' are imperative for our trade . . . it is sort of a statement of our allegiance to the state . . . well, it doesn't really bother me as long as we get to do what we want to do.

As mentioned earlier, 'Siam, the Land of Smiles' was selected as the third promoted track on the *Haang Noi, Toi Nid* album. Azona is cautious to temper its 'sensuous explosion' with 'patriotism'. Its imagery of the ethnic groups from 'across the Mae Khong river' – the Laos and the Khmer – is unsympathetic to the 'aliens' but converges with the 'national'.

Siam Muang Yim ('Siam, The Land of Smiles')

Be proud that you are a Thai
Uncolonized and generous
Siam is the Land of Smiles
We should be proud

The Thai is known for her sincerity
Whoever you are, our nation welcomes you
Crossing the Mae Khong, the troubled water
We welcome you with our smiles.

We are famous, we the generous people
Caution, our settler
For our tradition, a bowl of rice
Must not be forgotten

We Thais love our nation and religion
Adore the virtuous king
Respect our rights, forever welcomed
With a Siamese smile

The defiance of restrictive pleasures and the challenge to the sexual hierarchy in *Haang Noi, Toi Nid* is thus juxtaposed with the patriotism–cum–ethnic exclusivism of the dominant power bloc.

The overwhelming success of the album however, eases tight self-regulation. It brings out the artistic creativity and autonomy of the composer. The satirical tradition of the Luktoong emerges in the 'extra' in the second cassette, *Krasae*. *Man Yang Ngai Yu Na* ('That's Odd') is cynical about the 'Thainess' incessantly propagated on the official programs. In its comical juxtaposition of music and lyric, the song projects an imagery conflicting with the statement of allegiance in 'Siam, The Land of Smiles' in the previous album.

Man Yang Ngai Yu Na ('That's Odd')

Hey, Thailand-freedom land
Think what you want, do what you want
Yeh, some are too good, but some are too bad
Some push but some pull
Hey, ain't it confusing, ain't it odd (repeat)

Hey, Thai people-free people
Sell what they banned, eat the forbidden.
Ain't it confusing

Hey, Thai people-funny people
Some are helpful, some are selfish
Some are gracious, some are modest

Yeh, some bow to foreigners

Humiliate us Thais
Hey, ain't it odd (repeat)

This humorous tune and self-mockery appears in the middle of the second album. It is a low-key track that went almost unnoticed. But a modernist style of satire combining in the earnestness of Yomabaan Jao Ka and the humor of Puyai Li is in the making. We shall come to this point presently.

In the album, *Takatan Puk Bow* ('The Grasshopper'), distributed by CBS, the music in the promoted tracks followed the success 'formula' of the previous cassette albums. *Cheui Boran* ('Listen to the Old') is erotic while *Takantan Puk Bow* is a comic teaser. The co-presence of the contradictory images of a woman in control and subordinate continues, albeit with further modification. The Chinese melody, from the theme song of a Hong Kong gangster romance soap opera, and the Carpenter's *Only Yesterday* are juxtaposed to form the 'modern' outlook. At the same time, nostalgic music is coupled with the imagery of feminine submissiveness. In the track *Atit la Won* ('Once a Week') for example, the mistress pleads tragically for the opportunity to be with her lover even if it is only once a week. The visual presentation on the album jacket reinforces the image of the twin persona. On the front of the cassette Pumpuang is riding on a 'motor bike', in her black leather outfit. This is contrasted with the 'feminine' image folded on the inside. The picture shows Pumpuang wearing a long white dress with a broad-brim hat, resting leisurely in the garden.

On the other hand, the disco beat is reworked and dispersed to other tracks on the album. They are juxtaposed with humor and satire in *Out Ter Kong Free* ('Yes, It's Free') and *Ta Wiset* ('The Magic Eye'). Although both tracks characterize the best of Lop Burirat's compositions they are rarely played on radio. Released prior to the 1986 general election, *Out Ter Kong Free* ('Yes, It's Free') reveals the underside of the political campaign. The one-and-a-half-minute track is both 'didactic' and 'dialogic'. The composer suggests that the audience, 'accept whatever the politicians offer, 'cause they are free of charge'. This is counter-posed with the voters' discourse in the northeastern vernacular, 'Ah, I will not vote for you, I come for your free gift. Ah, free of charge, Yeh, yeh, yeh, free gift, free gift . . .'

The lyric and the foreign but comic melody of an old Chinese tune subvert the seriousness of the election ritual. It argues against official optimism about the parliamentary system. Not only are the politicians not 'honest', the people are not 'naive'.

Ta Wiset ('The Magic Eye') on the same album experiments further with the city beat of rock and saxophone. The music at the beginning of the song plagiarizes an old Luktoong melody before leaping into its percussion theme. The switch however, is a parody of the theme from the *Technology* album by a marginal rock band. The accompaniment of the saxophone rouses the beat to its emotional height. It ends with a return to the dialogue in the introduction.

In the latter half, the musical pastiche shifts to a comical mood. The

percussion is comparatively subdued whilst the changing tone of the saxo-phone is highlighted. Its playfulness is used to comment on the city scene in the final verse. It is presented both within the comments on the 'country and city' and between these antagonistic polarities.

Ta Wiset ('The Magic Eye')

W: Do you see? M: Yes, I do (repeat)
W: Yes, hush, hush

W & M: The living, the dead.
 Beginning and end
 Above, below
 What do you see (repeat)

Good people are here to stay
The bad are gone, don't you see?
All is well, ah, ha

In the city hall the clerks are smiling
Wow. the nurses are not grumbling
See the EGAT, cheap electricity for all
Folks are happy, stupid they may be
But have sympathy
Ah, it's unreal. but ain't it nice!

Here, here, the magic eye
Clear, clear, clear of rubbish
Ah, ha, no flood no flood in Bangkok
Ah, ha, no more criminal
Look under the tree, look in the bath tub
Talking, whispering, ain't it familiar
Uuh, when he turns round,
Oi, he's my daddy

The composer also introduces a backup singer who takes the position of the audience in the dialogue. The lyric is a surreal collage which is both comical and cynical. Following the introductory dialogue is a parody of the well-known pleading with Mephisto in Paibun's *Yomabaan Jao Ka*. The title, 'The Magic Eye', is borrowed from the cleanliness campaign sponsored by the commercial banks and other financial institutions. Defying its connotations with authori-tarian surveillance, 'The Magic Eye' pierces into every corner of 'high and low' society, cynically and satirically. The paradox eventually, returns to reality in the final verse in which sex and everyday politics are interwoven.

Although social commentaries are tolerated in the present age of consensus building, they are drowned when juxtaposed with the 'promoted' disco tracks and the tragic love songs. The beat of the new synthesis expresses a different source of defiance. The practice of resistance is shifting towards a new form of language which lies predominantly in the physical activity of the music.

In advancing in this new direction, Pleng Luktoong converges with the emerging ethos of secularization, but at the same time, resists its inhumane mode of social relations, as numerous songs about poverty and urban degradation unfailingly testify. The tragic feeling of hopelessness is accelerating not receding. None the less, the aggressive beat of the disco music expresses the rage, the frustration and the fear with optimism in its style of eroticism and humor. This sensual explosion not only presents an alternative to the daily drudgery, it emerges at the precise historical moment of social transition when the official ideology of the triple alliance is regenerated in the new 'Pandin Dhamma, Pandin Thong' doctrine. Its call for moral ethics and work discipline comes face to face with the 'semiotic guerilla warfare' to use Eco's (1972) term, that presents sensual pleasure as its doxa.

Notes

1 Genealogy of contemporary Thai popular music

Unlike many of her Southeast Asian neighbors Thailand has never been physically colonized by any Western powers. But during the reigns of King Rama IV (1851–67) and King Rama V (1868–1909), the Siamese kingdom was forced to surrender parts of her eastern, western and southern territories to the French and the British empires. It was at this disjuncture that Western influences upon the Siamese polity and culture began to take shape. Bureaucratic reform by King Rama V, in order to strengthen the power of the state, led the way to further political and cultural modernization in the 1920s and 1930s.

In the realm of music, Thai classical music was historically (from the fourteenth century) under the influence of Indian and, to a lesser extent, Chinese music. Traditional court music used local musical instruments combined with some musical instruments which came originally from India. The articulation between Western music and Thai classical music was first brought about by the princes who were sent to study in Europe, i.e., England, France and Germany during the late nineteenth century. But the popularization of Western music was launched during the cultural modernization era (under a constitutional monarchy

system) in the 1940s when radio broadcasting was the new medium of mass enter-
tainment.

References

Aiewsriwong, N. (1985) 'Pleng Luktoong Nai Prawatisart Wattanatham Thai (Pleng
Luktoong in the history of Thai culture)', *Slilapa Wattanatam* 6: 6.

Barthes, R. (1975) *The Pleasures of the Text*, New York: Hill and Wang.

Benjamin, W. (1970) 'The Work of Art in the Age of Mechanical Reproduction,' in:
Illminations, London: Jonathan Cape.

Burirat, L. (1986) Interview with composer, September 21st.

Changyai, B. (1986) 'Cholati Tarntong: Naktang Pleng Luktoong Lueadnamkem
(Cholati Tarntong: the Luktoong songwriter from the East)', *Baan Mai Ru Roei* 2: 6.

Eco, U. (1972) 'Towards a semiotic inquiry into television messages', *Working Papers in
Cultural Studies* 3, Centre for Contemporary Cultural Studies, University of
Birmingham.

Nawikamoon, A. (1978) 'Pleng Punmunag Tung Pleng Luktoong (From folk music to
Luktoong)', *Pleng Nok Satawas* (Music of the Past), Bangkok: Karawek.

Phutharaporn, K. (1985) 'Country folk songs and Thai society', *Tradition and Changing
Thai World View*, Bangkok: Chlualongkorn University, Social Sciences Research
Institute and Southeast Asian Studies Programme.

Siriseriwan, W. (1984) 'Pleng Luktoong Ma Jak Nai (Where does Luktoong music orig-
inate from?)', *Jak Pleng Thai Tung Pleng Luktoong* (From Thai Music to Luktoong),
Bangkok: Soon Sangkit Slip.

Wongtes, S. (1984) 'Pleng Thai Tung Pleng Luktoong (From Thai music to Luktoong)',
Jak Pleng Thai Tung Pleng Luktoong (From Thai Music to Luktoong), Bangkok: Soon
Sangkit Slip.

11

REPRESENTING THE VOICES OF THE SILENCED

East Timor in contemporary Indonesian short stories

Budiawan

Constructing an Otherness within 'the Oneness'

'They really have no sense of nationalism to the nation and state', said the Commander in Chief of the Indonesian Armed Forces, Gen. Feisal Tanjung, when asked about the twenty-nine East Timorese students who were seeking political asylum in the US Embassy in Jakarta during the APEC (Asia-Pacific Economic Cooperation) Summit in November 1994. 'Their sense of nationalism is really poor,' added the General (*Kompas*, 1994).

One point is implicit in the statement of the high-ranking military officer, i.e., 'East Timor has been an integral part of Indonesia.' So, what he meant by 'sense of nationalism' is 'sense of being an Indonesian'. This raises a question: did those East Timorese ever imagine themselves to be Indonesians?

This question is important since the process of East Timor 'becoming an integral part of Indonesia' itself, legally at least, is still questionable. The issue of East Timor is still on the United Nations' agenda. And, more importantly, the aspiration for independence is alive and well among the East Timorese people. The twenty-nine East Timorese students who sought political asylum in the US Embassy, I am sure, still hold strongly to such an aspiration. This means that they actually have a keen sense of nationalism. But, their sense of nationalism, of course, is not being Indonesian.

The fact that such an aspiration for independence is still alive among the East Timorese seems to be something difficult to understand for most Indonesian people. For one thing, and most importantly, it is because the Indonesian government-constructed-story that the vast majority of East Timorese had a really strong and spontaneous desire to integrate themselves with Indonesia seems to have become an established narrative in the social discourse, so much so that the story of 'integration' is taken for granted. Therefore it is not that there were hardly any critical reactions in the Indonesian mass media to what

228

happened in Dili on 12 November 1991, which was officially constructed as just an 'incident' between the security apparatuses and hundreds of demonstrators 'who had been provoked by a very minority group of East Timorese who were trying against the integration'.[1]

It is indeed right that the absence of critical reactions – in the sense of questioning why those demonstrators could easily be provoked had they really been so – to a large extent is because of the government's heavy censorship of the mass media. But it is undeniable that the story of 'integration' has strongly conditioned the making of the public opinion on the issue of East Timor. The idea that 'East Timor is an integral part of Indonesia' is always present, at least implicitly, in the discourse of East Timor. This means that East Timor has been unilaterally constructed within 'the oneness' of Indonesia.

The construction of East Timor within 'the oneness' of Indonesia can be seen clearly in the dominant rhetoric in facing the plan of the *Lusitania Expresso*, a Portuguese ship bringing some Portuguese and large numbers of East Timorese overseas to scatter flowers offshore from Dili to offer condolences to the victims of the 'Dili Incident', in March 1992. At that time the Indonesian mass media perceived that the *Lusitania Expresso* would act as an instigation to the East Timorese to conduct a demonstration against 'integration'. And, more convincingly, it was regarded as a violation of the sovereignty of the Indonesian territory. Therefore, the Indonesian mass media said, 'we are obliged to defend every piece of our territory from any threat and interference; we indeed love peace, but we love independence and sovereignty more.' Just as the *Lusitania Expresso* was approaching 'the Indonesian territory', the Indonesian Navy successfully drove it away. This was enthusiastically reported in the Indonesian mass media as 'a victory of nationalism on any ideas to revive colonialism'. This certainly has reinforced the construction of East Timor within 'the oneness' of Indonesia. But East Timor is also exclusively constructed as 'an otherness'. Paradoxically, the latter construction is made to affirm the former one.

Such a paradox can be easily found in the statements contrasting 'the past' – in the sense of before – and 'the present' – in the sense of after, 'being an integral part of Indonesia' – of East Timor. The conditions of the two periods are always described as two poles of extreme difference. Words such as 'backward', 'poor', 'underdeveloped', are typical in the construction of 'the past' of East Timor. 'The past' is constructed in such a way that it produces a strong image of 'a long period of history of nothing'. As if East Timor had never had its own past. In short, 'the past' is present at the present time.

On the other hand, 'the present' of East Timor is constructed by using a keyword like 'more', as seen in the phrases like 'more school buildings', 'more hospitals', 'more paved roads', 'more educated population', etc. The condition of having 'more' is always related to the development efforts initiated by the Indonesian government. In other words, the better (physical) condition of East Timor is always narrated as the main result of its 'integration' into Indonesia.

The contrast of 'the past' and 'the present' showing the rapid growth and

change of social conditions is exposed mainly to build an image that the Indonesian government has seriously been giving a lot of attention to development in East Timor. This is because East Timor, regarded as 'the newest province of Indonesia', is supposed to be able to catch up with the stages of development in 'other provinces'.

By making such a contrast, East Timor is constructed as 'an otherness', simply in the sense of being a specially different(iated) 'province'. The logic is that East Timor is perceived to require very special attention since it is, to a large extent, admitted to be different. Thus, the exposure of 'the success story' of the development in East Timor, which is aimed at affirming the claim that 'East Timor is an integral part of Indonesia', at the same time also constitutes an acknowledgement that 'East Timor is an otherness'.

Such a paradox could be more clearly read in the statements aimed at silencing the protesting voices of the East Timorese. For example, when sixty-nine East Timorese students in Jakarta demonstrated to protest – in the words of the Indonesian press – 'the defensive action of the Indonesian Armed Forces' in the 'Dili Incident', a newspaper wrote an editorial as follows:

East Timor, Milk Returned by Poison

Sixty-nine East Timorese students demonstrated in Jakarta on November 19. They cursed the defensive action of the Indonesian Armed Forces in the Dili Incident November 12. They also expressed their support to the anti-integration movement.

As a sovereign nation-state, we deserve to be offended by that demonstration. So far, they have got facilities to study in colleges and universities in some big cities in Indonesia. But, they have returned those facilities provided for them by doing an action which has discredited the honour of the state and the unity of the Indonesian nation. This is just like giving some milk returned by poison.

According to some historical records, when East Timor was integrated to the territory of the Republic of Indonesia, the condition of its population and region was extremely poor and backward. The Indonesian government has been attempting to lift the dignity of East Timorese. Compare the present condition of this province to the era when it was still a Portuguese colony, which is of course extremely different.

East Timorese people should (have) express(ed) a gratitude to the Indonesian government who has helped them to get out from a backwardness.

We do not want milk to be returned by poison.

(*Jawa Pos*, 1991)

In the text above, the East Timorese are constructed as 'they' who 'have got facilities', while the nation-state of Indonesia is constructed as 'we' who

'deserve to'. This mode of construction reflects an acknowledgement that East Timor, in spite of 'being an integral part of Indonesia', is anyhow 'an other'. If 'we' – the nation-state of Indonesia – 'deserve to', why is this not similarly applied to 'they' – the East Timorese? It is obvious that the East Timorese are considered as 'an object' to whom facilities are given. This means that the act of giving is in fact aimed at establishing the position of 'we' as 'the subject'.

As 'the subject', 'we' is in the position of constructing the discourse of 'they' as 'the object' or 'the other'. This means that the voices of 'the other' are silenced and/or misrepresented. The dominant discourse of East Timor in Indonesian society is thus constructed by silencing and/or misrepresenting the voices of East Timorese. This editorial text is just one example of many.

The voices of the East Timorese are indeed silenced and/or misrepresented. But it does not mean that there is no attempt at representing their silenced voices. This means that there is an alternative discourse; and one of the main alternative voices appears in the form of literary works, namely an anthology of short stories, written by Seno Gumira Ajidarma, a young well-noted Indonesian journalist and short story writer. The anthology consists of thirteen short stories. The title is *Saksi Mata* (Eyewitness). If this anthology is considered to be an alternative discourse, to what extent does its alternativeness go? How far does it represent the voices of the East Timorese? Which repressed voices are represented and which are not and why?

Literature: constructing an alternative discourse

Although the latest theories of literary criticism resist attempts at connecting a text intrinsically to its author, learning the background of the production of a text is considered to be important. In what kind of moment is a text produced? Is there any relation between the kind of moment and the form of a text (and the mode of expression) produced (and applied) by an author?

In an essay telling the process of creating some of his short stories on East Timor, Seno wrote that 'when journalism is silenced, literature has to speak, for the source of the former is facts, the source of the latter is truth' (Ajidarma, 1994: 261). This statement is based on his own experience when he, as a journalist, was to cover the issue of East Timor.

Just a few days after the 'Dili Incident', Seno visited East Timor. There he saw and learned many things which had never been reported in the press releases of the government. Then he wrote some investigative reports to the news magazine for which he worked. One of them, which was much based on his personal interview with the then 'Governor' Mario Viegas Carrascalao, was published in the edition of the first week of January 1992. What happened then?

The publication of that report made the management of the magazine ('demanded' by the central authority) remove Seno (and two other editors) from their position as editorial staff. This magazine, too, was forced not to

publish other reports on East Timor which were not confirmed by the central military administration. For Seno, all of this was really serious repression. He tried to resist this by trying to make the 'Dili Incident', which the Indonesian government wanted to erase from public discourse, prominent in the memories of the Indonesian people. So his thirteen short stories on East Timor were written, spread out in several large newspapers and magazines during the years of 1992–94, which were then re-published in this anthology.

In an essay commenting on some of Seno's short stories on East Timor, another young well-noted Indonesian journalist and short story writer, Bre Redana, wrote that 'a short story, which is often categorized as a fictional work, perhaps could be an alternative when what is commonly called 'reality' makes us skeptical or distrust' (Redana, 1994). In the case of the issue of East Timor, 'the realities' of it, in Redana's words, 'have constituted noises on the surface [of talk]'. This means that (almost) every story on East Timor in the Indonesian mass media is just 'a noise': something heard loudly which is then to be forgotten as soon as possible. As if nothing had happened.

Under such conditions, Redana continued, Seno's short stories 'have questioned "the realities" which have been commonly accepted' by presenting the other side of the prevailing stories. It is in such sense that the term 'alternative' is applied here.

The thirteen short stories are 'Saksi Mata' (Eyewitness), 'Telinga' (Ears), 'Maria', 'Salvador', 'Rosario' (Rosary), 'Listrik' (Electricity), 'Pelajaran Sejarah' (History Class), 'Darah itu Merah, Jenderal' (The Blood is Red, General), 'Manuel', 'Misteri Kota Ningi' (The Mystery of Ningi City (or the Invisible Christmas)), 'Klandestin' (Clandestine), 'Seruling Kesunyian' (The Flute of Lonesome), and 'Salazar'.

For the consumers of Indonesian mass media, reading the text of this anthology is perhaps like watching censored scenes of a movie on East Timor. Interestingly, these censored scenes can be re-assembled into another 'movie', which is very different from the one performed on the main screen. This means that there are 'two movies': the one is entitled 'facts', and the other one is entitled 'fiction'.[2] This anthology belongs to the latter.

By such an analogy I do not mean to say that this anthology constitutes 'unmanipulated realities' and the 'movie' entitled 'facts' is full of 'realities manipulated by the censorship institution'. This anthology has nothing to do with manipulation of realities, in the sense of falsifying the data on realities, as commonly defined by historians. By this analogy I want to restate a famous statement of a Marxist literary critic, Pierre Macherey, as quoted by Raman Selden: 'for in order to say anything, there are other things which must not be said'. This anthology is a text representing 'other things which must not be said' (in the dominant discourse of East Timor) (Selden 1991: 41).

The short stories of this anthology, except 'Klandestin', are concerned with the brutalities of – in the words of some short stories here – *tentara asing* (foreign soldiers), which means the Indonesian Armed forces, on the one hand, and the

affliction of the victims on the other. In other words, the central focus of these short stories are the practices of the violations of human rights – 'other things which must not be said' in the grand story of East Timor.

This anthology hits out at the perpetrators of the violations of human rights on one side, and shows a deep sympathy for the victims on the other side. Interestingly, some short stories present these criticisms not angrily but jokingly instead. This especially can be clearly seen in 'Saksi Mata', 'Telinga', and, to some extent, 'Listrik'.

In 'Telinga', for instance, the brutality of Dewi's boyfriend in the battlefield is presented as if it were an everyday occurrence. There cutting off the ears of spy suspects and beheading the dead enemies is seen as an entertainment; and slices of ears are sent as 'souvenirs from the battle-field'. This is indeed a joke, but it is a cynical joke: a sarcasm.[3]

Seno himself admitted that 'Telinga' is a sarcasm. In his own words: 'If you are brutal, I could be more brutal.' He has said that in order to be more brutal, he did not present the brutality angrily, but treated it as a common thing: a bitter joke on a reality (Ajidarma, 1994: 261).

Such sarcasm is also found in 'Saksi Mata'. In this short story, an eyewitness, who had lost his two eyes, was in fact a victim of the brutality of the Nin-jas. He was called to the court to be an eyewitness of the crime which had victim-ized him. But, his performance there was like a comedian rather than an eyewitness. This made the audience of the court laugh and laugh. While he was giving his testimony, blood was flowing out from the holes of his eyes, then down to the floor, to the streets, and everywhere in the city, so that the city was like a sea of blood, but nobody saw it.

'Saksi Mata' can be read as a cynical comment on the court with respect of the case of East Timor, which itself is just like a comedy: a bitter comedy; or perhaps an ironical comedy. This short story can also be read as an attack on the brutality of the Indonesian Armed Forces in East Timor, which had made the city 'a sea of blood', but the story of it was silenced, so that 'nobody saw it'.

Who is meant by 'nobody' in this short story is none of the audience of the Indonesian mass media, since those brutalities are never publicly reported, but, those brutalities are well-preserved in the memories of the victims, and told to their following generations. This is clearly seen in 'Pelajaran Sejarah' (The History Class), where those sad and bitter stories are not written in the books of history, but cannot be lost from the memories of the victims. In this short story, the silenced victims, through the figure of Alfonso, the history teacher, represent themselves.

Such a 'self-representation' is done by Manuel in 'Manuel' and Antonio in 'Maria'. Both Manuel and Antonio were victims of the brutalities of 'the foreign armed forces'.

They narrated the brutalities which had orphaned them (the case of Manuel) and a lost son who was not recognized any more by his mentally-ill mother when he was back home (the case of Antonio). This means that the brutalities

of the foreign soldiers had caused an alienation of the people, and a destruction of the social order and environment of respected society.

Like Manuel and Antonio, Fernando in 'Rosario' and Januario in 'Listrik' are constituted as silenced victims. Fernando fell into a coma; and in his coma he 'went to the past when a soldier with his bayonet forced him to swallow a rosary', as if the horrible past could be expressed only in 'an unconscious condition', 'unheard by other people'. This means that the human rights violations have been practiced to such extremes that the victims have lost their very existence: they live an 'unconscious life'. This is also clearly seen in Januario, who was physically tortured as he was interrogated. He was tortured in such a way that he then 'went to the past': a peaceful past. As if going back to the past is the best way to escape from the present reality.

The 'peak' of the practice of human rights violations is then seen in a kind of systematic hidden ethnic cleansing of the local population of Ningi City in 'Misteri Kota Ningi'. As told by the census officer, a non-local person, the size of the local population was decreasing.

'Misteri' can be read as an allusion to the politics of 'stability', in which people are easily suspected as *pengacau keamanan* (peace breaker); and such suspected persons could be easily shot and killed (without any legal procedure). Thus, this is also a criticism of the image construction of the local people as 'having no sense of nationalism': an image which is then used as justification 'to cleanse' them.

Such a justification seems to be used by the retired General in 'Darah Itu Merah, Jenderal'. He did not feel that he had slaughtered innocent people, since for him 'they were all dangerous'. This means that the image construction described above has been effective in 'the foreign armed forces'; and this is then in turn used to justify the repression on the local people; to make them obedient to 'the new rulers'. This is clearly seen in the exhibition of the dead body of Salvador in 'Salvador'. But does this all mean that there is no spirit of resistance?

In 'Salvador', such a spirit is obviously seen in Carlos Santana's action to take Salvador's dead body. This action looks heroic, and Santana's claim as the new leader of the resistance movement is really a heroic action showing that they still exist.

The existence of such a resistance movement is then presented in 'Klandestin'. This underground movement has built its own community with its own social order and ideology for three generations. But, it seems that this movement, in the eyes of 'I', does not offer a better alternative, since its ideology is unquestionable. They claim that they have constructed the most perfect ideology. This can really imprison the human mind.

It seems that 'Klandestin' is a kind of skepticism to any resistance movement, since such a movement usually claims that they have a more perfect ideology than the one they fight against. Such a claim reflects a tendency to perceive things absolutely. This certainly represses freedom of thought.

Perhaps, because of such skepticism, this anthology, after criticizing the brutalities of 'the foreign soldiers' and showing a deep sympathy for the victims of those brutalities and other practices of human rights violations, tends to silence the idea of the independence of East Timor. (In fact, this is also a human rights violation, since independence is also one of the basic human rights.) This is seen in 'Salazar', in which Salazar's brother wanted Salazar to leave his obsession for independence, as if the idea of such independence is illusory, or unrealistic. This short story seems to suggest adopting a more realistic attitude.

Being realistic, however, means to accept the present condition as what it is, and building a future based on the present reality. That is why one has to escape from the prison of the past. One must be able to be wise about the past, however sad and bitter it may have been. Such a message can be read in 'Seruling Kesunyian', in which the 'I' figure was playing his flute, trying to throw away all the bitter stories of the past told by his mother. But, he could not because he still had hope.

The grand story: in the shadow of 'unity and oneness'

This anthology, then, represents 'other things which must not be said' (in the dominant discourse of East Timor). It seems that 'the nature of fiction is to attempt to express the inexpressible' (Kennedy, 1979: 2). This sounds romantic, in the sense that fiction is like a hero: liberating the inexpressible from any kind of repression. Consequently, fiction should always be seen as a text of consciousness, in the sense that there is nothing silenced or repressed or dominated in itself. This is of course a naiveté for it neglects the paradoxical nature of fiction.

The paradox can clearly be seen in Macherey's statement that: 'in order to say anything, there are other things which must not be said'. Fiction, just like other texts, is supposed 'to say anything', therefore 'there are other things which must not be said' in themselves. This means that there are also silenced or repressed or dominated things in fiction-as-a-text. This is because, referring to Edward Said's comment that, 'all texts essentially displace, dislodge other texts or, more frequently, they take the place of something else'; or, in Nietzsche's words, as quoted by Said, 'texts are fundamentally facts of power, not of democratic exchange'. Thus, 'all texts are in some way self-confirmatory' (Said, 1979: 178–9).

From such a proposition, the critic's role is then not only bringing literature to performance, but, according to Said, 'more explicitly, the articulation of those voices dominated, displaced, or silenced by the textuality of texts', since 'texts are a system of forces institutionalized at some expense by the reigning culture, not an ideal cosmos of ideally equal poems' (Said, 1979: 188). This simply means that a text does not only represent the silenced voices of other texts, but, paradoxically, also silences some voices in its own textuality. If so, this

anthology does not only represent the silenced voices on East Timor and/or the voices of silenced East Timorese, but also, paradoxically, silences (or at least take a part in the silencing of) some voices on and/or of East Timor(ese). In more simple words: not all of the silenced voices are represented; some, or certain parts, are (re-)silenced. In short, the representation has its own limit(s). The question is: what is (are) the limit(s)?

As I stated earlier, this anthology, after criticizing the brutalities of 'foreign armed forces' and showing a deep sympathy for the victims of those brutalities and other practices of human rights violations, tends to silence the idea of the independence of East Timor, as clearly seen in 'Salazar'. Perhaps this is the limit of the representation: this anthology (only) represents the silenced critical voices on the practices of human rights violations in East Timor and the silenced voices of the afflicted East Timorese. But this anthology silences the idea of the independence of the East Timorese; or, at least, this anthology regards the idea of independence as something unimportant for East Timor(ese). However, for (many) East Timorese, independence is still a central issue. At least, it can be said that not every East Timorese necessarily agrees that East Timor is an integral part of Indonesia. What the twenty-nine East Timorese students were doing in the US Embassy in Jakarta as the APEC Conference was running, is perhaps just one aspect of the evidence that supports the idea that the issue of independence is still alive among East Timorese people.

The limit of the representation shown in this anthology is not unique in Indonesian intellectual discourse, for what is called 'the process of integration' is seen as a complete project. It is not ridiculous if even the so-called 'critical intellectuals' perceive the idea of independence of East Timor as something unrealistic. What has made such a perception dominant? Is this merely (or mainly) because of the success of the propaganda on 'the historical process of the integration' of East Timor into Indonesia?

To restate what Said has said, texts are a system of forces institutionalized at some expense by the reigning culture; not an ideal cosmos of ideally equal poems. If so, a text is never (completely) sterile from what is called 'a master narrative', a concept adopted from James Clifford's 'master script' by Ariel Heryanto: 'a stable corpus for interpretation', which 'functions as a canon, on the basis of which "a potentially endless exegetical discourse can be generated"' (Heryanto, 1993: 16).

Such 'an endless exegetical discourse' is found in what is called the 'grand story': a story of established and naturalized normative values which is reproduced every time legitimation for power is needed. This means that a grand story is like a source of legitimation. If so, a text always has 'a will to power'.

In New Order Indonesia, there are five sources of legitimation to the regime: (i) Nationalism; (ii) Pancasila (Five Principles of State Ideology); (iii) the 1945 Constitution and its formal embodiment; (iv) development programs; and (v) propaganda on stability and order. These five cultural products, one can probably argue, 'are hierarchically structured'; in which 'Nationalism is by no

means the exclusive preserve of the New Order state', but 'nationalistic gestures appear to have become a constant necessity' (Heryanto, 1990: 290). This is clearly manifested in the words *persatuan dan kesatuan* (unity and oneness), which are often used to repress or silence opinions different from (let alone against) the regime's. And one of the risks of (openly) expressing such different opinions from (let alone against) the regime's is being suspected of having no sense of nationalism; or that his/her sense of nationalism is seriously questioned (*rasa kebangsaannya dipertanyakan*). And one of the real consequences of being suspected like this is that s/he could have considerable trouble when s/he has to deal with government bureaucracy, especially as, in New Order Indonesia, bureaucracy dominates every aspect of social life.

Interestingly, the practice of using 'unity and oneness' to judge others as having no sense of nationalism is also often found in civil society itself. This happens when there is a critical conflict of interests between the two opposing groups of interests. The real consequence of being suspected of having no sense of nationalism, then, is being isolated from society. In short, the construction of nationalism as a grand story has constituted a comfort zone which makes people 'feel (more) secure'. People do not want to be thrown out of such comfort.

Perhaps in such a perspective Seno's anthology on East Timor can be called an alternative, but not a counter discourse, in the sense of opposing the underlying principles of the dominant discourse.

Notes

I would like to thank Ariel Heryanto for his intellectual encouragement in allowing me the opportunity to take a part in this prestigious conference. Special thanks are also due to George Junus Aditjondro for his (informal) lectures on the issue of East Timor.

1 Foreign sources mostly call this the 'Dili Massacre', where 271 young people were killed, 250 went missing, and 382 were wounded and hospitalized. These figures are taken from 'Peace is Possible in East Timor', Lisbon, 1992, as quoted in George J. Aditjondro, *In the Shadow of Mount Ramelau: The Impact of the Occupation of East Timor*, Indoc., Leiden, 1994, p. 75. Compare these figures to the report of the National Investigative Commission, formed by the Indonesian Government, which reported 50 people killed, 91 wounded, and only 18 unidentified graves.

2 The dichotomy of 'fact' and 'fiction' seems to have been so established in the social discourse that people do not see the possibilities (even the practices) of the integration of both.

3 The term is used by Nirwan Dewanto, a young Indonesian literary critic, in his introductory note in 'Pelajaran Mengarang': Cerpen Pilihan *Kompas* 1993 ('The Composition Class': Selected Short Stories of *Kompas* 1993), Kompas Publisher: Jakarta.

References

Ajidarma, S. G. (1994) 'Tentang empat cerpen (On four short stories)', in *Basis* 7: July.

Heryanto, A. (1990) 'Introduction: state ideology and civil discourse', in A. Budiman (ed.) *State and Civil Society in Indonesia, Monash Papers on Southeast Asia* 22, Clayton: Monash University Press.

—— (1993) 'Discourse and state-terrorism: a case study of political trials in New Order Indonesia, 1989–1990', unpublished PhD dissertation, Dept. of Anthropology, Clayton: Monash University Press.

Jawa Pos (Surabaya), 22 November 1991.

Kennedy, A. (1979) *Meaning and Signs in Fiction*, London: Macmillan.

Kompas (Jakarta), 20 November 1994.

Redana, B. (1994) '*Cerpen dang ugatan terhadap "realitas"* (Short story and questions on "reality")', *Kompas* February 6.

Said, E. (1979) 'The text, the world, the critic', in J. V. Harari (ed.) *Textual Strategies: Perspectives in Post-Structuralist Criticism*, New York: Cornell University Press.

Selden, R. (1991) *A Reader's Guide to Contemporary Literary Theory*, Yogyakarta: Gadjah Mada University Press.

12

WHITE PANIC OR MAD MAX AND THE SUBLIME

Meaghan Morris

> There were no Alpine precipices, no avalanches or volcanoes or
> black jungles full of wild beasts, no earthquakes . . . Nothing
> appalling or horrible rushed upon these men. Only there happened
> – nothing. There might have been a pool of cool water behind any
> one of those tree clumps; only – there was not. It might have rained
> at any time; only – it did not. There might have been a fence or a
> house just over the next rise; only – there was not. They lay down,
> with the birds hopping from branch to branch above them and the
> bright sky peeping down at them. No one came. Nothing hap-
> pened. That was all.
>
> (C. W. Bean, 1945: 2–3)

> Well, how the world turns! One day, cock of the walk; next, a
> feather duster. . . . So much for history. Anyway – water? Fruit?
> (Aunty Entity, *Mad Max Beyond Thunderdome* 1985)

> Soon, very soon, we will have to . . . recognize that Australia is an
> off-shore island in an Asia-Pacific world of very dynamic and fast-
> growing societies and civilisations. If we continue to turn our backs
> on them . . . we are doomed to isolation and insignificance as a
> nation.
>
> (Jamie Mackie, 1992: v)

A recent history of the relationship between immigration and foreign policy in
Australasia and North America this century begins by noting that while 'much
had been written on the origins of the White Australia Policy, very little had
been written on its maintenance' (Brawley, 1995: 1). As in the United States,
Canada and New Zealand, during the later part of the nineteenth century new
notions of 'race' – linked to rising nationalism and emerging Social Darwinism,
useful to the economic protectionism espoused by farmers, manufacturers, and
trade unions alike – intensified pressure to restrict Asian immigration to the

Australian colonies. However, this does not explain how the policy effected by the first Act of the new Australian Commonwealth in 1901 lasted as long as it did (1973); why Australian governments were vocal in defending it, while others with similar policies were discreet; nor why and how it was abolished. To answer these questions, Brawley looks to the international context of Australian domestic policies.

I am not a historian, but my concern in this chapter is also with 'how and why' questions of maintenance and change. The methodologies of cultural studies sometimes incline us to give far more weight to the latter than the former; doing so, we too easily rest content with a 'thin' account of the past that underestimates both the resilience of old stories and the complexity of cultural change. 'White Australia', for example, was not only a policy valorized by a set of beliefs instilled in people over decades, but a wild array of stories, myths, legends, rumors, images, factoids and ideas not necessarily coherent with the policy's aims or with each other – and always taking on a life of their own. This essay is a brief and selective account of the life of one such story, 'the sublime', as it has been maintained, changed, even nudged towards its 'use-by date' (Carter, 1996: 95) in recent years, by Australian films in international distribution.

Drawing on a larger research project,[1] I trace a line of allegorical thinking *about* policy logics and popular myths of race wandering through action and horror cinema in the 1970s and 1980s; I ask how such a calculatedly 'national' cinema as Australia's has dealt with what David Walker (1995: 33) calls 'the psycho *dynamics* of whiteness'.[2] Action films generically tend not only to experiment technically with 'special effects' of becoming-other (Deleuze and Guattari, 1987: 232–309) but also rhetorically with the very fantasies of invasion by Otherness that politicians, journalists and intellectuals have invested in 'white' (more recently and narrowly, 'Anglo-Celtic') popular culture for over a century.[3] I take cinematic thinking to be affective and energetic in character, reading films as events rather than as symptomatic statements (Morris: 1988). So I ask what these films *do with* cultural materials now often simply labelled 'Orientalist' (extrapolating from Said, 1978), but which have been used as diversely in the past as in the present to transform historical clichés and to try out models for a *potential* national narration (Bhabha, 1990).

My purpose in this chapter, however, is less formal than this outline implies. I try to sketch an aesthetic genealogy for the remarkable rhetoric of *menace* (see Perera, 1993: 17) used in recent years by some enthusiasts for the idea of enmeshing Australia culturally as well as economically in 'an Asia-Pacific world'. Jamie Mackie's ominous pairing of 'Asian' dynamism with Australian 'doom' in the passage cited above is only one example of an authoritative discourse, pervasive in recent years, whereby Australia is 'likened to a malaise that requires resolution' (Kong, 1995: 91).[4] What follows is really an argument against this discourse, and the affective politics of 'white panic' that it exploits – and the cinema I study explores.

Max and the sublime

In 1979, Dr George Miller ended one of the two main plot lines of *Mad Max* by symbolically exterminating the private sphere. The killing of the hero's wife and child cuts his last links to a dying order that divided social life between spaces of work and leisure, time for mates (other men) and family demands, war on the road and uneasy peace at home. In the most famous scene of the film, avenging bikers simply run down Jess Rockatansky (Joanne Samuel) as she flees with her baby down the highway. We don't really see the impact, but we do hear a thump as Jess falls down out of the frame, and then a child's shoe flutters on to the tarmac.

By Australian standards at the time, this was an appalling transgression; *Mad Max* provoked an outcry about violence in the cinema and people would 'remember from the film a violence in excess of what was literally there' (O'Regan, 1989: 126). No doubt this sort of 'false memory' can arise in reaction to any cleverly edited action sequence that works more by suggestion than showing; our imagination excessively completes the scene. The question still arises, what is being suggested? what do we imagine? Memories, versions, readings of any film will differ with the complex histories that spectators bring to a screening and the act of 'completing' a scene (Chow, 1991: 3–33; Willemen, 1994: 27–55). So what made *this* scene so powerfully articulate 'collective neuroses and fears' (O'Regan, 1989: 126)?

Although we learn in a 'hospital' coda that Jess is not yet dead, the smashing of his family leaves Max (Mel Gibson) free to follow the other plot line – his struggle to *not*-become another crazy in a violently male, indivisibly anarchic world – towards the wasteland. Max survives to become the hero of two more films: *Mad Max 2* (aka *The Road Warrior*, 1981) and *Mad Max Beyond Thunderdome* (1985), co-directed by Miller with George Ogilvie. The trilogy is now famous as a formally influential action epic about car crashes, homosocial subcultures and the end of the world as we know it. Yet while the films attracted attention internationally for their mythical force and strong visual style, Constance Penley summed up the early critical response to them when she dismissed the first two as exemplary of 'recent dystopian films . . . content to revel in the sheer awfulness of The Day After' (1986: 67).

In Australia, the social realist edge and the humor of these films more immediately inflected their meaning: the first film's vision of a bellicose car culture could be seen as 'predominantly naturalistic' (Gibson, 1992: 159), while the formalist *élan* of the second was grounded by 'insider' jokes about Australian popular culture (Cunningham, 1983). With the release of *Beyond Thunderdome*, critics soon began to read the *Max* films seriously as reworking 'Australian historiographical understandings' (O'Regan, 1989: 127).[5] It is not hard to see why. Moving from a loss of family to a nomad/settler conflict (*Mad Max 2*), and the making of a new society partly based (in *Beyond Thunderdome*) on convict labor, the Max trilogy revised the dreams and nightmares of white settler mythology,

as well as probing fears of a nuclear future. Rhetorics of movement, loss and alienation have often shaped the writing of histories in modern Australia, a nation created by and for trade flows, transportation, immigration, and anxious dreams of conquering space (Blainey, 1966). Max is an emigrant with no hope of returning home; his is a story of displacement and traumatic severance, and it serves on many levels as a myth of origin projecting into the future a scene of repetition in which the repetitive ('on the road again', heading for the Unknown) can always be redeemed as a brand new start. However, it is also a story of sometimes violent *contact*. Max's adventures are all about the others whom he meets along the way, and how he slowly changes in response.

Moreover, the trilogy is not a simple 'Day After' story. It has an interesting temporal structure: the catastrophe is not only undramatised but diffused over time. In *Mad Max*, apocalypse is present as a potential of the spectator's present; the film always begins 'a few years from *now*', in a world a little worse than the one we know, and ends, some time later, with Max *en route* to a world worse again. At the beginning of *Mad Max 2*, an apocalyptic Oil War is already in the past, fictively located 'between' the first two films. But this beginning is narrated from the *future* of the events that *Mad Max 2* will depict and an opening collage of images, evoking a disaster that occurred before the narrator was born, mixes stills from *Mad Max* with archival scenes of war – as though Jess died during, not before, the conflagration. 'The End' is most vividly envisioned in these films as a running down, not a sudden, drastic rupture; time 'after' is clearly marked only in relation to Max's personal tragedy. The temporal setting of *Beyond Thunderdome* is also drifting, vague; it is 'after' *Mad Max 2*, Max is older; society is becoming more complex as a harsh law and politics replace the open savagery that succeeded, in the second film, the degenerative madness of the first; the continent of Australia is once again occupied by several different cultures, if still divided between those with access to 'power' and those without.

As stories of 'contact', then, these films are also about the tensions between memory and history, personal and public time, repetition and singularity, entropy and dynamism, banal and unprecedented events; at every moment of Max's trajectory from suburban bread-winner to road warrior to reluctant hero of legend, he faces problems of moving and acting between radically different orders of experience. This is one reason why the trilogy, with its narrative emphasis on 'sheer awfulness' and its emphatic poetics of landscape, resonates strongly with the 'plot of the sublime' (Otto, 1993: 547) – in modern times, a scenario in which a dynamic self, normalized white and male, is overwhelmingly threatened by a fearsome power of alterity;[6] freezes in astonishment ('that state of the soul, in which all its motions are suspended, with some degree of horror'; Burke, 1968: 57); then bounces back with renewed strength and vigor by making sense of the threatening power, while appropriating some of its force.

Let me say three things about my interest here in the sublime. First, it is limited. The critical revival of interest in Anglo-American Romantic literature

(Bloom, 1973; Weiskel, 1976) and in philosophical aesthetics as a discourse on the 'transport' of thought towards its limits (Lyotard, 1994) has produced a body of theory so vast and difficult that it has its own sublime effect; I am more concerned with popular or casual versions of the sublime, which often work with older and less overtly self-reflexive aesthetic ideas. Where most serious post-Kantian readings think the sublime relationally as a problem of/for a subject caught up in incommensurability (de Bolla, 1989; Ferguson, 1992; Hertz, 1985), I want to keep hold of the vernacular use of the term to refer, in an 'essentialist' and often humorous way, to something treated *with admiration or respect* (for Burke, 'inferior effects' of the sublime; 1968: 57) as the cause of a feeling of shock, amazement, or simply of being 'impressed'.[7]

Second, I want to emphasize the historical variability of the scenario's contents and uses. For my purposes, it matters that the sublime in Australia has had *practical* force as a story elaborated for a particular form of settler colonialism as it extended across the continent, Aboriginal land – and as immigrants from Europe began to think of themselves as 'close' to the vastness of 'Asia'. It follows that if the concept of the sublime always entails a limit-event of some kind, readings rendering that event in terms of modern European and American histories of gender (Diehl, 1990; Yaeger, 1989), sexuality (Edelman, 1989), slavery and racial terror (Gilroy, 1993), individualism (Ferguson, 1992), nationalism (Simpson, 1993) and 'heady imperialism' (Weiskel, 1976: 6) may need to be cited with caution in other contexts.

In Australian white settler literature, for example, the 'language of the sublime' was invoked 'well into the twentieth century . . . by travellers, explorers and writers as a discourse appropriate for an encounter with an alien land or people' (Otto, 1993: 548), and the 'language' was primarily Edmund Burke's. Britain's invasion of Australia began in 1788, and *A Philosophical Enquiry into the Origin of Our Ideas of the Sublime and Beautiful* (first published in 1757 and 1759) was widely read by the early colonists, serving as 'a basic handbook – even in the field' (Dixon, 1986: 48) for ordering their responses to 'scenery'. However, it is often a *failure* of that language, a mismatch between handbook and field, model and experience, that precipitates in settler texts the 'plot' of the sublime; the botching of a first, formal exercise in 'European vision' (Smith, 1960) follows a struggle to reconstitute a way of seeing and reappropriate descriptive power (Carter, 1987; Gibson, 1992).

'There were no Alpine precipices', writes C.E.W. Bean (1945: 2) in *On the Wool Track*, rehearsing with a magisterial eloquence the sublime *topoi* that do not describe 'the country where men have died'.[8] In their place is a 'nothing appalling and horrible' that is itself so appalling and horrible that its power as 'a nothingness which is actually something, an immensely powerful, active force' (Thompson, 1987: 164) is the thing of which men die: it had 'actually done them to death' (Bean, 1945: 2). Practiced in this way, the sublime displaces the often bloody human conflicts of colonial history with a pale metaphysics of landscape in which Man confronts the Unknown (Otto, 1993: 549). Aboriginal

peoples are written out of this scenario as it creates its *terra nullius* (see Reynolds, 1982); if in North America the 'Western' genre conceded that there was violence between settlers and indigenous people, in this country 'there happened – nothing'. Bean's text is subtly explicit on this point, as the 'effects of blackness' that terrified Edmund Burke (1968: 147–9; see Gilroy, 1993: 8–9) are set aside with the cliffs and the avalanches: 'There was some danger from blacks – not a very great risk. The real danger was from the country itself' (Bean, 1945: 2).

Bean's extraordinary account of death by thirst in country that was not a desert but 'looked like a beautiful open park with gentle slopes and soft grey tree-clumps' (1945: 2–3) exemplifies *how* a Burkean aesthetic was popularized in Australia: encountering its limits, white settlers made new clichés; describing a different country, they made national myths. In a book published a year after *On the Wool Track*, Bertrand Russell would rattle off the 'old' European clichés as they were used by the young Kant: 'Night is sublime, day is beautiful; the sea is sublime, the land is beautiful; man is sublime, woman is beautiful; and so on' (1946: 679; Kant, 1960: 46–8). Australian writers of a metaphysical bent could be moved well into the 1950s by the *problem* posed by this schema: what is 'Man', if little of his world seems beautiful and may prove deadly when it does look beautiful; if the land is more terrifying than the sea; and if the night brings relief from 'the demon dread of day' (Otto, 1993: 549)?[9]

What, then, is 'woman'? The third thing that interests me about the sublime is the way that popular versions tend to complicate rather than bracket (as most recent theoretical treatments have done)[10] a symbiotic relation to the Beautiful understood right up front as feminine, sociable and domestic (in Bean's terms, 'gentle' and 'soft'), but also as unreliably oppositional to the sublime; staging a sort of failure of binary thought, popular sublimes may grapple more intensely with problems of similarity, resemblance and convergence than with 'critical' questions of difference. However, migrant nostalgia can introduce a stabilizing element here, whereby the contrastive force of the Beautiful is most securely preserved *in time* as a lost 'home' or 'mother country' accessible only to memory, while persisting in space as an inaccessibly distant place. Graeme Clifford's film, *Burke and Wills* (1985) performs this double movement in an instant at the end of the opening sequence, when a scene of gentlemen and ladies playing at being lost in a lovely green English garden maze is displaced by a frame-full of 'nothing' – the endless desert in which the explorers will lose their way, and die.

In this (intensely clichéed) movement, women disappear; left behind in time as well as space, they too are consigned to the order of memory. The most stable opposition, then, is that which organizes a division between past and present, or between the past and all time *after* an event or a moment that produces this division and renders it absolute. Such a twisting of narrative time into a 'then' and an infinite 'after' has its effects on conceptualizing the future; happy endings, the resolution of a disequilibrium, the achievement of a sociable balance or a 'return' to a state of harmony, become more difficult to achieve.

Inside/outside: phobic narrative

Consider the sentimental or 'bathetic' version of the sublime in recent Hollywood films about Aliens. These days, they often express a desire for reconciliation with 'ET': *Close Encounters of the Third Kind* is paradigmatic of this desire, on which the *Alien* trilogy, with its logic of convergence between murderously self-sacrificing human and alien mothers (Creed, 1993: 52), is a perverse variation; the best rendition I know has a classic figure of sublimity as its title, *The Abyss*. Optimistic contact allegories of this kind are rare in Australian cinema, which emphasizes fantastic animals (*Long Weekend*, *Razorback*) or *super*-natural forces channeled by mystic Aborigines (*The Last Wave*, *Dead Heart*) rather than extra-terrestrials, avoiding happy endings – especially the bellicose triumph for 'our' side reclaimed by Hollywood with *Independence Day* – unless legitimised by comedy (*Crocodile Dundee*, *Marsupials: The Howling III*).

Much more common in the action cinema of the 1970s and 1980s is a double reworking of, on the one hand, the thematics of the colonial natural sublime (deadly space, isolation, 'nothing') with, on the other, that peculiar dread of the future as the *outcome* of an inner decay already menacing the 'race' that has haunted social Darwinist narratives since the later nineteenth century (see Beale, 1910). This has been by no means a uniquely Australian dread. Significant numbers of intellectuals in most Western countries were obsessed by it until after the Nazi Holocaust; globally popular spin-offs of *Rosemary's Baby* and the *Omen* films continue to exploit its broad folkloric appeal; postcolonial governments, too, have used it to produce their own 'narratives of national crisis' (Heng and Devan, 1992: 343). However, it is hard to exaggerate the influence of the twin scenarios of 'race suicide' – that is, miscegenation between 'fit' and 'unfit' persons and classes as well as races (Finch, 1993; Hicks, 1978) and '*white* peril' – falling birth rates among white Australians, compared with the 'sheer terrifying numberlessness' (Barrell, 1991: 5) of the populations of a deliriously totalized 'Asia' (Brawley, 1995; Pringle, 1973) – that circulated *in* Australia during the very decades at the turn of the century in which the modern nation was shaped.

So it is not surprising that these bizarre, apocalyptic scenarios, obsessed with 'breeding' and 'degeneracy' rather than love or sexual morality and with population 'bombs' rather than pods from outer space, should have fascinated filmmakers creating a new national cinema in Australia after the late 1960s, when social Darwinism was at last discarded as a legitimizing narrative of state. The film revival of the 1970s 'played' in a climate of heady *anti*-imperialism, sexual liberation, and cultural revolution. Five years before *Mad Max*, Peter Weir's horror-comedy *The Cars That Ate Paris* (1974) used a car-crash allegory to pillory the racist insularity and heterophobia of a nation that had found it logical to go to war in Vietnam to 'stop them coming over here'. A small town isolated in the middle of 'nothing', Paris cannot tolerate change or difference;

but in reality, it feeds on strangers. Parisian women do not bear enough children for the town to survive: so, like the mutant cars that terrorize the streets, Parisian patriarchy reproduces by making over the remnants of the car-crashes caused by the men.

This macabre and very funny parable about a paranoid, exclusionary society with a cannibalistic immigration policy opened up a whole series of scary narratives in which a white group or couple is contained in a 'safely' closed space – a house (*Shame, Phobia*), a remote town or farm (*Wake in Fright, Turkey Shoot*), an isolated beach (*Long Weekend*), a boat (*Dead Calm*) – which is invaded by an outsider/other and turns into a trap, or is revealed to be itself a prison that accelerates the community's tendency to degenerate from within. This second nightmare of insularity, an entity's potential for disaggregation by an *internally* proliferating otherness or 'infection' (Barrell, 1991), is often forgotten these days by critics of British Australia's obsession with being invaded or 'swamped' by outsiders. However, it is integral to the 'peril' projected by the population sublime. A fear of 'in-breeding' invests the invasion scenario with intense ambivalence, with desire as well as hostility; the fearsome power of alterity is always needed to save us from ourselves.

Correspondingly, problems of control and mastery may be most acutely posed not by 'aliens', but by the go-betweens (Chambers, 1994) or *carriers* who exemplify contact between inner and outer worlds and, quite commonly in cinema, between genres. Thus a long tradition of European family melodrama about 'bad blood' informs the horror of Colin Eggleston's *Long Weekend* (1977), in which a corrupt white couple, having sinned against Nature (the man casually kills animals, the woman has had an abortion) is driven mad by 'nothing' – birds, a dugong calling her lost calf – in the bush; the sound of the mother dugong's grief *carries* between the human and natural orders, shattering the woman's brittle urban shell. In action films, peril is more overtly externalized as the 'enormity' of other people: this is the terrain of *Mad Max 2*, in which a weakened, vestigially heterosexual band of white-clad settlers marooned in the wasteland, dreaming of a beach with 'nothing to do but breed', confronts the greater violence of the black-leather queers, sadists and degenerates ravening around their fort. With his 'terminal crazy' tendencies and ascetic post-sexuality, Max himself is the carrier, of violence and salvation, *par excellence*.

These films work with a way of structuring historical materials that I call 'phobic narrative' (Morris, 1993). Widely used today in the media to frame economic and political debates about Australia's future, phobic narrative constitutes space in a stifling alternation of *agoraphobia* (fear of 'opening up' the nation to an immensely powerful Other, typically 'the global economy') with *claustrophobia* (fear of being shut away from a wider, more dynamic, typically 'Asian-Pacific' world): pressure accumulates in this way on the figure of the border between forces pushing in and forces pushing out. History is then caught in an oscillation between *entropy*, a slow running down of closed, communal time, and an explosive temporality of *catastrophe* unleashed by the Other

coming from elsewhere. The driving force of phobic narrative is then a pre-emptive desire for avoidance: how to avoid invasion at one pole while avoiding isolation at the other; how to avoid stagnation while avoiding revolution and disruption.

In practice, this repetitive swinging between opposite extremes of anxiety about the future can serve to shape not a quest for national 'identity' in the European sense (unity of language, 'blood' and territory), but a pragmatic emphasis on solving 'how?' problems of becoming rather than 'who?' or 'what?' questions of being.[11] For this very reason, however, the question arises of phobic narrative's recurring power to shape 'Australian historiographical under-standings' (O'Regan, 1989: 127). Any revision of historical materials creates a remainder, something left over each time; we can think of this as an edge of dif-ference or an incommensurability, but it can also be something that *returns* as an element excluded from differing versions of a story, securing their similarity.

Phobic narratives of Australian national space clearly worry over the possi-bility of at least one specific form of historical repetition. The simplest way to render this is to consider that both the colonial sublime of landscape (the 'noth-ing') and the social Darwinist sublime of population (the 'numbers') entail invasion scenarios in which white people are *victims*. In the first, the bush and the desert act as inhuman agents of a *de*-population: tales of lone white men dying of nothing in an 'uninhabited' land condense and censor a history of Aboriginal deaths and black resistance to white settlement; responsibility for colonial violence passes to a homicidal land. In the second, the coast is a per-meable barrier against waves of *over*-population rolling in from the future (often, 'Asia').[12] This figure operates most powerfully in a register of paranoid antici-pation. However, it also carries a pressing mnemonic force (saying that invaders will come by sea, we admit that it is we who came by sea) that secures a chain of displacement: something we did to others becomes something that happened to us and could happen all over again; on the beach, we replay our genocidal past as our apocalyptic future (Morris, 1992).[13]

'Terror in the Bush', or the risks of maternity

Thus it happens that a woman, peacefully sunbathing alone on a quiet, idyllic beach, will raise her head for no obvious reason and look around with an unaccountable sense of unease. It is almost mandatory in action films that a shot of calm, beautiful scenery anticipates terrible events; in Australian film, an idyl-lic beach scene in particular marks a *premonition* of repetition, running in reverse Burke's 'plot' of delight as the *aftermath* of danger or pain, a 'tranquillity shad-owed with horror' (Burke, 1968: 34). In *Mad Max*, Jess hears seagulls, sees 'nothing' along the beach; the dog has run off, but dogs do that; she gathers her things and heads for home through bush that looks like a beautiful park, with gentle slopes and soft grey tree-clumps.

I am not sure where I first heard the phrase, 'white panic',[14] but it always

comes to mind when I watch the next scene. As I understand it, this phrase refers not to white bodies *in* a state of panic but rather, by metonymy, to that hallucinatory blurring or bleaching out of detail produced *by* the blinding heat of panic. Such panic is 'white' in that it erases differences from the field of sensory perception; panic motion is clumsy and uncontrolled. Fittingly, then, panic for theoreticians is not strictly a sublime emotion. Panic is a response to an objective cause of some kind, and it is a precondition of the modern sublime that we are not really in peril: 'if the danger is real we turn and flee, without pausing for our sublime moment' (Weiskel, 1976: 84; see Burke, 1968: 40, 46). At the same time, anxiety is also subjective in that it is retroactive: 'the threatening occasion appears to revive a fundamental fantasy of injury and escape . . . played out hypothetically (pictured to ourselves) in the phenomenal terms of the occasion before us' (Weiskel, 1976: 84–5). In other words, a work of memory is involved when we recognize a danger; we panic when something tells us we have seen this movie before.

Watching a film, any spectator is in a complex, doubled position in this respect. In a cinema, we can certainly savor our sublime 'moment' if what we see stirs feelings of panic; watching a video, we can replay the occasion and 'pause' it as many times as we wish. However, the social ' "givenness' of subjectivity' that Rey Chow (1991: 19–27) calls 'pregazing', already caught up as it is in larger historical processes of interpellation and recognition, ensures that such feelings are also *retroactive* – and not only in relation to the formal dynamics of identification with a camera, a gaze, an editing principle, and so on. However rarely it happens to film-literate people, we can perfectly well be panicked by a *non*-cinematic fantasy or a memory in some way played out in the phenomenal terms of the cinematic 'occasion before us'.

Mad Max is not the only film to have made me flee the cinema (at a blundering run quite unlike the lucid 'walking out' that signifies distaste), but it is easily the most memorable; the first time, I didn't make it through Jess's headlong flight through the bush. A cut takes us from behind Jess as she leaves the beach to a frontal view of her walking cautiously up the slope in the bush. As noises thicken in her sound-world and chords stir nervily in ours, she hesitates; the camera comes in closer and a strange cry curdles the air; Jess stops, bites her lip and looks around. Abruptly, we see men running behind trees in the distance! – but does she? or do we see them from the perspective of men closing in from the other side? Suddenly, we are behind her: in the most aggressive movement in the film, the camera lunges at her back; she screams, she turns – and from Jess's point of view we see 'nothing', a frame-full of beautiful bush.

From here, the scene plays out what is for many people a powerful *cultural* memory, 'terror in the bush'. As urban souls who only see the bush from planes and cars or on a nice stroll in a National Park packed with tourists, many Australians know about this terror while never having felt it. Without warning or reason, a person or a group (it is a highly contagious form of fear) is

overwhelmed by a feeling of being watched from all sides, caught in a hostile gaze rushing in around the 360 degrees of a circle; panic flight is a common reaction. Describing this experience in his 1923 novel, *Kangaroo*, D.H. Lawrence (1950: 19) laid out what would become, relayed by critics and historians (Carroll, 1982; Clark, 1980: 46–7; Holt, 1982: 94–7), the canonical literary account of it when he ascribed 'the horrid thing in the bush!' to '*the spirit of the place*', assimilating this in turn to 'a long black arm' and then 'an alien people' watching (again) its 'victim' while patiently 'waiting for a far-off end, watching the myriad intruding white men'.[15]

More mundane explanations can be given of terror in the bush. When I first felt it as a child, playing with a friend not ten minutes' run from her house, my father told me it was only sheep or kangaroos peering at us from behind the trees. At the other extreme, it can be theorized away as a purely cultural phenomenon, a 'white guilt' acquired (but how?) in infancy. Despite its racial romanticism (Muecke, 1992: 19–35), Lawrence's version is at least capable of admitting, like *Mad Max*, that terror in the bush involves not only a response to something powerful in nature *and* a narcissistically 'bounced', accusatory historical gaze, but *also* a fear of the actions of other human beings. 'Panic' is a good name for this compound sort of fear; in Greek mythology, Pan was a hybrid creature, half-human, half-goat, who made noises in the woods which terrified people.[16]

Pan was also a lustful god. Like the 'obscurity' and 'darkness' prized by Burke as productive of the sublime, woods and 'low, confused, uncertain sounds' (Burke, 1968: 83) carry special terrors for women and vulnerable men.[17] Rational fear of rape and murder saturates the scene of Jess's terror: three more times, we see her see 'nothing' as we see the bikers come closer while the cries grow louder and unmistakably human and male; she falls, and her beach-wrap flies open up to her waist. This scene terrified me because the editing 'joined' my own vivid memory of terror in the bush to the knowledge all attentive spectators will share that 'the horrid thing in the bush!' is, in this instance, not a 'spirit' or 'a long black arm' but a bunch of crazy white men.

Clearly, the chase scene splits along gendered lines the white Australian 'we' I have been using to this point. If *Mad Max* portrays a society disintegrating into two groups, hunters and hunted, this is the scene in which the feminized side of that dichotomy is elaborated paradigmatically (Jess crashes into a bird, the corpse of her dog, then a lumbering, childish man); routinely splitting the narrative image of 'woman' from the movement of the narration (De Lauretis, 1984), it induces in at least this female spectator the sense of externalization that makes most rape scenes 'alien'. Yet something else drifts across this division, holding Jess's image as 'woman' in the historical field of *white* panic composed by the articulation of the natural with the population sublime.

For me as a white female spectator, this 'something' is neither a memory nor a 'fantasy of injury and escape', but a trace of a knowledge acquired from other texts and stories (see Langton, 1993: 33) and brought to bear,

retroactively, on the scene. Jess in *Mad Max* is not simply a 'woman'. Jess is a *mother*, her abstract status affirmed by the generic name Sprog ('offspring') that she and Max have given their child. Only in the beach–bush–house sequence is Jess a woman alone; in every other situation of danger, she carries Sprog in the posture of an iconic 'mother with child'. This sequence in fact mediates between two other chases in which a *child* is menaced: near the beginning of the film, the Nightrider tries to run down a toddler on the road; near the end, the Nightrider's mates run down Jess and Sprog. At this level, the narrative is organized by a triptych of 'victim' figures: child/woman/mother-with-child.

What happens if we see Jess in these scenes as black? if we hallucinate her as an Aboriginal *mother*, fleeing terrified with a gang of white men in pursuit?[18] As well as restoring a still often suppressed dimension of sexual violence in Australia, we retrieve a scene of racial terror crucial to national history but almost never dramatized in mainstream 'national' cinema. At various times, most intensely between the 1920s and the 1960s, all Australian states forcibly took children away from Aboriginal families, placing them in state 'homes' or in white foster care, with the aim of assimilating them to white society (Edwards and Read, 1989). Inspired by *utopian* futurist forms of eugenics, extreme proponents of this policy hoped it would result in the 'biological absorption' of Aborigines by white people in a few generations (Haebich, 1992: 316–25). While this genocidal program was unrealized, failing at the time to win public support (Haebich, 1992: 318), its monstrous fantasy of exploiting black women and children to build up White Australia's 'numbers' against the *external* threat of the future/'Asia' passed rapidly through the media into popular lore about the population 'problem' (for example, Hill, 1963: 225–32) – and the children were no less cruelly taken from their mothers.

Once their stories of terror and privation are not only included but made central in 'Australian historiograpical understandings', we might one day be able to see the ferocious pursuit of the mother in *Mad Max* as an allegory which, at the beginning of a period of profound transformation in Australian society away from the twentieth-century model of racist mono-culturalism, complemented and partially revised Bean's elegy for the white men dead in the bush. These passages complement each other not when we notice that Bean wrote a history of Man while *Mad Max* opened a space for the experience of women and children (in this they diverge), but when we can see both as enacting the displacement that founded the old 'national culture': Jess is, of course, white, but more significantly there are no Aboriginal people anywhere in her world. However, the 'dystopian' futurism of *Mad Max* changed the traditions it drew on – and deeply shocked its early audiences – by projecting a mythic landscape and a (future) past in which *something* happened (telling in fiction a terrible historical truth), while showing us unequivocally that 'the real danger' in this landscape was *not* from 'the country itself' (Bean, 1945: 2).

Nobody, somebody: women of the future

From this premise, different stories can begin to be told. If the future remains an object of dread, it is less predictable; open to change by human actions, endings become an object of experiment and even happiness a narrative option. I have space here only to suggest some directions for further discussion by jumping over to the images of the future in *Beyond Thunderdome*.

By the third film, new peoples are creating themselves by alliance and improvization; there is no nation, and no state to administer a 'population'. Presumably, the Northern Tribes who set off for Paradise at the end of *Mad Max 2* are still breeding away on the coast. In the desert, a White Tribe of children is living in a lush lost valley, the 'Crack in the Earth': looking like ragtag extras from a Hollywood jungle movie, their style of life is adapted from Tom Cowan's *Journey Among Women* (1977), a lesbian-influenced film about a new society founded by women convicts, and their 'fecund haven concealed in the blasted interior' (Gibson, 1992: 162) is an old motif of Australian fantasy literature. Then there's Bartertown: a wild, hard-trading, frontier city, formally invoking the Hollywood biblical or Roman epic with its pell-mell costume clichés ('African' warriors, 'Roman' soldiers, 'Arab' souks, an 'Asiatic' despot), with 'British' colonials and global media icons tossed into the mix, but threaded together by the East Asian motifs – a headdress here, a tattoo there – that make Bartertown unmistakably a desert descendant of today's fantastic, hyper-capitalist 'Pacific Rim'.[19]

Each group is developing a distinct political system. The Northern Tribes are patriarchal. The White Tribe is a sexually egalitarian gerontocracy (older children lead), and Bartertown is dominated by a single woman, Aunty Entity (Tina Turner). While always signifying herself, a Black American superstar, 'Tina Turner' is styled here as 'Cleopatra-esque', and thus coded, in the old Hollywood manner, as an 'Oriental' woman of beauty, ferocity and power; ruling by public rituals of punishment ('the Law') and behind-the-scenes intrigue, Aunty uses a deft combination of forced labor and environmentally sustainable technology to build Bartertown on a Pharaonic scale.

Max, ever the go-between, provokes an encounter between those two futures. From the crossing of White tribalism with entrepreneurial multiculturalism emerges a third future, the mixed society that salvages the city of Sydney ('Home') at the end of the film. Unsurprisingly, Home offers the best of both worlds. Like Bartertown it is innovatory, but it remains egalitarian like the Crack in the Earth. Unlike the Crack in the Earth, it is technologically based; unlike Bartertown, subject to the violence and spectacle of the Law, Home is made socially cohesive by a communal practice of narration and memory. Home's leader, Savannah Nix (Helen Buday), is a white woman who embodies the best of both sexes. A warrior *and* a mother, Nix is a compulsive historian: she makes the people recite their history every single night of their lives.

It is easy to produce a series of binary oppositions between Nix ('Nobody') and Entity ('Somebody'); the film invites us to do so. Nix is to Entity as white is to black, innocence to sophistication, idealism to pragmatism, memory to forgetfulness – and as history is, not to nature (a dualism made meaningless in *Mad Max*) but to *economy*. Aunty Entity is a business woman. If her view of history broadly resembles Henry Ford's ('history is bunk'), as she explains her approach to Max, it more exactly recalls a philosophy associated with the late Fred Daly, a much-loved Australian Labor politician: 'one day, cock of the walk; next, a feather duster'. However, for Aunty, history's *content* is not a struggle for justice but a random play of individual survival and opportunity: 'on the day after, I was still alive. This Nobody had a chance to be Somebody. So much for history'.

Yet there is a double historical displacement going on around the charismatic figure of Tina Turner. She is a black ruler in the Outback, 'in the place' of the Aboriginal women who never figure in this epic (which provoked some controversy when the film was released). She is also a woman in charge of an 'Oriental-multicultural' trading zone in which, despite its lavish iconic diversity, the only woman from Asia in sight is tattooed on the Japanese sax-player's back. So if we decide to read *Beyond Thunderdome* as a significantly Australian film, there is a sense in which we can say that troubling issues of race and gender in representation are *peripheralized* by the figure of 'Tina Turner'. I mean this literally: all through the trilogy, glimpses of other stories (the Feral Kid with his boomerang in *Mad Max 2*, the saxophone player himself) flash by in the 'peripheral vision' of the narrative. At the same time, this whole saga of the destruction and rebuilding of society is all about those peripheralized figures, and the roles they play in other stories of depopulation and repopulation, war and migration, historical dominance and economic power.

If we stay with the opposition between Nix and Entity, it is clear that the film sentimentally resolves their conflict in favor of the brave new world built in Sydney by Nix. Hers is the good way forward, and it leads to the future that the Labor government of 1983–96 promoted in its utopian moments: an open, tolerant, enterprising, 'clever' society, creating new industries or recycling the debris of the old, welcoming people from everywhere, while retaining the *good* old white Australian values of collectivism, historical consciousness and care for social welfare. These are virtues distinguishing Home from brutal Bartertown, where atomized, competitive individuals must fight for their lives without a safety net.

If this is a sentimental resolution, it is also a phony one. As a happy ending, it didn't take; *Thunderdome* was the most costly and the least successful film of the trilogy. At the level of the economic allegory of 'survival' subtending the national cinema (Morris, 1988), Tina Turner's presence is primarily a sign of the global distribution and massive budget of the film; she is 'in place' for marketing purposes. And on screen, Aunty is a lot more fun than Savannah Nix. Aunty has wit, sexiness, style, humor and a real affinity with Max; she exudes a lively

cynicism more in tune (I venture to assert) with Australian popular culture than Nix's tense, puritanical fervor; a media creature, Aunty inhabits the big-screen spectacle of *Thunderdome* with grace, consistency and ease. In contrast, Nix, for all her social *bricolage* and home-spun historiography, is perhaps less a portent of the future than a nostalgic reminder of the poor technical conditions in which the first *Mad Max* was made.

When we ask how Max mediates the dyad of black and white heroines, the happy ending is more ambiguous. Max cannot join the maternally nurturing utopia of 'Home' any more than he could really live in an infantile lost valley; cut off from Nix's future by the searing *knowledge* of his past, Max admits the spiritual congeniality of the unmaternal Aunty by staying in the dystopia where each has thrived: Max, by devolving from lawman to 'Nobody' ('The Man With No Name'); Entity, as a Nobody enabled to become the Law. To the end, then, something *grates* about the figure of the white mother-and-child.

Something always did. Even in *Mad Max*, only Jess and Sprog truly live the inhibiting ideals of normality, order, control; almost all the other characters are already, one way or another, social 'feather dusters', except Max's mate Goose (Steve Bisley), the road war's first casualty. Max himself is a waverer, afraid of becoming one of the crazies he is meant to control – which is exactly what he needs to do. As O'Regan (1989: 127) points out, the death of his wife and child *makes* Max; 'Mad', he can avoid the ' "vegetable" fate of his mate', survive the apocalypse and enter the new world. This has often led feminists to take a dim view of the films (Dermody and Jacka, 1988: 177–8), particularly since casting white women as 'God's police' – moral guardians of community, enforcers of social law – is an old colonial tradition (Summers, 1975).

Yet Jess herself is a lot more fun than Savannah Nix, to whom the 'guardian' cliché better applies. We are not incited to rejoice at Jess's fate, and so *Mad Max* is all the more shocking for the directness with which it offers a cure for the 'psycho dynamics' of white settler history: imagine a future, even narrate the nation, without recourse to the biological mother-with-child. This opens another series of questions about the impact under colonialism of the concept of population. If we read allegorically for ways in which the iconography of white Motherhood displaces other histories of sexuality and race in the national frame, it is crucial also to attend historically to this icon's luminous *negativity* in much Australian popular culture.[20] Why is the 'private sphere' of reproduction (in Burke's terms, the white Beautiful) so often cast as an obstacle to the emergence of a Brave New World?

One approach would consider the practical force of a more complex aspect of the sublime than the basic themes I have set out here. It is useful to bring Lyotard's (1989) analysis of 'the event' and the terror of death in Burke's sublime to bear on the anxiety about mothers in phobic national narratives, and on the apocalyptic hyperbole of the narration. Lyotard argues that Burke's sublime is 'kindled by the threat of nothing further happening'; he reads Burke as a theorist of the event and 'the question of time' ('"*Is it happening?*"'), for whom

the greatest terror is that '*It*' will stop happening in the ultimate privation, death (Lyotard, 1989: 204). This is why the sublime is a revitalizing experience: since a healthy soul is an agitated soul, ever ready for the next event, the 'exercise' of the sublime (Burke, 1968: 136) simulates and overcomes a fear of being 'dumb, immobilized, *as good as* dead' (Lyotard, 1989: 205, my emphasis).

It is clear that the unhealthy lassitude threatening the 'nerves' for Burke (and the power of art for Lyotard) is a feminizing 'evil' (Burke, 1968: 135) associated more readily with bourgeois home life than with war or rebuilding a city. Equally, it is clear that Lyotard shares Burke's disinterest in the eventfulness of *birth*; for neither thinker does the concept of 'labor' (or terror) have maternal connotations. In eugenic mythology, however, the event of a birth can bring into the world the most dreadful of deaths, slow, collective, inexorable:[21] one can never be sure exactly what a woman is 'carrying', or whether a threat to the future of a family, community, nation, 'race' will successfully be contained.

In this context, Lyotard's account does get at something crucial about the myth of the mother-as-carrier reworked by the *Mad Max* trilogy. Herself a go-between who bodily mediates (in this discourse) inside and outside worlds, the mother can be a bearer of a 'peril' from the *past* as well as of hope or fear for the future. Sweet, suburban Jess errs on the side of an inadaptive inheritance; with her, a whole way of life that is no longer viable is destroyed. Futurist Nix, in contrast, is able to reconcile the dynamism of free trade Bartertown with the commemorative hyper-activity of the protective Crack in the Earth, where the White Tribe fends off 'slackness' (their term for cultural degeneracy) by telling agitated stories of an apocalyptic event.

Again, a historiography is invoked by these tales of dynamism and 'slackness', one whereby the sublime organizes 'othering' tropes into a vision of Australian society as a catastrophe waiting to happen – if not in a collision between (Their) powerful and (our) feeble energies, then as an inner Nothingness spreading *unopposed*. Consider Lawrence writing not about terror in the bush but an Englishman's perception of Australian urban democracy: 'The *vacancy* of this freedom is almost terrifying. . . . Great swarming, teeming Sydney flowing out into these myriads of bungalows . . . like shallow waters spreading, undyked. And what then? Nothing' (1950: 32–3). Again, Lawrence was not the only writer to find Australians suffering a deficit of the spiritual vigor that comes from a bracing exposure to terror; in this highly selective account of history, popular culture was constituted for decades as an oscillation between *stupor* (Conway, 1971) and *nihilism* ('The Kingdom of Nothingness'; Clark, 1978).

Fictively remedying what is only a deficit in critical vision, no longer thinking history 'through' the body of the mother, the *Mad Max* trilogy tries to transcend this culture of futility and its compensatory, ennobling stories of 'heroic failure' – stories at the heart of the conquistador vision of Man confronting 'the land' (Gibson, 1992: 173–4). *Beyond Thunderdome* may fail because it does strain for transcendence, while leaving Max in the wasteland as a hint that there might be a *Mad Max 4*. However, as Gibson (ibid.: 175) says, it is

significant that Max doesn't die, that the land doesn't kill him, and that he, unlike Bean's victims, succeeds 'in *living*, rather than escaping . . . into apotheosis'. For my purposes, it is equally important that the vitality of the 'Home' Max can't desire is signified by the child Nix holds in her arms as she tells the city's survival stories, and by the image of a mother assuming the power of historical narration.

Conclusion

This is only a story, one of many to use lucidity and humor to salvage something from twentieth-century Australia's 'waning myths' (Gibson, 1992: 175) and do something different with them. However, stories do know a thing or two about the power and resilience of myth that scholars and politicians often seem to miss. If panics over immigration from Asia seem (as they do in 1996) to be recurrent in Australian public life, how surprised can we really be – when so much official rhetoric of 'Asianization' addressed to us in recent years has been marked by the very same panic, prompted now by economic rather than racial anxiety about the future?

When, for example, Jamie Mackie issues the stern warning I cited at the beginning of this chapter – 'soon, very soon, we will have to be capable of meeting [Asians] on their terms' (1992: v) – a truth is told with good intentions: in many ways Australia *is* 'an off-shore island in an Asia-Pacific world of very dynamic . . . societies'. Yet it is told by reanimating White Australia's menacing 'Asian' sublime. After all – to whom is this lesson addressed – ? not to Asian-Australians. What is wrong with living on an off-shore island, and what power does Mackie assume 'we' have had, that we should find this humbling? What is an 'insignificant' nation? In whose 'terms' is drawn this distinction between significant and 'insignificant' nations? Whose gaze is being invoked? Must significant relationships be defined at the national level? What sacrifices are we asked to make by this invocation of an overwhelming 'other' power, on whose 'terms' we are asked to remake ourselves? Are these not, in fact, *Australian* terms, through and through?

It is remarkable how this imaginary simply has no room for the ordinary; for banal, friendly, unsensational contact, everyday mixed experience, the event of a *routine* 'birth': everything happens in a frenzied and apocalyptic register. One of the best films to deal with this material, John Dingwall's *Phobia* (1988), imploded its conventions brilliantly by allowing the agoraphobic migrant heroine (Gosia Dobrowlska) to walk outside with no appalling or horrible consequences; her fear has been created by her Australian husband (Sean Scully) harping about her strangeness in an 'alien' land. Renate's discovery of the outside as an everyday, negotiable reality is lethal to the hyperbolic drive of phobic narrative, in which all 'events' are on a grand scale and every encounter overdetermined.

Going outside means talking *to* the people – in Renate's case, Anglo-

Australians – cast as 'Them' in phobic narrative. This, too, is something scholars and politicians could learn from filmmakers, obliged as the latter are to tell stories for an irrevocably diverse world. Responding to the book that Mackie introduces, Alison Broinowski's *The Yellow Lady: Australian Impressions of Asia* (1992), Foong Ling Kong (1995: 91) points out that this text, intensely critical of the past and present limitations of settler Australians, assumes that Asian women 'exist in a one-dimensional space and listen as they are spoken about; they do not hear themselves'. In the process, it reconstitutes in its mode of address as well as its title the cultural closure it berates.[22] Excluded from the field of 'Australian' impressions of 'Asia', Kong's writing as a woman who 'shuttles' (1995: 83) between Kuala Lumpur and Melbourne is consigned by *The Yellow Lady* to the peripheral vision of history – another tattoo.

However, new modes of address are hard to develop and practice, failures ordinary, helpful examples sparse. I have been interested here in how one work of cinema, firmly based in the most uncompromisingly masculine myths of the white Australian tradition, changes them in definite ways. A study of the *Max* films, however, should above all provide a context for valuing the achievement of less widely distributed, more evidently experimental films about action, domesticity and 'contact' made by women in recent years: Tracey Moffatt's *Night Cries: A Rural Tragedy* (1987), about an Aboriginal daughter caring for her dying white mother in a glowingly aestheticized 'desert'; Pauline Chan's *Traps* (1993), in which a British Australian couple, absorbed in their professional and marital everyday, stumble into the beginning of an insurgency they can barely comprehend in French-occupied Indochina in 1950; Margot Nash's *Vacant Possession* (1994), where a white woman returns after her mother's death to her home at the 'national birthplace', Botany Bay, to face a father crazed by the Pacific War – and the family of her Aboriginal lover, whom her drunken father shot.

Such films are often relegated by critics to the worthy periphery of national cinema – 'independent', 'feminist', or 'multicultural' films. Certainly, they mark the limits of the national cinema project classically understood; centered on the experience of women and children shuttling or shuttled around the world, they internationalize local knowledges of national tensions rather than helping to build a cohesive 'population' in one place. However, I hope my account of phobic narrative in the past helps to show why these films are also creating, without panic or hyperbole, 'historiographical understandings' for the future.

Notes

1 This project began as the 1991 Mari Kuttna Lecture on Film, Power Institute of Fine Arts, Sydney University. My thanks to Laleen Jayamanne for inspiration and advice, and to Terry Smith and Power Publications for their patience.

2 Without space to elaborate a historical argument here, I can only assert that for my purposes John Barrell's study of the 'psychopathology of imperialism' offers the most useful model of these dynamics. In contrast to the 'apparently exhaustive' binary

schemes of self/other, black/white, Eastern/Western, Barrell (1991: 10–11) describes a *triangular* dynamic – 'this/that/the *other* thing' – which better captures the complexity and flexibility of 'White Australia' as a historical formation. Here I deal only with the dominant twentieth century triangulation – 'white/Aboriginal/ Asian' – as projected from the enunciative position (my own) of 'white' as 'this'. However, Australia is and always has been a multi-racial society, and other ways of triangulating social space have always shaped its history: such as, in the early nineteenth century, 'English/Irish/Aboriginal', sometimes 'English/Aboriginal/Irish'. For fine analyses of how the stakes of discourse *about* Australian history shift when the 'this' of Australian enunciation is not projected as 'white', see Hage (1994) and Kong (1995).

3 This does not mean, of course, that only people who identify as 'white' respond to these fears and fantasies, or enjoy films experimenting with them; nor does it mean that all or even most white people do. However, I am not concerned in this chapter with the problem of how we can know what different people and differing audiences 'make' of texts; Hay *et al.* (1996) is an excellent survey of the difficulties of this issue. Rather, I am interested in the historical issue of what filmmakers 'make' of the materials of previous films; this entails a positive description of the recurring tropes of culture.

4 My attention was drawn to Mackie's text by Perera (1993).

5 Many readings appeared in ephemeral publications and are now unavailable. Among those still accessible, see Dermody and Jacka (1988); Gibson (1992: 135–57, first published 1985); Morris (1993, first published 1989); Stratton (1983). Later readings with a national–historical emphasis include Cranny-Francis (1994) and Falconer (1994), while Broderick (1993) develops the global reading of the trilogy as a postmodern myth that is favored by Miller himself.

6 For an important alternative to the orthodox account of the sublime's Eurocentrism which I find useful here, see Vijay Mishra's (1989, 1994) comparative studies in English literature and Sanskrit aesthetics.

7 Arguably, in an era when sublimity is ascribed by advertising to ice cream and tourism sells alterity, there is no 'popular' sublime. There is only a theoretical discourse that *represents* the popular as the aesthetic excess, hybridity and confusion that Pope (1987) called 'bathos' in his 1727 satire on false sublimity, 'The Art of Sinking in Poetry'. However, I prefer Vidler's (1990; 1992) emphasis on the inseparability of 'true' sublimes from those ambiguous genres, such as the grotesque and the uncanny, by which sublimity has been popularized and 'falsified' historically. This approach makes it possible to say that popular sublimes corrode the possibility of making purely aesthetic distinctions between critical and popular discourse: their force is precisely to blur the finely differentiated categories multiplied by theories of the sublime, and to *produce* the 'numberless confusions' (De Man, 1983: 139) about the sublime from which theorists must distinguish our own discourse before performing (as I have here) another act of critical clarification.

8 *On the Wool Track* is an Australian literary classic. However, I owe my awareness of the importance of this passage to Christina Thompson (1987).

9 Otto is citing J. W. Gregory's 1909 account of his travels, *The Dead Heart of Australia* (London: John Murray). Writers with these concerns in the 1950s include Ernestine Hill, Randolph Stow and Patrick White, while Otto's essay is a review of a David Malouf novel, *Remembering Babylon*, published in 1993 (Sydney: Chatto & Windus). For readers unfamiliar with these writers, I should stress that they represent only one strand of Australian literature. While 'landscape' metaphysics has been valued highly by critics and historians of national culture (hence my interest in a feminist analysis of it), it has never been the only or even the dominant preoccupation of writers in Australia's predominantly urban society.

10 The most influential contemporary polemic against Beauty is Lyotard (1984: 71–82). Significant recent exceptions to this tendency are Gilbert-Rolfe (1996) and Hickey (1993). My thanks to Paul Foss for introducing me to both these texts and showing me an English manuscript of the former.

11 Thus there is sometimes a perceived gap between the virulent rhetoric of phobic nationalism in Australia, and the *relatively* low levels of political violence attending actual conflicts over the nature and future of the nation. On this phenomenon in controversies over Chinese immigration in the nineteenth century, see Markus (1979).

12 If the 'future' has often been spatialized by this discourse as 'Asia', or specified at different times as a particular country (China, Japan, Indonesia . . .), its basic structure is able to accommodate any number of ethnic, racial, religious and social prejudices – including a generalized anxiety about the economic impact of immigration itself. Thus it was common for nineteenth-century English settlers to express fears of being 'swamped' by *Irish* immigrants, and complaints are heard today from Australians of many ethnic backgrounds that too many New Zealanders are 'allowed in'.

13 In discussion, Fu Daiwei pointed out that this use of the sublime is not exclusively European. Aboriginal people in Taiwan recall an old myth (similar to one attributed to Native Americans in Kevin Costner's *Dances with Wolves*) that predicted a future in which large numbers of Han Chinese would come across the water to the island. At the same time, people aspiring to an independent Taiwan today have their own fears about overwhelming numbers of people across the water, even as TV and tourist promotions pour out images of 'the sublime of mainland China'. This Taiwan-centered comparison helps me to clarify the *constitutively* Eurocentric – i.e., practical – force of the sublime in Australian culture; it is precisely the latter's imperviousness to intimations that its materials might *not* be unique or distinctive which helps to secure a myth of identity based in a lonely, cosmic fear.

14 An obvious source of the concept, as distinct from the phrase, is the chapter on 'The Whiteness of the Whale' from Herman Melville's *Moby Dick* (1851): 'It was the whiteness of the whale that above all things appalled me . . . for all those accumulated associations, with whatever is sweet, and honourable, and sublime, there yet lurks an elusive something in the innermost idea of this hue, which strikes more of panic to the soul than that redness which affrights in blood' (Melville, 1953: 169–70).

15 To clarify my argument here, the text is worth quoting in full:

> There was something among the trees, and his hair began to stir with terror, on his head. There was a presence. He looked at the weird, white, dead trees, and into the hollow distances of the bush. Nothing! Nothing at all. He turned to go home. And then immediately the hair on his scalp stirred and went icy cold with terror. What of? He knew quite well it was nothing. He knew quite well. But with his spine cold like ice, and the roots of his hair seeming to freeze, he walked on home, walked firmly and without haste.
>
> (Lawrence, 1950: 19)

Often used pedagogically to explain how Europeans 'really felt' about the Australian bush, this passage is also a formal exercise in the sublime: the narrator not only describes his terror of an overwhelming 'something', but also the turn of his *mastery* over it ('firmly and without haste'). Control is crucial to the sublime, whereas panic is a feminizing state because it tends to involve a 'failure' of control.

16 On the modern sense of 'panic' as a contagion which 'spreads' or is carried between people, taking on a political dimension in contexts of social crisis, see Bhabha's (1994: 198–211) account of panic and rumor in the Indian Mutiny.

17 My thanks to Gu Min-Jun for bringing home to me the importance of this aspect of this scene.
18 I gratefully borrow the notion of reading as 'hallucination' from Ding Naifei.
19 In fact, Bartertown also looks back, like the Crack in the Earth, to Australian popular fiction in the 1890s when Orientalist tales of a 'lost civilization' in Central Australia enjoyed considerable success (see Docker, 1991).
20 For an early cry of outrage at the hostility and contempt for white women in frontier society, see Barbara Baynton's (1980: 81–8) story 'The Chosen Vessel', first drafted in 1896, about a young bush mother murdered in front of her baby. For a contemporary urban comedy about failed matricide, see John Ruane's film *Death in Brunswick* (1991).
21 Beale (1910) offers a comprehensive guide to this mythology, compiled by a believer. See Pringle (1973) for an account of its effects on the status of women at the turn of the century.
22 'The Yellow Lady' is the title of an erotic etching from the 1920s by the painter Norman Lindsay, an enthusiast for White Australia. Reproduced on the cover of the first edition of Broinowski's book, this intensely 'othering' image was meant to define the book's object of study, not reiterate Lindsay's values. However, reproductions do reproduce; Kong's 'Postcards from a Yellow Lady' is an analysis of this problem.

References

Barrell, John (1991) *The Infection of Thomas de Quincey: A Psychopathology of Imperialism*, New Haven and London: Yale University Press.

Baynton, Barbara (1980) 'The Chosen Vessel' in Sally Krimmer and Alan Lawson (eds) *Portable Australian Authors: Barbara Baynton*, St Lucia: University of Queensland Press. First published 1902.

Beale, Octavius C. (1910) *Racial Decay. A Compilation of Evidence from World Sources*, Sydney: Angus & Robertson.

Bean, C.E.W. (1945) *On The Wool Track*, Sydney and London: Angus & Robertson.

Bhabha, Homi K. (ed.) (1990) *Nation and Narration*, London and New York: Routledge.

—— (1994) *The Location of Culture*, London and New York: Routledge.

Blainey, Geoffrey (1966) *The Tyranny of Distance: How Distance Shaped Australia's History*, Melbourne: Sun Books.

Bloom, H. (1973) *The Anxiety of Influence: a Theory of Poetry*, Oxford: Oxford University Press.

Brawley, Sean (1995) *The White Peril: Foreign Relations and Asian Immigration to Australasia and North America 1919–78*, Sydney: University of New South Wales Press.

Broderick, Mick (1993) 'Heroic Apocalypse: Mad Max, Mythology, and the Millenium' in Christopher Sharrett (ed.) *Crisis Cinema: The Apocalyptic Idea in Postmodern Narrative Film*, Washington, D.C.: Maisonneuve Press.

Broinowski, Alison (1992) *The Yellow Lady: Australian Impressions of Asia*, Melbourne: Oxford University Press.

Burke, Edmund (1968) *A Philosophical Enquiry into the Origin of Our Ideas of the Sublime and Beautiful*, ed. J.T. Boulton, Notre Dame and London: University of Notre Dame Press. First published 1757 and 1759.

Carroll, John (ed.) (1982) *Intruders in the Bush: The Australian Quest for Identity*, Melbourne: Oxford University Press.

Carter, David (1996) 'Crocs in Frocks: Landscape and Nation in the 1990s', *Journal of Australian Studies*, 49: 89–96.

Carter, Paul (1987) *The Road to Botany Bay: An Essay in Spatial History*, London and Boston: Faber.

Chambers, Ross (1994) 'Fables of the Go-Between' in Chris Worth, Pauline Nestor and Marko Pavlyshyn (eds) *Literature and Opposition*, Monash University: Centre for Comparative Literature and Cultural Studies.

Chow, Rey (1991) *Woman and Chinese Modernity: The Politics of Reading between West and East*, Minneapolis: University of Minnesota Press.

—— (1993) *Writing Diaspora: Tactics of Intervention in Contemporary Cultural Studies*, Bloomington: Indiana University Press.

Clark, Manning (1978) *A History of Australia* Vol. IV, *The Earth Abideth For Ever 1851–1888*, Melbourne: Melbourne University Press.

—— (1980) *Occasional Writings and Speeches*, Melbourne: Fontana/Collins.

Conway, Ronald (1971) *The Great Australian Stupor*, South Melbourne: Sun Books.

Cranny-Francis, Anne (1994) *Popular Culture*, Geelong: Deakin University Press.

Creed, Barbara (1993) *The Monstrous-Feminine: Film, Feminism, Psychoanalysis*, London and New York: Routledge.

Cunningham, Stuart (1983) 'Hollywood Genres, Australian Movies' in Albert Moran and Tom O'Regan (eds) *An Australian Film Reader*, Sydney: Currency Press.

de Bolla, Peter (1989) *The Discourse of the Sublime: Readings in History, Aesthetics and the Subject*, Oxford: Blackwell.

de Lauretis, Teresa (1984) *Alice Doesn't: Feminism, Semiotics, Cinema*, London: Macmillan.

Deleuze, Gilles and Guattari, Félix (1987) *A Thousand Plateaus: Capitalism and Schizophrenia*, trans. Brian Massumi, Minneapolis: University of Minnesota Press.

de Man, Paul (1983) 'Hegel on the Sublime' in Mark Krupnick (ed.) *Displacement: Derrida and After*, Bloomington: Indiana University Press.

Dermody, Susan and Jacka, Elizabeth (1988) *The Screening of Australia: Anatomy of a National Cinema* Vol. 2, Sydney: Currency Press.

Diehl, Joanne Feit (1990) *Women Poets and the American Sublime*, Bloomington: Indiana University Press.

Dixon, Robert (1986) *The Course of Empire: Neo-Classical Culture in New South Wales 1788–1860*, Melbourne: Oxford University Press.

Docker, John (1991) *The Nervous Nineties: Australian Cultural Life in the 1890s*, Melbourne: Oxford University Press.

Edelman, Lee (1989) 'At Risk in the Sublime: The Politics of Gender and Theory', in Linda Kauffman (ed.) *Gender and Theory: Dialogues on Feminist Criticism*, Oxford: Blackwell.

Edwards, Coral and Read, Peter (1989) *The Lost Children. Thirteen Australians taken from their Aboriginal families tell of the struggle to find their natural parents*, Sydney, New York and London: Doubleday.

Falconer, Delia (1994) '"We Don't Need To Know The Way Home": Selling Australian Space in the *Mad Max* Trilogy', *Southern Review* 27, 1: 28–44.

Ferguson, Frances (1992) *Solitude and the Sublime: Romanticism and the Aesthetics of Individuation*, New York and London: Routledge.

Finch, Lynette (1993) *The Classing Gaze: Sexuality, Class and Surveillance*, Sydney: Allen & Unwin.

Gibson, Ross (1992) *South of the West: Postcolonialism and the Narrative Construction of Australia*, Bloomington: Indiana University Press.

Gilbert-Rolfe, Jeremy (1996) *Das Schöne und das Erhabene von Heute*, trans. from the

English ('Beauty and the Contemporary Sublime') by Almuth Carstens, Berlin: Merve Verlag.

Gilroy, Paul (1993) *The Black Atlantic: Modernity and Double Consciousness*, Cambridge: Harvard University Press.

Haebich, Anna (1992) *For Their Own Good: Aborigines and Government in the South West of Western Australia 1900–1940*, 2nd edn Nedlands: University of Western Australia Press.

Hage, Ghassan (1994) 'Anglo-Celtics Today: Cosmo-Multiculturalism and the Phase of the Fading Phallus', *Communal/Plural* 4, Research Centre in Intercommunal Studies, Nepean: University of Western Sydney.

Hay, James, Grossberg, Lawrence, and Wartella, Ellen (1996) *The Audience and Its Landscape*, Boulder, CO: Westview Press.

Heng, Geraldine, and Devan, Janadas (1992) 'State Fatherhood: The Politics of Nationalism, Sexuality and Race in Singapore' in Andrew Parker, Mary Russo, Doris Sommer and Patricia Yaeger (eds) *Nationalisms and Sexualities*, New York and London: Routledge.

Hertz, Neil (1985) *The End of the Line: Essays on Psychoanalysis and the Sublime*, New York: Columbia University Press.

Hickey, Dave (1993) *The Invisible Dragon: Four Essays on Beauty* (Los Angeles: Art issues. Press).

Hicks, Neville (1978) *'This Sin and Scandal': Australia's Population Debate 1891–1911*. Canberra: ANU Press.

Hill, Ernestine (1963) *The Great Australian Loneliness*, Sydney: Angus & Robertson. First published 1937.

Holt, Stephen (1982) *Manning Clark and Australian History 1915–1963*, St Lucia: University of Queensland Press.

Kant, Immanuel (1960) *Observations on the Feeling of the Beautiful and Sublime*, trans. John T. Goldthwait, Berkeley: University of California Press. First published 1763.

Kong, Foong Ling (1995) 'Postcards from a Yellow Lady' in Suvendrini Perera (ed.) *Asian and Pacific Inscriptions*, Melbourne: Meridian.

Langton, Marcia (1993) *'Well, I heard it on the radio and I saw it on the television . . .': An essay for the Australian Film Commission on the politics and aesthetics of filmmaking by and about Aboriginal people and things*, North Sydney: Australian Film Commission.

Lawrence, D.H. (1950) *Kangaroo*, Harmondsworth: Penguin. First published in 1923.

Lyotard, Jean-François (1984) *The Postmodern Condition: A Report on Knowledge*, trans. Geoff Bennington and Brian Massumi, Minneapolis: University of Minnesota Press.

—— (1989) 'The Sublime and the Avant-Garde' in Andrew Benjamin (ed.) *The Lyotard Reader*, Blackwell: Oxford.

—— (1994) *Lessons on the Analytic of the Sublime*, trans. Elizabeth Rottenberg, Stanford: Stanford University Press.

Mackie, Jamie (1992) 'Foreword' in Alison Broinowski *The Yellow Lady: Australian Impressions of Asia*, Melbourne: Oxford University Press.

Markus, Andrew (1979) *Fear and Hatred: Purifying Australia and California 1850–1901*, Sydney: Hale & Iremonger.

Melville, Herman (1953) *Moby Dick*, London and Glasgow: Collins.

Mishra, Vijay (1989) '"The Centre Cannot Hold": Bailey, Indian Culture and the Sublime', *South Asia* [New Series] 12, 1: 103–14.

—— (1994) *The Gothic Sublime*, Albany, NY: SUNY Press.

Morris, Meaghan (1988) 'Tooth and Claw: Tales of Survival and *Crocodile Dundee*', *The Pirate's Fiancée: Feminism, Reading, Postmodernism*, London: Verso.

—— (1992) '"On the Beach"' in Lawrence Grossberg, Cary Nelson and Paula Treichler (eds) *Cultural Studies*, New York and London: Routledge.

—— (1993) 'Fear and the Family Sedan' in Brian Massumi (ed.) *The Politics of Everyday Fear*, Minneapolis: University of Minnesota Press.

Muecke, Stephen (1992) *Textual Spaces: Aboriginality and Cultural Studies*, Kensington: New South Wales University Press.

O'Regan, Tom (1989) 'The Enchantment with Cinema: Film in the 1980s' in Albert Moran and Tom O'Regan (eds) *The Australian Screen*, Ringwood and Harmondsworth: Penguin Books.

Otto, Peter (1993) 'Forgetting Colonialism (David Malouf, *Remembering Babylon*)', *Meanjin* 52, 3: 545–58.

Penley, Constance (1986) 'Time Travel, Primal Scene, and the Critical Dystopia', *Camera Obscura* 15: 67–84.

Perera, Suvendrini (1993) 'Representation wars: Malaysia, *Embassy*, and Australia's *Corps Diplomatique*' in John Frow and Meaghan Morris (eds) *Australian Cultural Studies: A Reader*, Sydney and Chicago: Allen & Unwin and University of Illinois Press.

Pope, Alexander (1987) 'The Art of Sinking in Poetry' in Paul Hammond (ed.) *Selected Prose of Alexander Pope*, Cambridge: Cambridge University Press. First published 1727.

Pringle, Rosemary (1973) 'Octavius Beale and the Ideology of the Birthrate. The Royal Commissions of 1904 and 1905', *Refractory Girl* 3: 19–27.

Reynolds, Henry (1982) *The Other Side of the Frontier: Aboriginal Resistance to the European Invasion of Australia*, Ringwood and Harmondsworth: Penguin.

Russell, Bertrand (1946) *History of Western Philosophy*, London: Allen & Unwin.

Said, Edward (1978) *Orientalism*, New York: Random House.

Simpson, David (1993) *Romanticism, Nationalism, and the Revolt Against Theory*, Chicago: University of Chicago Press.

Smith, Bernard (1960) *European Vision and the South Pacific 1968–1850*, Oxford: Oxford University Press.

Stratton, Jon (1983) 'What Made *Mad Max* Popular?', *Art & Text* 9: 37–56.

Summers, Anne (1975) *Damned Whores and God's Police: The Colonisation of Women in Australia*, Harmondsworth and Ringwood: Penguin.

Thompson, Christina (1987) 'Romance Australia: Love in Australian Literature of Exploration', *Australian Literary Studies* 13, 2: 161–71.

Vidler, Anthony (1990) 'Notes on The Sublime: From Neoclassicism to Postmodernism', *Canon: The Princeton Architectural Journal* 3: 165–91.

—— (1992) *The Architectural Uncanny: Essays in the Modern Unhomely*, Cambridge and London: MIT Press.

Walker, David (1995) 'White Peril', *Australian Book Review*, September, 33.

Weiskel, Thomas (1976) *The Romantic Sublime: Studies in the Structure and Psychology of Transcendence*, Baltimore and London: Johns Hopkins University Press.

Willemen, Paul (1994) *Looks and Frictions: Essays in Cultural Studies and Film Theory*, London and Bloomington: BFI and Indiana University Press.

Yaeger, Patricia (1989) 'Toward a Female Sublime' in Linda Kauffman (ed.) *Gender and Theory: Dialogues on Feminist Criticism*, Oxford: Blackwell.

13

AFRICAN–AMERICAN CULTURAL STUDIES

PostNegritude, nationalism, and neo-conservatism

Mark A. Reid

African-American culture wanders among three major philosophical frames that accommodate, appropriate and resist the hegemony of racial dualism; accommodationist thought circumscribes the philosophical paradigm of black conservatism. In 1890s America, the politics of racial accommodation publicly accepted segregation in all its social, political and cultural forms. Between 1890 and 1915, Booker T. Washington was the most prominent black American leader because he was able to publicly promote racial segregation while he built the first black-controlled trade school and privately fostered anti-segregationist activities.

Black accommodationist thought is a reaction to debilitating racial and social inequities that seem endless. During periods of economic instability, racial accommodation becomes a strategy of survival for certain black American leaders. The video-taped beating of Rodney King by Los Angeles police officers documents the continuum of the dehumanization of blacks; the Simi Valley jury's decision against prosecuting the white officers is another marker of the prevalence of racially biased all-white juries.

Yet and still, race is not the sole mediating factor in American judicial decisions. Supreme Court Justice Clarence Thomas, an African-American, is an eminent example of contemporary black conservatism. Judge Thomas rejects the policy of affirmative action, even though such a policy could have prevented the composition of a predominantly white middle-class jury. Though I shiver at the racial dualism of this criticism, the race and class differences between Rodney King and the white Simi Valley jury are important factors. The jury was composed (with the exception of one person of color) of white middle-class suburbanites whose families are composed of largely white Los Angeles police-officers. The Simi Valley jury's conclusions sanctioned the beating of King and other black men he resembles in hue and class.

Appropriation and entering the middle class
(1915–1964)

Black progressive thought tends to appropriate and borrow from American middle-class and mainstream social reform models. It stresses social, political and legal remedies for black social progress. Rather than publicly accepting an unequal socioeconomic status like black conservatives, black progressives use Western liberal notions of justice, social equality, and self-betterment through education, and democratic social reforms. In the beginning of the twentieth century, W.E.B. DuBois, a contemporary rival of Booker T. Washington's, was the most important black intellectual to propose a liberal arts education for certain African-Americans. DuBois argued that the 'Talented Tenth' of the African-American population would prepare the remaining blacks for the responsibilities of full American citizenship. DuBois believed that educated blacks would return to their communities to become the politicians, teachers, and religious leaders of the illiterate black masses. The political writings of W.E.B. DuBois, the 1940s-1960s court battles of the National Association for the Advancement of Colored People (NAACP), the 1960s' grassroots organizing of the Dr. Martin Luther King Jr.-led Southern Christian Leadership Council, the interracial coalition of the Student National Coordinating Committee and other civil rights organizations as well as Jesse Jackson's 'Rainbow Coalition' exemplify American liberalism and black progressive thought. The Rainbow Coalition consisted of a multi-racial, multi-ethnic and progressive group who sponsored Jesse Jackson's presidential campaign.

Similar to the developmental history of Asian-American, Chicano and Native-American Studies, the African-American Studies movement, commonly referred to as Black Studies, has had an ambiguous relationship with universalizing and consensus-like American cultural paradigms. Regardless of the political and ideological merits of universal or national approaches, African-American culture, like any other non-European American subculture, resists the national consensus because this consensus has historically suppressed liberation movements in South Africa, the Caribbean, and Central America while it indirectly supports undemocratic policies in China.

African-American studies emphasized a racial consensus where American Studies adopted a universalizing national approach. The academic and non-academic practitioners of African-American cultural studies criticized the color-blind use of Euro-American norms and models used by the white male arbiters of American culture. These taste-makers discerned the intellectual and aesthetic merit of black works based on Euro-American values.

In commenting on systems that establish universal interests, Pierre Bourdieu offers a set of questions which one should consider before proposing such universalizing norms. He asks,

> Who has an interest in the universal? Or rather: what are the social conditions that have to be fulfilled for certain agents to have an interest

in the universal? How are fields created such that agents, in satisfying their particular interests, contribute thereby to producing the universal? Or fields in which agents feel obliged to set themselves up as defenders of the universal (such as the intellectual field in certain national traditions . . . ? In short, in certain fields, at a certain moment and for a certain time (that is, in a non-reversible way), there are agents who have an interest in the universal.

(Bourdieu, 1990: 31)[1]

Generally, white middle-class male academics established programs to study American norms and values. Though they had honest intentions when constructing the American mind as a universal, these men were agents of their class position, race and gender. Largely, the founders of American cultural studies were middle-class, white males who were attacking the European hegemony in the academy. Blinded by their ideological goals, they created an America psychologically driven by their ethnocentric myths. Quite understandably, when other Americans refuted their claims, they were affronted since it was their liberal policies that permitted open space for academic debate as long as subversive agents did not replace their Euro-American patriarchal myths and values.

In the 1960s, the civil rights movement and black nationalism demanded a re-formulation of the American values and norms; these two pressures and the rise of other racial minority cultures fractured the illusion of any unique American cultural paradigm. Blacks, feminists and other socially and economically discriminated groups questioned the myths and symbols of the not-so-great white patriarchal American leaders. American culture has historically maintained racially separate and economically unequal places for its non-European and female citizens. Now, these groups rejected their positions of silence, invisibility and unimportance.

African-Americans, like other members of racially oppressed communities, grew separate from, but in many ways similar to, the white American mainstream. In describing the cultural tension between celebrating ethnic difference and affirming an American identity, Asian-American scholar Elaine H. Kim notes,

So much writing by Asian Americans is focused on the theme of claiming an American, as opposed to Asian, identity that we may begin to wonder if this constitutes accommodation, a collective colonized spirit − the fervent wish to 'hide our ancestry,' which is impossible for us anyway, to relinquish our marginality, and to lose ourselves in an intense identification with the hegemonic culture. Or is it in fact a celebration of our marginality and a profound expression of protest against being defined by domination?

(1990: 147)

Kim underlines the ambiguity that reigns in the un-meltable lives of non-European Americans. Consequently, black intellectuals and artists portray their criticisms of mainstream American culture in a conspicuously racial manner yet they argue for opportunities to participate in the mainstream. Their criticisms celebrate marginality and are profound expressions of protest against being defined by hegemonic Euro-American standards.

Unfortunately, some African-American reproaches sustain the racial dualism that European colonizers initiated to explain their imperialistic intrusions in Africa, Asia and the Americas. In addition, if socially and economically oppressed groups merely focus on single issues such as race, their efforts will conceal the extra-racial issues of class, gender, and sexual orientation. Curiously, both the American and African-American cultural studies programs glossed over issues of gender, class and sexual orientation.

Racial essentialism and nationalism

Black Nationalism is a third general philosophical form that has and remains important to black cultural studies. It is a form of political and economic resistance. As a political and cultural movement it expresses the African-American community's connection to Africa. In its academic setting, it embraces an internationalist black perspective referred to as the African Diaspora. The culture of the African Diaspora constitutes the experiences of black people after their physical removal from Africa. The interdisciplinary curriculum of Black Studies, on the other hand, comprises the total experience of black people. The politics of any one of these areas may appropriate dominant forms of racism to celebrate Blackness, patriarchy, heterosexuality or class and, in doing so, demean its so-called enemies in a generalized hatred for the specific community of intruders or miscreants.

Accommodation, appropriation, resistance

The philosophies of black conservatism, liberalism and nationalism overlap the other and, at particular moments, accommodate, appropriate, and resist mainstream white American culture. No political stance or posture is without its compromise. The raw material of African-American culture develops from the tension created between the intermittent use of all three of these strategies – accommodation, appropriation, and resistance. African-American cultural studies, however, is an academic field that desires, like any other academic discipline, respectability. Thus, its practitioners, such as Houston Baker at the University of Pennsylvania, Hazel Carby at Yale, Henry Louis Gates at Harvard and Cornel West who was formerly at Princeton, create strategic alliances between black intellectuals and American universities. Each of these scholars directs an African-American studies program. The alliance between one and the other of these scholars is of a political nature given the marginality of blackness and the

European origins of all four of these institutions. Nevertheless, the marginality of this cultural studies area does not disengage its scholars from pursuing the quest for legitimacy within the academy. Pierre Bourdieu states that 'in every field . . . there is a struggle for a monopoly of legitimacy' (Bourdieu, 1990: 37). Professor Barbara Christian, who directed the Afro-American studies department at the University of California at Berkeley, underscores the problematic of this struggle. In criticizing the race for legitimacy by black academics, she writes,

> My major objection to the race for theory . . . really hinges on the question, 'For whom are we doing what we are doing when we do literary criticism?' It is . . . the central question today especially for the few of us who have infiltrated the academy enough to be wooed by it. The answer to that question determines what orientation we take in our work, the language we use, the purposes for which it is intended.
>
> (Christian, 1990: 47)

In response to Christian's question I offer a tentative answer. PostNegritude aesthetics has roots in a type of black feminism which Michelle Wallace describes as,

> A socialist feminism, not yet fully formulated, whose primary goal is a liberatory and profound (almost necessarily nonviolent) political transformation. Second, I assume as well that black feminist creativity, to the extent that its formal and commercial qualities will allow, is inherently critical of current oppressive and repressive political, economic and social arrangements affecting not just black women but black people as a group.
>
> (Wallace, 1990: 215)

The language of postNegritude inevitably appropriates certain theoretical notions without relying on their paradigms. The root of postNegritude is the psychical and cultural history of postcolonialism. A postNegritude orientation appropriates ideas while it resists the colonizing urge to find legitimacy in the arms of static academic discourses. PostNegritude wants to bring the videotaped beating of Rodney King into the churches of white middle-class America.

Micro-struggles and the mini-politics of blackness

The growth of any paradigm is measured by its ability to sustain its canon and lessen the destructive effects of dissent by those exterior texts and discourses that would usurp its rules and beliefs. African-American studies has always been a marginal discipline within the academy. It has also sustained its place within the academy by assimilating, appropriating and resisting those black texts and discourses that threaten its unity of voice.

Recently, black feminists, gays, and lesbians have expressed critical paradigms that synthesize racial and extra-racial issues. It is their advancement of this synthesis that rejuvenates the present debate in black cultural studies. The 'minority discourses' of these doubly oppressed members problematize the initial conception of African-American cultural studies. Their extra-racial concerns expand the meaning of blackness and create diversity where racial stagnation and fraud once reigned. PostNegritude shifts reveal the rich polyphony that has always existed in African-American culture.

Before I discuss these minority voices of a racial minority community, I should like to refer to the cautionary words of Caren Kaplan, a first world feminist critic. In commenting on feminist criticism, she provides an understanding of the political nature of the postNegritude project that I am describing. Kaplan writes,

> The first stage in this process is refusing the privilege of universalizing theories. Some of us may experience ourselves as minor in a world that privileges the masculine gender. But our own centrality in terms of race, class, ethnicity, religious identity, age, nationality, sexual preference, and levels of disabilities is often ignored in our own work. All women are not equal, and we do not have the same experiences. . . . When we insist upon gender alone as a universal system of explanation we sever ourselves from other women. How can we speak to each other if we deny our particularities?
>
> (1990: 364)

Kaplan underscores the arbitrary nature of minority and majority status for white women. Her comments are also relevant for people of color whose gender, class, ethnicity, nationality and sexual orientation may afford them privileges over others like them. All postcolonial people are not equal. We do not have the same experiences. Thus, we must avoid universalizing race and postcolonial subjectivity, and acknowledge our particularities as we learn to speak of our similarities.

Kaplan also warns first world feminist critics against repeating forms of imperialism. She writes, 'First world feminist criticism is struggling to avoid repeating the same imperialist moves that we claim to protest. We must leave home, as it were, since our homes are often sites of racism, sexism, and other damaging social practices.' (ibid.) African-American cultural critics should consider her advice when debating the constitution of black culture, black identity, and black theory. Critics who desire a world in which racial dualism, ethnocentrism, and nationalism have lost their currency, must avoid the same imperialism and racism that enslaves and dehumanizes Third World people, though they may live in First World metropolises such as Paris, Berlin, London, Toronto and New York.

I now move from a description of the macro-politics and, somewhat dualistic

racial history, of African-American culture to discuss the appearance of minority discourses within the African-American community. As I suggested above, postNegritude represents a reconstructed Black Studies paradigm. This last section analyzes how certain African-American artists use visual arts to scrutinize monolithic forms of black subjectivity. Their works insert feminist, gay, lesbian, and inter-racial experiences into the African diasporic culture.

Visual production: the black sexual subject

In recent years, African diasporic video artists, filmmakers and photographers have redefined the visual construction of black sexuality. The postNegritude revision of blackness is present in black films, videos, and photography. One needs only to view some of the works by African-Americans such as Michelle Parkerson and Marlon Riggs; by African-Caribbeans such as Maureen Blackwood and Isaac Julien; and by the expatriate Nigerian photographer Rotimi Fani-Kayode. These black visual artists have produced films, videos and photographs that disrupt the hegemony of an erotic colonialist and heterosexist gaze upon the black body. Such a colonialist gaze frames the German photographer Leni Riefenstahl's pseudo-ethnographic photographs in *The Last of the Nuba* (1973), and the homoerotic portraits of black men in Robert Mapplethorpe's *Black Book* (1986). There exist, however, more complex and slippery examples that receive a mixed reception. The controversial reception of Trinh Minh Ha's film *Reassemblage* (1982) illustrates how a critique of the colonialist gaze might be perceived as a celebration. Consequently, the manner in which black bodies have been visually constructed and exchanged for erotic and political consumption, is of theoretical importance. Additionally, one must recognize that certain works, like *Reassemblage*, require that one pose different questions to assess their artistic and political merits.

Questions concerning the reception of black bodies

The documentary framing of black sexuality calls forth a variety of modes of reception whose selection depends on how the viewer negotiates the interpretive exchange between the artistic image and its meaning. An onlooker can resist, assimilate, or perform a combination of the two when interpreting a work's meaning and worth. The recent controversy over Robert Mapplethorpe's photographs, and of the rap group 2 Live Crew's lyrics shows that reception is not a fixed entity. Socio-political and socio-psychical forces determine how one perceives the erotic, the political, and the pornographic. Thus, the interpretation of the sexualized or (de)sexualized black subject requires an interdisciplinary mode of inquiry. I suggest a comparative approach in which interpretation considers the various narrative modes a viewer may employ when observing images of sexualized or (de)sexualized black subjects. It is also important to consider how artist and audience psychically and socially

269

resist, appropriate, or assimilate hegemonic narrative modes of reading and creating. One must employ, as Miriam Hansen has argued,

> A concept of *experience* which not only is the opposite of socially constructed signs and systems of representation but, rather, mediates between individual perception and social determinations, and emphatically entails memory and an awareness of its historical diminishment.
>
> (1982: 172)[2]

Thus, any black womanist/feminist alternative tradition must not hesitate to critically assess how black artists negotiate between racist and sexist individual perception and its socially determined correlation. The tradition must equally assess the processes of resistance that construct emphatic black womanism. Both moves entail memory and an awareness of its historical diminishment. I borrow the notion of 'womanism' from Alice Walker who describes it as a feminist activity. She writes,

> A woman who loves other women, sexually and/or nonsexually. Appreciates and prefers women's culture, women's emotional flexibility . . . and women's strength. Sometimes loves individual men, sexually and/or nonsexually. Committed to survival and wholeness of entire people, male *and* female. Not a separatist, except periodically, for health. Traditionally universalist, as in: 'Mama, why are we brown, pink, and yellow, and our cousins are white, beige, and black?'
>
> Loves struggle. Loves the Folk. Loves herself. Regardless. Womanist is to feminist as purple is to lavender.
>
> (1983: xi–xii)

Womanism espouses a feminism that equally considers issues of gender, race, class, ethnicity, and sexual orientation. In essence, womanism is a profane mode of feminism. Later, I discuss how Marlon Riggs's *Tongues Untied* (1989) constructs a profane mode of black sexuality that is emphatically empowered through the memories of different black gay voices. The term 'profane' expresses that the subject is 'Not sacred or holy; not devoted to religion or religious ends; secular; – opposed to sacred' (*Webster's Collegiate Dictionary* 1937: 792). Profane is to respectable, as womanist is to feminist, as feminist is to masculinist, as movement is to reflection, as stagnation is to the fluid and ever-changing movement of resistance and appropriation.

Feminism and gay and lesbian pride: socio-historical

In the 1970s, black women and men began to attack patriarchal conventions in both the black and nonblack communities. Black gay activists took to the

streets and registered their pride in annual marches throughout the United States. Black participation in the gay and lesbian pride marches increased the African-American community's awareness of the existence of sexual diversity within the black community. The growing presence of proud and outspoken black gays and lesbians, not only demystified the dominant image of black America as a strictly heterosexual entity, but provided visual proof that the black homosexual community was equally proud of its racial heritage.

By the 1980s, African-Americans had come to recognize, yet some would never accept, that many of their community leaders and artists would no longer be passive, silent, and contented within the strictures of a heterosexual blackness. Many blacks perceived black gay activism as detrimental to the black community that was already faced with the socioeconomic effects of institutional racism. This anxiety exacerbated the past fears that racists would use the newly emergent black gay, lesbian and feminist voices, to further dehumanize black people. Reactionary forces within the black community increasingly appropriated the master narratives of homophobia and misogyny in their nationalist calls for racial solidarity. The sexually marginalized blacks criticized the backwardness of certain black leaders and artists. They called for a true black solidarity and looked for the community to support their celebration of blackness. Consequently, a few progressive black artists like James Baldwin, Audre Lorde, and Samuel Delany seized upon this dilemma and expressed it in their literary works. A multi-layered, black creative paradigm unfolded and expressed the internal and external forms of sexual oppression. This paradigm has created spaces and free zones of discourse in which the *re-figured* sexuality and engendered black others become empowered with voice and presence.

Following the move to de-center the sexual construction of the black subject, black cultural criticism must interpret the sociological and psychical forces that determine this sexualized refigurement of what was once invisible and unvoiced. Such forces include but are not limited to: the artist-producer, the apparatuses of production and consumption, and the audience's *imagined* and *experienced* identification with the *black* sexualized subject of creation at any socio-historical moment.

The video text and double-voiced testimonies

Marlon Riggs's *Tongues Untied* (1989) articulates two identification modes that intersect, and result in the production of 'differing forms of reception'. One might view the film as a celebration of blackness, or a celebration of homosexuality. A womanist reading would permit the film to celebrate its intended message – affirming the black-gay experience. As stated earlier, I intend to discuss a profane mode of constructing black sexuality, by focusing on its filmic and extra-filmic construction of African-American gay men in *Tongues Untied*.

The above revisioning of black subjectivity, thereby, resists one singular

271

realism and suggests that black cultural experience includes a multitude of *possible* realities. Each form collaborates with another 'free radical' at different historical moments to resist or compromise with a hegemonic form. Thereby, these relations create a hybrid radical or a hybrid hegemonic order of the 'real'. Consequently, 'womanism' as a notion does not escape into some utopian reality, but it is an importance element in organization of other *lived* experiences of class, race, and sexuality. Womanism, however, collaborates to resist the destructive elements in certain masculinist and nationalist forms of subjectivity. A few illustrations of these destructive forms are present in the stand-up comedian humor of Eddie Murphy and Andrew Dice Clay as well as in the lyrics of 2 Live Crew and Guns and Roses.

The U-turn of the repressed: an untied gay tongue

Tongues Untied opens with a series of off-screen chants of 'Brother to brother, brother to brother'. On-screen images of groups of black men move in and out of the camera's frame. The voice-over of an omniscient narrator confesses:

> When talking with a girlfriend, I am more likely to muse about my latest piece or so-and-so's party at Club She-She, than about the anger and hurt I felt that morning when a jeweler refused me entrance to his store because I am Black and male, and we are all perceived as thieves.

The narrator's memory informs the audience of his encounter with the jeweler; racial meaning inflects the subject's memory that paints a black and white issue. Newsreel footage and a voice-over narration overlap to express a public and personal anger of the narrator. He calls upon his brothers to testify. Then images of black urban uprisings, the destruction of shops, and the entry of uniformed police fill the frame in *very* black and white time. The newsreel footage links the narrator's personal anger with that of his black brothers' very public displays. They take to the streets, as he has taken to the pulpit, they loot and pillage the immediate representatives of capital while he makes a mockery of any black struggle that ignores his very black and gay voice. The auditory and visual languages meet where personal and public anger intersect. The jeweler rejects the narrator/subject as America's racial barriers reject the African-American community's participation in the American mainstream.

The film lists individual racist attacks on the body of black men: Howard Beach, Virginia Beach, Yusef Murder, Crack, AIDS; the list constructs a racial and gender community. The posing of the rhetorical question 'Are black men an endangered species' seems to hint that the answer is yes. The narrator remains a polyvocal subject since different males function as its interrogatory voice and the object of its gaze.

A singular image of a nude black man in a sort of death dance dominates the frame. His movements seem to be in response to some impending harm which

he wards off. If 'black men are an endangered species', then the dancer/warrior has avoided the previous catalogue of death merchants.

Later, the film develops another personal but publicly voiced experience. It constructs an emphatically racial and sexual black gay community. Again, the individual black experience calls upon a racial and gay-inflected memory that generates oral and visual documents. The musical form of rap provides a venue for a double-voiced, call-and-response testimony. The subconscious reflections of black gay men permeate the communal being and reveal their psychology of homosexual oppression.

THE SUBJECT	DISCOURSE OF THE OTHER
THE CONSCIOUS CONFESSES	*THE UNCONSCIOUS*
Silence is my shield.	(It crushes.)
My cloak.	(It smothers.)
My sword.	(It cuts both ways.)

[THE NARRATOR(S) MOVES TOWARDS A SYNTHESIS
OF THE DOUBLED VOICE]
Silence is the deadliest weapon.
What legacy is to be found in silence?

How many lives lost?
What future lies in our silence?

How much history, lost?
So seductive its grip.

This silence.
Break it!

Our silence.
Loosen the tongue!

Testify.

The double-voiced and double-veiled character of the testimony corresponds with the socio-historically inflected slave narrative and Jacques Lacan's discussion of 'The letter, being and the other'. The film's Lacanian aspects are generally depicted in the film's articulation and framing of either a gay or a black heterosexual consciousness. Each of the two frames contests the other. However, it is the testimony that establishes the double-consciousness of the repressed subject, and the discourse of the black gay OTHER who desires public recognition. The dialogic exchange between veiled-subject and the affirming Gay Other generates an interrogatory discourse that exposes the subject as veiled or closeted while the Other is an emphatic 'beyond-the-veil' Gay. Lacan writes, 'the unconscious is the discourse of the Other (with a capital O), it is in order to indicate the beyond in which the recognition of desire is bound up with, the desire for recognition' (Lacan, 1977: 172).

Similar to the constructive properties of the slave narrative, the film documents an escape that is verified by the presence of male bodies whose names

are registered in the film credits. The language of *Tongues Untied* negotiates between the conventions accepted by black and gay film audiences as well as the semi-documentary form. This negotiation is apparent in the film's even-handed affirmation of Gay and African-American experiences. Interestingly, both Blacks and Gays alternate between veiled and beyond-the-veil strategies that permit them to endure and, sometimes, to actively resist discriminatory practices directed at their respective community. Marlon Riggs purposely contested homophobia and racism in the black and gay communities. His film bears witness to the double oppression which black gay men experience.

In conclusion, *Tongues Untied* documents the formation of a community, which meets at the juncture of race and sexual orientation. The existence of homophobia and racism forces the gay-black subjects to either adopt a two-fold reality, or endure racist and/or homophobic attacks. The film successfully depicts a group's coming-into-awareness of an *emphatic* gay and black identity. The film creates a black gay narrative tradition to celebrate its socio-historical experience. *Tongues Untied* reaffirms womanist survival strategies, and empowers the slave to resist master narratives that demean both black and gay men alike.

Jungle Fever, race, and the in-between

My assessment of African-American cultural studies describes the dissolution of racial dualism as a paradigm for explaining the totality of black experiences. In some instances, race is an arbitrary term that requires a historical contextualization and the consideration of other issues. For example, South Africa's legal distinction between 'Coloreds' and 'Blacks,' or Brazil's copious list of terms to describe the complexion of its Afro-Brazilian citizens, or the United States notion that one drop of African blood places the person in a black category, these are examples of the arbitrary nature of race. Race, therefore, is a social construction rather than a biological given.

When black cultural critics speak of this racial arbitrariness and discuss issues of class, gender, and sexual orientation, they describe black culture within postNegritude. This moment evokes free zones of discourse in which extra-racial minority discourses are uttered.

> Minority discourse implies that it is the perpetual return of theory to the concrete givens of domination, rather that the separation of culture as a discrete sphere, that militates against the reification of any dominated group's experience as in some sense 'privileged'. Just as domination works by constant adjustment, so the strategies of the dominated must remain fluid in their objects as in their solidarities.
>
> (JanMohamed and Lloyd, 1990: 13–14)

Certain black-directed films have militated against the reification of the

dominated black protagonist's experience as one that privileges the racial over other issues. In discussing this I make a strategic move from the topic of gay identity and the inter-racial love to analyze heterosexual interracial intimacy in the film *Jungle Fever*.

Spike Lee's fifth film, *Jungle Fever* (Universal, 1991), dramatizes interracial love, lust and inter-ethnic hatred between the Italian-American residents of the Brooklyn neighborhood of Bensonhurst and the African-American residents of the New York City neighborhood of Harlem.

In *Jungle Fever*, Lee presents two different types of interracial sexual intimacy. One of Lee's portraits of love meanders through the African-American loins of Flipper Purify to the Italian-American heart of Angie Tucci, Flipper's temporary secretary. The other portrait concerns Paulie Carbone, an Italian-American and Orin Goode, an African-American woman.

The film's title and much of the dialogue would have us believe that both Flipper's and Angie's motivations are determined by 'jungle fever' that is explained as: a sensual adventure through the blackest and whitest terrain of sexuality in its most physical and psychological manifestations. In this chapter I argue, however, that the film subtly ruptures the jungle fever discourse on interracial intimacy as doomed to failure. Angie and Flipper's class, marital status and race register their difference and construct the societal barriers they must surmount. The conventions that organize class, marriage and race deny Angie and Flipper success in their romance. Even though, the Angie and Flipper union fails, the film does not reject all forms of interracial intimacy.

The Flipper–Angie love affair challenges three social taboos that determine the failure of their relationship. First, their love affair violates a social taboo against interracial sexual intimacy; second, it transgresses both religious and social conventions against adultery; and third, their union defies the unwritten law of black bourgeois success that denies lasting interracial love affairs with the white lower-classes. I will now discuss how each of these transgressions affects the development of the film's main narrative level.

Flipper is married to Drew, a mulatto. They are the parents of Ming, a pre-pubescent girl. Flipper, Drew and Ming represent the conventional black middle-class family. Flipper is a successful architect and Drew is a buyer for Bloomingdales, an upscale Manhattan clothing store. The Purify family live in a Harlem brownstone apartment that they have furnished with all the middle-class comforts of modern American technology. Flipper's temporary secretary Angie Tucci's family is far different from the Purify nuclear family.

Angie lives in a Brooklyn bungalow located in the infamous community of Bensonhurst. She lives with her widowed father and two brothers for whom she cooks after she has returned from her secretarial job. The film portrays the Tucci men as distinct members of the Italian-American working-class. The film establishes their ethnicity in their language, their spaghetti dinner and their Catholic-ness. Angie belongs to an Italian-American working-class family but desires something that her family, her Bensonhurst neighbors, her Catholic

upbringing, and her boyfriend Paulie has neither given her nor permitted her to experience. Angie's life lacks a sensual romantic adventure. This deficiency in her sexual life leads her into an amorous adventure with a married black man. Angie's Italian-American family, her Bensonhurst community, her Catholic upbringing, and even her sensitive boyfriend cannot and would not offer her such a romantic choice.

In the film's first scene, we witness Ming listening to the ecstatic screams of Drew as Flipper makes love to her. This scene informs us that sex with Flipper is gratifying and even his young daughter knows of its pleasure. Flipper, however, is not satisfied with making love to Drew and develops an adulterous relationship with Angie. On the second day of Angie's job as Flipper's temporary secretary, they work into the evening, eat Chinese food, exchange knowing glances, and begin their sensual mixing of the races. Neither of their parents, Flipper's wife and Angie's boyfriend, their best friends, nor their racial and ethnic communities condone sexual intercourse between the races or sex between married men and single women.

Cyrus, a black boyhood friend of Flipper, describes Flipper and Angie's attraction as a case of jungle fever. After Flipper indulges his fever, he severs his relationship with Angie to whom he repeats Cyrus's jungle fever analysis. Flipper's change results from at least three social pressures he is faced with: (1) the unwarranted attack by the police because he was with a white woman; (2) the immorality of the adultery which led to his alienation from his wife and daughter; and (3) Angie's limited education and lower-class status. Angie cannot replace his wife Drew who helps Flipper attain his middle-class socioeconomic status. Like a martyr, Angie accepts rejection by her clan and resists Flipper's description of their love as one of racial lust. On one level, the film's narrative structures Angie as romantically in love with Flipper. Like many women, Angie breaks off her longtime but boring romance with her Italian-American boyfriend Paulie. Angie's devotion to Flipper is romantically constructed and expressed by her actions but there still remains the hint of the forbidden carnal desires.

Flipper's velvety blackness, his middle-class status and his professional education might have attracted Angie. But it is Angie's northern, Italian, marble whiteness that evokes the white patriarchal discourse on the primitive lust between the races. The racist discourse of the phallic jungle views Flipper's black vein as giving demonic value to Angie's pure northern marble. This discourse permits Flipper's darkness to render Drew, his mulatto wife, blacker than her near-white complexion indicates. Flipper's motivation reflects the primitive and racist discourse that angers Angie's father who, after learning about Angie's black boyfriend, beats her. Her father has undergone an emasculation. The Angie–Flipper relationship cannot escape the determinism of white patriarchal authority, which also surfaces in the white police officers, who stop the two lovers and put a gun to Flipper's head. It is a struggle over who controls the female body, a struggle between men who deny the self-determination of

one woman. In reality, Angie determines when and where these men enter to abuse her in their own very malevolent ways: one as a lover, another as a weak father, and the two police officers who serve and protect white patriarchy – Catholic girls, like Angie, who have left their church and homes to roam the wild urban prairies of multi-cultural America.

One question haunts the racist discourse of the phallic jungle: if there wasn't a near-white Drew would there be a too-white Angie? This concern ignores the presence of dialogue between the phallic jungle of racism and those discourses on the periphery that make Lee's film a complex statement on interracial intimacy.

Angie's initial attraction to Flipper is spurred by a multitude of urges that do not deny Flipper's blackness, but do not limit his blackness to fictions about black and white sexuality. Flipper's acceptance of the jungle fever myth psychologically defeats him and destroys any chance to return Angie's love. The 'jungle fever' myth finds fertile grounding in the minds of the film's black and white characters, and their limitations are eventually shared by Flipper. He circumscribes his subjectivity within a phallic vision that limply begins and ends between his emasculated loins. The 'jungle fever' pathology enlivens a racial death dance between sexual desires and racial myths that condemn Flipper, Drew, and Angie to singular identities.

Transgressing marital, racial, ethnic and class conventions

According to African-American common wisdom, the Flipper–Angie love affair fails because it is against middle-class morality, class-consciousness, and racial conventions. Flipper's marriage, his race and his middle-class aspirations destroy any chance of a prolonged union with Angie. Flipper has too much to lose and only love to gain. The failure of their affair results from additional societal inhibitions. First, his middle-class aspirations do not permit him to have a working-class woman as a mate, any more than his adulterous act is condoned by his equally middle-class professional wife. The middle-class narrative structure requires that adultery be punished. Thus, the narrative demands the termination of the Flipper–Angie relationship.

The film *Jungle Fever* also presents the beginnings of an interracial romance between Paulie Carbone and Orin Goode. With the introduction of the Paulie–Orin friendship, Spike Lee subtly diverts attention away from a negative portrayal of interracial love to challenge the arguments against it. Unlike the Flipper–Angie affair that transgressed marriage, class, and racial conventions, the Paulie–Orin relationship only challenges racial conventions. Orin Goode, a black college student frequents Paulie's Bensonhurst candy store where she buys a daily newspaper and encourages Paulie to attend college. When she leaves, the young white neighborhood toughs express how much they would like to have sex with Orin. Ironically, the neighborhood's toughs echo the

white patriarchal discourse and express their primordial fear of black male sexuality, while they fervently boast of their lust for a black woman.

None of these young white men want to publicly acknowledge their attraction through the conventional channels of dating or marriage. There are no policemen to point their guns, and no Italian-American fathers to beat these young men senseless for entertaining the forbidden thought. These men are their own policing force who beat Paulie when he acts upon his desires in a very human way.

Unlike their African and Italian-American peers, Paulie, Angie, and Orin venture into an unknown territory that borders the marginal worlds of both the African and Italian-American subcultures and deny the sexual myths that stagnate these worlds. Different from the Flipper–Angie border crossing, Paulie survives the physical and psychological attacks that his father and the young Italian-American toughs direct at both his mind and body. He triumphantly strides toward Orin's apartment, an open racial and ethnic space in which postNegritude intersects with free zones of multiple identities.

Jungle Fever offers a bourgeois closure to transgressions against the family unit and class. It leaves the contested space of interracial love open for further debates between visionaries like Paulie, Angie, and Orin while members of the status quo such as Flipper, Cyrus, The Good Reverend, and the Italian-American toughs demand allegiance to a dying paradigm. The two portraits of interracial intimacy provide *Jungle Fever* with a dialogism that disrupts any attempt to interpret the film as a criticism of all interracial unions. The film condemns the adulterous affair of Flipper and Angie while it portrays, in a minor chord, the Paulie and Orin relationship as resisting the racist ways of thinking which destroyed Angie's romantic advances and catalyzed Flipper's jungle fever. Spike Lee creates a primitive adventure, a transgressive sexual quest that disturbs family, ethnic and racial solidarity. *Jungle Fever* is one of Lee's best films because of its complex portrait of the shared racism of both African and Italian-Americans. The film delineates how certain forms of identity interrogate and dismiss racial hierarchies as exemplified in Paulie's sincere attraction to Orin and Angie's romantic attraction to Flipper. Lee's two portraits of interracial love permit a multiplicity of reconstituted racial, moral, and social others who usually are silenced in mainstream films dealing with interracial intimacy between black and white Americans.

Conclusion: fluidity and the black studies canon

This chapter has selectively presented different historical shifts in the African-American cultural studies paradigm. In establishing the existence of various philosophical tendencies within this paradigm, I have referred to seminal socio-cultural texts in different media. The texts, their authors and readers help to sustain the black studies paradigm, and aid in its ongoing development as an important part of the American studies canon.

When and why do certain forms of ethnic, gender and sexual subjectivity interrogate and dismiss racial hierarchies? And how does this dismissal permit or

deny a multiplicity of reconstituted racial others? These are questions that are central to my analysis of the two films *Tongues Untied* and *Jungle Fever*. The analysis and posing of such questions provides cultural studies with a postNegritude understanding of black diasporic culture.

Finally, my review of black cultural studies is equally interested in how and when these marginalized blacks coalesce with other people to build a world without psychological and social boundaries that impede international fellowship on an ecologically healthy planet.

Notes

1 All further references to this text will be cited as *In Other Words*.
2 In discussing film and spectatorial relations, Hansen argues, 'we need to grant the "ordinary" female viewer a certain interpretative capability, a reflective distance in relation to the roles she is expected to assume. For one thing, there is a *hermeneutic* trajectory, discontinuous and problematic as it may be, which links the critic with both the past empirical viewer and the hypothetical spectator insofar as both the historical horizon of reception and textual positions of address are critical constructs . . . both depend on the critic's conscious and unconscious mediation. . . . More specifically, conceptualizing an alternative tradition requires a concept of *experience* which not only is the opposite of socially constructed signs and systems of representation but, rather, mediates between individual perception and social determinations, and emphatically entails memory and an awareness of its historical diminishment.

References

Bourdieu, P. (1990) *In Other Words: Essays Towards a Reflexive Sociology*, Stanford, CA: Stanford University Press.

Christian, B. (1990) 'The race for theory', in JanMohamed and Lloyd (eds). (1990).

Hansen, M. (1989) In *Camera Obscura* 20/21.

JanMohamed, A.R. and Lloyd, D. (eds) (1990) *The Nature and Context of Minority Discourse*, New York: Oxford University Press.

JanMohamed, A.R. and Lloyd, D. (1990) 'Towards a theory of minority discourse', in JanMohamed and Lloyd (eds) (1990).

Kaplan, C. (1990) 'Deterritorializations: The rewriting of home and exile in western feminist discourse', in JanMohamed and Lloyd (eds) (1990).

Kim, E.H. (1990) 'Defining Asian American realities through literature', in JanMohamed and Lloyd (eds) (1990).

Lacan, J. (1977) *Ecrits: A Selection*, trans. A. Sheridan, New York: W. W. Norton & Company.

Mapplethorpe, R. (1986) *Black Book*, New York: St. Martin's Press.

Riefensthal, L. (1974) *The Last of the Nuba*, New York: Harper and Row.

Walker, A. (1983) *In Search Of Our Mothers' Gardens: Womanist Prose*, New York: Harcourt Brace Jovanovich, Publishers.

Wallace, M. (1990) *Invisibility Blues: From Pop to Theory*, New York: Verso.

Webster's Collegiate Dictionary, 5th edn (1937) Springfield, MA: G. & C. Merriam Co., Publishers.

Part III

RENEGOTIATING MOVEMENTS

14

TAIWAN QUEER VALENTINES

Hsiao-Hung Chang

Including more than twenty local lesbian and gay organizations, T'ung Chih Space Action Network (TCSAN) is a newly established coalition in Taiwan to launch a campaign for protecting gay rights using the Taipei New Park.[1] To achieve this aim, TCSAN organized a local event in 1996, inviting lesbians and gays in Taiwan to vote for 'The Top Ten Queer Valentines'. A total of 5,000 votes were distributed through various channels, including lesbian and gay organizations, bars, newspapers, radio stations, and BBS (electronic bulletin board), and the final voting result was announced in the media on the eve of Saint Valentine's Day. This event epitomizes the recent attempt of Taiwan lesbian and gay organizations to bring queer issues out into mainstream culture through a media camping/campaign and has also had a crucial impact on both the studies of popular culture and queer movements in Taiwan. This chapter attempts to explore its strategies and to chart its significance. It is divided into four parts: the first sketches the paper's theoretical framework and its discursive point of departure; the second focuses on the event's strategy of bringing out queer desire; the third investigates the social impact caused by the activity and the unstable structure of identification/desire as revealed in the final list; and the fourth highlights the contradiction of homophobia/homophilia in Taiwan's popular culture.

Inside/Out in popular culture

In recent critical analyses of television, film, popular music, commercials, and fashion, interrogations have been repeatedly directed at what has been named 'compulsory heterosexuality' by Adrienne Rich, 'the straight mind' by Monique Wittig, or 'the heterosexist matrix' by Judith Butler. Lesbian and gay consumers and critics have been engaged in negotiating, subverting, exposing and opposing the heterosexual hegemony of popular culture in order to create within it a homoerotic space of desires. In the words of Creekmur and Doty, for lesbians and gays to be 'out in culture' is to discover 'how to occupy a place in mass culture, yet maintain a perspective on it that does not accept its homophobic and heterocentrist definitions, images, and terms of analysis' (Creekmur and Doty, 1995: 2).

Generally speaking, two approaches can be distinguished in queer cultural studies: a subversive critique of mainstream heterosexist culture and an affirmative elaboration of queer culture. And yet, the alleged borderline between 'mainstream heterosexist culture' and 'queer culture' is far from clear-cut: lesbians and gays may internalize the homosexual stereotypes perpetuated by the heterosexist culture while codes of the lesbian/gay cultures may be constantly appropriated by the mainstream. The complex interaction between the two is probably the most interesting aspect of queer cultural studies. For example, recent works have demonstrated that queer consumers and interpretive communities do not receive passively what the heterosexist society has produced for them; on the contrary, they actively 'queer' the straight codes and images (Burston and Richardson, 1995; Creekmur and Doty, 1995). What is more, as queer aesthetics are appropriated and commercialized by mainstream culture, the taste of straight consumers in turn might become queered.

Viewed from this perspective, I do not presume the a priori existence of a timeless, essentialized, and unique queer desire in my analysis of 'The Top Ten Queer Valentines' voting activity. Neither do I think the names appearing on the top ten list will change significantly if the voters are straight. My investigation focuses on the process of *identification*, rather than any stabilized or essentialized lesbian/gay *identity*. I attempt to explore the ways such an identity is constructed in, and not before, the flow of erotic desires when the binary oppositions of heterosexuality/homosexuality and male/female are constantly (de)stabilized. Queer idol worship has thus always already been structured by the heterosexual matrix; accordingly, the heterosexual matrix has already been disrupted by the return of the repressed queer desires.

Moreover, the Taiwan queer movement's local social context and direction of development serve as another discursive point of departure for this chapter. It is commonly accepted that the current lesbian and gay movement in Taiwan which emphasizes a collective identity began with the establishment of the first lesbian group 'Between Us' in February 1990. After the lifting of martial law in 1987, the end of the 1980s witnessed a rapid democratization in the political and social arena of Taiwan. Following the women's movement, labor movement, and aborigines' movement, the *t'ung chih* movement has gained much visibility in the shifting cultural scenes of Taiwan. The Chinese translation *t'ung chih* (comrade) of the English 'queer' has now come to designate lesbians, gays, and queers at the same time. Originally used to refer to partners who share the same revolutionary passion and ideal, *t'ung chih* is also employed to refer to members of the same political party, as used by Dr. Sun Yat-sen in his dying wish, 'The revolution has not yet completed; comrades must still carry on.' Its straight and righteous connotations are now appropriated and queered in the process of translation. What is more, the fact that *t'ung chih* is extensively used as a title in Communist Mainland China gives the term a special political edge when it is used in Taiwan. Actually, the term's use as a translation for 'queer' originated in Hong Kong and was introduced into Taiwan in 1992. Since *t'ung*

means 'the same,' and *chih* denotes 'will,' 'ideal' and 'orientation,' the local queer communities embrace this term as signifying their common will/ideal to dismantle the heterosexist regime. Condensed in this Chinese term is the vacillation and hybridization of various forms of politics in the 1990s – the politics of identity, the politics of difference, demands for a civil rights movement, sexual liberation, etc. Political strategies that have been developed historically in the West thus seem to emerge simultaneously in Taiwan.

Collective coming out and bringing out queer desire

In the continuing warfare against heteronormative society, media campaigns and collective activism have become the current *t'ung chih* movement's main concern. 'The Top Ten Queer Valentines' voting event can thus be counted as one of the local movement's most successful cultural campaigns. Although the flow of desires resists the restriction of geographical and historical frames, the voting activity embodies a politics of desire that can be localized specifically in Taiwan's setting. TCSAN has been organized with the aim of protesting against the so-called Capital's Nucleus Project. Proposed by the Taipei City Government, this project is designed to carry out an urban space reorganization that effects not only a substantial change in the physical space of the city but also a political resignification by changing the authoritarian ambience of the Po Ai district, where the Presidential Palace is located.

Towards the end of 1993, the first citizen-elected mayor, a member of the oppositional Democratic Progressive Party, was sworn in. He has called for the turning of Taipei into a city of hope and happiness and started to lift the special regulations imposed upon the Po Ai District. Under this Capital's Nucleus Project, the newly-elected mayor has requested groups of city planners to redesign the historical sites of Taipei city in order to preserve the city's historical memory. The redesigned areas include the north-western side of the original old town and its vicinity (called Ta-Tao-Chen in Japanese colonial times and renamed as Hsi-Men-T'ing after the Second World War), the northern and western sides, and the southern side with the Presidential Palace as its hub (including the Presidential Palace Square, the Chieh-Shou Park, and the New Park). However, as one city planner pointed out in her paper presented at the Mapping the Desire Conference,

> one crucial matter is that in the recovery of Taipei's historical sites, should the New Park's significance for gay people be taken into account and thus become part of the collective memory of Taipei.
>
> (Hsieh, 1996)

Thus the New Park's status as the gay mecca in the Taipei area becomes the focus of everybody's attention in the controversy over the Capital's Nucleus Project. What is interesting is that under the rubric of campaigning for the

physical space of the New Park, TCSAN launches the queer idols voting event to create an erotic space of non-normative desires. The trajectory of this strategy which circumvents the voyeuristic mass media through deliberately seducing its gaze will be carefully traced to explore the dynamic relations of the gay space of the New Park and the popular cultural space of queer idol worship foregrounded by this event.

As one of the landmarks with the most complex political totems in Taipei, the New Park was set up during the reign of the Ching Emperor Kuang Hsu in the late nineteenth century. It was originally the site of a temple consecrated to Matsu (the Goddess of the Sea) which had served as the religious center of Taipei. In the Japanese colonial era, it was turned into a recreation park for Japanese officials. When the KMT Central Government came to Taiwan in 1949, the park was renamed as Taipei Park (also known as New Park), and pavilions of northern mainland architectural style were built around the lotus pond. In the early 1990s, the 228 Monument was erected there also to placate the historical tragedy of the February 28 event, in which unarmed anti-government demonstrations led to a massacre of thousands of Taiwanese by the KMT Government in 1947. However, the New Park is not merely a terrain inscribed with the change of political powers and political totems. As an open space for the local gay community, its territory marks the collective memory of those who have been sexually marginalized in Taiwan society. This space of non-normative sexuality has been labeled as 'the kingdom of darkness' in *The Crystal Boys* (originally published in Chinese as *Nieh tzu* in 1983) by the local gay novelist Hsien-yung Pai. The heteronormative society has long associated the park at night with degradation and homosexual promiscuity, a lair abundant in one-night stands, young male prostitution, and sexual perversions. In the popular voyeuristic imagination, such stigmatization has turned the New Park after nightfall into a dangerous zone where unnamable desires reign.

The strong contrast between the park's day and night in the popular imagination, as well as the co-existence of political totems and underground desires, make the re-locating of the New Park in the Capital's Nucleus Project a heatedly debated issue. For members of TCSAN, the construction of the Mass Rapid Transit System (MRTS) round the park has already done great damage to the original erotic ecology. The lighting, the noise, and the removal of benches have destroyed the secret cover the park offered, not to mention the hustle and bustle of the thirty or forty thousand daily commuters after the completion of the MRTS. It is painfully true of every city's renewal plan that minorities' rights are often overlooked. When the park's recreational function for the heterosexual family is amplified, gay activities developing around the park will soon be further 'purged away'. Therefore, the motive behind TCSAN's campaign is to save the New Park's queer space from the fate of being erased both from the city and from history.

However, as a queer space, the New Park actually serves only as a gay men's

mecca. Asymmetry in genders and sexualities can be mapped onto the erotic topography of the park: straight men have access to the park both in the day-time and at night; most straight women use the park only in the daytime; gay men use it for erotic purposes at night; lesbians generally do not find the park erotically facilitating, whether in the daytime or at night (Hsieh, 1996). What is interesting is that most of the core members of TCSAN are lesbians. Though the fact that lesbians take the lead in campaigning for gay men's public space can be explained by applying Eve K. Sedgwick's gender-transitive model, it can also be best approached by situating this phenomenon in the special context of the *t'ung chih* movement in Taiwan, both in terms of the convergence/divergence of the women's movement and the lesbian movement and the strategy of 'col-lective coming out'.

In the late 1980s, many lesbians took their nourishment from the local women's movement, assimilating what the women's movement had to offer them, whether in theoretical resources or campaigning experiences. They have thus also constituted a force in the expansion of the women's movement. Nevertheless, with the establishment of lesbian and gay organizations in the 1990s, tensions begin to emerge between the lesbian movement and women's movement which seems to organize around basically heterosexual issues. A recent example is lesbians' critique of the heterocentric orientation in women's organizations' campaign to amend the Familial Chapter of the Civil Law. Lesbians and gays are allowed to enter into the judicial purview only as poten-tial breakers of familial relations in the amendment, while the *t'ung chih* movement's demands for marital rights are completely denied. The tensions between lesbians and straight women in the women's movement have become the central topics in the local feminist periodical *Awakening* (vols 159, 160, 161, 162).

As for the strategy of collective coming out, since lesbians have at their dis-posal not only the campaigning experiences of the women's movement, but also the maneuvering space created by representing themselves also as feminists, they have much more space than gay men in confronting the voyeuristic media. Comparatively speaking, in the current *t'ung chih* movement in Taiwan, lesbians are more active and have more locutionary space. This probably has also some-thing to do with the different attitudes towards lesbians and gays in Taiwan society. Gay men receive more pressure from the traditional imperative to carry on the patronymic line. The refusal to procreate is deemed as a son's greatest violation of his filial duty. On the other hand, lesbianism is more often misread either as transitory or as less threatening to patriarchy. Needless to say, this is a form of discrimination that is the more serious in terms of the invisibility of the existence of lesbians.

In this battle, TCSAN not only demands the gay rights to continue their use of the physical space of the park, but also struggles to destigmatize the queer space. As quoted from a member of TCSAN:

The change in space takes place in the process of history; the change in the meanings of space is implicated with the struggle and interpretation of power. . . . Homosexuality has long been stigmatized in society, and so has the space frequented by lesbians and gays. The New Park and the Red Chamber Theater are such examples. It is important that queer people should speak for themselves and take the initiative to remove the stigma. Apparently, the policy makers and city planners do not understand queer people's motive in coming out together to reinterpret the significance of the New Park through their actions and writings. The official promise to reassign a space for the use of lesbians and gays overlooks the queer community's efforts to redefine the queer space of the park.

(Su, 1996)

What is most interesting and politically significant is that the first move taken by TCSAN towards redefining the New Park is the activity of voting for 'The Top Ten Queer Valentines' rather than debating right off the justifiability of same-sex desire and public sex. This tactics of juxtaposing an invocation of queer erotic space with the claim of the open space of the park can be first investigated in the context of the representations of queer issues in Taiwan's popular culture and mass media. Generally speaking, mass media representations of gay and lesbian issues in Taiwan are homophobic and voyeuristic. The media's representational policy of sensationalism leads exclusively to voyeuristic reports of gay sexual recreational centers, homosexual murders, sexual adventures, and one-night stands. On the other hand, in contrast to this pan-sexualization of gay people, a new tendency to 'de-sex' queer people emerges in the 1990s, when gay rights are stressed in the public arena. Due to a change of attitude in certain friendly media (especially those with lesbians and gays on the staff), public hearings for queer rights and queer demonstrations are reported and presented favorably. But as a result, there appears a gap between the positive image of lesbian and gay activists and the sensationalized representation of gay men lurking in the dark corners of the New Park, struggling with their desires. It seems the two images of queer people are placed in opposing definitions, the former without sex and the latter preoccupied with sex only.

Faced with the representational tension between the pan-sexualization and de-sexualization of queer people produced by the mass media, TCSAN cleverly deploys the projection of desire in popular idol worship to dismantle the stereotyped reduction of 'desires = sexual desires = sexual intercourse = penetration' in the public imagination. To render queer desires visible in public spheres may be deemed as a strategic move in a procedure to release the energy of desires and also to create the space for discourses of desires. As Pei-chuan Hsieh commented at the Upheaval of Queer Cruising Colloquium,

What is important is to speak out the legitimacy of queer desires, to let lesbians and gays realize that it is their right to express their desire in all kinds of public spheres, including the media.

(Feng *et al.*, 1996)

At the same time, what must be made visible is that homosexuality and heterosexuality are not totally different, although they are not completely the same, either. The binary opposition between the two does not hold in the flow of desires. Bringing queer desires out in popular culture is to force heterosexuals to perceive that there are elements of heterosexuality in the construction of homosexuality and that homosexuality also plays a significant part in the construction of heterosexuality. This strategy adopts the 'universalizing' view of desires but speaks from an anti-discriminational, anti-oppressive 'minoritizing' position. Since the claim for the use of the park's physical space cannot be answered with an official policy to ghettoize queer desires, the campaign aims at lifting the stigma of queer desires and reaffirming the memory inscribed in history and on the body. In other words, queer activists' intervention in the Capital's Nucleus Project aims not only to preserve the queer space of the New Park, but also to preserve the space of a collective memory of queer desire.

During the voting, TCSAN further mobilized lesbians and gays across the island to dress in the colors of the international lesbian and gay's rainbow flag from 8 to 14 February. This amounted to an island-wide costume show in local streets and constituted a kind of collective coming out. The strategy of collective coming out plays on the (in)visibility of queer desire. In a place like Taiwan, where the family structure is compact and personal space extremely limited, the individual coming out adopted by lesbians and gays in places such as the United States never appealed to their counterparts in Taiwan. Collective coming out, on the contrary, satisfies local sexual dissidents' longing for 'speaking out' in public and tactfully avoids their being tracked down at the same time. What is more, since the term '*t'ung chih*' is now used extensively to refer to women liberation activists, sex emancipation activists, lesbians, gays, and queers, through the common use of this term, a kind of coalition is formed and the space for maneuvering is accordingly enlarged for queer comrades' action. Therefore, queer people's collective coming out emphasizes not so much the number of the comrades who break into the view of the public, but rather the way in which queer people are perceived. As pointed out by Butler, coming out of the closet may mean stepping into another closet – 'before, you did not know whether I "am," but now you do not know what that means . . .' (Butler, 1993: 309). At present, the two strategies used by *t'ung chih* (collective coming out and bringing out queer desire) are meant to fashion queer images and identities and to define what it means to be queer. By actively creating news and topics, TCSAN unites the voting for queer idols with the political campaign for the queer space of the New Park. Starting off with the notion 'desire knows no

boundaries,' *t'ung chih*s infiltrate into the heteronormative mass media and seek the re-allotment of public resources and physical space.

The flow of identification and desire: vampiric consumption and cross imitation

On the whole, the campaign itself received wide coverage in the media. It helped to disclose popular culture's homocomplex on the one hand and to foreground the boundary-crossing flow of desire on the other. To begin with, there was uproar when the preliminary Top Twenty candidate list was released. Most of the candidates were stars and singers in show business, but the list also included prominent political figures such as Ying-chiu Ma, Minister of the Justice Department, and Ch'u-yu Sung, Governor of Taiwan Province, as well as the top woman basketball player in the national team. However, when interviewed by reporters in regard to their nomination, these candidates for queer valentines demonstrated polarized reactions: some broke into laughter while the others showed indignation. Ma smiled without giving an answer, and the spokesman for the Provincial Government said Sung made no comments. Li-hua Yang, the leading female cross-dressing artist in Taiwanese opera, graciously expressed her acknowledgment. On the other hand, a male pop singer said, 'It's all right as long as they don't cause me any harm.' Another male singer replied, 'I have been carefully maintaining a healthy image, why me? I will try to be more macho in my future performances.' These negative comments revealed not only the homophobic bias that looks upon lesbians and gays as unhealthy and dangerous but also an anxious and desperate gesture of asserting their own straightness.[2]

Moreover, several interesting points may be gleaned from the final list and the comments written by lesbian and gay voters. As far as the images of queer valentines are concerned, lesbians' dream lovers range from female singers who are thought to embody the essence of femininity, to those whose images are decadent and rebellious. As for gay men's dream valentines, some are macho, some are effeminate, some are simple and naive in appearance, while some are sexy or even coquettish. To sum up, the reasons why these idols are found alluring to lesbians and gays in Taiwan can perhaps be categorized as follows: 1) Being cool, wild, or showing character and attractiveness. 2) Manifesting a homoerotic appeal in their lyrics or the visual images of their MTV clips. 3) Famous for cross-dressing performances or having appeared in positive lesbian and gay roles in movies. 4) That many Japanese and US stars appear on the final list points to an internationalizing tendency in the local worship of idols. This 'postcolonial aesthetic' demonstrates inevitable cultural influences from the Japanese obsession with the fair adolescent male and the Hollywood muscle cult.

Take Ching-wen Wang, a Chinese-born Hong Kong singer who ranks third on the final lesbian list, for example. She has long been noted for the non-

conformist style of her character, appearance, costumes, MTV and stage per-
formances. As critic Ch'ien-i Chou points out, 'since Wang's debut her body
has been a locus of much anxiety. Wearing crew-cut, she is readily associated
with the image of the tomboy. Her costumes can be quite alluringly feminine
sometimes, and attractively masculine at other times. Her personality has long
been well known for being cool. Basically, her body cannot be pinned down by
the straight mind that depends on the rigid dichotomies of male/female, mas-
culine/feminine, desiring/desired' (Chou, 1996). Chou further indicates that
Wang's MTV body performances are situated in a space marked by the nonex-
istence of the other sex and by the lack of the male gaze. This emphasis on
narcissistic self-indulgence and self-enjoyment brings forth an uncertainty of
desire and thus opens up an erotic space for female homoerotic projection of
imagination.

And yet, viewed from another perspective, there does not seem to be any-
thing peculiar in the final Top Ten list of Queer Valentines. Most of them will
be sure to appear on the list of favorite idols of heterosexual fans. Therefore,
what the voting result reveals is not so much how totally different lesbian and
gay idol worship is from straight idol worship, but rather, the subtle dynamics
in the economy of desire and identification. The 'difference' of queer desire
does not abide in the absolute contrast between queer idols and straight ones;
nor does it reside in a unique queer sensibility that exists outside straight domi-
nant popular culture and aesthetics. Rather, it is to be located in queer people's
politicized ways of self-positioning within mainstream popular culture.

I will thus try to approach the queer difference of the non-normative desires
released from this event from three perspectives. First, voting activity demon-
strates the exclusive/inclusive tension in the cultural dynamics. In traditional
heteronormative society, persons who are labeled as homosexuals or suspected
as such are excluded and marginalized. Moreover, due to a homophobic imagi-
nation, people are eager to purify and regulate any ambiguity in erotic desires.
Thus it is fairly common to hear assertions like 'Shakespeare is absolutely not a
homosexual' or 'Chu Yuan (the first poet in Chinese literary history) could
never have been homosexual.' On the other hand, because of the florescence of
the queer movement and queer studies, there emerges a counter-discursive
impetus to queer every desirable figure. The wish to expand queer territory
leads to grapevine information such as 'The four Hong Kong superstars are
closet gays.' Here we have seen a transition from the exclusion and phobia of
'nobody is' to the inclusion and celebration of 'everybody is'.

Whether the idols themselves are queer-identified or not is, of course, not the
deciding point in the exclusive/inclusive tug of war. In the first place, it is hard
to guess at a certain person's 'real' sexuality: sexual behaviors, desires, and iden-
tities may not cohere. Furthermore, there are no rules in the flow of desires:
queer fans may idolize straight stars while straight fans may be crazy about queer
performers. However, the queering of idols takes place right in the process of
desire projection. Through the voting, *t'ung chih*s bring out queer desire for

their idols and create an erotic flow in between. It does not matter whether queer valentines are lesbians and gays or not; what matters is the formation of queer people's projective desires. And hence, the voting not only makes its way into a mass culture dominated by heterosexist ideology, but also introduces straight/queer warfare into the tug of war both among and within different groups of fans.

Second, the voting event reveals the confluence of identification and desire in idol worship, and the inherent instability of the Oedipalized heterosexual structure. According to the tradition of Freudian psychoanalytic theory, the transition from the pre-Oedipal stage to the Oedipal stage is accomplished through the split of identification and desire, with the child identifying with the parent of the same sex and desiring the parent of the opposite sex. Through identifying with the same sex and desiring the different sex, one enters into the Oedipalized heterosexual matrix. As John Fletcher puts it, 'you cannot be what you desire; you cannot desire what you wish to be' (quoted in Dollimore, 1991: 195). However, the polarity of being and having tends to be obscured in the vertigo of the fan's idol worship. For example, we can observe the confluence of identification and desire in some lesbians' voting comments on a young actress: 'Our wish is to be as charming and carefree as she is, and to have a partner as cute as she is.' Or the comment on Ching-wen Wang: 'Ching-wen Wang is our ideal vamp.' To love the ideal vamp and to be the ideal vamp – the two are the same thing. In the psychic life of an idol worshipper, the erotic flow reciprocates between self/other, worshipping/being worshipped, being/having, and identifying/desiring.

This complicated relation can be best understood on the model of 'vampiric identification'. As Diana Fuss points out in 'Fashion and the Homospectatorial Look,' the vampiric ritual can be regarded as 'a having through becoming' (Fuss, 1994.: 224), since 'being can be the most radical form of having' (ibid.: 228). Vampirism is 'identification pulled inside out – where the subject, in the act of interiorizing the other, simultaneously reproduces itself externally to the other' (ibid.: 224). In the confluence of blood, desire and identification become indistinguishable.[3] Indeed, the uncanny twilight zone of life/death, male/female, consciousness/unconscious in the legend of the vampire leads to the verging terrain of identification/desire and subjectivity/objectivity. That Brad Pitt of *Interview with the Vampire* appears on the final list of the voting brings into relief the vampiric identification associated with queer desire. To quote a gay voter's comment, 'I would like my blood to be sucked dry by Brad Pitt.' The eroticism of vampirism is drawn upon to represent the vertigo of identification/desire in idol worship: to be consumed by one's idol/lover is to consume/consummate the desire for the idol/lover. In vampiric identification, identification and desire need not go in counterdirectional trajectories. The best way to love a vampire is to become a vampire.

Nevertheless, speaking from the politics of desire, vampiric identification must undergo two steps of politicization. In the first step, as most psychoanalytic

studies in popular idol worship point out, the erotic projection in idol worship is a process of deconstructing the subject. The idol serves as the mirror image for the fan; to become one with the idol is to return temporarily to the pre-Oedipal stage of undifferentiation. In the second step, the tension between differentiation and undifferentiation has to be further explored. After all, heterosexist hegemony is built upon the Oedipal family romance, which stipulates that the object of identification and the object of desire be arranged according to sexual difference. Therefore, to highlight the possible confluence of identification and desire in the structure of idol worship becomes the leverage in subverting the heteronormative economy of desire.

Moreover, the voting event foregrounds the element of gender crossing in the flow of desire. Sexual attraction is usually modeled into two ways. The first one is the attraction between the different sexes (heterosexuality) or between the same sex (homosexuality). The second one is the attraction of the same gender or of the different genders. We can draw four formulae from combinations of the two models: 1) different-gender heterosexuality (for instance, masculine man and feminine woman); 2) same-gender heterosexuality; 3) same-gender homosexuality; 4) different-gender homosexuality (butch and femme, macho brother and fairy sister). The first formula adheres to the heteronormative ideal of a 'normal' and 'natural' sexuality while the last one constitutes the only possible form of homosexuality in the dominant heterosexist imagination because it seems to preserve, on the surface, a heterosexual structure in same-sex desire. When idol worship introduces an element of identification into the flow of desire, more variegated and complicated formulae of identification–desire combinations might immediately emerge. Accordingly, cross-gender identification has long played a significant part in queer culture. Many lesbians are infatuated with James Dean, while many gays are devoted to Garbo and Dietrich. It is no wonder that there were many cross votes found in this queer valentine campaign. A young female singer collected quite a few votes in gay bars. After all, the process of identification–desire and having–being can never be dichotomized by the rigid demarcations of heterosexuality/homosexuality and male/female.

A gender-crossing tendency can also be witnessed in the androgynous styling of most queer valentines. If difference has to be found to distinguish between idols for the queer community and those for straights, it can be said that lesbians and gays are more attracted to the sexual ambiguity and erotic swoon caused by androgynous style. As critic P'eng Wei indicates, 'Ching-wen Wang and Shu-i Kuan have created a cult of imitation in gay bars and lesbian bars because of their short hair and feminine costumes. It is apparent that androgyny is an undying fashion' (Wei, 1994: 137). After the announcement of the voting result, a cross-dressing imitation show bought the whole activity to a climatic end. Believing that to love her/him is to be like her/him, lesbians and gays masquerade as their idols to embrace/incorporate their dream valentines.

Homophobia/homophilia: popular culture's double track of desire

After investigating the voting event's tactics and media impact in the above sections, I want to further explore its politics of desire by locating the campaign in a larger context – Taiwan's contemporary popular culture. On the whole, local popular culture is saturated with homophobia and scapegoating mechanisms. In newspapers and magazines, one often encounters reports that a certain male star opposes homosexuality, detailing his experiences of being sexually harassed by gay fans. The press likes to pry into the star's privacy and is quick in following up a report that a male star is gay with another stating that the star denies his alleged homosexuality and actually has a girlfriend. The media institutions in Taiwan are good at framing homophobic reports to satisfy their voyeurism and administer heteronormative discipline at the same time.

On the other hand, Taiwan's popular culture also displays a tendency to follow the Western trend of 'homophilia'. When Western popular culture manifests a new trend of queering or appealing to lesbian and gay communities, it is basically a process of appropriating queer subcultural codes for commercial purposes or a way of baiting the queer consumer group. Some advertisers in the United States have deployed a dual marketing strategy to attract the queer consumer in a way that will not offend the heterosexist society (Clark, 1993: 187). Since Western popular culture has always been a part of Taiwan mass culture, the production of 'local' images, media codes, and idols gradually comes to take on dual or even multiple tracks. As critic Ming-chun Ku comments:

> To manufacture an idol is to absorb from the ambiance an unnamable erotic aura to produce the idol as a commodity that can be circulated in the cultural market. The erotic aura surrounding an idol cannot be fully described in the heterosexual terms of attraction between different sexes. Moreover, queer consumers' substantial economic power in the cultural market makes it impossible for certain idols not to become objects of same-sex erotic projection. On the other hand, the idol still has to disclaim any homoerotic projection lest s/he be labeled homosexual. As the idol is a production of the institution of mass culture, s/he has close connections with the media. When the society is the more homophobic, the media will become the more voyeuristic in treating same-sex desire as an exotic sexual object. And hence, the idol who appeals to the queer community will be in greater danger to become the voyeuristic target of the media. The idol will be treated as a homosexual, whose privacy is to be pried into and whose fame is to be turned into an infamy. It is a difficult problem of trigonometry for the idol. How to achieve balance between the dominant society's heteronormative regulations and the homoerotic aura s/he has absorbed? How to survive within the media and other institutions of popular

culture without offending the queer consumer? And even how to face
the possibility that s/he may actually fall in love with the same sex?

(Ku, 1996)

The trigonometric problem Ku refers to may be drawn upon to understand the
interrelations among three forces in popular culture's production of idols: the
logic of heterosexist hegemony, the commodity logic of capitalism, and the
logic of the flow of desires. The current schizophrenic tension of
homophobia/homophilia in Taiwan's popular culture can thus be read as the
symptom of the conflict among these three forces. For instance, the male Hong
Kong singer Te-hua Liu has repeatedly declared that he is not gay. Nevertheless,
in his MTV 'Once in a Lifetime', the narrative of a man who fears the com-
mitment of heterosexual marriage is entwined with a subtle subtext of same-sex
attraction. In another of Liu's MTV productions, 'Truly Forever', the video
imagery is both homoerotic and autoerotic. In a local flower tea commercial
video, the image of two intimate girls taking a stroll in the woods creates an
ambiguous erotic space of 'sisterhood'. In a Ford automobile commercial, a man
in a new car picks up another man for a basketball game. The two basketball
players lie down together in the car to demonstrate the spaciousness of the prod-
uct. Thus, a space for the male homosocial/male homosexual imagination is
opened up within traditional car commercials in Taiwan which appeal chiefly
to heterosexual attraction, romance, and familial love.[4]

What is more, in investigating popular culture's dual track of erotic desire, the
focus must be placed on an analysis of popular culture's process of
heterosexualization/homosexualization, and the interaction between queering
the straight and straightening the queer in the structure of spectatorial
desire–power. Or else, it may become nothing more than a fiction of liberal plu-
ralism or a commercial strategy that welcomes queer people as consuming
subjects rather than as social subjects in capitalist society. First of all, we must
explore how people 'queer' the straight through various strategies of opposition,
subversion, parody, and play in the midst of popular culture's heterosexualizing
process. In the case of queer reading, the basis for its camp pleasure comes
exactly from twisting the straight reading. Adopting 'a reading practice that dis-
tances, subverts, and plays with both heterosexist representations and images of
sexual indeterminacy' (Clark, 1993: 194), *t'ung chih*s can develop a queer space
of reading that the dominant culture attempts, but fails to colonize.

For example, under the commodity logic of capitalism, the fashion industry
saturated with queer aesthetics tends to 'homoeroticize' straight consumers in
their taste and style. The heterosexist hegemony may be destabilized or restabi-
lized in the process of identification–desire involved in consumption. Fuss has
made an interesting observation: women's viewing/consuming of commercial
fashion photography 'provides a socially sanctioned structure in which women
are encouraged to *consume*, in voyeuristic if not vampiristic fashion, the images
of other women, frequently represented in classically exhibitionist and sexually

provocative poses. To look straight *at* women, it appears, straight women must look *as* lesbians' (Fuss, 1994: 211).

The politics of queer reading and the commercial queering of the straight (for Fuss, this process of queering only serves to reinforce the heterosexist denial of same-sex desire) are two cases of exploring the structure of desire and power in the spectatorial process. The multiple possibilities of desire's permutations exclude any binarism or one-to-one relationship. As Fuss declares, 'subject-positions are multiple, shifting, and changeable, readers can occupy several "I-slots" *at the same time.* . . . [T]here is no "natural" way to read a text: ways of reading are historically specific and culturally variable, and reading positions are always constructed, assigned, or mapped. . . . Readers, like texts, are constructed' (Fuss, 1989: 35). We have to recognize the multiplicity, contradiction, changeability, vacillation, and conflict of spectatorial positions to see that the voting result of 'The Top Ten Queer Valentines' does not point to a monolithic queer aesthetic and that there is not an essentialized queer desire that stands in binary opposition to the heterosexual aesthetic.

The Taiwan *t'ung chih* movement has come onto the cultural stage with the florescence of publications and the frequency of activities as part of the rapid democratization of Taiwan. Nevertheless, as a new political era is claimed to come in the wake of the first presidential election in 1996, it remains to be seen which direction the new power structure is heading in: Taiwan may go from its present state of vital destabilization to a state of restabilization and an anti-queer backlash may gradually emerge following the florescence of the Taiwan *t'ung chih* movement; or it may constitute a new starting point for lesbians and gays to carry on their revolutionary campaign. 'The Top Ten Queer Valentines' voting activity has ended successfully while the campaign to save the New Park still goes on. The joyous process of voting signals that the Taiwan queer movement in the 1990s has come out of sadness into a carnivalized political campaign. Alongside struggles for civil rights, queer activism opens up a political space of desire. It enters into the terrain of popular idol worship and exposes the confluence of identification and desire in its structure. What is more important, the activity manifests the current dynamic relations of physical space/erotic space, universalizing view of desire/minoritizing position of movement, eroticization of politics/politicization of eros, and individual coming out/collective coming out. Wherever desire flows, *t'ung chih*s will be there. Such is the seduction of the queer revolution in Taiwan.

Notes

1 I would like to thank members of TCSAN, without whom this paper would have been impossible, and also Chih-wei Chang for translating this paper from Chinese to English.
2 Popular singers' homophobia comes not merely from their concerns with box-office profits. It is further implicated by the homophobic media's irresponsible reporting style. One example is the TTV's untruthful handling of the female singer Mei-ch'en

P'an's 1992 interview video to represent P'an as a lesbian. The distorting report not only victimized P'an, who had to declare that she was not a lesbian, but also reinforced the stigmatization of homosexuality as the nightmare of entertainers.

3 A more refined discussion on the complicated relations of identification and desire can be found in Butler, 1993. Butler bases her discussion on the psychoanalytic notion of identificatory mimetism.

4 Another interesting example is the gay characters from Japanese young girls' comic books which are fashionable in Taiwan. The voyeuristic idealization of male homoeroticism in these comic books deserves a detailed analysis. One critic offers such an analysis: 'Young girls satisfy their desire for knowledge through the plots of comic books. Once female roles are excluded from the interrelations of the main characters, the female reader will occupy the imaginary position of the defender for the gay protagonists. Playing the part of the defender, the female reader will not try to project herself onto a female character in the comic book. She will regard herself as the best friend of the gay protagonist, or even as his mother and sister. She will uphold the idealized purity of male homosexual romance and come to detest the female character that plays the third party in the romance' (Ch'iu, 1994: 103).

References

Chinese texts

Ch'iu, Wei (1994) 'The school of the roses: the homosexual characters in young girls' comic books', in Gay Chat, National Taiwan University (ed.) *Homosexual Union*, Taipei: Horn Publications.

Chou, Ch'ien-i (1996) 'Popular music, body experience, and queer comrades' desire', presented at the Mapping the Desire Conference, Department of Foreign Languages and Literatures, National Taiwan University, 20 April.

Feng, Kuang-yuan, Hsieh, Pei-chuan, Ts'ai, K'ang-yung, and Chang, Hsiao-hung (1996) 'The upheaval of the queer cruising', *Marie Claire* February: 86–93.

Hsieh, Pei-chuan (1996) 'The spatial performance of sexualities', presented at the Mapping the Desire Conference, Department of Foreign Languages and Literatures, National Taiwan University, 20 April.

Ku, Ming-chun (1996) 'Please, don't fall in love with me!' *Independent Daily News* 24 January.

Su, Hsi-t'ing (1996) 'When can the lesbian and gay community enjoy its rights?' *China Times* 22 January.

Wei, P'eng (1994) 'The male, the female, and the androgynous', in Gay Chat, National Taiwan University (ed.) *Homosexual Union*, Taipei: Horn Publications.

English texts

Burston, P. and Richardson, C. (eds) (1995) *A Queer Romance: Lesbians, Gay Men and Popular Culture*, New York: Routledge.

Butler, J. (1993) 'Imitation and gender insubordination', in H. Abelove, M. Barale, and D. Halperin (eds) *The Lesbian and Gay Studies Reader*, New York: Routledge, 307–20.

Clark, D. (1993) 'Commodity lesbianism', in H. Abelove, M. Barale, and D. Halperin

(eds) *The Lesbian and Gay Studies Reader*, New York: Routledge, 186–201.

Creekmur, C.K. and Doty, A. (1995) 'Introduction', in C.K. Creekmur and A. Doty (eds) *Out in Culture: Gay, Lesbian, and Queer Essays on Popular Culture*, Durham, NC: Duke University Press, 1–11.

Dollimore, J. (1991) *Sexual Dissidence: Augustine to Wilde, Freud to Foucault*, New York: Oxford University Press.

Fuss, D. (1989) *Essentially Speaking*, New York: Routledge.

—— (1991) 'Inside/Out', in D. Fuss (ed.) *Inside/Out: Lesbian Theories, Gay Theories*, New York: Routledge, 1–10.

—— (1994) 'Fashion and the homospectatorial look', in S. Benstock and S. Ferriss (eds) *On Fashion*, New Brunswick, NJ: Rutgers University Press, 211–32.

15

CULTURAL ACTIVISM

Indigenous Australia 1972–94

Stephen Muecke

Dedicated to the memory of Rob Riley, political activist

Delivering this paper in Taipei, I was motivated by two ideas. One was that the analysis of local Australian Aboriginal political movements, over the last couple of decades, had not yet talked much about the relation of politics to recent forms of Aboriginal culture. This is the idea about 'cultural activism', culture being brought out *as politics*. The second idea was one which wanted to stress the importance of international links in indigenous political action. While I was a nervous non-Aboriginal ambassador for these ideas, I had no doubt that the indigenous Australian cultural activists whose names I went on to mention in the course of the paper would find their work being used. I stressed that I would not be speaking on their behalf. Rather I had decided to provide an overview of recent cultural activism in Australia and I was deliberately maintaining a distance between what I would have to say and what I knew others would say. As Kuan-Hsing Chen has put it:

> before objective conditions can be constructed for the oppressed to speak, oftentimes you are forced into a situation where you have to speak 'for' them, to defend the interests of minority groups. Thus you always walk a line between 'speaking for' and opening up a space for others to speak.
>
> (Chen, 1992: 481)

Cultural activism is for me a quite specific category, one that I wish to introduce and define here through a number of examples. By 'cultural activism' I don't mean *anything* people might do in the promotion and manipulation of their political representations (this would be to espouse too broad a definition of culture), and I would also want to distinguish cultural activism from political activism. Political activism consists of non-governmental political tactics such as lobbying and demonstrations which operate within a public domain to change

general opinion, electoral opinion and eventually government strategy and the law. In this sense it can be described in Deleuzo-Guattarian terms as a fluid nomadological war machine opposing itself to rigid segmentation of the State machine – the political activist does not or cannot use 'the proper channels'. Cultural activism can have the same result as political activism, but it doesn't look the same. It has the feature of mobilizing cultural representations as performances. It is a tactical 'bringing out' of culture as a valuable and scarce 'statement' (in the Foucauldian sense of *énoncé*).[1]

We could say that the photograph of Denis Walker's children (Figure 15.1) is a good recent example of cultural activism. These boys are painted up evoking a kind of ceremonial life which under 'normal' circumstances would not take place in the inner city as a street demonstration. Whatever such a ceremony may be, it would not have the aim of liberating an incarcerated father either. Semiotically, the performance signifies continuity of tradition. I read the image like this: they are showing that they have retained their culture – their grandmother the famous poet and their father the political activist have taught them well; they have survived the pressures of assimilation, poverty and their consequences. They carry the didgeridoo in order to perform, and this musical instrument brings with it a kind of generalized representation of Aboriginality, as it is used as a sound backing for many films, TV shows and rock performances. The Press has hastened to the scene, and a photograph has been taken presumably with the cooperation of the young men – so a successful public relations exercise has also been accomplished.

My argument is that Aboriginal politics has for a long time been characterized by aspects of this kind of cultural activism, that this politics is effected by a special sort of performance, evocation or re-production of traditions of various sorts. Seminal events include the Tent Embassy in Canberra in 1972; Gary Foley's performed belligerence (at seminars, in meetings, as a movie actor, singing with *The Clash*, punching a high-ranking anthropologist at a cocktail party); the performance of traditional dances at the handing over of Uluru (Ayer's Rock) to the traditional owners, and so on.

I am ambivalent about the political effectivity of these instances of cultural activism. On the positive side, it makes a culture physically recognizable as specifically different from any other political lobby group. Through cultural identification Aboriginal and Torres Strait Islander peoples can distinguish their special case from that of other minorities and in particular other ethnic migrant groups.

On the negative side, as Tim Rowse has argued, 'accounts of "Aboriginality" and politics which invoke "culture" to question "politics" may not be as perspicacious or useful as they first seem' (1993: 59). What instances of cultural activism often create is the inability to specify indigenous needs or desires in anything but the most general terms. The performance therefore is 'sublime'; and as Rowse argues, 'The result is an incomplete argument, a romance of the unrepresentable, as "Aboriginality" is assured its place in as the eternal Other of

Figure 15.1 Dennis Walker's sons arrive at the court to perform a dance in support of their jailed father.
Source: The Sydney Morning Herald, 2 December 1994. Reprinted by permission of Dean Sewell, photographer and the Fairfax Photo Library

power' (ibid.). So this is the sublime force of the Walker boys' performance. The passers-by might not have the slightest clue what it might mean, but they stop to look and applaud because they are broadly in sympathy with Aboriginal causes, and are used to Aborigines in the role of entertainers. These people in the street know nothing of the legal case, which was about Mr Walker using a customary tribal law defence (he claimed he was defending a native site) when he was charged with unlawfully discharging a firearm. In a small town café in the north of the state of NSW he was approached by a policeman with a drawn revolver; he took the revolver from him and discharged it six times into the ceiling. He faced a sentence of up to fourteen years, but was not convicted in the end.

I am not in a position to speculate on the authenticity of this performance, not even having seen it, but it is conceivable that it could be postmodern in the sense of being a simulacrum of an Aboriginal ceremony, stripped of the usual ritual or spiritual functions associated with such events. If it is a performance with these functions – which need not be 'traditional' in the sense of 'pure' – then it would be authorized by a community of Aboriginal people 'backing it up,' as it were, allowing for the *expenditure* of an amount of their cultural capital. The event would not have taken place 'for nothing'; people speak of there being a 'cost' in giving away such a representation, and hence a *value* expressed in terms of the power relations involved from the community to the performers and back again.

In the past the force of a lot of Aboriginal culture has been based on limited dispersal, i.e., on secrecy. As Alphonso Lingis says, 'Secrecy can be a force that sanctifies and exalts ritual knowledge' (1994: 124). In the Aboriginal economy of discourses the first separation is between the 'public' and the 'secret'. The colonizers too have always felt that there was, or is, a great wealth of knowledge lying below the surface to be discovered, just as they thought that there was much to be discovered in the land – the desert – as the mystical utopia prepared for them by Judeo-Christian thought.

This same thought called for confession, for the making present of the word as expression: 'Tell us what you are like,' the white institutions seem always to be saying, 'sing your songs once more and tell your stories'. As if the production of discourse can only be aligned with truth and liberation, or at least be a good thing generally. But in the face of this powerful demand, could it be the case that Aboriginal peoples have learnt to retain a judicious silence, only giving out a certain amount of carefully constructed discourse? 'The power to keep its secrets is the secret of its power', is how Alphonso Lingis concludes (ibid.). And I would conclude that the performances of cultural activism speak more clearly of a cultural value and its necessary expenditure, and less clearly of the meaning of specific political tactics. And the performances depend, for their rhetorical reception, on a fairly narrow view of Aboriginal cultures – typically the 'traditional' has to be evoked in one way or another.

Let us go back to 1985 – but this will not be a chronological history by any

means – when the famous Ayer's Rock (Uluru) was returned to traditional owners amid much controversy, media coverage and political point-scoring. Again, the debate is about the *value* of the site – the tourist dollar versus the cultural value as understood by Aboriginal people. Apart from political expediency, the exchange of the Rock as property only becomes possible when it is understood that there has been a convergence of these values. The Rock now has a new value as annexed to Aboriginal cultural values. It is no longer just as it once might have been, a spectacular landform. The consequence is that there is a whole industry of commentary explaining the rock to tourists in quasi-Aboriginal terms. A little-known commentator on the handover was Jean Baudrillard:

> This reclamation was fixed on an object which they never possessed and they would have thought the idea of possessing it offensive and sacrilegious. Typical Western trick. In return, they have sent back a virus which is even more lethal, the idea of origins.
>
> The Aborigines have been given back Ayer's Rock, the flamboyant monolith in the middle of the desert. But to whom does it belong, among all the tribes? In order to prove their original right, the Umburu [sic] have organized a dance, that is, they jumped up and down for an hour, an aesthetically poor and unrewarding exercise, but the proof was there: these were the sacred inheritors of UHURU [sic]. And everybody paid homage. One day, perhaps, the Aborigines will give the Sydney Opera House back to the Whites, on condition that they (the Whites) know how to perform the 'good dance'!
>
> (Baudrillard, 1990: 32)

Baudrillard was operating with the cynicism typical of his abandonment of the real – which includes the real spelling of names of people and places. While the handover of The Rock had already been set up by all the necessary political and bureaucratic procedures, the dances were seen by some as simply euphoric expressions of cultural pride, rather than (as Baudrillard sees them) as necessary demonstrations of tribal authenticity which must be performed in order to come (once again) into rightful ownership of the site. What Baudrillard has also failed to notice is that the Rock is about visibility, and the visibility of Aboriginal peoples and how even as a minority they ostensibly and obviously occupy the open spaces of the outback and the public spaces of the cities.

'How did a liberal tradition of respect for indigenous rights survive at all in twentieth-century Australia?' asks Tim Rowse, and he finds an answer in Fay Gale: 'spatial separation as a means of ethnic survival' (Rowse, 1993: 24). And I would add, physical and performable visibility, along with its forceful corollary – verbal secrecy. So as far as the white institutions are concerned, this enigmatic presence which won't go away has to be approached and made to talk ('Ask that oldfella!' is a typical deflecting response to these persistent demands).

STEPHEN MUECKE

Regimes of knowledge (like Anthropology) need this talk, and at the same time politics demands that people 'express themselves'. Hence with a seminal example of the new Aboriginal politics, the Tent Embassy of 1972, we have elements of cultural activism as expression, an aesthetico-political formation.

Political expression

'Out of repression, expression.' This is the formula which would seem to inform many accounts of the mutual emergence of new versions of Aboriginal culture and politics in the early 1970s. For instance there are statements from Aboriginal playwright Gerry Bostock:

> When you had a situation like what was happening in Canberra such as police pulling down the Embassy tent in 1972, you had lads bussing down and we took our theatre groups there and we performed on the lawns of Parliament House along with the protesters . . . we were just expressing our feelings of what we thought of contemporary society . . .
> (Bostock, 1985: 70)

This activism came at the tail-end of the 1960s movements, but it coalesced politically as many Aboriginal people found positions in and around the Whitlam Labor government's new administration which came in in 1973. The resulting two decades have seen a growth in the indigenous population, a flourishing in the Arts, and the establishment of broader social infrastructures (including indigenous media) – while the realities and representations of poverty and disenfranchizement persist.

As a 'theory' of aesthetic production, expression occupies a privileged position. I think it is safe to say, at the risk of oversimplification, that it emerged less than two centuries ago with a marked emphasis on the author as the creator of imaginative work which transcends particular time and place. What happened then was the birth of a romantic literary subject and attention was focused on this subject in ignorance of collectivist cultural value and production. If one wanted to make a cross-cultural comparison to the production of Aboriginal texts, then it is in marked contrast to the situation there where 'custodianship' tends to displace 'authorship', where individual subjects are socially positioned as the repeaters of traditions rather than the sources of original or creative material (Muecke, 1992: 45–6).[2]

A political–expressive telos develops a structure of 'before' and 'after' in which the 'before' marks the point at which Aboriginal expression is not allowed to develop (or has not had the political occasions like the 1972 Aboriginal Embassy with which to develop in conjunction) and the 'after' is conceived in utopian terms, as the moment at which social constraint is lifted and subjects natural rights to self-expression come into their own.

Now this narrative, the one organized around repression/expression, is a

304

forceful one because it can be uttered not only as an explanatory account of the emergence of new Aboriginal culture, but it also works at the individual level as a technique for the psychological construction of a specific sort of Aboriginal subject. The repression/expression nexus is at the heart of the autobiographical attempt to inscribe a politics of Aboriginal coming-to-consciousness on the same page as a post-Freudian journey of self-discovery.

Now in spite of all claims to authenticity, Aboriginal uses of this theory of the relation of subjectivity to political formations are neither Aboriginal nor new. Aboriginal speakers tend to be stuck in a bind where theoretical protocols have been inscribed in advance and they have used the ones which seemed best to serve their cause at the time. If it is the case that the 'interpretative devices' of a culture are invented by dominant groups, then there will be no form of access to interpretations through which those on the outside can understand their conditions of existence in their own terms, the familiar subaltern problem. And there are generic and historical constraints. A literature of protest, for instance street theatre, cannot simply be conceived of as original and authentic expression; it is as much a product of 1970s literary formations as it is a unique Aboriginal voice. Street theatre is one of the lines of descent out of which the Walker boys' performance emerges as a transformation.

Aborigines and Nation

The tradition of Australian liberalism has in fact allowed for the progressive re-evaluation of Aboriginal cultures since the assimilationist 1950s, to the point of their integration in the image of the nation. The irony is that the Aboriginal movements which were born out of resistance to assimilation in a monocultural Australia, found themselves finally being integrated as national icons in an Australia which had switched from monoculture to diversity in the official form of multicultural policy. And suddenly, but not surprisingly, there is vocal Koori resistance to multiculturalism. When Race Discrimination Commissioner Irene Moss said 'Australia must work through its identity crisis. It is an Asian nation with a European heritage'[3] Aboriginal leader Shirley Smith (Mum Shirl) retorted: 'There is only *one way* Australians can belong here. This is not part of Asia, Race Discrimination Commissioner Irene Moss needs to understand this . . . We are your only true connection to this continent, to this entire region. We are the land, and we are here forever.'[4]

Mabo

Eddie Mabo is the name of one man who, with his colleagues from the Torres Strait Islands, brought indigenous Australians' title to land into the law by establishing that his family's original property rights over land had persisted since colonization. The long-standing legal understanding that Australia was *terra nullius* [empty] at the point of occupation was thus overturned, and the

precedent for further cases was set. This 1992 judgment by the High Court confronted for the first time in this court's history (since 1901) the place of native title in Australian law.

The train of events put in place leading to the passing of legislation in parliament was carried by a skilful team of Aboriginal negotiators including Marcia Langton, Peter Yu and Noel Pearson. Significantly, there was another Aboriginal position led by the Aboriginal Provisional Government which operated with *sovereignty* rather than with *property* as a category.[5] A challenge to sovereignty had already been dealt with by the High Court in 1979 as a premise for the very existence of Australia as a nation, and thus could only be dealt with externally, internationally, and perhaps by military conquest. This is the reason why Michael Mansell and other members of the APG had sought, in the late 1980s, the help of Colonel Gaddafi of Libya in their liberation struggles based on the notion of sovereignty.

The success of the more reformist Mabo strategy was also a success for the Prime Minister, Mr Keating, who claimed the legislation as a step towards what is known as reconciliation – official policy replacing the superannuated previous indigenous policies: Assimilation (1950s), integration (1970s); multiculturalism (1980s). Mabo and republicanism (our 'postcolonial' gesture rejecting the British tie as anachronous) are intertwined. Australia needed the gesture which was Mabo in order to transform the nation politically. I focused cultural forces on a national scale through the depth and resonance of an historical and cultural genesis. This moment of genesis is symbolized by sacrifice and death.

Death, I should point out immediately, is at the heart of the formation of the nation, in as much as nation is an entity that emerges from statehood. States can be set up as political entities, but they only become nations through the magical or spiritual agency of death. Mythologists and anthropologists have explanatory accounts for this: a people recognizes itself as a people, that is, as a culture, through the symbolic treatment of its dead. So that social order can be maintained, cultures don't just bury their dead and forget them, they have to attribute some power to the dead. A surplus of social energy or power is transferred to the dead so that in their fixed and symbolic narrative they can control us, the living. The myths of the dead tells us where we come from, who we are and how we behave towards each other. This is why we have monuments to the dead, this is why the sacrifice at Gallipoli in World War Two is a crucial nation-forming narrative for Australians.

Now, for its political power to operate, the Keating government had to find a space to move in. Because, if the totality of a territory is occupied, power has nowhere to go – the space of power is a moving one, it is always *about to be* fixed. Imperial history has shown us the movement of power through real spaces, this history is a colonial history of spaces to be conquered and occupied. Mabo gave Keating the opportunity to say that the country we thought was fully occupied, fully 'covered' by a history which has its point of origin and

completion in London, is not finished at all in that sense. The narrative has to take a different turn. We now pay our dues to the dead in a different way, our cultural excess is now to be expended in an Aboriginal memorial for which the emblems are genocide and the martyrdom of black deaths in custody. So the affirmation of new forms of Australian cultural life already means that the national dead will be, at least to some extent, the Aboriginal dead. This is a profound change because it literally means the enhancement of Aboriginal cultural forces through each ritual which symbolically transfers power to their dead. There is nothing morbid about this, it is just one theory of the way cultures work. They work through the ritual production of structures of feeling, how else can one explain funeral rites, Anzac days and historical monuments? By reorienting our focus on death, Mabo has given Keating's government the power to change nationhood. Mabo is an example which has invented a new politics.[6]

Orientation/international solutions

As I worked on the preparation of this chapter I found myself increasingly compromised, not only by being a whitefella speaking where blackfellas should be speaking, but not knowing how to sort out the Asian-Australian relational complexities. As Blanchot might have said, I had set myself the task of talking about an impossible relation (1993: 208). The impossibility of representing Aboriginality; the impossibility of representing Asia, even as pluralist; the crazy project of talking about them together. And yet there *are* the historical facts of Aboriginal–Asian relations to draw upon.

But having spoken a little about the complexities of cultural value in this racial and national context, what I will do in the rest of this chapter is talk a little from history, and then try to conclude by balancing the notions of cultural value against economic value. For example, what persists in Australian white cultural hegemony which enables the following structure of difference to occur in Australia in this context? The marketing people at Singapore Airlines are confident that the image of the Singapore Girl will launch a thousand planes, but, sexism aside, there is no equivalent Aboriginal Girl. Aboriginal cultures are seen as having a relatively fixed value in the representations of Australia used for nationalist or tourism purposes. They are represented as past, traditional, and authentic. Asian cultures, on the other hand, are seen as mobile and tied to the speed of economic transactions – modernizing, in other words, with all the dubiousness of that process. In this representational game, let us not say that Aboriginality is Australia's past and Asia is our future. It is one of the hallmarks of nationalist thought to see the Other as displaced in time.

Then there are European discourses in Australia which talk like me. They strive for hermeneutic value, for the capacity and right to interpret. They are brokers putting a value on values, sorting and ranking them. Caught in a paradox of wanting to devalue one's own speech as 'European', and then to strive

for a local idiom, I wish to avoid succumbing to an absolute statement of cultural relativity. One must rather bring the evaluative mechanisms to visibility, show how they emerged historically, and I will bring in Steven Connor's work on cultural value to support this position.

In my deliberations I was saved from ignorance about Aboriginal Australians' attitudes to Asia, and the international scene generally. In May I went to the Australian Broadcasting Commission to listen to the Australian Screen Directors Association debates.[7] On that evening it emerged that Wal Saunders (Manager, Indigenous Branch, Australian Film Commission) had called for a moratorium on the filming of Aboriginal people by non-Aboriginal people. Eventually someone from SBS [Special Broadcasting Services] asked if he too was subject to this ban:

> I'm from SBS television, um, I'm not Black Australian or White Australian. I have an interest in Aboriginal issues and ah I like to, you know, capture that in my films, if I ever get a chance to make one. And ah can, Wal . . . Wal Saunders can you tell me why I can't 'cos I'm at SBS and I'd be using or abusing government money so ah, can you tell me why I can't make the film?
>
> *Wal*: [rambling reply] . . . I took a far-left view that's been bit tempered since then. It's about collaboration on film [only successful ones have had this].
>
> *Philip Adams*: It's interesting that the question was put by an Australian of Asian background. In a couple of weeks Marcia you and I are heading for Broome are we not? Oh no, you're not going to Broome . . .
>
> *Marcia Langton*: No, I've handed over to Rob Riley on that one.
>
> *PA*: But you've made the point to me today that there's a very high incidence of Aboriginal–Chinese intermarriage in Broome.
>
> *ML*: And with a lot of other Asian cultures, yes.
>
> *PA*: And we're dealing with cultural miscegenation tonight but it's . . .
>
> *ML*: Miscegenation is such a *horrible word*.
>
> *PA*: But it's been a part of the process has it not? For almost 200 years . . .
>
> *ML*: Let me just say that miscegenation is one of these eugenicist terms straight out of the fascist debates from the 1930s (laughter, applause). Let's talk about intermarriage, yeah? Let's talk about inter-ethnic relations.
>
> *PA*: I think miscegenation sounds almost better than that but ah
>
> *ML*: Well, it means to . . . um cross gene pools in the wrong way um perhaps . . .
>
> *PA*: But Marcia you can see the point I'm getting at . . .
>
> *ML*: I know I know . . . there's already been intermarriage why not intermarriage in the arts? I think it would be the healthiest thing in the world for this debate if every person involved in the film industry said, 'Let's forget about this psychotic debate we keep having with

white Australia and let's start talking to Asians and people from Eastern Europe and Africa and so on and South America and talk about something else for a change. Let's do some films about genocide. How about us and the Timorese get together um how about us and the Cambodians get together, you know. That'd be so much more interesting and we could bring our experiences as human beings together you know, having been victims of ah . . . human tragedies and let's look at these things 'cos there's one thing for sure and that is that Anglo Australians are still too frightened to talk about a lot of these things frankly and honestly . . .

Marcia Langton was in despair. She had seen the debate, despite Philip Adams' flamboyance, reduced to a miserable and punitive measure: banning of representation. She had understood long ago that it was no longer a question of policing representation, but of the creation and mobilization of ideas. She wondered if anyone had read her (1993) book. To be caught in a 'psychotic debate with white Australia' was precisely to be caught in an oedipal and regressive colonialism: these sub-colonials exploited 'us' economically because they were exploited, now they want to exploit 'us' again symbolically to squeeze a bit of republican identity out of Aboriginality. She saw the value in moving sideways. She seemed not to be interested in the preservation of cultural authenticity (after all, what on earth is a correct representation now?), but in the elaboration of ideas forged by a common history of the intolerability of colonialism. To understand these common histories on an international scale is to guard against repeating the mistakes of the past.

Nor is this cliché about the mistakes of the past anything to go on because 'we' are no universal subject of history. Aboriginal Australia may have much to teach the world about philosophies of place, as opposed to time, if we are to believe the comments of Tony Swain who claims:

More than any other cultures for which we have historical evidence, those of Aboriginal Australia pursued a philosophy of the enduring immanence of autonomous yet related places. The emergence of time, the quest for Utopia and the moral order of 'cargo' each contradicted that world view, but have each been to some extent acknowledged [within it].

(Swain, 1993: 288)

Time is an introduced virus, he claims, which required inventive cultural adaptation on the part of Aborigines.

'Autonomous yet related places' might be a good starting point for an indigenous philosophy, a philosophical position critical of various colonial and postcolonial imperialisms. On the outside then, in the 'Asia' that surrounds Australia, is a plural domain which is open to multiple connections. Here one

309

is sure to find the time/utopia/cargo philosophy which is the dream of capitalism, and dislocates many Asian peoples from a sense of belonging in their own place, and sweeps them up in a global economical order in which the market is the determining factor. In other places there are indigenous peoples throughout Asia who have and will continue to work with indigenous Australians, Ainu in Japan, Taiwanese Aborigines, Andaman Islanders, etc. As Helen Corbett said in the 1993 Boyer lectures:

> Many people, including indigenous Australians, assume that Aboriginal and Islander issues are purely domestic matters. But we have much to gain from the international arena . . . there's the chance to use the broad principles of human rights established in the international community.
>
> (Corbett, 1994: 76)

Aboriginality is poised for the moment as an emblem of symbolic exchange with other parts of the world. Common histories of colonial exploitation are their *lingua franca*. But Australia is pressured in this regional context towards reducing all forms of exchange to one – the economic. We are urged to be inventive and diversify, but this diversification is in the name of only one value, market value. The paradox is that market values will probably benefit from the kind of diversity which actually extends the range and types of value themselves. As Steven Connor says:

> The forms of plurality must therefore be both protected and themselves pluralised; and we need to think and institute ways in which the protection of pluralism is enacted precisely through its pluralisation, rather than instituting limits.
>
> (Connor, 1994: 4)

So I would *not* suggest that Aboriginality remain the sacred domain of the non-economic. Aboriginal people should continue to do business in economic and all sorts of other senses, with whomever they like and on whatever terms they like. Yet these people represent, and are used to represent, an ethically incomplete project – Australia's shameful human rights record which is a thorn in the diplomatic side, and a weapon for some Asian negotiators. Yet the principle here is not to remove that ethical imperative by finally setting the wrongs to right, the aim should no doubt be to intensify and diversify the ways in which values are made visible.

The consequences of culture

In conclusion I want to offer another example as a device for concluding and wrapping up my themes. In summary, cultural activism has historically emerged

in Australian indigenous politics over the last twenty years. It has displaced the 'straight' political activism which tended to take no specific cultural form, modeled as it was more on mass and popular demonstrations of collective will which characterized many left-wing movements. Now, the performances of cultural activists articulate with a variety of other strands: a 'cultural renaissance' over the last twenty years; a series of bicentennial events which asserted Aboriginal pre-colonial history and made demands for its positive representation (rather than just critique and protest); the demand for Aboriginal cultural production to play a part in nation-building – ideologically and industrially – for the republic and for tourism.

These threads would be difficult to disentangle, but combined they make for a force of a set of indigenous cultures articulated with the national machinery of culture which is more important than the relative numbers of people in these minority communities. I think these forces of cultural politics could be even stronger with greater understanding, and this is where I come to my last example which is a discussion of a paper by a Torres Strait Islander, Martin Nakata. Simply entitled 'Better', it is an intervention by an indigenous educationalist in national education policy, and it is so brilliant that it makes a 'white expert' like myself feel happily redundant. 'Culture' and 'the subject' are key elements in the paper, and he seems to support the critique of the confessional production of subjectivity:

> I am not comfortable talking about myself, precisely because marginalized people are often called upon to do a kind of public confession. The others say, 'If you speak to us about your personal experiences we can better understand your position.' I often wondered why people from dominant groups couldn't understand my position by reflecting more on their own actions.
>
> (Nakata, 1995: 64)

Fascinated by the intricacies of otherness, Martin, they probably like to watch the native intellectual perform. The relation of education to culture, in Nakata's paper, is one of a relation of completion. In a critique of victimhood, he rightly targeted the construction of indigenous *lack*: 'a lot has been written about Aboriginal and Islander people with regard to how we have lost our culture'. And he quotes the Education Department policy document as saying 'the historically developed education processes of Aboriginal culture have been eroded in many communities for a variety of reasons' (ibid.: 70). Then presses home his point: 'Our education is defined only as cultural event. Our culture was once whole, but we have "lost" it (we "lack" wholeness): it is represented only as something which can be handed back' (ibid.: 71).

The education department's humanistic use of the concept of 'whole' culture has been criticized elsewhere (Hunter, 1994), but Nakata describes its uselessness in the daily political context of the way education gets 'done' to his people

in a world of prejudice and exclusion. So rather than seeing indigenous education as a cultural 'add on' to what is already seen as a virtual whole culture in dominant Australian terms, the notion of lack needs to be redirected towards those who would use it on others. You could say that no-one, however privileged, has access to a 'whole culture'; it is always a variety of skills and performances to be learned and practiced. So maybe what should be said is that we are always adding on or taking away, trading one item of value for another. Apart from street theatre, cultural activism can also take the form of international conferences for indigenous peoples, and essays like Nakata's which articulate local dispossession and international history.

Brief chronology

1972 Tent Embassy, Canberra
1975/6 Land Rights Act
1978 Ranger Agreement
1980 Noonkanbah
1982 Human Rights and Equal Opportunities Commission established
1982 Commonwealth Games demonstrations, Brisbane
1985 Uluru 'handover'
1988 Bicentenary
1989 Racial Vilification Act
1993 Native Title Act (Mabo)

Notes

1 For my purposes I wish to distinguish 'cultural activism' from 'cultural action', the latter being, in the tradition of Paolo Friere, a kind of consciousness-raising activity which develops its expression in the medium appropriate to the group in question – it often takes the form of theatre. What I mean by cultural activism is more general than that, and I am using it to carry out a historical exercise in cultural studies.

2 For a view of individualist production and responsibility, by an indigenous scholar, see Philip Morrissey, 'If I'm not for Myself . . .' *The UTS Review*, Vol. 1, No 1, 1995: 50–8.

3 *The Sydney Morning Herald*, 4 February 1993.

4 Letter in *The Sydney Morning Herald*, 28 February 1992.

5 See Martin Nakata's account of his family's financial dispossession, in the Torres Strait Islands, under colonialism, a somewhat more mundane instance of the denial of property rights:

> [My mother's] grandfather was a prosperous and enterprising Samoan. When he died early this century, his assets, including £10,000, were left to his family. We never saw it. It was irrecoverable, lost in the maze of so-called 'protection' offered by the Department of Native Affairs or whatever it was called at the time.
>
> (Nakata, 1995: 64)

6 See the special issue of *The Australian Journal of Anthropology*, 'Mabo and Australia: On Recognising Native Title after Two Hundred Years', 6: 1 & 2, 1995.

7 'Australian Screen Stories', with Philip Adams, broadcast on 17 May 1994, *Radio National* 'Late Night Live'.

References

Baudrillard, J. (1990) *Cool Memories, 1980–85*, New York: Verso.

Blanchot, M. (1993) *The Infinite Conversation*, Minneapolis: Minnesota University Press.

Bostock, G. (1985) 'Black theatre', in J. Davis and B. Hodge (eds), *Aboriginal Writing Today*, Canberra: Australian Institute of Aboriginal Studies.

Chen, K. H. (1992) 'Voices from the outside: Towards a new internationalist localism', *Cultural Studies*, 6/3 October.

Connor, S. (1992) *Theory and Cultural Value*, Oxford: Blackwell.

Corbett, H. (1994) 'International efforts', *Voices from the Land, 1993 Boyer Lectures*, ABC Books.

Hunter, I. (1994) *Rethinking the School: Subjectivity, Bureaucracy, Criticism*, St Leonards, NSW: Allen & Unwin.

Langton, M. (1993) 'Well, I heard it on the radio and I saw it on the television . . .', An Essay for the Australian Film Commission on the politics and aesthetics of filmmaking by and about Aboriginal people and things. Sydney: Australian Film Commission.

Lingis, A. (1994) *Abuses*, Berkeley, CA: University of California Press.

Muecke, S. (1992) *Textual Spaces: Aboriginality and Cultural Studies*, Kensington: New South Wales University Press.

Nakata, M. (1995) 'Better', in *Republica 2*, Sydney: Angus & Robertson.

Rowse, T. (1993) *After Mabo: Interpreting Indigenous Traditions*, Melbourne: Melbourne University Press.

Swain, T. (1993) *A Place for Strangers: Towards a History of Australian Aboriginal Being*, Cambridge: Cambridge University Press.

16

CRITICAL BODIES

Cindy Patton

From the epidemic's dawn, AIDS activists have been deeply aware of the ways that the body is constituted through biomedical and social scientific discourse, painfully cognizant of how that body is constrained through the public policies and health education programs developed from the research disciplines. Nevertheless, we are also desperately dependent on precisely those scientific institutions and practices for any hope of medical care, anti-discrimination statutes, or prevention programs. Thus, activists and cultural critics concerned with the epidemic are in the precarious position of deconstructing AIDS discourse and resisting its policing practices while inhabiting the bodies constituted through them, of living the material effects of the representations and policies into which we have sought to intervene. But while wrenching, this complicated, sometimes masochistic refusal to simply be the bodies of epidemiology has enabled theoretical and practical work that is exciting, volatile, and surprisingly effective.

Two waves[1] of AIDS activism growing out of the gay communities in the West have claimed a range of victories: the first five years witnessed the establishment of non-governmental institutions and the creation of visibility and voice through minoritizing politics.[2] By about 1987, anarchic protests known as treatment activism had forced a new understanding of the subjects of disease as active participants – consumers – rather than passive victims. By hammering away at multiple soft points in the scientific, drug marketing, and ethical frameworks, this form of activism apparently provoked the research system into streamlining US drug treatment trials and, in the early 1990s, broadening the definition of AIDS to include gynecological symptoms and low t-cell counts in the absence of opportunistic infection.[3]

Both kinds of political organizing have had international effects: the autonomous AIDS service organizations have served as a model for community-based programming in a wide variety of countries (Global Programme on AIDS (GPA), 1989). Similarly, the self-help-oriented people living with AIDS movement has spawned local organizations and transnational networks. While less popular outside of Anglo-European countries, ACT UP and its most visible leaders moved from relative obscurity in the late 1980s to structural incorporation; ACT UP's 'leaders' became required sources in news articles

about US government AIDS policies and a force to be negotiated with at international AIDS conferences, the major performance space for ACT UP's global visibility. But on a more abstract level, the two forms – in varying degrees anti-national, though often also in contention with each other – have together secured a rough oppositional narrative which can now be deployed against or alongside the official national narratives about the social dimensions of and response to the epidemic. But in part because AIDS was so early linked with sexual deviance, global activism has been perceived as an international gay – and probably gay *male* – social movement. This particular association of AIDS = gay and the activisms confronting it, have, together, in extraordinarily complex ways, framed 'global AIDS' through concepts that have made gender politics relatively difficult to pursue.

Feminizing 'Asian AIDS'

From the outset, the body subject to AIDS was thought to contain an unstable mix of social deviance and medical health. The emergence of substantial numbers of AIDS cases among 'heterosexuals' did not diminish the association of AIDS with sexual deviancy. Instead, heterosexuals who happened to contract HIV were assumed to be practicing some bizarre form of sex. The epidemiologic accident that many of the people diagnosed with HIV in Africa claimed to be heterosexual (by the Western researchers' prurient definitions) only made it easier for the US media and scientists to sustain their assumption that only perverse bodies were subject to HIV: African heterosexuality was persistently described as perverse, precultural, primitive. The same logic that figured intervention in Africa as 'too late', suggested that Asia, as the place where AIDS 'arrived late', should have been an ideal candidate for aggressive prevention campaigns.

The mid-1980s was the crucial period for the production of global AIDS policy. Ironically, the *lack* of HIV in Asia during the mid-1980s led to misperceptions that would enable HIV to quietly become established and, by the early 1990s, rapidly increase. The scientific description of the pandemic, which encoded the early association of AIDS with sexual deviance, combined with Western stereotypes about Asians' sexual passivity, produced a global nomenclature that implied that since transmission required infected insertive partners, an Asian epidemic was contingent on a massive influx of infected persons from elsewhere. HIV was only defined as a 'problem' in Asia when cases were found in among sex workers thought to be serving foreigners, but since the epidemic was seen as coming from elsewhere (rather than only being 'a matter of time'), AIDS was considered an import from the West, especially from Westerners on the exotic and infamous sex tours of Asia.

Initial Western discussion about HIV in Asia came through exposés of Australian and American sex tourism. This collision of Orientalism and Victorian sexual attitudes produced a frenzy over Asian women and children

swept up by the 'imported' Western perversions. But the moral panic to 'protect' women, children, and non-perverse men by policing Western deviance did not disassociate Asia from perversion: sex tourists are described as seeking 'outlets' in Asia for kinds of sex they cannot find 'at home'. In the context of global AIDS policy, Asia is hyperfeminized: passive ('AIDS *arrives* late'), but also, like the popular Anglo trope of the prematurely developed pubescent girl, alluring beyond her own comprehension, *attracting* fatal attention.

Since incidence was low and the proposed conditions for local spread – homosexuality and drug injection – were believed not to exist within 'Asia culture', little prevention work was initiated in Asian nations until the early 1990s. In WHO's global purview, HIV arrived late,[4] but once introduced, sexual stereotyping took another turn to endorse the idea that there was some form of local, 'Asian' resistance to dispersion of HIV. The idea of 'resistance' now had two, gendered usages in policy-speak, which, in turn, had opposite effects. In 'Pattern Two', 'resistance' was masculine, a refusal to use condoms which insured that Africa was all but lost (Patton, 1990; 1992). But in Asia, resistance was a vague, primordial incapacity to do anything other than become infected, a passivity that read as feminine. The result of the logic of gender quietly installed at the heart of the GPA's vision of the epidemic's 'patterns' was that risk reduction programs, and not HIV, truly arrived late.

While international forms of sex work are and should be considered in discussions of global sexual health, the West's admission to *this* form of colonial intercourse *rationalizes* the more organized state and corporate forms of domination. The West's condemnation of international sex tourism represents Asia as a feminized victim in the one domain of global regulation (sexuality) where the West still feels confident of its moral superiority (ironically, since postcolonial nations often cite modernization and Westernization of sexuality as the *cause* of apparently new sexuality-related problems). By focusing on the active culpabilities of individual sex tourists, Western health officials avoided acknowledging that their neglect of Asian countries on their own terms was responsible for the late development of HIV prevention programs. Treated largely as objects of tourist fantasies, the WHO waited to act until HIV was well-enough established in Asia to produce an epidemic, and only belatedly developed policy – largely dealing with prostitution – to manage the burgeoning HIV epidemic in Asia which health policy's 'late entry' helped create.

Gender, gender everywhere, but not a woman in sight

I'm suggesting that at least one important cluster of global health policy concepts are covertly and dangerously gendered. I want to suggest how this meta-discursive gendering of AIDS trickled down into planners' and program developers' attempts to address the specific issues faced by women in relation to HIV. In a disease phenomenon in which epidemiology figures prominently as

the policy frame, women enter the planner's landscape not as an epidemiologic category or target of education, but as a vector of transmission to men and babies. Implicit in both safe sex campaigns and research on HIV risk among women is the message that risk reduction is about preventing men from acquiring HIV and preventing women from passing HIV to children. The crucial link – preventing women from acquiring HIV in the first place – is rarely addressed. Because HIV/AIDS is widely perceived to stem from 'perverse' or 'abnormal' sexual behavior, few women identify themselves as at risk; they view themselves as practicing 'ordinary' sex with their partners and have difficulty believing that their partners may have engaged in the mysterious risk behaviors.

Cast primarily as the road or canal across which HIV will travel on route to a more clearly defined 'victim', it has been difficult for women to gain visibility as people who need care and treatment. But since the normative case of AIDS was early defined in relation to Western gay men, women's treatment and care needs are viewed as exceptions or variables to generalities about 'people living with AIDS', a term which implicitly refers to men. The concerns and issues of people living with AIDS support efforts oriented toward men's social situation, men's bodies, and men's needs. Women are thought to have 'special needs', and this only when the basic male-oriented model is clearly incapable of helping them. This is in no way to undervalue the importance of the PLWA movement, its conscious attempts to involve women, and its concrete role in improving the lives of women. However, the movement would have been different if it had arisen out of women's experience of the epidemic.

One problem is that the PLWA movement was initially modelled on the 'coming out' process in gay culture, and soon incorporated the 'storytelling' process within Alcoholics or Narcotics Anonymous culture. Both of these self-help models empower the individual by helping them to claim as positive an identity which society labels as bad or immoral. To the extent that individuals can relate to this model, the PLWA movement is empowering. However, women, especially those infected through 'ordinary' intercourse with their husband or boyfriend, have difficulty claiming this new identity – women weren't especially labeled deviant (though women's bodies have long been considered messy, cyclically ill), and the conditions of poverty and isolation which many men experience *because* of their AIDS diagnosis are already the lived experience of women. Thus, for women, AIDS usually does not cause as extreme a difference in social standing or identity that it does for the self-identified gay men.

Conclusion: finding activisms

Oppositional AIDS work has taken many forms, from the most visible work of American ASOs and ACT UP, to variants like Uganda's PLWA self-help project TASO, to projects that go unrecognized by official bodies. However, because

AIDS is differentially constructed by overlapping global discourses, governmental structures and multinational corporate interests, it is difficult to develop a single 'radical' agenda, or even to understand the meaning and efficacy of specific interventions. By no means am I suggesting that any or every project contributes somehow to a whole: on the contrary, I am suggesting that even apparently oppositional projects may conspire in the reconstruction of the systems they are designed to combat. Multilevel critical analysis of institutions, discourses, and local situations is essential to the creation of useful interventions, but even the best individual projects may – probably will – conflict with other, similarly thoughtful interventions arising out of other – even very similar – situations. Meta-narratives – even those noble ones like health for all – are fragmenting and, if held too dearly, may blind us to the truly innovative and world changing projects which, though incommensurable, may, on balance, finally disrupt the current state of global AIDS management.

Questions and answers[5]

QUESTION: I was struck by the way you talk about the use of gender, particularly femininity as a metaphor to represent people with AIDS as victims, as opposed to something that is more active. I'm wondering how you move between discourses about women with AIDS, the notion of femininity as a metaphor, and femininity as a life, as an experience in relationship to AIDS?

CINDY PATTON: I take your question to be in part raising the issue of how to deal with situations in which cultural metaphors do seem to also be locally descriptive, are the felt or the perceived experience of a group of individuals. On the theoretical level, it might be best not to assume that there are regular or knowable relations between the many meta-discursive notions of the feminine, specific colonial and national discourses of the feminine, and the local experience of being-a-woman. When I deconstruct the larger discourses and point out the ways in which the feminine is deployed on this level and then when I look at how the femininity is deployed in a local situation, I do not assume that there are close or regular relations between these ideas of the feminine: the local deployments of the feminine, and the local forces resisting or reworking femininity may or may not inflect the meta-discursive in clear ways. I would recommend a break from the commonplace assumption that there regular if not determining relations between higher and lower registers of use.

From the standpoint of activism, global discourses become locally effected through projects of organizations like WHO. It seems to me that we need to consider different kinds of interventions: one project is meta-discursive. Altering the way the GPA frames policy has an effect on the broad possibilities for generating and supporting local organizing, especially in developing countries which may not be able to get world attention or money except through global agencies' conduits. That is important for, but quite different from, doing work

on a local level. It's helpful to understand the how the larger discursive processes limit or allow for local work; local activists need to understand the WHO as much as global activists working in and through the WHO need not to smooth out the contradictory experiences of activists in locales. The tiny number of people who can move between these two must be more aware of these plays of discourse. This interstitial space provides a unique vantage point from which to critically observe the strategic construction of self and community to their government and non-government benefactors. But while this very specialized form of activism can help local projects use global agencies, they are not necessarily able to see the best ways to act locally. Globally-oriented activists have to be careful to avoid assuming that a locally expressed description of 'the feminine' is, in fact, the same as a feminine that they have observed or experienced in some other context. The appearance of local regularities that are generated *through* global discourses must be discovered and questioned. This has been one of the difficulties when Western feminisms have moved outside the cosmopolitan, Euro-American countries. When you hear someone talking about femininity, it is easy to assume that what you're hearing is an unreformed version of an universal female experience of oppression. Universalizing women's experience is a dramatic mistake that can result in policies that are not at all suited to a particular place.

Let me give you a concrete example that has to do with sex work. In many so-called developing countries, working-class urban women systematically trade companionship and sex in order to supplement their income, a practice women refer to by names like 'going out'. But from the perspective of researchers, and implicitly, of the GPA,[6] who considered these situations under the purview of the prostitute's program, this practice is simply another form of prostitution. But in many locales, especially postcolonial countries with extensive experience with Europeans, there is *also* a concept of prostitution, which may be understood as devoting most of one's work attention to selling sex and favors *to European men*. This *other* form conceives sex barter – *prostitution* – as a profession rather than an income supplement.

Particular styles of sex work emerged, at some or several points in the history of global trade and formal colonialization, as specific forms of socio-sexual role. Each evolution in these socio-sexual roles fused differing ideas of sexuality and sexual exchange in a changing sexual economy, parts of which were explicitly related to European men and ideas of Europeanness. These different roles had and have different symbolic meaning, and women who engage in them organize their lives in different ways, even organize parts of their lives to accommodate multiple roles in the sexual economy (sex worker, lover, mother, wife, lesbian). This has a major impact on both prevention work and service delivery. For example, to the extent that 'going out' is part of an urban working class woman's identity as a feminine person, she may strongly reject the idea that her activities have anything in common with 'prostitution', which she may see as immoral or as 'modern' and in violation of traditional gender roles.

But 'going out' is still different than sex with a domestic partner. If condoms are heavily associated with prostitution, women who 'go out' may not perceive their utility, or may be actively hostile toward their use. Once they become infected, however, service delivery toward urban working class women who are not associated with career 'prostitution' may actually go more smoothly, since they are likely to be perceived as victims of modernity or of immoral men. By contrast, women who identify as prostitutes may be more eager to initiate risk reduction projects, but governments may be less willing to fund care or treatment for sex workers who become infected or develop illness.

QUESTION: There are lots of hierarchical categories in your paper including Pattern I, II and III; classes, etc. When you talk about women, you use words like 'women living with AIDS', etc. There's no classification of 'women'. I want to know whether you think it's necessary to divide them into classes, like women, feminists, or lesbians? And if yes, what are their positions in your paper?

CP: The hierarchical categories I am using are those that have been proposed by the World Health Organization and which have defined international policy discourse. My primary purpose has been descriptive: I do not mean to imply any endorsement of these categories. Talking about and programming for women is not the same as discovering the workings of culturally and politically overdetermining concepts of gender. Paradoxically, women *per se* never appear in any of these schemes as a category, despite the fact that Patterns I and II are implicitly defined according to the presence or absence of cases among women (i.e., Pattern One = dominance of homosexual male cases, or, a relative lack of female cases and Pattern Two = dominance of heterosexual male and female cases, or, a high number of female cases relative to Pattern One). While Pattern III does not make a specific reference to cases among women, the whole idea of AIDS 'arriving late' evokes a passive, implicitly feminine sexuality. The problem facing activists is to recognize the ways that gendered concepts inflect local discourses and practices, creating roadblocks – or opportunities – for actually helping women in varied concrete situations.

I'm quite anxious about proposing classifications of 'women' as if these could ever be 'neutral'. Engaging with and reconstructing categories is an intervention to be carefully undertaken. For example, there has been a tendency in the US for feminists to say no one is paying attention to women. Initially, feminists raised the issue of women by saying we need to have 'women', understood as a self-evident category, inserted into the discourses of AIDS. To some extent that was very important, because visibility and classification enable the people who inhabit a category to get medical resources. But on the other hand, the production of the category 'women with HIV' placed the people so designated under medical surveillance. In this sense, they *lost* the power to determine what the category they asserted for themselves would mean and do. Often, 'women

with AIDS' were represented as proof of the need for the state in intervene on behalf of 'the family': not at all the project feminists had in mind. That is the paradox of visibility: once your self-determined image and group definition gains some purchase on institutions, you lose control over the meaning of your presence and over the criterion for counting your members. It's very, very difficult to figure out how and in what ways we can have women's needs identified and dealt with while minimizing the harms of being constituted as an epidemiological category.

The general problem of categorization is especially acute in the context of the HIV pandemic because of the way US epidemiology operates – there are some specific reasons why US epidemiology had difficulty situating women among its categories. Epidemiology sees itself as discovering regularities based in the trajectory or dispersion of a pathology – in the ideal case, the class of those at risk are an unnatural category based in their sharing some trait, location, or behavior that has made them especially susceptible to a *particular* disease. But women are viewed first and foremost as a 'natural' division: women's bodies are expected to operate 'differently' and to be 'differently' susceptible to disease than the presumptively male normative case. So it does not immediately make sense to epidemiology to designate women as a risk category. This is why women are always classified either as a gender breakdown of the primary category, 'drug user', or as passive 'partners of' men who are *actively* at risk through their sexual or drug use practices. To the extent that epidemiology classifies woman, it is by fragmenting her into a sexual receptacle or a mother who might perinatally pass HIV to a fetus, ideas that fit neatly into the story of AIDS that epidemiology was already telling. So women do not get counted as women, they get counted as 'prostitutes', 'mothers', or 'partners' of men.

That women are always masked in other categories became clear to me when I was working on a WHO–GPA needs assessment about women. When I asked various department heads for relevant studies and projects, I got small stacks of material on maternal and child health, sanitation, and literacy, but I got a really big stack on prostitution. When I asked for material that was simply on women's health, I was initially met with blank stares. Because WHO sees itself as promoting 'public' health, it, too, does not conceptualize women *per se* as a group. Only in so far as women are a problem – or a solution – to a 'public' health problem do they achieve visibility within international health policy. That's not to say that there are not projects having to do with women, but they tend to be things like sanitation and water control in countries in which women have traditionally carried water from point A to point B. But often, when an international health organization comes in and installs pipes, men take charge of water and sanitation.

Or, to take another example, I learned that for several decades, health planners were concerned about women's literacy, not because anyone really cared whether women could read, but because maternal literacy is considered a predictor of child health and mortality and a marker for a country's level of

development. Women appear as characters in literacy projects, not as women, but as markers of development and of child health. This was the form of the existing discourses that the global program on AIDS inherited, and through which it had to think about women in the epidemic.

QUESTION: I'd really like you to say more about your experience in a bureaucracy like WHO. When you say 'it's very hard to tell World Health Organization that . . .' what does that mean? How did you function as a consultant? And what kinds of processes did you find? And are those processes changing in response to situation like AIDS?

CP: As you might imagine it was rather strange for me to find myself in the belly of the global beast, and a beast that turns out to be rather amorphous and difficult to pin down. I had usually been a don't-work-in-the-system kind of person. It was through my experiences, especially in the first few years of the AIDS epidemic, that I realized that while I might still believe that, I was not in a situation where I could practice it. I can remember meeting with people from the Centers for Disease Control in the early 1980s. I'm sure it was bizarre for all concerned. I didn't know whether I was demanding action or providing them with information about a world that was to them, at that time, shrouded in mystery. They have a tremendous amount of medical information which I needed, and which was not otherwise available to me. At that time, the medical journals were very slow to publish anything on AIDS, so it was only by at least partially engaging with the system that activists were able to gain expertise in once apparently academic but now obviously political forms of knowledge. This activism landed me, briefly in a couple of WHO projects. I never had any intention of doing consulting for the WHO, but I came to their notice when I had put my hand up at several conferences and said things as simple as 'what about women?' Although I had written about women and AIDS from the early 1980s, I wasn't primarily involved in projects for women: there were plenty of other women who were more exclusively identified with women and AIDS work. But, I ended up being asked to submit a proposal to do a needs assessment on women and AIDS.

What happened is symptomatic of the problems of dealing with women and AIDS. In addition to a lot of documents analysis, the project proposed to contact and interview the principles of various organizations working on women and AIDS. Well, some of these were self-help groups, which meant, in effect, we would be talking to women living with HIV. Well, this small section of the proposal hung things up for half a year. It turned out that if you talk to someone who is subject to a disease, you were doing behavioral research and had to get approval through the social science unit. I fully support controls on human subject research – I helped form and served on one of the first Institutional Review Boards supervising AIDS epidemiologic research. However, despite the fact that we were proposing to interview the women living with HIV as group

322

leaders and not as 'patients', the proposal kept getting kicked back and forth. Finally, WHO hired a woman from Burkina Faso as my collaborator and, because she was a specialist in child health and orphanhood, they added a section on orphans to our proposal. From that point on it was unclear whether we were doing a project on women *and* children or two parallel, if inter-related, projects. And, because Maternal and Child Health is a separate division of the WHO, we couldn't necessarily even move too far in that direction.

We finally got the document finished and it came back with a letter saying WHO couldn't approve it. We asked what the problem was, and they said it was too feminist and contained no new information. Since there was no global survey yet available, I was quite anxious to get our document approved. We offered to changed the wording to dampen the association with 'feminism', whatever they understood that to be. Because there was no existing needs assessment, I never did understand what they meant when they said the document contained 'nothing new', especially given the limits on interviewing they set for us. Maybe they expected some dramatic revelation about the situation of women and AIDS. Perhaps the issues faced by women were already too obvious, and it was embarrassing to admit that AIDS was another example of a longtime mishandling of women's health: women were both too present and too absent. Without some novel problem or solution to the 'woman question', it seemed that WHO could receive no information. In a way, it was true that the report contained nothing new: we already knew that global health policy was not doing much for women. The gender biases built into AIDS policy up to that point meant that 'hearing' women's needs required changing the whole conceptualization of the epidemic, something which WHO is probably not capable of doing. So the document was basically canned, along with a series of other contemporaneous projects on community issues. This all happened during the change over from Jonathan Mann, the American who had run the global programs on AIDS until the summer of 1990, when he resigned and was replaced by a career WHO administrator, Michael Merson, who had been running the diarrhea control program. As a result of this change of command, a generation of people on consultancies who were producing documents that could have been key program or policy references disappeared: most of their documents were never approved and their work will never appear as part of the citational chain that constitutes the institutional memory of global health efforts.

The issue of documents as institutional memory is quite crucial to global health politics. Because of the slowness of the official approval process, the documents many of us were using as references were stamped in about seven languages 'do not distribute' and 'not for the publication'. It made writing and being up to date difficult, because you were constantly citing WHO-generated documents you ultimately had to drop from your citations because they were not approved by the time your document was to go forward. This led to a certain amount of vagueness and allusion to projects whose documents didn't get

approved but which other consultants would know about, and know couldn't be specifically referenced.

This may seem like so much internal intrigue, but what I learned was that WHO is largely a discourse. I mean that quite literally, because its primary purpose is to produce documents that serve as references for governments or for non-government agencies to produce other policy documents that set the parameters for subnational planning activities. Within WHO, if you read the citations closely, you can begin to unearth different phases of political intervention: who is citing which studies, who is citing which previous policies?

Asian responses

QUESTION: Regarding strategies of AIDS prevention and the politics of government, I have some experiences to share. I taught the freshmen English course that is required of students in this country. I let them read a few [English-language] essays that basically promoted safe sex. The students' common sense understanding was that this meant simply not having sex with anyone who is infected. This interpretation became interesting once it was placed in the context of an Eastern society. Due to the commonly accepted idea of virginity, safe sex for women means having sex with only one 'reliable' man, supposedly your husband or a long-term boy friend. The traditional values of this society allow men to have many sexual partners.

When AIDS began to spread here, the Health Bureau had to publicize its AIDS policy. (Incidentally the director of the Health Bureau is a woman, used as a double token, she is not a KMT Party member and she is a woman.) According to documents released by the government Health Bureau, women with AIDS here have basically been infected through either sexual contact with infected men or blood transfusion. This means at least two possibilities for explaining prevention: the one actually practiced by official discourse and mainstream media is that men should take their wives into consideration, and, thus, should have their wives as their only sexual partner. But the other, the one taken up by my female students, is that women should not trust men in terms of sexuality: because it involves their own life and death, women should not trust their own husbands or their men. In discussion of this issue, students found out that the traditional sexual diseases experienced by women mainly came from men: this was beyond the imagination of the much regulated romantic love story. They reacted very strongly: given the doxa that man's body is clean where woman's body is dirty, open discussion of men transmitting disease to women attacked women's traditional respect and trust for men. This attack enabled a subversive reversal: women are clean, men are not. If we start from this point, we would publicize the issue as: your husband or man is not reliable.

Of course, official discourse will not adopt this point: the government will not tell women that their husbands are not reliable. Thus, the government policy on AIDS is as you are suggesting: women are ignored, except in so far as

child welfare connects AIDS to women. As a feminist who fights for women's self-understanding and consciousness raising, I wonder whether it is possible to insert this mode of thinking into the official discourse, telling women that bedroom-legitimate sex is not reliable. If this can be done, it can work effectively to protect women. As a feminist group, could we possibly negotiate with the Health Bureau to publicize this type of warning to women? How likely are we to succeed? Given that in the Western context, as you describe your experience, to consider the situation from the angle of women will draw the charge of being too feminist, do you think it is possible for international organizations to strategically initiate the call, in order, perhaps, to press the local governments to take the necessary steps in warning to women?

CP: Your question points to the complexity of local politics in a situation in which organizations like WHO and the UN are promoting unified global policies. The question is, on one hand, can the supranational groups open up space for local interventions, even shape the response of nations to their people? On the other, can local groups make inroads in their governments alone? I still don't know how possible it is for local groups to affect the discourses on AIDS that their governments actuate. The situation is different in each country, but, in general, in terms of health policy, governments have not, finally, turned out to be our friends in the epidemic. In the United States, official campaigns still will not talk about the effectiveness of condoms. In the wake of the Magic Johnson episode, several key public health figures were asked, 'Will you promote condoms use among teenagers?' And officials responded by saying: 'No, because it will be condoning sex.' I think it is important to continue to try to intervene in relation to governments, especially in the areas of treatment and direct services. But in regard to educational efforts, one probably ought to act with the idea of loosening governments' stranglehold on AIDS education rather than hoping governments will actually produce anything worthwhile. The best outcome is probably opening up space for discussion, rather than getting official sanction for messages that we, as activists, want to see in circulation. It might be possible to generate materials or campaigns (like those of early ACT UP, for example), which the government does not feel the need to intercept. All governments both produce messages and censor alternative ideas: the trick is to find the narrow space between these official activities. What are the limits of a government's tolerance for dissident ideas? What is its threshold of indifference?

It may be the case that extra-governmental or international agencies can recommend campaigns or ideas that, if proposed by local activists, would seem too radical or politically problematic. Part of the objective of document-writers at GPA was, in fact, to put into the supposedly neutral recommendations of WHO language that created windows of opportunity for local groups. This was most successful in the men who have sex with men projects: by sidestepping the now-Westernized concepts of 'gay' or even 'homosexual' the staff people at that project gained fairly easy entry into 'gay' communities and were able to get local

homosexualities embraced as 'indigenous' rather than something foreign.

Because the American and European women's movements did not immediately frame a way of seeing AIDS as a feminist issue, the global women's movement has not been very effective at using the resources we already have to find out about the myriad local situations of women in the HIV pandemic: existing feminist groups assumed they already knew what 'women' experienced. Global feminism had difficulty placing HIV within its agenda in large part because HIV was first associated with prostitution, an issue that had already troubled the Euro-American women's movement.

The globalized image of the epidemic constituted women as victims of ruthless bisexual men, as pure bodies that needed to be protected in order to save the family. This use of men's sexuality became an impediment to linking feminist and gay male concerns over HIV, and reified the woman as the emblem of family in a way that obviously ran counter to feminist efforts to articulate women as autonomous persons. Instead of taking the opportunity to be critical of media coverage and come to a new understanding of the circumstances of women's oppression regarding sexuality, the Western women's movement haphazardly addressed the growing pandemic. A third wave of feminism, including more regionally organized women's groups – a globalized feminism influence by the West, but now coming more strongly from the specific cultural experiences in African and Asian countries – emerged in relation to AIDS organizing: this drew heavily on gay organizing and only indirectly on the women's health movement. By the 1990s, feminist analyses had taken up AIDS, but it is still urgent to link women's and feminist groups with AIDS-exclusive organizations, increasing attention to women in the latter, while incorporating AIDS awareness and planning into the former. For example, shelters for battered women had great difficulty coming to terms with the increasing number of women they saw who were HIV positive, much less understanding the ways in which dealing with HIV within a couple could result in very particular patterns of domestic violence.

Publicly, feminist strategies will continue to be very problematic, because they will be interpreted as anti-male regardless of the actual content of the message. Slogans or strategies associated with feminism must be employed carefully: by no means am I saying to leave feminist politics out, but I want to argue for clear understanding of the ways in which messages have unintended consequences. The reaction to 'feminist' ideas happens as often in relation to the government as in relation to the local groups. I have sometimes suspected that official *local* campaigns use anti-feminism to make their own proposals seem a more acceptable, 'sensitive', alternative to national proposals. For example, the complaint that feminism will destroy the family is subtly worked into several local African campaigns that promote monogamy over condoms. In this context, feminists promoting condom use as a means of women taking control over their bodies may find people armed with anti-imperialist or nationalist rhetorics that thwart their campaign. Or, government campaigns promoting condoms may, in some contexts, be viewed as illegitimate attempts to control a local populace.

Many women will not buy into something they perceive as a political description or intervention, especially if they believe they are being pitted against men or against their family. 'Consciousness raising' is always a very difficult and subtle process of, on one hand, acknowledging the mechanism through which women now get power, even strategically reinforcing their base of resistance within the 'patriarchal' structures, but, at the same time, suggesting that women can be and have more if they reform familial and social structures. That's a very difficult and subtle line to negotiate. In the context of HIV education, the difficulty is that we are heard to be saying 'jeopardize your physical, emotional, and economic health in order to protect your biological health'. Focusing on condom use *per se* has been part of the problem. 'Emotional safe sex' has to part of the picture, too: safe sex has to be reframed as part of a sexuality that can make life better, rather than being about making men do something that women are afraid men will react violently to.

QUESTION: The official health authority in Taiwan, which is in charge of AIDS policy, says in their leaflets that this year's focus of AIDS awareness will be on women. Women are now subjected, one of the groups that the authority is going to deal with. What I find interesting here is that the government will attempt to mobilize women's groups over which they can exert pressure, getting these groups to do the health promotion. Our group [Awakenings Foundation], labelled as a feminist group, is one of the names in the authority's list. We are ashamed to say that we haven't done anything about AIDS prevention and that it has not been on our agenda.[7] But this year, we are willing to be mobilized and to participate in work concerning AIDS. Professor Huang has mentioned that in traditional Chinese culture, female bodies are thought to be contaminated and dirty whereas male bodies are clean, reliable. After women are mobilized to participate in AIDS prevention work, we have been assigned to distribute condoms: we are becoming more and more aware of the importance of condoms, with the result that women are coming to realize that men are not reliable in the whole situation. We have demystified the notion that male bodies are clean, but we have not yet established in the subjective sense that female bodies are *not* dirty. That's precisely the point that women's groups should focus on. So far in AIDS prevention women are so passive and seem to be so alienated. We are waiting to be mobilized by the government, whose solution is to promote the importance of condoms. The subtle message is not to protect women as autonomous persons but to keep female bodies clean so that they can produce a superb future generation, so they will be clean tools to breed children. I think we should start doing something progressively.

Global analysis/global activism

CP: The original question I raised keeps re-emerging: can the new politics of ACT UP or cultural theory do anything for anybody? And I don't want to

make the claim that the analytic frame toward which I have gestured is useful in every situation in which organizing needs to occur. I think AIDS may be a somewhat unique situation because AIDS, and to some extent the kind of homosexuality and sensibility about female sexuality that gets invented to go alone with it, don't exist until they discursively arrive. You may have HIV in your country or in your locale, but 'AIDS' doesn't exist until this set of discourses arrives, thoroughly shot through as they are with the colonial ideologies that I have tried to describe. We have become critical of identity politics, despite their value in getting new players to the official table. We need, as sensitively as possible, to become more active in constructing identities that enable people to make alliances that will accomplish evolving strategic goals. And that's extremely problematic. I've written critically about the imperialism that gay organizing or AIDS organizing has sometimes represented as they travel. And yet I don't have clear alternatives. If you are faced with doing nothing and taking something that has a lot of problems associated with it, it may be better to try problematic strategies with your eyes open, knowing that you are going to encounter the fairly well known problems at some point down the road: for example, gay identity is, finally, limited in its capacity to move across different socio-sexual terrains. Similarly, constructing an identity as HIV positive person does not always prove liberating: it continually risks turning you into a better research subject. Nevertheless, if the number of activist bodies are limited, and people who are desperately in need of contact or resources, the traditional organizing models centered around consciousness-raising may still work best. But highly articulated identities have to find ways to connect with more ethereal, but existing networks – the cruising grounds, VD clinics, clubs, etc. It is often easier to start informally in these existing places than it is to hold a meeting. Meetings presume a kind of identification that may not exist and may even be fatal to claim under some circumstances. It is never clear what will be needed in any particular situation. Identity is not always bad, especially if it is one that is inductively discovered in a local situation. But I would guard against holding my identity too dear, and I would always leave an escape hatch.

Notes

1 By two waves, I mean to acknowledge both the organizing activities begun in the early years and now precariously institutionalized at the margins of formal public health systems, and the agit-prop form whose most obvious example is ACT UP. There is an uncomfortable domestic/public split between these two groups' activities and media representations of them. See also Patton (forthcoming).

2 Eve Sedgwick (1990) developed the idea that recent gay liberation/civil rights politics have exhibited two tendencies, one toward universalization ('everyone is a little queer') and minoritizing ('homosexuals are a fixed minority'), in the effort to negotiate cultural incoherences intrinsic to modern ideas of sexuality.

3 The original 1982 definition of AIDS was purely clinical, since no etiologic agent had been identified. AIDS was defined as occurrence of kaposi's sarcoma, pneumocistis pneumonia, or one of a proliferating number of uncommon infections

called 'opportunistic infections' to indicate that their appearance in the 'previously healthy' person being diagnosed was due to an immune system malfunction. Once a virus was identified and strongly associated with AIDS, many pushed to have the syndrome reconceptualized as HIV disease, which would have a spectrum of manifestations from ones an individual actually experienced (the night sweats and malaise of the prodrome to the secondary diseases of 'full-blown' AIDS) as well as subclinical changes that could only be identified through monitoring of blood chemistry. This idea was only partially accepted: researchers now include stages, but these are still primarily oriented in relation to the original AIDS definition and the concepts it embodied. Activists in the US have largely focused their efforts on expanding the original case definition to include dramatic symptoms experienced by people living with HIV who fall outside the original conception of the probable client population – i.e., those experienced by women, people who have not had adequate access to health care, drug injectors, etc.

4 The Global Programme on AIDS designated three 'patterns' of AIDS: Pattern One, which was characterized by homosexual and injection drug cases, Pattern Two, which was characterized by heterosexual cases, and Pattern Three, which was characterized not by the particular construct of cases but the 'late arrival' of HIV. See also Patton (1995) for greater detail about the political and scientific implications of having divided the cases in this way.

5 Transcribed by and translation of questions by Hans Huang and Hsiaow-Ling Kuo.

6 The situation is much more complex than I can detail here. The term 'prostitute' was adopted with eyes open to the politics of naming sex work. Indeed, it is has been used within projects in extremely subversive ways. Nevertheless, to outsiders with little knowledge of the actual programs and strategies produced, the subdivision's name does not much challenge dominant research and policy paradigms. But that only shows that terms are always labile and strategic and never comprehensive in their ability to convey meanings or enable politics. See also Patton (1994).

7 Shortly after these comments, the group undertook a translation project which combined a women's safe sex advice book co-authored by Janis Kelly and myself, with a historical overview of AIDS in Taiwan, and new comics illustrating safe sex negotiation. To my knowledge, this is the most extensive feminist-oriented AIDS information booklet available in Chinese (traditional characters).

References

Global Programme on AIDS (GPA) (1989) *Inventory of Nongovernmental Organizations Working on AIDS in Developing Countries*. Geneva: World Health Organization.

Patton, C. (1990) *Inventing AIDS*, New York: Routlege.

—— (1992) 'From Nation to Family: Containing African AIDS', in A. Parker, M. Russo, D. Sommer and P. Yaeger (eds) *Nationalisms and Sexualities*, New York: Routlege.

—— (1994) *Last Served? Gendering the HIV Pandemic*, London/Philadelphia: Falmer/Taylor and Francis.

—— (1995) 'Queer Peregrinations', in M. Shapiro (ed.) *Challenging Boundaries*, Minneapolis: University of Minnesota Press.

—— (forthcoming) *Global AIDS/Local Context*, Minneapolis: University of Minnesota Press.

Sedgwick, E. K. (1990) *Epistemology of the Closet*, Durham, NC: Duke University Press.

17

THE MEDIA, CIVIL SOCIETY, AND NEW SOCIAL MOVEMENTS IN KOREA, 1985–93

Yung-Ho Im

Introduction

With the tide of political democratization in the late 1980s, new social movements have flourished in various sectors of Korean society. For instance, 'citizens' press movements' have challenged the mainstream media. Those movements represent attempts at the grass roots level to reform problems of the press. On the theoretical level, the notions of civil society and new social movements became hot issues among social theorists in Korea (e.g., Korean Sociological Association & Korean Political Science Association, 1992). An analysis of citizens' press movements may illuminate the nature of the media and civil society in the rapidly changing Korean society of the 1980s and 1990s.

This chapter traces the trajectory of citizens' press movements and delves into the characteristics of those movements and, more fundamentally, into civil society in Korea. This chapter also explores whether Western notions of civil society and new social movement are applicable in the historical circumstances of Korean society. To what extent are citizens' press movements in Korea similar to new social movements? What makes the Korean phenomena distinct from their counterparts in the Western hemisphere? Where do such differences come from? Given the nature of the issue, this chapter relies on well-documented historical instances and speculates on their implications.

The media and civil society in Korea

The unfolding of social movements reflects particular characteristics and problems of the societal structure in which they take place. More specifically, one has to understand citizens' press movements within the structural context of the state, civil society, and the market with which the press is closely associated.

The notion of civil society is diverse, depending on the context. For instance, it often refers to the realm of the economy or market, while in other contexts

it may also suggest the non-state arena, including the market (Shin, 1991). In this chapter, however, I would like to define civil society as a 'normative' concept akin to what Jürgen Habermas (1974) calls 'the public sphere'. In civil society, actors are expected to pursue the common good or universal values instead of private interests as in the market. However, the process is rarely as institutionalized as it is in the state.

In west European societies, civil society is closely associated historically with the advent of liberalism. The press represents a good historical example of such an area. The state and the market represent two major forces, which have undermined the possibility of the media as a potential realm of civil society or public sphere. Primarily in the European context, however, John Keane (1991) identifies the market as the primary cause for the disappearing public sphere.

Because Korea has rapidly grown into a capitalist society under a bureaucratic-authoritarian regime, civil society, including the media, has failed to maintain diversity of ideas and autonomy from the state. Post-war McCarthyism annihilated any media source with radical flavor, as well as those reporting against the government. The authoritarian government attempted to maintain high entry barriers and circumscribe competition, leading to an oligopolistic media market. With the inception of a legitimate civilian government in Korea after massive civil protest in 1987, media channels multiplied without constraint and came into fierce market competition. However, the media did not diversify politically and the radical press failed to take roots. Despite quantitative expansion, alternative media movements were unsuccessful and the media scene remains predominantly conservative.

The second president under elected civilian government, Young Sam Kim, pursued a deregulation policy, under the rhetoric of 'globalization', and attempted to lift the traditional entry barriers and ban on media cross-ownership. Now the market has emerged to replace state control as a potentially threatening force to civil society. However, in Korea the market is not necessarily the primary force that undermines the autonomous, critical, and public nature of the press as a part of civil society. Despite the end of authoritarian government, the press is still accused of being extremely conservative and maintaining symbiotic relations with the state. The lack of a tradition of criticism and autonomy plagued the Korean press even after political democratization brought power to it. Furthermore, in spite of deregulation policy, the state has strengthened its control over the major decision-making processes concerning media policy.

Consequently, the freedom of the press and the vices of commercialism have been perennial issues of press movements through the early 1990s. In Korea, 'free market competition' has been associated with negative aspects of commercialism rather than 'freedom' and 'choices'. Of course, the negative perception of commercial media may originate from specific circumstances in Korea. But it also may be attributable to the traditional discourses on the

ideal of the press, which emphasizes a morally responsible and 'enlightened' role rather than a liberalist model of check and balance for the powerful media. Although this argument is hardly verifiable, it accounts for many of the unique characteristics of citizens' press movements in the 1980s and 1990s.

The nature of the citizens' press movement

Citizens' press movements have taken place in response to the specific problems of the Korean media. 'Citizens' press movement' is a rather ambiguous term, which gained popularity in Korea in the late 1980s. It is a form of press reform at the grass roots level. But it is distinct from alternative media movements and partisan journalism based on class politics, in that the citizens' press movement, as with new social movements, claims to have its base in non-class coalitions ranging over diverse social groups. Citizens' press movements emerged in the mid-1980s and flourished through the early 1990s. Given the unfeasibility of alternative media based on class politics, citizens' press movements from the mid-1980s have pursued reforms within the existing media and attempted to have a voice within the system.

The origin of citizens' press movements goes back to the 1960s. In 1964, for example, civilian groups rose to repeal a bill establishing a press ethics council, which the government introduced, presumably to control newspapers. However, such intermittent movements developed into more consistent and organized 'audience movements' in the 1980s. The License Fee Boycott Campaign in the mid-1980s was a nation-wide movement against commercialism and biased reporting by public television, i.e., Korean Broadcasting Station(KBS). After the Korean National Council of Women initiated a media monitoring group in 1984, many organizations formed similar programs. The notion of new social movement provides a useful framework for examining the characteristics of the citizens' press movement.

The notion of new social movement is based on historical experience. In the West, historically, new social movements arose, after the issues of old social movements were incorporated and institutionalized as a part of the political process. In old social movements, marginal social groups within the hierarchy of power attempted to represent their material interests in the polity. Organized labor is a typical example of an old social movement. On the other hand, new social movements have pursued universal values, which have been excluded from the existing political process. Table 17.1 shows a general comparison of both types of movements.

However, social movements developing within specific circumstances may betray the theoretical typology based on the historical experience of Western society. This chapter attempts to uncover such idiosyncrasies and examine whether it is possible to regard the citizens' press movement as a form of new social movement.

Table 17.1 A comparison of old and new social movements

	Old	*New*
actors	socioeconomic groups acting as groups(in the groups' interest) and involved in distributive conflict	socioeconomic groups acting not as such, but on behalf of ascriptive collectivities
location	increasingly within the polity	civil society
aims	political integration, economic rights	changes in values and lifestyle, defense of civil society
organization	formal, hierarchical	network, grass roots
medium of action	political mobilization	direct action, cultural innovation

Sources: Offe, 1985: 832; Scott, 1990: 19.

Actors

Citizens' press movements seldom had any class-affiliation nor any permanent organizational resources. They have mostly taken place as subsidiary activities of existing organizations established for other causes. Only a few organizations, e.g., the Council of Democratic Press Movements (CDPM) or the Citizens' Group for Audience Movement (CGAM) of YMCA, have specialized in issues regarding media. Religious groups, including Protestant, Buddhist, and Catholic groups, together with women's organizations, have been instrumental in citizens' press movements. In Korea, religious groups represent a few arenas which have maintained autonomy even during the era of authoritarian government. In a sense, religious groups continue the tradition of the democratization movement since the 1960s. In the 1980s, women's groups have increased in number and have played a more central role in citizens' press movements. Another distinctive feature is that most organizations are either nation-wide or concentrated in Seoul, the capital of Korea. Local organizations in other areas are rare.

When major issues broke out, individual organizations combined to temporarily form a broad coalition. Table 17.2 shows examples of coalitions in citizens' press movements.

Until political democratization in 1988, citizens' press movements remained a part of broader social movements for political democratization. For instance, the License Fee Boycott Campaign around 1986 proceeded under the leadership of the Protestant churches. The organization quickly expanded to include a broad range of social groups, regardless of political lines, such as an opposition party, non-party politicians, various religious groups, and women's organizations. However, the nation-wide political movement gradually turned into a specialized press reform movement after 1987. With the democratization of institutional politics, activists with a career of political struggle joined parties or

Table 17.2 Temporary coalitions in press movements

Coalitions	Participating Organizations
Christian Movement for License Fee Boycott (January 1986)	Protestant churches
Joint Commission for License Fee Boycott and Free Press (September 1986)	Catholic & Protestant churches, opposition party, non-party politicians' group, women's organizations, CDPM
Women's Coalition for License Fee Boycott (May 1987)	17 women's organizations
Citizens' Movement for License Fee Boycott (September 1988)	Catholic and Protestant churches
Joint Commission against Obscenity and Violence of Sports Newspaper (November–December 1990)	17 Christian organizations, Seoul YMCA, Catholic youth organization
Anti-payola campaign (November 1991)	3 Christian organizations, YMCA, a women's' organization, CDPM, Korean Media Research Group (KMRG, a critical communication researcher group), National Association of Student Journalists
Citizens' Solidarity for Election Reporting Watch (CSERW) (1991–93)	CDPM, KNCC Press Commission, KMRG, a women's organization, Catholic & Buddhist press committees
Citizens' Coalition for Fair and Clean Election Campaign (CCFCEC) (1992)	57 civil groups including YMCA, Citizens' Coalition for Economic Justice, YWCA, Korean Association of Trade Unions, National Commission of Farmers' Organizations
Audience Commission for Say No to Television (ACSNT) (June–July 1993)	42 organizations, including those of women, parents, senior citizens, Christian, Catholic, handicapped, and local YMCAs
Audience Solidarity for Broadcasting Reform (ASBR) (September 1993)	11 organizations, including those of women, Christians, Catholics, Buddhists, YMCA, KMRG, CDPM

Sources: Koo, 1992: 21; Kim, 1991: 242–3; CSERW, 1993: 72–3; CCFCEC, 1992; ACSNT, 1993: 71–2; KFPU, 1991.

a newly-founded oppositional newspaper (*Hangyorae-Shinmun*). Consequently, participants in the press movements began to be de-politicized.

Like new social movements in the West, the citizens' press movement in Korea seems not to be based on class politics. Participants consist mostly of young women in their twenties and thirties, and students and religious believers also play a prominent role. Female predominance in press movements might be due to the fact that women have more time for social activities and are in a position to feel the problems of the media in relation to their everyday life more

acutely. But it is also due to the patriarchal structure that has circumscribed career opportunities for well-educated women in Korea.

In terms of organizations, citizens' press movements in Korea are quite distinct from the grass roots network type of new social movement. Intellectuals and celebrities play pivotal roles rather than professional activists or grass roots networks. Press movement organizations in Korea tend be hierarchical. Furthermore, although many organizations emphasize the uniqueness of their activities, their issues and political lines are not quite divergent. Nevertheless, attempts to form a broad coalition among diverse groups around crucial issues often broke up in the final stage. The trial to forge the Citizens' Solidarity for Election Reporting Watch in 1992 ended up with small separate coalitions, presumably due to the struggle for internal hegemony (Lee, 1992: 2). Of course, the grass roots nature of new social movements might make it difficult to organize heterogeneous forces across a broad range, but celebrity-centeredness might have aggravated the potential split. Interpersonal networks or connections among leaders, rather than differences in political orientation, might have been more influential in the specific formation of organizations.

Major issues

New social movements generally address issues which are not directly related to the class interests of participant groups. In this respect, citizens' press movements in Korea are not exceptional. Table 17.3 shows the major issues of citizens' press movements.

Apparently similar agenda may have diverse implications, depending on the context. The License Fee Boycott Campaign in 1986 addressed the issue of biased reporting and sensationalism in the media, but under an authoritarian government they helped undermine the legitimacy of the government itself, thereby expanding it into a political movement. However, under the civilian government after 1988, the most conspicuous agenda of press movements concerned sensationalism, violence, and biased reporting of the media, especially television.

First, biased reporting has consistently been one of the major targets of criticism. For example, in 1992, two coalitions of citizens' groups initiated campaigns to oversee election reporting. These organizations monitored election reporting and made an issue of problematic cases. These campaigns have taken advantage of legally legitimate means which have increased with political democratization. This issue indicates that, despite the official claim to democratization, the infrastructure and political practices of the state still remain considerably undemocratized.

The second issue involves a reaction against sensationalism in the media. Typical examples include the crusade against obscene and violent content of sports newspapers in 1990, and the Turn off Television Today Campaign in 1993 (see Kim, 1991; 1993). These movements follow the tradition of the

Table 17.3 Issues of major press movements

Movements	Instrumental goals	Intermediate goals	Final goals
License Fee Boycott Campaign (1986–88)	to boycott television license fee	to stop biased reporting; to stop advertising on public television; to stop sensationalism; to stop pro-government attitude	democratization of broadcasting; political democratization
Anti-Yellow Newspaper Campaign(1990)	to stop obscenity, violence of content; to boycott products of advertisers	to reform sensationalism of newspapers	to restore social responsibility of journalism
Anti-Payola ('chonjie') Campaign (1991)	citizens' watch for chonjie; to support good journalists	to stop chonjie-taking practices among journalists	to encourage un-corrupted journalism; to restore autonomy of journalism
Citizens' Solidarity for Election Reporting Watch (1992)	to watch and indict bias, distortion, unfairness of election reporting		to encourage fair reporting by the press
Citizen's Coalition for Fair and Clean Election Campaign (1992)	to watch election reporting		to encourage fair reporting by the press
Turn Off Television Today Campaign (1993)	to turn off television for one day	to publicize problems of television; to exercise pressure on broadcasting companies; to activate audience movements through the experience of coalition	to restore the social responsibility and public status of broadcasting
Audience Solidarity for Broadcasting Reform (1993)		to prepare policy alternatives in financing, audience participation, broadcasting laws; to watch for program quality	to encourage publicness, fairness, autonomy, diversity; to prevent commercialism of public broadcasting; to keep commercial broadcasting healthy; to affirm audience sovereignty

Sources: Kim, 1991: 240–9; ASBR, 1993; ACSNT, 1993: 66; CSERW, 1993; CCFCEC, 1992; KFPU, 1991.

Note:
The typology of goals is taken from Kim, 1989: 154.

License Fee Boycott Campaign, but unlike their precursors they are mostly de-politicized. These cases reflect the everyday-life concerns of the middle class as media consumers. Except for intermittent collective action, most activities consisted primarily of monitoring television. The criteria of monitoring emphasized public responsibility and the educational role of the media, and tended to be conspicuously moralistic. One may also find a similar concern in a 'desirable' video culture campaign, such as the 'Gun-Be-Yeon' (Citizens' Group for a Healthy Video Culture) or the Video Shop Owners' Group for Good Video Culture of YMCA. Both represent efforts to keep youth and children from watching obscene and violent videos, and encourage audiences to watch wholesome videos.

The values underlying these issues may be summarized as 'fair reporting', public responsibility of the media, and anti-commercialism. Given that the critiques underscore the autonomy and social responsibility of the press, they suggest something close to the social responsibility theory (Siebert, et al., 1956). Although an anti-commercialist tendency is evident in most cases, the market system itself is not denied. In a word, citizens' press movements hardly propose alternative values alien to the status quo. While criticizing the established media, the critiques tend to emphasize reforms within, rather than searching for alternative modes of media.

These campaigns mostly pursue changes in particular programs or practices, without any institutional or structural reforms. The major participants are middle-class women, i.e., the targets of consumer product advertising. In some cases, attempts to boycott particular products, which sponsored the programs in question, led television stations to cancel or change the targeted programs. Although new social movements are not necessarily accompanied by visible results, press movements in Korea sometimes have led to an immediate response, or even a 'surrender', from the mainstream media, albeit mostly a symbolic one.

In Korea, the notion of media as a public realm distinct from the market seems to have secured legitimacy among the public, as well as in official discourses on the media. Such a notion is distinct from the Anglo-American notion of the freedom of the press, which is closely related to property rights. In ideological terms, citizens' press movements are not quite aberrant from what the status quo advocates. In a sense, the ideological struggles between both parties have proceeded with recourse to similar discursive resources. The issues raised by press movements are not deemed illegitimate even within the official political sphere. In a sense, one may regard press movements in Korea as officially legitimate claims expressed outside the official sphere. Not surprisingly, what has distinguished citizens' movements from the status quo may be the virtues and moral legitimacy of participants rather than ideological challenges.

While issues of press movements diversified after political democratization, class-wide and nation-wide concerns, as before 1988, have virtually disappeared in major political events. Given the fact that the state secured political legitimacy, it became much less feasible for the government to make a politically

disastrous blunder as to provoke public reaction on a national scale. While some movement groups have tried to form nation-wide coalitions in vain, small-scale campaigns based on the everyday life concerns of the middle-class have become popular. Citizens' press movements in recent years have began to reflect the particular concerns of major participants, rather than 'universal' values. In this context, from an activist's point of view, Kang (1993) argues convincingly that citizens' press movements should make a strategic turn to 'decentralize movements in various social arenas'.

Another feature of citizens' press movements is the lack of institutional or structural issues. Press movements have aimed at resolving visible short-term conflicts rather than the structural contradictions which generate those symptoms. Above all, the myopic tendency of strategic goals seems to come from the inherent limitations of spontaneous grass roots action. In order to mobilize heterogeneous groups more effectively, the agenda might well be limited to short-term goals. However, the amateurism of celebrity leaders might be another reason for the ambiguity of directions. This interpretation is supported by the fact that citizens' groups have failed to influence major policy-making processes in broadcasting sectors. In other words, the leadership has succeeded in developing newsworthy events, but has failed to develop clear ideological blueprints or alternatives. Also one might attribute the myopic tendency to the politically conservative nature of press movements, which rarely go beyond the given institutional framework. While struggles remain within the ideological and institutional confines of the system, ironically, the impacts of those movements on the system are hard to discern.

In sum, citizens' press movements have raised issues and conflicts which are not based on class interests of specific social strata and may not be resolved within the given political system. They apparently have much in common with new social movements in the West. Nevertheless, press movements in Korea hardly challenge the dominant value system of the status quo. Instead, they make efforts to 'normalize' the inherent functions or roles of the state and the market. In a word, the political orientation of citizens' press movements in Korea is a model of conservatism.

Medium of action and expression

In general, citizens' press movements have employed non-violent means of expression within legally-sanctioned limits. Citizens' press movements have depended primarily on modes of symbolic action and expression, such as media-event making. Direct actions, such as boycotting license fees or advertised products,[1] are exceptional cases. Nevertheless, specialized activities, such as legal consulting, addressing as election issues, or lobbying the Legislature, have been rare.

Citizens' press movements mostly took advantage of legally sanctioned means, instead of challenging them. The License Fee Boycott Campaign under the

authoritarian government was frequently in conflict with the state. But this confrontation ended with political democratization. It was not uncommon for representatives of movement groups to show up as participants in televised debates, or to join official institutions as representatives of citizens' groups. Their leadership in movements made them a sort of celebrity (or vice versa), and they even provided a potential pool for recruitment to government or political organizations. Despite their active liaison with the political process, it is surprising that the activities of these movements seldom led to visible institutional reforms. However, the press ombudsmen established by most major newspapers and broadcasting companies have to be considered as the accomplishments of citizens' press movements.[2]

For channels of publicity, press movements depended on mainstream media rather than establishing their own. Except for the targeted media, mainstream media have allotted space for reporting developments of movements. Since 1988, newspapers assigned even a fixed page for media, where they had extensive coverage of press movements. For instance, major newspapers reported in detail on the License Fee Boycott Campaign.[3] In the Anti-Yellow Newspaper Campaign, major broadcast networks gave coverage to various statements and proceedings (Kim, 1991: 245–6). The mainstream media in Korea, especially those in direct competition with the targeted media, contributed considerably to press movements. In a sense, citizens' press movements became big business events through which various groups and celebrities received publicity. This might be one of the reasons why the initiatives of newsworthy celebrities, rather than organized activities, became a major trait of citizens' press movements in Korea.

Pros and cons

Insofar as social movements challenge the status quo, various groups, who are involved directly or indirectly, may have been either favorable or hostile towards these movements. Not surprisingly, their attitude may have varied depending on what the issues were and how broad the coalition was. It is illuminating to examine which groups were in direct conflict with press movement groups.

Table 17.4 shows a few examples of strategic relations of conflict and cooperation in major movements. What is notable is the relation between the state and movement groups. In the License Fee Boycott Campaign, the government's lack of political legitimacy led even ideologically moderate movements into direct confrontation with the government. In later instances, however, conflict disappears. The Election Watch Campaign, for instance, focused on overseeing government bodies and the media, which had been favorable to the ruling party. Consequently, the campaign could have undermined the *de facto* benefits of the ruling party, but hardly provoked a manifest reaction from the government. Under the civilian government, moreover, the need for political and social

Table 17.4 Strategic relations of cooperation and conflict

Issues	Supporters	Opponents
License Fee Boycott Campaign	newspapers; opposition parties; political forces outside the polity	the government; broadcasting network; broadcasting advertisers
Anti-Yellow Newspaper Campaign	broadcasting network; other newspapers	sports newspapers; newspaper advertisers
Election Watch (CSERW, CCFCEC)	opposition parties	the ruling party; newspapers; broadcasting networks
Turn off Television Today Campaign	newspapers	television networks; television advertisers

reforms made possible the strategic cooperation between press movement groups and the state. In some cases, press movement groups accepted aid from the state.

It is also highly suggestive to look at how strategic relations among different movement groups were formed. Because press movements since the 1980s have rarely involved controversial political issues, informal factors have exerted influence in forming coalitions. Above all, interpersonal networks, as well as differences in political orientation, have played a considerable role in Korea. For instance, radical groups and trade unions tend to consider citizens' groups as 'middle-class' reformism. Regardless of the issues in question, some citizens' organizations are negative towards groups with a history of political struggle. Such differences in organizational sentiment have often affected even activities on the official level.

Ongoing changes in the political situation could trigger potential conflict within the press movements as well. In the 1980s, the undifferentiation of issues encouraged a heterogeneous social groups to gather under one banner, irrespective of material interests. However, if issues become more specific in the near future, heterogeneity of political orientation and material interests among movement groups might emerge. As is common with new social movements, citizens' press movements seldom rely upon class interests. They do, however, reflect the peculiarities of participating strata.

Trade unions as new social movements?

If new social movements, although based on specific social groups, rarely represent their collective interests, how are they different from old social movements, such as the labor movement? In general, labor movements pursue class-specific interests. However, press labor movements in Korea reveal some features of new social movements. Most trade unions in the major Korean

media underscore the primary goal as organizational activities, which is similar to what citizens' press movements have pursued. Not surprisingly, press unions have cooperated with civil movement groups for nation-wide issues.

Even in market systems, of course, the press historically has been a special realm distinct from other businesses. But the peculiarity of the socio-political context has also influenced the specific trajectory of trade unionism in the Korean media. Since the establishment of press unions in 1987 and the subsequent legalization of the Korean Federation of Press Unions (KFPU), regular channels of negotiation have been established to resolve labor disputes. However, the issues of 'editorial rights'[4] and fair reporting rather than monetary concerns have been central issues in labor disputes. Some conflicts went even beyond the boundary of shop floor disputes and expanded to nation-wide concerns. Then, the management–labor conflict turned into a confrontation between a coalition of union/citizens' groups and that of the press and the state. In these cases, each side attempted to relate the case to a kind of a 'common cause'.

There were a few prominent cases, which extended to larger social movements (see Korean Association of Journalists, 1990). In February 1990, for a minor misdemeanor, the government fired the president of KBS, who was the first elected by employee voting. The police dispersed and arrested union members, who went on a sit-in strike. The labor dispute became a national issue and other civilian groups joined the KBS union in protest. The participants ranged over diverse social groups including: trade unions and journalist organizations (National Council of Trade Unions; Korean Association of Journalists; Federation of White-Collar Unions), women's organizations (Korean National Council of Women), religious groups (National Council of Christian Women), students (National Council of College Student Organizations), and various social groups and civil movement organizations (e.g., Lawyers Group for Democracy; CDPM, Citizens' Coalition for Economic Justice, YMCA, Citizens' Group for Consumer Affairs, National Federation of Farmers' Organizations, and National Federation of Artists).

These instances have mostly been concerned with broadcasting, presumably because there has been a general consensus on the status of broadcasting as a 'public' resource and a realm independent of the state and market. Not surprisingly, the apparently various sources of the disputes converge on a common concern, i.e., the autonomy of broadcasting from the state. The social groups involved in the protest interpreted the instances as a governmental strategy for extending its influence over the broadcasting sector.

Such an interpretation may be attributed to the structural problems of the media system in Korea. Broadcasting in Korea is a two-tiered system of the public and commercial networks. Even in the commercial broadcasting sector, i.e., MBC, any monopoly by a particular business or social group is strictly prohibited. In reality, however, the state has seized power over both the public and private sectors, and other forces have been excluded from the broadcasting

sector. In other words, despite the trend toward 'deregulation', state power has not diminished in Korea. Clearly, such a monopoly may lead potentially to social conflicts over major media issues.

With few exceptions, most labor disputes remain within media organizations. But especially in the major media, even internal issues tend to focus on 'non-economic' issues (see Kang, 1989). This phenomenon, bizarre in labor–management relations, may be attributable to the peculiar circumstances of the Korean media in the 1980s. First of all, since the 1980s the wage level of media employees has been high in comparison to other white-collar jobs. In 1980, the state intervened in the media market and restructured it, by force, into an artificially oligopolistic structure in broadcasting and national dailies, and regional monopoly in local dailies. The absence of competition drove the industry to rapid growth. To appease them, the state solicited the management to improve wage levels and fringe benefits of media employees dramatically. The material compensation came from the extra profits which the monopolization of the industry yielded.

It is also discourses regarding the role of media in Korea that prevent labor movements from pursuing monetary concerns. The traditional discourse on journalism has emphasized the 'public service' role of journalists. In addition, the memories of the 'dark' years of the 1980s forced press unions to hold fast in recovering 'legitimacy' even at the minor sacrifice of material benefits. The taboo on the secularization of press movements is further constrained by Korean culture, which discourages people from expressing their secular interests in public.

Nevertheless, in the long run, the mundane interests of workers might have a determining impact on labor movements (see Chang, 1992). In Korea, press unions are motivated not only by the individual gains of workers but also those of the company as a whole. Examples can be found even in the short experience of the press labor movement. For instance, in April 1990, although the Korean Federation of Press Unions decided to go on an industry-wide strike as a protest against the government's intrusion into the labor dispute of KBS, few local unions followed it. In this case, the collective benefits of the company took precedence over the private gains of individual workers. In reality, as the romantic enthusiasm for labor movements diminished, many union members began to lose interest in issues which had no tangible material substance. Based on an analysis of material conditions from a perspective of game theory, Chang (1992) argues that the future goals of the press labor movement in Korea will shift to the improvement of working conditions of participants.

Despite internal limitations, press unions will continue to play an important role in press movements in Korea. By tradition, the occupational culture of Korean journalists has placed great emphasis on resisting government encroachment on their autonomy. The tradition of heavy government intervention may continue in the near future, and could trigger conflicts with press unions. Besides, press unions have assumed strategically important roles within the area

of civil society, whose growth has been limited by the presence of the strong state. In sum, in Korea, press unions as well as citizens' press movements may continue to play a role in new social movements.

Conclusion

An examination of citizens' press movements in Korea from the mid-1980s through the early 1990s reveals typical characteristics of new social movements. However, unlike their counterparts in the West, old and new social movements are not clearly distinguished in press movements in Korea. Despite much divergence, both pursued similar goals to a certain extent. At this historical point, press unionism in Korea has much in common with new social movements.

Political circumstances in Korea render the differentiation of press movements infeasible. The media in Korea not only show symptoms of market failure, but have also failed to perform a role in civil society. The media often ignore rules for fair competition or rational business practices and they barely represent the diverse voices of the society. The source of problems lies in the state. The media in Korea, especially broadcasting, have claimed the status of a public realm, but the tradition of a strong state has alienated all social groups, except for the state and capital, from the area. Nevertheless, problems in the market system, such as sensationalism, are widely felt. The contradiction is as follows: 'deregulation' (or commercialization) of the media is increasing, while significant control through state regulation is being retained. Under Young-Sam Kim's civilian government, where discourses of 'deregulation' and 'globalization' prevailed, this double-sided problem became more conspicuous. The discourse on deregulation in Korea does not imply decreasing power in the role of government. Although deregulation entails expanding the power of capital, the state is still expected to play a dominant role.

In Korea, citizens' press movements represent the voices and complaints of various social groups, which have been resolved neither through the market mechanism nor the political process. However, citizens' movements in Korea accept the status quo and seek to make the system function more properly, instead of searching for alternative modes of media. In a word, their political orientation is basically moderate and conservative.

However, even though the scope of citizens' movements has widened, their actions failed to lead to tangible institutional changes. Despite political democratization, civil society in Korea is still extremely weak, in comparison to the strong state. The state has hardly developed democratic procedures, which may incorporate diverse voices of civil society and interest groups. In a sense, the booming movements in effect legitimize the civilian government, whose claim to democratic reforms scarcely yielded much visible results.

In spite of the subsistence of the authoritarian state, a nation-wide movement of the last decade may not be feasible in the future. With the establishment of

a legitimate civilian government, many civilian groups lost interest in issues which were not directly related to their everyday-life concerns. While issues surrounding the freedom of the press in press union movements is at a low ebb, good video campaigns by YMCA have been successful. Citizens' press movements seem to have shifted to decentralized small-scale activities, based on the particular concerns of various social groups.

Nevertheless, there is still the possibility of a class-wide social movement, such as strategic cooperation between press unions and citizens' groups. In their struggles against the state, they need each other. Citizens' press movements may take advantage of strategic cooperation between citizens' groups and the state, established under the civilian government. The state is not a unified whole. Instead, it may be called a 'dominant power bloc' (Freiberg, 1985), which consists of heterogeneous interest groups. Within the civilian government who took power through the merger of three major parties, the ruling minority wants to make the most of the press for the internal control of the power bloc.[5] The faction also needs the cooperation of citizens' press movements in order to reform the established media. Although the mainstream media are symbiotic with the dominant class, the market situation of intra- and inter-media competition motivates them to assist citizens' movements. Insofar as citizens' movements provide the media with newsworthy events, the former may secure channels of publicity. If the movement group takes advantage of strategic ties with the state, it may also expand the legal space within which it may maneuver legitimately.

Notes

1 Product boycotts were used in the License Fee Boycott Campaign and Anti-Yellow Newspaper Campaign.
2 For instance, television companies began setting aside hours for audience opinions, such as *TV in TV*, but these were offered early on Sunday mornings when few people watch.
3 In the case of the Turn Off Television Today campaign, 83 articles appeared in national dailies (ACSNT, 1993: 86).
4 The notion of 'editorial rights' in Korea is concerned with who is the *subject* of the freedom of the press. Unlike Anglo-American culture, journalists have argued that the right should rest with the shop floor journalists, not with owners or executives. The genesis of this notion is rooted in the public perception of media as public property, and at the same time reflects the public distrust of the media owners and management who have failed to maintain autonomy from external pressures during the political 'Dark Age'.
5 In 1993, the ruling party took power through a coalition of three political parties, including the former ruling party and two opposition parties. The elected civilian president came from an opposition party, and after inauguration took a series of measures to enfeeble the majority faction.

References

[in English]

Freiberg, J. W. (1985) 'Toward a structural model of state intervention in the mass media: the case of France', in M. Zeitlin (ed.) *Political Power and Social Theory, vol. 5*, Greenwich, CT: JAI Press.

Habermas, J. (1974) 'The public sphere: an encyclopedia article (1964),' *New German Critique* 1, 3: 45–8.

Keane, J. (1991) *The Media and Democracy*, Cambridge: Polity Press.

Offe, C. (1985) 'New social movements: challenging the boundaries of institutional politics', *Social Research*, 52, 4: 817–68.

Scott, A. (1990) *Ideology and the New Social Movements*, London: Unwin Hyman.

Siebert, F.S., Peterson, T. and Schramm, W. (1956) *Four Theories of the Press*, Urbana: University of Illinois Press.

[in Korean]

Audience Commission for Say No to Television (1993) *Report on Turn Off Television Today Campaign*, Seoul: YMCA.

Audience Solidarity for Broadcasting Reform (1993) 'ASBR Constitution'.

Chang, Y.H. (1992) 'Material base of press union movement and rational choice of actors', *Korean Journal of Journalism and Communication Studies*, 28: 309–35.

Citizens' Coalition for Fair and Clean Election Campaign (1992) *Report on Activities: First Half 1992*, Seoul: Citizens' Coalition for Fair and Clean Election Campaign.

Citizens' Solidarity for Election Reporting Watch (1993) *Report on Activities in the 14th Presidential Election*, Seoul: Citizens' Coalition for Fair and Clean Election Campaign.

Kang, M.K. (1989) 'Press union movements and the democratization of the press', *Korean Press Yearbook 1989*, Seoul: Korean Press Institute.

Kang, S.H. (1993) 'Citizens' press movements in the information age', *The Korean Society and the Press*, 3: 86–132.

Kim, K.T. (1989) 'Characteristics of media audience movements in Korea: a case study of the License Fee Boycott Campaign', unpublished PhD dissertation, Sogang University.

—— (1991) 'Newspaper readers' movement: the case of the sports newspaper readers' movement', *Journalism*, 21: 230–51.

—— (1993) 'Media audience movement: the case of the Turn Off Television Today campaign', *Newspaper and Broadcasting Monthly*, 273: 50–4.

Koo, N.H. (1992) 'The development and effect of the License Fee Boycott campaign', unpublished MA thesis, Chung-book University.

Korean Association of Journalists (1990) 'Media chronicles: 1 January – 30 June 1990', *Journalism*, 19: 310–19.

Korean Federation of Press Unions (1991) *KFPU Newsletter*, 2 December.

Korean Sociological Association and Korean Political Science Association (eds) (1992) *The State and the Civil Society in Korea*, Seoul: Hanwool.

Lee, J.S. (1992) 'Achievement and prospects of election reporting watch campaign', *Democratic Press Movement*, 10: 1–5.

Shin, K.Y. (1991) 'The civil society and social movements', *Economy and Society*, 12: 13–36.

18

ALLIANCE OF HOPE AND CHALLENGES OF GLOBAL DEMOCRACY

Muto Ichiyo

Global power center

Two features of the world today seem to stand out – an unprecedented concentration of global decision-making powers in the hands of the North on the one hand, and global chaos and human and environmental destruction resulting from it, on the other.

There is no need to reiterate the roles played by the IMF-World Bank, GATT, G-7, transnational corporations, and other institutions of Northern dominance, which in the course of the 1980s introduced a new process of 'recolonization' as Chakravarthi Raghavan termed it, into the socio-economic and political life of billions of the world population, hitting the weakest hardest. In the 1990s, the concentration of power was completed with the disintegration of the Soviet Union. Characteristically, this came as the landmark event of a dual nature. It represented the dramatic failure of the major twentieth century project of emancipation of the poor and the underprivileged from the yoke of world capitalism, and simultaneously it came as the emancipation of peoples subjected to a singular non-capitalist type of rude state authoritarianism, namely the state socialist system, that, in spite of its revolutionary origins, had ruthlessly imprisoned and killed a vast number of its own citizens and suffocated civil societies. Ironically, this emancipation immediately hurled the free people into the embrace of the other ruthless giant.

At that stage, the United Nations, which rightly claims to be the only existing universal organization of the world today, has been called in to legitimate the operations of the Northern powers that be. Such legitimation is necessary since the global power center, being a self-appointed entity, has never been mandated by the majority of the world population to rule them. The Gulf War, fought in the name of the UN, was a menacing show of force not only to Saddam Hussein but to all who may defy the North-dictated order.

The global power center does not limit itself to economic, political and military domination. It is a crusader for an ideological dogma that freedom, democracy, and the free market are three in one. The impudence with which

this ideology, let me say, theology, is being imposed as the unquestioned obvious on us is indeed appalling. Free-market ideology is bound to create chaos because it does not provide norms regulating harmonious human relationships. It is the rule of the strong having the right to prey on the weak, the rule of avarice. On a global level, it conveniently perpetuates Northern domination.

The state of statehood

It is this global structure that we face and are called upon to transform. For without disintegrating the global power center and replacing it with an alternative governance of the people we can hardly hope to ensure the survival of human kind, hand down a life-giving environment to the coming generations on this planet, let alone overcome the immense gap between the rich and the poor in the world.

But how? Toward what? The twentieth century answer was through the state: real, substantive changes come only through the state, whether through the welfare state, proletarian dictatorship, or the newly-acquired development state, but through the state anyway. That was the unswayed credo of the twentieth century. But now we realize that the failure of twentieth century socialism stemmed from state absorption of civil society. In the process of capital globalization in the last third of the century that induced the prevalence of the global power center, state solutions as panacea are being questioned.

The state legitimacy is being eroded when willingly or unwillingly it must enforce decisions made by the IMF-World Bank, for instance, on, and against, its own people. Most states no longer stay sovereign in their relationships with the global power center. Of course a better state makes a difference. But even the best of states trying to be accountable to the people cannot hope to get loose of the deadly embrace of the world power center. The contradictions between globalizing capital and territorial states make themselves felt even in Northern states. The Northern states, taking care of globalizing capital as a whole and thus having the whole world as their constituency, still have their respective people within their respective territories as their source of power and legitimacy. Uncontrollable capital movement out of their territories can, as it actually does, cause domestic economic depletion, plant closures, layoffs, and unemployment. But they cannot enclose capital activities within their territories. In other words, protectionism is not possible. This puts them in a very difficult position. Each of them thus seeks to 'solve' this contradiction by political means, trying to export negative consequences of this development to another country, which naturally provokes antagonism from it. The world power center is thus ripped by chronic conflicts, but nevertheless behaves as one power center in the face of the South.

All this seems to indicate that statehood as the strongest and most viable system of the modern era is gradually approaching the end of its historical lifespan.

If not to the state, then who can we look to as the alternative agent of change? This is a crucial question we all are asking ourselves. This is a historic challenge we are taking after the collapse of the century-old formula of social change to which we were inured. We need to be both daring and patient, for we are talking about long-term perspectives, a new paradigm of social change addressing the roots of the problem.

Here, we need to introduce a new level of argument which takes the global structure as the unit of analysis. That is to say, in addition to changing the internal structures of individual countries, we need to set ourselves the task of democratizing the global structure itself. This task, specifically in the context of North–South relations, is not entirely new. In the 1950s, the coalition of newly independent countries, whose great leaders gathered at Bandung, challenged it. In the 1970s, a consortium of 130 Third World countries pushed for the righting of economic disparities and injustices through the New International Economic Order. In both cases, the subject for global structural change for more equality was coalitions of states, and both efforts failed as we all know. Given the erosion of states in the 1980s, and with the loss of countervailing power to the global power center in the 1990s, it is hard to hope for the resurgence of a viable alliance of states to act effectively on behalf of the people to rectify the global structure of injustice although such a coalition should still be encouraged wherever possible.

PP21 and transborder participatory democracy

What we need in this historical setting is a global democracy based on the global constituency – the people themselves. This corresponds to the newly emergent situation where the global power center exercises its power all over the world and where transnational capital regards the whole world as its unitary arena of accumulation.

We were searching for a way to such global democracy when we inaugurated the People's Plan 21 (PP21) in 1989. In August that year, a coalition of Japanese people's movements and action groups hosted the first PP21 program comprised of nineteen international workshops, conferences, and festivals, most of them held in the midst of communities, where 360 activists from Asia, the Pacific, and elsewhere met with thousands of Japanese activists, and worked out the Minamata Declaration. Together with seventeen regional organizations that co-convened the program, the participants agreed to make it a continuing process. The second PP21 program was held in Thailand in November–December 1992, with increased grass roots and international participation and adopted the Rajchadamnoen Pledge. Earlier, in August 1992, people's movement representatives from six Central American countries met in Managua together with a Japanese PP21 group under the aegis of the newly organized PP21 Central America and issued the Managua Declaration.

In these declarations, we developed a new concept of global democracy,

which we termed 'transborder participatory democracy' with the people of the world as the constituency. Transborder participatory democracy we posited is a dynamic process as well as a goal. It is a permanent democratization process based in 'democracy on the spot' – the emancipatory transformation of everyday relationships in the family, community, workplace, and other institutions of life – extending beyond social, cultural, and state barriers, and reaching, influencing, and ultimately controlling global decision-making mechanisms wherever they are located. In the Minamata Declaration, we declared that 'all people, especially the oppressed people, have a natural and universal right to criticize, oppose, or prevent the implementation of decisions affecting their lives, no matter where those decisions are made'. This right, we proclaimed, is more fundamental than any artificial law or institution established by the state and means the right of the people to cross all borders, national and social, to carry their struggle to the exact sources of power seeking to dominate or destroy them. PP21 in Thailand, concretizing this line, called for participatory democracy at the community, national, and global levels. No doubt, the global power situation calls for such political action and such global democracy.

Alliance of hope

But how and by whom can transborder participatory democracy be implemented? 'The people of the world' is too abstract since it only designates the constituency of the global democracy. In fact, there is no ready-made 'people of the world'. On the contrary, people are divided into large groups often engaged in conflictual situations. Divides are varied: South–North, state boundaries, gender, religious, caste, ethnic, communal, racial, cultural, linguistic, historical, and numerous others. When they clash over real or misinterpreted immediate interests, people are even killing each other as we sadly witness in Sri Lanka, India, former Yugoslavia, Angola, Somalia and many other places. Chauvinistic tendencies are ominously gaining ground in many parts of the North, leading to the heinous persecution of minorities. In many such cases, brute sexist violence is attacking women. The global power center capitalizes on such internecine conflicts in order to legitimate itself by posing as if it were the only power that can enforce law and order. This is a grotesque and hypocritical claim for it is largely (if not exclusively) their gospel of free market that is sowing the seeds of conflicts, thus creating general chaos.

The picture is dire. Pandora's box has just been opened, and all evils are at large. Is hope still lurking inside? We must talk about an alliance of hope. The people of the world as the subject of transborder participatory democracy can emerge only in the form of an alliance of large, significant groups of people – an alliance informed and enriched by great diversities and varied identities. But is such an alliance possible?

To say the least, it is not only possible but inevitable. Because the new situation characterized by the domination of the global power center has the effect

of forcing all of us to live together in a single, global division of labor. This single system of division of labor, however, divides us into the North and South, winners and losers, oppressors and victims, and numerous other categories whose positions are externally designated in the global hierarchical system of domination. In other words, this is also a system that perpetuates inter-people conflicts and antagonisms. The state aggravates the situation because it is a system of exclusivity and so inevitably provokes political struggle over which group takes its control to maximize its benefits through the monopoly of state power. Pushed into this huge global organization, few of us now can escape being forced to live together. The point is that we must live together, like it or not, and so must manage to find ways to co-exist unless we wish to perish in conflicts that have no solutions. This is however the bottom line. It is a forced co-existence and has no element of hope as yet.

Can we go a step further from there? I am convinced we can. Because the antagonistic mutual relationships between people's groups are basically those imposed upon them externally, by the global system, by history, and chauvinist misleaders. Existing relationships among peoples are not of their own choice.

Can we regulate our mutual relationships? If so, on what basis? In the 1989 PP21 program, we postulated 'peopleness' as the basis to make alternative inter-people relationships possible. Whatever it may be called, there is no doubt that as much human bondage as hatred can, and does, exist, and it is at work in individuals as well as communities, especially when different people discover that they share something in common. Such discovery would make positive interaction possible. When, by recourse to this commonality, people's groups begin to enter into mutual interaction and regulate their own mutual relationships, then they are entering into a positive alliance. In 1989, we termed this 'inter-people autonomy' that, by definition, cuts across group borders and other borders including state barriers. Such an alliance is itself a dynamic process as it is constantly renewed through inter-group interactions. Interactions, if properly stimulated and organized, can cause mutually liberatory changes in the practices and cultures of the communities involved, and the community with a modified internal culture, by deepening its understanding of the partner communities, will certainly improve its relationships with them. This is what I would call an alliance building process. When this unravelling of the imposed mutual relationships occurs inducing internal transformation, we already see a process of an alliance of hope being built. As is obvious, this is a dynamic, ever-self-renewing, cross-fertilization process. But isn't this a mere wishful thinking?

In fact, it is not. The Alliance of Hope building process is partly a description of what is happening on a significant scale and partly a new context whereby what is happening is to be understood and oriented. Ms. Mirna Cuningham, the leader of the 500 Years of Resistance campaign based in Nicaragua, told us in her moving keynote address to the PP21 Thailand main forum, about how the 500 Years of Resistance was working to unite indigenous people, black people, and popular movements. On the Atlantic coasts of Nicaragua, deep

cleavages exist between the indigenous people and black people who were brought as slaves and made to open fields at the cost of the indigenous people's rights. It was not easy for them to unite. Mirna told us that it was by recourse to history, namely, the history of conquest, that the entangled relationships between these groups became unravelled so they joined the campaign in the end. This is by no means an isolated example. In solidarity movements, NGO work, farmers' movements, transnational labor organizing, and cross-sector encounters, we find elements of alliance building and cross-fertilization at work. Diversity in culture and values does not mean mere coexistence of separate, unrelated entities.

Cross-fertilization can occur between civilizations as dominance of one upon others is overcome. It is happening already. The human rights concept, origi-nating in Western Europe, has been greatly enriched and modified as it interacted with Third World realities, Asian civilizations, and indigenous people's cultures as well as feminist thoughts and ecological world views. The humanization of the human rights concept through such encounters has been so profound that the typical US government version of the holy trinity, which is used as a diplomatic leverage, looks miserably poor and pitiably arrogant by the side of the statements of human rights NGOs such as the ones adopted in Bangkok during the PP21 in Thailand in December 1992 as well as the Bangkok NGO Declaration on Human Rights presented to the Asian Regional Meeting of governments in March 1993.

International civil society

In 1989 we said that the Alliance of Hope meant an alliance of billions of people to replace the inter-state system through transborder participatory democracy. In other words, the Alliance of Hope we envisage is nothing but a global soci-ety of tomorrow in dynamic and dialectical processes of self-generation through interactions. Alliance of Hope also envisages not just alliance amongst large communities as such, but processes of interaction that will transform the inter-nal life of the communities involved in favor of freedom of individuality and abatement of repressive relations.

What is termed 'international civil society' in this sense seems to be very close to what I mean by Alliance of Hope. However, I have some reservations about calling it international civil society although it is understandable that civil society is emphasized as against the state. First, civil society is largely a creation of the modern nation-state. It is demarcated by national borders and filled with nationalist substance. That is why it is called 'inter-national civil society'. Shouldn't we envisage broader social relationships beyond national borders, instead of linking already nationally constituted civil societies? Second, as a con-cept modeled after European experience, civil society inevitably carries with it strong European flavors. I am afraid efforts to deodorize it may turn it into a meaningless abstraction. For instance, is Islamic Ummah a civil society? Civil

society is a historical product – a product of modernity which is the creation of the West. Aren't we in a position to face the entire consequence of modernity? Third, does civil society include all the residents in a certain territory as its fully-fledged members? Weren't the working class in the eighteenth and nineteenth century considered the outcasts of civil society? Aren't there equivalents in civil societies of today? Are 'illegal' migrant workers members of civil society? Last but not least, isn't it necessary to transform civil society itself since it is in civil society that the exploitation of labor takes place and dominance of the poor by the rich, of women by patriarchy, and other social-economic forms of dominance are entrenched? The civil society approach does not give us a guideline as to how civil society should be transformed.

There is no doubt that civil society with all its values and modernity, should be considered an important element to be integrated with the global society of the future. It is a heritage with rich potentials which will be positively displayed through exposure to, and interaction with, its external. But I am afraid that making it the single model of global society, even with thoughtful redefinitions, may bind our hands too tightly. By calling it an Alliance of Hope, I want to keep it more flexible and open-ended.

Having said this, I would like to address some of the issues that arise from our alternative society building approach, whether it is called international civil society or Alliance of Hope.

Paradigmatic changes: beyond the state

The new approach and perspective designate new areas of possibilities and directions for our action.

Talking about Alliance of Hope means that we depart from the twentieth century state-centered approach as our strategy of global social transformation. The state-centered approach assumed revolutionary global social change to occur in the following manner: (1) country-by-country seizure of state power by the vanguard party claiming to represent the working class and full commencement of social transformation within the country's territory using the coercive power of the state as the primary leverage, (2) creating revolutionary states one after another, which are cemented into a socialist camp to serve as the basis of support for revolutionary movements outside of it, and (3) forming an international united front between the revolutionized states and Third World countries to press democratization of the global structure.

The key to this strategy was the state both in terms of internal social transformation and of global democratization. Now this whole paradigm is called into question.

While the old perspective assumed that real social change in a country occurs after the seizure of state power, the new one envisages alternative social relations and systems prepared autonomously by social movements prior to a change in the nature of the state. This does not mean that a completely new society will

emerge under the existing state, nor does it mean that the state will allow such a change to happen without resistance. It should be emphasized here that state-wise solutions should be pursued wherever possible and feasible, and in quite a few cases even as a precondition for any meaningful social change, particularly where the state, having lost its legitimacy in its relationship to civil society, imposes itself by sheer violence. Take Burma, Haiti, and Guatemala, for instance, where there is no democratic space. Nothing positive will occur without first dismantling the militarized state structures. The East Timorese people are fighting against Indonesian invasion to recover independence and their own statehood. This is a crucial task never to be skipped. But even in many such cases, we witness people and their communities organizing and beginning to build new socio-economic relationships, if simply to survive, for they know that they cannot sustain their political struggle without survival. In other cases where there is more democratic space, changes may occur in a more evolutionary manner, with emphasis on transforming the relationships in the existing civil society. Whichever the case may be, the point is that alternative systems defining a new society begin to be organized and made operative, if partially, prior to 'seizure' of state power.

There is another angle to it. In the 1960s and 1970s, the world saw explosions of new people's movements, especially in the so-called First World, radical not only in action but also in perspective – the Black Power movement, the Native American movement, the anti-war movement, the French May 1968 student movement, and the women's liberation movement, to name only a few. These new movements, though not all of them were successful in achieving their immediate goals, opened new horizons for social movements and moved our concept of politics to a point of no return. The discovery is that politics is in the midst of everyday life, in the social relationships into which we are born and cultured. As the feminist motto aptly formulated, the personal is the political. After the radicalism of the 1970s waned, the ecological movement followed.

It is of course out of the question to dream of repeating the same thing, but we would be punished for ingratitude should we forget the unique lessons contained in the experience. One of the lessons is that the oppressive and exploitative social relations should, and can, be changed here and now, without postponing it to a remote future day when the state has become 'ours' either in a revolutionary or social democratic way. When social movements start changing the existing relationships here and now, they are already building an alternative society here and now. And if it is an alternative society that is emerging, if partially, then, social movements must integrate social, economic, political and cultural aspects with an articulated process of society building.

The revolutionary struggles of the Central American people, which were a great source of inspiration and one of the foci of the world affairs in the 1980s, seem to be facing the same problematic. Ruben Zamora, President of the Democratic Alliance of El Salvador, in his proposition to the PP21 Central

America conference in Managua in August 1992, mapped out new perspectives of the twenty-first century type of revolution, by bringing home the need to overcome 'statist tendencies' and redefining the relationship between the state and popular movement. His point is that social movements, and for that matter, civil society, should maintain their autonomy and establish the capacity to resolve problems for themselves. 'We of the popular movement must try to regain our autonomy and our ability to do and build things outside of the state, or drawing only sparingly on the state from time to time,' he said. Political parties are necessary as long as the state remains, but popular movements should not be controlled by parties. The popular movement 'must be depoliticized in the sense of removing political party politics from it' and 'must find a new means of expressing the political role of the popular movement in light of the multiple subjects that definitely must be a part of the process of change that society must undertake'. Ruben called this the 'repoliticization' of the popular movement, suggesting a new way of being political.

This brings us to another important point that requires a Copernican change in the understanding of social movements – from the notion of social movement instrumental to seizure of state power to that of social movement as a process of building an alternative society. Viable social movements, whether labor movement or other movements, always represent empowerment of people, the creation on the spot of a new way of organization of society. However, under the old state-centered paradigm, the on-the-spot social change was considered incidental, and regarded as significant only insofar as it was instrumental to the ultimate goal of the seizure of state power. The political party being assumed to be the vehicle to the state, success or failure of the social movement was measured not so much by what it had achieved in the actual reality as by its contribution to the buildup of the party solely through which universal liberation could be achieved. The party was considered the only organization having concerns with universal liberation while the social movement was assumed to be concerned with particulars. Being the pre-state state, the party had to be shaped after the model of the state. It was vertically organized, and its claim to leadership over the mass movements was exclusive and monopolistic because the state is by nature a monopolistic organization. In actuality, there being more than one party, the parties representing diverse interests of the population had to coalesce in a united front to form the single body to rule. But the united front never worked harmoniously for long, simply because the underlying principle was monopoly and the bonding factor the concurrence of immediate interests. The motivation to unite being utilitarian, it tended to collapse as soon as the immediate goal was attained. Bitter infighting would ensue. It was an alliance of convenience.

Here it should be noted that in this setting the people's groups and communities did not forge their mutual relationships directly but only through the medium of vertically organized political parties.

The Alliance of Hope approach ventures to negate this instrumentality and

seeks to restore direct relationships between communities, large and small, to see to it that they begin to constitute an alternative society here and now.

Here we need to refer, if briefly, to another similarly important aspect of the new paradigm – the integration of the economic aspect into the popular movement. If an alternative society should be built here and now, we need to have a perspective of developing people's own alternative systems of economy. In this respect, we have rich mines of experience. Southern and Northern NGOs have been engaged over years in the development of self-reliant economic bases in rural villages. Farmers in Asia have organized buffalo banks, rice banks, and credit unions while a self-managed 'informal economy' has been organized successfully by poor urban communities in a number of Third World countries. In the North, consumer cooperatives, workers' production cooperatives, alternative trade, and other interesting initiatives have been developed. In Japan, too, we have developed a banana trade with poor farmers' communities in the Philippines in which not only a trade system returning part of the wealth Japan exploited to the people of the exploited country has been developed (cooperative members pay three times the market price) but also a regional self-reliant economic program has been launched on the basis of capital accumulation made possible through trade.

But have these economic ventures been properly situated in the general perspective of social movements? Are these an integral part of new politics? I think much can be done in the area in question, particularly in respect to the local and global organization of alternative economic systems as an integral part of the Alliance of Hope building work.

Mediation and NGOs

The Alliance of Hope building, however, would not happen automatically. To get under way, this process requires mediation. And the mediation required is one to universal change. We are here talking about a new universalizer replacing the party as the sole and privileged universalizer. Or rather, we are talking about changing our perception of universality.

Our assumption, and perception also, is that an element that goads us to expand the notion 'we' beyond the given and safe demarcation lines is at work at the depth of every social movement. It is a radical element. It is an urge to relate. It involves an urge for human equality. It mobilizes wisdom also. We have no name for it yet. We called it 'peopleness' in Minamata, but that was tentative. Certainly, the great religious teachings have their respective names for it even if they have often degenerated into banality through overuse. 'Peopleness' works at moral, cultural, ontological, and functional levels. Functionally, we witness voluntary solidarity movements and campaigns assiduously undertaken between the North and South and in the South itself on a large variety of issues. NGOs are working all over the world for the empowerment of the grass roots. In the best of these cases, 'we' means people with discernible human faces living

in very different and asymmetric social and cultural settings, who are bound in a relationship in which the joys and sufferings of one are felt as the joys and sufferings of the other.

The point here is that as chains of inter-relationships extend, the 'world' as seen from each partner group gets peopled, broadened, and enriched. It evolves from a poor original image of the world confined to the circle of its immediate interests and contacts complemented by an abstract representation of the rest of the world, into an increasingly concrete world peopled by identifiable partners. The visions of the world will certainly vary in accordance with the positions the respective communities occupy in the whole structure, but these visions will alike be mirroring the same global community as the chains of inter-relationships take hold of more and more communities. In this process, the structure of the world will also be brought to an increasingly lucid cognition, not as a dry, descriptive analysis of the 'objective,' but as a living whole in which each community is embedded. The world thus ceases to be a cold external monolith and emerges as an ensemble of more or less malleable relationships which can be worked upon for change.

What I mean is mediated concrete universality. It is, like the dragonfly's compound eye, composed of hundreds of small eyes, each of which holds an image of the same surrounding with its own respective bias. This is a new way of approaching the whole question of universality. Thus mediated, the universal is pulled down from the heaven to the earth, ceases to be vertical and becomes horizontal, and comes to mean human totality being lived, and no longer an abstraction from it. Unlike the state-centered approach, the new approach allows us to find a path to universal change without leaving the community, or to think globally while acting locally as well as globally.

Who then are the mediators? Here, we depart from the old tradition of separating the universality-oriented activists from their backgrounds and organizing them into a specialized universalizing organization, typically the party. Basically, the mediators are there within the communities, who bring themselves into mutual communication and facilitate interaction of the whole communities.

It is only in this context that NGOs can play their mediating roles. They should not be regarded as specialized universalizing agents for whom a closed, privileged space is set aside. European NGOs, working in the Third World, are still committed to the European community and culture as Japanese NGOs are to theirs. Third World NGOs come mostly from urban middle-class backgrounds. These NGOs are not just working for, and with, grass roots communities. They are not agents of change on behalf of somebody else, nor are they residents in a cosmopolitan space. They are meaningfully functioning as mediators only when they also work to fundamentally change societies and milieu of their origin. Being NGOs, they do so by bringing the communities on both sides into productive, dynamic, and dialectical interaction, developing means, devices, and institutions to narrow the scandalous inequalities, and thus helping the Alliance of Hope gradually to emerge.

Global popular representation

For such an Alliance of Hope to prevail as the people's new global governance, we need intermediate steps. One such step has been already marked in the form of the emergence of NGO coalitions as influential actors in orienting world affairs in the arena of the United Nations. Rio 1992 in fact made the advent of the new actor definite. There is no doubt that this is how the people of the world at this stage can express their demands, aspirations, and power in front of the global power center.

But by the same token, this seems to be a time of crisis for NGOs. For, faced by the objective impossibility of the scheme it promotes either in the area of development or environment, the global power center has set out to co-opt, tame, and usurp NGOs. Most of the excellent slogans worked out through years of experience have been stolen by agencies of the global power center. The World Bank nowadays appears to be in love with NGOs without ever backing off from its own destructive principles. There is a temptation for NGOs to begin to feel comfortable and become complacent with the prestigious status attained through their years of struggle. I am not saying this has happened. But beware of the pitfalls.

The rise in the power of NGOs as global actors is important only when it is a breakthrough toward a further goal – achieving the representation of the people of the world themselves in the world arena in the form of, say, a World People's Assembly, directly rooted in the Alliance of Hope. To eliminate mis-understanding, I immediately add that I am not proposing to hold such an assembly in the near future. A hasty attempt to call such a global assembly would end up in another global conference of NGOs. That would only serve to deceive ourselves. But as our goal and guideline, I think talking about it is rel-evant if only to abate the likelihood of degeneration of NGOs into an exclusive club united to protect its own interests. NGOs are instrumental to the process of 'making the people themselves visible' in the terminology of PP21 Thailand.

Our perspective is not the abolition of the state in dramatic ways in the fore-seeable future. We have to co-exist with ever-degenerating, ever-self-protective, and ever-declining states, which will be depleted as our Alliance of Hope building work proceeds. Thus we envisage eventual absorption of the state by the Alliance of Hope, where we shall make transborder participatory democracy fully operative. This will certainly be a long process carried into the coming century. The United Nations likewise will continue as the universal assembly of states. We have to co-exist with it for quite a time. But it is also clear that the states, and the United Nations for that matter, can no longer represent the people of the world. The notion of the World People's Assembly is to orient ourselves in this relatively long transitional period. In this process we must first build up a global countervailing power of the people, and then enable the coa-lesced people of the world to penetrate the arena of the inter-state system to hollow it out.

The groundwork at the grassroots level for the formation of an Alliance of Hope should precede concrete steps to convene such a global assembly of the people. It is premature to call such an assembly but not premature to envision it, for thus we can avoid the pitfalls and identify our intermediate goal – steady but systematic replacement of NGOs with people's organizations as the representation in the global arena.

Challenges

The challenges we face at the end of the twentieth century are unique. For globalization of capital supported by the global power center has not only made the world smaller, but also has telescoped major events and problems which arose in past centuries into the present. This defines the nature of alternatives we are committed to create. In other words, in resolving burning problems of today, we must undo history tracing back to where the problems originated. As it were, we face a single complex of problems. And the problems integrated into this single complex, having arisen at different times and settings in history, not only have been bequeathed to us unresolved, but have been fused in peculiar combinations so that the possibility of resolving those problems separately and one by one is close to precluded. To simplify, the present condenses in its midst at least the following problems and their legacies:

1 Thousands of years of domination of women by men;
2 Five hundred years of domination of the South by the North; the conquests of the people and their civilizations in the 'new continent' legitimated the notion of conquest in general – the conquest of people by the 'civilized' and the conquest of nature by human beings;
3 Two hundred years of domination of agriculture by industry (industrial revolution);
4 Two hundred years of domination of society by the modern state and inter-state system;
5 Two hundred years of the domination and exploitation of labor by capital;
6 One hundred years of imperialist domination of colonies;
7 Forty years of destruction of nature and diversity (homogenization) in the name of development.

You can add any number of 'current' problems having survived through history. The point is that none of them has survived in its original shape. These have been brought into a deformed synthesis in diverse combinations. Modern capitalism, for instance, integrates (2) to (5) on the basis of (1) while (7) integrates all the preceding problems. Item (2), mediated by (1), (3), (5), and (6), produces (7) in the form of the widening gap between the North and the South.

Our alternatives address precisely this problem complex. Given the organic intertwinedness of the problems, the process to overcome it needs be a single

process. 'Single' does not mean 'in one fell swoop'. Nor do we anticipate an apocalyptic settlement. It means disentanglement in the same historical time and in interrelatedness. It means that trying to fully resolve any one of the problems as separate from the others won't, after all, succeed in resolving even that problem. This is a crucial point. For instance, the environmentalist movement will never succeed in preserving nature if it refuses to consider poverty in the South.

Having recognized the intertwining of the problems, we set out to disentangle the complex. The clue to disentanglement is to begin taking the side of the dominated in the above list: women, indigenous people, the South, agriculture, labor, (civil) society, nature, and diversity. Already, vigorous voices have been raised and demands presented by or on behalf of them. We have fairly active social movements on all of those issues. The starting point in our search for global alternatives is to go full out to work changes in line with the demands of the dominated on the dominating side – men, conquerors, the North, capital, the state, the human species, and homogeneity. Without the prerogative of the dominated, there is no emancipatory alternative.

Through maximum effort we shall find that an alternative world will not be constituted by the mechanical summing-up of such efforts. For there is no guarantee that alternatives evolved by different sectors and on diverse issues fall in predetermined harmony into a single picture of an alternative world. Alternatives pressed by urban citizens may collide with those developed by farmers. The feminist perspective may not suit traditional communities. Conflicts are bound to occur.

But the differences and even conflicts can be constructive. They may be a driving force toward weaving comprehensive alternatives. If the conflicts end in antagonism, the current system will survive capitalizing on them. Mere compromise is the postponement of antagonism. But if the differences are brought to a higher level of synthesis through dialectical interaction, then we have an Alliance of Hope with ever self-enriching alternative visions and programs that fully cope with the entirety of the historical problem complex.

This is the challenge we need to take. It is indeed a profound change that we need to work. But that we have gathered here in this Encounter is proof enough that the march has begun.

A TOKYO DIALOGUE ON MARXISM, IDENTITY FORMATION AND CULTURAL STUDIES

Stuart Hall and Naoki Sakai

NAOKI SAKAI (NS): For the last four days (15–18 March 1996) we have participated in an international symposium, entitled 'Dialogue with Cultural Studies',[1] organized by the Institute of Social Information and Communication Studies at the University of Tokyo. As one of the keynote speakers, you delivered a speech in the Yasuda Memorial Hall, located at the center of the main campus of the University of Tokyo. While I was listening to your speech in the hall, packed with an exceptionally large audience, I could not help feeling a certain sense of irony. You were probably aware of this same irony which your presence there, in that particular location, must have evoked in the minds of some of the audience. And that awareness about your locality was more than a few times expressed or signaled, if not directly, in your speech. For a long time the Yasuda Memorial Hall has been regarded by the Japanese public as a symbol of Japanese imperial education, since it occupies a central place in the most prestigious university in Japan. And as a matter of fact, until the defeat of the Japanese Empire in 1945 at the end of the fifteen-year Asia–Pacific War, the University of Tokyo served as the top university of the Japanese imperial university system which covered not only Japan proper but also Korea, Taiwan and so on. Probably in a subtle and less obvious way the empire has survived even after this defeat and might have been re-invigorated during the last few decades. In this particular sense, that building still symbolizes the authority of knowledge that has created and maintained the Japanese Empire and the upward mobility which has pulled so many people from all over the Japanese territories toward the center. Your presence on the platform in the center of that large hall evoked a strong emotion in me. What has been addressed in the subsequent symposium, along with the fact that the symposium was planned and organized by some people belonging to the University of Tokyo, made me ponder some questions. The symposium, I feel, was a great success primarily because it generated so many important questions instead of pretending to have solved them.

360

And, I guess, those questions were actually thought through by the organizers themselves, and, in a sense, they knowingly tried to create this ironic situation.

So, let me first elaborate on those questions. In so many ways, your work has been closely related with another empire, that is, the British Empire. Now you live and work in that empire – perhaps I should add the adjective 'former' – while I myself live and work in another, definitely not former but current, empire. To my knowledge you have tried to bring some intellectual and political tensions into the center, although the center in this case was not so directly affiliated with the state as the University of Tokyo has been. I wonder what the creative ways are to bring tension into the center. And how do we sustain a critical linkage between those who are marginalized in the society and those at the central and dominant place in the production of knowledge? In other words, how can we possibly utilize this or other similar ironical situations in order to allow the marginalized to participate critically in the political center? Please permit me to use a kind of trope in order to combine these heterogeneous questions. That is the trope of the margin and the center. I feel this is rather overused and too often applied to too broad a context. In each case, we need a much more sharply focused understanding of that relationship between the social position of the neglected or dispossessed and the locus of imperial and state authority. None the less, as I cannot think of a better way of addressing these questions, let me now try to frame these questions in terms of the opposition of the margin and the center, in the sense of the geopolitical periphery of an empire and its metropolis. But I would also like to ask a question about the relationship between, for instance, Marxism and the center, at certain stages in history. Let me note this point because Marxism played an important role in Japanese history as well. It goes without saying that there have been many politically and intellectually different stances and nuances among people who allied themselves with Marxism, and I hope that the readers will understand that we are aware of this diversity. But for the sake of convenience, please let me talk of Marxism in the singular. From perhaps the 1910s until the present, Marxism has been regarded as a certain form of marginality in Japanese society. On the other hand, of course, until the 1970s, Marxism really occupied a central position within Japanese academia and educational institutions including the University of Tokyo. In 1969, when the large-scale student protest took place at Tokyo University, the center of university authority, against which students organized themselves to call into question the authority and politicality of academic knowledge, was as a matter of fact occupied by a Marxist economist. The highest position in the entirety of the Japanese national educational system was symbolically occupied by a Marxist scholar. Here let me issue a warning disclaimer. I do not mean this to be a simple denunciation of Marxism or its role in Japanese history at all.

So I wonder whether you have any reflections on these issues.

STUART HALL (SH): Yes, I, of course, was aware also, or became aware in the course of agreeing to participate in the symposium, of exactly the irony

of my speaking in that hall and of that hall being chosen as a place to open certain critical questions around cultural studies, and of the fact that I think that dialogue was inevitably bound to have an effect, namely to open the topic to, on the one hand, academic and on the other, non-academic and more politicized reflection. So I could see from the beginning that, even before I got there, it was a point of confluence of different things, including especially different kinds of margins and different kinds of centers. I want to say that margin/center has been a trope of my adult life, really. I once explained to someone why I wanted to live in London rather than in the countryside. I said, you know, if you come from the periphery of the British colonies and you come to the metropolis, where you really want to live is in Piccadilly Circus itself or on top of Big Ben, you want to live in the center of the center. There's no point in coming to England and living in the countryside, I'd stay in Jamaica and live in the countryside. I was a Rhodes Scholar. I went to Merton College as a Rhodes Scholar. Just think about what this experience is. What the son of a black low-middle class scholarship family in Jamaica, funded by this English-South African diamond imperialist, is looking for. The whole idea of the Rhodes scholarship was to gather together in Oxford and to give a superior education to the white sons of the empire. But of course gradually, you know, the color of the Rhodes Scholars get browner and browner until they got to me. But, you know it's an extraordinary thing to arrive as a Rhodes Scholar sent from Jamaica to sip at the fount of knowledge of Merton College, Oxford, which is what I did. Of course there isn't a perfect comparison between Oxford and Tokyo in that sense. Oxford wasn't quite state-centered, imperial-centered in that way. But within the English and British context, it is of course the absolute summit, not only of knowledge but of the formation of the ruling class. It is the cradle of the ruling class. Everybody who is going to play any role of leadership in national life passes through this aperture into Oxford or Cambridge. So from the very beginning I was aware of this paradox, of being kind of lifted out, expected indeed, by my own family, to go to the center somehow and snatch the fire that was there, and of course to bring it back to the periphery. What they meant by that was that I should come back, crowned with the glory of the center, annointed by the center, and I should return and reflect the glory on my family. So this is the point at which the irony in the story somehow breaks. I never went back. I refused. Somehow I refused to perform this circular route, you know. I stopped where I was and began to reflect on how on earth I had come to this center in the first place.

Now, I mean there's a curious thing about the center, which is that it was from the center that the New Left emerged. The first New Left journal was printed in Oxford. It was in Oxford that I met most of the people who have remained my political colleagues throughout life. It was in Oxford that I really became a West Indian. I came to England as a Jamaican. I had never met other people from the rest of the Caribbean area. I learned to be a Caribbean in

Oxford. Now this is a curious paradox but, of course, it is partly because the metropolis draws so many people to it that exactly you can have a variety of experiences there, if you know how to use it. And I was actually, I think – I am speaking personally now – I was actually transformed by that experience in a personal way. And so I have to say that I take enormous pleasure out of going to the center and not performing the expected role. Going to the center and doing something there which is not the prescribed task. And I think that that has been, in some ways, the fate of cultural studies: not just to speak on behalf of the marginalized and the dispossessed, but to lay a kind of claim on behalf of the dispossessed, for that which the dispossessed need which is knowledge and understanding. We can't, we won't be written out of the resources, the intellectual and political resources to change our world, because the hierarchies have consigned us to the margin. I think that's one way of thinking about marginalization.

Now let me think about another way which is very pertinent to the last fifteen or twenty years. In that period in England, I worked on and off very closely with people coming from my own region. Migrants who have come from the Caribbean or from Asia to live in England, to live and work in England. I was sort of at the forefront of that wave. I went to England in the early 1950s, and by the mid-1950s the wave of Black migration into Britain had begun. And, so for most of the early period in England, I was struck very much by the enormous difficulties those people were having to make any kind of life or to win any kind of recognition for themselves. But in the last ten or twenty years, I have been impressed by exactly the opposite. I have been impressed by the enormous creativity of the margin itself. The very marginal experience somehow becomes a kind of pressure cooker. It forces things to the surface, largely in the first instance, because of the capacity to survive, just because you have to survive in the teeth of the circumstances. You become a new kind of person or you get, you learn, resources which you didn't think you had before or you make new uses of them. And I suppose I would say now that in England, if I think of the visual arts, if I think of what's happening in music, if I think of what's happening in creative writing, almost all of it seems in some ways invested with the energy of the margin rather than the center. The center seems to be rather dead. And it's only those people, not necessarily people of the margin themselves, but people who have contracted some connections with the margin, or who have tried to resight or relocate the center from the margin, who have put themselves imaginatively at the edge, and then looked at the center again in a sort of displaced way, who are creative. That exactly seems almost a kind of definition of what creative energy is like in our time.

So, whereas in my earlier life, I would have thought the margin was a very bad place to start from, I now think it's not a bad place to begin. It's quite a good place to start from. And so finally I would say that I think one of the skills that this requires, and I would be interested to know what you have to say about this, because you are one of us in this sense, is the doubleness of knowing

enough about the center, not to be taken by surprise by it. You have to be familiar enough with it to know how to move in it. But you have to be sufficiently outside it so that you can examine it and critically interrogate it. And it's this double move or, what I think one writer after another have called, the double consciousness of the exile, of the migrant, of the stranger who moves to another place, who has this double ways of seeing it, from the inside and the outside. It's what W.E.B. DuBois says about the African-American. African-Americans are what he called burdened by this double consciousness, because they are as American as you can get in some ways and yet they have never been permitted to become properly American.

C.L.R. James says it exactly of the Caribbean. We are both in and not of Europe, because we have a colonial relationship with it. I think increasingly there are metaphors of creativity which are ones of this kind, of the margin, of the colonial, of the exile, of the migrant, of the mover. That is to say of the person who has an investment in two worlds. Inside and outside the academy. Inside intellectual work and also inside popular discourse. Speaking to more than one audience. Translating between audiences. Making a kind of bridge or facilitator between different positions. This seems to me to be almost a kind of definition of creativity in late modernity. And so I would have been much less happy about the symposium, if it would have taken place in a designatedly modern spot because I would have missed exactly that frisson of being in the space of power and contesting power at the same time.

NS: I would like to come back to the issue of doubleness later. I think it's a very important issue and I like to engage in that topic very much.

But, in the meantime, let me persist with the issue of Marxism, partly because many Japanese readers are very much concerned with the historical connections between cultural studies and Marxism, how cultural studies have been interwoven with Marxism. This is one of the reasons why I suspect that cultural studies might evolve very differently in Japan than in the United States where the tradition of Marxism is almost negligible in comparison with the burden of various Christian churches on the intellectual lives of university students. Perhaps this is one of the aspects of American society which intellectuals from western Europe and Japan might find difficult to appreciate, although I hear that, even in Japan and western Europe, religious movements have been gaining some popularity among the university student population recently.

Until the 1960s, particularly in the humanities and social sciences, what qualified and distinguished the Japanese intellectual elite from the non-elite was basically a knowledge of Marxism. And, of course, even at that time, Marxism was regarded as the form of knowledge which was designed to speak for the dispossessed. There was an implicit agreement among the leftist intellectuals that they were expected to speak and act for the dispossessed. But, looking back, we can see that they had not really discovered the way to speak not necessarily on

behalf of, but along with, the dispossessed and marginalized. In a sense, in your career, you have also had a very ambiguous relationship with Marxism and I wonder if you could possibly talk about that relationship.

SH: I should say one thing, and that is, that I know what you mean about the intellectual centrality of Marxism in Japanese culture, I know a little bit about that. And I would say that the situation certainly in the United Kingdom was different. That is to say, Marxism was what is sometimes called the official heteroxy. It was the established counterculture. But it never became the dominant intellectual tradition. I mean, all the outstanding English Marxist writers of the last period, for example, lived a relatively marginal intellectual existence. Edward Thompson was never a professor of history. Eric Hobsbaum was refused a chair at Cambridge, only made a professor in his seventies. You could go through the list. Some people managed to achieve a sort of quasi-official-unofficial status. It was thought that if you were opposed to the system, sooner or later you would speak Marxism, because that's what was expected, but it never gained the ascendancy within the established legendry as such. But obviously someone like me with a kind of anti-imperialist, left-wing background, coming out of Jamaica during the period when it's moving towards independence and so on, I was a young radical and Marxism was always the sort of thing that one looked towards. I was actually – this runs a little bit opposite to what I just said – taught Marxism in school in order to innoculate me against it. My History teacher, who was an Englishman, thought he ought to go to the colonies and tell all these bright students how terrible Marxism was. And so he made us read Marxism and I thought this is quite interesting, there's something here. You know, Lenin on imperialism, and Lenin who made the Russian revolution; he said these were terrible. I want to read some more of them. You can never pet a god, it always has a way of turning back on itself and of creating more. So of course I knew about that and there was a generation of West Indian students who took on Marxism partly because of the heroic example of C.L.R. James. He was their hero and he was a great Marxist intellectual and Marxist historian, and they modeled themselves after him. And I remember my mother saying to me, when I went to London first as a young student, don't go to the West Indian student center, grow a beard and hang around with those Marxists down there. It was sort of known, you're going to England, you would come back as one of those bad Indians or Caribbean Marxists. And of course I went to England and I went straight to the center, I grew a beard which I've never lost and I became Marxist, or at least I started to read Marx.

But the fact is that, for some reason which I find difficult now to say to you, I was never an orthodox Marxist. I'm not one of those people who went into Marxism and lost my faith or changed, etc. I was always drawn to certain questions that Marxism posed. I was always drawn to certain writings of Marx. I like some of the things that people wouldn't think of as classics – I like the *Eighteenth Brumaire* for instance. I think the *Eighteenth Brumaire* is a fantastic piece of

writing. I like it better than *Capital* Volume Two, which I can't get my head around. But it's not that. I never felt about Marxism, that because you accepted this and this and this idea of Marx, you had to swallow the whole shoot. I somehow never got into that orthodox trap of believing I had to be converted to Marxism as such. And I think, to be honest, the reason was because I was never persuaded about the Soviet Union. I just never thought that the Soviet Union was anywhere near the model. Of course, people say that you can be a Marxist without thinking that the Soviet Union was right, but somehow the two seemed to me to be connected in some important historical way, and if you have questions about the first you couldn't just give over your independence of thought. So it's not the case which some people who know my own career imagine: that at some point back then, I became a kind of a historical materialist in the full sense and have been leaving the faith since then. I have always had a more, what I would call, eclectic or dissident relationship to Marxism. I feel myself a kind of Marxist dissident. And I think one of the main reasons was because my field at that time was literature. I have no formal social science background, people may be surprised to know, I don't have a single degree in social science. My field, my training has been in literature. I taught myself social science at one point, but that was because I became engaged in debates about culture. Now it just seems to me that if you are seriously interested in culture, there was a problem about the Marxist conception of the superstructures in relation to the base, class reductionism, materialism, etc. All those bits that seemed to explain my topic to me had holes in them and problems in them. So I sort of got into the habit of arguing with *The German Ideology*. That was my stance towards Marxism. Something that you wrestle with, close to you, important to you, but something that you struggle with.

I don't want to give you a long answer. I've been through many cycles in relation to Marxism. In the period of the New Left, for instance, when I left university, there were some older Marxists like Eric Hobsbawn and Edward Thompson, and that group who had been Marxists, but the younger group that I was with contained a number of us who were on the left, in dialogue with Marxism, but not Marxists and had never been communists. So even my politics, the politics of the first New Left, was a politics again in touch with Marxism but not of it. Because the most formative political experience for us was 1956, the Soviet invasion of Hungary. So how could you be an orthodox Marxist at the moment when Stalin was chasing Lukács, it's just impossible. So that's one moment when people might have imagined, well the New Left was a Marxist. Yes, it was a kind of Marxist formation and some people around it were more orthodoxly Marxist than I was, but I don't really think it's true that I was.

Now, the moment at which I came closest to calling myself a Marxist is the 1970s. That is the period that I am closest to it. And the Marxism I nearly called myself in those days was Althusser and Gramsci's, and that's because, of course they, precisely, they addressed the problems that had kept me from identifying with Marxism before. They were trying to think a non-reductionist Marxism.

They were trying to think over-determination rather than 'determination in the last instance by the economic'. They were trying to think a more pluralized, a more democratic, a more inflected cultural conception of power. So all of these things fitted me, so I thought, if that's what Marxist is, Marxism can be corrected through Althusser or through Gramsci then, of course. So that is why in that period, in the Center's work, taking the atmosphere of the 1970s in general, we were quite close to being Marxist. But still, you can see that that is not an orthodox Marxist position. When the Center for Cultural Studies first started, we wanted to pose the question about the relationship between culture and society, between the cultural and the social, but because the route to economic reductionism seemed to be blocked, we went around the houses to find alternative theoretical starting points. We read German idealism, we read Kant, we read Max Weber, we read Mannheim, we read anybody who would take us past those logjams in classical Marxism. So, to put it shortly, I've been inside that language, I know it extremely well. For a time I always used ideology and culture interchangeably, though I wouldn't do so now. I'm much further away from those formulations than I was, though I've never been fully in the Marxist mode. So it's a complicated story.

When we were at Oxford as students in the worst days of the Cold War, and to be a member of the Labour Party, in those days, you had to never have been in the Communist Party. So close friends of ours who were in the Communist Party in the early 1950s, about the time of the Korean War, were not allowed to attend official meetings of the Labour Party. They weren't allowed by the constitution to be in the Labour Party. And there were a number of us who called ourselves people of the independent New Left, who refused not to talk to these people. We said, we must talk to everybody. We're going to be an organization, but we're not going to accept the Cold War bar against talking to them. On the other hand, we are going to polemize with them about the questions we don't agree with. So that has been a kind of intellectual dialogic tradition between myself and a lot of people of my generation who have been 'within Marxism'.

NS: It seems to me, then, that your stance with Marxism is in a sense another intellectual question of double move and double consciousness. Let me talk about myself because I am now involved in Japanese studies in the United States. I became really interested in Japan not *in* Japan but when I spent two years in London. At the same time, being acutely aware that an explanation about why I am doing what I am doing is, to a large extent, always a retrospective justification of what I think I am. I cannot understand why I moved to the States unless I take into account the fact that I wanted to study things about Japan. For I became interested in Japan because, by then, I could not take Japan or its image for granted. At that time I felt hesitant to study Japanese history or things Japanese while living in Japan. I could not accept the idea of studying things Japanese in Japan.

There are problems which may appear very different but are somewhat related to my problems, in the humanities in general in the United States. These problems are serious particularly in fields such as Asian studies..

In those fields, a scholar want to study his or her own background and some kind of continuing lineage with which to identify. The subject of the study and the object of the study could be taken to be continuous with one another. Often a part of the field consists of those people who feel somewhat innately related to the object of the field. And then we have to deal with other parts of the field containing those who do not feel that way. And if we simply accept that one could immediately identify with the object of that field there may be some kind of danger in the sense that that kind of identification should probably be very similar to the form of narrative in which the fetishism, national history, national language or tradition is formed, on the one hand, and that those who cannot feel that way should be alienated from the field, on the other. That's exactly the way in which various regimes of national identification have come into being, which necessarily give rise to various forms of exclusion. One of the principles of the modern nation-state is the fundamental distinction between the members of the national community and foreigners, and there is a danger that our own field might duplicate some aspects of the national exclusionism. There are many people who are attracted to cultural studies precisely for the reason that their own backgrounds were in some way oppressed, erased and rejected. They are attracted to those fields because they want to recover their background. I am in no position to deny those people the right to recover their past and reconstruct what has been violently erased. At the same time though, I tend to see a danger in that.

And I would like to have your opinion about this.

SH: Well, I agree with what you've said very much indeed, and I'm sure each of us has experienced this as part of a personal experience. But I'm sure we're talking about something which is more than personal. I do think that form of identification, precisely because it seems so natural – that's where you came from, what else do you know about, go and study the thing you know about best – is difficult. This is a kind of closure, a kind of foreclosure, a kind of foreshortening, it reaches its point of identification too soon. And it is, I think, extremely close to exactly the kind of closure which is a discourse of a national culture, and which naturalizes what is obviously the product of many determinations and many contradictory things that have gone into the making of this assumption of identity as a final sort of point of arrival. I want to give you a sort of inflection which, I think, contributes to this. One of the ways that I first got into the debate about culture was when I was doing graduate work at Oxford, in American literature. I went to – I really taught myself anthropology. I read a great deal of anthropology in pursuit of the idea of culture. What I wanted to know was something about exactly the background from which I came, I wanted to try to understand Caribbean culture. But of course Caribbean culture

has this fault line through it because the majority of the population there are from Africa. They're brought to the Caribbean during slavery. They're obliged to acculturate themselves through slavery, through the plantation system, the horrors of the plantation system. The only book they're allowed to read is the English bible. So when Bob Marley comes to sing of freedom he has only one language to speak of it and it is the language of the Protestant bible and of the exodus from Egypt. He didn't have any other language, he only had the master's language, or some version of it in patois to speak. He had no other way of expressing the desire, the dream of freedom. In thinking about this place which I've come from and that I'm shortly to go back to, I wanted to know, what is it I'm going back to? Now as you know very well, the idea of Africa to that culture is very important. It was suppressed for many, many years. When I was a child I never heard anybody ever refer to anything in Jamaica as having anything to do with Africa. Hardly as having anything to do with slavery, let alone Africa. So the most enormous cultural change has happened in the Caribbean as a result of reidentifying with Africa.

On the other hand, what is the nature of this reidentification? Because the people cannot be African in any pure sense. They're African through Spain, or African through Britain, or African through France. This thing in this third place, the new world, belongs neither to Africa nor Europe but is another sort of space, a kind of scene, a primal scene of the encounter between these two other worlds. They are the product of three worlds. I could only think that to go back home, I don't mean literally whether I was going to go back home or not but, to go back home in my mind or my spirit, I would have to go home to three places. I couldn't go back home to one. And what is more, the most damaging thing would be to try to go back as if the beginning was still there. Not only because of what it would do to me but because of what it would mean to Africa. You see, Africa would be required to end its history and stand still and wait for me to come back to it as it was in the sixteenth century. Africa is now itself something different, it's three centuries ahead, it is through colonialism and into the postcolonial crisis. I can't ask it to solve my identity problem for me. In other words, in my experience, the return has always been a displaced, a pluralized one, a point of trying to go back home but knowing you can never go back home, you can never repeat, you can never get back to the beginning. You can think about that in Lacanian terms. The lust for home is a wish to return to the imaginary but we are already in the symbolic. Home has become symbolic. You would feel things about home, about what it would be like at home, if you could ever really get there. That one feels all the time. But the idea of really being at home, like one's people once were at home in the sixteenth century, forget it. So I've always had to come to terms with that long, protracted, never-arriving way home. I've therefore been deeply suspicious of those people who said, 'I know where I come from, that's who I really am, I could travel the world and I would remain inside whatever that is, and one day I'm going to go back to it and I will settle back into the space that was

originally there.' It's a comforting myth but it's a myth and I think increasingly in our world a dangerous one. That is the myth of national culture. And I think it is, if I can risk the generalization, operating very powerfully in Japanese culture, very powerfully. Which is why I tried to signal that, not just as a topic that we might talk about but in a way as the topic for Cultural Studies in Japan.

NS: Sometimes I have to take into consideration what motivates people in the humanities, and of course one of the very strong moving forces is the one you have just mentioned, this amazing search for origin and identity. But, at the same time, you have to acknowledge there are some people, as you mentioned at this symposium, who need, however temporarily it may be, such narratives that would empower them. But, on the other hand, going back to my own feelings, there are people who do not feel related to the object of the field at all so it's very difficult for those people to be attached to the object of the field. Sometimes I wonder, probably in most cases those who are really involved in the study must have some experiences, for instance, of pain or outrage against certain social reality. And then when you lack that kind of emotive attachment to the object it will be very difficult to pursue a study. So I'm talking about two different modes of attachment to the object of the field.

Probably the case of those who find it very difficult to feel attached to the object of the field can be found, for instance, in the field of English literature in Japan. This is a huge field, an industry, employing probably more than a million people if you include English language instruction methodology and other related areas. I think this is a very serious problem for them. The majority of them are not related to anything British or American, to things English within the range of objects authorized by the discipline, provided that we limit the sense of 'relatedness' to that of naturalized cultural, ethnic, or national heritage. It should be very hard for them to feel strongly attached to it if they do not develop their own different modes of attachment. Why do Japanese scholars of English have to spend months and years to produce scholarly books about nineteenth-century English writers which no experts from Britain will ever read because they are written in Japanese? To my knowledge, Japanese scholars in English literature seem much less involved in scholarly debate and conversation with scholars of the English-speaking world than Japanese scholars in Japanese history or literature, for example, today. A peculiar insularity seems to characterize English literature in Japan in which all the recent developments in English literary studies in the United States, Britain, Australia and so forth are introduced but apoliticized and sanitized. Although there are clearly ways for scholars of English in Japan to positively *relate themselves* to the objects of their field, English literature as a discipline tends to discourage people in the field from seeking new ways of attachment which will inevitably be political. I was rather surprised that so few people from English literature attended our symposium on cultural studies, knowing that cultural studies is such a big thing in English in the United States.

370

Here, I would also like to stress that many disciplines in the humanities are said to originate in the so-called West or Western Europe. I cannot think of any domain of knowledge where the paradigm of what you call 'the West and the Rest' is more conspicuously dominant than the humanities. One of the reasons why a student wants to study European art history, for instance, could well be explained by the fact that the discipline of Art History itself appears to be somewhat innately related to the object of the field. In the United States, if we abide by this mode of attachment to the object of study, a mode of attachment through the naturalized sense of ethnic origin, many of the disciplines in the humanities, philosophy, literary studies, psychology, and so forth, would merely become the sub-genres of what could be called European American studies, although such a field does not exist yet. The situation would be even more severe in Japan, because, for the last one hundred years or so, most of the Japanese intellectuals were disciplined in those Eurocentric fields, and the majority of Japanese intellectuals formed their own individual culture by reading Western thinkers and writers. Most Japanese intellectuals and a great number of the non-Western intellectuals cannot feel innately attached to things European, but, unknowingly perhaps, they managed to develop certain different modes of attachment to them. They have proven that it is possible to develop different modes of attachment particularly through their political engagement in the local situations. We have already mentioned the case of Marx in Japan.

What I am afraid of about our field is that Japanese Studies in the United States could well be like that of English literature in Japan, if new modes of attachment are not found. Until recently there have been certain ways in which those in the field who were not innately, or through ethnic origins, related to the objects of our field could feel attached to them. In spite of a lack of innate connections with Asian societies and cultures, they could keep interested in them because there were certain regimes through which certain forms of attachments were produced. The Modernization Theory is probably the best example in this respect. Asian experts could be interested in Japan or Asian societies, because they could weave narratives in which the superiority of the West or the United States could time and time again be affirmed in reference to some observed features of these societies. In this case too, however, the West is typically a historical construct as Gramsci explained some seventy years ago. Thus the contour of the West is shifting all the time, and it would reveal itself excessively overdetermined and indeterminable, unless it is sustained by a lot of myths and fantasies about the West and the Rest, as you have analyzed the 'idea' of the West on a number of occasions. In that those narratives could repeatedly insert the reflection of the West's or the United States' advance over those societies on almost every phenomenon those experts encountered there, the narratives were essentially narcissistic. People in Asia were represented as adoring the putative West and tirelessly seeking to catch up with it: 'Japan is almost an American style democracy, but not quite'; 'Asian peoples try to modernize

their societies to certain extents, but not quite at the level of Western liberal capitalisms'; and so forth. Often implicitly constructed in those narratives is the sexualized perception of the relationship between the West and Asia. The scenario of Madam Butterfly could be found in one modified form or another, in almost every one of those narratives, even in the domains of social scientific discourses. But, recently, as typified by the news of the trade imbalance, technological competition, and the prospects of economic growth in Asian countries, there have been an increasing number of instances in which this narcissistic attitude has been undermined. Concurrently some Japanese and Asian intellectuals begin to generate the narrative of Japanese superiority over Europe or the superiority of Asian values over Western values, as if they had wished to simply replace the Eurocentric narcissism with Asiacentric narcissism. Perhaps those ethnocentric non-Western intellectuals are not aware of it, but this form of mimicry, too, relativizes Eurocentric narratives and renders them glaringly obvious.

Since those experts' attachment to the non-West of Asian societies and peoples has been sustained by their desire to identify themselves with the idealized image of the West, these instances often either make it very difficult to keep them interested in the object of the field or to induce them to withdraw their libido from these objects. This tendency for the scholars to withdraw their interest and curiosity from the non-West, which I have called 'Return to the West', has become more and more conspicuous in not only the Asia-related fields, but also in the humanities in general. Under such circumstances, one may rather find a parallel development between the emphasis on national or ethnic culture on the part of people who wish to speak on behalf of the dispossessed ethnic communities, and a 'Return to the West' on the part of those experts who are not innately related to the societies of 'the Rest'. It is, they who regard themselves as 'the Westerners' repeatedly claim, 'because minorities are ethnocentric' that they are entitled to be equally ethnocentric. Too often, the 'Return to the West' means a return to culturalism. In Japanese studies, the notion of national culture is increasingly popular, not among those who feel innately attached to the object of their study, but among those who cannot feel that way.

What I believe to be one of the most productive and attractive aspects of so-called postcolonial theories is that new approaches allow not only those who can claim to occupy the position of the putative victims, but also those who are put in the position of the victimizers to address these erased histories *together*, to confront the various effects of histories which have separated them, not in isolation but in some common social space. Even those narratives about the erased histories must not be collective monologues to be circulated within the confine of an ethnic or national community: these must be enunciated across ethnic, racial, and national boundaries, dialogically.

Although it should certainly not appear 'comfortable' to many Japanese, particularly males, to listen to the stories of the comfort women in Korea, the

Philippines and so forth, for example, it is very important to maintain some common social space where the putative victims and the putative victimizers can be co-present and where we can learn through debates and interactions that the division between the victim and the victimizer is far from clear and is overdetermined. And, my concern is how to turn disciplines such as the field of Japan studies or Asian studies into such a common social space. That is, how to prevent those not innately related to the object of the field from returning to the West or returning to Japan. In fact, many people who are not innately related to the objects of the fields have managed to be genuinely and personally involved in them. My question is how can I learn from them different ways to relate myself to the object of the field, different modes of attachment.

You have studied those issues extensively. You have contributed so much to our understanding of these two directions, one about the erased histories of the dispossessed, the recovery of which is absolutely necessary, but could lead to the naturalization of ethnic, racial, or national identity, and the other about the withdrawal and disavowal of the colonizers particularly in the events of the loss of empire which also leads to cultural nationalism. Postwar Japan is a very interesting case because these two extreme opposites are synthesized in its cultural nationalism, in the obsession with 'Japaneseness', due to the history of Japanese imperialism and the postwar East Asian situation as well as the prevailing paradigm of 'the West and the Rest'. But your work seems to indicate that there are some ways of avoiding the two opposites, and then you're trying to work out the ways to link two different possibilities.

SH: Yes, you're very shrewd about that. It's a sort of characteristic of mine to think I can have my cake and eat it. It's sometimes called believing in the third way. I feel that about this question of identity, because I feel almost as powerfully on the one hand that you can't go home again, but on the other that if you don't know what it is to want to go home, you have no attachment to anything. I suppose a lot of my work in the last ten years has been exactly about how to theorize and conceptualize identity and identification which holds these two things together. I mean, the closest that I can come to it is to say that, of course, all enunciation is positioned. Without positioning, there is no meaning. You have to take up a position. If we believe in the infinite semiosis of meaning, no position is final. It's a question of how to think the need for a positionality that is not final, what a not fully closed position is. I'm trying to think identity exactly like that. The reverse side of the sides that, you were pointing me to, of wanting at the same time to acknowledge one's histories, one's languages. I'm not one thing, but I've come by this route, the fact that I've come by those languages and that set of experiences and those histories, it makes my route and identity different from yours. It's very particular and I must feel attached to it and thus to its vissitudes which includes its pains, its wounds, its losses, its absences. What I've described to you about the Caribbean, being always elsewhere, is rightly seen by Caribbean writers and poets as a loss. One

has got to be committed to always telling the story of travelling and never telling the story of arrival. Arrival is always an enigma, as Naipaul has said. For us, 'travelling, travelling, travelling', is why one of our finest poems, which is Derek Walcott's *Omeros*, is a poem like Homer's *Odyssey*. It says the Caribbean is like Homer, we are endlessly on the sea trying to get home, but we can't. So I think our narratives are always narratives of loss and wounds, and what constitutes that loss for us historically is slavery and its aftermath. And that is, you know, just a permanent, deep, profound fissure in our collective consciousness. I'm bewildered by the depth of the wound of slavery. Absolutely bewildered by it. Only in *Beloved*, or some novels, only in Toni Morrison, does one occasionally begin to get a literate representation that explains to one why so many years afterwards, it is as if it happened yesterday. None of this is without its attachments, and the pains and strengths and pulls and so on of attachment. I agree with you that it would be hard to understand what a purely intellectual commitment to these things would be, if the fate of the object of investigation was not of any consequence to you. That is to say, I would put it this way, although many people would misunderstand what I meant; if it wasn't a political project. I think it's a political project, because you have to take a position in relation to it. Which doesn't mean, of course, that you have to tell yourself lies about it or fake it, but you do have to invest in the position. It has to matter to you which story comes out, which story you are able to tell yourself, which stories you can live by, which fictions you can bear, and which you can't bear. It has to matter to you all the time. And thus the intellectual project is in a sense – I'm kind of with Max Weber there – so powerful, that you need methodologies to set you apart from the pain a little bit, so that you can look at it for long enough to find out how it works. So it's quite the reverse, it's not the scientific attitude laid out on the table like an anatomy, and it doesn't matter to me if I discover later either cancer or tuberculosis or whatever. It can't be scientific. The interest in the fate of cultures cannot be of the nature of a blind neutral scientific fact. Which means, that the study of culture is always motivated. It is always motivated by exactly those attachments. What I think, then, is that one has to think about the multiple nature of the attachments. They're not one, there are many attachments, and there are attachments in different places and different moments and different times, and they sometimes conflict with one another rather than just reinforcing one another as you go along. So you're always prevented from that kind of closure that we were talking about before. It's not, it cannot be. That is why I've only explored those methodologies which are non-positivistic in character. Because I think positivism assumes that the object of investigation is outside of the purchase of one's commitments. I mean, it may be true in biology or genetics, but in the human social sciences that cannot be the nature of the object of investigation.

NS: I think you have already pointed out and have expressed well the danger of one of the most likely scenarios for cultural studies in Japan is that culture

studies will be appropriated by cultural nationalism. That is the danger that we really have to denounce aloud. But it seems to me that the attraction of cultural nationalism is in fact related to what you just mentioned about positioning. Because, going back to the question of the imperial past, there is a past that indicates unambiguously that Japan was an imperial nation. But it is very difficult for the Japanese to admit it. People here once occupied the position of victimizers not victims. Of course, there are degrees and nuances, and I would really hesitate to put all the people in Japan in one category, particularly in view of the fact that a great number of people who had been Japanese subjects suddenly became non-Japanese as the empire was lost.

None the less, in many instances, the majority of people here have to begin to speak by really marking the position as victimizers in order to talk to people without and within Japan. And it seems to me that postwar cultural nationalism served to make it possible for them to put themselves on the side of the victims. In a sense their yearning for some kind of loss is fully understandable. But in order to prevent this form of, what shall I say, victim fantasy, from foregrounding Japanese relations to people in Asia and minorities within Japan, it is absolutely essential to emphasize that, through cultural studies, we are able to study such workings of cultural nationalism which is dominant in Japan.

SH: I think the separation between cultural studies and cultural nationalism is extremely important. And I think it's somehow more important in Japan than it is in Britain. I don't quite know why, because Britain after all is also an imperial formation. The heritage industry has its own form of cultural studies, it has its own version of the culture that permits the closure of cultural nationalism to occur everywhere, and we are absolutely full of it in England. In television, in films, in the structure of theme parks, one way or another; cultural nationalism has hold of the culture without bothering to go through cultural studies. But I can see where in the Japanese circumstances, it might be a very convenient route to go precisely to producing that cultural nationalist closure. I think that separation is important. But what is lying behind your question is almost, well I suppose, the question that might be rephrased like this: If, then, in order to prevent that closure, it is necessary to mark, how can one mark without beginning to inhabit that position or positionality as if it is a permanent fixed position? If you mark outside and inside, what prevents the political from simply repeating? It is that fantasy of opposition which puts someone permanently in the victim's status, etc. What enables you, at the same time, to take on the extremely uncomfortable thought that it is possible to be both victimizer and victim? Yes, until we can get those two markings to occupy the same space we are in difficulties.

I have to say to you that, in some ways, that is why in recent years I have drawn more on psychoanalysis than I have before. I know all the problems about the Eurocentric nature of psychoanalysis, but as a form of thought, it does help one to think the double-sidedness of the ambivalence of cultural process.

That one is both victimizer and victim, one is driven by violence and desire at the same time. That the rejection is a form of desire and so on. This is a very uncomfortable way of thinking, and it is also extremely difficult to understand what our politics is like when framed from that point of view because our politics is grounded on the fantasy of the barricade. Politics means drawing the line. The enemy over there, us over here, and the barricade's in between. And that's not just the class struggle, whatever it is, that's how we think of politics. Politics as the frontier. So how can you create the necessary frontier effect which allows you to fight the struggles you need to fight, and indeed to be an ethical human being at all. You have to make some choices between one way of doing something and another. You have to say, that is the wrong way. How can you do that with conviction which mobilizes action and energy and creates institutions and organizations and movements, and still say 'Actually if I were in their place, I might do the same thing.' You see? Ambivalence takes the rug from under your feet. The ground of moral certitude on which you were trying to stand, I am the wounded or the injured, is immediately reversed, because you are also the injury. And we see those moments occurring again and again in politics.

In my case, there is a very particular version of this which troubles me profoundly, which is the way in which many black men live their racial subordination as a form of patriarchal relation to their own women. The racial discourse requires you to struggle against the white plantation owner and his progeny who will always call you a boy. You compensate for being a boy to the white man by being a, being a father to your wife, to put it crudely. This is a very profound crisis inside the black community itself, and one could repeat that again and again and again. Gender is, I think, a particularly interesting case, because it exactly cuts across those other well-established frontier antagonisms. We sort of know how to manage them, until gender draws a line in some peculiar way. So that where you had just found yourself with an enemy in your sight, you discover that there's also an enemy in the line beside you looking the same way, who usually asks you to postpone this particular struggle until we've sorted that out. Don't talk about feminism until we've freed ourselves.

We're talking about what the nature of modern politics is. That is, the proliferation of antagonisms. It's not that antagonism has gone out and the class struggle has ended, and there's nothing to fight about. There are hundreds of things to fight about. The difference is that they don't converge into a single us and them, the whole class versus the whole class, or the whole of the victims and the whole of the victimizers. They keep positioning us in different ways, and we can just about bring ourselves to understand what that is like to inhabit but I don't know that we know how to conduct a political struggle on these novel terms. Consequently, one is driven back to a 'strategic essentialism'. In the absence of a more differentiated struggle, you have to return to an appeal to some culturally essentialist identity – 'black' or 'Japaneseness'. Black kids can't wait for me to solve the conceptual problem of how to occupy two fronts at the same time while they are being mown down in the streets by the Los Angeles

police. You know, I'm sorry. You've got to confront them, you need some friends. If you say black and people will run to you, you're not interested in whether that's essentialist or not. It works. You get some mates. So I think we're caught, which is why we're in a moment of extraordinary political confusion, because we just don't have the recipes for saying, this is what a differentiated, non-essentialist, non-reductionist ethical political life would be like. We don't know how to live that. We are caught between the fragmentation of these different struggles and their proliferation, and our conceptual difficulties. Therefore, we need new ways of thinking about identity and positioning in this fragmenting situation. Meanwhile, these very old and archaic political struggles for survival and recognition and so on still have to be fought, and in a sense with the old weapons.

NS: Well, probably you have heard about the case of the comfort women. There was an incident just last year in Okinawa, which had a similar implication. Very complicated problems of race and of the remnants of imperialism, such as extraterritoriality, are present in it. I sometimes wonder how I could possibly address myself to an Okinawan woman, when the speech situation does not allow us to put aside or ignore the history of the turbulent relationship between Japan and Okinawa.

In speaking to Okinawans, for instance, you would probably have to begin by marking your position as a member of Japan proper. But, as soon as you do so, you would probably have to consider another question. Is this distinction between Okinawa and Japan proper itself, not discriminatory? But, then, is it justifiable to include the Okinawans and yourself under the general category of the Japanese? I am sure more questions would arise. So, this initial marking does not confine a person to that position at all. Rather it is a step to be taken in order to realize that the position you hold is internally fragmented, far from being a stable closure, and in fact is open to multiple commitments and multiple contexts. It is necessary to mark your position in order for you not to be contained by it.

If we could think about these multiple contexts not separately but simultaneously, we may be able to deal with the question of cultural nationalism itself, not simply for the benefit of international relations but for the sake of those histories of the dispossessed who absolutely needed to consolidate their alliance against unbearable adversaries at one time or another.

SH: Yes, I agree.

NS: Time and time again, you have reminded me that it is important to keep in mind that the dispossessed are never fully allowed to speak out. If one assumes that everyone is capable of speaking out, one would then forget that there are always certain people whose history is invariably repressed.

Note

1 The dialogue between Stuart Hall and Naoki Sakai took place in Tokyo, right after the 'Dialogue with Cultural Studies' Conference, organized by Professor Tatsuro Hanada (with the Institute of Socio-Information and Communication Studies, the University of Tokyo), 15–18 March 1996. We wish to thank both of them for allowing us to include the English version of the dialogue in the book, as well as for their support of the project.

We wish to acknowledge and thank Iwanami publisher (Tokyo) for granting the right of publishing the text. In particular, we deeply appreciate Mr. Kiyoshi Kojima, the editor of *Thought* (*Shiso*), for his effort to set up the interview, his patience in facilitating the flow of texts (between Tokyo, Ithaca, London and Hsinchu) and communications after the event, and his unfailing support on different fronts.

INDEX

Note on personal names: Chinese (including some Singaporean and Taiwanese names), Thai and Malay names have not been inverted and will be found under the first part of the name as given in the text.

nation-states 34–41; and Europe 93; formation of 186–205, 306; homogenization of 61–2; *see also* statehood
National Association for the Advancement of Colored People (NAACP) 264
nationalism 1, 12–15, 18, 20, 80–1, 148; black 265, 266; Chinese 153–85; cultural 374–5, 377; as defense 62–64; East Timorese 228; entrapment by 37; ethnic 14, 35, 38–9, 98, 161; in Indonesia 228, 236–7; and Marxism 6; Nation Thing 81–3; postcolonial 26–7, 30
nativism 1, 15–16, 19–20, 20, 25
natural resources exploitation 59–60, 62–3
Nawikamoon, A. 207, 213
Nedvereen, Pieterse J. 93, 102–3
Negritude *see* postNegritude
Negro identity 66
Nehru, Jawaharlal 6
neocolonialism 1, 2, 13–14, 19–20
Netherlands: Dutch colonialism 91; television content 106
New Left movement 366, 367
New Left Review 362
new social movements in Korea 330–45
Newsweek 105
NGOs (non-governmental organizations) 351, 355–8
Ngugi Wa Thiong'o 9
Nicaragua 350–1
Nietzsche, Friedrich 7, 235
Night Cries: A Rural Tragedy (film) 256

'oceanic imagination' 5
Oedipal complex 71, 292, 293
Ofreneo, R. 59
Okakura, Tenshin 30, 68–71, 75–7, 79–81, 82, 83, 84; 'Asia is one' 31, 34
Okinawa comfort women 377
O'Reagan, Tom 241, 247, 253
Orientalism 77, 88; Australian 240, 259
Osamu, Dazai 65
Oswald, Eric 365
Otto, Peter 242, 243, 244
Oxford University 362–3

Paibun Butrkan 211
Pakistan 148; Hong Kong films in 123

pan-Asianism 31
Parkerson, Michelle 269
Patton, Cindy xv, 44, 316, 318–28
Pearson, Noel 306
Pei-chuan Hsieh 285, 287, 288–9
Penley, Constance 241
Pennycook, A. 202
People's Plan for the 21st Century (PP21) 46–7, 348, 350, 351, 353–4
Perera, Suvendrini 240
Philippine–American War 57
Philippines: AIDS activism in 44; cultural studies and the state 40; drug industry in 61; religion in 57; social activism in 49; Westernization of 57–64
Phobia (film) 255–6
'phobic narrative' 246–7
photographs and cultural activism 300
Phutharaporn, K. 213
Pipat Boribun 211–12
Pitt, Brad 292
Plato 147
Pleng Luktoong (Thai pop music) 36, 206–27
PLWA movement, Uganda 317–18
Police Story III, The (film) 134
political activism 299–300
Pongsri Woranut 215
pop music: Thai 35–7, 206–27
Pope, Alexander 257
popular culture: homophobia/homophilia in 294–6; *see also* pop music, Thai
popular movements *see* social movements
postcolonialism: critical syncretism 20–9; postcolonial nationalism 26–7, 30; 'postcolonial' resentment 5; postcolonial studies 3, 5–6, 28–9
postmodern in European culture 97, 106
postNegritude 38, 267, 268–9, 274, 279
PP21 (People's Plan for the 21st Century) 46–7, 348, 350, 351, 353–4
Prani Wongtes 209, 213
press movements in Korea 330–45
Pringle, Rosemary 245
privatization in Singapore 199, 200
prostitution 319–20, 321, 329; *see also* comfort women; sex tourism
psychoanalysis 375; of black identity 11; of decolonization 12; and idol worship 292–3; Oedipal complex 71, 292, 293